THE PELICAN HISTORY OF ART

Founding Editor: Nikolaus Pevsner

Joint Editors: Peter Lasko and Judy Nairn

J. C. Harle

THE ART AND ARCHITECTURE
OF THE INDIAN SUBCONTINENT

James Harle is Keeper of Eastern Art at the Ashmolean Museum and a
Student (Fellow) of Christ Church, Oxford. He also lectures for the
Oriental Studies faculty of the university on Indian art and architecture.
His interest in Indian art dates from his first visit to the subcontinent in
1951; since then he has returned almost annually. His two earlier books,
Temple Gateways in South India and *Gupta Sculpture*, both broke new
ground, and he has contributed articles to learned journals on most aspects
of Indian art through the ages. The present work, the product of many
years' research, attempts to give as complete an account as possible within
the compass of one volume of the glories of India's three-millennia-old
artistic and architectural heritage.

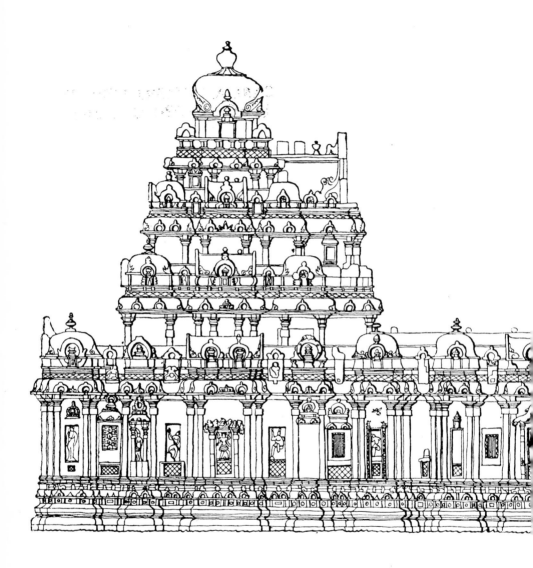

J. C. Harle

The Art and Architecture
of the
Indian Subcontinent

Penguin Books

Penguin Books Ltd, Harmondsworth, Middlesex, England
Viking Penguin Inc., 40 West 23rd Street, New York, New York 10010, U.S.A.
Penguin Books Australia Ltd, Ringwood, Victoria, Australia
Penguin Books Canada Limited, 2801 John Street, Markham, Ontario, Canada L3R 1B4
Penguin Books (N.Z.) Ltd, 182-190 Wairau Road, Auckland 10, New Zealand

First published 1986

ISBN (hardback) 0 14 0560.49 1
ISBN (paperback) 0 14 0561.49 8

Typeset in Monophoto Ehrhardt
and printed by Butler & Tanner Ltd, Frome and London

Designed by Gerald Cinamon

TO BETTY

CONTENTS

PREFACE

The original Indian volume in *The Pelican History of Art* series, Benjamin Rowland's *The Art and Architecture of India: Hindu, Buddhist, Jain,* first published in 1953, dealt with South East Asia as well as with the Indian subcontinent. The present work oversteps the political boundaries of India only to include Afghanistan, Bangladesh, Nepal, Pakistan, and Sri Lanka, but it adds a section on Indo-Muslim architecture.

I have adopted a fairly conventional art-historical approach, emphasizing styles, their character, origins, and development, and supplying only as much of the cultural background as seemed necessary for an understanding of the basic features of artistic, sculptural, and architectural forms. In a field where the great preponderance of art, mainly religious, relies to some extent at least on ancient traditions, many areas of interpretation are open - geomantic, cosmological, mystical, and sometimes, in the later periods, magical. Any charge that some of these interpretations seem unnecessarily arcane, or derived from rather than underlying a sculpture or a building, may be countered by pointing to the fact that craftsmen and builders today still invoke traditional texts, albeit usually accepting their precepts in a simplistic way which has little to do with actual practice. Stella Kramrisch's great *The Hindu Temple,* published in 1946, remains by far the most important study of the temple in all its aspects, in all periods. In its comprehensiveness and its inspired exposition of the conceptual basis of the temple and its sculpture, based on traditional Indian sources, her book is one of the intellectual monuments of our time. Although I have not been able to follow its approach, the sheer distinction and originality of its conception, richly and unwaveringly executed, has been my principal inspiration during many years devoted to the study of Indian art and architecture.

My dating of the post-Gupta age - from *c.* 550 to *c.* 950 - will not meet with universal acceptance, but research into this, perhaps the most fascinating period of sculpture and architecture on the subcontinent, has only confirmed my sense of the rightness of my decision, in *Gupta Sculpture,* to end at about A.D. 550, a date which includes a 'late' or 'later' Gupta period. I have eschewed the term 'medieval', meaningless in the Indian context, for the years from *c.* 950 to *c.* 1300, as did Rowland, preferring 'Later Hindu' as a substitute. Tamilnāḍu and Kerala, the true South India in my opinion, have been treated outside the chronological framework of the remainder of the book.

References are not exhaustive but are included, in the conventional way, to provide authority for statements or views, or to furnish additional information too detailed or specialized for the text. They are also intended to provide the lay reader with an entrée into the relevant scholarship: earlier accounts referred to in a more recent work are not listed. Unfortunately, owing to delays in writing and publication, the text has been established with reference to scholarship published up to and including 1981, and in some cases 1982. A great deal of importance has been published in the following few years, with which I am generally familiar, but of which I have not been able to take account in the text. Some of the principal works in this category are included in the bibliography with asterisks. Citations, abbreviated in the notes, are given in full, chapter by chapter, in the bibliography. No glossary has been provided: instead, the system adopted in the index will direct the reader to full definitions incorporated in the body of the text.

I would like to record my gratitude to the Visitors of the Ashmolean Museum, Oxford, for the grant of two periods of sabbatical leave, without which this book would have taken even longer to complete. I am also particularly grateful to Mr M. S. Dhaky, Mr Simon Digby, the late Professor J. E. van Lohuizen-de Leeuw, Dr P. Pal, and Mr W. Zwalf for having consented to read chapters of the book. Many museums throughout the world have most kindly provided photographs of objects in their collections; I have especially drawn upon the archives of the Archaeological Survey of India and the Center for Art and Archaeology of the American Institute of Indian Studies. Dr Kapila Vatsyayan, Additional Secretary, Ministry of Education and Culture, Government of India, provided invaluable support at a critical moment. Finally, I would like to signal my unstinting admiration for Mrs Judy Nairn and Mrs Susan Rose-Smith, editor and illustrations editor respectively.

GUIDE TO PRONUNCIATION

a	*as in*	America	au	*as in*	house	
ā		father	r		pretty	
e		maid, there	c		church	
ai		aisle	ch		churchhouse	
i		sit	th		anthill	
ī		litre	dh		redhead	
o		note	bh		clubhouse	
u		foot	ṁ	ṅ	ṇ	sing
ū		boot	r		red	

The t and d sounds in Sanskrit t, th, d, and dh are true dentals, i.e. the tongue is pressed up against the teeth. The sounds represented by Sanskrit ṭ and ḍ in ṭ, ṭh, ḍ, and ḍh are approximately the same as in English.

ś and ṣ are pronounced *sh*.

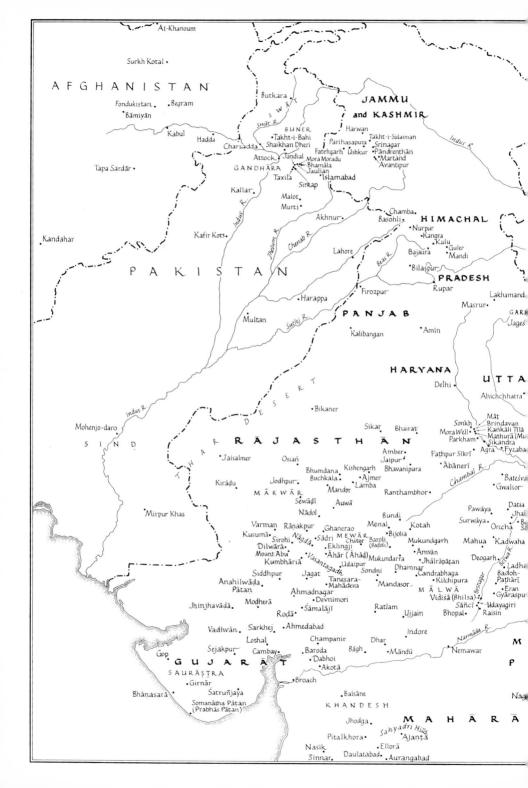

NORTHERN and CENTRAL INDIA

showing sites named in the text

0 100 200 miles 0 100 200 300 km

C H I N A

T I B E T

Brahmāputra (Tsangpo) R.

m ā

N ll a y a s

E

(see map at beginning
of Chapter 35)

P

BHUTAN

UDH

Śrāvastī · Lumbini

RADESH

Kapilavastu

L

Brahmāputra R.

ASSAM

Kanauj · Lucknow

Kuśinagara

Lauriyā Nandangarh

rgaon

Vaiśālī · Rampurva

alabhagat Gangā (Ganges)

Jaunpur

Chausa

Kumrahar

Vikramaśīla (Antichak)

Mahāsthān

Yamunā (Jumna) R.

Allahabad

Patna Gangā (Ganges)

Hankrail

Pāhārpur

Kauśāmbī R. Varanasi · Sārnāth

Masārh

Nālandā

Rajaona Sultanganj

Gaur · Nārhattā

Gadhwā · Bhītā

Rājgir · Aphsad

·Mankuwar Chunār

Ramgarh Barābar

Kurkihār

raho

Kālanjar

Mundeśvarī Sasaram

Hills Dāpthū

BANGLADESH

ELKHAND Baijnath

Masaum

Bodhgayā

B I H Ā R

Dhaka
(Dacca)

Bhārhut·

Candrehi

āchnā

Bhumara

MAGADHA

Murshidabad·

Maināmatī

uthara ·

Marhiā

Barākar·

Burdwān·

W E S T

Jabalpur

Kukurnāth

B E N G A L

Candraketugarh

ghat

Bilaspur

Tamluk· Calcutta

H Y A

Khiching·

B E N G A L

D E S H

Kharod · Rājagrha

Mahānadī R.

Sirpur·

Gangā Sāgar

Bay of Bengal

auni

· Rājjim

O R I S S A

Lalitagiri

RA

Khandagiri
Hill

Ratnagiri

Cuttack

Bhubaneswar

Udayagiri Hill

Śiśupālgarh

Dhauli

Chaurasi

Konarak

Puri

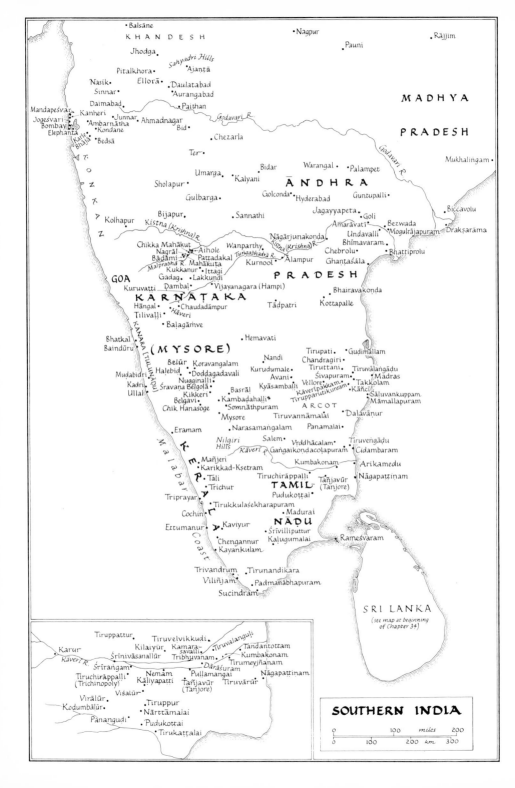

• Balsāne

KHANDESH

• Nagpur

• Pauni

• Rājjim

Jhodga •

Sahyadri Hills

• Ajantā

Pitalkhora •

Nāsik • Ellorā • Daulatabad

Sinnar •

Daimabad •

Mandapeśvar • Kanheri • • Junnar

Jogeśvari • • Ambarnātha • Ahmadnagar

Bombay • • Kondane

Elephanta • • Bedsā

Kārle

Bhājā

Paithan

Godavari R.

MADHYA

PRADESH

• Mukhalingam

Aurangabad

• Bid

• Chezarla

Ter •

• Bidar

• Warangal

• Palampet

Umarga •

• Kalyani

ĀNDHRA

Sholapur •

Gulbarga •

Golconda • • Hyderabad

• Guntupalli

• Biccavolu

Bijapur •

Kolhapur •

Kistna (Krishna) R.

• Sannathi

Jagayyapeta •

Goli •

Amarāvatī • • Bezwada

• Drakṣarāma

Chikka Mahākūt •

Nagrāl • • Aihole

Bādāmi • • Pattadakal

Malprabha R. Mahākūta

Kukkanur • • Ittagi

Gadag • • Lakkundi

Kuruvatti • • Dambal

Wanparthy •

Tungabhadra R.

Kṛṣṇā (Krishna) R.

Nāgārjunakoṇḍa •

• Undavalli

• Bhīmavaram

Chebrolu •

• Mogulrājapuram

• Bhattiprolu

GOA

KARNĀTAKA

Hāngal •

Tilivaḷḷi •

• Chaudadāmpur

• Hāveri

• Balagāṁve

Kurnool • • Alampur

Ghantaśāla •

• Vijayanagara (Hampi)

PRADESH

• Bhairavakoṇḍa

• Tāḍpatri

• Kottapalle

Bhatkal •

Baindūru •

(MYSORE)

• Hemavati

• Tirupati • Gudimallam

• Nandi Chandragiri •

Kuruḍumale • Tiruttani •

Avani • Śivapuram • Tiruvālangāḍu •

Belūr • Koravangalam •

Halebid • • Doddagadavali

Nugginalli •

Mudabidri • • Śravana Belgoḷā

Kadri • • Kikkeri

Ullāl • Belgavi •

Chik Hanasōge •

• Kyāsambaḷḷi

Vellore •

Kāverippakkam •

Tirupparuttikunram •

• Madras

• Takkolam

• Kāñcī

Basrāl •

• Kambadahaḷḷi

• Somnāthpuram

Mysore •

• Narasamaṅgalam

• Tiruvannāmalai

• Panamalai

ARCOT

• Sāluvankuppam

• Māmallapuram

• Dalāvānur

Eramam •

Nilgiri Hills

Kāverī R.

• Salem

• Vṛddhācalam

Gangaikondacolapuram •

• Tiruveṅgāḍu

• Cidambaram

• Mañjeri

• Karikkad-Kṣetram

• Tāli

• Trichur

Tripprayar •

• Tirukkulaśekharapuram

Cochin •

Ettumanur • • Kaviyur

Tiruchirāppaḷḷi •

Tanjāvūr •
(Tanjore)

• Kumbakonam

• Arikamedu

• Nāgapaṭṭinam

TAMIL

• Pudukoṭṭai

NĀḌU

• Madurai

• Śrīvilliputtur

• Kalugumalai

Malabar Coast

KERALA

• Chengannur

• Kayankulam

• Rāmeśvaram

Trivandrum • • Tirunandikara

Viliñjam • • Padmanābhapuram

Sucindrām •

SRI LANKA

(see map at beginning
of Chapter 34)

Tiruppattur •

Tiruvelvikkudi •

• Karur

Kāverī R.

Kilaiyūr •
Śrīnivāsanallūr •

Kamara-
savalli •

Tiruvalanguḷi •

Tandantottam •

• Kumbakonam

Śrīrangam •

Tribhuvanam •

Tirumeyjñanam •

Tiruchirāppaḷḷi •
(Trichinopoly)

Nemām •

Kaḷiyapaṭṭi •

Dārāśuram •

Pullamangai •

• Nāgapaṭṭinam

Viśalūr •

Tanjāvūr •
(Tanjore)

Tiruvārūr •

Virālūr •

Kodumbāḷūr •

• Tiruppur

Pānaṅguḍi •

• Nārttāmalai

• Pudukoṭṭai

• Tirukaṭṭalai

SOUTHERN INDIA

0 100 miles 200

0 100 200 km 300

EARLY INDIAN ART

EARLY MONUMENTS AND SCULPTURE

Traces of human activity, almost entirely limited to animal remains and to flint tools and weapons, have been found in India stretching back at least 150,000 years. Relatively recently on this time scale, the inhabitants of the subcontinent discovered fire and commenced – not necessarily in this order – to domesticate animals, to raise crops instead of relying for nourishment on hunting or food-gathering, to make and decorate pottery, to use metals, and to construct permanent buildings. These neolithic and chalcolithic societies were not innocent of art in the widest sense, as proved by the not infrequent beauty of form and finish of their pots and of their copper and bronze implements.[1] Human and animal figures in terracotta are fairly common, and they have also been found scratched or painted on rock surfaces.[2]

Thanks to the unprecedented number of excavations since Independence, many of the highest technical standard, a great deal is known about the material aspects of these societies and their links with ancient cultures in Iran and even Turkmenistan. However, in the absence of writing, or of any recognizable shrines or indisputable cult figures, their religious ideas remain unknown, except for what can be divined from the elaborate modes of burial of the megalithic peoples of South India of the Iron Age (c. 700-200 B.C.) of rituals concerned with death. Writing, the creation of cities, large buildings, tombs, and canals, and presumably integration into wide-ranging political structures was yet to come. India still has enclaves of people living in similar conditions, and it is the studies by anthropologists and ethnologists of these so-called tribals that shed most light on the non-material aspects of life in this environment, at least until the second millennium B.C. The early cultures, in detail bewilderingly varied to all but the professional archaeologist, all conform to this pattern.[3]

The one exception so far discovered comprises the cities and settlements of the Indus or Harappan civilization (c. 2250-1750 B.C.)[4] now known to have extended over an area of at least 1200 by 700 miles, from west of the Indus to the longitude of Bombay, and as far north as the sub-Himālayan Panjab and the environs of New Delhi. Although largely derived from earlier chalcolithic societies, some of which survived it, the Indus civilization stands in complete contrast and is marked by an astonishing uniformity wherever it appears, by the existence of writing, and by the development of cities. Hence it is to the city-cultures of Mesopotamia that one must look for parallels, and Indus seals and sealings found there provide proof of physical contacts between the two civilizations.

Among the settlements of the Indus culture Mohenjo-daro and Harappa, both now in Pakistan, one a couple of miles from the present bed of the lower Indus, in Sind, the other on the Ravi, a tributary in the Panjab, were preeminent both in size and in the wealth of ob-

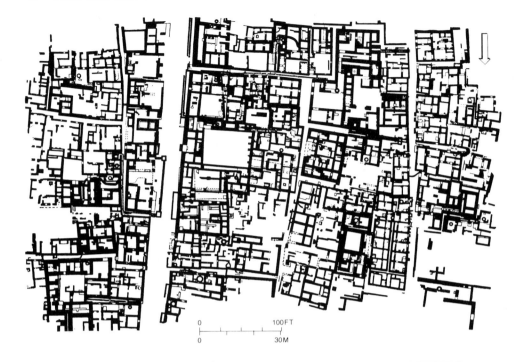

0 100 FT

0 30 M

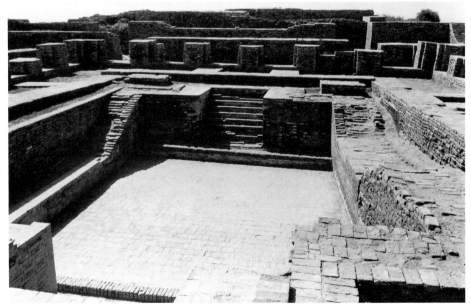

1 (*left*). Mohenjo-daro.
Harappa or Indus Valley Civilization,
c. 2300–1750 B.C. Plan

2 (*below, left*). Mohenjo-daro, Great Bath.
Harappa or Indus Valley Civilization,
c. 2300–1750 B.C.

toys. There is only a handful of works in stone, all small, and bronze figures, such as the celebrated dancing girl [3], are equally rare. The craftsman's skill is probably at its highest in the seals which have been found in great number bearing animal and (partly theriomorphic) human figures and short inscriptions in the Indus Valley script. Bulls, including the humped Brahmin type, buffaloes, rhinoceroses, tigers, are among the rich variety of ani-

3. Dancing girl from Mohenjo-daro.
Harappa or Indus Valley Civilization,
c. 2300–1750 B.C. Bronze.
New Delhi, National Museum

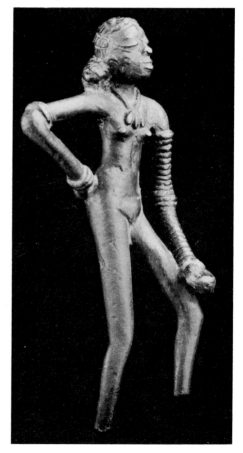

jects of all kinds which have been recovered from them. Nevertheless, among other sites, the more recently discovered Lothal, with what is almost certainly a rectangular graving dock built of masonry and once accessible from the Gulf of Cambay, and Kalibangan, on the now dried up Ghaggar river in Rājasthān, show the same pattern of fortifications, citadel and lower town. Rectilinear street plans were rigidly imposed on earlier settlements [1], and the houses, almost invariably with an upper storey, are of mud and baked brick in standardized sizes. The streets are wide, with drains collecting from bathrooms and latrines by means of chutes. Public buildings include the granaries and the Great Bath at Mohenjo-daro [2]. Among the extensive remains, however, the visitor cannot but be struck as at no other site on the subcontinent – including Sirkap at Taxila – by the overwhelming preponderance of dwellings and the total lack of identifiable religious edifices.

Bronze and copper tools were standard, though stone tools manufactured according to stone age techniques continued in use. The pottery, painted in a wide variety of geometric designs and often with animal or vegetal motifs, shows little or no variation, although it was almost certainly locally made. Terracotta figures abound. Some may or may not represent mother-goddesses. Those in animal form, of which a wide variety exists, are probably

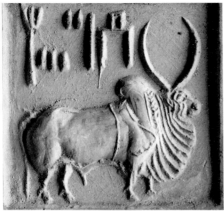

4. Modern plaster impressions of steatite seals, with undeciphered script, from Mohenjo-daro. (A) Bull; (B) rhinoceros; (C) 'lord of beasts'. Harappa or Indus Valley Civilization, *c.* 2300–1750 B.C.

mals rendered with great skill and liveliness [4]. None of the many structures excavated can unequivocally be identified as shrines, and the civilization has a strongly utilitarian flavour. The wide range of utensils concerned with crafts, provender, and domestic life, more often than not taken over from pre-Indus cultures, are competently designed and made but show little inventive flair and, except for the pottery, are undecorated.

At the same time, certain elements do seem to foreshadow aspects of later Indian civilization, its religious preoccupations and its particular aesthetic bent. Principal among these are terracotta phalluses and figures on seals seated in the yogic position on low thrones, some of them ithyphallic;[5] however the time gap is so large that one hesitates to conclude – particularly when they are surrounded by animals – that these are proto-Śivas in his guise as Paśupati, 'lord of beasts'. Some of the human figures on the seals are horned.[6] What is undeniable is that the splendidly naturalistic way, full of sympathy and understanding, in which so many of the animals are shown on the seals [4] finds an echo throughout most of the course of Indian art. The same is true of a charming pair of squirrels (or chipmunks) now in the National Museum, New Delhi. One or two stone sculptures, on the other hand, are in an archaic style more reminiscent of Mesopotamia.

The Indus civilization will probably continue to remain somewhat enigmatic until its script is deciphered.[7] Only then will we know a little more of its religion and anything at all of its polity and history. Why, alone of the chalcolithic societies of the area, it grew into an urban culture of such extent and uniformity, why it developed eastward – whether from the push of invaders in the west, or attracted by the richer lands to the east – why it was destroyed and by whom are all unknown, although there is some evidence that the Sanskrit-speaking invaders brought about its downfall.

Whereas we know nothing of the Indus civilization but what may be inferred from its abundant material remains, there exists a large body of literature relating to most of India north of the Narmadda and extending back perhaps as far as 1500 B.C., although here, somewhat paradoxically, the earliest surviving written records (Aśoka's edicts) are no earlier than the third century B.C.[8] Quite a lot is known about the invading Vedic peoples,[9] speakers of an Indo-European language, the earliest form of Sanskrit, who entered India from the north-west about 1500 B.C. Their hymns and prayers, the Vedas, preserved for three thousand years through an almost unbelievably accurate system of oral transmission, are exclusively religious, but they nonetheless reveal a picture of Vedic society and illuminate the origins of caste. As well as geographical information, relating principally to the Panjab (*panch ab*), the land of the five rivers, they incorporate references to the populations they found there and vanquished – *śiśna devatas*, worshippers of the phallus, who lived in fortified cities – and have therefore been identified, although not with absolute certainty, with the peoples of the Indus civilization.

The Vedas were followed by a rich ritual and philosophical literature, the latter dating from the seventh to the fourth centuries B.C. and paralleling – perhaps even remotely related to – the rise of the Greek pre-Socratic thinkers. The two great Indian epics, the Mahābhārata and the Rāmāyaṇa, although they did not reach their final form until a much later period, contain material of even greater antiquity.

Finally, the sixth century B.C. saw the birth of the Buddha. The circumstances and setting of his life have been preserved in the earliest canonical writings, which, while not strictly contemporary, are, like the Christian gospels, essentially authentic accounts. Thus a great deal is known about the local kingdoms in Bihār and what is now eastern Uttar Pradesh, including contemporary customs and even the names of some of the kings and other personages of the time. In the absence of inscriptions, and partly because stone had not yet been adopted for building and sculpture, partly because, in spite of references to 'cities' in the literature, urban development was still at a very early stage, archaeological excavations, while revealing abundant evidence of chalcolithic and Iron Age settlements at many of the sites mentioned in the literature, have failed to reveal very much that can be connected with the historical information in the texts. Such major questions as which of these cultures, or groups of them, can be related to the Vedic peoples remain unanswered. The distinctive pottery known as Painted Grey ware is known to have been in use in an Iron Age context *c*. 1050–450 B.C. at most of the places mentioned in the Mahābhārata, in levels between those of the Indus civilization pottery and the Northern Black Polished ware (*c*. 700–200 B.C.). It may hence be associated with the epic heroes, just as the Northern Black Polished ware was probably used by the kings and rich merchants of the Buddha's time. The lack of more artefacts from this period is explained by the fact, confirmed by great numbers of excavations, that India in the Bronze Age made relatively little and strictly utilitarian use of metal.[10] The large heavy bronzes, animals and a chariot and charioteer, recently found at Daimabad in Mahārāṣṭra, if they are, indeed, of the middle of the second millennium B.C., are

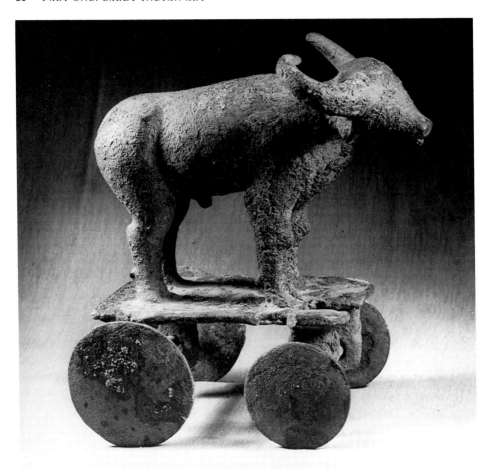

5. Buffalo from Daimabad. Mid second millennium B.C. Copper

unique [5].[11] After the Indus civilization, practically no terracotta sculpture can be confidently dated earlier than 250 B.C.

The Buddha was born *c.* 560 B.C. the son of the chief of the Śākya clan, whose capital, Kapilavastu, lay some 150 miles (240 km.) north-east of the present-day city of Patna, at a place now just within the borders of Nepal.[12] Features of the Buddha image as it appears throughout the centuries in sculpture and painting ever after reflect his martial and aristocratic lineage. He is reported to have been conceived in the form of an elephant by his mother, who gave birth to him through her side while standing under a sāl tree [6]. His given name was Siddhārtha, that of his *gotra*, or sub-caste, Gautama, and he is often referred to as Śākyamuni, the Sage of the Śākyas. In spite of the advantages afforded by his birth, Siddhārtha soon perceived that man's lot was, in the main, an unhappy one, and he set forth secretly one night from his palace, leaving his

sleeping wife surrounded by her ladies, to seek a cure for man's immemorial suffering. Abetted by his faithful groom Chandaka, he mounted his favourite horse Kanthaka and rode out of the city, the earth-gods in their delight muffling the sound of hoof-beats. Soon abandoning all the attributes of his princely origin, the future Buddha took to the road as a mendicant and sought out the religious teachers of his day. But none could match the rigour of his physical austerities, and he renounced them and their doctrines. It was by his own unremitting spiritual efforts that, alone under a pīpal tree at Bodhgayā, he finally achieved Enlightenment (hence the name Buddha). After preaching his First Sermon at the Deer Park in Sārnāth outside Varanasi (Benares) and thus, in Buddhist parlance, setting the Wheel of the Law (*Dharma*) in motion, he travelled constantly, during all but the rainy season, through the kingdoms and tribal lands of what is now Bihār and eastern Uttar Pradesh, preaching, converting, attracting disciples and performing miracles. He died at the age of eighty (his *parinirvāna* or 'blowing out' finds him again in the hill country, at Kuśinagara) mourned by his monks (the *Sangha*) and leaving his doctrine (the *Dharma*) which, together with the Buddha, constitute the triple support of Buddhism. These events and many others in the life of Śākyamuni, as well as the lives of mythical earlier Buddhas, have been depicted innumerable times ever since, first in India and then throughout Buddhist Asia. In spite of its exceptionally individualistic, anecdotal, and in the main historical character, the life of the Buddha, who was, of course, born a Hindu, reflects a great many of the aspirations and ideals of Hindus of all periods.

Buddhism, at least in its primitive form as preached by the Buddha himself, is practical, atheistic, and non-speculative, starting from the premise that man's lot is mainly suffering which is caused by desire. In the Four Noble Truths he taught how to escape from this suffering by the extinction of desire and by leading an upright, non-violent life (the Eight-

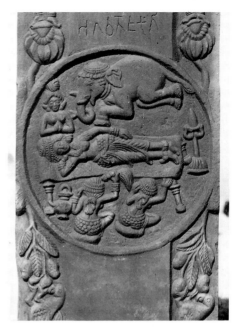

6. Dream of Queen Māyā from Bhārhut.
Second century B.C. Red sandstone.
Calcutta, Indian Museum

fold Path). There is no after-life, there are no gods, least of all the Buddha himself, and philosophical speculation is discouraged as a distraction from the single-minded working out of one's own salvation. These aspects of Buddhism, and the fact that its founder was a historical personage, account for many features of the earliest surviving Buddhist art which have particularly appealed to Europeans: it is non-symbolic, anecdotal, and its narrative scenes reveal a strong ethical bias. At the same time many aspects of traditional Indian culture and religion are retained, even some of the gods, reduced to ordinary beings, though of heroic stature, who totally accept the supremacy of the Buddha and often serve as his acolytes. Excavations have revealed contemporary settlements at Vaiśālī, Rājagrha, Śrāvastī, and other famous scenes of the Buddha's ministry, but (with the exception of the

fortifications at Rājagṛha, the capital of ancient Magadha) nothing that can be directly connected with the Buddha or contemporary figures mentioned in the Buddhist scriptures.

In 326 B.C., Alexander of Macedon marched into India and penetrated to the Beas river in the Panjab, the furthest reach of the greatest feat of arms in recorded history.[13] Accounts of his campaign by Greek writers mention Taxila (Takṣaśilā), the king Porus (Paurava?) whom he defeated in a great battle on the Jhelum, and a king Candracottus, who has been identified as Candragupta Maurya, the founder of the Maurya dynasty, with his capital at Pāṭaliputra (modern Patna), and the grandfather of the great Indian king Aśoka (c. 269–232 B.C.). The great pillared hall at nearby Kumrahar was undoubtedly part of his palace, probably rebuilt by his grandson.

Aśoka's edicts, engraved on pillars, rock surfaces, and tablets, have been found in almost every region of India except the far south, and as far west as Kandahar (often erroneously claimed to be a corruption of Alexandria in Arachosia) in present-day Afghanistan.[14] Although they no doubt conformed to a practice derived from Achaemenid Iran, Aśoka's edicts, which prescribe rules for the governance and religious and moral well-being of the peoples in his vast empire, are unique and provide considerable insight into the mind of this great ruler. A mighty conqueror, he soon expresses compunction for the death and suffering he has caused and, now an active supporter of Buddhism, enjoins upon his subjects the practice of non-violence and a generally humane, if somewhat puritanical, way of life.[15] The edicts testify, moreover, to the centralization of Aśoka's empire compared to the loose collections of vassal kingdoms usually assembled by later Indian conquerors. His importance in the history of Indian art lies in the fact that a number of monolithic pillars, most of them bearing his inscriptions, have survived in widely separated parts of the subcontinent. The animals which form the crowning feature

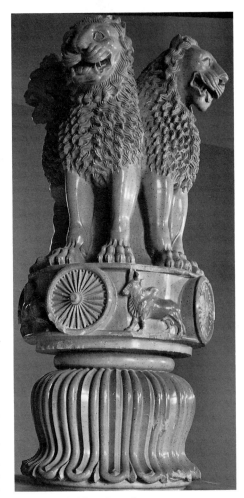

7. Lion capital from Sārnāth.
Third century B.C. Polished sandstone.
Sārnāth Museum

of these columns comprise the first important group of Indian stone sculpture.

It can no longer be confidently asserted that the pillars, locally called *laṭs*, were all quarried at Chunār, near Varanasi, and that they are thus manifestations of the official art of Aśoka's centralized empire, and even less that they are essentially of foreign, i.e. Iranian, inspiration.

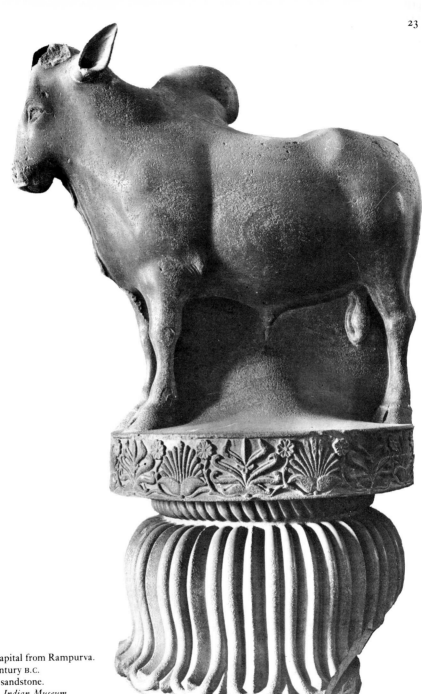

8. Bull capital from Rampurva.
Third century B.C.
Polished sandstone.
Calcutta, Indian Museum

They are, nonetheless, remarkably similar, plain monolithic shafts some 40-45 ft (12-14 m.) high, with no bases and very little entasis, bearing bell-shaped capitals with a petal-like decoration and – all carved from separate blocks – abaci with animal figures above them. Only two still stand intact, both at sites between the Ganges and the Nepalese border. Including these, six of the crowning animal sculptures have survived: two sejant lions, an elephant, a bull, and a pair of quadruple addorsed lions, one of which, from Sārnāth and surmounted by a wheel, now serves as the official emblem of the Republic of India [7].

A great many misguided judgements have been made about the purpose and style of these pillars and their capitals, due in part to a grossly uninformed drawing of Iranian parallels, in part to the absence of any surviving progenitors of the pillars in India, and in part to a failure to disentangle the complex relationship between the physical and historical reality of a work of art and all that it embodies. Some of the pillars were unquestionably raised by Aśoka; others are probably somewhat earlier, but not a great deal, for a longer tradition of stone carving would certainly have left other remains. The sudden appearance of stone carving of such sophistication probably argues for some foreign workers or at least contacts, just as the rather cold hieratic style of the Sārnāth lions shows obvious Achaemenid or Sargonid influence. But the motifs on the abaci, with one or two exceptions, are more likely to derive from an earlier western Asian tradition than from the Hellenistic world.

In fact, as has recently been persuasively argued, the pillars with their capitals and crowning animals must be the product of a long tradition in India (there are no examples elsewhere, much less in Iran) of single free-standing pillars, doubtless of wood, surmounted by copper animals.[16] It is quite likely that these structures embodied the symbolism of the *axis mundi*. The style of one or two of the animals, moreover, notably the Rampurva

bull, and some of the reliefs on the abaci, show the extraordinary sympathy for their subjects characteristic of Indian animal sculptors from the time of the Indus civilization [8]. Finally, any interpretation of these 'Aśokan' pillars must take into account that many of them are found at Buddhist holy places or depicted on Buddhist reliefs during the next three hundred years or so, by which time they have undoubtedly acquired a Buddhist significance, in the same way that yakṣas were incorporated into Buddhist lore and iconography, as will be discussed later.

Aśoka is also associated with a small number of excavated cave-shrines in the Barābar Hills, just north of Bodhgayā, the 'Marabar' Hills of E. M. Forster's *A Passage to India*. Simple in plan and devoid of all interior decorative carving, they are, like all subsequent cave-temples, based on contemporary structural buildings. In one way they are exceptional: the longer side runs parallel to the rock face, not into it, probably on account of the shallowness of the outcropping in which they are carved. The only sculptural feature is the doorway to the Lomas Ṛṣi cave [9], obviously based on a wooden model, with a fine relief band of elephants. It is the earliest example of the *caitya* arch, later *gavākṣa*, a kind of double-curved arch, called an ogee in European Gothic, the most ubiquitous of all Indian architectural motifs. Although this cave is undated, the one beside it, identical in all respects except for the doorway, bears an inscription to the effect that it was excavated in Aśoka's tenth year for the Ājīvikas, a non-Buddhist sect.[17] Like the pillars and their capitals, the interiors of these caves bear a very high polish which has come to be known as 'Mauryan' – somewhat misleadingly, since the technique was used on occasion up to the first or second century A.D.[18]

9. Lomas Ṛṣi cave, Barābar Hills. Third century B.C.

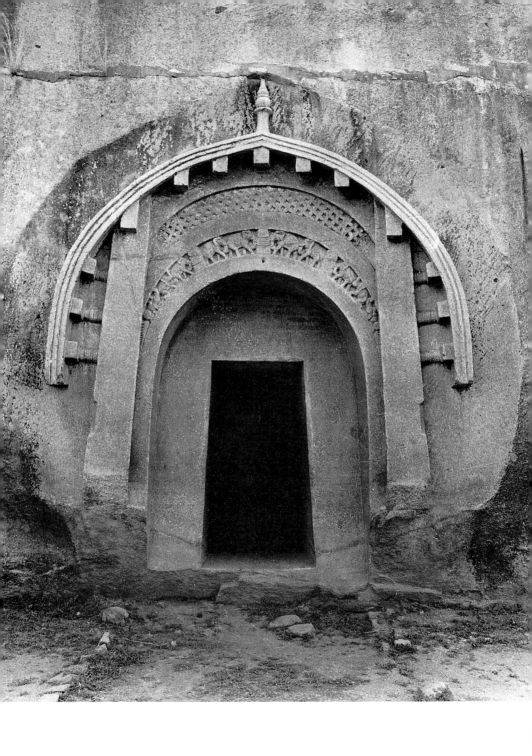

The Buddhist monument par excellence is the *stūpa*, and some of the great stūpas of Sri Lanka and Burma continue today to be the objects of the most fervent veneration. Various origins have been suggested. One is the tumulus or earth mound raised in many parts of the world over the remains of the dead; another is a support for the pillars representing the cosmic axis of the world or *axis mundi*. What is indisputable is that the Buddhist scriptures speak of the Buddha's relics being divided and stūpas raised over them. In the ensuing centuries they have been erected at places connected with the Buddha's life, to enshrine relics of celebrated members of the Saṅgha, as objects of devotion within Buddhist monasteries, and as votive offerings, usually in miniature form, at Buddhist holy places. The stūpa obviously ante-dates Buddhism, and its hemispherical shape indicates a symbolic significance, for it is not a form naturally taken by heaped-up earth.

Of the many stūpas raised by Aśoka – invariably of brick – several survive as the cores of subsequent stone structures. Like most early works, their age is suggested by the larger size of the bricks.[19] Already in Aśoka's time the stūpa, then a low dome, less than a full hemisphere, was mounted on a cylindrical drum or base of no great height; the whole structure must have been surrounded by a wooden fence (*vedikā*), of a characteristic shape, usually with entrances at the cardinal points and sometimes elaborately carved gateways as well. Although none of these wooden fences or gateways have survived, stone versions of a hundred or more years later plainly betray their wooden origins: the cross-bars for instance are lenticular in section, which is quite foreign to stone construction [17]. The relief carvings on the cross-bars, usually medallions, as well as on the uprights and copings of many of these fences are a storehouse of early Indian decorative motifs. Moreover the figures and scenes depicted provide a unique insight into daily life, as well as into the artistic vision and technical capacity of these early sculptors in stone. The *pra-daksiṇapatha* – the space between the stūpa and the vedikā, later paved in stone – was used for the immemorial rite of clockwise circumambulation still performed today around temples and shrines.

The earliest stūpa railing to have survived, along with part of a gateway, is from Bhārhut in eastern Madhya Pradesh.[20] Now in the Indian Museum, Calcutta, it is of monumental proportions, over 6 ft 6 in. (2 m.) high. The carving appears to have been done piecemeal during the second and first centuries B.C., often called the Śuṅga period after a rather shadowy dynasty of the time. As in the case of some other early stūpa railings and of early cave-monasteries, reliefs and figures were donated, i.e. paid for, by individuals whose names, often with their home-towns, are inscribed beside them. Many were merchants, some from distant parts of India, which provides important information about the early Buddhist laity. A surprising number of monks and nuns, moreover, had the means to commission such work.

One of the pillars showing a kingly figure on an elephant bearing a casket undoubtedly refers to the enshrinement of the stūpa's relics [10]. Small reliefs on the uprights and cross-bars depict scenes from the life of the Buddha or from the *jātakas*,[21] as well as the worship of the Buddha in the form of various symbols, such as his *āsana* (throne), for at this time he is never represented in human form. Some of the scenes (of which almost all have been identified) have considerable charm, some are humorous, but they never rise above the level of an inspired *art naif*. Occasionally they embrace a multiple time-scale, successive incidents being shown in the same panel. As Buddhist iconography was still in its infancy, inscribed labels often identify the scenes, and sometimes even the actors, thus underlining their didactic purpose [11]. In marked contrast are those deities and mythical concepts which are not specifically Buddhist, already presented in ways familiar from later times. They include Sūrya, the sun god, with his chariot, Śrī Lakṣmī, with elephants on each side pouring water over her,

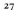

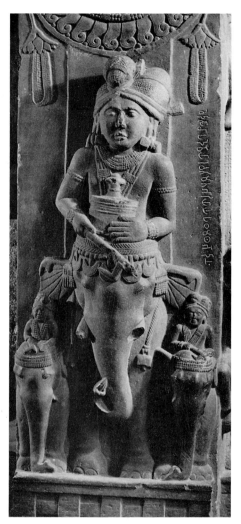

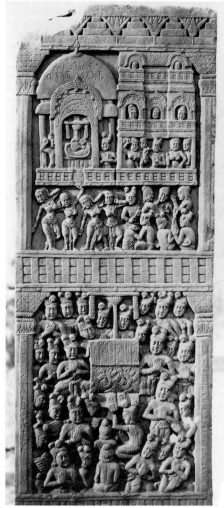

10. Interment of relics from a stūpa railing
from Bhārhut. Second century B.C. Red sandstone.
Calcutta, Indian Museum

11. Panel from a stūpa railing from Bhārhut.
Second century B.C. Red sandstone.
Upper register:
In a palace of the Hindu gods
a festival is held for relics of the Buddha.
Lower register:
Hearing the news that the Buddha has been born,
the Hindu gods in their multitudes
enter his father's palace and worship his presence
in the form of his footprints.
Calcutta, Indian Museum

serpent kings (*nāgarājas*), *kinnaras* or bird gods, the woman bending the tree (*śālabhañjikā*), and the jewel-bearing vine.

A stūpa at Pauni in Mahārāṣṭra had a double vedikā.[22] One *stambha* (upright; usually 'pillar' or 'column') had reliefs carved in a late Śuṅga or early Sātavāhana style with attendant figures, their hands in *añjali* (the gesture of greeting or adoration), a throne with a five-headed serpent behind it, a stūpa, a *cakra* (the wheel or discus), and a sacred tree. Remains of vedikās and *toraṇas* (gateways) have been recovered from numerous sites in North India including Mathurā, Sārnāth, Amīn, and Lalabhaghat.[23] The reliefs, in a remarkably uniform style, are not necessarily all from Buddhist monuments, for vedikās were used to enclose sacred buildings and even trees [28].[24] At Bodhgayā, a vedikā running in a straight line and presumably demarcating the Buddha's Hundred Paces after achieving enlightenment is of the same period, with Gupta additions.[25] Two large stambha figures are noteworthy, as are many of the smaller relief scenes.

To what extent early Buddhist art incorporated pre-Buddhist elements is best demonstrated by the presence of large standing yakṣas, identified by inscribed labels, on many of the vedikā uprights at Bhārhut, their hands in añjali, indicating that they too are humbly worshipping at the shrine. Some are female. A male one, in boots and tunic, with a diadem and short curls, is among the first of many such figures in Indian art to be dressed in *udicya* or northern costume, usually associated either with the sun god or with shrine guardians.

Yakṣas are minor local deities whose worship is of immemorial antiquity and continues all over India to this day.[26] They are usually associated with a place and frequently connected with wealth. Some are simply ogres, as their names imply. They have supernatural

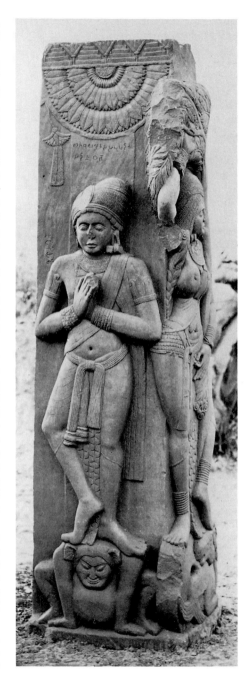

12. Kubera yakṣa from Bhārhut.
Second century B.C. Red sandstone.
Calcutta, Indian Museum

powers and are sometimes beneficent, sometimes malevolent. The Bhārhut yakṣas, however, and the *yakṣīs* their female counterparts, were it not for the names inscribed upon them – 'Kupiro yakho' (Kubera yakṣa) [12], 'sudasana yakhini' (sudarśana yakhinī, the fair one), 'suciloma yakho' (with bristles all over, literally 'needle pelt') – would be taken for princely donors or rich merchants and their wives, for, except for the animals on which some of them stand (the earliest example of the Indian custom of assigning an animal, or sometimes a human, as a 'vehicle' (*vahana*) for individual deities), they are not iconographically differentiated in any way. They are painstakingly executed in a miniaturist, linear style, probably based on carving in ivory.[27]

The free-standing stone yakṣas of the third/second centuries B.C. to the first century A.D., known from most areas of northern and eastern India, are often remarkable examples of early art.[28] Usually portrayed standing, and meant to be viewed frontally, they are over life size and corpulent, with swelling abdomens, their bulging masses, with ponderous sashes and ornaments, conveying a great sense of power. Their backs on the other hand are flat, with the details simply suggested in low relief. One of the few to have survived intact is the yakṣa from Vidiśā, all of 6½ ft (2 m.) tall [13]. He carries a purse. Figures of roughly the same type, but holding yak-tail fly-whisks (chowries), are also generally believed to be yakṣas, probably honouring some deity or symbol of the Buddha, since the chowry was a prerogative of royal rank. The Parkham yakṣa from near Mathurā is perhaps the most impressive of all these figures. When first discovered it was in worship under the name 'Jakhaiya' [14]. With one leg slightly and rather awkwardly bent, it foreshadows the contrapposto which is such a constant feature of later Indian figure sculpture. *Yakhinīs* (yakṣīs with roughly the same characteristics) have also been found, including a figure from Mathurā seated on a wicker stool which is the earliest example of *pralambapada*, often called 'in the European

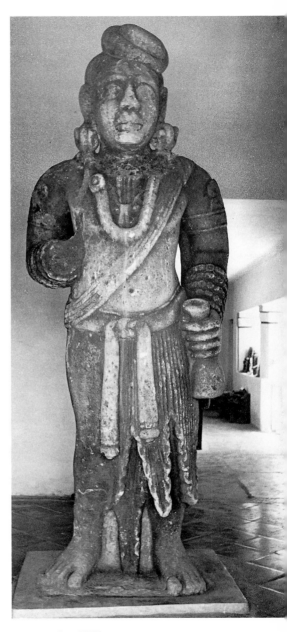

13. Yakṣa from Vidiśā.
First century B.C. Sandstone.
Vidiśā Museum

14 (*below*). Yakṣa from Parkham.
First century B.C. Sandstone.
Mathurā, Government Museum

15 (*right*). Yakṣī from Didarganj.
First century A.D. Polished sandstone.
Patna Museum

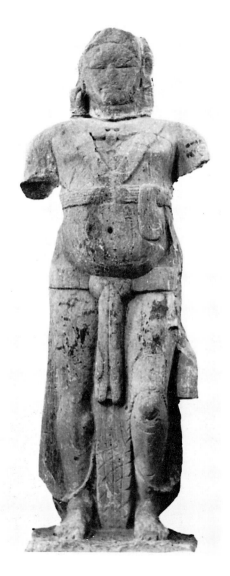

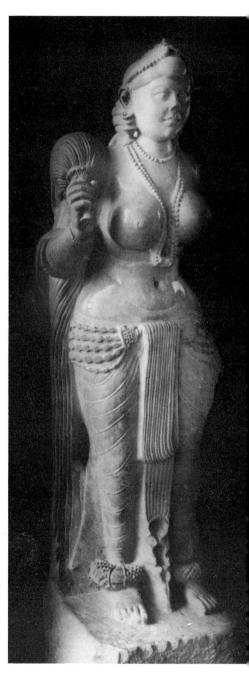

fashion', i.e. with the lower legs hanging down, as people commonly sit on a chair in modern times. The famous yakṣī from Didarganj (a suburb of Patna) [15], long thought to be of Maurya date because of its polish, and beautifully preserved, is almost certainly a work of the first century A.D.[29]

There is inscriptional and archaeological evidence for the existence of the great theistic cults, or their prototypes, during this period from the second century B.C. to the first century A.D. The famous Besnagar pillar bears an inscription of *c.* 150 B.C. in which a certain Heliodorus, a native of Taxila, relates that he raised a *Garuḍa-dhvaja* (lit. 'banner', here 'pillar') in honour of 'devadeva Vāsudeva' and terms himself a *Bhāgavata*, or devotee of the god's cult.[30] An early shrine-building and some pillar-capitals from Besnagar can be associated with divinities of the Kṛṣṇa-Vāsudeva cult, the precursor of Vaiṣṇavism. The third-century-B.C. inscription from the Ghosundi Well states that the enclosure there was for Saṃkarṣaṇa and Vāsudeva.[31] Two centuries later, the famous inscription from Mora Well, near Mathurā, tells of the installation in a stone temple of images of the *pañcavīras* (Saṃkarṣaṇa, Vāsudeva, Pradyumna, Samba, and Aniruddha) of the 'Vṛṣṇis', Kṛṣṇa's clan or tribe: a pair of headless torsos found here may well be two of them.[32] Actual images from this period, however, are all but non-existent. One figure, in relief on what is thought to be a railing pillar, now in the State Museum, Lucknow, can be identified as Balarāma from the plough and pestle which he holds; another, partially recut, and still in worship near Bilaspur, Madhya Pradesh, bears a conch and discus, which leaves no doubt that it is Vaiṣṇava or proto-Vaiṣṇava.[33] Both sculptures can be dated to the second or first century B.C., as can an exceedingly interesting but much worn piece from Bhītā (Allahabad District) consisting of two addorsed standing figures with four heads, the small figure of a lion on one side and a boar on the other, which also obviously belong to the early formative stage of Vaiṣṇava iconography.[34] So far no very early Śiva images have been found, although there are references to them in the literature.

The area around Vidiśā, in western Madhya Pradesh, the ancient Avanti, has important

16. Sāñcī, Stūpa I, from the north. First century A.D.

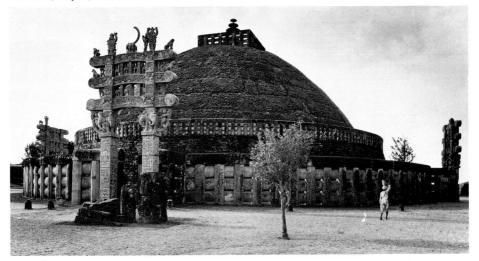

historical associations and is rich in archaeological remains from Aśokan times onwards.[35] At Sāñcī, on a low hill, stand three stūpas of which the largest, with its four superb toraṇas covered with reliefs, is the largest and most splendid of all surviving Indian examples and the greatest sculptural monument, along with Amarāvatī, assignable to the Sātavāhana period.[36] Originally built of brick in the third-second century B.C., Stūpa I as it stands today, after being nearly demolished by early excavators, has a diameter of over 120 ft (about 40 m.), includes a lofty platform (medhi) with two stairways (sopana) leading to it, and is surmounted by a harmikā (a square platform enclosed by a vedikā) and a triple parasol [16].

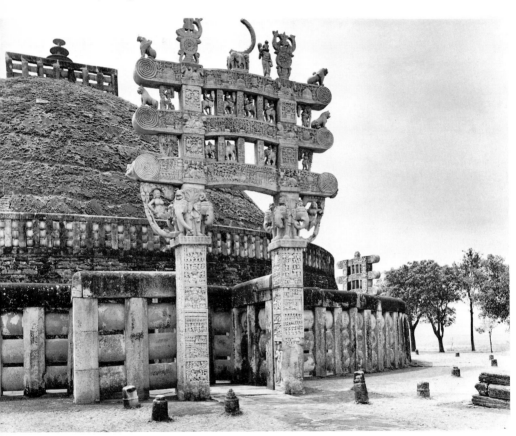

17 and 18. Sāñcī, Stūpa I, northern toraṇa (above) with reverse (opposite). First century A.D.

Both the processional path atop the platform and the one at ground level are enclosed by vedikās, the lower one of huge proportions and measuring 10 ft 7 in. (3.2 m.) from the ground to the top of the coping (uṣṇīṣa). The complete lack of decoration emphasizes its monumentality.

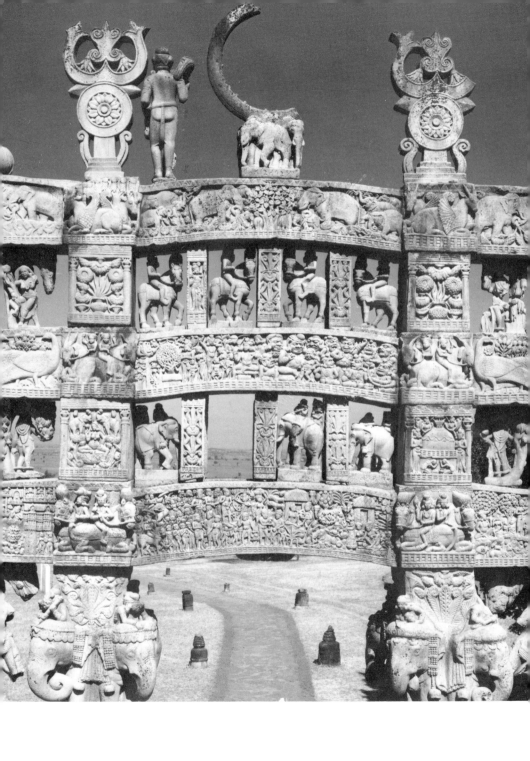

The four gateways at the cardinal points opposite entrances through the vedikā, dating from the late first or early second century A.D., are in a superb state of preservation.[37] The small standing figures on the cross-bars and the women leaning out as brackets are very fine, the modelling taut, the figures completely integrated and conveying a sensuous physical beauty rarely equalled [17]. The women's almost total nakedness, with jewelled girdles and exposed pudenda, is consonant with a Late Sātavāhana date. More important, however, are the relief panels and friezes depicting scenes from the Buddha's life and from his previous incarnations which cover every available space, on the rear as well as the front of the toraṇas. The friezes depict vast pageants thronged with people, cities, and vegetation. Processions and battles, with kings in their chariots, alternate with the sylvan abodes of sages, providing a unique source of pictorial information about Indian life and its natural environment at the commencement of our era. Certain of the panels with figures in rows one above the other hark back to Bhārhut. No attempt is made to indicate that certain figures are further away than others, and sometimes there is no background. The Buddha, of course, is never portrayed. On the other hand, on the friezes stretched along the cross-bars people are shown in action against natural backgrounds, no longer psychologically isolated from each other, and there are genre scenes. In its superb combination of close observation and sophisticated group composition, the elephant frieze is a masterpiece [18].

The smaller Stūpa II is very similar but has a single toraṇa. Unlike Stūpa I it contained relics, indisputably of Modgalyana and Sariputra, the Buddha's favourite disciples, who predeceased him. Stūpa III, some way down the hill, has no platform or gateways, but its vedikā around the processional path is decorated with medallions and half-medallions in an earlier style very similar to that of Bhārhut. A few corner stambhas are entirely covered in reliefs – not scenes but individual figures, animals,

mythical creatures, and decorative motifs. An Aśokan pillar being worshipped by two figures, and a Yavana soldier with a short tunic and a square shield, strike the only topical note. Lakṣmī being lustrated (anointed with water) by a pair of elephants appears several times; this is thought to represent the conception of the Buddha. The women are attired below the waist in decorous non-transparent dhotis.

From the early period at Sāñcī remain a stone umbrella of Maurya date and a Maurya lion capital. There are also two or three other stūpas in the vicinity with railings of roughly similar date, as are a Nāga and Nāginī from nearby Nagouri.[38]

In Āndhra, centring on the lower reaches of the Krishna, monumental stūpas decorated with reliefs seem to have been built from the second century B.C., culminating in the sculptural treasure-house of the Amarāvatī reliefs of the second and third centuries A.D., the jewel in the crown of early Indian art, and those of a quality not quite so outstanding from Nāgārjunakoṇḍa of the third and fourth centuries.[39] Lesser stūpas with sculptural reliefs, all in the marble-like limestone of Palnad, were erected at a few other sites [19], among them Goli, Bhaṭṭiprolu, Ghaṇṭaśāla (probably the Kantakossyla of Ptolemy), and Jaggayyapeta, the source of the famous *cakravartin* (world-emperor) relief.[40] Isolated finds of reliefs in the Āndhra style, some in a local stone, as far to the north-west as Ter (Tagara of the western classical authors) testify to not-unexpected links with other parts of the Sātavāhana domains.[41] Except for the splendid standing Buddhas, none earlier than the third or fourth century A.D., which will provide the model for those of Sri Lanka and South East Asia, Early Āndhra sculpture consists almost exclusively of reliefs.[42]

It is upon the great stūpa of Amarāvatī, the largest of the Āndhra stūpas, that interest has principally focused for nearly two centuries, on account both of the abundance and surpassing quality of its surviving sculptures and, to some extent, of the long saga of their res-

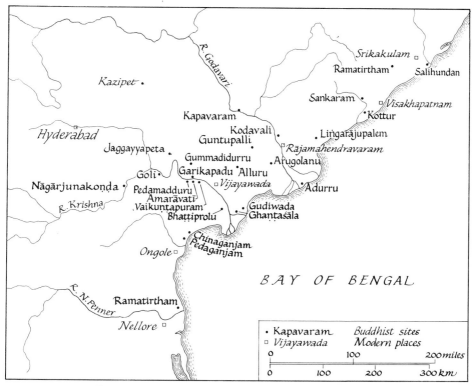

19. Buddhist sites in Āndhra

cue.[43] Nothing remains of the stūpa now but a large pit, part of the vedikā, and the cladding of drum and *aṇḍa* (dome), now almost equally divided between the Government Museum, Madras, and the British Museum.[44] Thanks to the work of scholars, the appearance of the stūpa in the third century has been largely reconstituted, gleaming white with touches of brilliant colour, the greatest monument in ' Buddhist Asia [20].[45]

The stūpa in its final form was surrounded by a vedikā with a diameter of 192 ft (58 m.), extended outward to form gates at the four cardinal points. The uprights were approximately 9 ft (3 m.) high, with three circular cross-bars between them surmounted by a coping. Railing pillars and cross-bars were richly carved with full- and half-lotus medallions, often accompanied by figures and superb decorative detail, or else interspersed with scenes [22]. Sometimes the central medallions bear crowded scenes from Buddhist story; those of the cross-bars, projecting as they do from the curved cross-section, form magnificent tondi, aesthetically, as Barrett has remarked, the most satisfying of all the carvings [21]. The coping was decorated by a continuous thick waving garland, most often supported by young men, with figures and symbols in the spaces created by its undulations. The stūpa stood on a low drum, with projecting platforms (*vāhalkaḍas*) bearing *āyaka* pillars[46] at its cardinal points. The dome rose vertically at first, clad with sculptured slabs depicting the

20. Amarāvatī, stūpa, conjectural reconstruction

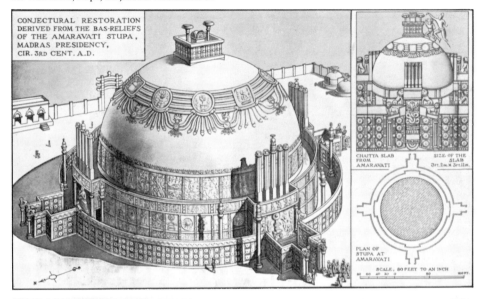

CONJECTURAL RESTORATION
DERIVED FROM THE BAS-RELIEFS
OF THE AMARAVATI STUPA,
MADRAS PRESIDENCY,
CIR. 3RD CENT. A.D.

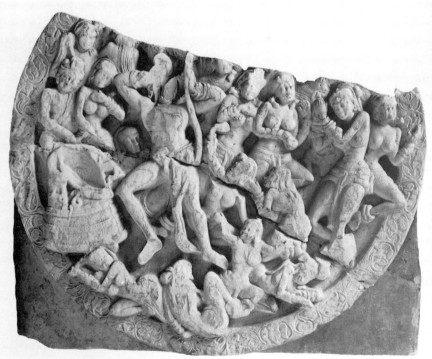

21. Tondo from a cross-bar from the railing of the stūpa at Amarāvatī.
Second century A.D. *London, British Museum*

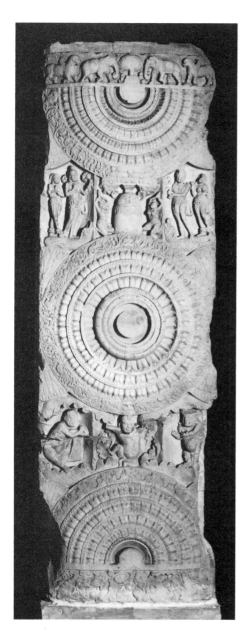
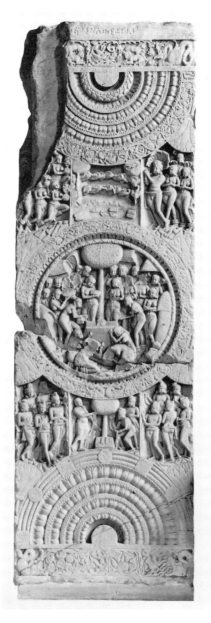

22. Inner and outer faces of a railing pillar from the stūpa at Amarāvatī.
Second century A.D. *London, British Museum*

stūpa itself; the rounded element probably bore garlands in relief and was surmounted by a harmikā and umbrellas.[47]

The changes in style of the Amarāvatī sculptures have been traced in some detail.[48] In reliefs prior to the second century A.D. the Buddha is represented by a symbol, compositions are simpler, decorative detail less luxuriant. In the mature phase (second half of the second century to first quarter of the third), decorative elements reach a suave richness never surpassed even by the finest Gupta works. In the narrative scenes, the deep cutting permits overlapping figures on two and even three planes, the figures appearing to be fully in the round. The superlative beauty of the individual bodies and the variety of poses, many realizing new possibilities of depicting the human form, as well as the swirling rhythms of the massed compositions, all combine to produce some of the most glorious reliefs in world art. The latest sculptures (second quarter of the third century) are all but indistinguishable in style from those of Nāgārjunakoṇḍa.

Nāgārjunakoṇḍa, unlike Amarāvatī, has been systematically excavated, revealing a large monastic complex with many stūpas.[49] It is securely dated in the late third and fourth centuries A.D. by means of inscriptions recording donations by ladies of the Ikṣvāku dynasty. Lively and interesting as the reliefs are, they show a great decline since the mature phase at Amarāvatī. Equally deep cut, figure groupings are less complex, particularly in the arrangement of overlapping planes. Mannerisms appear, notably elongated and even spidery human legs and bulging eyes. The sculptors on occasion take exaggerated liberties with the human body. The natural evolution of motifs, which are often treated in a summary way (hatchings, etc.), would in any case point to the style as being the last of the Early Āndhra period. It is quite unmistakable, however, due to a surface flatness common to all the figures, although deeply cut, quite unlike the fully

rounded faces, bodies, and limbs of Early Āndhra sculpture at its apogee.[50]

Infinitely more terracottas are known from the early period than artefacts in stone, metal, silver, or ivory. This abundance is due to the cheapness and wide availability of clay, to close association with the work of the potter and later the brickmaker, and to the impossibility of re-using terracotta, and its freedom from decay compared to other materials. Terracotta ornaments such as bangles, toy animals and vehicles, and human figurines, many probably of a religious nature, are common, commencing with the Indus Valley civilization sites and certain earlier chalcolithic ones. In the historical period, the terracotta human figures found at almost every important excavation can be divided into three types. The first are entirely hand-modelled, with pinched-nose faces, split-pellet eyes, and appliqué ornaments. They differ little from those of the prehistoric civilizations, belonging as they do to Stella Kramrisch's 'timeless' category, i.e. they do not evolve stylistically and figures of a roughly similar type are made today.[51] The second type has moulded faces with hand-modelled bodies with appliqué, sometimes punch-marked, decoration. They represent, as Härtel notes, an important aspect of early Indian art, and mirror, however crudely, stylistic developments in stone sculpture.[52] One variety, usually grey in colour, is found in great abundance at Mathurā [23].[53]

The great majority represent women. Male figures sometimes wear the turbans of the Early Sātavāhana period. Far more sophisticated, and occasionally reminiscent of Tanagra figures, are the rare standing feminine figures from Bulandibagh (Patna) and one or two other sites in Bihār. They are quite exceptional in having stands. Once labelled Maurya, they are now assigned to the third and second centuries B.C. Of probably late Sātavāhana date are the characteristic little figurines (usually only heads have survived) made of kaolin from sites in the Deccan such as Sannathi.

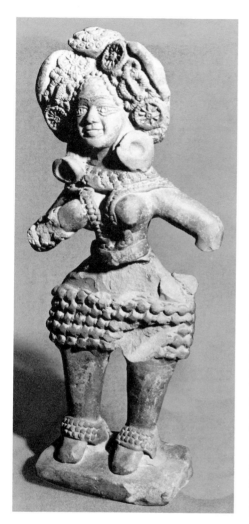

23. Woman from Mathurā.
Second century B.C., second half. Terracotta.
Mathurā, Government Museum

Equally common, and more widespread, are moulded plaques, most often depicting a standing female figure.[54] They are notable for a more precise and detailed depiction of costume, huge bi- or tri-cornate headdresses, jewelled girdles, and heavy bracelets. The finest, its astonishing wealth of detail revealed by its near-perfect state of preservation, is the plaque from Tamluk, the ancient Tāmralīpti, near Calcutta [24].[55] Most striking are the huge barbaric headdress, with five pins tipped with traditional symbols such as the axe and the elephant goad, the bolster-like ear-rings, one shown resting on the shoulder in a three-quarter view, and the heavy tubular bracelets. There is also an almost invisible clasp on the chest composed of a deer and a makara, and mysterious small squatting human figures hang down from the girdle. In contrast to the figure's stiff pose and staring face is the remarkably sensual rendering of the chubby arms. The Tamluk plaque, and numerous fragmentary ones found in the area, notably at Candraketugarh, reflects a distinct Bengali style, but generally similar plaques have been found at Mathurā, in the north-west, and elsewhere. On rare occasions the figure is male, sometimes winged, and couples are sometimes depicted. It is likely that the female figures are mother-goddesses.[56]

Some stamped plaques, usually square or circular, show two or more figures, sometimes in sophisticated compositions. The subjects are usually erotic. There are also fragments of terracottas in the round in a Hellenistic style, but likely to have been made locally, usually moulded and hollow, the two halves made separately and then joined together, a technique which must undoubtedly have been imported from the West.[57] Moulded figures, usually female, were also used to decorate the handles of vessels.[58]

These techniques, or variations of them, made possible the few large terracottas of the Kuṣāṇa period, measuring as much as 3 ft (1 m.) in height, like the too little known Gajalakṣmī

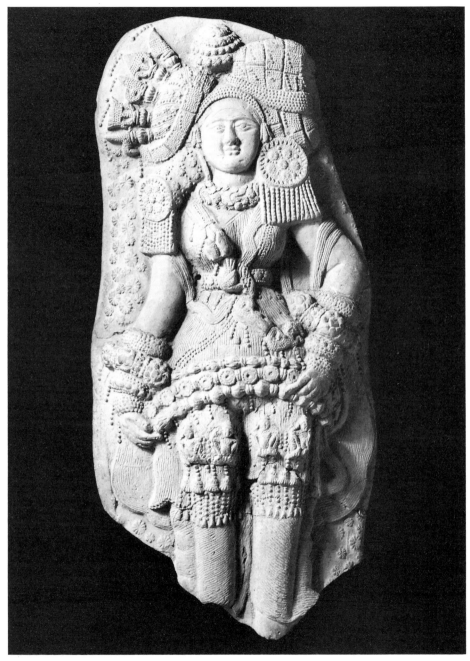

24. Mother goddess or yakṣī from Tamluk. Second/first century B.C. Moulded terracotta plaque. *Oxford, Ashmolean Museum*

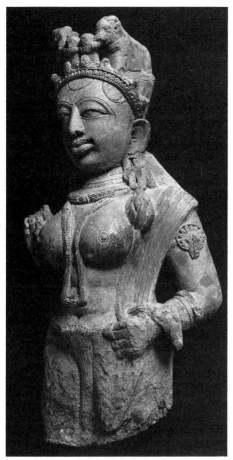

25. Gajalakṣmī from Kauśāmbī.
Second/third century A.D.
*Allahabad University, Department of Ancient History,
Culture, and Archaeology*

and Hārītī from Kauśāmbī [25].[59] The style
of these figures is bold; in the easily recog-
nized small figures of the Kuṣāṇa period, ani-
mals as well as humans, the latter with solid
heads and tenons for affixing to a hollow body,
the execution is slapdash to the point of un-
intentional grotesquery. This is somewhat sur-
prising, considering the long tradition behind
them, as well as the splendid large terracottas

occasionally produced in Gandhāra and the su-
perb techniques of the stuccos there, although
it is true that these may all be later. Some of
this rough boldness also characterizes many
Gupta terracottas; the finest ones, however,
must have been created by a new type of
specialist craftsman.

Figures in bronze go back as far as the
Indus Valley civilization, but early survivors
are rare and all small. They include a number
of purely Hellenistic type, unquestionably im-
ports; the remainder come from many areas,

26. Family riding on an elephant
from Kolhapur. Second century A.D. Bronze.
Kolhapur Museum

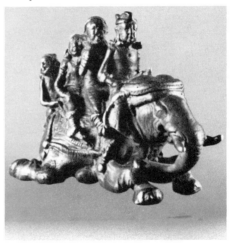

from Āndhra to the north-west and from
Mahārāṣṭra and Gujarāt to Uttar Pradesh and
Bihār. They vary greatly in style, in artistic
merit, and in skill in bronze-casting. The
charming little family group of riders on an
elephant found in the Kolhapur hoard, which
included Hellenistic bronzes, is purely Indian
in style [26], as is the fine elephant, the largest
of the bronzes of the early historical periods,
probably of slightly later Sātavāhana date, in a
private collection.[60] There are some excellent
little Tīrthaṅkara figures from Chausa (Patna) as
well as a few lively and skilfully conceived fi-
gurines from regions as far apart as Gujarāt and

Āndhra.[61] In the north-west a number of small bronze figures from Taxila and Rupar vary from crude linear mannikins through Hellenistic work to figures in a current Indian style.[62] A small number of standing Buddhas of Gandhāra type have survived.[63] The sixth century would seem to be the earliest possible date for these well-made figures.

Although of deplorably crude workmanship, a pair of small bronze images from Sonkh are of great interest,[64] for not only are they in a recognizable Kuṣāṇa Mathurā style but one of them is contained within a wire-like frame sparsely decorated with simple volutes, the precursor of the *prabhāvallis* which frame so many later metal images. They are also the first unquestionable Hindu images (one a Kārttikeya) in metal, since most early Indian metal sculpture found so far, including two small figures found at Lumbini, and possibly of Kuṣāṇa date, do not appear to be cult objects.[65] One which certainly is not is a small female figure, markedly similar in its plastic treatment and certain details of costume to the Tamluk terracotta plaque but with a hole at the top of the head for making an attachment by means of a spike.[66] Repoussé plaques range

from the little schematic mother-goddess from Lauriyā Nandangarh (*c.* 300–200 B.C.) through small Hellenistic works to the superb *mithuna* (loving couple) from Patna, probably of late Kuṣāṇa date.[67]

The Begram ivories are mentioned in Chapter 4.[68] A small female figure with two attendants, found at Pompeii and consequently made before A.D. 79 when the city was destroyed, is the earliest object of Indian origin known to have been imported into Europe.[69] Elaborately carved throne legs, usually in the form of a rearing mythical animal with attendant figures, from eastern India and Orissa have survived from a much later time.[70] Some very fine silver has been found, most of it in the north-west and even beyond the confines of the Indian subcontinent.[71] Some of it probably dates back to the Seleucid period, but most belongs to the wider horizon of the Hellenized Middle East, with strong Parthian and Iranian stylistic influence. Perhaps the most widespread of these essentially foreign types is the carinated and ribbed goblet, also sometimes used as a reliquary, of which examples in bronze and even terracotta, as well as silver, are known from as far south as Mathurā.[72]

EARLY ROCK-CUT ARCHITECTURE

The earliest elaborated edifices in India of which we have any visual knowledge are in most cases not shrines but secular buildings. Palaces and architecturally complex city gates are depicted on the early reliefs [27D], particularly at Sāñcī and Amarāvatī, and on the façades of rock-cut monuments, and descriptions abound also in the literature.[1] Exceptions are the Bhārhut relief of the bodhi-tree shrine at Bodhgayā, and others from a number of early sites showing structures of an unmistakably religious nature [27B, G, H, I, 29].[2] As in the Graeco-Roman tradition, sacred buildings were adapted from secular ones. Extensive excavations of large sites occupied over long periods, however, have so far yielded curiously few important secular remains; at Kumrahar (Patna), in the old Maurya capital of Pāṭaliputra, a pillared hall,[3] at Śiśupālgarh, outside Bhubaneswar, a set of columns from a maṇḍapa (pillared hall) of uncertain date,[4] at Kauśāmbī a palace(?) dating from the first/second centuries A.D.[5] Massive early fortifications have been found at several sites, notably at Rājgir, the capital of Magadha in the time of the Buddha, and later ones at Kauśāmbī.[6] Although wood was the principal building material there is ample evidence of the use of brick, and even occasionally – principally in the foundations – stone, and it is surprising that so little has so far been discovered by the excavator's spade. Unquestionably, however, the first shrines of any architectural pretension were modelled on the plans and structures of secular buildings, commencing with the ordinary house.

To begin with, and in their simplest form, the shrines of the subcontinent appear to have been hypaethral (open-air), ranging from the simple enclosure by a vedikā of a liṅga (sacred phallus) or a sacred tree [28] to pillared galleries like the bodhighara depicted on the Bhārhut relief [29]. The earliest inscriptional evidence of a stone shrine, the pūjā śila prākāra ('worship stone enclosure') of the Ghosundi inscription, suggests that it was open-air, probably with rectilinear sides and bounded not by a stone vedikā, based on a wooden fence, but by upright slabs of thin stone between posts.[7] When a surviving ground plan is circular, as at Bhairat, oval, as at Besnagar, or apsidal-ended, a roofed building is implied [27C].[8] The single apsidal-ended building, with its hastipṛṣṭha (elephant-back) roof, is well known from a relief [27F], from its exact reproduction in the rock-cut caitya gṛhas or caitya halls (see below), and from surviving structures of later date.[9] Buildings, not necessarily religious, with peaked tiled roofs appear on one or two reliefs, and small thatched huts are frequently shown [27A, B].[10] The crowning dome-like element, later to become known as the South Indian śikhara, appears on many little tower-like shrines and, in a fully-fledged octagonal shape, on a relief from Ghaṇṭaśāla [27E, G, H, I, J].[11] Gandhāra alone, besides innumerable relief representations of architectural elements and even small shrines, provides examples of complete standing edifices, small and simple though they are.[12] Where their superstructures remain they are invariably of the throated dome-like type just mentioned and of circular form. Like so much of the Gandhāra remains, however, they may not be earlier than the fourth or even fifth century A.D.

Simple dolmenoid shrines were no doubt constructed from monolithic slabs from very early times, as they still are today, and this method has occasionally been used for more evolved buildings. The construction and symbolism of the altars used in Vedic rites had a

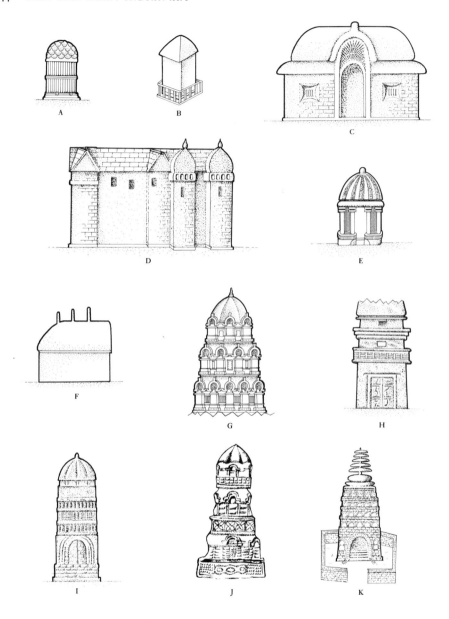

27. Types of buildings depicted on early reliefs:
(A-D), (F), (H), (J) Mathurā (Vogel, *La Sculpture de Mathurā* (Paris, 1930), figures lx(a), viii(d), viii(c), xxiii(a) (same relief), lv(b), vii(c)); (E), (G), (I), (K) Amarāvatī, Ghaṇṭaśāla, Mathurā, Kumrahar (Franz, *Pagoda, Turmtempel, Stupa* (Graz, 1978), figures vi, 5; viii, 11; v, 2 and 3; viii, 10)

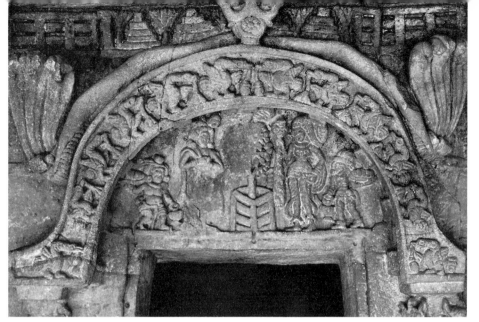

28. Udayagiri (Orissa), Cave 5, relief of a sacred tree surrounded by a vedikā. First century B.C./A.D.

considerable influence on the later temple, but the early shrines appear to have developed independently.

It is thus to monuments, shrines, and monasteries dug cave-like into the vertical faces of low cliffs and graced with such architectural features as façades, interior columns, and even rafters hewn out of the solid stone that we must look for the first surviving examples of Indian architecture until well into our era. That these monuments indeed reproduced all the features of contemporary free-standing buildings in wood allows them to be considered as architecture and used as architectural records, strange as the form may at first appear. It occurs in the Middle East and Ethiopia as well. Its first appearance in India under Maurya patronage indeed suggests a link, as with so many aspects of early Indian art, with western Asia. Rock-cut monuments at the same time were particularly well adapted to Indian conditions, material and spiritual. Cool in summer, warm in winter, cave-temples and monasteries are well adapted to the Indian climate. Low cliffs often mean welcome water-falls, a stream through a ravine, or simply water permeating down from the tableland above. More than this, the concept of the cave with its elemental, uncreated (*svayambhu*) nature strikes one of the fundamental chords of Indian spirituality. At the same time, it must not be forgotten that for every rock-cut monument there must have been scores, if not hundreds, of structural buildings of which no trace has survived.

From the late second century B.C. until the mid second century A.D., when such construction ceased fairly abruptly, upwards of a thousand caves of varying sizes and degrees of elaboration were excavated in the northern Konkan (the coastal region south of present-day Bombay), in the Western Ghats behind the coastal region, and in the Sahyadri hills as far inland as Aurangabad, the ancient Aparānta. They were apparently all for Buddhist communities.[13] This first great burst of activity, the 'Hīnayāna' phase, unrivalled elsewhere in the world until the 'Mahāyāna'[14] began some three centuries later, appears to have been fostered by an active trade with the rest of India

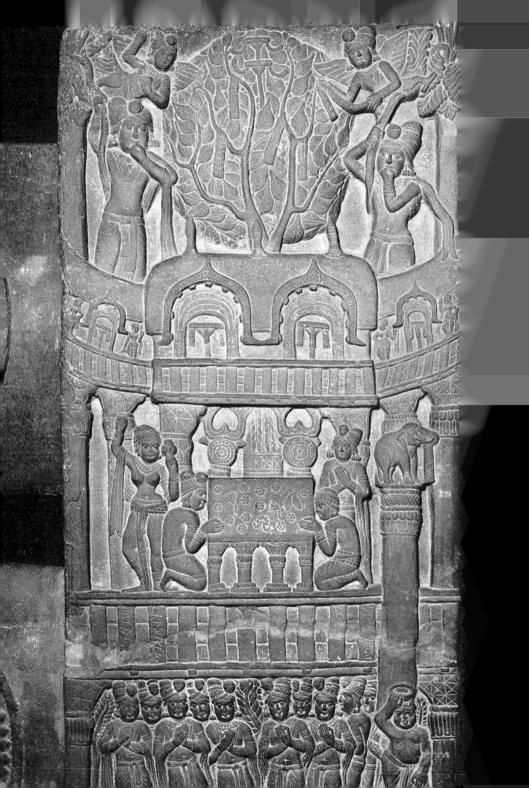

29 (*opposite*). Relief showing the Mahābodhi
shrine from Bhārhut.
Second century B.C. Red sandstone.
Calcutta, Indian Museum

originating in the Konkan ports, the caravan
routes forced to climb the Western Ghats be-
fore proceeding to the north and east [30], a
vigorous merchant community, and a forceful
dynasty, the Sātavāhanas, with their capital in

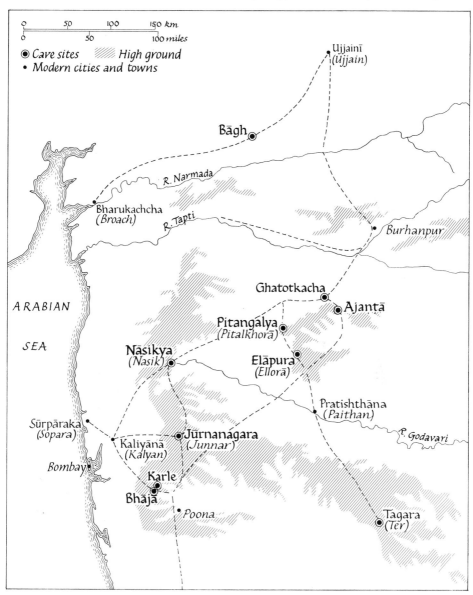

30. Map showing trade routes and sites of rock-cut monasteries in western India

the region, at Paithan, as well of course as by the trap and conglomerate formations of the Western Ghats and the hill ranges extending inland from them which provided rock faces of a uniform and cohesive stone.[15] The caravan routes, with their entrepots, meant easy access for the laity. Even in the Buddha's day, the Saṅgha ceased from wandering, as did most holy men, during the rainy season and took up abodes (saṅghārāmas) which eventually turned into settled communities.[16] The sites were likely to be chosen according to the Buddhist prescription that the Saṅgha should live not too near and not too far from the cities of men – not too near to be distracted, not too far to make begging rounds impractical or to put the monks out of reach of the laity.[17] The existence of a natural cave may have been another determining factor.[18]

Donative inscriptions of monks and nuns as well as of the laity afford fascinating glimpses of the way in which the work of excavation and carving was paid for and the monasteries endowed. The donors' home-towns, most of them identifiable, are so far-flung as to prove the wide dissemination of Buddhism throughout the Sātavāhana dominions and beyond. A surprising number of donors describe themselves as Yavanas, a general term for foreigners, originally derived from Ionia; their Indian names, however, testify to a considerable degree of cultural assimilation.[19]

The manner in which these many hundreds of cave-shrines and monasteries were dug out is known in its broad outline since a number were abandoned at various stages. Work proceeded from the top downwards, eliminating the need for scaffolding. Caves were created in groups to provide accommodation for outside workers, since such undertakings were beyond the resources of a very small community. They consist essentially of two types, caitya gṛhas or caitya halls (for the meaning of caitya, see below) and vihāras. The former enshrined a stūpa and were intended for congregational worship – an activity which fundamentally distinguishes Buddhism from Hinduism. Vihāras

were the dwelling places of the monks, usually cells cut into the walls around three sides of a hall. Either vaulted and apsidal-ended, thus conforming to the stūpa at the far end, or rectangular and flat-roofed, the caitya hall was lit by the great caitya-arch window at the entrance. The larger ones were divided by a row of columns down either side into the equivalent of the nave and aisles of Romanesque and Gothic churches. At the same time the apsidal-ended hall is a copy, in the negative, so to speak, of a wooden edifice of the hastipṛṣṭha variety. The derivation from wooden prototypes is left in no doubt. On the façades, and sometimes inside, brackets, railing-motifs, windows, balconies, pavilions, all carved in relief, faithfully reproduce the upper storeys of palaces built of wood; what is more, dowel-holes still exist to show where porticoes and balconies, actually in wood, were affixed to the façades.[20] To what lengths conservatism could go is shown by the practice of reproducing in wood members such as rafters of no significance in this kind of construction and of no ornamental value. Considerable numbers have survived in situ to this day.[21]

Caitya is a keyword in the history of worship and shrine-building in India. A nominal derivative from something heaped up (cita is the past participle of ci, to heap), it meant a mound or a pedestal and, by extension, a lieu sacré; a sacred tree is a caityavṛkṣa. As applied to a stūpa it gave its name to the Buddhist caitya halls, because they contained a stūpa, the shape of whose great façade windows, themselves the cross-section of a vaulted wooden building, came to be known by writers in English as the caitya arch (properly gavākṣa, gomukha, or kūḍu). Reproduced in miniature in their myriads, gavākṣas – also termed candraśālās in Gupta times – became the most common motif of Hindu temple architecture, a constant reminder of the wooden forms which underlie its origins.

Almost certainly the earliest of the caves are those at Bhājā, Pitalkhora, and Kondane (late second/early first century B.C.).[22] The caitya

31. Bhājā, caitya hall, façade. Late second/early first century B.C.

halls have plain chamfered columns without capitals – at Bhājā with an excessively pronounced batter – recalling their wooden prototypes [31]. In one of the vihāras at Bhājā are important reliefs, including one representing Sūrya, the sun-god, and the famous 'Indra' panel [32] which, with its wealth of detail and great differences in scale, represents a rather

different artistic conception from the narrative panels at Bhārhut and Sāñcī.[23]

Pitalkhora is remarkable for its huge terrace forecourt supported in part by elephant caryatids, the forerunners of those at Karle and eventually of the Kailāsanātha at Ellorā. Two dvārapālas (doorkeepers) guarding the staircase up to the terrace are perhaps the finest

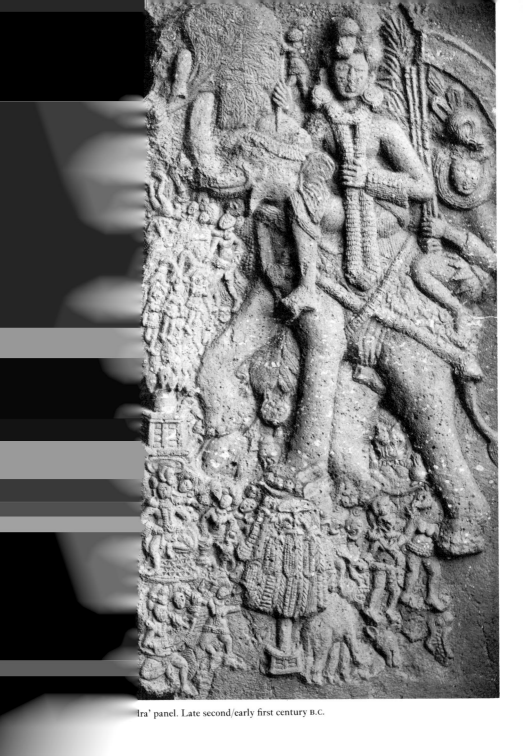

Ira' panel. Late second/early first century B.C.

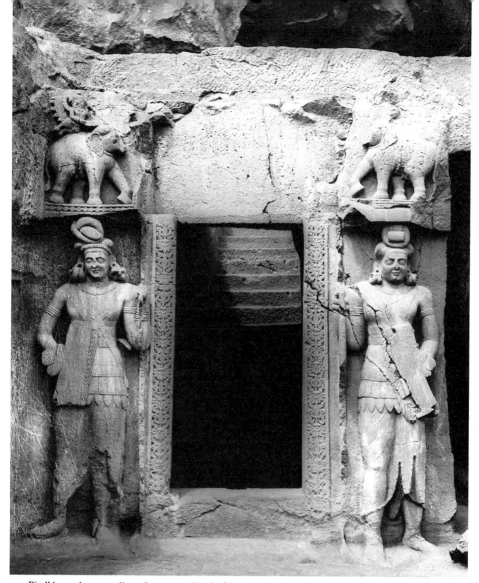

33. Pitalkhora, door guardians. Late second/early first century B.C.

examples of the archaic style [33]. Their
fringed tunics, possibly mailed, strike a Yavana
note but the *dhotis* (the characteristic lower
garment of the Indian male) below them, the
massive serpentine ear-rings, and the turbans
with their huge knots are purely Indian.[24]
Detached sculptures have been found, some of

them apparently made to replace reliefs lost in
the rock-falls which have so savaged this site.
There are also traces of masonry repairs. Many
of the sculptural themes of early Indian art are
found at Pitalkhora: the goddess Śrī, elephants
dousing her with their trunks, yakṣas with
fin-like ears, juxtaposed animal figures, mithu-

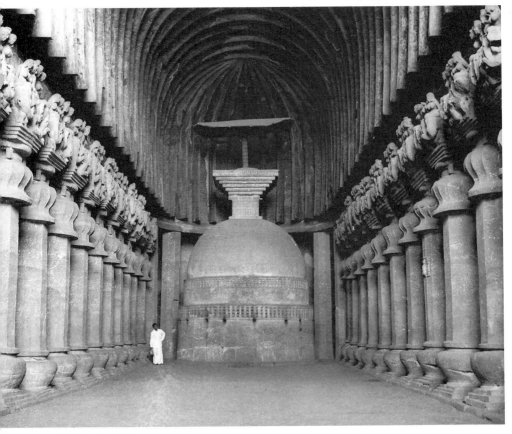

34. Karle, caitya hall. *c.* A.D. 50–70

nas and flying figures, some with wings (*kinnaras*) and others in the beautiful and distinctive pose, legs flexed trailing behind the body, which henceforth indicates that a figure is flying.

The chronological sequence of the caves, extending down to the mid second century A.D., has been ascertained only in its broad lines. Some caves have inscriptions containing the names of Sātavāhana and Kṣahārata kings and princes but not a single date, and so bedevilled with problems are the genealogies and orders of succession of these rulers that even though certain of the caves, notably at Nasik, are royal

donations, neither their relative nor their absolute chronology has been determined.[25] Palaeography, the study of the characters (*akṣaras*) composing the words from inscriptions and the changes and variations in their shapes, is an inexact science which cannot be relied upon for dating within much less than a century. As in architecture and sculpture, stylistic change does not occur at a constant rate, nor does it affect all features at the same time. Many factors unknown to the historian may slow down, accelerate, or conceivably even reverse development (archaism), and even if they are known are all but impossible

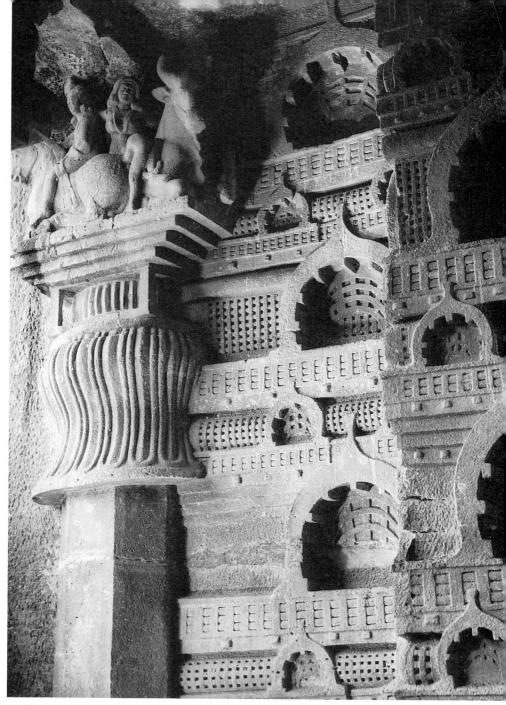

35. Bedsā, caitya hall, capital of veranda pillar. *c.* 50-30 B.C.

to evaluate correctly. An example is the erratic treatment of the domes (*aṇḍas*) of the stūpas in the caitya halls, where the unquestionable long-term evolution from a hemisphere to something more than a hemisphere, as well as the greater and greater importance accorded to the base, does not proceed consistently, i.e. in accordance with the other accepted indications of the passage of time.

The latest caves, however, show an unquestionably more developed form than the early ones. Echoes of the structural features of wooden architecture tend to disappear: the unfinished Budh Lena caitya at Junnar, for instance, has a blind caitya 'window' surmounted by miniature stūpas, although the batter of the posts below is still pronounced. But the themes of wooden architecture are still retained to decorate façades (Cave 18 at Nasik). The deep atavistic attachment to timber can still be seen, most astonishingly, at Karle, where actual wooden elements survive in the most splendid example of the evolved caitya (*c.* A.D. 50–70) [34].

Whereas in the earlier caityas the porticoes were of wood, long since vanished, here the actual entrance to the caitya hall is set back, preceded by a monumental propylaeum cut deep into the rock. At Bedsā, two splendid columns 'support' this propylaeum, with pot-shaped bases, bell capitals reminiscent of Aśokan ones surmounted by enclosed *āmalakas* (a notched ring stone, named after the fruit of the Embilic Myrobalan), and inverted stepped abaci upon which rest splendid groups of animals with riders. On a smaller scale, this will henceforth be the form of interior as well as exterior columns in both caitya halls and vihāras [35]. The interior of Karle, the largest of the caitya halls, is rightly considered a supreme achievement of the early cave-temple excavators, and its façade is equally fine. The propylaeum is faced by a rock-cut screen with three entrances and a pillared clerestory above. Even here, however, mortice holes exist for the installation of a wooden minstrels' gallery. In the inner court, the side walls are adorned with architectural motifs supported at the base by couchant elephants whose tusks were probably of ivory (the Buddha figures carved into the rock above and elsewhere are of a later period). Justly famous mithunas are carved on either side of the doorway into the interior [36].[26] If some of the sculpture at Pitalkhora represents the peak of the archaic period of Indian art, then the entrance mithunas at Karle, and, in a lesser degree, those at Kanheri, are the culmination of the early Indian sculptural style in the western half of the country, along with the carvings of the Sāñcī gateways and the best of early Kuṣāṇa sculpture at Mathurā. In front of the Karle cave stands a massive stambha surmounted by lions such as are often shown on early Buddhist reliefs; its twin, surmounted by a cakra, probably rose where the little modern shrine now stands.

Cave 3 at Kanheri is almost certainly the last of the Hīnayāna caitya halls to have been excavated. As at Karle, there is a pillared portico atop the entrance screen, with a splendid group of donors on either side of the door into the hall. Here both the stambhas in the forecourt are in place. Upon one of them small Buddhas stand in relief, the earliest representations of Śākyasiṃha in the whole region and the only contemporary ones in any of the hundreds of Hīnayāna caves. In this and other ways, Kanheri at one and the same time signifies the end of a tradition and is a herald of the future. Its façade owes little to the wooden origins of the rock-cut caitya hall. The two door guardians, a yakṣa and a *nāgarāja* (serpent deity), on each side of the entrance to the courtyard through the solid barrier with its vedikā pattern, are in scale and style more akin to Kuṣāṇa Mathurā arrangements than to those of the earlier caves. Similarly, the lively groups and scenes atop some of the interior pillars are in marked contrast to the solemn grandeur of the mounted groups at Karle and particularly the much earlier Bedsā (*c.* 50–30 B.C.).

The vihāras, the dwellings of the monks and nuns, by their nature show a much greater variety in both size and plan, from single cells

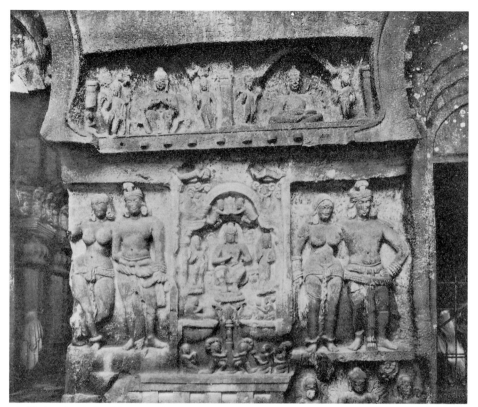

36. Karle, caitya hall, mithuna couple. *c.* A.D. 50–70

to groups opening on to colonnaded verandas, or large interior halls with the cells opening on to them. The cells are frequently provided with slightly raised platforms as beds. The interiors of the halls are often decorated with the usual motifs of wooden architecture carved in relief. In the later examples, such as those at Junnar and Nasik, the verandas outside are 'supported' by columns of the same developed type as inside the late caitya halls [37]. These columns have a bell-shaped capital with an āmalaka, sometimes 'boxed', above, and then an inverted pyramidal stepped member, like the upper portion of a harmikā, above the stūpa. Upon this stand the elephants or horses with

their riders. The prototypes are the two pillars supporting the veranda in front of the Bedsā caitya cave. Sometimes the bases consist of large jars. In Cave 3 at Nasik, the veranda columns spring from a solid balustrade in turn supported by caryatids in the form of *bhūtas*, corpulent and dwarfish earth-spirits, followers of Śiva. In relief around the entrance door to the interior is a toraṇa, the only rock-cut one, flanked on either side by a rather crudely carved male figure. The stambhas of the toraṇa are divided into panels containing pairs of figures, etc., forerunners of similar stambhas and door jambs at Mathurā in the Kuṣāṇa and Gupta periods. Inside, on the rear wall, is a

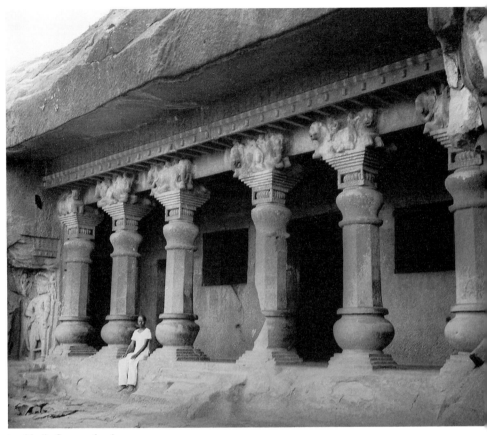

37. ·Nasik, Cave 10, façade

large relief of a stūpa with worshippers. (The remains of a similar and finer panel in Cave 10 bear precursors of the Buddhas and other sculptured figures which abound in the caves of the Mahāyāna period.) It is elsewhere, however, that one must look for the developments which these features herald.

A rock edict of Aśoka at Dhauli, near Bhubaneswar, is accompanied by the well-carved head and fore-part of an elephant emerging from the same boulder. Some miles away, in the opposite direction from Bhubaneswar, twenty or more monastic dwellings have been carved out of the sloping sides of two hills,

Khandagiri and Udayagiri, which face each other across a defile.[27] The inscription in the natural Hāthi *gumphā* (the local name for a cave) on Udayagiri recording the *praśasti* (panegyric) of King Khāravela (first century B.C.), the only notable figure known to early Orissa history, besides listing his conquests, informs us that the king was a devout Jain and that he had hewn a number of caves out of the hill, presumably for monks of that faith. The gumphās are mostly small and follow the irregular configuration of the rock. Some are unicellular; others consist of a veranda in front of four or five cells. The entrances give the impression

of an arcade springing from pilasters. In this respect, the caves reproduce features of wooden architecture different from those of the western ones but known from reliefs; brackets incorporating figures and associated with pillars, so common in later architecture, also make their only early appearance here. Some of the pilasters take a familiar form, with couchant animals on a bell capital and sometimes rising from jars, but always crudely executed compared to the pillars at Bedsā and in the Nasik vihāras.

The courtyards in front of the more important caves are open to the sky, the relatively gentle slope of the hills precluding deep excavation. The Rāṇī gumphā, the most elaborate, has a large open court, with two storeys of cells and arcades on parts of three sides. The single-cell Bāgh gumphā, carved in the form of an open-mouthed tiger's head, has a counter-part at Śāluvankuppam just north of Māmallapuram in Tamilnāḍu.

The sculptural carving is rather crude, partly owing to the coarse sandstone of the two hills, for which they were doubtless chosen in a region where the harder laterite prevails. Scenes and motifs occur principally in bands towards the top of the arcades. In a lively style with some folk elements, themes and personages and their iconography in this area remote from the main centres are none the less those of early Indian art elsewhere: the *srivatsa* symbol of two opposed Ss, Sūrya in his chariot, sacred trees surrounded by vedikās [28], and many others, with nothing to indicate that these were Jain caves.[28] The most likely date for the full-size relief figures including both male and female dvārapālas in Yavana costume would appear to be the period between 50 B.C. and A.D. 50.[29]

38. Mathurā and its environs

MATHURĀ

Mathurā, still a thriving city on the Jumna (Yamunā) between New Delhi and Agra, and its surrounding countryside are of supreme importance in the history of Indian sculpture, in the early period producing work in quantities rivalled only by Gandhāra and eagerly sought after and imitated all over northern India. It can be said without exaggeration that here, in the Kuṣāna period, the Brahmanical icon was born.[1]

Early excavation was unsystematic, and many of the most important sculptures have come to light in the course of modern building or road-making [38]. Even today, *tīlās* (the local name for large mounds) rise up within the city, probably the remains of stūpas unexplored because of the buildings on and around them. As a result, unlike other important sites, not a single early building or monument has survived, even in excavated form. Yet few cities in India can boast of greater antiquity. Mathurā, mentioned by Ptolemy, was the seat of the early Kṣatrapas and then the southern capital of the Kuṣānas, and the abundant remains testify to the important Buddhist and Jain establishments which flourished under their rule. It remained one of the main centres of sculptural tradition throughout the Gupta period and beyond. Because of their association with Krṣna's birth and many of the incidents of his early life, Mathurā and its environs are still today a major religious centre and place of pilgrimage. The characteristic red sandstone with beige spots from which almost all the sculpture is carved is still being used for building and fencing today.[2]

Considerable light has been shed on the early cultural and political history of the region by major excavations at Sonkh.[3] From a large area free of modern habitation explored to a depth of some 56 ft (17 m.) a stratification has

been obtained beginning with the virgin soil and continuing through finds of Painted Grey ware up to the late Kuṣāna period – no less than thirty-six levels in all. The numerous characteristic terracotta figurines with moulded faces, usually grey [23], have been securely dated to 200-100 B.C. Two types have been distinguished, one slightly later than the other.[4] Groups of women seated around a tank(?), also in terracotta, are probably the earliest surviving representations of the Mothers. The first known instance of a mould is provided by a small group of nāga figures taken from a stone relief for reproduction on a terracotta plaque. Influence from farther afield is attested by a bronze chalice of Parthian inspiration found together with a unique local pottery imitation, and by an as yet unidentified fitting, perhaps part of a hydraulic system, covered with the typical Parthian greyish-blue glaze.[5]

Although an apsidal-ended shrine surrounded by a peristyle was already known from a relief, the remains of an actual survivor were revealed for the first time at Mathurā. Reliefs on parts of a toraṇa also found left no doubt that this did not belong to a Buddhist or Jain sanctuary, but to a nāga shrine. The lovely yakṣī figure, probably part of the toraṇa and indistinguishable from other such figures found at Jain and Buddhist shrines, proves how little Indian art was influenced by sectarian considerations.

Given the very different aesthetic which animated them, the achievements of Gandhāra and Mathurā are surprisingly similar. Both created, in their respective styles, the Buddha and Bodhisattva (and, in Mathurā's case, Jina) image. These are the first icons in India in the true sense of the word: the god to be depicted in this way and no other, instantly recogniz-

able by attitude, gesture, and accompanying symbol. Variations most likely indicate a different aspect of the god, or, in the case of the Buddha, are to be referred to different episodes in his life.

Narrative friezes and architectural elements carved with figures and decoration have been found in far fewer numbers in Mathurā than in Gandhāra, signifying no doubt that the monasteries and stūpas there were not revetted with carved stone to the same extent as in the north-west. Sculptured lintels and elaborately

rather exaggerated breasts and over-thin legs from which the glow of feminine sensuality, as evidenced in the best Late Sātavāhana figures, has departed. Plastically far richer are some of the contemporary Nāgarājas from Mathurā [40], one of whose shrines was discovered at Sonkh (see above). Besides sharing the stūpa with the

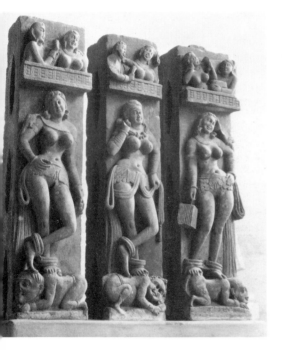

carved door jambs, however, have survived, as well as the remains of real vedikās, absent in Gandhāra. The stambhas bearing the voluptuous pillar figures of women which are perhaps the best known examples of Mathurā sculpture [39] may have been elements of enclosures. They almost certainly represent the alluring denizens of one of the heavens. Much praised, most of them are stereotypes, with

39 (*above, left*). Yakṣīs on railing pillars from Bhūteśar.
Second/third century A.D. Spotted red sandstone.
Calcutta, Indian Museum

40 (*above*). Nāgarāja from Mathurā.
Third/fourth century. Red sandstone.
Paris, Musée Guimet

41. Āyāgapaṭa from Kaṅkālī Ṭīlā.
Second century. Spotted red sandstone.
New Delhi, National Museum

Buddhists,[6] Jains produced distinctive cult objects in the form of the *sarvatobhadrika* images (four standing Jinas back to back) and the *āyāgapaṭas* or votive tablets, square slabs bearing relief sculptures on one side, possibly used as altars near a stūpa for the deposit of offerings.[7] Some show figures or scenes or stūpas, others are carved with decorative patterns and such ancient Indian symbols as the svastika and the twin fish, adopted by the Jains as well as the Buddhists [41]. It is interesting that Jain inscriptions of the Kuṣāṇa period at Mathurā are more numerous than Buddhist ones.[8]

The great Mathurā standing Buddhas are usually well over life-size - the largest, installed at Śrāvastī by bhikṣu Bala, is 8 ft 3 in. (2.51 m.) high.[9] They owe nothing to western classical influence, and their filiation to the free-standing yakṣa figures, although both are conceived frontally, is not as obvious as is often supposed. The yakṣas derive their

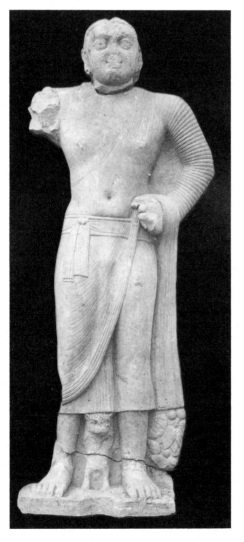

powerful presence from their bulk; the Buddhas have very little depth for their great size and the backs are flat, the details little more than reliefs. They nonetheless exude a sense of power, with their excessively wide shoulders, their prominent breasts and deep navels. They invariably stand with their feet well apart in *samapada*, the legs so stiff that they appear almost to bend backwards at the knees, and usually with a lion or a sheaf of lotuses between the feet. The surviving heads bore an uṣṇīṣa of a peculiar spiral shape - hence the name *kapardin* (from *kaparda*, snail). The hair was a smooth close-fitting cap and the foreheads were marked with the *ūrṇā* (believed to be a hairy mole, one of the marks of the Buddha). The right shoulder is invariably bare, the upper garment looped over the left arm, the left hand resting on the hip, in a characteristic bunch of tight tubular pleats.[10] The right hand, usually missing, was raised in the same characteristic gesture as that of the seated Buddhas. The famous Buddha from Mathurā installed at Sārnāth by the ubiquitous bhikṣu Bala [42] had in addition a tall shaft (*daṇḍa*) standing behind it supporting a beautiful carved stone parasol (*chattra*), which has survived.

Other great standing Buddhas from Mathurā were installed at famous religious sites such as Kauśāmbī, where, according to the inscription, a *bhikṣunī* (nun), a pupil of bhikṣu Bala, was responsible. Not all the donors were monks or nuns: they included lay people and even two Kṣatrapas, at the time the foreign rulers of western India. At Sārnāth, a copy was made in a local stone. Small seated Buddhas from Mathurā have been found at Ahichchhatra, at Sāñcī, and as far east as Bengal and north-west

42 (*left*). Sārnāth, standing Buddha.
c. 100. Spotted red sandstone.
Sārnāth Museum

43 (*opposite*). Seated Buddha from the Katrā mound.
Early second century. Spotted red sandstone.
Mathurā, Government Museum

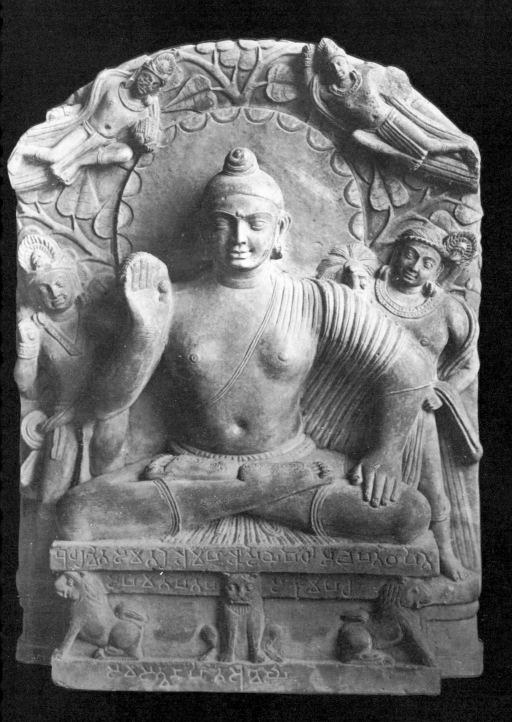

as Charsadda, outside Peshawar, and it would be interesting to know how they were transported over such vast distances in a land where, until fairly recently, sculptor-stonemasons (*śilarūpakaras*) were more apt to migrate than sculpture to travel.[11] These exports testify to the pre-eminence of Mathurā sculpture. Granted that the Jumna provided a means of transport by water to many of the most sacred Buddhist sites and their monasteries, it is nonetheless significant that no sculpture from Gandhāra, which was also producing Buddha images at this time, has been found anywhere else except at Mathurā.

The famous Buddha from the Katrā mound [43], the finest and best preserved of the kapardin seated Buddhas, is a stele, a form which the great majority of Indian images have continued to take until the present day. Even more than the standing Buddha, it is repeated over and over. A well known example dated in the year 32 was found at Ahichchhatra.[12] For these reasons, and because their iconography is richer, the seated Mathurā Buddhas of the Kuṣāna period are even more important than the standing ones.

The Buddha sits in a yogic position called *padmāsana*, his legs tightly folded so that the soles of both feet, decorated with the Buddhist *triratna* ('triple jewel') and *dharmacakra* ('wheel of the Law') signs, face upward.[13] At either end of the throne sejant lion supporters face outwards; otherwise the figure is similar to the standing Buddha. His right hand is held up, the palm open and turned sideways, an archaic gesture which will soon evolve into the standard abhaya mudrā.[14] The left hand rests lightly on the left thigh in a gesture which the sculptor has cunningly contrived so as to emphasize the physical vitality of the figure. The face does not have the bizarre physiognomy of many, probably later, Kuṣāna Mathurā heads. The eyelids are not very wide in proportion to the eyes and there is only a trace of a line prolonging the outer corners of the eyes. The eyebrows are indicated by a raised ridge, but it is quite narrow and is almost broken at the

ūrṇa. The mouth is slightly pursed but the expression remains, in Rosenfield's phrase, one of 'radiant good nature'.[15]

The two standing crowned or turbaned male figures holding chowries on either side of the Buddha are the first of the attendants which will henceforth flank so many Indian divinities. There is a plain halo with scallops around the edges, and on the ground of the stele the branches and leaves of a pīpal tree appear in low relief, the symbol of the Enlightenment. The iconographical significance of these images remains unclear, complicated by the fact that in most of the inscriptions, but not all, it is the setting up of a Bodhisattva image, not a Buddha, that is recorded.

Large standing Bodhisattvas in the round also figure among the Buddhist images at Mathurā. In contrast to the Buddhas, they wear jewellery and usually a rolled scarf over a shoulder and looping down below the knee, but the robust and well-fleshed bodies are the same. One of the few Bodhisattvas to possess its head, now in the National Museum, New Delhi, is identified by the inscription as Maitreya [44]. Found at Ahichchhatra, it is from the same atelier, if not the same hand, as an Indra in a private collection found in Gandhāra.[16] In Indian sculpture and with such widely separated find places, it is not very often that such a close relationship can be traced. Nāga images usually show much the same plastic treatment: some stand in the usual samapada position, some display a marked torsion (*bhanga*), like the superb Musée Guimet Nāgarāja [40].[17] Images of Hārītī abound, as in Gandhāra, the goddess often squatting on a peculiar cross-barred stool, with her feet in the framework.[18] She is sometimes accompanied by her consort Pāñcika.

It was at Mathurā during the Kuṣāna period that the first Hindu icons were made.[19] Their appearance coincides with the emergence of the two great theistic systems, the Śaiva and the Vaiṣnava, each with its pantheon. Usually small in size, fairly insignificant numbers have survived compared to those of Buddhist and

44. Maitreya from Ahichchhatra.
Second century. Spotted red sandstone.
New Delhi, National Museum

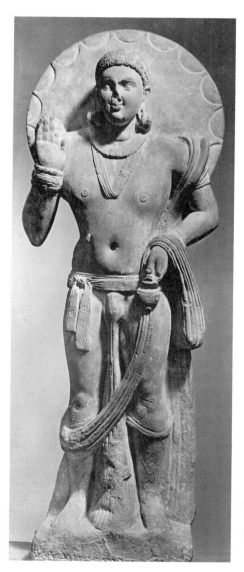

Jain images, but among them two exist in suf-
ficient numbers to be able to speak of an estab-
lished iconography: liṅgas with one face or four
faces of Śiva projecting from them, and the god-
dess Durgā slaying the demon buffalo (Durgā
Mahiṣāsuramardinī). The buffalo rears up in
front of the goddess who stands with one of
her four or more arms pressing stiffly down on
the animal's haunch.[20] Small icons of Varāha
Viṣṇu, recognizable by his characteristic crown
(*mukuṭa*), Śiva as Ardhanārī, half man half
woman, the division being vertical, Ṣaṣṭhī and
Kārttikeya, have all been found.[21] The last is
identified only by his lance, and a large head
of Śiva, with a third eye and crescent moon and
at the same time the curls and diadem or fillet
of a Greek god, shows to what extent the icon-
ography of the principal gods was still in the
process of formulation.[22] One aspect of this
process is of unique interest: the icons consist-
ing of numerous conjoined figures, such as the
Nand pillar and the well known so-called
'Indra' and 'Nāga Queen', the former, in fact,
embodying an emanatory conception of Viṣṇu,
which give iconographic form to complex
Pāñcarātra metaphysical conceptions [45],[23] the
Pāñcarātra being an early Vaiṣṇava religio-
metaphysical system.

The stylistic evolution of Mathurā sculpture
during the first centuries of our era takes place
within a much more easily delimitable period
than that of Gandhāra. A considerable amount
of sculpture is easily recognizable as belonging
to Śuṅga or Sātavāhana times, for Mathurā has
always been in the main stream, if not the van,
of Indian art.[24] Then, at the end of the period
under consideration, pieces in the Gupta style
appear, a few bearing inscriptions dated in the
first half of the fifth century,* and already in
a mature form of the style.[25] In the early part
of the period, a considerable number of
statues, predominantly Buddha images, are
firmly dated in the era of Kaniṣka, beginning
with one of the year 3 and extending over
nearly a hundred years [50]. Although many

* Dates are A.D. unless otherwise noted.

66

45. Caturvyūha Viṣṇu from the Sapta Samudrī well.
Third century. Spotted red sandstone.
Mathurā, Government Museum

are fragmentary (sometimes consisting of no more than the base) they provide an indisputably dated sequence not found elsewhere until the tenth century in South India. To complicate matters, however, a substantial number of other sculptures, mostly Jain *Tīrthaṅkaras*, corresponding to the historical Buddhas, also bearing dates up to about the year 50, of extremely poor quality but at the same time stylistically more advanced, must almost certainly be assigned to another, unknown but later, era.[26] From this rather unsatisfactory evidence, it would seem that the Kuṣāna Mathurā style commences with a full-blooded naturalism based on later Sātavāhana sculpture, but with a diamond-hard quality reminiscent of some of the finest Egyptian work.[27] The lively immediacy of this style is well shown in the head of a man [46] and in the famous Ṛsyaśṛṅga figure [47]. The manner then evolves into a curious attempt at stylization distinguished by a head with exaggeratedly pursed lips, a raised

continuous ridge for the eyebrows, and a bizarre facial treatment with the upper and lower lids covering a disproportionate area of a round or nearly round eye. The bodies assume an inflated appearance, probably a foretaste of the theory of *prāṇa* or vital breath. In seated images, the lions on the base invariably face forward, and the intervening space is usually crowded with donor figures, the sexes usually separated by a symbol in the middle. Haloes become more and more decorated, presaging those of the Gupta period to which some of them almost certainly belong [72].

In spite of the quintessentially Indian aesthetic of most Mathurā sculpture, it would be false to think of Mathurā as culturally isolated, a sort of Indian fortress. Its position on important trade routes from the Konkan to the lower Doab and Pāṭaliputra on the one hand and Gandhāra on the other would make this unlikely even were it not for its eminent position in the Kuṣāna empire, notably eclectic in

46 (*opposite, right*). Head of a man.
Early second century. Spotted red sandstone.
New Delhi, National Museum

47 (*above*). Adolescent, possibly the young sage
Ṛsyaśṛṅga, relief on a railing pillar
from Chaubārā.
Early second century. Spotted red sandstone.
Mathurā, Government Museum

culture and religion. Direct artistic influence
from Gandhāra there certainly was. Imports of
the characteristic sculpture in grey schist, in-
cluding a large and fine female figure, probably
a donor, have been found at Mathurā.[28] A
number of Mathurā seated Buddhas, crude and
of obviously late date, show unmistakable signs
of having been influenced by Gandhāra models.
The *saṁghāṭī* (upper garment) covers both
shoulders, and a clumsy attempt has been
made to imitate Gandhāra drapery. The hair is
dressed in snail curls. These hybrid creations
must be distinguished from certain Mathurā
Buddhas, usually kapardin, where Śākyamuni
also wears a saṁghāṭī covering both shoulders
but with the folds symmetrically draped down
the front of the body. This type usually
appears on reliefs.

Signs of more direct contact with the West
are not lacking at Mathurā. A modified acan-
thus motif and the olive-leaf band occur
widely on door surrounds and lintels. One
famous statue, the Hercules and the Nemean
Lion [48], is indisputably based on a famous
Greek or Hellenistic statue extant in dozens of
Roman copies. There is no Gandhāra sculpture
whose source can be so directly traced. Of the
so-called Bacchanalian groups, one at least,
showing a drunken Silenus in a rocky setting
flanked by men and women in Greek dress, is
probably also based on a Roman group, so far
unidentified. An Indian name, *madhupana*
(wine-drinking), has recently been bestowed
upon these groups and the Silenus identified
as Kubera; the latter, however, while some-
times shown holding a wine cup, is nowhere
else depicted drunkenly sprawling. Scenes of
vinous carousals are Roman in spirit.[29] A
similar secular spirit pervades two or three
other relief groups whose figures are more
Indian in costume and appearance [49]. One
of them, which exists in two almost identical
versions, shows a woman, over whom a smaller
figure holds a parasol, caught in motion. Her
huge anklets are drawn up to her knees, most
likely to muffle their jingling. Two men stand
in the background whispering to each other.[30]

68

48. Hercules and the Nemean Lion from Mathurā.
Second century. Spotted red sandstone.
Calcutta, Indian Museum

49. Intoxicated courtesan (?) from Mathurā.
Second/third century. Red sandstone.
New Delhi, National Museum

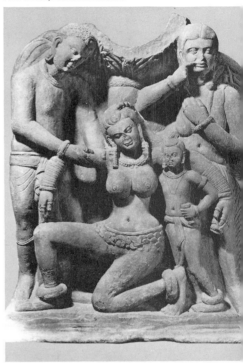

Whatever the scenes depict there is no denying
the intensely secular atmosphere, which places
them beside the mainstream of Indian sculp-
ture. Curiously enough they are all parts (the
base) of stone bowls whose purpose is not
clear, though one at least was installed in a
Buddhist saṅghārāma.

A number of statues represent Kuṣāṇa kings
and princes, invariably in their native costume
– the trousers or boots, the sewn tunic, and
the pointed 'Scythian' cap of Central Asian
horsemen – as they appear on their coins. As
in Gandhāra, reliefs quite often show figures in
'Scythian' garb, presumably members of the
foreign ruling class who retained their distinc-
tive dress even while converting to Buddhism

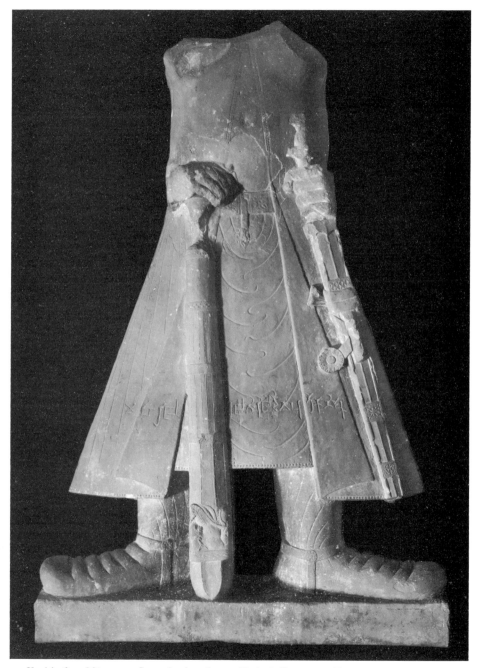

50. Kaniṣka from Māṭ. *c.* 100. Spotted red sandstone. *Mathurā, Government Museum*

and Jainism and even worshipping at liṅga shrines. What makes the larger free-standing sculptures exceptional is that they are portraits, which are rare in Indian art,[31] and that the most important of them were found, like similarly dressed individuals from Surkh Kotal in Afghanistan, in what appears to have been a royal shrine at the nearby village of Māṭ.[32] One of these majestic figures, unfortunately headless, seated in European fashion on a chair-like lion throne of obviously non-Indian origin, may represent Wima Kadphises, a predecessor of Kaniṣka. There is no doubt, however, as to the identity of the famous standing figure, also alas headless, known through an inscription to be the great Kaniṣka [50]. One of the finest works of art produced on Indian soil, in style it combines Indian motifs with a hard and jagged angularity harking back to the Kuṣāṇas' Central Asian origins. In this it is unique as the only major Indian work of art to show a foreign stylistic influence that has not come from Iran or the Hellenistic or Roman world.

A number of squatting figures in the same costume, including a very large one in worship as Mahadeo in a modern Mathurā temple, are not necessarily Kuṣāṇa rulers, for Sūrya the Sun god and his two attendants are portrayed at this time in a variety of northern dress of which traces, particularly the boots, continue to distinguish images of Sūrya for centuries.[33]

THE ART OF GANDHĀRA

Gandhāra is the name given to an ancient region or province[1] invaded in 326 B.C. by Alexander the Great, who took Charsadda (ancient Puṣkalāvatī) near present-day Peshawar (ancient Purūṣapura) and then marched eastward across the Indus into the Panjab as far as the Beas river (ancient Vipāśā). Gandhāra comprised the rolling plains watered by the Kabul river from the Khyber Pass area, the present frontier between Pakistan and Afghanistan, down to the Indus river and southward to the Murree hills and Taxila (ancient Takṣaśilā), near Pakistan's new capital of Islamabad.[2] Its art, however, during the first centuries of the Christian era, embraced a considerably larger area including the upper reaches of the Kabul river, the valley of Kabul itself, and ancient Kapiśā, as well as Swāt and Buner to the north.

A great deal of Gandhāra sculpture has survived, dating from the first to probably as late as the sixth or even the seventh century but in a remarkably homogeneous style, almost always in a blue-grey mica schist, though sometimes in a green phyllite or in stucco, or - very rarely - in terracotta. The general quality of the vast output was not high. Because of the appeal of its Western classical aesthetic for the British rulers of India, schooled to admire all things Greek and Roman, a great deal found its way into private hands or the shelter of museums.[3] Among the motley assortment of small bronze figures, as often as not Alexandrian imports, four or five Buddhist bronzes are very late in date.[4] Vestiges of mural painting have been found, but the only considerable body of painting, at Bāmiyān, is relatively late, and much of it belongs in an Iranian or Central Asian context rather than an Indian context.

Gandhāra became almost a second Holy Land of Buddhism and, except for a handful of Hindu icons, sculpture took the form either of Buddhist cult objects, Buddhas and Bodhisattvas primarily, or of architectural ornament for Buddhist monasteries. The monasteries were almost invariably of stone; an example is Takht-i-Bahi [51], high on a spur of the hills overlooking the road to Swāt. Much of the sculpture, such as friezes and stair-risers, serves as cladding for the rather rough masonry or to decorate the lower portions of stūpas.[5] The monastic establishments consisted of one or more stūpas, chapels for images, with cells for the monks and halls for assembly and domestic purposes. A number of practically intact stūpas are known, notably in Swāt and the environs of Kabul, most of them plain [52]; the more ornate kind are illustrated by small votive stūpas, and bases crowded with stucco images and figures survive at Jaulian and Mora Moradu, satellite monasteries in the hills around Taxila.[6] Haḍḍa, near the modern town of Jalālābād, has produced some groups in stucco of an almost rococo morbidezza [53], while more recently ambitious compositions in baked clay, with strong Hellenistic affinities, have been uncovered there in what amount to small chapels.[7] It is not known quite why stucco, an imported Alexandrian technique, was used. It is true that grey schist is not found near Taxila, but other stone is available, and against the ease of working in stucco, and the particular artistic effects which can be achieved [54], must be set its impermanence: fresh layers had frequently to be applied. Except perhaps at Taxila, its use appears to have been a late development.

Non-narrative themes and architectural ornament are as often as not of purely Western classical derivation; *bravi* and wreaths supported by *putti* are ubiquitous. Mythical figures and animals such as atlantes, tritons, dragons, and sea-serpents derive from the

51. Takht-i-Bahi. Second/fourth century

52. Guldara, stūpa. Second/fourth century

53. The Great Departure, stucco from Haḍḍa.
Third/fifth century. *Paris, Musée Guimet*

54. Head of the Buddha, stucco from Haḍḍa.
Third/fifth century. *Kabul Museum*

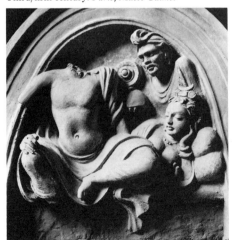

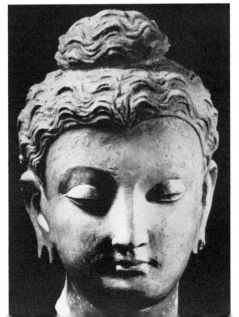

same source, although there is the occasional high-backed, stylized creature associated with the Central Asian animal style. Mouldings and cornices are decorated mostly with acanthus, laurel, and vine, though sometimes with motifs of Indian, and occasionally ultimately western Asian, origin: stepped merlons, lion heads, vedikās, and lotus petals. Architectural elements such as pillars, gable ends, and domes as represented in the reliefs tend to follow Indian forms, but the pilaster with a capital of Corinthian type abounds, and in one palace scene Persepolitan columns accompany Roman coffered ceilings.[8] The so-called Shrine of the Double-Headed Eagle at Sirkap, in reality a stūpa base, well illustrates this cultural eclecticism [55]: the double-headed bird atop the

trousers and tunics of the Śakas and Kuṣāṇas. Sometimes there are soldiers in Roman armour and helmets, and *bravi*, the over-muscled wrestler types of Hellenistic origin, in the *subjaculum*, an entirely non-Indian garment.

Narrative friezes are all but invariably Buddhist, and hence Indian, in content; one showing a horse on wheels approaching a doorway may represent the episode of the Trojan horse, but even this has been questioned.[9] The Dioscuri, Castor and Pollux, well known from the earlier Greek-based coinage of the region, appear once or twice as standing figures probably because, as a pair, they correspond to an Indian mithuna couple. There are also female figures representing city goddesses.[10]

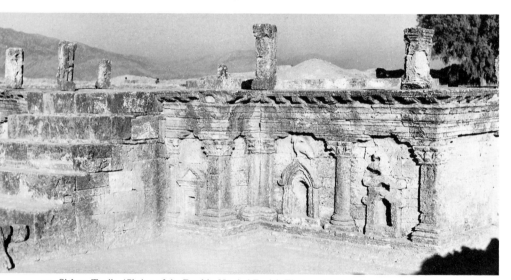

55. Sirkap, Taxila, 'Shrine of the Double-Headed Eagle'. First century B.C./A.D.

caitya arch is an emblem of Scythian origin which will appear as a Byzantine motif and emerge much later in South India as the *gaṇḍa-bheruṇḍa* as well as on European armorial bearings.

Costumes in Buddhist scenes are, not surprisingly, usually Indian. Elsewhere they may be Greek or Roman. Men often wear the

Although figures from Butkara, near Saidan Sharif in Swāt, are noticeably more Indian in physical type, and Indian motifs abound there,[11] sculpture is, in the main, Hellenistic or Roman, and the art of Gandhāra is indeed 'the easternmost appearance of the art of the Roman Empire, especially in its late and provincial manifestations'.[12] Sometimes, however,

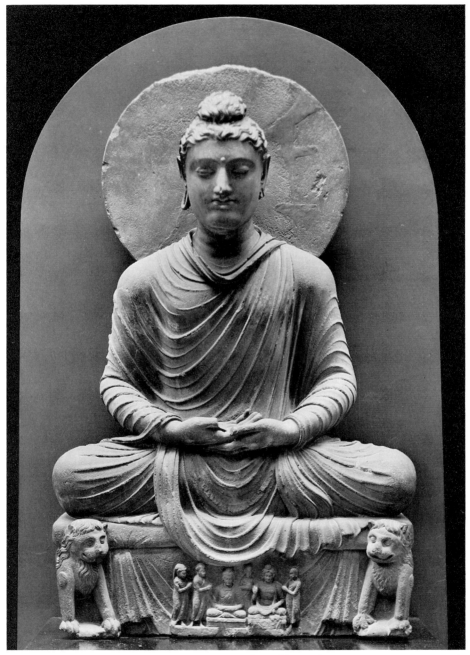

56. Seated Buddha from Gandhāra. Second century A.D. Grey schist.
Edinburgh, Royal Scottish Museum

two or more successive incidents are shown on the same panel, as at Bhārhut, and there is occasional massing of figures one above the other in the Early Indian manner. Moreover realistic portrait heads, one of the glories of Roman sculpture, are all but absent in Gandhāra, in spite of the occasional detached head, possibly that of a donor, with a marked feeling of individuality. Some compositions and poses parallel those from western Asia and the Roman world; for example the way in which a figure in a frequently illustrated scene from the Dīpaṅkara jātaka prostrates himself before the future Buddha is echoed in the pose of the vanquished before the victor on a Trajanic frieze on the Arch of Constantine[13] and in later representations of the adoration of the divinized emperor. One particular frequently occurring muscular male figure, hand on sword, seen in three-quarters view from the rear, is borrowed from Western classical sculpture. Sometimes standing figures, even the Buddha, betray the subtle stylistic tricks of the Roman sculptor seeking to convey *majestas*. The drapery is essentially Western – the folds and volume of hanging garments are carved with realism and zest – but it is chiefly the recurrent attempts at illusionism, although often blurred by crude carving, which mark out Gandhāra sculpture as being based on a Western classical aesthetic.

The characteristic Gandhāra sculpture, of which hundreds if not thousands of examples have survived, is the standing or seated Buddha. This perfectly reflects the essential nature of Gandhāra art, in which a religious and an aesthetic element drawn from widely different cultures are brought together [56]. The iconography is purely Indian. The seated Buddha is almost always cross-legged in the traditional Indian way. He has the physical marks of a Buddha, chief among them the uṣṇīṣa, the ūrṇā, and elongated ears. Uṣṇīṣa simply means 'peak', 'top', by extension even 'a turban', but the Buddha's uṣṇīṣa almost certainly derives from the topknot or chignon in which the uncut hair of a member of the warrior caste, whence the

Buddha came, was worn under the turban, as it is done by Sikhs today. However, later generations, accustomed to think of the Buddha as a monk, and unable to conceive of him ever having had long hair or worn a turban, came to interpret the chignon as a 'cranial protuberance' particular to Buddhas.[14] But neither is the Buddha ever shown with a shaved head, as are the Saṅgha, the monks; his short hair is dressed either in waves or in tight curls over his whole head, including the uṣṇīṣa. The elongated ears are likewise simply due to the downward pull of the heavy ear-rings worn by a prince or magnate; the deformation of the ear-lobes is particularly noticeable in the Buddha who, in Gandhāra, never wears ear-rings or ornaments of any sort. As Foucher has it, the Gandhāra Buddha is at once a monk without a tonsure and a prince stripped of jewellery.[15]

Except in occasional action scenes, the Gandhāra Buddha is invariably shown making one of the four significant and unchanging hand-gestures known as *mudrās* which will henceforth be one of the most characteristic features of Indian iconography. They are *abhaya*, 'do not fear' [83, 146]; *dhyāna*, where the Buddha is seated, one hand upon the other in his lap, palm upwards, signifying meditation [56]; *dharmacakra*, the preaching mudrā associated with the Buddha's First Sermon in the Deer Park at Sārnāth or with the Great Miracle at Śrāvastī [84]; and *bhūmisparśa*, 'earth-touching' (although it is usually the throne which is touched by the right hand), recalling the Buddha's 'calling the Earth to witness' just before the Illumination at Bodhgayā [145]. Very rarely he holds a begging-bowl in his right hand.

The Western classical element resides in the style, in the treatment of the robe, and in the physiognomy of the Buddha. The robe, which covers all but the extremities (although the right shoulder is often bared), is treated as in Greek and Roman sculpture [57]; the heavy folds are given a plastic interest of their own, and only in poorer or later work degenerate into incised lines, partly a return to normal

THE ART OF GANDHĀRA · 77

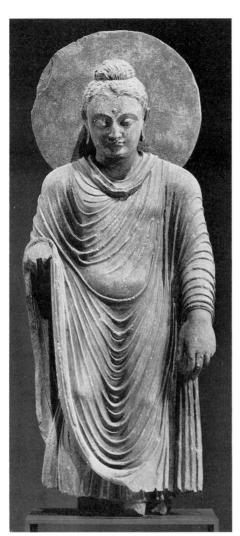

57. Standing Buddha from Gandhāra.
Second/third century A.D. Grey schist.
Berlin (West), Museum für Indische Kunst

Indian practice.[16] The 'Western' treatment has caused the Buddha's garment to be mistaken for a toga; but a toga is semicircular, whereas the Buddha wears a plain rectangular piece of cloth, i.e. the *saṁghāṭī*, the monk's upper

garment.[17] The head gradually veers towards a hieratic stylization, but at its finest it is naturalistic and almost certainly based on the Greek Apollo, doubtless in Hellenistic or Roman copies.[18]

Almost as common is the Bodhisattva, a future Buddha, standing and seated. Prince Siddhārtha, the historical Buddha, was a Bodhisattva until he achieved Enlightenment, and the fact that he was the son of a petty prince or clan chief determined for centuries the way in which Bodhisattvas were represented. Unlike the Buddha, they wear ornaments and jewellery, and their hair is often ornately dressed and even crowned with a jewelled head-piece. This, of course, is consonant with Hindu practice, where the gods, except in their ascetic aspects, are dressed as princes or kings. The dhotis and sandals (the latter most unusual in the art of the subcontinent) of the Gandhāra Bodhisattvas lead one to believe that their appearance must reflect with considerable accuracy the costume and accoutrements of princes and magnates in North West India during the first centuries of our era.[19] Maitreya, the Buddha of the future, can usually be recognized by the combination of a large figure-of-eight loop of hair on the top of his head and a jar held in his left hand.[20]

Early Buddhist iconography drew heavily on traditional sources, incorporating Hindu gods and goddesses into a Buddhist pantheon and adapting old folk tales to Buddhist homiletic purposes. Pāñcika and Hārītī are probably the best known examples of this process. Pāñcika is another name for Kubera, a powerful *yakṣa* or *guhyaka*, who becomes the regent of the north. Hārītī, an indigenous Indian demoness, goddess of smallpox and both scourge and protectress of children, is taken over as his consort, and they are most often shown seated together in the pose of a Roman tutelary couple, in Western classical dress or, in the god's case, Kuṣāṇa costume. Hārītī depicted alone is usually festooned with children and wears a mixture of Roman and Kuṣāṇa accoutrements. The narrative reliefs, however, show

almost exclusively events in the life of the historical Buddha, chiefly his birth [58], Great Departure, and parinirvāṇa.

to the Buddha, who has taken up his residence in a cave indicated by the wavy outline of a rocky landscape and the wild animals scattered

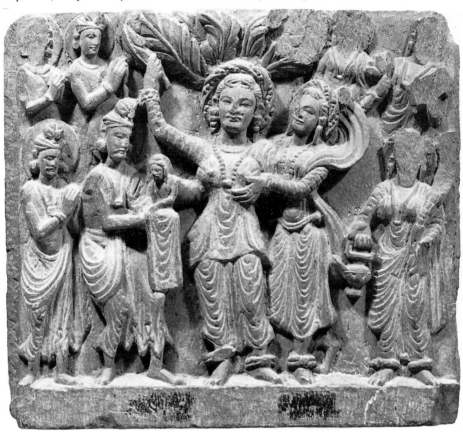

58. The Birth of the Buddha from Gandhāra. Second/third century A.D. Grey schist.
Oxford, Ashmolean Museum, Murray-Ainsley Collection

Gandhāra also developed at least two species of icon, i.e. not part of a frieze, in which the Buddha is the central figure of an event in his life identified by attendant figures and an elaborate *mise-en-scène*. Perhaps the most striking of these is the Visit to the Indraśāla Cave, of which the finest example is dated in the year 89, almost certainly of the Kaniṣka era [59].[21] Indra and his harpist are shown on their visit

over it.[22] The small figures of the visitors appear below, an elephant identifying Indra. The more common of these elaborated icons, of which some thirty examples are known, is probably associated with the Great Miracle at Śrāvastī. In one dated to the year 5 one of the flanking Bodhisattvas is identified as Avalokiteśvara by the little seated Buddha in his headdress.[23] Other features of these icons include

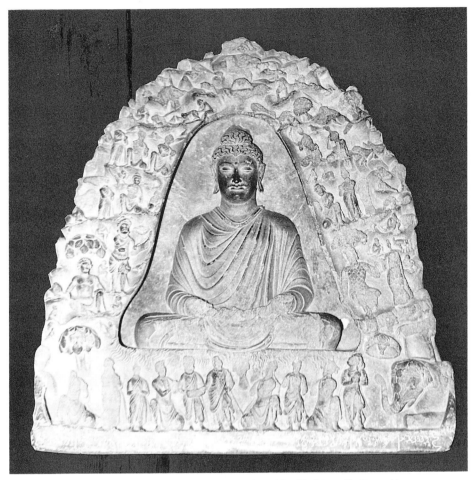

59. The Visit to the Indraśāla Cave from Mamāne Ḍherī. Dated 89 (Kaniṣka era?). Grey schist.
Peshawar Museum

the perhaps imaginary species of tree above the Buddha, the spiky lotus upon which he sits, and the easily recognizable figures of Indra and Brahmā on either side. A number of stelae have survived with even more elaborate theophanies which may perhaps represent the same event.[24]

Systematic study of the art of Gandhāra, and particularly of its origins and development, is bedevilled by many problems, not the least of which is the extraordinarily complex history and culture of the region. It is one of the great cultural crossroads of the world as well as being in the path of all the invasions of India for over three millennia. Bussagli has rightly observed, 'More than any other Indian region, Gandhāra was a participant in the political and cultural events that concerned the rest of the

Asian continent.'[25] Even before Alexander's raid, there was at least one Greek settlement in Bactria, the region of the Amu Darya (ancient Oxus) now shared between northern Afghanistan and Tadzhakistan in the Soviet Union.[26] After Alexander, the Seleucids, the Śakas (Scythians), the Parthians, and eventually the Kuṣāṇas all tried with varying success to take over Gandhāra and what Indo-Greek

60. Double decadrachma of Amyntas (obverse), with Tyche enthroned (reverse), from the Kunduz hoard. 85/75 B.C. Silver. Actual size.
Kabul Museum

states remained.[27] To the cultural influence of Greece, Rome and the Romanized Near East, Iran, and Central Asia must be added close and constant contacts with the rest of the Indian subcontinent. Yet historical sources are few, and the rare mentions in classical authors and Chinese sources and inscriptions in the Kharoṣṭhī script peculiar to the region have to be fleshed out by the study of coins. In spite of the labours of many scholars over the past hundred and fifty years, the answers to some of the most important questions, such as the dates of Kaniṣka and the number of centuries spanned by the art of Gandhāra, still await fresh archaeological, inscriptional, or numismatic evidence.[28]

The coins of the Graeco-Bactrians – on the Greek metrological standard and many of a quality equal to the finest Attic examples – and of the Indo-Greek kings have until recently been the only examples of Greek art to be found on the subcontinent.[29] The famous silver double decadrachmas of Amyntas [60], probably a commemorative issue, are the largest 'Greek' coins ever minted; the largest in gold is the unique decadrachma of the same king in the Bibliothèque Nationale, with the Dioscuri on the reverse. Otherwise there was little evidence until recently of Greek or Hellenistic influences in Gandhāra. A reflection of Greek urban planning is provided by the rectilinear layouts of two cities of the first centuries B.C./A.D., Sirkap at Taxila and Shaikhan Dheri at Charsadda. Remains of the temple at Jandial, also at Taxila and probably dating from the first century B.C., also include Greek features, notably the huge base mouldings and the Ionic capitals of the massive porch and vestibule columns.[30] In contrast, the columns or pilasters on the innumerable Gandhāra friezes, when they are not in an Indian style, are invariably crowned by Indo-Corinthian capitals, the local adaptation of the Corinthian capital – a sure sign of a relatively late date.

The famous Begram hoard testifies eloquently to the number and diversity of origin of the foreign artefacts imported into Gan-

dhāra. Similar hoards have been found in peninsular India, notably at Kolhapur in Mahārāṣtra, but there the imported wares are strictly from the Roman world.[31] At Begram (the ancient Kapiśā, near Kabul) there are bronzes probably of Alexandrian manufacture cheek by jowl with *emblemata* (plaster discs, almost certainly meant as models for local silversmiths) bearing reliefs in the purest classical vein, Chinese lacquers, and Roman glass. The hoard was probably sealed up in the mid third century, when some of the objects may have been as much as two hundred years old, 'antiques', often themselves copies of classical Greek objects. The abundant ivories, consisting in the main of chest and throne facings carved in a number of different relief techniques, were probably produced somewhere between Mathurā and coastal Āndhra. Some are of unsurpassed beauty [61]. Although a few

isolated examples of early Indian ivory carving have survived, including the famous mirror handle from Pompeii, the Begram ivories are the only considerable assemblage known until fairly recent times of what must always have been a widespread craft.[32]

Other sites, notably Taxila, have yielded a great many examples of such imports, some from India, some, like the charming little bronze figure of Harpocrates [62], almost certainly from Alexandria. The remains of the unique temple at Surkh Kotal north of Kabul in Afghanistan are almost certainly associated, at least in part, with Kaniṣka, the greatest of the Kuṣānas, who ruled over Gandhāra during the early period of its art. Surkh Kotal was a royal shrine, as proved by the presence of full-length figures in Kuṣāna garb, like those from Māṭ, near Mathurā. The inscriptional evidence is far from clear because of Iranian

61. Part of the engraved top of a chest or stool from Begram. Second/third century A.D. Ivory.
Kabul Museum

62. Harpocrates as a child, found at Sirkap.
First century B.C./A.D. Bronze.
Taxila Museum

elements, and the claim that it was a fire temple is not beyond dispute.[33] Further cultural influences are attested by the Scytho-Sarmatian jewellery, with its distinctive high-backed carnivores, and by a statue of St Peter.[34] But all this should not obscure the all-important truth that the immediately recognizable Gandhāra style was the dominant form of artistic expression throughout the region for several centuries, and the extent of its influence on the art of central Asia and China and as far as Japan leaves no doubt as to its integrity and vitality.

The origins of the style have been a major subject of contention. Foucher believed that Gandhāra art was directly descended from Greek or Hellenistic traditions established in Bactria by the followers of Alexander, whereas Wheeler and others maintained that the faint spark of Hellenism brought by Alexander could not have survived the intervening centuries and that there must have been massive contacts with the Roman world in the first and second centuries.[35] Foucher, the author of the classical work on the sculpture of Gandhāra, journeyed to Balkh (ancient Bactria) itself, yet he could point to no example of Graeco-Bactrian or Indo-Greek art with the exception of the coinage.[36] But he has been to a certain extent vindicated by the sensational French discovery of Aï-Khanoum, beside the Oxus in northernmost Afghanistan.[37] Excavation of the site – which, by almost miraculous good fortune, had known no occupation of any consequence since its abandonment in the first century B.C. – revealed a true Hellenistic city, a thousand miles further to the east than any hitherto known. Large-scale administrative buildings (of a size revealing an orientalized Hellenism) were uncovered, together with a stadium, a theatre, an acropolis, and the tomb

of the founder of the city, perhaps one of Alexander's captains.[38] There are even inscriptions copied from Delphi. The rare finds of sculpture have been in a pure Hellenistic style.

The hiatus remains between the Hellenistic city and the beginnings, almost certainly in the first century A.D., of Gandhāra art.[39] No certain examples have been identified of a proto-Gandhāra style, to which the abundant terracotta figurines probably of the second century B.C. have no relevance.[40] Most Gandhāra sculpture seems to date from the second and third centuries A.D., its principal characteristics deriving from Roman Imperial art, and it almost certainly continued into the fourth and fifth centuries and even beyond. Its rather slight development, however, remains hypothetical. In the first place, most of it was cleared and collected from monasteries and stūpas, in non-archaeological fashion, before the Second World War, and is largely without provenance. Later, more scientific excavation has however provided pointers to an early chronology. The characteristic Gandhāra Buddha, for instance, existed towards the end of the first century,[41] if we accept that A.D. 78 marks the beginning of Kaniṣka's era, for a coin of that great ruler bears on the reverse a standing figure of the Buddha clearly labelled in Greek letters BODDO [63] and indisputably of the Gandhāra type.

Five dated images from Gandhāra do exist; the snag is that the era is never identified.[42] The dates are in figures under 100 or else in the 300s. Moreover one of the higher numbers is controversial, besides which the image upon which it is inscribed is not in the mainstream Gandhāra style. The two low-number-dated images (year 5 and year 89) are the most elaborate and the least damaged. Their style is classical Gandhāra. The most straightforward interpretation of their dates relates them to Kaniṣka, and if A.D. 78 is adopted for the commencement of his era, then they fall at the very end of the first and past the middle of the second century A.D. If a dropped hundred is

63. Kaniṣka and the Buddha on a coin from the reliquary deposit of the stūpa of Ahīn-Posh, near Jalālābād. Second century A.D.
London, British Museum

added to the year 5 date, then, referred to the base A.D. 78, they both fall in the second half of the second century A.D., and correspondingly later if a later date is postulated for the beginning of Kaniṣka's era. This calculation roughly parallels the numismatic and archaeological evidence. As for the high-numbered

images, the earliest date in the Christian reckoning to which they can be assigned, by using an era which commenced about 150 B.C., is the second half of the second century and the first half of the third. The use of other eras, such as the Vikrama (base date: B.C. 58) and the Śaka (base date: A.D. 78), would place them much later.[43] The badly battered figures represent standing Buddhas, neither with a head of its own, but both on original figured pedestals. They appear to be in the classical Gandhāra style; resolution of where to place these two dated Buddhas, both standing, must remain problematical until more evidence emerges as to how late the classical Gandhāra style continued.

Of the final phase of Buddhist art and architecture in the north-west of the subcontinent remains have survived in Afghanistan as well as beyond the Oxus in Central Asia.[44] The ground plans of monasteries evolve and the trilobate arch appears. So does the stūpa with a high, stepped cruciform base and reentrants between the arms, as demonstrated by remains at Bhamāla, one of the satellite monasteries of Taxila. Statues are almost invariably of unbaked clay, and wall-painting was common. At the recently excavated Tapa Sardār, outside Ghazni, a large Mahiṣāsuramardinī testifies to a growing Hindu-Buddhist syncretism notable in Kashmir but not further north at the time.[45] From the well-known site of Fondukistan, north of Kabul and probably of seventh-century date, come superb nearly life-size clay images including a jewelled Buddha wearing a camail now in the Musée Guimet, Paris.[46] Bodhisattvas seated in graceful poses, with beautifully modelled torsos, are executed in a soft, somewhat rococo manner which represents one of the final fruitions of the Gupta style [64].

At the superb site of Bāmiyān, a mountain valley in north-central Afghanistan, a high cliff forming one of the sides of the valley is honeycombed with monastic dwellings and bounded on either side by two colossal Buddhas in niches cut out of the rock.[47] They are in the Gandhāra style, the technique adapted to their stupendous proportions. The largest is 174 ft (53 m.) high. The folds of the gown are represented by looping ropes attached by wooden pegs and covered with stucco. The sides, and particularly the vaulted summits, of the niches are painted in a variety of styles, some showing strong late Sasanian influence, some, in an Indian style, practically unique documents of painting in a Gupta or early post-Gupta style, yet others describable only as Central Asian. On the other hand the caves, some of them in tributary valleys, have nothing to do with the purely indigenous Indian tradition based on structural building. Instead, cosmopolitan influences are at work, some of them harking back to the late Roman world: squinched domes and coffered ceilings appear. Remote as it is, Bāmiyān's position on a caravan route gave it a role of inestimable importance in the transmission of artistic influences from India and from the West to Central Asia and the Far East.

64. Bodhisattva from Fondukistan.
Seventh century A.D. Clay.
Paris, Musée Guimet

THE GUPTA PERIOD

INTRODUCTION

With the Gupta period a long evolution, both formal and iconographic, came to fruition in some of the greatest sculptures ever produced anywhere in the world. It was an age of universal achievement, a classical age in that it 'aspired to create', in Goetz's words, 'a perfect, unsurpassable style of life'.[1] Its standards of form and taste determined the whole subsequent course of art, not only in India but also far beyond her borders.

The Gupta period saw India free of all foreign domination for the first time in several hundred years. Outside influences were not rejected in the resurgence of indigenous culture[2] – how could they be when wave upon wave had been so thoroughly assimilated? For example, although the great Varāha panel at Udayagiri (Vidiśā) is unquestionably a creation of the Indian genius, the conception and the water imagery would seem to owe a great deal to the Nymphaeum at Haḍḍa. Enormous strides were made in mathematics and astronomy, driven onward by vigorous interchanges with the West. The age also produced important philosophers. Kālidāsa, the greatest Indian dramatist, almost certainly lived in the Gupta period, contributing to the unequalled excellence of the courtly poetry and prose, often in dramatic form, known as *kāvya*, proffering 'the experience of the ideal, all the flaws of nature corrected, all the unfinished aims of men completed, everything in its proper place performing its proper function in an orderly, therefore beautiful way'.[3] Gupta sculpture, with its as-

surance, its balance and harmony, proclaims the same ideals, although here the parallel ends, for kāvya's most easily recognizable characteristic is the ornateness of the language and the abundance of figures, puns, and *double entendres*. It is certainly excessively mannered at times, in complete contrast to the delicacy and chasteness of Gupta decoration, and more comparable to the florid and over-abundant post-Gupta forms.

At this time the earlier *Purāṇas*, those compendia of traditional Indian legend, learning, and myth, reached their definitive form, providing the basis for the iconography of most Gupta art, including the great high-relief tableaux of events in the lives of the gods which are among the chief glories of Indian sculpture. Iconographic formulations, still variable and experimental in Kuṣāṇa times, become fixed, and almost every major type was established in the Gupta period.

Surviving Gupta art is overwhelmingly religious or, like the Ajaṇṭā frescoes, adorns a religious establishment. Buddhism and Jainism continued to flourish, and the more complex images of the Mahāyāna pantheon made their appearance. The earliest extant free-standing temples also date from this time, although few survive of the hundreds, if not thousands, that must have been built to house either representations of the gods or liṅgas. Yakṣas and nāgas are replaced as independent cult images, except in rare instances, by the gods and goddesses of the two great theistic

cults. Vaiṣṇavism appears to have had the edge, perhaps because of the Gupta dynasty's partiality to it, although their lack of strong sectarian bias is proved by the names of the emperors Kumāragupta and Skandagupta, and by the appearance of this son of Śiva on their coins. Pāñcarātra concepts concerning the nature of the godhead continued to be widely disseminated and embodied in many-headed or emanatory images, and ancient speculations were given physical form in multi-headed Śivas and four-faced liṅgas.[4] The lions' and boars' heads on either side of several Viṣṇu images from Mathurā probably represent the god's most popular avatars.[5]

In most of the surviving Gupta temples the liṅga was the principal cult image. Its widespread worship may largely be due to the popularity of the Pāśupatas, a sect to whose first-century founder, Lakulīśa, it was of paramount importance. The large figure in the National Museum, New Delhi, said to be from Bhopal and in a markedly provincial style, is probably the earliest composite Viṣṇu-Śiva (Harihara). Images of the śakta cult goddesses, named after the śakti, the active, energetic aspect of a god, always embodied as a woman, begin to appear in increasing numbers and size, in particular Durgā and the mother-goddesses. The burgeoning vogue for personifications of Gaṅgā and Yamunā, the two great rivers encompassing the Gupta heartland, not at this period the subject of any cult, may be owed to the political renaissance.[6]

Great civilizations are always complex, and the Gupta civilization was no exception. Although only religious art has survived, literary evidence leaves no doubt that painting as well as connoisseurship flourished, at least in the houses of the rich. Kāvya was composed for an extremely cultivated audience who could follow and appreciate the way it makes use of all the resources of pun, simile, and metaphor, tightly bound together by intricate metrical patterns, of which a highly inflected as well as extremely rich language is capable. Probably at no other time has the elite of the cities in India been as sophisticated. The focus of this civilization was urban, to an extent probably unknown until the present day. Satirical literature on the other hand caters to a society of a far less elevated moral tone than does kāvya. Here courtesans figure largely and – in spite of the Chinese pilgrim Faxian's much-quoted observations on the sobriety and austere habits of the people – drunkenness seems to have been common and bacchanalia not unknown. Sculpture points up similar paradoxes: a combination, in Goetz's phrase, of the dainty with the earthy, of the balanced and harmonious with a marked skill and sympathy in depicting grotesques.[7]

To what extent the Gupta dynasty was responsible for its own golden age is not known. No surviving monument or sculpture is directly associated with its members, no poem, play, or treatise dedicated to them. If their coinage (and no other native Indian kings have regularly minted in gold) is any indication, they were indeed intensely preoccupied with art. Finer by far than those of any other indigenous dynasty, their coins are magnificent examples of the Gupta style – and coinage is the most intimate attribute of sovereignty. Moreover, this was the only period between Aśokan and modern times when the whole of the north was under one rule, and that an Indian one. The Chinese pilgrim Faxian (Fa-Hsien) testifies to the benignity of Gupta government and the peaceful and prosperous life of the people. At the zenith of its extent and power, the empire extended from Bengal to the neighbourhood of Lahore and included Gujarāt and Rājasthān. The dynasty, like the Mauryas, originated in Bihār. Candragupta I founded an era commencing in A.D. 320, the date either of his accession or of his investiture, and laid the foundations of the empire. The career of his successor, Samudragupta, is better known because of his praśasti, one of the extravagant panegyrics which nonetheless form the basis for much Indian history.[8] From it can be learned how, a great conqueror, he vastly extended the Gupta dominions. Under

Candragupta II the western Kṣatrapas, the foreign rulers established for centuries in Gujarāt and western Mālwā, were defeated, their capital Ujjain captured, and the Gupta capital transferred there from Pāṭaliputra. This move must have been of great significance, for the Guptas were now established in regions which had been in the forefront of artistic development for centuries. Kumāragupta had a long and peaceful reign, but Skandagupta, who died c. 467, had to defend the empire against the inroads of the Hūnas.[9] The dynasty continued to rule in Bihār for a century or more but soon lost all pretensions to imperial dominion. Since, however, art history is concerned with style and patronage rather than the shifts of political power, and since works totally impregnated with Gupta ideals continued to be created after the empire went into decline, the Gupta period may be considered to continue until c. 550.

One of the most remarkable aspects of Gupta art is its uniformity over the whole of the empire, with which it is co-terminous at its greatest extent. The pure style of the remains of the temple at Murti, in the Salt Range beyond the Jhelum, is as convincing proof as any inscription that Gupta power extended there. This uniformity is even more marked in the terracottas. The other astonishing fact about the Gupta zenith is its duration, five long reigns and more, contrasted for instance with that of Periclean Athens, with which it has been compared. This is not to say that strong regional differences cannot be detected, or that the style did not evolve during the period: it develops in fact from an emphasis on massive power and volume inherited from Kuṣāna sculpture to the graceful and more linear creations of the late style, with its occasional mannerisms. But the overall imprint and aesthetic impulse are so powerful that there can be no mistaking a sculpture made during the approximately two hundred years of Gupta rule. Here began the realization, so important to the Indian aesthetic, of 'sensuous physical beauty as an emblem of spiritual beauty'.[10] The *cakravartin*, the universal ruler, is superseded by, or rather blends into, the *mahāyogin*, the great ascetic. Whoever doubts this need only compare the growing likeness of form henceforth between Buddhas and Bodhisattvas and most of the Hindu gods and goddesses. Perhaps it is this all-pervading inwardness that accounts for the unequalled Gupta and post-Gupta ability to communicate higher spiritual states. Equally, as the style evolves, there commences that identification of human form with the forms of nature which is one of its most striking aspects. Nowhere is this easy and all-pervading rapport better exemplified than by the gaṇa at the base of a vegetal scroll which sprouts from his navel, or the *makara*, a semi-aquatic mythical beast, its body terminating in foliage rather than a tail. Gaṇas are members of a host (the literal meaning of *gaṇa*) of minor godlings, followers of Śiva, frolicsome, impudent, and dwarfish. The metaphysical foundations which underlie much Indian sculpture are now well known, thanks in large part to the writings of Stella Kramrisch and of classical Indian aestheticians; it is harder to explain the unsurpassed elegance, stylishness, and liveliness of so much Gupta work.

The origins of the Gupta style are not far to seek. Many of its characteristic architectural forms and motifs were inherited from Kuṣāna Mathurā and Gandhāra, where the T-shaped doorway, the jambs decorated with superimposed panels containing figures, the laurel-wreath moulding, the acanthus scroll, and even the chequerboard pattern are all common. Many of the problematical Buddha and Jain figures from Mathurā bearing dates in an as yet unidentified era may well belong to the third or even the early fourth century.[11] In one such seated Jain figure, dated in the year 31, the 'spiritual' smile, the well decorated halo, and the treatment of the body proclaim it, for all its roughness, a transitional if not an early Gupta sculpture [65].[12] From Gandhāra the Gupta style derived certain stylizations, particularly the knife-sharp meeting of eye-

65. Seated Tīrthaṅkara from Kaṅkālī Ṭīlā, Mathurā.
Perhaps third century (dated 'in the year 31'). *Lucknow, State Museum*

66. Udayagiri (Vidiśā), Cave 6, Viṣṇu at proper left of entrance.
Early fifth century. Buff sandstone

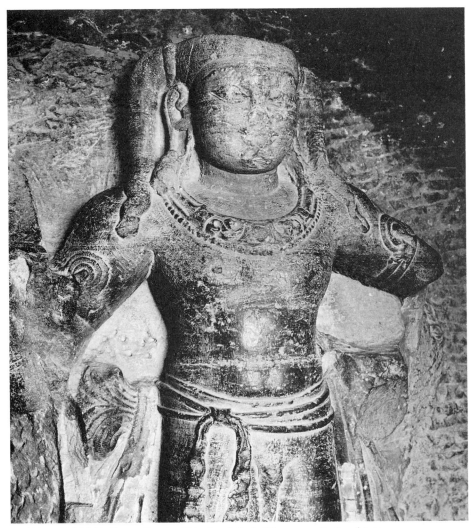

67. Udayagiri (Vidiśā), Cave 3, Kumāra (Kārttikeya). Early fifth century. Buff sandstone

socket and brow; there are also similarities which may be accounted for by borrowings, since a good deal of sculpture in the Gandhāra style almost certainly dates from the fourth century, and some probably from the fifth.[13]

The first dated sculptures in a fully-fledged early Gupta style are from Vidiśā and the nearby Udayagiri caves in Madhya Pradesh. Three battered but inscribed Jina images of the late fourth century are in the Mathurā tradition,[14] but if a common denominator of the early Gupta style is to be found anywhere it is in the rock-cut sculpture at Udayagiri. The caves are also the only monuments with a link, albeit

indirect, with one of the Gupta monarchs, for an inscription on the outside of one of them, by a minister of Candragupta II (*c.* 380–414), tells us that it was in attendance upon his king that he, a man of Pāṭaliputra, came there, presumably in connection with Candragupta II's ultimately victorious campaign against the western Kṣatrapas. Another cave bears an inscription dated 402.

The caves, all Hindu and at ground level except for a single Jain cave half way up the hill, are of negligible importance architectur-ally; only one has internal columns. A great deal of the sculpture is outside, on prepared surfaces of rock.[15] The most characteristic images are the four-armed standing Viṣnus with plain cylindrical crowns standing stiff-legged in samapada [66], one of them flanked by *āyudhapūruṣas*, the personified weapons or symbols which are among the most charming inventions of the Gupta period. The most powerful of these images, with barrel chest, enormous rounded shoulders, and rather tightly treated legs, is the Kumāra of Cave 3

68. Udayagiri (Vidiśā), Cave 4, ekamukhaliṅga. Early fifth century. Buff sandstone

69. Udayagiri (Vidiśā), Cave 6, door guardian. Early fifth century. Buff sandstone

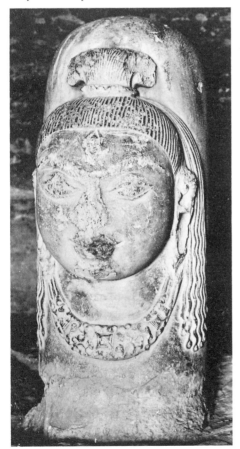

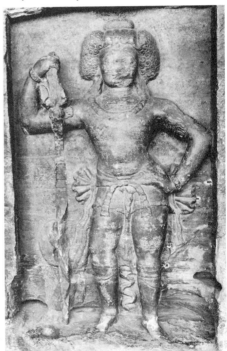

[67]. The features, though badly damaged, are recognizably similar to those of the superb *ekamukhaliṅga*, a head of Śiva emerging from a liṅga, in Cave 4, the almost completely round head pulsating with psychic power [68]. The entrance to Cave 6 is flanked by two doorkeepers,

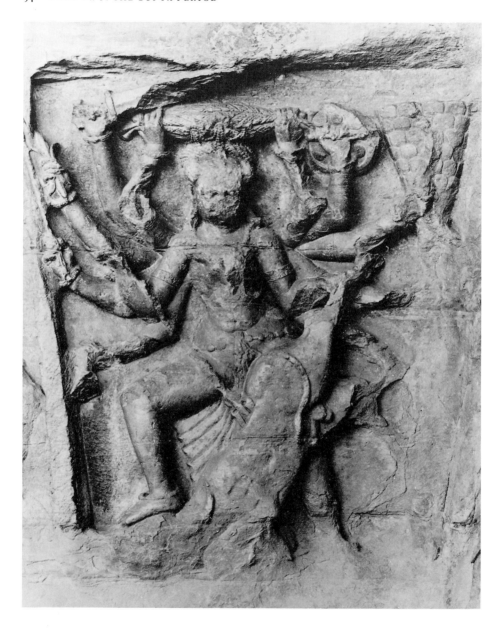

70. Udayagiri (Vidiśā), Cave 6, Durgā. Early fifth century. Buff sandstone

the earliest of all the innumerable guardians of Hindu shrines; termed *pratihāras* in the north, it is especially in the south that they are largest and most impressive. Typically for the Early Gupta style, their muscular thighs contrast almost ludicrously with the dainty pleats of the tab-ends of their belts and sashes [69]. Durgā killing the demon-buffalo is represented three times: beside Cave 4 she stands in the same pose as the earliest examples of this image at Mathurā, her left arm stiffly pressing down on the beast's haunch, whereas beside Cave 6 [70] the buffalo has reversed itself, as has the goddess, who now stands in the archer's *ālīḍha* pose, her right foot on the buffalo's head to indicate her mastery.[16] This is the type which will henceforth prevail.

The great boar panel [71], measuring nearly 22 by 13 ft (7 by 4 m.), is one of the largest as well as the earliest of the great high-relief scenes depicting a divine event of mythological or cosmic significance. Viṣṇu, incarnated as the boar with a man's head, is raising the goddess Earth (Bhū Devī) from the primal waters – one of the most popular myths of manifestation. She is propped against his shoulder; left knee bent, he steps forward and upward in an exultant pose of triumph. Nāgas worship him from the waters. What is more, here at Udayagiri far more of the myth is represented than usual.[17] In low relief on either side of the central figure rise row upon row of *ṛṣis* (sages) and celestial beings, surmounted by a group of gods. The lower part of the ground of this

71. Udayagiri (Vidiśā), 'Cave' 5, boar (Varāha) incarnation of Viṣṇu. Early fifth century

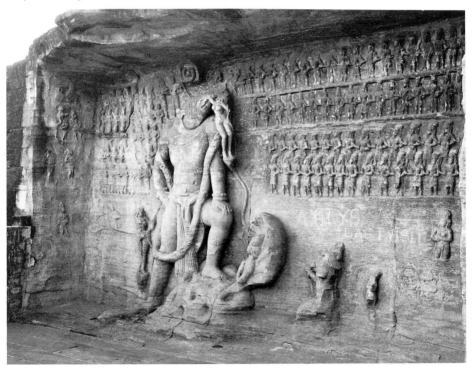

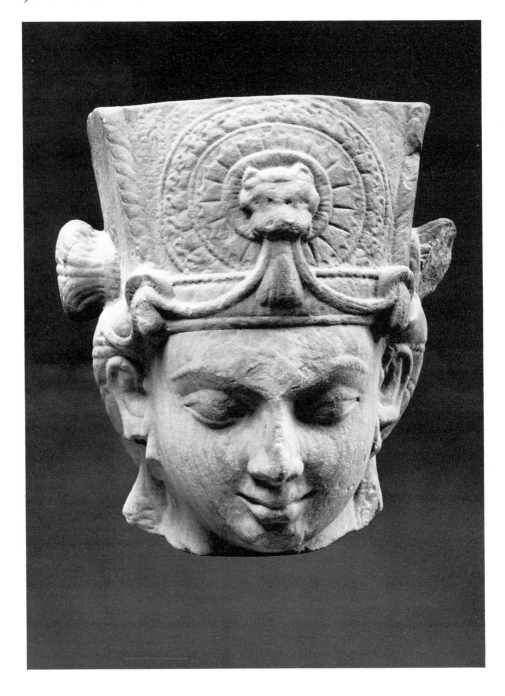

great relief is covered in ambitiously conceived aquatic imagery, with incised wavy lines representing the water, lotuses, and two solitary little men, probably in each case the god Ocean, a minor mythological figure. Finally – something attempted nowhere else – the decoration of the ground is carried on to the sides of the panel. Below a group of celestial musicians the wavy lines of water divide into the two great rivers of the Madhyadeśa, identified by their tutelary goddesses, Gaṅgā on her makara, Yamunā on her tortoise.

Nearby Besnagar has yielded important sculpture of the Gupta period. The early date of a beautiful Viṣṇu head [72] now in Cleveland is attested by the simple mukuṭa, with its single lion's head, and the trefoil pattern on its barely curved surface. It is fully in the round, revealing how these headdresses were fastened on at the back with a band of cloth whose bouffant ends protrude. The pensive face, with its slightly pursed lips, has nothing in common with Udayagiri sculpture but harks back to the finest Mathurā tradition. Also from Besnagar is a superb but savagely battered group of goddesses (the *Sapta Mātṛkās*, or seven mothers) sitting bolt upright on benches with carved baluster legs.[18] They are again fully in the round, an early Gupta feature, as is the elegance and individuality of their hair and bodices. They originally held children [73], also an early feature, linking the Mātṛkās to the Hārītīs of Kuṣāṇa times. At the same time, their breasts are stylized into almost perfect spheres. Their pose is largely responsible for their demonic and imperious appearance, slightly softened by an occasional half-smile. A cruder rock-cut group at Badoh-Paṭhārī, frankly menacing, in a markedly provincial style with too short legs, includes a skeletal Cāmuṇḍā and an ithyphallic Śiva to whom an elegant Gupta wig gives a rather incongruous urbanity.[19]

72 (*opposite*). Head of Viṣṇu from Besnagar.
Fifth century. Grey sandstone.
Cleveland Museum of Art, John L. Severance Fund

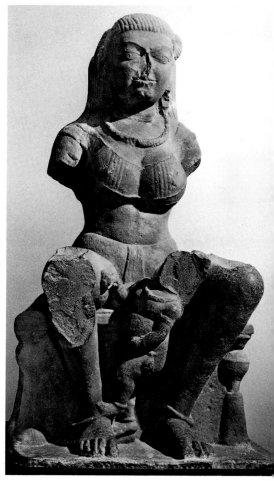

73. Mātṛkā from Besnagar.
Early fifth century. Sandstone.
New Delhi, National Museum

Eran, the ancient Airikiṇa, now an insignificant village but a place of some importance in Gupta times and earlier, is principally known for the inscription on the great theriomorphic boar which gives Toramana as the suzerain lord of the local kings – astonishing evidence of how deeply into India the brief

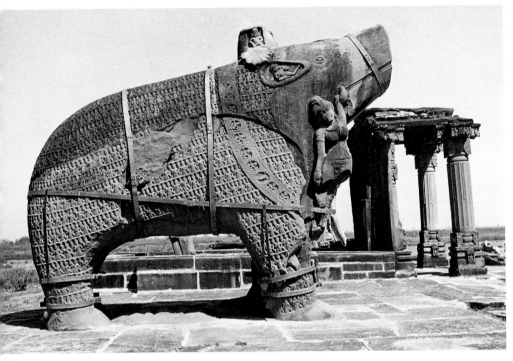

74. Eran, boar incarnation of Viṣṇu. Late fifth century (dated 'in the first year of Toramana'). Sandstone

Hūṇa power penetrated.[20] The boar itself [74] is both the earliest and the largest example of this purely animal form of Viṣṇu as Varāha which was to have such a long vogue. The creature's body is invariably covered with rows of tiny figures like those on the ground of the Udayagiri panel: the sages are supposed to have taken refuge from the primeval waters among the bristles of the boar. One so far unexplained feature is the stump behind the animal's head.

With the exception of a Narasiṁha (Viṣṇu as man-lion) image[21] formerly in the ruined Gupta temple on the site, the sculpture at Eran is in a slightly provincial and *retardataire* style. The column dated 485, the only one still standing from Gupta times, makes a final break, apart from the bell capital, with the formal archaizing tendencies of so many post-Maurya laṭs. The two addorsed figures beneath the crowning cakra represent Garuḍa, Viṣṇu's bird vehicle, in purely anthropomorphic form: the projection between the figures on each side, standing for the wings, and a slightly grotesque treatment of the faces, besides the snakes held in their hands, are the only identifying features. There is no relationship in style between them and the other known important Gupta pillar sculpture: the rather insipid figure from Pawāya, also addorsed and holding a sun-wheel,[22] and the splendid fan-palm capital also from Pawāya.[23] The masterpiece of the Eran style, however, and one of the greatest of all Indian sculptures is the magnificent Varāha in human form now in the Sagar University Museum [75]. Its close stylistic links to the other works are obvious: the head of the boar is as simplified and sche-

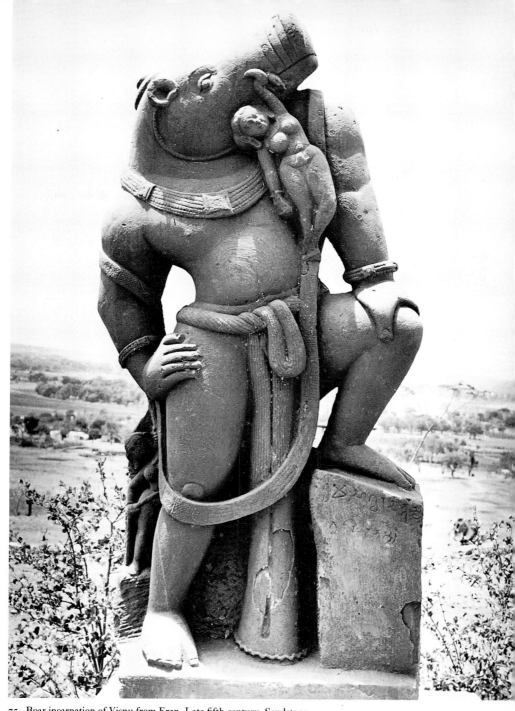

75. Boar incarnation of Viṣṇu from Eran. Late fifth century. Sandstone.
Sagar University Museum

matic as that of the giant theriomorphic one, and Bhū Devī's arm, looped through the boar's tusk, droops down in the same lifeless manner. There is moreover the same predilection for cylindrical forms, the boar's exaggeratedly thick sash being treated in much the same way as the serpents held by the Garuḍa figures. But nothing can match the figure's air of insolent triumph, the way in which he is unashamedly given the flesh of a fat man, a *sumo* wrestler, on his arms, while his hands and legs are almost total abstractions.

Sāñcī was an important centre of sculpture in the fifth century. Some nāgarājas and nāginīs from the summit of a vanished pillar at Firozpur, a few miles away, have noticeably elongated serpent hoods;[24] they and another pair in the Sāñcī Museum are very much in the Udayagiri style. The museum also has three Bodhisattvas

which may be as late as the end of the fifth century. One, almost in the round, with a powerful presence, may be the figure from a pillar top mentioned in an inscription,[25] a hypothesis to which holes drilled into the pleated *śiras cakra*, or halo, probably to fasten on an extended copper nimbus, lend weight.[26] Four seated Buddhas inside the processional path of the great stūpa, one at each entrance, with moon-like fleshy faces, are related to the Bodhisattvas. They have splendidly decorated haloes and large attendant figures. Except that they have no bases, their stylistic affinities are thus with Mathurā and western Uttar Pradesh rather than with areas further east. Almost certainly the images referred to in a mid-fifth-century inscription, they have the downcast glance henceforth associated with Buddhas in the Gupta tradition.

MATHURĀ

In spite of an apparently uninterrupted production, dated sculpture of the third or fourth century is practically non-existent at Mathurā as elsewhere.[1] A small standing yakṣa or Kubera, with its Late Kuṣāṇa face but ornaments of a later date and a swelling chest mounting to over-rounded shoulders reminiscent of Udayagiri, almost certainly does belong to the third or early fourth century.[2] So do the Jain

76. Seated Tīrthaṅkara from Mathurā.
Third/early fourth century.
Spotted red sandstone.
Lucknow, State Museum

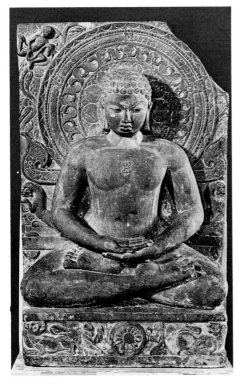

Tīrthaṅkaras with dates in single or double digits already referred to, including the one in the State Museum, Lucknow [76].[3] A seated Buddha with equally crude lions and donors on the base wears a Gandhāra-type robe covering both shoulders. On one of the rings of the halo however are the widely and symmetrically spaced rosettes characteristic of the following century.[4]

In the fifth century, most seated Mathurā images are Tīrthaṅkaras. Bases have become much lower in proportion to width and completely contain the lions, couchant in profile, their heads confronting either the viewer or their own tails. In the centre is a cakra or other religious symbol with kneeling worshippers on either side, usually two, their hands in añjali, palms pressed together and held in front of the chest in a gesture of greeting closely resembling the Christian position of the hands in prayer. The single Gupta image of a seated Tīrthaṅkara, unfortunately headless, is dated in the 113th year of Kumāragupta (422–33).[5] Many of the figures are in the round, but the developed Gupta style, like the high Kuṣāṇa, favours stelae. The figure may appear against a throne back or simply flanked by *cāmara* (fly-whisk) bearers, usually raised above the level of the throne. They have a rather epicene, wide-hipped and high-waisted appearance, and the crossed legs appear to be tilted downward. Faces follow the rather hard formulations current for Buddhas as well in fifth-century Mathurā.

The most impressive achievement of the Gupta sculptors at Mathurā are the standing Buddhas, though most are neither particularly moving nor appealing owing to a certain stiffness. The largest surviving complete example, in the Mathurā Museum, is 7 ft (over 2 m.) high; the finest is now in the President's Palace,

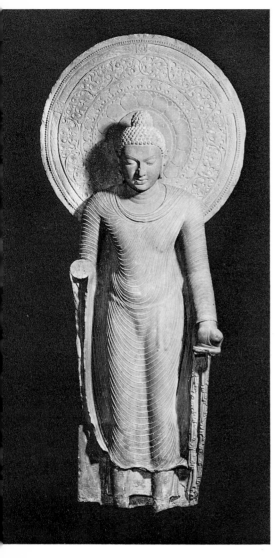

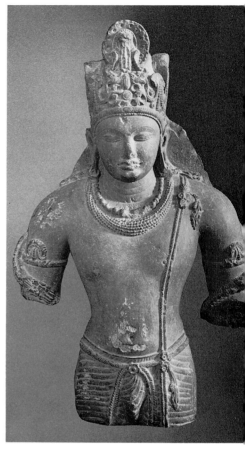

77 (*left*). Standing Buddha from Mathurā.
Mid fifth century. Red sandstone.
New Delhi, President's Palace

78 (*above*). Viṣṇu from Mathurā.
c. 500. Red sandstone.
New Delhi, National Museum

New Delhi [77].[6] They stand with a barely perceptible flexion, the left hand, palm outward, holding one end of the saṁghāṭī; the right, missing in every case, was presumably raised in the 'do not fear' gesture. Contrary to Sārnāth practice, the pleats of the saṁghāṭī are string-like ridges, an echo of Gandhāra; with one or two exceptions,[7] they are draped asymmetrically across the chest as well. The superb haloes consist of concentric bands of great beauty and variety, the outer one generally adorned with the scallops inherited from the early Kuṣāṇa

Buddhas, the next a tubular band representing a wreath, with occasional rosettes, followed by wider bands of the beautiful Gupta laterally cut foliage. At the centre, a multi-petalled lotus radiates from the head. The discovery of a figure of this type dated 435[8] confirms the view that these Buddhas precede those at Sārnāth.[9]

The finest Hindu sculpture of the Gupta period from Mathurā so far known is a Viṣṇu, unfortunately without legs or lower arms [78]. The other, far less powerful Viṣṇu images from Mathurā are all similarly mutilated. The face could be a Buddha's, but the powerful chest and shoulders are not those of an ascetic. The armlets resemble those at Udayagiri, but the rest of the god's jewellery, particularly the crown, despite their decorative exuberance, lack definition compared to the best Early Gupta work. In fact they are no longer ornaments worn by real people and have slipped into a purely sculptural idiom – decoration of a statue and not of a living god. There are some excellent Gupta *mukhaliṅgas* (liṅgas with one or more heads emerging) in museums and collections and *in situ* in temples at Mathurā,[10] and a fine Śiva head from a liṅga survives detached in the Ashmolean Museum, Oxford.[11]

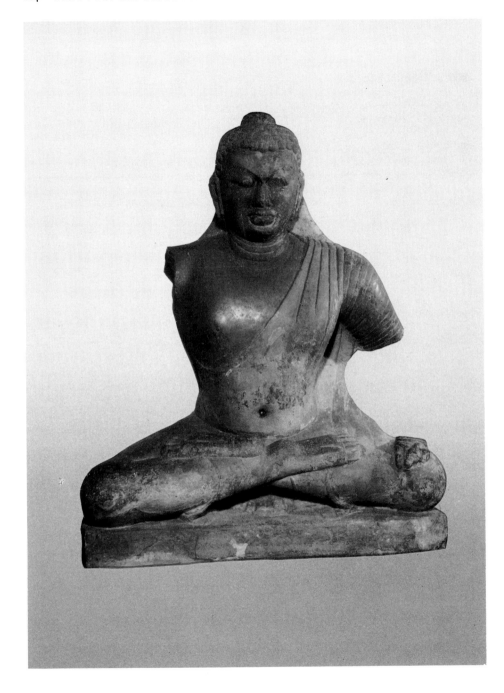

SĀRNĀTH, EASTERN UTTAR PRADESH, AND BIHĀR

During the first three centuries of our era, the workshops of Gandhāra and Mathurā produced nearly all the surviving free-standing stone sculptures, including stelae. A handful of works, mostly yakṣīs, in styles related to Mathurā are found as far east as Patna.[1] For images of the Buddha, however, both standing and seated, exports from Mathurā itself were relied upon.[2] The Kanoria Pārśvanātha stele, from Patna, is generally agreed to be of the late fourth century, and the fragmentary inscription of the Rājgir seated Neminātha may, because of the way the lower garment of the standing attendant figure ends just above the knees, with four bold ripples falling down between the legs, be ascribed to the reign of Candragupta II (c. 377-414).[3] Both demonstrate the initial stages of a style which will culminate in the post-Gupta Buddhas of Nālandā, but not, curiously enough, the great Gupta Buddhas of Sārnāth, admittedly further to the west.

The famous seated Buddha from Bodhgayā, dated in the year 64 of an unidentified king who almost certainly reigned within the Gupta era (i.e. 320 + 64 = A.D. 384), is one of the pivotal pieces in the long history of Indian sculpture [79]. It was long believed to be an import from Mathurā because the body is in the same posture as the Katra-type Buddhas produced there, the pleats of the robe are massed in a similar way, and it throbs with their great physical vitality. But the head is quite different: the face is brooding, heavy-lidded, the eyes focused on the end of the nose – an extraordinarily powerful evocation of the Buddha as the great yogi. In Stella Kramrisch's words, it is 'the first image in India which by its form signifies what its name implies'.[4]

The seated Buddha from Mankuwar in eastern Uttar Pradesh, dated 429,[5] shows the influence of the more or less contemporary styles at Mathurā, with its low base bearing a central cakra and two forward-facing lions. The face, although rounder, also shows some of the hardness of fifth-century Mathurā Buddhas. Unquestionably the finest Hindu image of the Gupta period so far known from the eastern Madhyadeśa is the great 6 ft 10 in. (2.1 m.) Kṛṣṇa Govardhana (Kṛṣṇa holding up the Govardhan Mountain) from Varanasi now in the Bharat Kala Bhavan [80]. The arms are restored, not unsuccessfully, although they are perhaps a shade too massive. The young prince (kumāra) Kṛṣṇa wears the typical pair of tiger's claws (vyāghra nakha) on his necklace, a low crown, and the three locks of hair (triśikhin),[6] the usual marks of Kārttikeya (Skanda) and of the Bodhisattva Mañjuśri, all depicted as kumāras. The lower torso and stomach have the Sārnāth sensitivity, a barely perceptible roll of flesh swelling out above the constricting top of the dhoti. The broad round face, however, and the not very deep set eyes are still reminiscent of Udayagiri.

One of the loveliest of all Indian sculptures is the Gaḍhwā 'lintel' or frieze, its appeal perhaps enhanced by the uncertainty surrounding its purpose and its themes [81].[7] In the centre of the long narrow carving stands Viṣṇu Viśvarūpa, one of his emanatory forms. At one end is Sūrya in his chariot against a circular disc, at the other Candra (the moon) seated with his consort on a crescent moon.[8] On the

79. Seated Buddha from Bodhgayā.
Probably 384 (dated 'in the year 64').
Buff sandstone.
Calcutta, Indian Museum

80 (*below*). Kṛṣṇa Govardhana (holding up the Govardhan Mountain) from Varanasi.
Fourth/fifth century. Chunār sandstone. *Varanasi, Bharat Kala Bhavan*

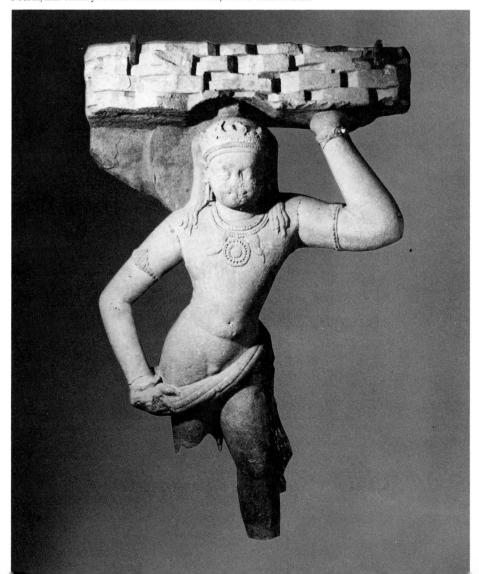

81 (*opposite and above*) and 82 (*below, detail of above*). Gaḍhwā 'lintel'.
Fifth century, second half

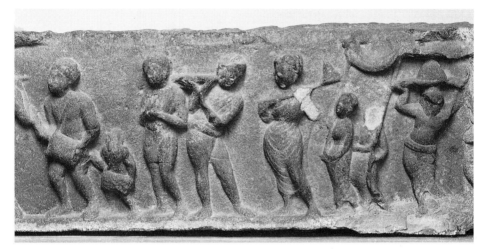

proper left, a long procession of musicians, young girls, and others bearing food winds its way, behind a figure kneeling at the feet of Viṣṇu, a parasol denoting high rank held over his head. On the other side, with further gifts of food, another procession approaches, including a burly soldier(?) with a large mop of hair bearing a sword resembling a Nepalese kukri.[9] At its head is a figure also honoured by a parasol. They are met by two others issuing from a building, probably a *dharmaśālā*, or pilgrims' hall, in which crouching figures are being fed by women wearing a distinctive head-covering coming down under the chin.[10] The Gaḍhwā lintel is distinguished by the absence of purely decorative elements (no

jewellery even is worn) and by the skilful rhythmic placing and variety of attitudes of the procession, the work of a master sculptor 'unusually adept in representing three-dimensional poses, with an exceptionally slender canon of proportions' [82].[11] On stylistic grounds the lintel would appear to belong to the latter part of the reign of Kumāragupta (c. 414–55), whose inscriptions appear at the site among others of Gupta date. It represents the zenith of Gupta narrative relief.

Turning to images, the Sārnāth Buddhas are probably the greatest single achievement of the Indian sculptor [83]. They are also the most widely disseminated, and continued to influence Buddha representations in eastern India,

83 (*opposite*). Standing Buddha from Sārnāth. 474. Chunār sandstone. 109
Sārnāth Museum

84. Seated Buddha from Sārnāth. Fifth century, last quarter. Chūnar sandstone.
Sārnāth Museum

and far beyond in South-East Asia, for centuries. By a stroke of good fortune rare in early Indian art history, dated examples exist, proving that they are a relatively late development – not before the third quarter of the fifth century.[12] Nothing seems to herald these suave creations of an almost unique perfection: they show a complete break, at last, from the plastic conceptions of Mathurā, and a treatment of the human body which will henceforth prevail in eastern India.

The Buddhas stand in very slight *déhanchement*. They wear the conventional lower garment, covered with the saṁghāṭī, indicated only by the lines tracing the edges; the body is therefore totally revealed, except for the sexual organs. The large, beautifully decorated haloes closely resemble those of the contemporary Mathurā standing Buddhas; the faces on the other hand are those of beings who have transcended the world of *saṁsara* or flux and exist in a state of perfect spiritual awareness – a quality which informs the entire image. Perfectly proportioned, the bodies are not naturalistically treated but achieve an almost miraculous harmony of interflowing planes. They are among the world's great classic achievements, classic both in being subsequently unrivalled and, in the historical sense, in determining the form which the Buddha image was to take for centuries.

On the majority of the Sārnāth Buddha stelae Śākyamuni is seated, his hands in the mudrā of *dharmacakrapravartana*, 'setting the wheel of the law in motion', i.e. preaching the First Sermon in the deer park at Sārnāth – a supremely appropriate theme [84]. On the bases, deer face a cakra. Most of the Bodhisattva images are later, but one or two have survived from this period. Sārnāth also produced narrative sculpture of a high order, chiefly stelae showing events from the Buddha's life.[13] In the high Gupta style, they nevertheless have a slightly naïf quality compared, for instance, to the Gaḍhwā lintel – perhaps on account of the traditional subject matter.

TEMPLES AND SCULPTURE

It is among the hilly wooded tracts of Madhya Pradesh, on the southern fringes of the Gupta empire, that the majority of the earliest surviving free-standing shrines are to be found. They are mostly from late in the Gupta period. It is undoubtedly to the relative isolation of the region, south of the invasion routes, that they owe their preservation. The area is rich in stone, unlike the Madhyadeśa, where most of the temples must have been of brick and hence more easily destroyed. Less than a score remain, some little more than heaps of fragments; none have preserved intact superstructures.[1] They consist for the most part of a single cubical sanctum (garbhagṛha) of well dressed masonry, with a minimum of mouldings, entered by intricately carved doorways of the greatest beauty [85]. Lying about loose around several of these shrines were decorated dados, stone grilles, waterspouts, and āmalakas, testifying to a discreet use of sculptural ornament in the purest Gupta style. The cult images of two of them, both Vaiṣṇava, the Narasiṃha at Eran and the Vāmana incarnation of Viṣṇu at Marhiā, have been identified among surrounding fragments. The Śaiva shrines must all have housed liṅgas.

The much restored Gupta temple at Sāñcī, the Kaṅkālī Ṭīlā at Tigowa, together with the only partially rock-cut Cave no. 1 at Udayagiri (Vidiśā), are probably the earliest of the surviving shrines. Their porticoes with four columns in antis, the space between the middle columns wider than the others, plain doorways, and, in the case of the first two, what may have been flat roofs[2] put them into a class somewhat apart from the others. But it would be wrong to postulate any historical development from these scanty survivals to the later Gupta shrines. Sāñcī is presumably the earliest (first quarter of the fifth century) because of

its bell capitals; the others have the vase and foliage type.

The remaining temples belong to the latter half of the fifth century and to the sixth. Dates are completely lacking, and a chronology must be based on stylistic grounds alone.[3] The temples had either an upper shrine or a superstructure (śikhara) of some sort, at this stage in some cases probably truncated: that of the Marhiā temple, without a porch, seems to have had only two low bhūmis (storeys or tiers).[4] Judging by the antarapatra (here a band of panels in the recesses between the bhūmis of bhūmiprāsāda- and late Kaliṅga-type temples) and gavākṣa elements which have survived, Bhumara may have had a śikhara of the same sort.[5] Most of the temples were raised upon a jagatī – a podium. The more elaborate Pārvatī temple at Nāchnā Kuṭhārā [86], altered almost beyond recognition by misinformed restoration, had an internal circumambulatory passage and an upper shrine room. Sculpture of varying quality was found at the site.[6] The Daśāvatāra at Deogarh, whose superstructure is largely conjectural, and the Bhitargaon temple near Kānpur, the sole survivor of the innumerable brick shrines which must have been raised in the Madhyadeśa during Gupta times, had higher, almost certainly curvilinear śikharas.[7] Also outside Madhya Pradesh, the largely ruined shrine at Mukundarra, south of Kotah – which probably had an attached front hall – boasted internal columns and pilasters, a feature unique in Gupta structural temples. It seems to have combined brick walls with carved stone pillars and capitals as well as other highly sophisticated decorative elements.[8]

If there is any conclusion to be drawn from this sparse, random collection of shrines preserved by the mere chance of survival (to

85. Deogarh, Daśavatāra temple, west entrance doorway.
Sixth century, first half. Red sandstone

which must be added the much restored Mahābodhi temple at Bodhgayā), it is to be found in the differences between them, which would seem to indicate that during the Gupta period the temple was still in a formative stage.[9] Many more types which have left no successors must have been built, a hypothesis strengthened by the unique features of the recently discovered Devarānī temple at Tali. In the same way, *sarvatobhadra* shrines (with entrances on all four sides), so popular in later periods, must almost certainly have been constructed in Gupta times, and yet none have survived.[10]

In quality of sculptural decoration nonetheless, and particularly in the unsurpassed beauty of their doorways, these little shrines embody the Gupta aesthetic at its highest. As a mark of its inventiveness and originality, what more charming conception than to rusticate the entire external walls of the Nāchnā Kuṭharā Pārvatī temple, with animals in the crannies and crevices? What is more, such a treatment is firmly based on two major aspects of Śiva, as the Lord of Kailas amongst the rocky peaks of the Himālayas and as the supreme ascetic in the wilderness. At Bhitargaon and Deogarh the images have already begun their move to the walls of the temple. At Deogarh, three walls are panelled with scenes from Vaiṣṇava myth: Naranarāyaṇa, Anantaśayana (Viṣṇu asleep on the serpent Ananta) [87], and the rescue of Indra's elephant (Gajendramokṣa). Majestic as are these last two themes – and the figure of the sleeping Viṣṇu dreaming another aeon (*kalpa*) of creation into existence is one of the most powerful of all Indian iconographic conceptions – the sturdiness and power of early Gupta sculpture is yielding to a softer, more delicate and ultimately weaker style. Mannerisms include the well-known stylized poses, probably imitated from the

86. Nāchnā Kuṭharā, Pārvatī temple. Late fifth/early sixth century

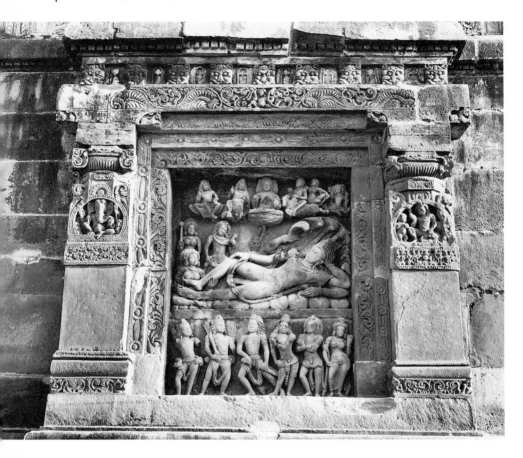

87. Deogarh, Daśavatāra temple, south side,
Viṣṇu Anantaśayana. Red sandstone

theatre, of the men below the sleeping Viṣṇu,
and even a note of irreverence can be dis-
cerned in the superciliousness of the god as he
arrives to free the elephant from the toils of
the lotus stems.

A small number of sculptures belonging to
the late Gupta period have been found at
Mandasor, at nearby Sondni, and at Kilchi-
pura, in an enclave of Madhya Pradesh in
Rājasthān but a part of Mālwā in earlier times.
The giant Śiva stele, its face recut in the earlier
part of the twentieth century, is surrounded
by massed gaṇas, some of them grotesques,
reminiscent of the hosts of Mārā in some Gan-

dhāra stele. The architectural settings of a fine pair of dvārapālas at Sondni, the site of Yaśodharman's grandiloquent inscription of 533-4, have distinctly post-Gupta features. The flattening of the relief in the Kilchipura stambha also heralds the coming style.[11] On the other hand, the radiating pucker-lines at the top of some of the dhotis, and sometimes even the small turn-over, are hallmarks of the Gupta style.[12]

A much larger body of sculpture from northern Gujārāt and southern Rājasthān, in an exceptional variety of styles, once more defeats chronology by its complete lack of dates.[13] From the main sash of some of the male figures from Śāmalājī a secondary loop hangs down, as sometimes at Parel and Elephanta. Iconography is well developed. An unusual number of these mainly small images are in the round. Dates in the sixth and early seventh centuries seem most likely. Among mother and child groups (Skandamātās: the god Skanda or Kārttikeya had six nurses or mothers) the finest are from Tanesara-Mahādeva (Rājasthān) [88]. Their stylistic antecedents are difficult to pin down. Softly modelled and in rather sentimental poses, they are perhaps more easily assimilable to Western taste than any other Indian sculptures, partly because of their evocation of the Virgin and Child.

If it is hard to visualize the original setting of much of the stone sculpture, it is even more difficult in the case of the terracottas, some of considerable size and many of them relief plaques; yet they rank among the artistic glories of the Gupta period. In an allied medium, the five stucco sculptures of the unique Maṇiyār Maṭh at Rājgir, probably a Nāga temple, were placed in niches, like so much later work.[14] Only the brick temple at Bhitargaon affords a glimpse of the way in which terracotta sculpture became an integral part of the temple [89]. The large relief panels in the niches of the main walls have all but disintegrated, but the upper storeys are still furnished (among other subjects) with grotesques (cf. the gargoyles of Gothic cathedrals) and makara

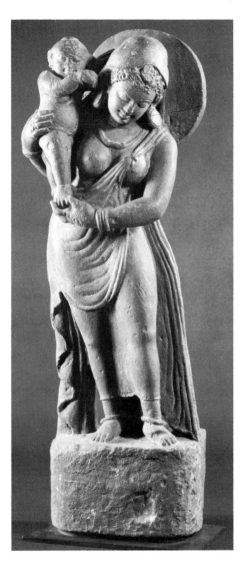

88. Skandamātā from Tanesara-Mahādeva. Sixth/early seventh century. Grey schist. *Los Angeles County Museum of Art*

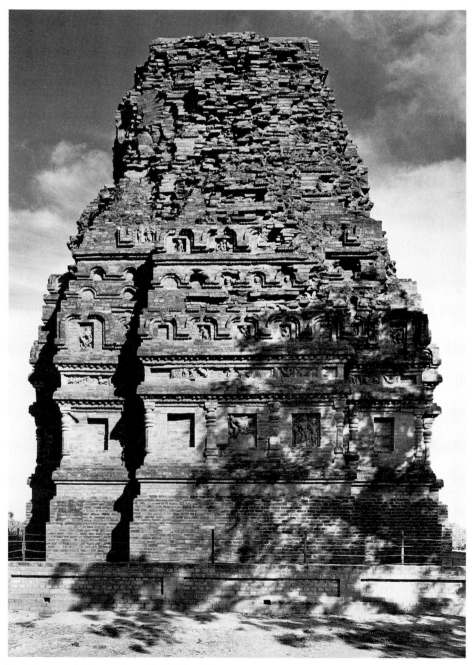

89. Bhitargaon, brick temple, north side. Late fifth century

friezes.[15] Of an elegance and sophistication rarely surpassed elsewhere in the world are the two large river goddesses, 4 ft 8 in. (1.47 m.) high, from the excavated remains of a large brick temple at Ahichchhatra [90]. Their recherché bodices and disdainful air, the mannered grotesquery of their attendants, and the extreme realism of the scales of the makara are the quintessence of the Gupta style. Many small terracotta figurines, much worn and rec- ognizable as Gupta principally by their hair-styles, have been found at Rājghat (Varanasi) and other sites.

Scientific excavation of the stūpa at Devnimori in Gujarāt, in advance of a reservoir project, revealed, along with rows of sensitively modelled terracotta Buddhas [91], a repertory of architectural decoration duplicating and often surpassing that in stone, including perhaps the earliest version of the superb laterally

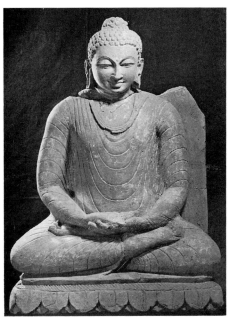

91. Seated Buddha from the stūpa at Devnimori. *c.* 375 (?). Terracotta.
H 2 ft 2 in: 66 cm. *M.S. University of Baroda, Department of Archaeology and Ancient History*

cut foliage friezes of the Gupta period, as well as acanthus friezes and ornate gavākṣas.[16] Another stūpa further west, near Mirpur Khas in Sind and a century or more later in date, has also yielded large terracotta reliefs of Buddhas and a good deal of ornamental detail, in a drier style than that of Devnimori.[17] The Mirpur Khas stūpa is the first to have a recessed chamber on one side of the base.

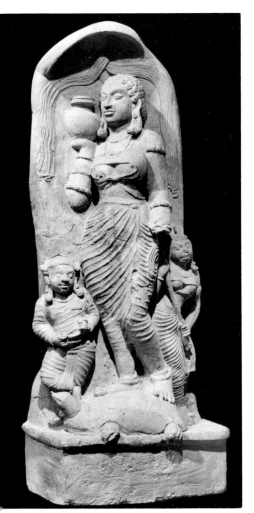

90. Ahichchhatra, river goddess (Yamunā).
Fifth/sixth century. Terracotta

THE LATER OR MAHĀYĀNA CAVES AT AJAṆṬĀ

Artistic activity at this time did not cease, of course, at the confines of the Gupta empire. Characteristic Gandhāra and Āndhra sculpture continued to be produced well into, if not throughout, the Gupta period. The only region beyond the periphery of the empire to give rise to something closely resembling the metropolitan style, however, was the ancient Vidarbha, now north-western Mahārāṣtra, whose craftsmen, sculptors, stone-cutters, and painters were responsible for the ornate decoration of the rock-cut Buddhist monasteries at Ajaṇṭā. The spectacular U-shaped ravine in a spur of the Sahyadri hills had early attracted a monastic community, and two caitya halls and three small vihāras were hewn out in Sātavāhana times.[1] It was in the latter half of the fifth century, under the powerful Vākāṭaka

92. Ajaṇṭā, Cave 19, façade. Fifth century, last quarter

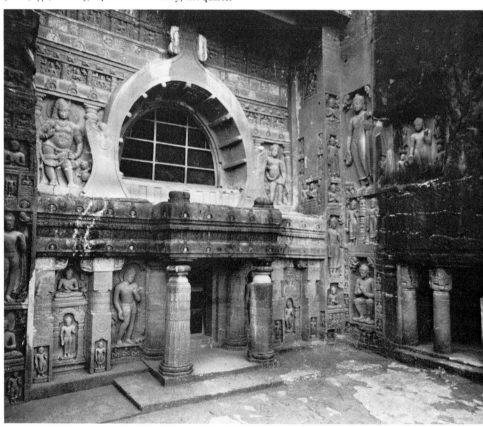

dynasty, allied in marriage but not subject to the Guptas, that the second and greatest phase of rock-cut architecture was inaugurated in the most splendid fashion with some twenty-three new caves, not all completed.[2] With the exception of the broken vihāras at Bāgh in western Mālwā, there is no mainstream rock-cut architecture within the Gupta dominions during this period, the caves at Udayagiri (Vidiśā) being of little architectural importance.[3]

The Mahāyāna caves at Ajanṭā consist mainly of vihāras, sometimes one above the other. The two caitya halls, Nos. 19 and 26, are comparatively far removed from their wooden prototypes. The great caitya window, while preserving a traditional form, is envisaged solely as a means of admitting light. Reliefs of vedikās are conspicuously absent from the façades [92], their place being taken by contemporary architectural ornament, such as the *kapota*, the characteristic, and, at least in the south, ubiquitous Indian eaves moulding, with miniature caitya windows and large figure reliefs like the two yakṣa guardians.[4] The vihāras all have basically the same plan. Cave 21 is typical: colonnaded porch, three entrance doors, the pillars in the hall arranged in a square, and the shrine-room, preceded by a vestibule with a pillared portico, in the middle of the back wall. The addition of vestibules and porticos to no

93. Ajanṭā, Cave 26, interior. Fifth century, last quarter

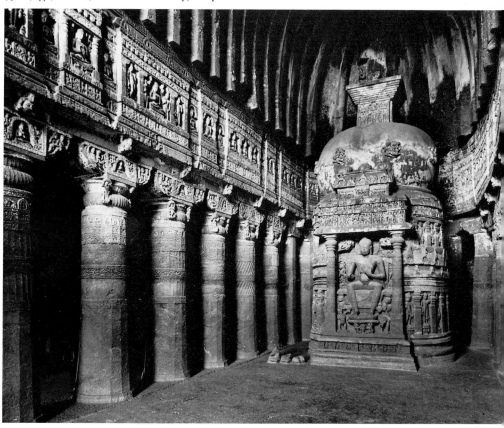

less than six of the cells shows it to be of the most advanced type. All the second-phase caves appear to have been hewn out during an extraordinary burst of creative activity and munificent patronage during the latter half of the fifth century.[5]

The principal changes in the function and iconography of the caves comprise the introduction of a shrine-room into the vihāras, the consequent decline in the importance of the caitya hall, and the emergence of a still very limited Mahāyāna pantheon consisting of the Buddha and the great (male) Bodhisattvas together with the 'historical' Buddhas and the other deities already adopted in the early period. The cult-object is always the Buddha, very often in the 'European' pose, and on the bases the appropriate wheel and deer of the First Sermon, worshipped by devotees, frequently appear. Behind the Buddha there is often a typical Gupta throne, with vyāla supporters and a cross-bar terminating in yāli or makara heads.[6] The *yāli*, more often termed *vyāla* in the north, is a griffin-like mythical beast, almost invariably shown in a rearing pose. The Buddha is occasionally flanked by Bodhisattvas holding chowries and sometimes by other standing Buddhas who may also line the side walls of the shrine-chamber and even of the vestibules. Other icons include the Great Miracle at Śrāvastī, popular in Gandhāra and also at Kanheri, near Bombay, whose numerous but small second-phase caves are notable less for their architecture than for their reliefs of Buddhas and Bodhisattvas; a very large Parinirvāṇa and the first Avalokiteśvara as Protector of Travellers appear also at Ajaṇṭā, but never in a central position. Stūpas, or representations of them, are almost totally absent, except in their usual position in the caitya halls, where they are almost obscured by large seated Buddhas in elaborate surrounds placed on the side facing the entrance and forming an integral part of the stūpa [93].

The Buddhas which constitute the overwhelming majority of the images at Ajaṇṭā tend to be heavy and somewhat lifeless; some of the surprisingly large figures are awe-inspiring, however, in the dim light of the shrines. There are some notably beautiful individual sculptures, like the famous Nāga couple outside Cave

94. Ajaṇṭā, Cave 19, Nāgarāja and his queen. Fifth century, last quarter

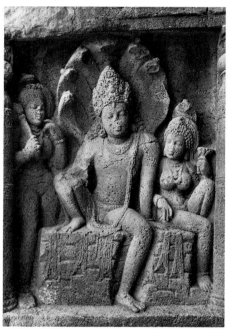

19 [94]. But it is for the variety of their columns and doorways, some relatively plain, others showing an almost unbelievable wealth of decorative detail,[7] that the caves are justly famous, as well as for their murals – the only large body of Gupta painting to have survived. These will be considered in Chapter 25, but it should be noted here that it is sometimes painting rather than relief that provides the decorative detail [95].[8] Here, and at Bāgh, fluted columns appear for the first time, and so do many other motifs. If not in the purest Gupta style, the Ajaṇṭā caves, because of their number and almost perfect state of preservation, and because of the pitifully few remains

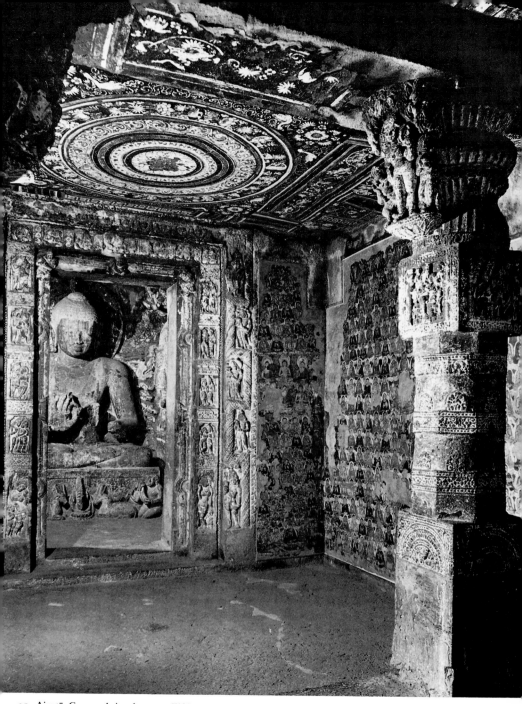

95. Ajaṇṭā, Cave 2, shrine doorway. Fifth century, last quarter

elsewhere, alone still project an abundant, varied, and complete vision of the artistic achievement of the Gupta period. True, for the first but certainly not the last time in the long history of Indian art, some of the more elaborate caves can be charged with being over-decorative, and in this respect, as well as on account of a certain lack of subtlety and depth in the carving, they depart from the Gupta style. If not over-decorated, they can nonetheless be criticized, as Spink has pointed out, for the lack of motifs on a larger scale to serve as focal points, and for the absence of plain surfaces to set off the carving. One splendid sculpture[9] from as far away as the vicinity of Nagpur is in the Ajaṇṭā style, which seems otherwise to have been concentrated at Ajaṇṭā itself and at one or two neighbouring sites. When patronage ceased, the workers and their descendants carried their skill and traditions first to the Konkan, then back to Vidarbha, where they created some even greater rock-cut monuments at Elephanta and Ellorā, and eventually to northern Karṇāṭaka.

THE POST-GUPTA PERIOD

CHAPTER 10

LATER ROCK-CUT TEMPLES

India far surpasses the rest of the world in rock-cut architecture, of which the finest monuments were created during the two and a half centuries from *c.* 550 to 800.[1] The principal caves are at Elephanta, Jogeśvari, Mandapeśvar, and Kanheri in the environs of Bombay, at Aurangabad and nearby Ellorā in Mahārāstra (ancient Vidarbha), and at Bādāmi and Aihole in Karṇāṭaka. The earliest are direct descendants of the Vākāṭaka caves at Ajaṇṭā, and it is indeed highly likely that generations of stone-cutters and sculptors moved from one site to another

96. Elephanta, Śiva cave, plan. Mid sixth century

1. Mahādeva
2. Ardhanārīśvara Śiva
3. Pārvatī in attitude of Māna
4. Rāvaṇa under Kailāsa
5. Śiva as Lakulīśa
6. Naṭarāja Śiva
7. Andhakāsuravadhamūrti Śiva
8. Śiva shrine
9. Kalyāṇasundaramūrti Śiva
10. Gaṅgādhara Śiva

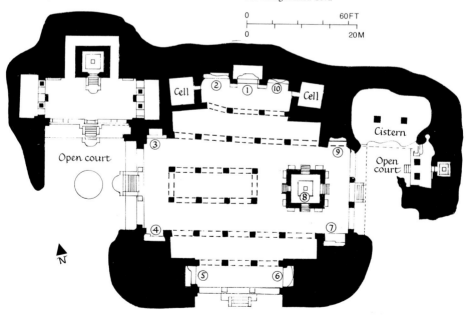

in the Konkan, western Mahārāṣṭra, and other parts of the western Deccan, driven perhaps by the successive waves of conquest by the Kalachuris, the Early Western Cālukyas, and finally the Rāṣṭrakūṭas, who went on to subdue the whole area. The Hindu – and even Jain – caves and temples introduced new and quite different ground plans and elaborate sculptural conceptions illustrating myths from the Purāṇas, influencing the later Buddhist caves and giving rise to a richer and more abundant iconography. New sculptures, principally of Buddhas and Bodhisattvas, were installed in many of the earlier caves, notably at Karle, Nasik, and Kanheri. Of the monolithic imitations of structural temples cut out of the solid rock at the end of the period the great Kailāsanātha at Ellorā is the supreme achievement.

Work is thought to have begun around the present city of Bombay in the mid sixth century, under the patronage of the Kalachuris and possibly of their predecessors, the Traikūṭakas.[2] The great Śiva cave at Elephanta (Gharapuri), an island in Bombay harbour, has a complex plan, making the most of a carefully chosen configuration of rock and at the same time betraying the influence of contemporary structural shrines [96]. It is essentially a rectangular maṇḍapa temple facing east. The garbhagṛha is sarvatobhadrika, each of the four entrances guarded by giant dvārapālas and their attendants. On the sides, instead of walls, there are rows of pillars opening on to vestibules, the northern leading to another entrance (there is a third one behind the garbhagṛha), the southern to the sculptured rock-face, with, in the centre, the other focus of the temple, the great Mahādeva image.[3]

The pillars are relatively plain, square to mid-height, thereafter round and fluted, including the cushion capitals. The entrances are unadorned; indeed the whole cave is devoid of decoration, heightening the effect of monumental dimensions and of the great sculptured panels depicting the god in various forms and activities, notably a Naṭarāja, an Ardhanārīśvara,

a Marriage of Śiva and Pārvatī, and a seated Lakulīśa.[4]

Dreadfully damaged though they are, the images combine the rapt and self-absorbed inwardness which has become the principal attribute of the godhead with an immensely powerful dynamism, and in this way, rather than by the presence of the attendant figures, convey the essential oneness of the human and the divine which is the greatest theme of Indian art. Greek gods are simply men and women, albeit idealized; these figures are superhuman, true divinities, the link with the human world achieved by plastic form in a way never perhaps equalled.

The great Mahādeva image rises to a height of 17 ft 10 in. (5.45 m.) above the base, itself nearly 3 ft high [97]. It is more of a mukhaliṅga than a full figure of Śiva. Its iconographic designation is Sadāśiva or Maheśa (the great lord). The right hand of the god is broken; he holds a *mātuluṅga* (citron) in his left. The face on the proper right, with the serpent, is Aghora-Bhairava, a terrible or angry manifestation, that on the left Vāmadeva or Umā, Śiva's śakti, with a lotus. Because it is so amazingly skilfully placed in relation to the various external entrances, the image receives exactly the amount of light necessary to make it look as if it is emerging from a black void, manifestation from the unmanifest, an effect heightened by the expression of the central face, sunk deep in contemplation and yet infinitely majestic.

Some loose sculpture, mostly fragmentary, said to have come from Elephanta is closely related to the prevailing style in northern Gujarāt in the sixth and seventh centuries.[5] However the great bas-relief at Parel of Śiva multiplying himself shares both the style and the type of metaphysical concept of the great image at Elephanta.[6]

The most important of all the rock-cut sites of the second phase is Ellorā near Aurangabad, now in Mahārāṣṭra. Here, in the western face of an outcrop of the Sahyadri hills, some thirty-five caves and rock-cut temples, Hindu, Buddhist, and Jain, extend for three-quarters of a

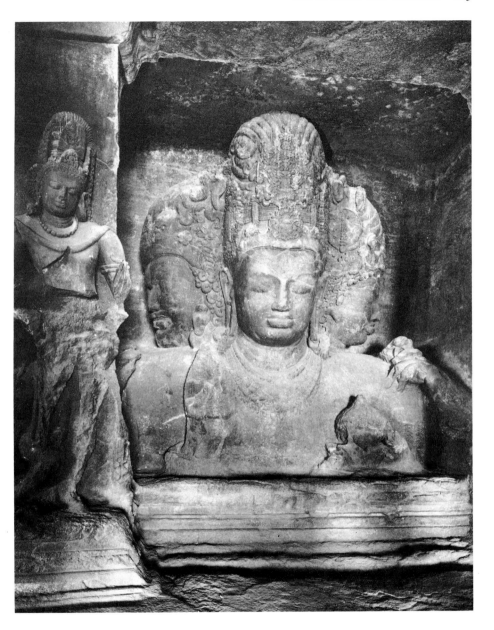

97. Elephanta, Śiva cave, Mahādeva. Mid sixth century

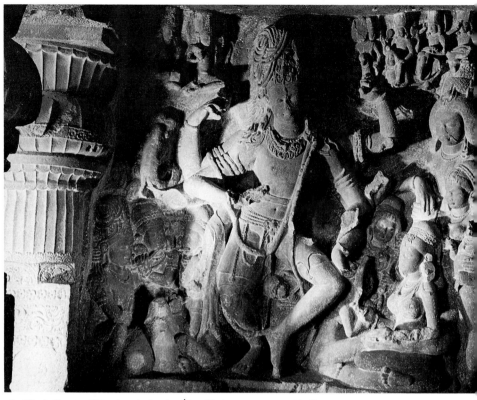

98. Ellorā, Cave 21 (Rāmeśvara), dancing Śiva. Sixth century, second half

mile. One of the earliest, probably of the mid sixth century, is the Hindu Rāmeśvara (Cave 21),[7] with a well-balanced plan, the refinement of an inner sanctum with a circumambulatory passage, and a Nandi on a high plinth facing the entrance wall, all just as in a structural temple. On the parapet wall between the exterior pillars of the hall are fine relief friezes of elephants and mithuna couples, and there are brackets in the form of śālabhañjikās. Inside, vestibules with two-column porticoes open on either side, their walls sculptured, as at Elephanta, with images of the gods and scenes from Purāṇic myths. Relief figures on either side of the entrances to the sanctum include a Durgā killing the demon buffalo and – perhaps

the finest – a dancing Śiva, both knees bent (kṣipta) and body facing the spectator in a manner characteristic of Indian dance throughout the ages [98]. Less heroic in size and pose than the Naṭarāja at Elephanta but far better preserved, the god is instinct with an extraordinary rhythm, accentuated by the fall of his jaṭā (crown of matted locks) in disarray on to his right shoulder. The musicians clustering, almost crowding, around, of a rare beauty and individuality and on a comparable scale, give a feeling almost of genre to the scene. The Seven Mothers seated in a row in the same vestibule have an equal charm of feature and individuality of pose. Outside, carved into the rock face at each end of the

veranda, are the river-goddesses, in a more conventional post-Gupta style.

Allowing for the different configuration of the cliff, the so-called Dhumar Lena (Cave 29) almost duplicates the Elephanta cave in plan, iconography, and ample scale, and was probably inspired by it. There is even a similar seated Lakulīśa image facing a Naṭarāja. Although the sculpture is of immeasurably inferior quality, much of it unfinished, the likeness to Elephanta postulates a link between the early Hindu caves at Ellorā and the Kalachuris, who must have been past their prime by the end of the sixth century, when they suffered a defeat at the hands of the Early Western Cālukya sovereign,[8] at whose capital in northern Karnātaka - Bādāmi - Cave 3, dated by inscription to A.D. 578, shares with the Rāmeśvara at Ellorā (see below) the striking feature of human couples as brackets [99]. The Hindu caves at Ellorā, exclusive of the Rāṣṭrakūta ones, thus almost certainly belong to the second half of the sixth century.[9]

The Hindu caves carved out of the red sandstone cliffs of Bādāmi are all Vaiṣṇava, with one Jain exception, and of modest size.[10] The most elaborate, Cave III, has been partly described in the preceding paragraph. The plan is simpler than that of the Rāmeśvara at Ellorā, without vestibules, and the sanctum is but a small square cell hollowed out of the back wall. The sculptures include Viṣṇu as a boar (Varāha), as a lion (Narasiṁha), and, repeated in each of the Hindu caves, as Trivikrama in the Vāmana (Dwarf) incarnation. The figures tend to be self-assertive, almost brutal, usually standing rigidly in samapada, with inflated legs and over-size hands. The gods' jewellery, on the other hand, is rendered with great delicacy. The compositions lack the atmospheric charm of the panels in the Kalachuri caves, although some of the attendant figures are often splendid grotesques in the purest Gupta style. Quality varies. The seated Viṣṇu at one end of the hall is a powerful brooding presence, the Narasiṁha at the other end an engaging figure.[11] Although small and simple in plan,

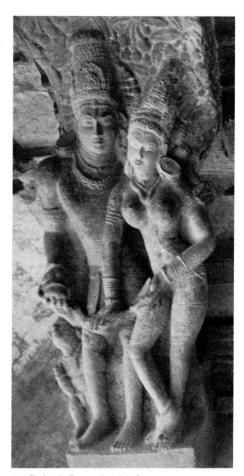

99. Bādāmi, Cave 3, bracket figures.
Dedicated 578

the Bādāmi caves give an impression of richness due to the fine carving of minor figures and decorative motifs, particularly on the ceilings.

The two Aihole caves, Hindu and Jain, are also splendidly decorated inside. The Rāvaṇaphadi boasts a more evolved plan, with a much larger sanctum, reminiscent of the Rāmeśvara at Ellorā. It too is 'Śaiva' (the adjective of Śiva), with a fine dancing Śiva flanked

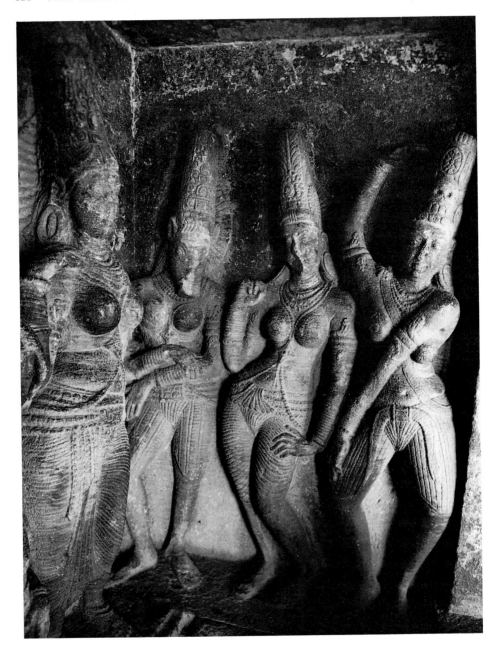

100. Aihole, Rāvaṇaphadi cave, dancing Mātṛkās. *c.* 600(?)

by dancing Mātṛkās in one of the vestibules [100] (the other is unfinished) and, on either side of the passageway into the sanctum, Durgā Mahiṣāsuramardinī and a Varāha. The sculptures are highly individual, quite distinct from those of Ellorā as well as of the Bādāmi caves. Further from the Gupta idiom, the figures are endowed with a gentle grace, the legs are slender and sensitively done, the crowns exaggeratedly tall, and drapery is obsessively indicated by means of deeply scored parallel lines. Outside the entrance, all but obliterated, is a pair of doorkeepers in 'Scythian' costume, an astonishingly late survival of a tradition of foreign guards first mentioned by Megasthenes.[12]

Unquestionably later, although difficult to date, is the Rāvaṇa-ka-Khai (No. 14) at Ellorā, placed as it is between the most elaborate of the Buddhist caves (No. 12) and the Daśāvatāra (No. 15), indisputably Rāṣṭrakūṭa in style. The Rāvaṇa-ka-Khai has an exceedingly rational, thoroughly Hinduized plan, with ample space for circumambulation and a colonnaded hall preceding the sanctum. On each side wall, separated by ornate pilasters, are five panels, Śaiva on the left, Vaiṣṇava on the right. The rectangular garbhagṛha indicates that this cave was almost certainly dedicated to a female goddess or goddesses.[13]

More or less contemporary with the Hindu caves at Ellorā are the second-phase Mahāyāna caves at Aurangabad. One group (1 and 3) seems to continue the finest Ajaṇṭā works; Cave 3, in particular, corresponds fairly closely in plan, and the carving of some of the pillars indeed surpasses anything at Ajaṇṭā. The second group (Caves 2, 5, 6, 7, 8 and 9) combines Hindu-type sanctums in the centre of what used to be the hall (one with a porticoed entrance) with cells cut into the side and back walls and (Cave 7) a columned veranda of Buddhist type. The hardness and lack of freshness and inventiveness in the carving of pillars and pilasters betray the later date.[14] On the other hand, nowhere is the litany of Avalokiteśvara more splendidly represented [101], and

the goddesses, doubtless Tārā with an attendant, standing on each side of the sanctum door are among the finest sixth- and seventh-century cave sculptures in Mahārāṣṭra. The dancing woman with flanking female musicians on one wall of the inner sanctum is unsurpassed in the entire corpus of Indian sculpture [102]. Most of the Buddhas in these caves are seated in European fashion.

The Buddhist caves at Ellorā were probably not begun until work on the earlier Hindu shrine had ceased. They belong to the later Mahāyāna (Great Vehicle) phase. Although Caves 2 and 3, for example, correspond to the more elaborate of the Ajaṇṭā caves more than a century before, not only do the plans soon become far more complicated, but a whole new iconography emerges, born of profound changes in doctrine, liturgy, and general outlook. The stūpa all but disappears. The stock of icon-types at Ajaṇṭā was little greater than in Kuṣāṇa times, but now many new Bodhisattvas appear, as well – for the first time – as female goddesses or Bodhisattvas such as Tārā, together with four-armed images, obviously adopted from Hinduism, and so-called litanies of Avalokiteśvara, with the great Bodhisattva shown as Lord of Travellers flanked by scenes of wayfarers in distress. A contemporary text shows to what extent the great Bodhisattvas were invoked and worshipped:

... If a man is surrounded by fearful beasts with sharp teeth and claws, he has but to think of Avalokiteśvara, and they shall quickly fly in all directions ... If this whole [world] were teeming with knaves, enemies, and robbers armed with swords, and if a merchant leader of a caravan marched with a caravan rich in jewels; if then they perceived those robbers, knaves, and enemies armed with swords, and in their anxiety and fright thought themselves helpless; if, further, that leading merchant spoke to the caravan in this strain: Be not afraid ... be not frightened; invoke, all of you, with one voice the Bodhisattva Mahāsattva Avalokiteśvara, the giver of safety; ... if then the whole caravan with one voice invoked Avalokiteśvara with the words: Adoration, adoration be to the giver of safety, to Avalokiteśvara Bodhisattva Mahāsattva, then by the mere act of

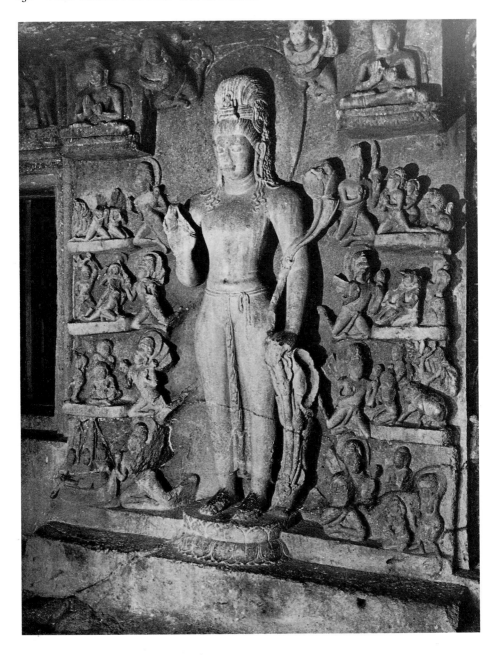

101. Aurangabad, Cave 7, 'Litany of Avalokiteśvara'. Sixth century, second half

102. Aurangabad, Cave 7, dancing woman (Tārā?)
and musicians.
Sixth century, second half

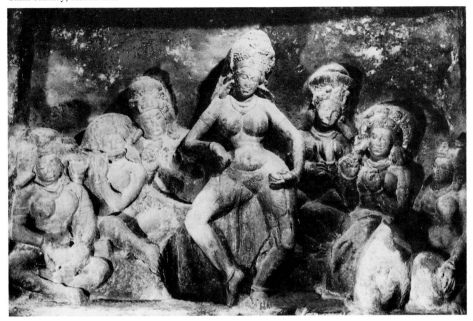

pronouncing that name, the caravan would be released from all danger.[15]

Finally, the Mānuṣī or historical Buddhas are joined by the Dhyāni Buddhas and the Primordial Buddha, Vajrasattva or Vajradhara, embodying religious, metaphysical, and cosmological conceptions of Mahāyāna Buddhism.[16]

Already the purpose of these rock-cut halls is changing. Cave 2 cannot have been a vihāra, for there are hardly any cells. Elaborations on the evolved Ajaṇṭā plan are introduced, like the colonnaded gallery on either side of the hall, behind which are rows of four Buddhas seated in pralambapada. Buddhas and worshippers now also line the walls of the sanctum itself. Capitals vary from the vase and foliage type (Cave 3) to chamfered cushions. The sculp-

ture, lacking the earlier abundance of detail, consists of conventionalized interlocking forms, prone to exaggeration, as in the oversized breasts. Faces tend to be over-simplified.

Some caves are larger and more elaborate than any Buddhist excavation so far undertaken. Cave 5 represents an entirely new type, in that it extends into the rock to a much greater length than its width and yet is not a caitya hall. It is rectangular, with two rows of ten pillars in the centre and between them two rows of continuous raised stone benches. It is not known what purpose these served. It has been suggested that they were used as refectory benches or tables (there are also seventeen cells and a shrine), but it is more likely that the monks sat there at assembly or for instruc-

tion, as must have been the purpose of the seats around the tiled courtyard at Harwan. There is a similar unexplained feature in one of the caves at Bāgh.

Large standing Bodhisattvas, with attendant figures, stand as dvārapālas on either side of the sanctuary of several of the caves, a feature obviously adopted from the Hindu cave. In Cave 6 these are particularly fine, with their swelling vitality, beautifully wrought mukūṭas, and attendants in typical Gupta poses. The identity of some of the Bodhisattvas is puzzling. Those with a miniature Buddha in their crown are invariably identified as Avalokiteśvara and frequently have a deer-skin (ajina) over their shoulders. Those with a stūpa in their headdress are usually thought to represent Maitreya, but the attendant figure of the Maitreya in Cave 6 wears a vajra in his headdress. On the right wall of the antechamber is Mahāmāyūrī, and opposite her, also seated, Tārā, with a stūpa in her jaṭāmukūṭa and wearing an ajina. Cave 8 is remarkably similar in plan to a Hindu shrine, and contains what is probably the earliest multi-armed Buddhist figure, the Avalokiteśvara beside the seated Buddha in the sanctum.

Cave 10, the so-called Viśvakarma, is the only caitya hall at Ellorā and the last of this type of cave to be excavated. The caitya hall had been made obsolete by three developments: the displacement of the stūpa as the main cult object, the enshrinement of Buddha images in the vihāras, and probably, as we have seen, their use as places of assembly or 'combination' halls like Cave 5. What is more the great three-storeyed caves like the Tīn Thal, with their enormous halls, now catered to the monks' need for grandeur as well as or better than caitya halls. The Viśvakarma shows the transformation almost beyond recognition of a type of rock-cut building dating back to the second century B.C. It is apsidal-ended. The row of interior columns and the high carved clerestory differ little from those of Caves 19 and 26 at Ajantā, but the stūpa is all but obscured by the huge figure of a seated Buddha. Entrance is now through a doorway in a screen

wall into a courtyard with two-storey verandas on either side, with cells behind them. Most remarkable is what has happened to the façade itself, the most striking and characteristic feature of a caitya hall [103]. A colonnaded entrance portico supports a broad terrace behind which rises a balanced composition of a caitya window flanked by two large niches surmounted by udgamas of already complex form, with split and superimposed gavākṣas. The shapes of these features suggest a date around A.D. 650, the udgama (pediment) emerging as one of the dominant features of post-Gupta architecture. The window still serves the purpose of the original caitya archway, to admit light to the interior, but its contours have become entirely decorative, bearing no relation to the barrel-vault within. Inside, corresponding to the terrace, is a gallery in the position of a European minstrels' gallery. Its purpose is not known.

Caves 11, 12, and 15 are all multi-storeyed, the first two three-floored and Buddhist, the last, with only a ground floor and first storey, Hindu. Cave 11, however, contains two or three Hindu images, and Cave 15 has some cells indicating that it had been planned to be Buddhist, although the nṛtya maṇḍapa (dance pavilion) in the forecourt is difficult to reconcile with this. Caves 11 and 12, because of their highly developed iconography and features of their sculpture, are almost certainly the last Buddhist caves at Ellorā.

Like Cave 10, Cave 11 (the Do Thal) has a large open court in front.[17] Its images include, for the first time, such figures as Sthiraketu, with a sword, and Jñānaketu, holding a flag, and Mañjuśrī holding a lotus on which rests a book, henceforth his most distinctive iconographic feature. Architecturally, it is a plainer and less ambitious version of the great Tīn Thal (Cave 12). Here, as in the Viśvakarma, the large forecourt is entered through doors in a screen

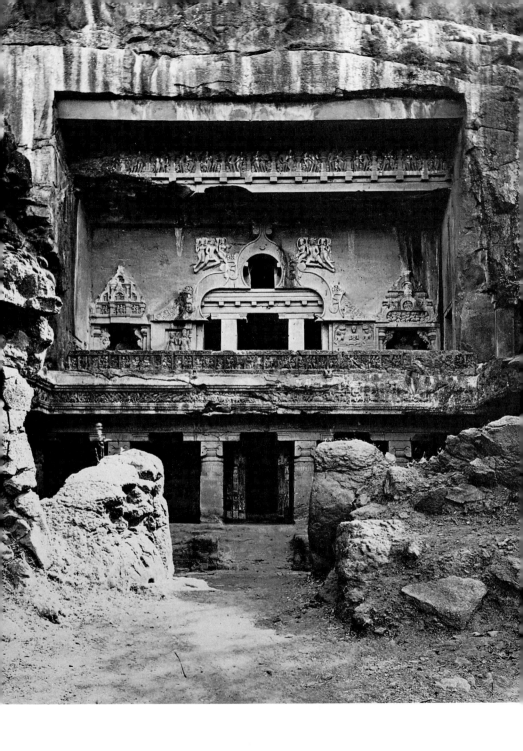

wall. The façade is completely plain, as in the Do Thal, giving no indication of the splendour within or the size of the three great superimposed halls. On the ground floor is a six-column vestibule in front of the main shrine, which has the now usual arrangement of guardians on the side and back walls; however all are seated in padmāsana, even the Bodhisattvas Mañjuśri and Maitreya, acting as doorkeepers one on either side of the entrance. Above the four Bodhisattvas on each side wall of the shrine are five Dhyāni Buddhas. Tārā and Cuṇḍā face the Buddha inside. The goddesses wear *kucabandhas* (breast bands), and some of the figures have *kīrttimukha* (lion-mask) armlets – late characteristics, as are the shapes of certain of the mukuṭas. There is also a pair of doorkeepers with their arms crossed and leaning on clubs, in the southern manner.

The first storey is unique in having cells on all four sides of the colonnaded hall. This is achieved by placing the side entrances from the veranda at the extreme ends of the façade, which, given the exceptional size of the hall, allows three inward-facing cells on either side of the central entrance. The second storey is a huge transverse hall with five rows of eight columns and Buddhas on the side walls at the end of each transverse aisle. In the centre of the back wall, a vestibule with two columns leads to the shrine. On either side of the vestibule, filling each wall space, are seven seated Buddhas: on the left, the Mānuṣī Buddhas, each identified by the particular *bodhi* tree under which he attained Enlightenment; on the right, seven Dhyāni Buddhas, their hands in dharmacakra mudrā and seated under parasols. Then, on each side of the vestibule and beside the shrine door, come six seated goddesses of which some have been tentatively identified: Vajradhātvīsvarī, Khadiravaṇī, Cuṇḍā, Janguli, Tārā, Mahāmāyūrī, Bhṛkūṭī, and Pāndarā. Inside on the side walls of the shrine are eight standing Bodhisattvas holding chowries in one hand. By the symbols in their other hands, Maitreya (*kamaṇḍalu*, water-pot), Sthiracakra (sword), Mañjuśri (book on lotus), and Jñānaketu

(banner) can be recognized. Thus the entire walls of the upper storey, including the interior of the shrine, are lined with figures. Repeated several times inside the cave is a square divided into nine compartments, eight with Bodhisattvas, a Buddha in the centre – perhaps the earliest surviving maṇḍalas.

Cave 15 (the Daśavatāra) is unquestionably late. With its upper storey it corresponds to Buddhist caves like Nos. 12 and 13 (some cells suggest that it was commenced as a Buddhist cave). A very deep court is also a late feature. What is more, the large, monolithic but quite separate maṇḍapa in the court has exterior niches topped with an udgama decorated with a mesh or honeycomb of gavākṣas, a characteristic feature of post-Gupta free-standing temple architecture. It is doubtful whether this feature occurs anywhere before the middle or late seventh century. The Daśavatāra is the only monument at Ellorā with an early inscription of any historical importance. It records that either the Rāṣṭrakūṭa Dantidurga (*c.* 730–55) or a contemporary magnate visited the temple, probably towards the end of Dantidurga's reign, when it appears to have been complete – indeed, it may have been so for some years or even decades. What is certain is that a new spirit animates the sculpture. The old Kalachuri compositions, large and packed with figures, are replaced by new, usually simpler and more dynamic ones often nearly identical to some in the adjacent Kailāsa (Temple 16), an undisputed Rāṣṭrakūṭa foundation. Armlets are no longer spiral, as in Kalachuri sculpture, or of pearls, as worn by many Gupta and post-Gupta figures, but kīrttimukhas, an eighth-century innovation from further south. Figures sprout additional arms, and their poses are more dynamic, when not simply theatrical in a vain attempt to compensate for weakness of composition. Typical is the Narasimha with, standing beside him, a Hiraṇyakaśipu of equal size, his head thrown back and sideways in a distorted Rāṣṭrakūṭa pose.

The great Kailāsa temple (No. 16) at Ellorā, together with three other, much smaller

shrines, is of a totally different type: a mono-lithic replica of a structural temple. These, however, constitute the northernmost examples of the genuine Drāviḍa style, and their sculpture reflects that of areas further south in the Deccan rather than of Mahārāṣtra and the Konkan. They will therefore be con-sidered elsewhere.[18] There are rock-cut repli-cas of northern-type temples at Dhamnar in Madhya Pradesh and at Masrur in Kangra.[19]

WESTERN INDIA AND MADHYA PRADESH

With three or four exceptions, all the surviving Gupta temples are in Madhya Pradesh.[1] The several score remaining from the post-Gupta period, on the other hand, are scattered over an area extending from the Indian desert in the west to Bihār in the east, between the Jumna (Yamunā) and the Narmada, and including the present states of Gujarāt, Rājasthān, Madhya Pradesh, and Bihār. The greatest concentration is towards the centre, in Mālwā, the ancient Mālava.[2] In spite of this diffusion and an innovative and experimental style, they tend to share the same themes and inspiration. The larger temples are very few, and not one remains in its original form. Time has taken a heavy toll. Much work remains to be done, particularly on sculpture, but in recent years a group of intellectually adventurous and highly competent scholars have made it possible for the first time to follow in some detail the most fascinating of all the stages in the development of the Indian temple.[3] Although it does not reach its supreme expression until the following period, it is now that all the foundations for that achievement were laid. Sculpture is still imbued with much of the vigour and sensuality of Gupta times, with an added element of baroque exaggeration, while the actual fabric of the temple lends itself more and more to sculptural treatment. Highly experimental, varied, rich and even florid, sometimes disordered, the temple architecture, and to a lesser extent the sculpture, of the post-Gupta period is the most exciting in all of Indian art, and in western India and Madhya Pradesh it can still be seen in relative abundance.

A number of curious and usually small shrines in Saurāṣṭra, in the south-west corner of Gujarāt, may include the oldest surviving structures in western India – unless (as suggested by their comparative isolation) they are later than they appear, with fossilized relics of earlier forms of superstructure not preserved elsewhere.[4] They are largely bhūmiprāsādas, slightly pyramidal, with tiers of kapotas representing storeys and a bewildering assortment of other elements: at the corners, small square pavilions, usually in the southern form, alternate with āmalakas, and sometimes the superstructure is topped by a Drāviḍa śikhara.[5] Gavākṣas, simple, unadorned, and of a size and boldness quite unknown at the time elsewhere in India, give these temples a marked individuality, although the general effect of their plain walls, without niches or articulation and with little or no carving, is rather severe. In at least two temples (Nos. 2 and 5 at Bhānasarā) the superstructures are more Drāviḍa (southern) than Nāgara (northern); furthermore, sanctums and hall are almost always enclosed by a single rectangular wall, even where there is a more conventional Nāgara superstructure. When one recalls such ground plans in Early Western Cālukya temples, and their corresponding mixture of styles, together with the fact that there are at least two bhūmiprāsādas at Aihole and practically nowhere else except in Saurāṣṭra, some exceptional contact between these two quite widely separated regions seems highly likely, particularly as there were political links.[6] Few of the more idiosyncratic features of these shrines survive or leave any permanent mark on the dominant style of western India; the exception is the *phāṁsanā* (wedge-shaped) roof.

The temple at Gop, although partly in ruins, is by far the finest as well as the best known of these shrines, a reminder of what must have been the architectural glories of the totally vanished Valabhī, the capital of the region during the sixth, seventh, and eighth cen-

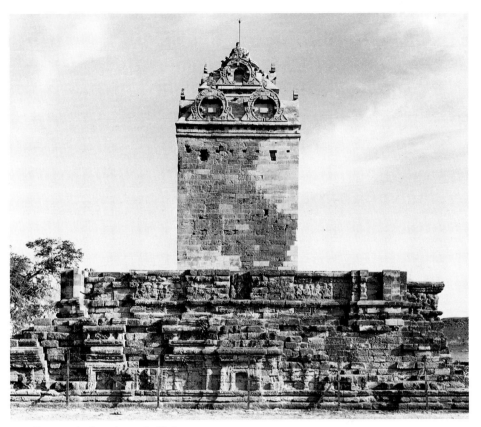

104. Gop, temple, from the south. Sixth century

turies and historically a place of considerable importance [104]. The temple stands on a large jagatī with projections housing niches, itself on a high base and surmounted by a double set of mouldings with a dado between them. The temple is oriented towards the east, where the platform is extended to accommodate two opposed flights of steps each beginning – perhaps for the first time outside Āndhra and Sri Lanka – with a semicircular projection or 'moonstone' (ardhacandra). The temple itself is sāndhāra, i.e. with an internal circumambulatory passage around the inner sanctum. There are three projections on a side, contain-

ing niches. A frieze of gaṇas is another Early Western Cālukya feature. The entrance appears to have been plain. The external walls are missing from a course above the frieze, and one can only conjecture how the pradakṣiṇapatha's roof was joined to the centre, now towering starkly like a medieval European castle keep. Its unique and extremely elegant superstructure, consisting of two sloping rectilinear roofs superimposed, the lower bearing two enormous gavākṣas to a side, the upper one a single one, is the earliest example of a phāṁsanā roof. It is surmounted by a finial (cūḍa) shaped like a bell (ghaṇṭā), not by an āmalaka –

an important distinction. The gavākṣas are actual hollow dormers in which stone images, not reliefs, were placed – interesting, because, except where they figure as the section of a barrel roof or of a projection in front of the tower (śukanāsa), gavākṣas, which proliferate on the temples of India, are normally shallow and to be measured in inches. The twice repeated rectilinear pent-roof is to be found in Kashmir temples of the eighth and subsequent centuries (e.g. Pāndrenthān).[7] The phāṃsanā roof disappears henceforth from main shrines except in Kashmir and certain Himālayan regions, although it persists over large halls in western India and Madhya Pradesh. Not dissimilar, however, are the superstructures of later maṇḍapas in North India and Orissa and the low elevations of some shrines in Karṇāṭaka where the serried ranks of eaves seem to derive from the widely separated kapotas of the bhūmiprāsāda.[8]

What little sculpture remains at Gop consists of a Viṣṇu and a Skanda, two door guardians, a Rāma, and a seated woman in one of the gavākṣas of the roof (a Gaṇapati has disappeared). The style suggests a late-sixth-century date and, as with some of the other temples, a link with the Early Western Cālukyas.

A group of small unicellular temples scattered to the east and west of the Betwa in central Madhya Pradesh can be assigned to around the seventh century. Many are of partly megalithic construction, with great flat slabs for base mouldings, individual upright ones for pilasters and the intervening walls, and single slabs for the roofs. Crude little dolmenoid shrines can be seen in India wherever stone is plentiful, and it has rightly been stressed that there is a conceptual relationship between them and the garbhagṛha, essentially a cube, its interior unlit and undecorated. However a wooden conception, the maṇḍapikā, a flat-roofed pillared pavilion, probably lies at the root of these little temples.[9] Most are now flat-roofed, but it seems likely that some originally had 'northern' śikharas, as witness

two very similar shrines of megalithic construction (Nos. 14 and 15) standing side by side at Bateśvar, one with a śikhara, the other without and thus 'flat-roofed'.[10] Built on a monolithic slab, not bonded in any way to the lower part of the shrines, the śikharas are tottery and easily dismantled.

These temples, almost invariably preceded by a simple two-columned porch, are exceptional. Although constructed of single blocks or sheets of stone, their bases, walls, and pilasters are shaped and carved in a somewhat provincial variant of the contemporary style, so as to be indistinguishable from those of ashlar masonry temples. The earliest, such as Mahua Temple 2 and the Mahādeva at Ladhaura [105], have columns and pilasters with interrupted shafts and little corner pendentives, sometimes plain, sometimes with large lotus medallions in the Vākāṭaka style, soon to be replaced by the typical post-Gupta pillar and pilaster with a pot and foliage both as capital and base. First in the latest Ajantā caves and then at Deogarh No. 3, and widely thereafter, a second capital or abacus with fan-palm leaves appears. At most, these little shrines have a single niche in the middle of each wall, at first surmounted by a single gavākṣa, then with two or three more superimposed. Perhaps the most advanced of these temples is the Kuraiya Bir at Deogarh, which, besides being roughly pañcaratha, i.e. having a central projection flanked on each side by a lesser projection, has a central niche shaded by a stone awning or chādya and for the first time topped by the well-nigh universal post-Gupta pediment, the honeycomb of gavākṣas.[11] The extraordinary shrine built on the flat roof of the Kuraiya Bir, with its little pillared porches on all four sides and its plainly contemporary śikhara, shows what fanciful superstructures could, and on occasion actually did, rear themselves over what appear to be flat-roofed temples.[12]

The Śiva temple at Kusumā, west of Mount Abu, now known as the Rāmacandraji, is still a work of great substance and beauty, despite much rebuilding in recent years. Probably

105. Ladhaura, Mahādeva temple. Seventh century

dated 636-7, and thus almost exactly contemporary with the Meguti at Aihole (634), it is one of only three important temples in western India, apart from Saurāṣṭra, which unquestionably belong to the seventh century or the early eighth.[13] Within its rectangular overall plan is included a sanctum (now completely rebuilt), amply lit by elongated openings on the three sides of the enclosing wall, a hall with four central pillars, and one surviving ceiling over the first bay, the first of those elaborately cusped and vaulted ceilings of the *utkṣipta* type which will become one of the great glories of western India, and particularly Gujarāt.[14] Here and here alone are the wooden origins of the type betrayed. Except for the two curious internal sub-shrines facing each other on each side of the maṇḍapa, with pillared porches and elaborate split gavākṣa pediments where for the first time the lotus-diamond (*puṣparatna*) and half-diamond (*ardharatna*) motifs appear, the plan is identical to that of the Cikki temple at Aihole.[15] Other striking affinities with Early Western Cāḷukya temples of the seventh and eighth centuries include the central pillars

with brackets supported by the projecting busts of youthful figures (*kumāras*) and the elevated figured clerestory of the central nave. The doorway to the shrine, now alas dismantled and replaced but fortunately recorded, was one of the finest in India, with a pediment of unique size and conception, its amply figured divinities in the purest and most moving early post-Gupta style.[16] The principal gods are Brahmā, Viṣṇu, and Lakulīśa (Śiva), the first of the rows of deities displayed on the lintels of sanctum doors of later temples. The fine Sadāśiva is the earliest in western India.[17]

Unfortunately, only the lower portion, much of it completely disfigured, remains of the original structure of the Sitaleśvara temple, on the little Candrabhaga, together with some sculpture, no longer *in situ*. The date of 689 is not universally accepted,[18] but the shrine is indisputably seventh-century and thus a precious document of architectural history, situated as it is near Jhālrāpāṭan and the upper tributaries of the Chambal on the borders of Rājasthān and western Madhya Pradesh.

In the more numerous temples of the eighth and ninth centuries, the common features of the post-Gupta style in western India and Madhya Pradesh emerge.[19] The superstructure of the shrine proper almost invariably consists of a northern or Nāgara tower of the simple or Latina type, i.e. without the agglutination of smaller śikharas which is such a dominant aspect of the larger temples of the following period.[20] On the front of the superstructure is a large, roughly triangular projection (śukanāsa or nāsika), sometimes containing a niche but always essentially shaped as, or dominated by, a large gavākṣa. In small shrines, it often projects over the porch; in larger ones it usually extends over a vestibule (ardhamaṇḍapa or antarāla). The śikhara itself is always crowned by a large āmalaka surmounted by a (usually missing) pot and finial. The surface of the tower is a mesh of gavākṣas in superimposed rows punctuated by āmalakas set into the corners and sometimes at those of the central offset as well. All these features are common everywhere, including Orissa and Karnāṭaka. Rare on the other hand are rectangular sanctuaries terminating in a barrel roof, called a Valabhī in the west. The main shrines in the larger temples have an internal circumambulatory, rarely lit by windows but frequently with open balconies [106]. Shrines grouped in a quincunx (pañcāyatana) occur, each preceded by a small porch. In the larger temples, more frequently in the western part of the region, maṇḍapas, both closed and open, appear between main shrine and porch, their roofs either of the phāṃsanā or of the saṃvaraṇā type, another low domical form, with siṃhakarṇas (large triangular pediments usually composed of gavākṣas) on three sides above the cornice.

The bases, soon elaborated, are of a pattern found all over India. A vertical element, rounded at the top (kumbha or khura), takes the place of the right-angled plinth (jagatī) of South India. Above are two or more mouldings, one invariably a kapota; in between, serried rows of decorated square bosses, originally

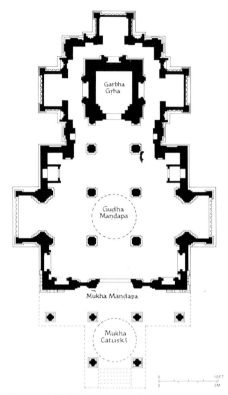

106. Osian, Mahāvīra temple, plan. Eighth century, last quarter

rafter ends, usually replace the ubiquitous kumuda (semicircular moulding), here called a kalaśa (stone jar), round or octagonal in section, of South India. In all but the smallest and simplest shrines the wall surfaces are broken up into and by vertical elements, chiefly the projections (bhadras) which carry all the way up the tower to the seat of the top āmalaka. The shrine with a single central projection per wall is known as triratha, with a subsidiary offset on each side pañcaratha; these are basic distinctions in the elaboration of the temple fabric. There may be only one central niche, or there may be one on either side as well, or, in a pañcaratha shrine, two. Entire sections of

wall may be pilastered, but never – as usually happens in Tamilnāḍu – are the projections, often more varied on plan and alternating with bays, framed by pilasters at the corners. The cornice consists of a kapota, often two. Figures or narrative scenes in relief are almost absent from the walls.

Image niches and their pediments, carved ceilings (particularly in the west), pillars and pilasters, all become more and more ornate, although the structure and the symbolic significance originating in the Gupta period are constantly recalled. The pillar with a pot and foliage at the base and another for capital, and the pilasters modelled upon it, is virtually the hallmark of the post-Gupta style. The capital or abacus with pendant fan-palms[21] at the corners is not a particularly successful development, for it seems too closely modelled on the pot and foliage. Sections of pillars are often ribbed, and sub-bases appear, some with miniature niches. Flat pilasters framing niches often yield to a new kind of pillar, thin, round, with a notched ring at mid-height and a little ribbed capital, and all but free-standing, supporting as they do a little stone chādya, coffered or ribbed. The pediments evolve from stretched or split gavākṣas into an elaborate honeycomb of little gavākṣas, tier upon tier – one of the most distinctive and ubiquitous creations of the post-Gupta period.

The post-Gupta repertory of mouldings and bands (particularly of alternating triangles) can be seen over the entire region, though narrative friezes appear to be confined to the west.[22] Looped garlands under the cornice framing bells or half-rosettes sometimes give way to interlooped garlands. Half-rosettes rather than birds inhabit the gavākṣas along the lower edge of the base kapota.

Doorways, even in very small shrines, grow increasingly elaborate, though essentially based on Gupta models and using Gupta elements, all in a single plane. At the foot on either side stand the river-goddesses, usually escorted by attendants, with a door-guardian [107]. The doorway is flanked by super-imposed panels with mithunas or other human figures, usually with pilasters on either side, and framed overall by five or six mouldings. New is a plaited band perhaps representing the tails of serpents. None of these mouldings can compare with the laterally cut vegetal Gupta ones or the fan-palm band. The sill, with lions and other motifs on its raised outer edge, is usually preceded by a moonstone. The chief innovations, however, consist of the ever-present bimba-lalāṭa, frequently Garuḍa, a diminutive figure half suspended from the middle of the lintel, and the general overloading at the top with divinities of all sorts, usually in niches and pavilions. With so much detail, the doorways often seem merely fussy, but their bases can offer some of the most beautiful figure groups in all Indian sculpture [107].

A nexus of temples in Rājasthān (Mārwār and Mewār), mostly well preserved, provides an ample view of the style in western India between c.750 and 850 or slightly later.[23] At Osiaṅ, upwards of a dozen temples remain. The diverse group of smaller ones below the hill and outside the town, mostly free from later accretions, stand on high platforms bearing niches. Harihara No. 1, from its style probably one of the oldest, is pañcāyatana.[24] Characteristic are the five wall-projections each containing a niche framed by flat pilasters, except for the central one, which already shows a post-Gupta tendency to be treated as a door, with figures at the base on each side and a frame of continuous mouldings. In Harihara No. 2, also originally pañcāyatana but with the subsidiary shrines missing, an open hall occupies the rest of the platform, partially enclosed by bench seats with sloping backs (kakṣāsana). Harihara No. 3 has an even larger open hall with an unusual domed roof of large curved slabs side by side, leaving at the top a large square aperture closed by three rectangular slabs. There was a rectangular sanctum, and almost certainly a phāṁsanā roof.[25] Full-height pillars occupy the centre of the open hall of the first of these temples; much shorter ones rest on the

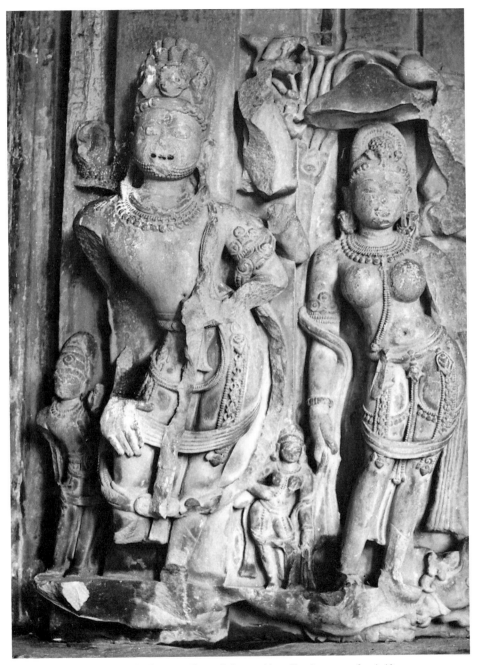

107. Baroli, Ghaṭeśvara temple, door-guardian and river-goddess. Tenth century, first half

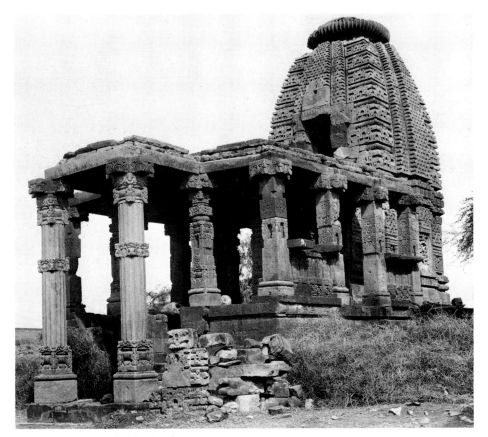

108. Osiaṅ, Sūrya temple (No. 7). *c.* 800

bench seats. In the second, the outer pillars also extend to the floor of the hall. In both temples elephant protomes project at the base of the seat backs. Temples 1, 2, and 3 have fine Kṛṣṇalīla friezes between the two kapotas of the *varaṇḍikā* or complex cornice.[26] The post-Gupta ceilings at Osiaṅ are of the *samatala* type, all in one plane and divided into quadrangular compartments, often with a large circular medallion in the centre.

In the fine Sūrya temple (No. 7) two extended porch pillars, perhaps slightly later, reach down to ground level while the rest of the structure stands on a high platform [108].

That the hall, now open except for a stretch on the south side, was originally partially enclosed, like Harihara No. 3, can be inferred by the mortise holes on the outsides of the pillars, now filled by elephant heads. Sūrya is also unusual in having an ardhamaṇḍapa with an external niche on each side incorporated into the shrine, so that on each side there are two niches on one side of the central one (a fine example of niche-cum-doorway) and three on the other.[27] The space between the two kapotas of the cornice is occupied by decorated square 'beam-ends', a typical post-Gupta motif.

The Jain Mahāvīra temple, on the western side of the town, is a thriving place of worship in contrast to the abandoned and sometimes misused temples just considered. It has paid the price in terms of a later śikhara and associated buildings, but the original part, considerably restored, belongs to the last quarter of the eighth century.[28] It is sāndhāra, with a closed maṇḍapa, an open front hall, and a porch.[29] Balconied openings on each side of the closed hall as well as on the side and back of the shrine proper are all fitted with early stone grille windows (jālas). Inside are numerous niches, including three (empty) around the sanctum, and two small shrines. Hall and porch have fine phāṁsanā roofs. What can be seen of the much restored base mouldings and wall fabric accords with the style of the temples outside the town, especially Sūrya (No. 7). The Saciyā Mātā temple, an even more renowned place of worship than the Mahāvīra and of approximately the same date, has suffered a similar fate. The small Sūrya shrine on its proper left, with a ruined śikhara, may, however, on stylistic grounds, be the oldest structure in Osiaṅ. The platform on which the temple rests has the finest 'wave' band or frieze of any at the site. This motif, although in the purest post-Gupta spirit, does not appear to have been reported anywhere else, and neither does a new type of niche on the Pipla Devī temple (from other aspects of style probably the latest at Osiaṅ), with slender round pillars or pilasters bearing a median notched ring and usually a simple ribbed padma (lotus) capital.[30]

Temples in the same region, at Bhumdana, Lamba, and Bhavanipura [109], closely resemble the Osiaṅ temples in style.[31] Lest too much emphasis be placed on a regional style, however, it is well to remember that they are not very different from the temple at Baijnath, on the longitude of Allahabad, some 540 miles (860 km.) to the east.[32] Moreover the temples at Buchkala, relatively near by, more closely resemble those at Roḍā, on the borders of Gujarāt, with their squat little niches with low pediments, and very few of them at that.[33]

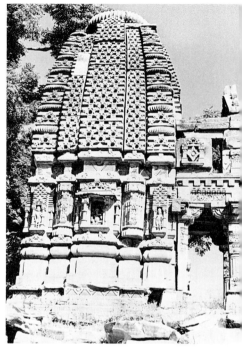

109. Bhavanipura, Nakti Mātā temple. Ninth century

Further, one of the subsidiary shrines of Harihara No. 1 at Osiaṅ has pilasters instead of niches beside the central niche, and, strangest of all, full-sized figures of apsarases (heavenly girls) between the pilasters, a fashion mostly associated with Madhya Pradesh a century or more later.

At Chitor (Cittauḍ), Mewār's ancient place forte, at least one temple, the Kṣemankarī, next to the Kālikā Mātā, is almost a replica of the temple at Bhavanipura near Osiaṅ, with similar laminated pilasters instead of niches on either side of the central bhadra. All the niches have round ringed pillars and stone awnings over them. Like Osiaṅ, Chitor has two large post-Gupta sāndhāra foundations, also much altered and added to. The Kumbhaśyāma, from its style, is probably coeval with the Kālikā Mātā, which is generally thought to belong to the

second quarter of the eighth century.[34] If so, the new kind of niche appears here at least three quarters of a century earlier than at Osian.

The iconography of these temples is richer than elsewhere in western India because of the greater number of niches on the main shrine. On each of the three sides of Harihara No. 1 at Osian, the two niches on either side of the central one are occupied by *dikpālas*, the guardians or regents of the directions, supplemented by Ganeśa and Durgā. In the central niches are Trivikrama and Narasimha, with Harihara at the rear, the position usually occupied by the divinity to which the temple is dedicated. It is here that Sūrya, a major deity in Rājasthān, is enshrined in the Sūrya (No. 7) temple, in which only a few of the dikpālas are represented, their places being taken by other mūrtis. As could be expected relatively close to the original grounds of theistic Vaisnavism,

Keśava, Vāsudeva, and particularly Balarāma, figure frequently, and so does Revanta, on his horse.[35] A Buddha in one of the niches of Harihara No. 1 is much cited as evidence that already by this time he was considered an incarnation of Visnu.

A group of small temples at Rodā in northernmost Gujarāt belongs to the late eighth century.[36] Roughly contemporary with the Osian temples, they are noticeably different in style.[37] Small and *nirandhāra* (without an internal circumambulatory) for the most part (I, IV, and VI are only triratha), even the pañcaratha ones (III, V, and VII) have but a single niche to a side, and only No. I stands on a platform. Their front porches are surmounted by telescoping versions of śukanāsas, triangular, although decorated with gavākṣas. The side is treated like a two-tier phāmsanā roof, with unusually large gavākṣas, echoing, at a

110. Rodā, Temple VII. Late eighth century

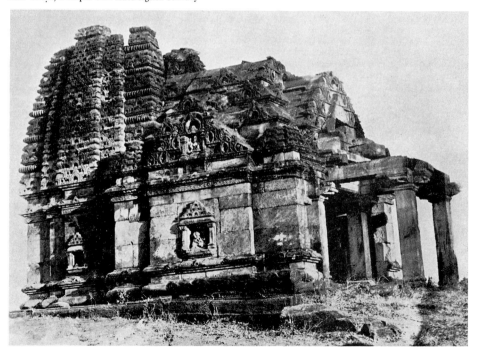

111. Śāmalājī, Nīlakaṇṭha Mahādeva temple, Viśvarūpa. Early seventh century

considerable chronological remove, some of the earlier temples in Saurāṣtra. On the one temple (VII) to have a closed hall as well as a porch there is a far-projecting śukanāsa, with double telescoping over the remainder of the hall, and then again over the porch [110].[38] On the sides, a three-tiered phāṁsanā extends down to where a siṁhakarṇa tops the projecting bhadra of the closed hall, flanked by two small corner śikharas. This rather confused arrangement gives a foretaste of later maṇḍapa roofs.

The general impression of these temples is of squatness, the śikharas low and overpoweringly massive, their successive tiers unrelieved by the alternation of larger and smaller gavākṣas as at Osiaṅ. The mesh of the same elements over the rare niches is also disproportionately small and squat, as are the niches themselves.[39] In the same region, the Hariścandranī Cori at Śāmalājī has an open balconied maṇḍapa, with the usual half-walls and pillars, which extend to the porch. The hall had a phāṁsanā-type roof.

At Temple III at Roḍā the bhadras on either side of the central one are treated as pilasters, the ribbing at the very top continuing not to a vase and foliage capital but to one essentially more akin to the Deccani cushion type [93] which forms an alternative on columns and pilasters in the 'southern' post-Gupta style in western India and in the Later Hindu period. On the fine doorway of Temple III are two bands of superimposed vyālas, an animal which flanks niches at Chitor and Ābānerī (see below), and floral diamonds as well as the deeply cut but essentially flat vegetal motifs which will be such a feature of later temples. The usual five deities are enshrined above the lintel in high-relief niches surmounted by low śikharas.

Probably built in the late ninth century, the white marble Brahmānasvāmi temple at Varman, in the same general locality as the earlier temple at Kusumā, already shows considerable complexity of plan and other features heralding later developments.[40] There are external projecting balconies, and a much more complex ceiling of the kṣipta type, with a central

pendant, than at Kusumā. On the base, a band of lion masks, called a grāsapaṭṭikā in western India, marks the early appearance of what will become one of the most common of all motifs. Obviously the successor to the widely spaced lion heads above the lintels of some late Gupta temples, in fairly high relief and probably harking back to rafter ends, nothing marks more strikingly the transformation in the aesthetic of the northern architectural style than their transmutation into flat linear masks lined up as tangential circles to form one more kind of decorative band.

Sculpture presents a confused picture, bedevilled partly by the uncertain date of the important works from Śāmalājī.[41] All that can be said is that fine images and relief figures on

112. Viśvarūpa from Kanauj. Ninth century.
Kanauj, private collection

pillars and doorways in a recognizable post-Gupta style are known. Outstanding is the great Viṣṇu Viśvarūpa stele from Śāmalājī [111]. No other Indian image incorporates so many and complex religious and metaphysical concepts as this three-headed (three-faced) seated figure with its swarm of emanatory and attendant figures constituting a unified and complex theogony. They are of considerable beauty, full of plastic vigour, and not mere assemblages of iconographically significant forms and symbols.[42] The Śāmalājī Viśvarūpa represents the final triumphant climax of the creative phase of Hindu iconography. Another impressive Viśvarūpa, in a private collection, comes from Kanauj [112].

Most of the finest sculpture is probably a little later in date. The dressing of the hair of the fine Mother and Child (a favourite theme of the region) from 'Koṭyarka'[43] recurs in the early post-Gupta period all the way to Orissa, at Ellorā, and as far south as Aihole. A Śaiva dvārapāla, also from Śāmalājī, in the same style is in the Prince of Wales Museum, Bombay.[44]

Quite a few brass images have been found, notably in Jain hoards from Akotā and Vasantagadh.[45] Among the earlier ones the *camaradhārinī*, a female attendant bearing a yaktail flywhisk, a symbol of royalty, from Akotā shows the sensuous modelling of which the sculptor was capable when freed from the constraint of portraying Jinas in their rigid poses. The two dated Pārśvanāthas from Vasantagadh (669 and 699) are as fine as anything of their kind, elaborate compositions with thrones, surrounds, and a multitude of subordinate figures where the bronzecaster again has free rein. Eyes and other features, such as the nipples or the *śrīvatsa* in the middle of the chest, are often inlaid in silver. The *śrīvatsa* is an ancient Indian sign or symbol, like the svastika, whose outline is composed of two opposed letter Ss. As the centuries pass, they are more and more liberally inscribed, a characteristic of Jain works of art in western India.

The mid-ninth-century Kāmeśvara at Auwā (Pāli District, Rājasthān) is exceptional in having a rectangular sanctum and yet being surmounted not by a *śālā* (a barrel roof, which is all but unknown in Rājasthān) but by a kind of phāṁsanā roof with high triangular pediments superimposed on each side and two little staggered śikharas, one above the other, at each corner.[46] Otherwise, the Kāmeśvara, its open hall topped by a bell-like dome, differs little from pañcaratha temples at Osiān, except for the splendidly delicate gavākṣa motifs, with little grace notes in the form of ribands, knots, and rosettes. These are even more characteristic of what little remains of the Harṣat Mātā at Ābānerī, famous for its sculpture.[47] Niches flanked by twin colonnettes, doubly ringed and supported by vyālas in pairs (single beasts in that position are already known from the Kumbhaśyāma at Chitor), are typical of the almost rococo quality here. Auwā and Ābānerī are two of the northernmost temples of Rājasthān and must have been stylistically linked to the vanished temples of the Panjab and the western Uttar Pradesh to the north. That they are also close to the temples of Osiān and Chitor suggests a relation between all three areas although, given the greater Gupta penetration of the Panjab, there is reason to believe that the lost temples were more advanced in style.[48]

Some figures at Osiān tend to be squat, with a marked folk element. Others of solid plastic form with a vibrant if heavy rhythmic quality include the two large women standing in *tribhaṅga* (the triple-flexed position of the body) on the half-pillars on either side of the doorway of the Sūrya temple (No. 7). Over one of them hangs a large campaniform lotus-leaf parasol of honour – a cliché of sculpture in western India and Madhya Pradesh at this period. Compare the figures similarly carved against pillars in the Rājiva-Locana temple at Rājjim:[49] the greater angularity of pose and the tauter and more nervous plastic sense would place the Osiān sculptures stylistically (and probably historically) later, but the similarity in general artistic conception and feeling to Rājjim seven hundred miles to the east leaves no doubt that they belong to the same time and artistic

113. Ābānerī, Harṣat Mātā temple, niche figures. Ninth century

climate. Another and very different strain of slender figures of great sophistication of dress and gesture, often in exaggerated poses, is evident on some of the doorways at Roḍā, on a couple of loose fragments, probably from a toraṇa, formerly in front of the great Śiva at Mandasor, and, at its most full-flavoured, at Ābānerī [113 and 114].[50]

114. Ardhanarī from the Harṣat Mātā temple, Ābānerī. Ninth century. *Mahārāja of Jaipur*

A group of temples at Baroli (Baḍoli), beside the Chambal, are finely proportioned but rather austere because of the almost total absence of external niches and the plainness of pillars and pilasters.[51] They were built over two centuries, beginning in the mid ninth. The earliest have brick śikharas. Little heart- or leaf-shaped pendants beneath a moulding make an early appearance; so do kapotas with gavākṣas flanked, at a considerable distance, by half-gavākṣas. In the tenth century the subordinate projections of the walls bulge into heavy pilasters, and lozenge-shaped or stellate ground plans herald the following period.[52] In the sanctum of the finest of the temples, the

Ghaṭeśvara, is an internal niche with a Pārvatī, as well as a liṅga [115]. The Mahiṣamardinī temple has a large image of that goddess similarly placed. The niches, like the rare external ones, have ringed colonnettes with ribbed padma capitals and attendant figures. The large six-columned porch of the Ghaṭeśvara, with a phāṁsanā roof, has a remarkable ceiling, the centre a version of the utkṣipta type, with the addition of groups of deities at the corners, the edges crowded with rows of over a hundred tiny figures. The doorway to the sanctum, relatively plain, is dominated by the huge lalāta biṁba, a dancing Śiva, a Viṣṇu and a Śiva on the same scale at the corners, and at the base the equally large river-goddesses shaded by lotus-leaf parasols.[53] The door-guardians, even larger, stand in exaggerated contrapposto, their exuberant vitality counterpointed by massive wreaths and jewellery of almost architectural heaviness [107]. The tension thus created is an essential element of the later post-Gupta style. High at the rear of the śikhara, more than half way to the summit, stands a *dhvajadhara* or banner-holder,[54] hands crossed to support the staff lodged in a hole cut in the stone, the first of the occasional figures which introduce a welcome note of fantasy into the austere monumentality of the śikhara. As in all such groups of temples, there is great variety. The Trimūrti has an antarāla, and, for all decoration between its base and the looped garlands beneath the cornice, a median band in relief on the central bhadra and the flanking pilasters. In the sanctum are the remains of a boldly stylized Sadāśiva.[55]

The majestic Telikā Mandir crowning the great fort at Gwalior, its front and gables unfortunately crudely restored, is the largest of the post-Gupta shrines [116]. The principal doorway is 35 ft (nearly 11 m.) high.[56] The temple is of the Valabhī type, with a deep antarāla, on a large rectangular platform. The base has a dado with relief figures of deities between pilasters. Above it is an exceptional band of leaf scrolls issuing from the tails of makaras and *haṁsas* (geese) which – together

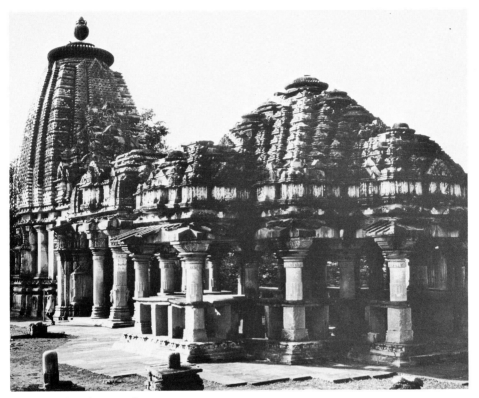

115. Baroli, Ghaṭeśvara temple.
Tenth century, first half

with other details – would seem to indicate
that the temple is no later than *c*. 750.[57]
Uniquely, the circumambulatory passage can
be entered by great doors on the sides of the
shrine and at the rear as well as in the usual
way. The temple is pañcaratha at the rear, tri-
ratha on the sides or ends, each offset occupied
by a niche, the outermost surmounted by tri-
ratha śikharas complete with śukanāsas and
āmalakas, the others by towering honeycomb
gavākṣas. Both reach up to the exceptionally
wide cornice, of six bands, including loops
with bells, one of beam ends, and two kapotas.
Above is a truncated version of a Nāgara śikhara
beneath a pair of superimposed śālās, the upper

(as appears on the cross sections at each end)
about half the size of the lower, which, except
for the openings of rock-cut caitya halls, forms
probably the largest gavākṣa in all of India. It
is instructive to note, in the elevation of this
exceptionally large shrine, how the various
elements emphasize the upward sweep of such
a high building and at the same time retain a
satisfying proportional relationship to each
other. A long row of miniature shrines extends
along the base of each of the crowning śālās.

The dilapidated Gargaj temple at Indore, a
good many miles to the south, is remarkably
similar in style to the Telikā Mandir. It has a
circular garbhagrha with twelve offsets, each

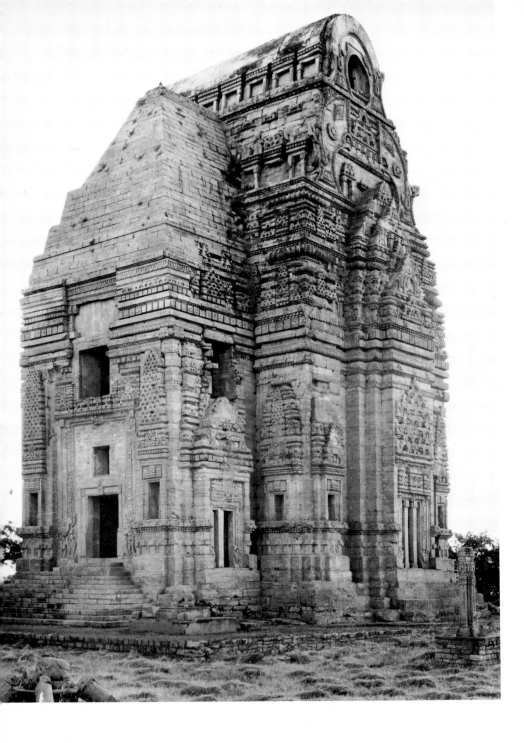

116 (opposite). Gwalior, Telikā Mandir.
c. 700–50

bearing a niche, and between them sharp an-
gled projections. Above the niches are rows of
surprisingly realistic lions' heads in exception-
ally high relief, like the occasional ones beside
the main pradakṣiṇa niches of the Kālikā Mātā
at Chitor. Other temples with circular garbha-
gṛhas survive at Candrehi (Śiva temple) and
Masaum (Rewa District), of the earlier half of
the tenth century.

Three relatively large temples in Madhya
Pradesh, the Gadarmal at Badoh (Pathārī) near
Eran and the Jaraika Mātā at Barwā Sāgar, both
partially ruined, and the Mālādevī at Gyāraspur
near Vidiśā, date from the late ninth and tenth

117. Barwā Sāgar, Jaraika Mātā temple, doorway.
Ninth century

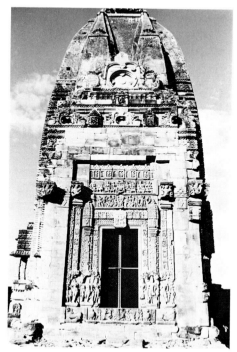

centuries.[58] The first two have rectangular
sanctums but are surmounted by massive
Nāgara śikharas. Both are sāndhāra. The smaller
Barwā Sāgar temple has a balcony on the central
offset of each wall except the rear one, and
perhaps the largest and most elaborate of
all post-Gupta doorways [117]. The Badoh
temple stands on an ornate platform sur-
rounded by seven subsidiary shrines. It has, in
addition, an open hall with elephant protomes
projecting from the outer columns, as at Osian.
The niches are shaded with ribbed stone awn-
ings. Both temples house little niches among
the base mouldings, with their own pediments,
in line with the main niches above, whose
greatly elongated gavākṣas then extend up to
the cornice, where they are continued in a dif-
ferent form by one of the rathas (projecting
elements) of the superstructure, thus giving
the effect of a single continuous buttress from
the base, or even the sub-base, up to the
crowning āmalaka. Both have heart- or leaf-
shaped pendants below some of their mould-
ings, much larger in the Gadarmal, which is
somewhat eccentric in the ordering of its sur-
face elements. The Barwā Sāgar temple, on the
other hand, presents a remarkably pure ex-
ample of the post-Gupta order, with beauti-
fully carved beam ends in the cornice.

At the Mālādevī at Gyāraspur, a Jain shrine,
the roof of a small cave is used as the roof of
the sanctum and the rear of the temple is cun-
ningly fitted into the hillside. Like the Kum-
bhaśyāma at Chitor, it is anekāṇḍaka (having
more than one śikhara). In this case there are
nine: the central tower and two small ones
staggered one above the other at each of the
corners. Peculiarities of the temple, which
probably dates from the last half of the ninth
century, include a garbhagṛha with very thin
walls (no doubt because they do not have to
support a ceiling) and an oddly placed phāṁsanā
roof to the hall. On the main offset are large
blind balconies.[59] There is an enormous dis-
parity between the niches, those on the side
projections, with decorated jambs and sills and
of great depth, being some six times the size

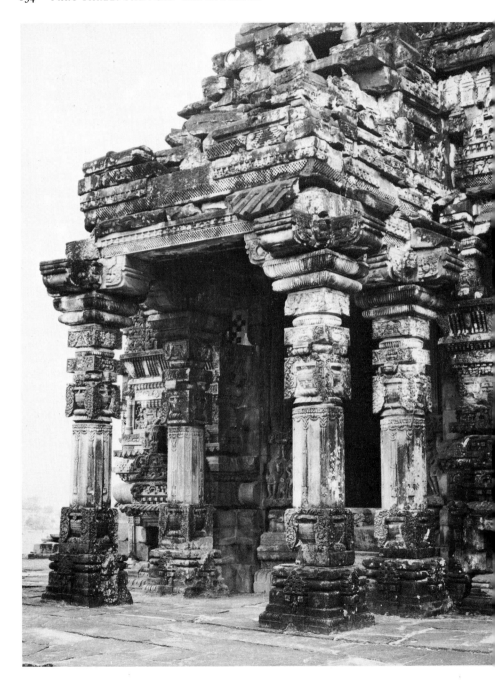

118. Gyāraspur, Mālādevī temple, porch.
Ninth century, second half

of some of the small niches with ringed colon-
nettes. The porch pillars are good examples of
the post-Gupta style at its most monumental
[118].

At least three post-Gupta temples in Ma-
dhya Pradesh have triple sanctums, side by
side.[60] In the temple at Menal, probably dat-
ing from the late eighth century, the shrines,
although very close together, and sharing an
extended common porch, are distinct units
from base to Nāgara superstructure. Even here,
however, the columns are grouped in pairs. At
the rear, the two outside shrines have a niche
in the central offset, while the two subsidiary
offsets are treated as decorated pilasters; the
central shrine, however, while similar on plan
at the rear, has perfectly plain walls there, dis-
tinguished only by a median band, as in the
Trimūrti (Temple IV) at Baroli. This serves
as a salutary reminder that differences in
temple-building modes may account for what
at first seem to be regional differences or de-
velopments in style. Perhaps as much as a cen-
tury later the three shrines of Temple No. 3
at Āmvān are built as one. The central one is
pañcaratha at the rear. The flanking shrines
have no projections but six niches each at rear
and sides, three at a corner in each group, all
with stone awnings. The cornice consists of
two cornices separated by a wide band of al-
ternating triangles. The stretch up to the base
of the three separate śikharas is as high again
as the base and walls below and in parts almost

completely ruined.[61] There appears to have
been, in part, an attempt to build a truncated
portion of śikhara, as at the Telikā Mandir, com-
mon to all three shrines. When the division
comes, the central tower is much bulkier than
the lateral ones, reversing the situation at
Menal. What remains of the fine pillars of the
shared porch is very similar to those of the
Mālādevī at Gyāraspur [118].

The Bajrā Math, also at Gyāraspur, of the
tenth century, again groups its three shrines
into a single mass.[62] Late as it is, it has several
features in common with temples of the fol-
lowing period. The central offsets at the rear
of each shrine project much further than in
older temples, have little offsets of their own,
and tend to dwarf their niches. Pendants below
mouldings become plain triangular teeth. On
some of the proper offsets, what is more,
niches are replaced by full-sized figures on the
walls themselves. Niches also start to appear
above the cornice. The main śikhara is intact.
The two flanking shrines are capped by a few
receding bhūmiprāsāda tiers stepped back from
the outer sides and hugging the central śikhara.

Other heralds of the next period to be seen
in temples assigned to the late ninth or early
tenth centuries include two superimposed re-
gisters of mūrtis, often without niches (Kad-
waha Nos. 3 and 5),[63] a profusion of vyālas and
apsarases, and a tendency to introduce new
elements, such as niches, to the śikhara, blur-
ring the clear-cut boundary with the walls and
giving an impression of haphazardness and
confusion (Ranmukheśvara at Kukurnāth,
Temple No. 2 at Surwāya).[64] Finally, the deep
but flat cutting of such details as gavākṣas,
which appears to have originated in Gujarāt,
spreads throughout the whole region.[65]

The ninth-century Caturmukha Mahādeva at
Nāchnā, known for its Gupta shrine and
remains, is one of the few surviving post-
Gupta temples from eastern Madhya Pra-
desh.[66] The śikhara is said to be later, perhaps
because the rathas end in points under the
āmalaka. In the sanctum, well lit by three stone
trellis windows, is a very fine *caturmukha*

119. Nāchnā Kutharā, Caturmukha Mahādeva, caturmukha liṅga. Ninth century

120. Naṭarāja from Ujjain. Ninth/tenth century. Gwalior, Archaeological Museum

(four-headed) liṅga [119] very similar in significance to the Sadāśiva image.[67] There are niches both above the trellis windows – a unique arrangement – and at an intermediate level, at the corner projections, housing the dikpālas. No temples from this period survive in the Gaṅgā-Yamunā Doab (although several fine doorways are preserved in the Lucknow and Allahabad museums), but there were some small ones in the sub-Himālayan regions.[68] Two important mūrtis of Śiva and his consort from Kanauj and Ajmer are distinguished alike by the exuberance of the surrounding figures and the poor proportions of the central ones.[69]

The Chauñsaṭ Yoginī shrine at Bherāghāṭ, near Jabalpur, on an old site, is one of a very few open-air temples.[70] It is mostly tenth-century, with a later shrine in the centre. The sixty-four (chauñsaṭ) goddesses, with some associated deities, are housed in eighty-one chapels forming a circle with a diameter of 115 ft (35 m.). The majority of the yoginīs bear labels, a veritable biographical dictionary of Hindu tantric goddesses. Remarkably homogeneous, their elaborate, formal, and rather stiff weightiness well illustrates the style at the end of the period in eastern Madhya Pradesh. A few dancing figures, probably originally Mātṛkās, in

red sandstone, all badly damaged, of a couple of centuries earlier closely resemble the dancing Indraṇī from Kotah and the well-known Naṭarāja from Ujjain, both now in the Archaeological Museum, Gwalior [120]. They probably approximate the post-Gupta norm. Beautifully integrated, eminently sculptural, unmannered though they are, we miss the Gupta magic, its power, its naturalism, and even its mannerisms.

ORISSA

We know almost nothing of the history of Orissa from the beginning of our era until the late sixth century. Roman and Kuṣāṇa-type coins have been found at Śiśupālgarh, which appears to have continued in occupation until the fourth century, and some yakṣa and nāga statues, usually in a very bad state of preservation, date from this era, when Orissa seems to have been outside the boundaries of ortho-dox Hinduism. Its exceptionally dislocated political history suggests that even in post-Gupta times it remained rather backward.[1] In the seventh century, however, it became one of the most important centres of architecture and sculpture, and remained so throughout post-Gupta and later Hindu times. Some of the earlier temples, never large, are among the most enchanting in India.[2] The richness of deeply cut relief sculpture emerging from the stone and covering almost the entire fabric at first bears the mark of a strong folk tradition; the inventiveness of the sculptors survives when a more sophisticated idiom takes over.

By far the largest concentration of temples is at Bhubaneswar, jostled by the modern town, clustered around the sacred lake Bin-dusarowar, and standing in the neighbouring fields. The oldest, of the late sixth or early seventh century, are probably the three little parallel shrines of the Śatrughneśvara group, mere shells, much restored. They consist only of the shrine proper (Orissa: deul) although they almost certainly once possessed front halls (Orissa: mukhaśālā or jagamohana).[3] Two char-acteristic features can be recognized: the eight, not nine, grahas (planets) in relief on the lintel of one of the sanctum doors; and the band of narrative or mythological scenes between the bāḍa, the wall area, of the shrine and the śikhara.[4] Similar bands appear in the same place on some of the temples at Osiaṅ, a strik-

ing example of features common to some of the most widely separated post-Gupta temples.

The Paraśurāmeśvara, somewhat larger and in a good state of repair, is the best known of the earliest Orissa temples.[5] Its excessively squat deul, crowned by an enormous āmalaka, and the walls of its mukhaśālā covered with sculpture in low relief lend it a slightly archaic charm [121]. A central niche projects from the walls below the spire, flanked by two smaller ones on either side, each with its own mouldings. Since they are all Śiva temples, the principal niches invariably house images of Pārvatī (here missing), Kārttikeya, and Gaṇeśa. The śikhara is pañcaratha with a boldly projecting central ele-ment on each side, widest at the front, with one large caitya window at the base below an-other bearing a dancing Śiva. All these temples, with their 'northern' śikharas, are classified in Orissa as rekha; the other type, the khākharā, has a rectangular inner sanctum crowned with a barrel-vaulted element (śālā).[6]

The rectangular mukhaśālā of the Paraśurāmeśvara, with its flat roof, raised clere-story, internal pillars, and jālas, brings to mind first-phase Early Western Cālukya maṇḍapas, except that here it is the outside walls which are richly carved while the interior is almost totally plain. The entrance on the side as well as at the end of the hall is, moreover, a unique feature, not to be repeated in later temples. Also typically early is the carving of fairly large images directly on to the walls, carrying over from one block of masonry to another - pos-sible only where the relief is relatively shallow. A further sign of an experimental stage is the apparently rather chaotic arrangement of figures and motifs, perhaps partly due to faulty anastylose (rebuilding with the original blocks of masonry). Lack of proportion rather than lack of order, moreover, seems to mark this

121. Bhubaneswar, Paraśurāmeśvara temple. Late sixth/early seventh century

rich sculptural ornamentation. The rows of figures, including the Mātṛkās with their attendants, Lakulīśa, and the rather rarely depicted Candra, seated between ridiculously short pilasters, are squashed by the towering architrave above, its outsize gavākṣas and figures not a great deal smaller than those below. Such imbalance is often associated with folk art, and there is unquestionably a strong folk element. Sometimes one senses – unless the sculptors were unusually inept – that a form is being attempted for the first time: a Gaṇeśa, for example, has a more or less human face which simply broadens out at the bottom and then turns into a trunk. The contrast between the decoration of the mukhaśālā of the Paraśurāmeśvara, with the exception of a particularly fine jāla carved with musician figures, and that of its deul, with a splendid deep-cut Kārttikeya in quite sophisticated surround, is puzzling, particularly in the light of the unsolved mystery as to why there is no architectural joining up of the two major parts of these early temples. All four façades of the deul are completely finished and the mukhaśālā connected up as a lean-to.[7]

Walls, doorways, niches, and windows are ornamented with split gavākṣas, pilasters with vase and foliage capitals (and bases), birds on the lower edges of eaves-mouldings, chequer patterns, fan-palm bands, rosettes, indeed almost the whole repertory of post-Gupta architectural decoration.[8] The lintels, however, tend to carry narrative or mythological scenes instead of beam-ends carved with lion masks, and the mouldings of the door jambs are not carried across them. The local folk flavour is particularly strong here, perhaps most noticeably in the over-use of dots (pearls?) to outline the elements. It is well, however, to remember Stella Kramrisch's words: 'None of the sculptures is architectural in the accepted sense for none enhances by its effect the function of that part which it decorates (decoration as a mere embellishment exists only by contrast with and as a supplement to naturalistic art); none of the carvings moreover is merely decorative for each has its meaning at its proper place and is an image or symbol.'[9]

Three of the earliest temples at Bhubaneswar, the Paraśurāmeśvara, the Svarnajaleśvara, and the Gaurī-Śaṅkara, have ākāśaliṅga finials instead of the usual pot shapes.[10] There is textual evidence for these 'air liṅgas' as the topmost members of śikharas. Other early temples include the Mohini, the tiny Paschimeśvara, and the Uttareśvara. The Mohini has its complete complement of pārśva devatās – accessory deities – in the main niches of the deul. The Uttareśvara, almost all its details plastered over in the course of restoration, stands in its own compound beside the Bindusarowar, with miniature shrines and a small tank. The niche sculptures, tall slender figures with noticeably small heads, are markedly different from those of the other early temples, and one authority believes that they were originally installed elsewhere.[11]

Not all the early temples are at Bhubaneswar. The temple at Kualo, north-west of Cuttack, is pañcāyatana. Some of the ancillary shrines are reasonably well preserved. A minute little Durgā temple on the Mahānādi, only

12 ft (nearly 4 m.) high, is khākharā. With their rectangular inner sanctums, these temples, in Orissa and elsewhere, are always dedicated to Devī in one form or other.[12]

The important Madhukeśvara temple at Mukhalingam in Āndhra, the ancient Kaliṅganagara and capital of the Eastern Gaṅgas, follows the Orissan tradition, although with significant differences.[13] It is larger than any of the temples noted so far, with the usual deul and columned mukhaśālā surrounded by a high-walled compound with subsidiary shrines at the corners, barrel-roofed shrines at the mid-points, and two entrance gateways. Oddly enough, while the smaller shrines follow the usual Orissa model, the central one has niche-less walls, a śikhara of perfectly plain superimposed courses with recesses between them, and a double āmalaka. The great glory of the Madhukeśvara complex is nonetheless its abundant sculpture – fine vegetal scrolls on doorways, and the mūrtis on the outside walls of the front hall. Although a certain folk element persists, Gupta echoes are clearer than in the early Bhubaneswar temples. The floridity and sheer luxuriance of the carving, no doubt abetted by the soft khondalite of which the temple is built, is of the very essence of the post-Gupta style. The most likely date is the second half of the eighth century; two smaller but fine temples at the same site are later.

To a more advanced though still early stage belong four interesting temples, three of them in the same part of Bhubaneswar. The Mārkaṇḍeśvara and the Śiśireśvara, both *rekha* deuls (western Indian: Latina type, i.e. ekāṇḍaka), are practically duplicates. The images of both principal and side niches of the deul are carved directly out of the stone of which the temple is built, a practice discontinued in later temples since any dislocation causes unsightly cracks across the surface. The base mouldings are more complex, and so is the elevation of the deul, with āmalakas at the corners, one above the other. The central ratha over the entrance projects considerably

farther, particularly the caitya windows at the base, corresponding, as in the Early Western Cālukya śukanāsi, to a vestibule between the deul and the front hall, which now has a back wall of its own. Interior pillars and side door have been abandoned. The mukhaśālā of the Mārkaṇḍeśvara is almost entirely modern, but the Śiśireśvara and the Siṅganātha, on an island in the Mahānādi some sixty miles (100 km.) upstream from Cuttack, show the ultimate development of the early rectangular front hall. At the Śiśireśvara a large mūrti takes the place of the window. At the Śiśireśvara, as at the Paraśurāmeśvara, the openings have straight cross-bars in the Gupta style, but elaborately carved and varied with kapotas. In their faithful adherence to the grille, with its echoes of the ancient vedikā, these Orissa jālas are in marked contrast to the more varied and sinuous patterns in contemporary Karnātaka. Gone is the confusion of the external walls of the Paraśurāmeśvara mukhaśālā, with its too-short pilasters. The decoration of the exterior of the Siṅganātha hall is even more elaborate, beautifully organized, in much deeper relief. A fine carved band of scenes from the Rāmāyaṇa runs along the base of the roof.

The Vaitāl deul, one of the most interesting of all Orissa temples, is in the same compound as the Śiśireśvara, to which it is related in style [122]. It is khākharā, with a rectangular sanctum. On the crowning śālā is a row of three āmalakas, each with a jar-shaped finial. For once the name of the temple (Vaitāl, having to do with vetalas, ghosts, demons, goblins, etc.) directly corresponds to a khākharā type named in one of the texts, which spells out that Vaitāla temples are for tantric (Kaula) worship of the Mothers,[14] who indeed occupy the sanctum, with Cāmuṇḍā in the central niche. The remaining images – and the Vaitāl deul is unique in Orissa in having figures carved on the inside walls of the garbhagrha – include some particularly ghoulish representations of Bhairava, a terrible form of Śiva, replete with severed heads, cups for blood-drinking, and corpses, all pointing to human sacrifice.[15]

On the other hand, on the back of the deul outside the feminine element is all seductiveness and charm. In five niches, not interrupting the base mouldings, on either side of a Śiva Ardhanārī stand the first of the full-size kanyās, the beautiful female figures looking in a mirror (darpanakanyā), tying on a scarf, putting on make-up, and so on, for which Orissan temples are famous [123]. This long façade at the rear is devoid of a central projection. Not so on the shorter sides of the deul where they surmount a larger central niche, also flanked by a pair of women on either side. The middle images are, respectively, Pārvatī and Mahiṣamardinī. The front façade, as usual, has the most prominent central projection: the upper part of the split gavākṣa adorning it contains, above, the usual dancing Śiva and, below, rather surprisingly, a Sūrya.[16] The roof, left plain according to the prescription of the Śilpa Prakāśa, the eleventh- or twelfth-century text quoted above, is in two parts; seen from the end, in section, it approximates very closely to the outline of a split caitya arch. The two pillars of the porch formed out of the lower part are in the round and surprisingly architectural for an eighth- or ninth-century temple outside South India. The front hall is exceptional in having little rehka deuls at the corners; otherwise it is quite plain (unfinished?), in contrast to the abundantly sculptured walls of the adjacent Śiśireśvara hall.

Śaivism, which was to dominate Orissa until at least the thirteenth century, dictates the iconography of the early temples. As elsewhere during the early Gupta period, the Pāśupata cult appears to have flourished, for images of Lakulīśa abound. Where he is seated (his usual pose) with his hands in the preaching mudrā (dharmacakra) and a pair of deer on the pedestal, there is obvious Buddhist influence.[17] Gaṇeśa and Kārttikeya are required deities in the principal niches of the deuls, and the dancing Śiva is the almost inevitable choice on the front of the śikhara, but most of the post-Gupta images are frequent, too. Ekapad, the one-legged Śaivite image, was unusually popular in

122 and 123. Bhubaneswar, Vaitāl deul (*opposite*), with detail of woman arranging her scarf (*below*). Late eighth century

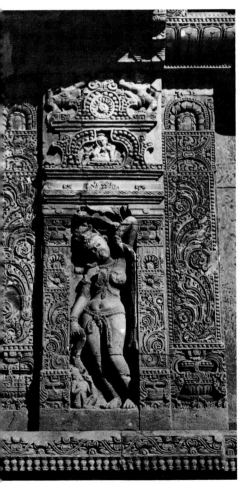

Orissa. In the earliest sculpture there is a strong folk element: figures are squat, and when (as commonly) they are seated, the legs are particularly awkward. Later, as at Khiching, they become more sophisticated, assimilating much of the post-Gupta aesthetic, and haloes tend to disappear.

The three hills of Ratnagiri, Lalitagiri, and Udayagiri (not the site of the early Jain caves near Bhubaneswar), north-east of Cuttack, bear important Buddhist remains.[18] At Ratnagiri careful excavation by the Archaeological Survey has revealed a large stūpa and two vihāras, of which the first, Monastery 1, is the finest in terms of carved stone decoration to have survived in India.[19] Originally at least two storeys high, it is of brick with abundant stone for doorways, pillars, and images. The carved stone base mouldings and niched figures of the main doorway, in the contemporary Orissa style [124], together with the entrance to the central shrine at the back of the internal courtyard, constitute some of the very finest compositions in existence[20] including the most elaborate tala-band, of which each element bears three blossoms.[21] Especially attractive is the chromatic contrast between the blue-green chlorite and the local khondalite, a garniferous gneiss with plum-coloured overtones. The original Monastery 1 is not documented, but the style of the architectural decoration and many of the figural carvings leaves no doubt that it belongs to the same time – about the eighth century – as the Vaitāl deul and the two other temples at Bhubaneswar mentioned with it.[22] There is, in fact, some evidence that the same sculptors were employed at times, demonstrating a lack of sectarian specialization. In a restoration, perhaps in the eleventh or twelfth century, true arches were constructed over the vestibules to some of the cells.[23]

The principal image of Monastery 1, constructed in courses of khondalite blocks, is Buddha seated under the bodhi tree, 11 ft 9½ in. (3·59 m.) high including the base. The other images form a notable early Mahāyāna

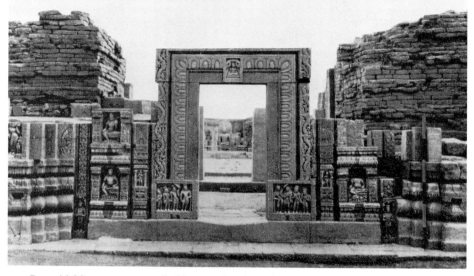

124. Ratnagiri, Monastery 1, rear wall of front porch and portal.
Late eighth century

Vajrayāna pantheon. In both chlorite and khon-
dalite, and of almost universally high quality,
doubtless for iconographic reasons they often
show a stylistic affinity to early Pāla sculpture
unknown elsewhere in Orissa.

Khiching, now remote and difficult of ac-
cess, was obviously a northern centre of some
importance. An abundance of sculpture indi-
cates that there must have been many more
than the three temples that remain, the largest
inaccurately rebuilt at the beginning of the
twentieth century. The images are unusually
large and often of exceptional beauty, tall and
slender, with gentle 'archaic' smiles, exuding
tenderness and grace. Particularly good are a
practically free-standing Mahiṣamardinī and a
seated Śiva and Pārvatī nearly 6 ft (2 m.) high.

The beautiful ninth-century khākhara Varāhī
shrine at Chaurasi belongs in most respects to
the culminating phase of the post-Gupta style
in Orissa.[24] It is pañcaratha on each of its
façades, and the tall columnar elements show
the same tendency to fragmentation by lami-
nation as some Karṇāṭaka temples of the period

[125]. Here, however, sculpture and ornament
continue to proliferate, giving a shimmering
richness of texture, baroque in its liveliness.
The mukhaśālā, one of the last on a rectangular
plan, has an elaborately decorated flat roof,
one of the friezes showing an army on the
march. The image in the sanctum is a perfectly
preserved Varāhī, her portly figure contrasting
with her elaborately carved ringlets. She holds
a fish in one hand.

The little scenes on the fabric of the temple
mostly show acts of copulation. One series
closely follows a text dealing with erotico-
religious practices. If the tantric rites associated
with the Vaitāl deul seem to have been predom-
inantly sanguinary, those of the Chaurasi
temple apparently belonged to the erotic type
associated with the Kaula Kāpālika sect.[25]

125 (*opposite*). Chaurasi,
Varāhī temple, from the west.
Ninth century

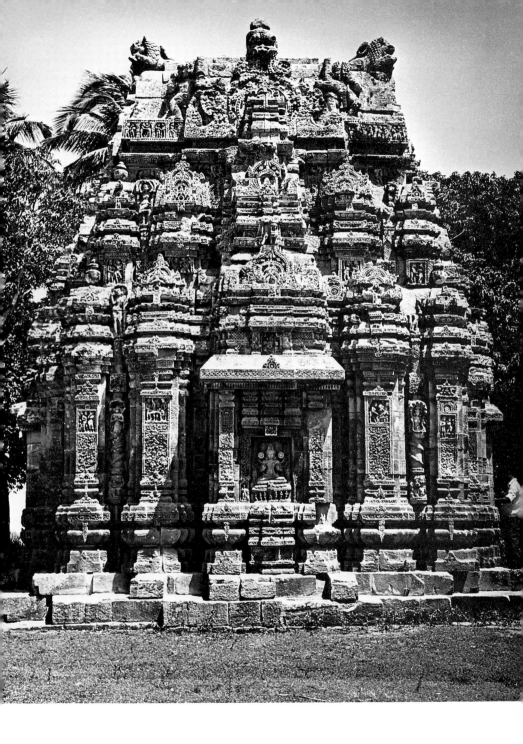

THE DECCAN, MEETING-PLACE OF NORTH AND SOUTH

In Mahārāṣtra, in the northern Deccan, the early part of the period saw intense activity in the creation and decoration of cave-shrines and monasteries, extending down as far as the cave-temples at Bādāmi and Aihole, in the northern part of the present state of Karṇātaka (see Chapter 10) west of the centre of the Deccan, sparsely watered by the Malprabhā and its tributaries but plentifully provided with excellent sandstone. This was the scene of extraordinary achievements in temple architecture in that mixture of styles henceforth to be the hallmark of Deccan architecture and sculpture, along with its unique regional elements.[1]

The handful of Gupta shrines that remain, many in a state of extreme dilapidation, nevertheless prove that a number of the characteristic features of the Indian temple had evolved by c. 550. They consist of a raised, usually rectangular platform, sometimes already with the principal shrine in the centre and subsidiary shrines at the corners, and a sanctum, almost invariably windowless and undecorated, surrounded, in larger shrines, by an enclosed ambulatory passage, often lit by stone-grilled windows to the outside, usually with an elaborately carved entrance doorway, and in some cases preceded by a pillared hall. Many of these developments can be seen in the Mahāyāna Buddhist caves at Ajantā and elsewhere; given the patronage they attracted and the extreme conservatism of Indian builders there must have been a reverse flow of influence at this time, from the rock-cut monuments to the new structural temples in stone.

Less is known about the superstructures of the early free-standing temples in brick or stone. From infrequent representations on stone reliefs and on sealings, principally the Kumrahar 'plaque' [27K], we know that many-storeyed superstructures like that of the

Mahābodhi at Bodhgayā (before its many restorations) probably existed from Kuṣāṇa times onwards. There are actual Gandhāra prototypes of one storey [51] for the shrine of the type shown on the Ghaṇṭaśāla relief, with its unmistakable Drāviḍa śikhara [27G].[2] With the exception of Bhitargaon [89], however, the superstructures of the surviving Gupta temples have either disappeared (if they existed) or are too ruinous to permit of accurate reconstruction. Some small shrines may have had two or more low courses topped by an āmalaka. Sirpur, in the seventh century, presupposes earlier forms, following the general model set by Bhitargaon (and adumbrated in the ruined Deogarh) of a fairly squat tower with slightly in-curving sides, incorporating, in highly varied ways, blind arcades, large gavākṣas (properly called candraśālās in the Gupta period), and āmalakas inset into the corners [154].

The many temples built under the Early Western Cālukyas between the end of the sixth century and the end of the eighth, which survive practically intact, provide important landmarks in the development of the Hindu temple. A few seventh- and eighth-century temples remain elsewhere in India; but only on or near the banks of the Malprabhā, in north-western Karṇātaka, however, is such an assemblage to be found, and (what is even more astonishing) only here is it possible to see side by side, and already fully developed, temples of the 'northern' Nāgara type and others in the Drāviḍa mode of South India. The Nāgara type has a 'tower' or śikhara of layer on layer of kapotas and gavākṣa courses, topped by a large āmalaka and with smaller ones inset at the corners, the Drāviḍa progressively smaller storeys surrounded by small pavilions and crowned by a dome (the 'śikhara' in southern terminology) above a narrower throat. A

third type, the Kaliṅga, not one of the major canonical ones, although later widespread throughout Karṇāṭaka and into Orissa, also appears. This incongruous juxtaposition, and the fact that a greater antiquity than now seems merited was once assigned to one of the temples, the Lāḍ Khān at Aihole, so fired the enthusiasm of some early scholars that they believed that here lay the cradle of all free-standing Indian temple architecture. However, in spite of some controversial excavation data, probably none of the temples as they stand today is earlier than the late sixth century. It is now generally accepted that the region was a meeting place of styles well on their way to development elsewhere, preserved because little or no subsequent building has taken place at these relatively isolated rural sites. Certain features of the Early Western Cālukya maṇḍapa attached to the front of the shrine proper, in conjunction with one or two of the temples, alone allow one to glimpse a fairly long period of development, a hypothesis to which the discovery of the remains of a brick pillared hall of possibly Sātavāhana date lends weight.[3] Even so, the type has partial analogues of early date elsewhere.[4]

Although traces of Buddhist activity, perhaps of the sixth century, have been found at Bādāmi and Aihole, the earliest excavated cave-temples, structural temples, and sculpture for which there is more than excavated or incidental evidence coincide with the rise to power of the Early Western Cālukyas in the mid sixth century, and are predominantly Hindu with a sprinkling of Jain monuments.[5] The first important king of the dynasty was Pulakeśin I (c. 535–66), but it was Pulakeśin II (610–42), who defeated the great Harṣa of Kanauj and captured Kāñcīpuram, the capital of the Pallavas, who extended the Cālukya dominions to include Mahārāṣṭra, the Konkan, the whole of Karṇāṭaka (later English 'Carnatic'), and perhaps even Laṭa (Gujarāt). His reign ended disastrously with the capture of most of his territory, including the capital Bādāmi, by the Pallava king. Cālukya power was soon restored,

however, by Pulakeśin's son Vikramāditya I (655–81) and continued until the middle of the eighth century.

The Early Western Cālukya temples may be divided into those of the late sixth, seventh, and probably early eighth cenutries at three different sites, Bādāmi (ancient Vātāpi), Aihole (ancient Ayyavole), and Mahākūṭa; and a 'second generation' in the following century, including some far larger than any that had gone before, at Paṭṭadakal. The categories are not absolute, and some temples at Aihole belong to the early eighth century. There are also the rock-cut Hindu and Jain temples at Bādāmi, one of them (Cave III) an art-historical landmark because, alone among the caves, it is dated (578), and the smaller but equally fine cave-temples at Aihole, all with notable sculpture.

The finest of the early 'southern' temples is the so-called Malegiṭṭi Śivālaya at Bādāmi [126].[6] Archetypally southern is the configuration of the vimāna (the shrine proper in Drāviḍa temples). Its superstructure consists of storeys (talas) with small solid pavilions forming a continuous parapet (hāra) around the central edifice, which culminates in a dome-like element, octagonal, round, or square, called a śikhara (not to be confused with the whole superstructure of a 'northern' temple). The pavilions at the corners (kosṭhas or karṇakūṭas) are square on plan, with oblong ones with barrel roofs (śālas) in between, interspersed with pañj-aras, projections topped by a large candraśālā (gavākṣa). Although both types of superstructure may occasionally accommodate an upper shrine room, the storeys or tiers are not designed to provide internal space. The elevation of the main storey reflects a strict architectural order which, although elaborated, will, in the Tamil region, remain virtually unchanged until modern times: first a square-edged plinth, then a large swelling semicircular moulding (kumuda) with a dado (kanṭha) above, surmounted by the characteristic Indian eaves moulding (kapota), and two narrow mouldings with the heads of mythical animals superimposed. Above the main walls is

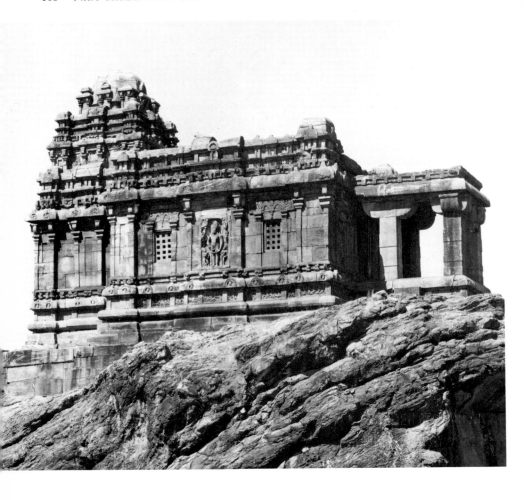

126. Bādāmi, Malegiṭṭi Śivālaya temple. Seventh century

another larger kapota in its original position as eaves, with another animal frieze, and, over the maṇḍapa as well as the main shrine, the hāra of miniature (solid) buildings. The main walls themselves are articulated in accordance with the pavilions above, with stone windows in the recesses and proper or blind niches in the projecting bays. Whether the wall is flat, or whether it is articulated into bays and recesses in what has been called the 'pilastered wall',[7] a fundamental characteristic of the 'southern style' and an obvious survival from wooden construction, it bears the slender pilasters, with their capitals and corbels, no longer of any structural significance but simply carved upon the masonry blocks, sometimes polygonal rather than rectangular, which comprise the walls. There are two large doorkeepers beside the entrance to the maṇḍapa – a 'southern' feature. On plan, the temple consists of a sanctum or vimāna, a pillared hall, and a small porch. It is notable that, as in the case of all Early Western Cālukya temples, the vimāna is narrower than the maṇḍapa.

There are three other 'southern' temples in Bādāmi, in various states of dilapidation. The famous Meguti temple at Aihole is Jain, built, according to a celebrated inscription, in 636,[8] though part of it is later. It has a curious plan, and it is impossible even to conjecture about the original superstructure. The wall fabric, however, is typically 'southern', and the bold mouldings at the base sufficiently resemble those of the Malegitti Śivālaya to indicate a similar date for both.

Nagrāl (or Nāgaral) is the only important temple not at one of the main sites.[9] Although the superstructure of its vimāna is largely in ruins, it has 'southern' features characteristic of Early Western Cālukya temples and no others. The square columns of the porch are carved with large mithuna figures. More important, the maṇḍapa has a raised clerestory and is roofed with large slabs of stone; over the joints are placed what are best described as stone logs split in two and set with the flat surface down.

From Bādāmi a pilgrim road, some of it on the sheet rock characteristic of the region, leads over the hills to Mahākūṭa, a typical *tīrtha* (holy place). A Vijayanagara-period toraṇa stands on the upland before the path dips down into a little glen between the hills where, grouped around a sacred tank fed by springs and surrounded by a wall, stand some twenty-five shrines, large and small, some with vimānas of the 'southern' type, some with 'northern'-style śikharas, and one with a Kaliṅga superstructure of the same type as the Mallikārjuna at Aihole. The two largest temples are the Mahākuteśvara and the Mallikārjuna, both intact and both of the same general type as Nagrāl, but larger and provided with statues in external niches. It was long believed that the Mahākuteśvara was the temple referred to in the famous inscription dated 601 on a pillar now in Bijapur which formerly stood outside the enclosure. The heavy whitewash masking the outside and the tastelessly modernized interior long made stylistic evaluation difficult, but now drawn elevations permit the two temples to be compared, and it seems probable that they both belong, along with the Nagrāl temple, to the third or fourth quarter of the seventh century.[10]

The third important site, with by far the greatest number of early temples, is Aihole [127], today an insignificant village. Many of the temples were used until recent times as houses or cattle byres the names of whose former owner they sometimes bear (e.g. Lāḍ Khān). Aihole's ancient prestige is witnessed however by the remains of a massive city wall and its entrances, at times complete with merlons, the only such fortification to have survived from such early times. The Meguti, already mentioned, dominates the town from a small acropolis.

A number of temples, notably Nos. 9, 12 (Tarappa Guḍi), and 14 (Huchimalligudi) [128], have 'northern' śikharas, relatively simple but fully developed, with a ratha on each side and āmalakas at intervals at the corners. On the façade, at the base of the śikhara is a

127. Aihole, plan

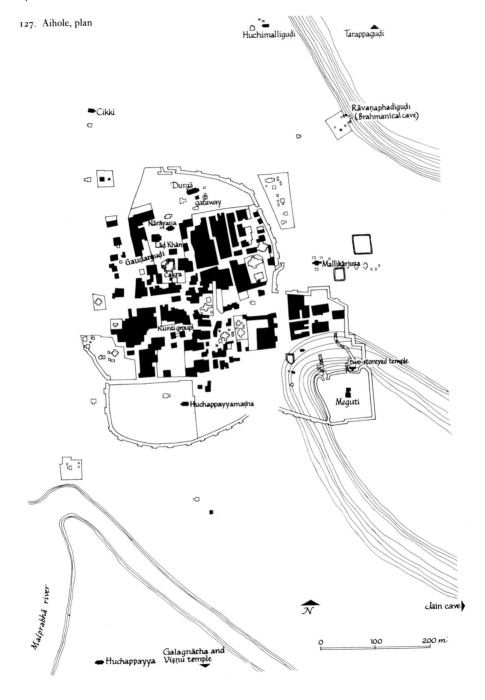

Huchimalligudi Tarappagudi

Cikki

Rāvaṇaphadigudi
(Brahmanical cave)

Durgā
gateway
Nārāyana
Lād Khān
Gaudargudi
Cakra
Mallikārjuna

Kunti group

two-storeyed temple

Huchappayyamatha

Meguti

Malprabhā river

N

Jain cave

0 100 200 m

Huchappayya Galagnātha and
Viṣṇu temple

128. Aihole, Huchimalligudi temple. Seventh/eighth century

projecting element called a nāsika or śukanāsa, and there is also a monumental gavākṣa, usually with a dancing Śiva in relief at the centre. The śikhara was crowned with a huge monolithic āmalaka, the flattish ribbed circular stone which is a characteristic of the 'northern' style. The temples are preceded by the typical Early Western Cālukya hall and porch. The hall is divided by four pillars into a nave and two aisles. Over the nave is a raised clerestory with

129. Brahmā on a ceiling slab from Aihole. Seventh century.
Bombay, Prince of Wales Museum of Western India

richly decorated sides, on occasion pierced by openings which actually admit light. The three central roofing slabs are elaborately carved with *mūrtis* (embodiments in sculpture of a god) of Viṣṇu, Śiva, and Brahmā and a host of attendant figures, some of them among the finest of Early Western Cālukya works [129]. The porches also may have ceiling slabs carved with nāgas coiled in a spiral, a motif already present in the Bādāmi cave-temples.

Significantly, however, the external walls are of plain ashlar masonry, usually pierced by small square windows with plain stone grilles but only rarely accommodating niches. They are never articulated or carved with pilasters. These features, as much as the 'northern' śikhara with which they are associated, attest to a completely different tradition from that of the 'southern' type temple, although both have accommodated themselves to the typical Early Western Cālukya ground plan and maṇḍapa. In Nos. 9 and 14, the sides of the porch are walled off at waist height, sculptured in relief on the outside and formed into benches on the inside. The inner sanctum of the Huchimalligudi (as of No. 15, the Cikki Gudi) is internal, i.e. not attached to the rear of the maṇḍapa; here the śikhara rises directly above it. Most of these temples would appear to date from the end of the seventh century and the beginning of the eighth.

It is impossible to do justice, in a small compass, to the wealth and variety of small shrines at Aihole. Some have simple 'southern' domes, others a superstructure of one or two courses topped by a dome, others again are simply small maṇḍapas with an area partitioned off for the sanctum. This abundance is not a local phenomenon: for every shrine large or important enough to find its way into art-historical books and monographs there exist a score of smaller or ruined edifices, often of considerable antiquity. Temple 73 (Mallikārjuna), in plan a conventional Early Western Cālukya temple of the 'first generation', deserves mention for its Kaliṅga-type superstructure, a succession of evenly spaced

kapotas girdling a straight-sided pyramidal tower with a large stone jar or *kalaśa* on its flat top.[11] In the immediate region are the similar Temple No. 10 at Aihole and one at Mahākūta; the nearest early parallels elsewhere are some of the early temples in Saurāṣṭra of the so-called phāṁsanā type.[12]

The famous Lāḍ Khān temple, probably originally dedicated to Sūrya-Nārāyaṇa, is one of the key buildings of the early period, although it remains problematical.[13] Except for the very large porch with its figure-bearing pillars indicating the front, the plan is that of an undifferentiated square hall, with a central square of twelve pillars supporting a raised clerestory and enclosing an inner group of four pillars [130]. A small enclosure against the back wall, now enshrining a liṅga, appears to be an afterthought, and the Nandi (bull) in the centre of the temple is also later. On the other hand, the little aedicule on the roof, to which there is no access from the interior, is original and bears reliefs of Viṣṇu and Sūrya. The heavy roof slabs, with long log-like stones over the joints, are typical of all the maṇḍapas at Aihole. The exterior is an unusual combination of 'pilastered wall' at the corners and huge structural pillars and corbels with, in between, massive ashlar masonry in level courses and large stone-grilled windows. Between the outside pillars of the porch are benches with *purṇakalaśas* (literally 'full [with foliage] vases') between miniature relief pilasters on the backs, as in the Huchimalligudi and Temple 13. These and the richly decorated interior columns and clerestory are in a style so similar to that of many other temples near by that they preclude any date earlier than the end of the sixth century; indeed the Lāḍ Khān may not be one of the earliest temples at Aihole. Recent excavations around it have revealed a previously unsuspected height to its base.

The Gaudargudi (No. 13), next to the Lāḍ Khān, has long been ignored because of the encroachment of neighbouring buildings and because the level to which the ground had risen partly obscured its most remarkable fea-

130. Aihole, Lāḍ Khān temple. Late sixth/seventh century. Plan

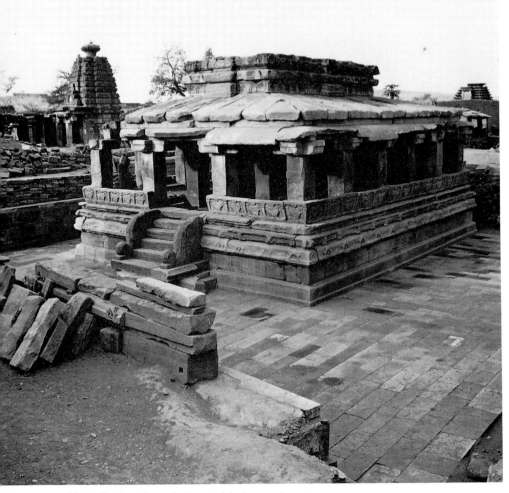

131. Aihole, Gauḍarguḍi temple. Late sixth/early seventh century

ture [131]. An early pillared hall of the type indigenous to the region, built of wood and without walls, had been postulated by Percy Brown, in a reconstruction, as the origin of the Lāḍ Khān.[14] Half-logs were used to hold down the thatched roof. The fencing of the space between the outer pillars to prevent the entry of animals serves as the backs of benches. The

Gauḍarguḍi is just such a building, except that it is rectangular and in stone, with an internal row of columns leading to the sanctum. In plan it resembles the Huchimalligudi; the difference lies in the absence of external walls, the space between the outside columns being filled with a parapet which serves as the back of benches on the inside. The garbhagṛha is

rectangular, and an inscription records that the temple, as one would expect, was dedicated to Durgā. Three low arcades of small pilasters like those on the clerestories of Early Western Cālukya maṇḍapas, surmounted by two kapotas, rise unbroken above nave and sanctum. It is difficult to imagine any further element to this rectangular superstructure. Recent excavations show the foundations of the temple to be lower than those of the adjacent Lāḍ Khān,

is apsidal-ended, like the shrines at Ter and Chezarla and the nearby Chikka Mahākuṭ, a type not very common but perennial, quite widely distributed at this time, and going back to the origins of religious architecture in India [34].[17] But whereas apsidal-ended temples are invariably surmounted by a barrel roof, rounded off at the rear as its name, *hastipṛṣṭha* or 'elephant back', implies, the Durgā is roofed in the usual flat Early Western Cālukyan man-

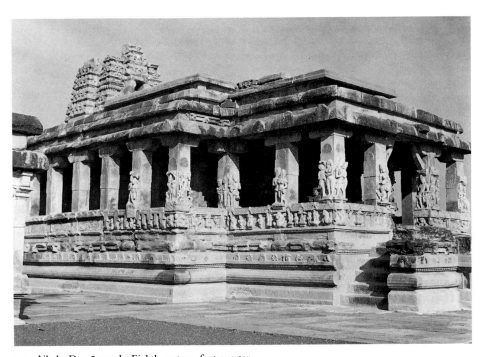

132. Aihole, Durgā temple. Eighth century, first quarter

and it has been dated to the early fifth century; on stylistic grounds, however, the present edifice cannot be earlier than the middle of the sixth, and a date in the early seventh century would seem the most appropriate.[15]

Even in an architectural milieu marked by extraordinary eclecticism, the Durgā temple stands out by its triumphant oddity [132].[16] It

ner, with a clerestory over the nave. Uniquely, over the sanctum rises a 'northern' śikhara.[18] The high base has many analogues in the region, none as ornate. The substitution for the wall of a peristyle of pillars, continuing those of the porch around the whole temple, has a precedent, moreover, in the Gauḍarguḍi. The sculptors have taken full advantage of this

arrangement, and also of the niches around the exterior of the sanctum wall, which they have filled with mūrtis, notable among them splendid images of Durgā and Śiva [133]. With its outstandingly rich sculpture, including a superb doorway and narrative friezes, the Durgā temple is the most splendid, as well as the largest, of all the 'first-generation' temples; interest-

133. Aihole, Durgā temple, Śiva.
Eighth century, first quarter

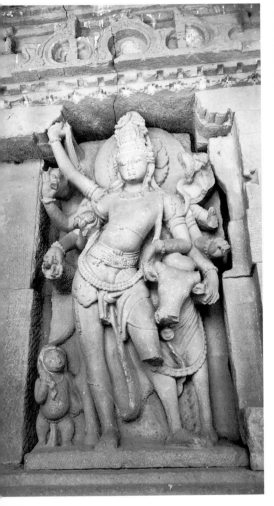

ingly, it is the only one that appears larger in real life than in photographs. The remains of its *gopura* (entrance gateway) indicate the largest known of such early date. The Durgā temple is very probably of the first quarter of the eighth century.

The four Kunti temples form a rough square.[19] They ring further changes on the basic ground plan of the Early Western Cālukya maṇḍapa temple, with one side of the rectangle turned into a pillared porch and a garbhagṛha simply built against the opposite wall. The south-east and north-west temples have mithuna pillar figures, the south-east ones similar in style to mithunas on the Durgā temple and, like them, surmounted by massive roll-moulding corbels. The temples would seem to be of about 700–750, the north-eastern shrine, the only one with a superstructure, with later features. Why the four shrines are so closely grouped, two of them linked by a four-pillar porch, is not known.[20] They may foreshadow the multiple-shrine temples (with interconnected garbhagṛhas) so popular later in Karnāṭaka. The earliest of these, the Jambuliṅga in Bādāmi (696), is, with the Meguti, the only dated 'first-generation' Early Western Cālukya temple.[21] The cruciform plan of the Jambuliṅga is forward-looking, but its sculptural decoration, notably the ceiling slabs, shows signs of archaism and declining standards.

The quite prolific sculpture of the 'first-generation' Early Western Cālukya temples is in a mixture of styles whose origins or analogues are to be found outside the region, leavened with a strong indigenous element, paralleling the architecture but with no broad correlations with it.[22] Oddly enough the two fine mūrtis of the Malegitti Śivālaya are very close to early post-Gupta sculpture in the north – basically naturalistic, yet over-sophisticated and rather blatantly assertive. Weapons and symbols are confidently individual, the attendants stylishly mannered, in the best Gupta tradition, of which the mūrtis of the Mallikārjuna at Mahākūṭa represent a debased version. A softer and quite charming early post-Gupta style marks the

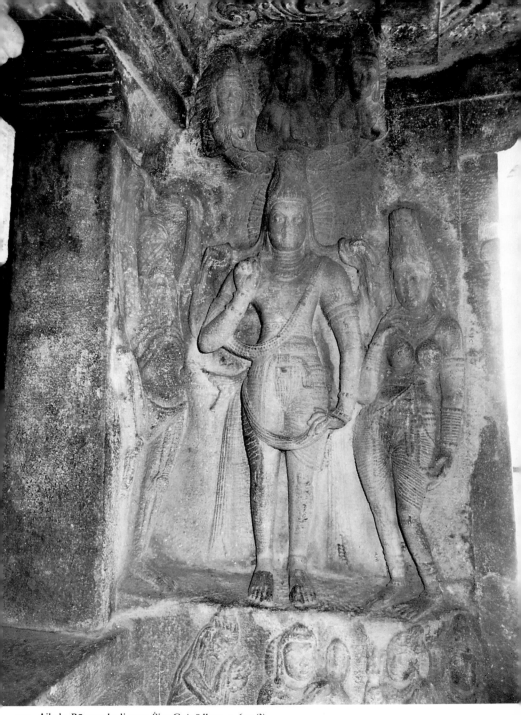

134. Aihole, Rāvaṇaphadi cave, Śiva Gaṅgādhara. *c.* 600 (?)

mithunas in temples as diverse as the Lāḍ Khān and the Durgā, and there is an occasional folk element, for example in the popular Aśvamukhī pillar sculptures, where the prim horse-headed yakṣī is boisterously approached by the male figure or stands demurely beside him.

The post-Gupta style is at its purest and best, however, in some of the niche figures of the peristyle inside the Durgā temple, particularly the Durgā, the Narasimha, and the Śiva [133]. Naturalism has largely been superseded by abstraction. Jewellery, for example, is sculptural rather than realistic; attendant figures tilt at impossible angles. The mūrtis on one of the smaller Mahākūṭa temples are in a less powerful, more sinuous style which probably also characterized the still imperfectly revealed sculptures of the Mahakuteśvara, two-armed and iconographically more simple.

There is little real evidence for Pallava influence. Pillars with large standing figures, usually mithunas here, belong ultimately to the tradition of carved Buddhist stambhas, but in free-standing buildings they do not appear in the south until the late Cola period, long after Āndhra and elsewhere. Ceilings elaborately carved with iconographic themes also remain purely Early Western Cālukya for a century or two until they emerge in later post-Gupta temples in Rājasthān and in Orissa. On the borders of many are the Guardians of the Quarters, particularly popular from now on in Karnātaka. Standing Lakulīśas are favoured and so are narrative friezes, usually of scenes from the Krṣna legend. Those in the Upper Temple in the North Fort again probably predate those at Osian by a couple of centuries. Unique to the region are stone lotus-headed women in a posture of parturition; a number survive loose at Mahākūṭa and Aihole.[23]

Most unaccountable of all, since stylistically they have neither predecessors nor successors, are the mūrtis in the Brahmanical cave (Rāvanaphadi) at Aihole. These splendid large figures – a dancing Śiva surrounded by standing Mātṛkās, an Ardhanārī, and an exceptional Śiva Gaṅgādhara with the three river-goddesses

[134], let alone the 'Scythian' dvārapālas – have no counterparts in the caves at Bādāmi.[24] Moreover there is little to connect the rather brutish figures there with the slender, tall-crowned images at Aihole, the long shafts of their weapons resting on the ground, to whom one idiosyncrasy carried almost to the point of mania – the scoring of drapery with parallel lines – gives an obsessive family air. The layout is also foreign to the region; it is closest to that of the Rāmeśvara at Ellorā.

Early Western Cālukya architecture reached the climax of its second phase at Paṭṭadakal, a few miles downstream from Aihole on the Malprabhā and possibly an exclusively ceremonial site. Oddly enough, of the four large temples built here in the first half of the eighth century, only one, the Pāpanātha, is Nāgara, despite the predominance of the type at Ālampur a hundred and fifty miles to the east. The three other temples are uncompromisingly Drāviḍa. The earliest, named the Saṅgameśvara or Śrī Vijayeśvara after its builder, Vijayāditya-Satyaśraya (696-733), does not even have a nāsika, reflecting the absence of a vestibule to the sanctum, whose walls are inordinately thick. The maṇḍapa has partially disappeared. The Virupākṣa and the Mallikārjuna were built by two sisters, successively the queens of Vikramāditya II (733-46), the son of Vijayāditya and conqueror of Kāñcī. The Virupākṣa [135], with its enclosure wall composed in part of shrines and its small gopura, was certainly inspired by the Kailāsanātha at Kāñcī. It has in addition, facing the entrance to the main shrine, a large Nandi pavilion housing Śiva's bull – the first of its kind. The Virupākṣa was then probably, with Kāñcī, the largest and most ornate temple in India; at any rate, none has survived of equal size and splendour. The Mallikārjuna is almost as big. Both have nāsikas. The importance accorded to the maṇḍapas, the beauty of the jālas, surpassed only by a few Gaṅgā ones, and the fondness for large mithuna figures are all in the Early Western Cālukya tradition. Only the porches and the way in which reliefs stray from the niches on to the walls

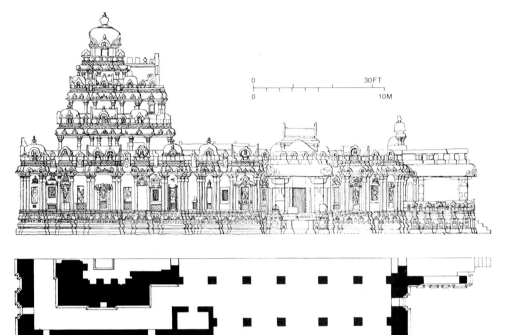

0 30FT

0 10M

135. Paṭṭadakal, Virupākṣa temple.
Mid eighth century.
Elevation and half plan

belong to the more cosmopolitan post-Gupta style.

The Virupākṣa and the Mallikārjuna are Drāviḍa in almost all their architectural details, their pilasters, corbels, gavākṣas, and base mouldings. Some features, like the yāli friezes above the kapotas both of the base and the main cornice, the makaratoraṇas above the niches, and the style of the dvārapālas, are uncannily similar to those of Early Cola temples a century and a half or two centuries later. The influence of Pallava architecture, the more or less contemporary style in Tamilnāḍu, on details and on sculptural style is more difficult to detect. The intense rivalry between the Pallava and Early Western Cālukya monarchs dur-

ing the seventh and eighth centuries led to the capture of each other's capital at least once, so that opportunities for artistic interchange doubtless existed, but we do not yet know quite how they were taken up.

From the outset the richly decorated interiors of the temples of the Deccan drew upon their own cave tradition and ultimately on Gupta sources rather than upon Tamilnāḍu where, until a very late date, interiors are starkly unadorned. The Paṭṭadakal temples, including the Drāviḍa ones, continue the local tradition. The interior pillars of the Virupākṣa are carved with scenes from the Rāmāyaṇa and the Mahābhārata; similar reliefs in the Mallikārjuna relate episodes from the Kṛṣṇa

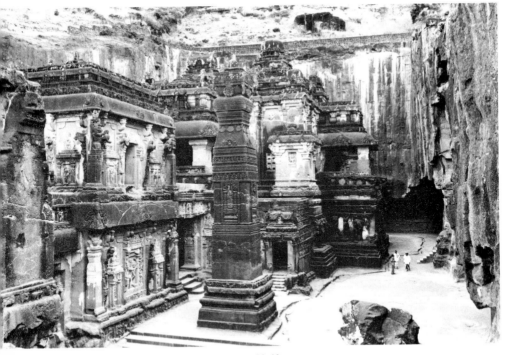

136. Ellorā, Kailāsa temple. Eighth century, second half

story.[25] Only in the iconography of some of their images is there a clear-cut debt to the Pallavas: one is claimed to be otherwise exclusive to Tamilnāḍu, and both Liṅgodbhava and Tripurāntaka are ubiquitous there and somewhat rare elsewhere.[26]

Of the four temples at Paṭṭadakal with Nāgara śikharas, by far the largest is the Pāpanātha. Distinguished by two maṇḍapas in series, and consequently disproportionately long in relation to the sanctum and to the height of the 'northern' śikhara (both probably planned or built before the rest of the temple), the Pāpanātha probably followed the Virupākṣa in time.[27] Any change of design or dedication was almost certainly made before the construction of either of the maṇḍapas. The temple is remarkable for udgamas over the niches of the Rājasthān honeycomb type, and for the

Rāmāyaṇa reliefs on the outside walls, some bearing the names of the sculptors, a very rare occurrence in India. They are occasionally duplicated on the Virupākṣa temple: sculptors thus working on two temples in completely different traditions is the most striking proof that the variety of styles for which the region is noted does not necessarily presuppose distinct groups of stone carvers.

Begun but perhaps not completed by Kṛṣṇa I (756-73), the Kailāsa at Ellorā is the largest and most splendid rock-cut monument in the world [136]. A passage from one of two contemporary copper-plate inscriptions fervently eulogizing the temple conveys the deep impression it must have created at the time:

A temple [was caused to be constructed] on the hill at Elapura, of a wonderful structure, – on seeing which the best of immortals who move in celestial

137. Ellorā, Kailāsa temple.
Eighth century, second half. Plan

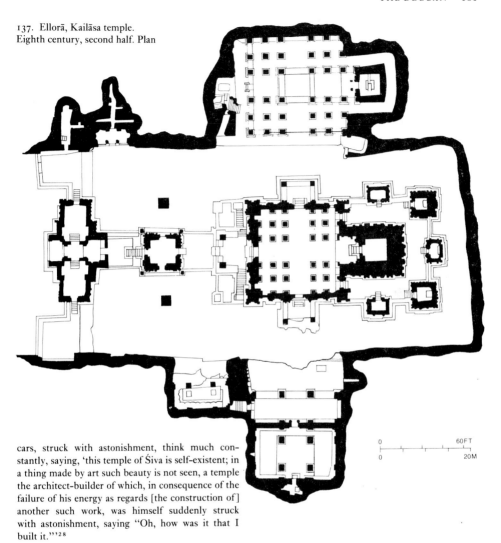

cars, struck with astonishment, think much con-
stantly, saying, 'this temple of Śiva is self-existent; in
a thing made by art such beauty is not seen, a temple
the architect-builder of which, in consequence of the
failure of his energy as regards [the construction of]
another such work, was himself suddenly struck
with astonishment, saying "Oh, how was it that I
built it."'[28]

Elapura has been identified as the modern El-
lorā (or Elūrā) and it is tempting to speculate that
the architect's failure refers to one of the two
incomplete monoliths to the north of the
Kailāsanātha. The breathtaking size of this tem-
ple, which still makes a powerful impression,
is suggested by the way in which it was created
[137]. Two great trenches some 300 ft (90 m.)
long were dug into the hillside at the level of

the surrounding countryside, connected at the
deepest point at the rear by another trench
some 175 ft (53 m.) across.[29] The temple thus
appears to rise from a vast courtyard at ground
level. The great mass of rock between the
trenches, rising to nearly 100 ft (30 m.) at its
highest point, was to become the temple, con-
sisting of a three-storey vimāna and a maṇḍapa
flanked by two giant dhvajastambhas (free-

standing columns, usually placed before the entrance to a shrine, literally 'flag pillars') bearing the trident, Śiva's emblem, and a Nandi pavilion.[30] The temple is Śaiva, as the name Kailāsa, Śiva's abode, implies, and the god is enshrined in the vimāna in the form of a huge liṅga. Out of the curtain wall left at the entrance was carved an elaborate (for the period) go-pura. All around the temple, galleries and shrines were cut out of the natural rock, some two storeys high, containing a great number of images. It was probably this surrounding 'wall' of cloister and shrines, together with the fact that both have a detached maṇḍapa, that prompted comparison of the Kailāsa with its namesake at Kāñcī. The Virupākṣa at Paṭṭadakal has also been put forward as a prototype, with more reason, since it is nearly contemporary; what is more, the region of Paṭṭadakal was brought under Rāṣṭrakūṭa rule by Kṛṣṇa I. Its sculpture too, although in a softer and more lyrical style, brings to mind the Kailāsa. Except for certain details, the Kailāsa is completely Drāviḍa.

It has been estimated that the construction of a built temple of equal size and elaboration would have involved more labour, bearing in mind the transport of the stone and the need for scaffolding (not required here, since work was undertaken from the top down). The Kailāsa, however, stands mostly in shadow in a pit, and it was partly to counteract this disadvantage that the relatively small vimāna was built on a monumental plinth 25 ft (7.5 m.) high, supported by massive elephants and lions.

No pains have been spared in the sculptural decoration, full but not over-dense. Narrative friezes, great mythological panels, and individual mūrtis all abound. Although the temple is Śaiva, friezes one above another relate stories from both the Mahābhārata and the Rāmāyaṇa in a style very similar to those on the interior pillars of the Virupākṣa at Paṭṭadakal. Among the Rāmāyaṇa subjects is the rarely depicted Rape of Sītā. The famous Rāvaṇa shaking Kailāsa has an exceptional dramatic quality based on psychological contrasts and tensions. The demon king, in a sort of cave under the 'mountain', is completely in the round. Durgā fighting the Demon Buffalo, of Pallava inspiration, is a young Valkyrie riding into battle on her lion. Particularly fine are the three river-goddesses in the largest of the chapels cut into the cliff surrounding the temple, though the Sarasvatī is no longer extant. She is rarely represented; even rarer are some of the mūrtis in the galleries.

Two principal considerations – the existence of more than one style of sculpture, and the fact that the base, including the great band of elephants and lions which appear to support it, is grossly out of proportion to the height of the vimāna proper – have led to the hypothesis that modifications and extensions continued under Kṛṣṇarāja's successors; but it is doubtful that patronage would have extended over so very long a period.[31] Two Jain temples at the extreme northern end of the scarp, the Indra Sabhā and the Jagannātha Sabhā, were probably the last works undertaken at Ellorā. The Indra Sabhā, a smaller version of the great Śiva temple, complete with a small gopura, houses some fine sculpture, and the decoration is of a very high order. The unfinished Chota Kailas is yet another version, even smaller.

The early Rāṣṭrakūṭas thus carried the Drāviḍa style into the northernmost Deccan, but there is so far no record of any structural temples there in the 'southern' style of their great rock-cut works at Ellorā.[32] Nor did this style persist as such even in central Karnāṭaka, where so many fine Drāviḍa temples had been built under the Early Western Cālukyas. By the end of the eighth century the genesis can already be perceived of Karnāṭaka's distinctive contribution to Indian temple architecture which culminated, in the Later Hindu Period, in the Hoysaḷa style. The transformation is exceptionally easy to follow, beginning in the Jain temple at Paṭṭadakal, in some of the late temples at Aihole, in the Kalleśvara at Kukkanur, and in the large Jain temple at Lakkuṇḍi.[33] These are all essentially Drāviḍa,

but the subordination of architectural features to the overall decorative ensemble, dominated by vertical elements, has already begun. Long, thin pilasters and niches crowd the walls. The pavilions of the vimāna become rows of narrow vertical slabs, as first seen in the superstructure of the north-east Kunti temple at Aihole. The śikhara (in the 'southern' sense of the word), invariably squarish in general outline, begins to break up, on plan, into two or more recessed planes on each of the four sides. The niches turn into mere *appliqué* decorative features, no longer capable of housing sculpture, and the careful distinction between architecture and images, so essential to the classical Drāviḍa style, vanishes altogether. The effect, at an advanced stage, is of an assemblage of innumerable small vertical blocks of masonry, a palimpsest upon which the basic features of a Drāviḍa temple faintly emerge. Pillars are no longer four-sided or polygonal but round and turned on a lathe, and multiple shrines like the Banantigudi at Aihole become the rule rather than the exception for larger temples.

The surviving shrines of the ninth and tenth centuries in southern Karnāṭaka, usually associated with the Gaṅgas, a local dynasty, are more or less provincial versions of Late Pallava and Early Cola types – well built, chaste, but rather barren, with a dearth of external niche sculptures in spite of some fine images inside. Less well proportioned but far more lively in surface texture, the rather more important temples of the Noḷambas, another local dynasty, favour parallel groupings rather than the cruciform arrangement, sharing a maṇḍapa, common elsewhere in Karnāṭaka.

In Kolar District to the east, the Rāmeśvara at Avani comprises four shrines, all but one with its own maṇḍapa, and all but one side by side. The Śatrughnéśvara, with a Gaṅga inscription but a modern brick superstructure, is probably the earliest. The Lakṣmaṇeśvara, somewhat later, already shows the Karnāṭāka tendency to crowd the vertical elements. At least one of the other vimānas has a superstruc-

ture built entirely of brick, as became common in Tamilnāḍu towards the end of the Cola period. In spite of later additions, the Rāmeśvara is perhaps the earliest example of a number of separate shrines and other structures within a large walled enclosure.[34]

The twin shrines at Nandi, the Bhoganandī-śvara and the Aruṇācaleśvara, are probably

138. Nandi, Aruṇācaleśvara temple, jāla carved with musicians and dancers. Ninth century

ninth-century and have Nolamba associations.[35] The upper storeys are of stone, except for the śikhara of the Aruṇācaleśvara. The miniature shrines on the hāras are interspersed with sculpture, carved fully in the round. The ornate *somasūtra* or *praṇāla*, the gargoyle-like spout, always to be found on the north side, which carries the liquids poured over the image in the sanctum to the outside is in each case a makara head, with human figures carved on the sides in relief. The Bhoganandīśvara somasūtra is particularly fine.[36] Some of the hall pillars and those of the two (now enclosed) Nandi pavilions, including their cushion capitals and outsize square abaci, are in the purest Early Cola style. Unique is the beautifully executed little maṇḍapa linking the two shrines. Rarely if ever have later additions been so logically and symmetrically incorporated into the original twin-shrine arrangement, the Amman (goddess) shrine equidistant from the two behind the linking maṇḍapa and the two Nandi shrines neatly enveloped by the Vijayanagara-period maṇḍapa. The jālas are particularly splendid, sometimes filled by a single figure, like the musicians and dancers of the linking maṇḍapa [138] or the Aruṇācaleśvara's dancing Śiva.

The Cāmuṇḍāraya, built about 980 on the Candragiri, the lower of the two hills at Śravaṇa Belgoḷā, is a fairly large, austere temple with an interior stairway leading up to the roof of the maṇḍapa. The carved doorway is the only concession to Karṇāṭaka tradition. The small but carefully restored three-shrined (*trikūṭa*) Jain *basti* (temple) in the village of Chik Hanasoge near the Kāverī river, some 30 miles (50 km.) upstream from Seringapatam, has a fan-palm (*tāla*) band around one of its doorways, by far the southernmost example of this typical late Gupta and post-Gupta feature.[37] There is also some fine sculpture inside.[38] The important temple at Kambadahaḷḷi near Śravaṇa Belgoḷā is *pañcakūṭa*, five-shrined – a plan best described as a cross of Lorraine without the lowest vertical element and with shrines at the topmost point and the ends of the horizon-

tals.[39] It originally consisted only of the top three shrines, in a fairly pure Late Pallava/Early Cola style. Exceptionally for southern Karṇāṭaka at this period, statues (standing Jinas) occupy most of the niches. There are three śikharas – square, octagonal, and round. The open maṇḍapa houses splendid free-standing black stone images.

Finally, in the very south of Karṇāṭaka, almost at the Nilgiri Hills, in the isolated village of Narasamaṅgalam stands the exquisite little Rāmaliṅgeśvara temple [139].[40] The date usually assigned to it – *c.* 800 – may be too early because of its remarkable resemblance to the Early Cola temple at Puḷḷamaṅgai near Tañjavūr, with projecting pañjaras coming right down to the base mouldings.[41] There are no niches or wall reliefs; instead, stucco figures stand free on the pañjaras or among the pavilions of the upper storeys. They have been restored from decay, but judging from earlier photographs their original quality was high. Inside there are some fine carved beams and an exceptionally good ceiling panel, a dancing Śiva in the centre surrounded by the dikpālas. Such ceiling slabs are found in all the finer temples in Karṇāṭaka at this period. A separate kā shrine houses a complete set of intact but rather lifeless Mātrkās accompanied by figures of more distinction, notably the Vīrabhadra.

At Ālampur to the north-east, some hundred and fifty miles east of Bādāmi and Aihole, near the confluence of the Tuṅgabhadrā and the Krishna, and elsewhere to the east and south-east as far as the Nallamala Hills and beyond, more temples have survived. At Ālampur influences are mixed, as throughout the 'borderlands' at this time, but more predominantly 'northern' than to the west.[42] Of the Navabrahmā group, all but one, the Taraka Brahmā, have Nāgara śikharas of the triratha type. The temples are typically post-Gupta, with close affinities to Rājasthān and Orissa. 'Northern' are the Gaṅgā and Yamunā at the bases of door jambs, image niches on the walls even of the enclosed sanctum, and, outside, niches with honeycomb udgamas. The char-

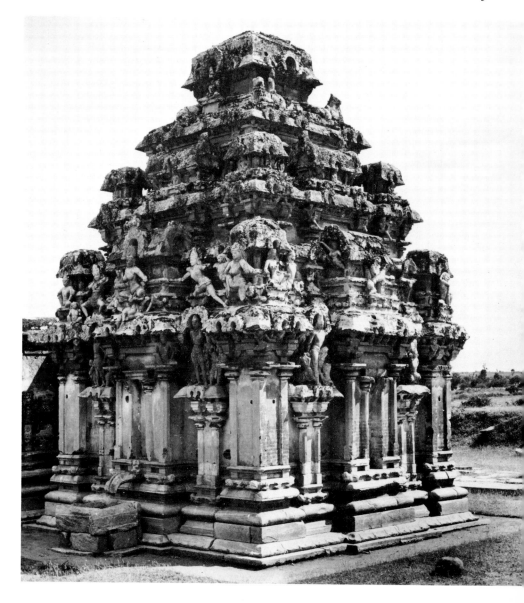

139. Narasamaṅgalam, Rāmaliṅgeśvara temple, from the north-west. c. 800 or later

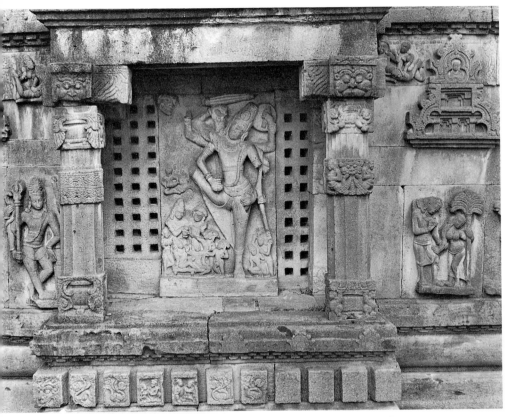

140. Ālampur, Svarga Brahmā temple, porch and jāla interrupted by a Trivikrama image.
Late seventh century

acteristic nāsika projects in front of the śikhara, corresponding to a vestibule (*antarāla*) on plan and usually in the shape of an enormous gavākṣa framing a dancing Śiva, as at Aihole, and also at Paṭṭadakal, where the great Drāviḍa temples share the same feature. In other respects the Ālampur shrines resemble the early Karṇāṭaka maṇḍapa temple, with its raised clerestory above the nave, its enclosed garbhagṛha, and its fondness for windows, often triple, and for porches, although at Ālampur there is no partial walling-up between the pillars.

In the finest of the temples, the Svarga Brahmā [140], built, according to an inscrip-tion, during the reign of Vinayāditya (681-96), the walls themselves bear large relief sculptures. Such typical post-Gupta motifs appear as square bosses representing rafter ends in the base, tāla capitals, and the pot and foliage, both at the base of pillars and as their capital. Porches are built outside windows which co-incide with the niches inside on the walls of the garbhagṛha. The latest of the temples at Ālampur, the Viśva Brahmā, although the quality of the sculpture is high, tends to over-decor-ation in the later Karṇāṭaka manner, and to the breaking up of surfaces into vertical lamina-tions. Also Karṇāṭakan is the partiality for the

dikpālas, the Guardians of the Quarters,[43] who occupy ten of the twelve external niches of the Svarga Brahmā. They are usually rather stiff compared with the wall sculptures here, and with the panels at the centre of the triple windows. The Viśva Brahmā has lost most of the images from its twenty-two niches; apart from mithunas and the occasional mūrti lower down on the walls, the sculpture is concentrated at the level of the niche pediments. The Bhikṣāṭana of the Svarga Brahmā and the beautiful Dakṣiṇāmūrti among the udgamas of the Viśva Brahmā spell Tamilnāḍu. Particularly impressive are the Mātṛkās of the Bala Brahmā [141]. Four-armed doorkeepers make their first appearance in the porch of the Svarga Brahmā, to emerge again a little later at Aihole and then at Paṭṭadakal. The trident of Śiva in the headdress of the one on the proper right suggests the horns of some Pallava dvārapālas; otherwise their style is as advanced as in the Early Cola period in the south, two centuries or so later.

The sculptural tradition of Buddhist and Jain establishments in the northernmost coastal regions of Āndhra continued to develop until the ninth or tenth centuries, growing closer to that of northern Orissa.[44] The Buddhist sculpture of Amarāvatī, in the eighth century resembling that of the Early Western Cālukyas though, at its best, more forceful, later grew closer to more northern styles.[45]

By the seventh century, the eastern branch of the Early Cālukyas had established themselves in the Telugu-speaking coastal regions on the lower reaches of the Krishna, the site of so many ancient Buddhist foundations, as well as further south. To them may probably be attributed the earliest Hindu monuments: the cave-shrines on either side of the Krishna near Vijayawada (Bezwada), of which the most important are at Mogulrājapuram and Undavalli; and the smaller but more elaborately decorated caves in the Bhairavakoṇḍa hills at Kottapalle (Nellore District) further south.[46] Undavalli has a many-columned ground floor and two upper storeys plus a third, smaller

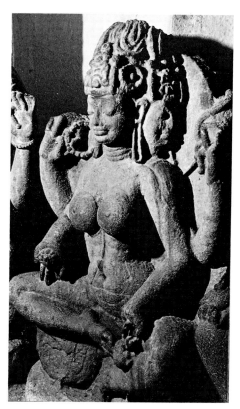

141. Ālampur, Bala Brahmā temple, Brāhmī (one of the Mātṛkās). Mid seventh century

one. At Bhairavakoṇḍa (eighth to ninth centuries), the squatting lion pillar bases and the corbels decorated with the roll-ornament (*taraṅga*) in particular reflect the influence of the later Pallava caves. The Pallavas are indeed believed to have originated in Telugu districts, as may their horned dvārapālas, for they appear at Mogulrājapuram as well as at Ālampur.

The temples built at Ālampur under Early Western Cālukya rule were almost exclusively Nāgara, with many typical post-Gupta features; those at Biccavolu (*c*. 850-950) in the East Godavari District, on the other hand, are in a regional variation of an uncompromisingly

Drāviḍa style.[47] The śikharas are square. Over the niches, their tops and sides fitted with narrow plank-like slabs, are makaratoraṇas with a pendulous central member as in the upper temple in the North Fort at Bādāmi; here, however, the makaras have long and luxuriant tails, which hang down on either side of the niches. An additional pair of makaras gazes down from the finial of the gavākṣas of the principal cornice. As in all the Drāviḍa buildings in Karṇāṭaka, pilasters are tetragonal and relatively close together, although a high block is here interposed between corbel and cornice. The sparsely distributed niches are usually filled with sculpture in a manner which owes something to Orissa: a narrow upright rectangular slab carved in high relief is set within the niche.[48] Sculpture at Biccavolu shows other influences from the north, for example a Sūrya wearing boots, and Gangā and Yamunā at the foot of the door jambs as in Early Western Cālukya architecture.[46]

The Eastern Cālukyas continued to rule over most of the coastal region of Āndhra until the twelfth century. Somewhat later shrines – the Bhīmeśvara at Drakṣarāma (Godavari District), the Cālukya at Bhīmavaram (East Godavari District), the Someśvara at Somarāma (West Godavari District), and the Amareśvara at Amarāvatī and the Bhīmeśvara at Chebrolu (both Guntur District) – all have two main storeys, the last two with the ground floor closed and the liṅga in the upper-storey garbhagṛha. They are of sandstone, with white or black marble liṅgas.[50] The śikharas continue square, and the upper storeys of the vimāna tend to be compressed, without hāras, a feature of long standing in some Cālukya temples.

KASHMIR

The fountainhead of Kashmiri art is the great valley watered by the Jhelum, some seventy miles long and surrounded on all sides by mountains, and particularly the area around Srinagar and the Dal lake. As its sculpture is so similar to that of the Swāt Valley to the west, they are usually considered together. Kashmir and Nepal are alike in being difficult of access and in having flourishing schools of sculpture in metal and stone and a distinct style of architecture; they differ in that historical and geographical factors peculiar to Kashmir have always given a wide-ranging cosmopolitan flavour to its highly individual art.[1] The Graeco-Roman echoes which sound occasionally and apparently unaccountably in the art of Kashmir and particularly its architecture, can be traced only to Gandhāra. The time gap is difficult to explain but not impossibly so if one takes the view that Gandhāra art, on its home ground, persists through the sixth century.

The earliest surviving monuments in Kashmir, mostly only at ground level, are the remains of the Buddhist establishments at Ushkur (ancient Huviṣkapura) and Harwan. The Ushkur stūpa bases and sculpture are reflections of the late Gandhāra period to the west. At Harwan around the fourth and fifth centuries, however, the quite exceptionally rough masonry of early Kashmir was clad in a novel and unique way: the caitya hall perhaps, and certainly the court around it with its raised border upon which the monks could sit, were covered with tiles, some as large as 18 by 12 in. (45 by 30 cm.), bearing moulded decoration including Indian and Sasanian themes and perhaps some Chinese motifs as well as human figures.[2]

In the seventh and eighth centuries, probably under the influence of the great Lalitāditya

Muktāpīda (c. 724–c. 760) of the Karkoṭa dynasty, who controlled extensive tracts of Central Asia and India, particularly monumental cut-stone architecture appears. At Parihasapura, north-west of Srinagar, the ruins of a huge stūpa and a whole complex of Buddhist buildings illustrate the new technique. The stones are often of enormous size, including a stupendous one measuring 16 by 14 by 5 ft 6 in. (4.9 by 4.3 by 1.7 m.) and weighing approximately 64 tons (65 tonnes). The blocks are evenly dressed and secured by lime mortar (a practice extremely rare in India until the arrival of the Muslims) or by metal dowels. The so-called caitya, a court with a central temple for the image, derives in part from Gandhāra and will provide the model for the larger Hindu temples. As in Nepal, Hinduism and Buddhism continue to co-exist, at least until the Muslim conquests, and images become increasingly syncretistic. The rare Buddhas and Bodhisattvas from Parihasapura, now in the Srinagar Museum, are in a variant of the early post-Gupta style. One or two almost certainly show Chinese influence.[3]

On the top of the Takht-i-Sulaiman hill beside the Dal lake and hence seen, if only from afar, by every tourist, the Śankarācharya temple is unique. Its square plan, with recessed sides, and circular garbhagṛha would seem to indicate that it is the oldest surviving Hindu shrine in Kashmir, representing a very early stage of development. The great temple of the Sun at Martand, beautifully sited near where the Liddar valley opens into the great Vale of Kashmir, is the largest of the Hindu temples [142 and 143]. It shares with a number of smaller but less ruined shrines the trefoil-arched recesses, entrances, and niches beneath steeply pitched triangular pediments, as well as the fluted columns and pilasters with a capital,

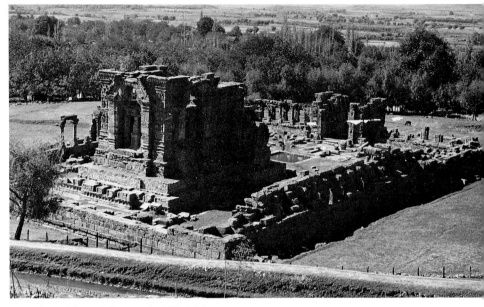

142 and 143. Martand, Sun temple. Mid eighth century

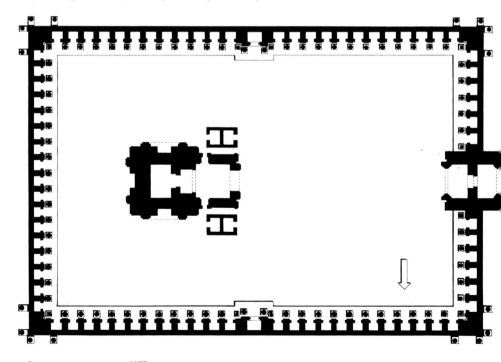

0 60FT

0 20M

more reminiscent of the Greek Doric than of any Indian type. The roofs, all missing, were doubtless of the rectilinear pyramidal kind, one often capping the other. The Sun temple differs from other Kashmiri shrines, however, in that – perhaps on account of its size – the central element, which is pañcāyatana, includes a (detached) portico or maṇḍapa. There is also a substantial gateway to the large walled-in court with its interior peristyle surrounding the shrines – a common feature of the larger temples. Some of these elements also have a distinctly Graeco-Roman flavour, both in details and in breadth and scope of execution, and it is surely not Western cultural ethno-centricity to agree with Percy Brown that 'the early mediaeval monuments of this country bring to mind, although indistinctly, recollections of some older architectural experiences, suggesting the final infiltration, towards the east, of the Graeco-Roman ideal'.[4]

Of the two temples at Avantipur, the now-vanished capital of King Avantivarman (855–83), the larger is second in size only to Martand, although little remains beyond the foundations. The other, dedicated to Viṣṇu as Avantiswami, i.e. the Lord of Avanti (varman), is also pañcāyatana, and the best example of the second phase in Kashmir, although not rich in innovations. The sculpture, in niches or in the form of panels, is in a recognizable post-Gupta idiom, for all its occasional Kashmiri idiosyncrasies. The rotund, smallish figures smack faintly of folk art, like contemporary sculpture in Orissa.

Probably the earliest Hindu image in stone of any size is the splendid six-armed Kārttikeya in the Srinagar Museum. The debt to Gandhāra Bodhisattvas is obvious, but the very broad face, the powerful rounded shoulders, and the realistically depicted reverse-curve bow bring Udayagiri (Vidiśā) to mind. The peacock as vahana is also a Gupta innovation. A late-fifth-century date seems quite possible. A Sadāśiva from Fatehgarh, near Baramula, is probably a century or more later. Its iconography is explicable only by the budding

syncretism between Buddhist and Hindu images.[5] Later icons in stone tend to be smaller and carved in a highly polished black chlorite. The 'archetypal' Kashmiri Hindu image is a four-armed standing Viṣṇu, flanked by his personified weapons, and with a minuscule bust of the earth-goddess (Bhū Devī) rising from a lotus at his feet [144]. The god is four-faced (caturānana), with a boar's head and a lion's on either side, and another head in low relief on the back of the halo.[6] Sadāśivas are also common. The sculpture from Pāndreṇthān appears to cover several centuries. The many large and mostly unpublished sandstone images in the

144. Srinagar, Gadadhar temple, Vaikuṇṭha Viṣṇu (Caturānana). Eleventh century (?)

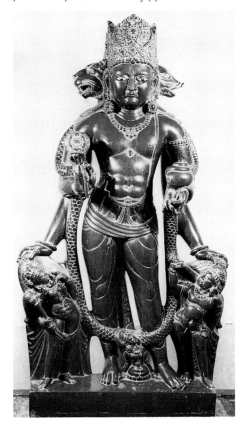

Srinagar Museum, including some standing Mātrkās, a Sadāśiva, and an amusing Kāmadeva, in a lively, somewhat fruity style, are probably contemporaneous with the Sun temple (eighth century).

The post-Gupta bronzes[7] of Kashmir are well documented in literary sources of the time. Because so many are now known, their characteristics can be catalogued with some confidence. In style they broadly resemble the works in stone. Central Asian and Sasanian echoes range from 'vague reminiscences of the animal style' to textile patterns on throne cushions.[8] Recurring items of dress, including the camail, a three-pointed little cape or bolero with an astonishingly long history, and an unexplained disc on each shoulder, point to elements of Central Asian origin – perhaps the Śāhis – among the population. A short dagger is worn suspended across the thighs both by donor figures and by images of Sūrya – less surprisingly, for Sūrya's costume retains foreign elements even in twelfth-century Bengal.[9] The new pointed prabhāmandalas almost certainly derive from T'ang custom.

The pose and drapery of the few standing Buddhas reflect Gandhāra versions in stone, although other features seem to point to a very late date.[10] The first indisputably Kashmiri bronze known, the sixth-century Viṣṇu in Berlin, is, like the stone Kārttikeya at Srinagar, a Gandhāra-Gupta amalgam. It must be early on account of the lion's and boar's heads sprouting from the shoulders rather than from each side of the god's face, and because there is no fourth face at the back. The drapery of the dhoti, the moustached face, the crown, and the lotus in the god's right hand all have Gandhāran analogues. On the other hand the *cakra-puruṣa* with his huge wheel is pure Gupta. The little torso of the earth-goddess on the pedestal, later virtually the hallmark of Viṣṇus in stone, the vigorously muscled torso, and the slightly dropsical legs all link this statue to later Kashmiri bronzes.

The greatest charm of these works lies perhaps in their variety. The inventiveness of the Kashmiri bronzecasters during the Karkoṭa period (eighth to tenth century) seems limitless; they are constantly devising new and imaginative forms of bases and aureoles and fresh iconographical groupings, no doubt reflecting the increasingly convoluted speculations of religious thought. Śaiva tantrism was to flourish in Kashmir. The quality of the work also varies, from exquisitely modelled, cast, and finished pieces to the most slapdash productions with crudely modelled faces and no attempt to finish the back of the image.

Viṣṇu is portrayed in several guises, sometimes seated on his vehicle Garuḍa, or in a rare androgynous form (Vāsudeva Kamalaja).[11] Buddhas too sit either in European fashion; or else in padmāsana or *lalitāsana*, with one leg drawn up, the other hanging down, on a wicker stool above the beautiful Kashmiri lotus with its smooth, fully rounded petals; or on a lion throne; or on cushions with textile motifs; or on a base intricately carved with rocky forms in the Gupta manner and peopled with animals, devotees, and donors [145]. By the eighth century he has become crowned, clothed, and jewelled, sitting in an elaborate bronze in the John D. Rockefeller 3rd collection between twin stūpas, a Central Asian rather than an Indian iconographical feature.[12] The base and the lotus stalk upheld by a pair of nāgas, on the other hand, are Gupta. The technique recalls the art of the jeweller rather than that of the bronzecaster or the modeller in clay.

145. Seated Buddha. Eighth century.
Bronze, copper, and silver.
Pasadena, California, Norton Simon Foundation

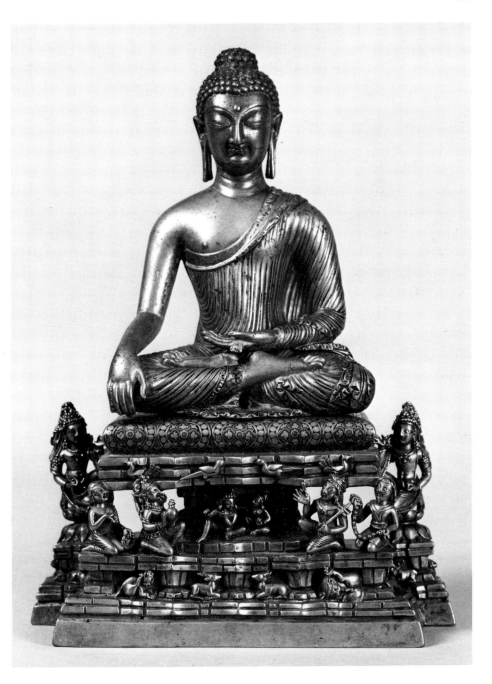

146. Buddha (inscribed). Probably eighth century. Brass.
Cleveland Museum of Art, John L. Severance Fund

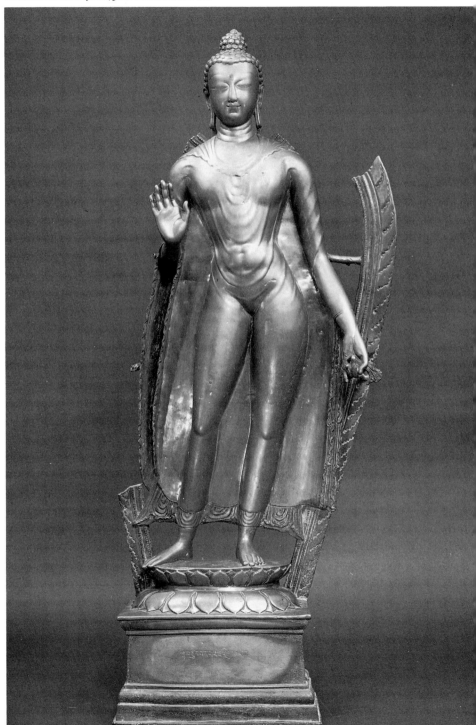

The largest of all Kashmiri bronzes so far known, $35\frac{5}{8}$ in. (90.5 cm.) high, is the standing Buddha in the Cleveland Museum of Art which once belonged to a high dignitary in Tibet [146]. It is in fact of brass, for all its beautiful golden colour; judging by metallurgical tests, a certain amount of lead in the alloy accounts for the buttery softness of modelling of so many Kashmir metal sculptures.[13] The emphasis on the crinkled folds of the saṃghāṭī under the lower abdomen, already noticeable in some earlier stone Buddhas and foreign both to Gandhāra and to Gupta work, probably derives from T'ang China.

The greatest triumph of Kashmiri metal image-making, however, is a unique *prabhā-maṇḍala*, in this case a veritable metal arch, surrounded by the avatars of Viṣṇu framed in the loops of a continuous swirling lotus tendril. At the apex stands a multi-headed Viṣṇu, with a seated Śiva below. The principal image is missing. It was obviously seated, from the inner contours of the frame, and may have been the Buddha, considered by this time one of the avatars of Viṣṇu.[14]

The ingenuity and diversity of the Kashmiri artists, sometimes at the expense of taste, characterize the post-Gupta style elsewhere, too, as does a fondness for portraying textiles. The cult of the 'foreign' god Sūrya was popular in Karkoṭa Kashmir, as witnessed by the Sun temple, and his images abound, mostly to a strict iconographic and stylistic formula, whether in stone or bronze.[15] The Cleveland Sūrya, however, in accordance with the Kashmiri genius, resembles none of them. Instead of a single lotus, the god holds a bunch in each hand; the crown and robe are both unique, both decorated with Central Asian or Iranian textile patterns, the robe flaring out in a most extraordinary way at the bottom. Striking rather than beautiful, this statue nevertheless conveys the image of kingship in these foreign regions better than any other sculpture except that of Kaniṣka.[16]

Some bronzes, mostly Buddhas, with very strong Kashmir affinities can be assigned to the Swāt Valley (the ancient Uddyāna), a known stronghold of Buddhism. Some were actually found there. This alone does not prove local manufacture; however, a group of Bodhisattvas sitting in lalitāsana on what are meant to be wicker hassocks conform closely to figures outlined in low relief on boulders in the Swāt Valley, down to peculiarities in the way the dhoti is tied in front. The pose of these Padmapāni images, the elbow of the right arm resting on the thigh and the index finger pointing back to the head, is one of pensive tenderness [147].[17] They have identical predecessors, not stylistically but iconographically, in Gandhāra.

147. Bodhisattva Padmapāni.
Seventh/eighth century. Bronze (?).
New York, The Asia Society,
John D. Rockefeller 3rd Collection of Asian Art

148. Bodhisattva Sugatisaṁdarśana Lokeśvara. 980/1003 (dated 'in the reign of Queen Diddā').
Bronze. *Srinagar, Sri Pratap Singh Museum*

A number of Buddhas in padmāsana, like all figures from the north-west shown seated in a yogic pose, may also perhaps be assigned to the Swāt Valley.[18] The right hand sweeps low in *varada* (conferring a boon); the left holds up the robe with the compressed end hanging down. Elbows held tight to the body with forearms and hands turned slightly outwards give an open-armed effect. Flames rise from the uṣnīṣa. Many of the Swāt Valley bronzes are very dark in colour and have noticeably narrower faces than their Kashmiri counterparts.

The only Kashmiri image which can be dated with any precision is the Lokeśvara dedicated during the reign of Queen Diddā (*c*. 980-1003) [148]. It shows that, by the beginning of the eleventh century, changes of style had taken place, most noticeable in the more complex petals of the bases, with swollen stamens, but also in the decreased amplitude of modelling, and in the deterioration in workmanship. New mūrtis appear, in ālīḍha, increasingly multi-armed, or sometimes embracing a *śakti* (the active, energetic aspect of a god, personified as his wife or consort) in sexual intercourse, such as proliferate in Tibet until modern times. Many of the later bronzes may in fact come from western Tibet, or else the western Himālayas or the Indian Hill States. Notable exceptions to a certain decline in quality are the splendid bronzes, all 3 to 4 ft (90-120 cm.) high, from the old Chamba State, and largely *in situ*. The temples here are in a local style, with high-pitched roofs. The shortage of stone accounts both for their wooden construction and for the fact that the principal images are in bronze.[19] There are small more or less conventional post-Gupta temples at Jageśvar, Bajaura, Mandi, Lakhamandal, Dvarahat, and other places in the Indian Hill States. Some of the stone sculpture is very fine, in a style related to early Nepal.[20]

South of the Vale of Kashmir, Akhnur in Jammu has produced a number of small terracottas, mostly detached heads, probably of the sixth century. In finely levigated clay, they have the sensitivity of modelling and psycho-

logical penetration of the best late Gandhāra stuccoes.[21] There is little evidence in the Panjab and north-western Pakistan, the main invasion route into India, of the monuments which must once have existed in abundance after the final eclipse of Gandhāra. Some statues and fragments in white marble, the finest the Gaṇeśa in Kabul, have been attributed to the Hindu Śāhis.[22] The few temples to have survived further south, in or near the peculiar geological formation known as the Salt Range, are either much restored or - like Malot, lonely on its superb site - almost in ruins [149].[23] Malot, with its gateway and fluted col-

149. Malot, temple. Eighth/ninth century.

umns, has clear affinities with the Kashmir style, with an added element of rococo drama. Another group in Dera Ismail Khān District forms an extension into north-west India of the architecture of post-Gupta Madhyadeśa. It includes – all in very poor condition – the temples at the two Kāfir Kots and the Kallar temple in Attock District, the last in brick, the others in a soft tufa which gives the same impression.

EASTERN INDIA AND BANGLADESH

Although it falls chronologically in the Later Hindu period, the art of the Pāla and Sena dynasties (c. 800–1200) is considered here. It consists almost exclusively of sculpture, and since the style was already formed in the ninth century, a division around 950, the date used in this volume to divide the post-Gupta from the Later Hindu period, would be meaningless in eastern India. The Senas are by no means of the same importance as the Pālas, in either the extent or the duration of their rule, but they have been included in order to conform with earlier practice.

*

The vast area here to be considered includes some of the most heavily populated regions of the subcontinent. Dominated by the lower courses of two great rivers, the Gaṅgā and the Brahmāputra, it stretches from just east of Varanasi to the borders of Burma, including the present-day states of Bihār and West Bengal in India and the nation of Bangladesh (the former eastern portion of Bengal). On the north it is bounded by Nepal and the eastern end of the Himālayas, on the south by the ancient Mahākośala (now partly in Madhya Pradesh and partly in Bihār), Orissa, and the Bay of Bengal.[1] Although hard pressed by a resurgent and often dominant Hinduism, Buddhism, with its great monasteries, continued to flourish as nowhere else in India, until the final Muslim onslaughts in the twelfth century. In contrast to earlier periods, it is from eastern India, now, that religious and artistic ideas are exported to Nepal, to Tibet, and to China. It is partly, no doubt, because of the *furor islamicus* that post-Gupta remains are surprisingly few in Bihār (with one exception, the surviving temples are all in the heavily wooded hill tracts of the ancient Mahākośala), while Bengal's position

on the rim of the former Gupta empire, together with shortage of stone and a consequent reliance upon brick, terracotta, and stucco, account for the dearth of surviving temples and sculpture there. From the ninth century onwards, however, the relative peace under the Pāla aegis, the wide dissemination for sculpture of the black or grey stone of the Rājmahāl hills, and vigorous activity in bronze make the region one of the most artistically productive in all India.[2]

The large Dhāmekh stūpa at Sārnāth is in its present form almost certainly seventh-century. The eight niches in the stone portion of the drum, doubtless for Dhyāni Buddhas or Jinas as well as other images, set the pattern for the countless votive stūpas of later centuries, particularly at Bodhgayā, where the niches are usually limited to four.[3] Around the drum is a splendid geometrical and floral relief band. The deep Gupta undercutting of the foliage motifs is replaced by a compensatory intricacy and formalization of design.

The stone temple on the Mundeśvarī hill (now Rohtas District, formerly Shāhābād District) lacks its superstructure but is nonetheless the most substantial post-Gupta architectural monument in eastern India proper, with the exception of the Mahābodhi temple.[4] The inscriptional date probably corresponding to 636 in terms of our era would fit this temple well, closely related as it is to temples further west. The inscription is also important in dating a number of images found at the site, not all in exactly the same style, to the seventh century, a date rare for sculpture in the region. The octagonal ground plan of the Mundeśvarī is unique, at least among early temples, and it is sarvatobhadra as well.[5]

The great Mahābodhi temple at Bodhgayā must take precedence over all the other great

religious monuments of the world because of the antiquity of the event connected with it.[6] It stands at most a matter of yards from the spot where the Buddha achieved illumination about 530 or 520 B.C. The present impressive edifice bears no relation to the original bodhighara erected around the bodhi tree and depicted on the Bhārhut relief [29]; much marked by the last restorations under Burmese auspices in the 1870s and 1880s, it does nevertheless essentially represent the structure which replaced the original shrine, the tree long since dead. The new building was intended to house an image of the Buddha seated upon the *vajrāsana*, the 'adamantine throne or seat', the *vajra* in later Buddhist thought having come to symbolize the immutable.[7] There is no firm evidence to date this event, so crucial to the history of the development of the Indian temple, particularly the Nāgara type, but it was certainly no later than the fifth or sixth century, to which the brick mouldings and stucco statuary photographed before the late-nineteenth-century restoration unquestionably belong.[8] It is thus by far the largest (160 ft or 50 m. high) and most important of the early structural temples to have survived, however much restored, and the first to be described by a historical figure, the early-seventh-century traveller, pilgrim, and Chinese monk Xuan Zang (Hsuan Tsang). There is evidence that such multi-storeyed temples, with straight-sided śikharas, existed from Kuṣāna times [27K].[9] The present Mahābodhi may well date essentially from the second or third century, the Gupta work belonging to the first of the restorations to which a brick and stucco edifice is liable every two or three hundred years.[10]

The temple stands on a high two-register podium entered through an impressive portico and housing the principal sanctum [150]. From the terrace above rises the great straight-sided śikhara, also entered through a portico and containing an upper shrine room. The temple is pañcāyatana, smaller versions of the central śikhara forming a quincunx.[11] The śikhara is crowned with an āmalaka topped by a miniature stūpa and a *chattrāvalli*, a succession of *chattras* or parasols superimposed (one of the latter was found on the site); the outer fabric consists of niches topped by gavākṣas, each storey separated by horizontal mouldings. A much larger gavākṣa marks the centre, and there are āmalakas at the corners.

The slightly factitious appearance of the Mahābodhi temple stems from the excessive regularity imposed by a heavy-handed restoration, the presence of the podium, admittedly unique, and the uncompromisingly rectilinear shape of the śikharas. Underlying the slightly uneasy impression is a sense that a Buddhist shrine with śikharas is an inexcusable hybrid. What one forgets is that the Indian temple śikhara is known to us only at a fairly late stage in its development, and that in its earlier forms it rose above Buddhist shrines as well as, and even perhaps more often than, above Hindu ones. One must bear in mind that it belongs, ultimately, to a class of structure not limited to India, and, finally, that the shrines at the apexes of the great brick-built Buddhist monasteries of the following centuries may well have been capped by śikharas, as discussed below.[12]

Architecturally the greatest undertakings of the post-Gupta period in eastern India are the monasteries at Pāhārpur and Maināmatī (begun in the Gupta period) in Bangladesh and Nālandā and Vikramaśīla in Bihār. Nālandā, the largest, where building continued until the twelfth century, was in addition the greatest centre of learning in all Asia [151]. According to Xuan Zang, Harṣavardhana of Kanauj (606-47) was a notable patron, and other Chinese and Korean pilgrims have left records of studying

150. Bodhgayā, Mahābodhi temple

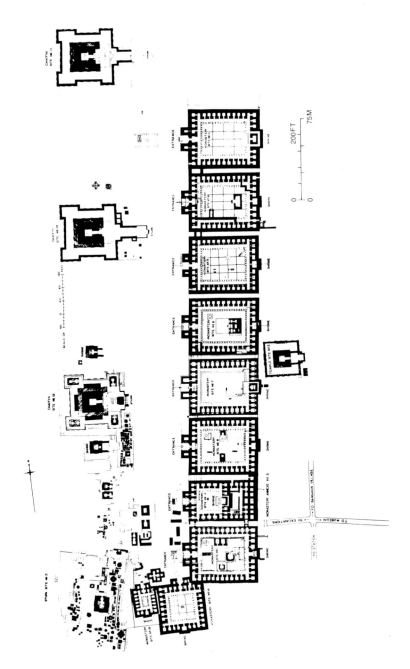

151. Nālandā, sixth-seventh centuries. Plan

there. Padmasambhava, the reputed founder of Buddhism in Tibet, came from Nālandā.

Although sealings excavated at Nālandā support accounts of patronage by some of the later Gupta kings (late fifth and early sixth centuries), the earliest monuments as they stand and the earliest sculpture date from the sixth–seventh centuries.[13] The monastery extended on a north–south axis, with vihāras of the usual type as well as prayer halls on the east. Most had at least one upper storey and the vestibule pillars were of stone. On the west side were small stūpas and temples, not surprising since shrines for images were already an important part of monastic complexes in Gandhāra. One can only surmise about the superstructures of these temples; beside one, exceptionally built of stone, fragments of bhūmi āmalakas were found, as well as stones with gavākṣa motifs, implying a 'northern' śikhara. The 'Main Temple' (Site 3) towers over the site, rising, even in its incomplete state, to 102 ft (31 m.) or more [152]. It has been enlarged, in the manner of stūpas, on at least five occasions, and excavators have deliberately left revealed examples of the various stages; it is therefore difficult to comprehend. A long flight of stairs leads to an upper platform and tower-like structures (two exposed) at the corners, their tops missing. Stucco covered the stairway walls and the sides of the two exposed towers; stucco too are the mouldings and the well preserved Buddha and Bodhisattvas in niches. It is still not clear whether the great monument is a shrine, with affinities with the Bodhgayā temple, or a pañcāyatana stūpa.[14] Only the floor

152. Nālandā, Site 3, 'Main Temple'. Fifth/sixth century (restored)

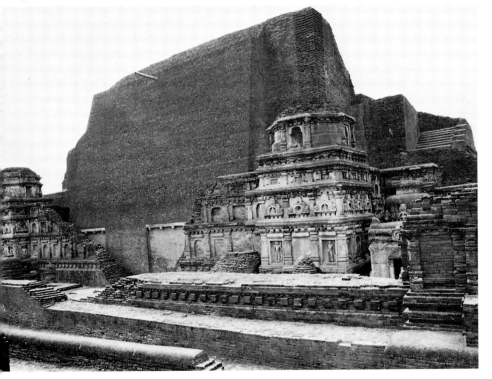

153. Pāhārpur, Somapura vihāra. Late eighth/early ninth century. Plan

remains of the largely determining topmost element, so that it is impossible to say what it was. Unfortunately the same is true about the exact nature of other great Buddhist monuments in brick in eastern India. At any rate, it seems that the distinction between stūpa and shrine is no longer absolutely clear, nor is the possibility of a stūpa-like monument crowned by a śikhara out of the question. Among the very few stone sculptures remaining *in situ* in eastern India, apart from reliefs on rocks or boulders, are those adorning the plinth of another temple at Nālandā (see below).

The recently excavated Antichak, on the edge of Bihār, may be the site of the Vikramaśīla monastery, probably founded by Dharmapāla (*c.* 770-810).[15] As at Pāhārpur and the Salban vihāra at Maināmatī, a large cruciform monument stands in the centre of a large vihāra measuring, like the one at Pāhārpur, approximately 360 ft (110 m.) from north to south.[16] Rising as a stepped pyramid, four large niches at the cardinal points must have housed large seated stucco images, doubtless the Dhyāni Buddhas, as seen on innumerable votive stūpas. Remains in a similar position were found at Antichak. The enclosing Somapura vihāra at Pāhārpur [153], probably also established by Dharmapāla, is far larger, indeed the largest known on the subcontinent, with more than 175 cells of which a very large number were later converted into shrines.[17] The cruciform central monument has a pañcaratha base supporting three terraces with an extension on the north side, opposite the principal entrance to the vihāra. At the centre was a square shaft with walls rising up 80 ft (25 m.) and over 18 ft thick at the top, so that the superstructure must have been massive.[18]

Another important brick-built Buddhist complex was discovered during military construction in the Second World War at Maināmatī, near Comilla in south-east Bangladesh. The Salban (*Śālavana*, 'Forest of Śāla trees'?) vihāra, founded in the sixth century, predates Pāhārpur, which it resembles on a smaller scale, with a less lofty cruciform cen-

tral monument, much modified later. A bronze base found in one of the niches or shrines at the cardinal points shows that metal images of the Dhyāni Buddhas were installed there. The crowning element, as elsewhere, is missing. The bases of all these monuments bear sculptured terracotta panels, particularly at Pāhārpur, where they are interspersed with stone panels. These will be discussed below.

Only on the upper reaches of the Mahānadi have a number of post-Gupta Brahmanical temples survived. The oldest, the stone Devarānī, of which nothing remains above the main cornice, probably belongs to the very end of the Gupta period; the elaborate reliefs which are all that remain of the sculpture belong with the finest late Gupta work, and only a slightly greater decorative exuberance links them to later sculpture in Mahākośala.[19] Of even greater interest are the ground plan of the Devarānī, unique at the time, and the extraordinary great pilasters flanking the outer entrance which must have extended all the way up to the cornice of a second storey. The presence of makaratoraṇas over some of the niches is also of great significance.[20] The Devarānī serves as a reminder that temple architecture was still in an early formative stage at the end of the Gupta period and that experimental types must have existed which are difficult even to conceive of.

The brick Lakṣmaṇa temple at Sirpur in the Raipur District of Madhya Pradesh dates from the late seventh century [154]. The only stone elements are the pillars of the front maṇḍapa, now completely ruined, the door frame of the sanctum, and the platform on which the temple stands. A small vestibule duplicates the one at the Devarānī.[21] The shrine was sarvatobhadra, although the three external 'doors' are blind (*ghanadvāras*).[22] The highly articulated walls have massive pañjaras on each side of the doors, with their little straight *chhajjās* (stone awnings). The base mouldings are massive and complex. Austere pot and foliage capitals, a kapota cornice, and a chequerboard pattern, all in carved brick, the rubbed-down finish

154. Sirpur, Lakṣmaṇa temple. Late seventh century

crisp and smooth, are in a highly individual idiom of the post-Gupta language. The early Latina śikhara, with bhūmi āmalakas, probably consisted of five storeys, the present topmost one a modern restoration. The different storeys, with gavākṣas varying greatly in size, are treated far more architecturally than in other surviving seventh-century śikharas. The doorway to the inner sanctum, of buff sandstone, is a superb example of post-Gupta exuberance combined with invigorating boldness and changes of scale: a sleeping Viṣnu, for instance, stretches over most of the lintel, and the beautiful śālabhañjikā and mithuna pairs flanking the doorway are twice the size of the various avatars of Viṣnu on the outermost frame.[23] The smaller brick shrine at Kharod showed, before its restoration, an equally complex but in no way similar ordering of the exterior and a shrine doorway of breathtaking boldness, with a life-size Gaṅgā and Yamunā on each side occupying the whole height of the opening.[24] Two monastic Buddhist complexes at Sirpur have equally fine decorative brickwork, and some large Bodhisattvas and seated Buddhas built up of separate pieces of stone as at Ratnagiri.[25]

Unlike Sirpur, also on the Mahānadi, Rājjim remains today a place of considerable religious fame.[26] The Rājiva-Locana temple, in spite of many changes through the years, appears to have been begun in the mid seventh century, and the śikhara of the main shrine, though much restored, probably preserves most of its original features. The small reliefs on the pillars and doors of the maṇḍapas and gates are in a bold and lively post-Gupta style quite free, for all its verve, of the folk quality of early Orissa sculpture. There are pillar figures of at least two types. A number of mūrtis in polished stone in subsidiary shrines are in a slightly bizarre but very striking style, which they share with a Viṣnu found at the Lakṣmaṇa temple at Sirpur. At another important temple in Rājjim, the Rāmacandra, the pillars of the maṇḍapa are carved with life-sized women (some with their faces recut)

under trees; here the extreme tautness of the mūrtis has given way to an excessive voluptuousness and even blowsiness.[27]

It is difficult to generalize about the stone sculpture of eastern India prior to the ninth century. None of it can be dated with absolute certainty and, except in Mahākośala, which is in a peripheral style, none is *in situ*, with the exception of the reliefs on the stone base of the Site 2 temple at Nālandā. Opinions vary regarding the dates of important detached

155. Narasiṁha from Shahkund.
Fifth/early sixth century

156. Siddhaikavīra, a form of Mañjuśri,
from Nālandā. *c.* 750.
New Delhi, National Museum

pieces; some, like the Viṣṇu from Hāṅkrail
and the recently discovered one from Nārhatta,
attributed to as early as the Kuṣāṇa period
and the late sixth century respectively, may be
much later.[28] The reliefs on the pillars from
Rajaona, Manghyr District, also usually given
a Gupta date, are also probably later on
account of their quite un-Gupta spatial order-
ing.[29] The appearance of a statue in an area
with no earlier, or even later, tradition of stone
sculpture introduces the further complication
of a possible import. The sixth- and seventh-
century sculpture still betrays influence from
the eastern Uttar Pradesh, whether Sārnāth or
Varanasi, although occasional figures are
masterpieces in their own right – the Shah-
kund Narasiṁha, for example, heavy and mas-
sive, and reflecting to a certain extent the style
found around Gayā [155].[30]

On the other hand the stucco Buddhas and
Bodhisattvas of Site 3 at Nālandā follow in the
Sārnāth tradition in spite of their short bodies,
slightly too large heads, and sharp features,
which make them look rather spidery. They
are seventh-century, like the jagatī of the Pat-
thar Ghatti at Site 2. The figures in their little
keyhole niches are reminiscent of late Gupta
sculpture in Madhya Pradesh, but the squat
intervening pilasters, with vase and foliage as
both base and capital, the tāla corbels, the shape
of the gavākṣas, and the presence of birds on
the kapota, are all in the general seventh–
eighth century post-Gupta style as it can be
seen as far south as Aihole.[31] Free-standing
stone images, mostly Bodhisattvas, usually
slender and elegant although not without a
certain hardness to the modelling, do not
appear until the early Pāla period (end of the
eighth century) [156]. They are in a buff sand-
stone, as is the sculpture from Shāhābād District
until the beginning of the ninth century when
the characteristic dark grey and black schists
from further east take over.[32] The fairly
numerous Viṣṇu images from the eighth cen-
tury are sometimes huge, like the one from
Masārh, Shāhābād District, 10 ft 9 in. (3.3 m.)
tall, now in front of the Patna Museum, and,

plastically very similar, the image from Dāpthū, Gayā District, and several from Aphsad, all in the Indian Museum, Calcutta, as well as those carved on the Jahāngīra rock at Sultanganj. The many four-armed Visnus continue to be portrayed with āyudhapūrusas, their lower hands coming down to rest on cakra and gadā; even when these two weapons are raised and held at shoulder height, the personified forms remain, to be superseded by Sarasvatī and Laksmi only in the Pāla period. Śiva is usually seated with his consort, as in Nepal. Stelae bearing images have rounded tops and are bordered by pearl-rows or ropes, or by a petal or flame motif often in the form of, or combined with, a motif like a question mark.

Finally, a number of eighth/ninth-century sculptures from Shāhābād District introduce an early version of the Pāla style. The figures are more slender, and some are characteristically cut away from their grounds. One of the Visnus wears a straight-sided mukuta.[33]

The vast assemblage of terracotta plaques decorating the basement and other areas of the great monument at Pāhārpur has evoked a good deal of discussion.[34] The plaques are rather roughly executed but full of life. There is quite a strong folk element. Only a few represent deities, so summarily that they are sometimes difficult to identify. On the basement, however, interspersed with the terracottas are sixty-three stone reliefs in a more sophisticated style, almost all carved with deities of the Brahmanical pantheon. These are the sculptures usually illustrated, and they show how long Gupta traits survived in eastern areas of the region. Both stone and terracotta plaques are almost certainly contemporary with the building of the monument at the end of the eighth century. Terracotta plaques of the same general type have been found at Antichak, at the Salban vihāra at Maināmatī,[35] and, in a considerably more sophisticated and probably earlier style, at Bhāsu Bihār, near Mahāsthān.[36]

To the environment of earlier Buddhist vihāras belongs a small but very important group of late and post-Gupta bronze Buddhas, mostly in American museums or private collections.[37] They are simple in conception, devoid as they are of inlays, attendant figures, or prabhāmandalas and relying for their effect entirely on the strength and sensitivity of their

157. Buddha from Sultanganj.
Early/mid seventh century. Copper.
City of Birmingham Museum and Art Gallery, Gift of Samuel Thornton

158. Goddess (Tārā?) enthroned from Sirpur. Eighth/ninth century.
Bronze with copper and silver inlay.
Los Angeles County Museum of Art, Nash and Alice Heeramanecke Collection

159. Tārā from Kurkihār. Early ninth century. Bronze. *Patna Museum*

modelling. The fine and famous Sultanganj Buddha, named after the monastery on the Ganges in Bihār where it was unearthed in the mid nineteenth century, is principally notable for its size: 7 ft 6 in. (2.3 m.) high, it is by far the largest known Indian metal sculpture and one of the largest of the pre-Renaissance world [157]. It is of copper, its clay core braced with iron armatures and mixed with rice husks which have permitted a radiocarbon dating. It was early assigned to the Gupta period, then to as late as the early Pāla period (c. 800). In fact it probably belongs to the early or mid seventh century.[38]

Many more bronzes survive from the eighth century onwards, a lot of them from known sites and a few dated. These are the 'Pāla' bronzes. At the same time there was a correspondingly large increase in the number of metal images cast in western India, in Kashmir, and in southern India. Nālandā yielded the largest quantity of bronzes, followed by Maināmatī and then by Sirpur (the site of an excavated Buddhist monastery as well as the Lakṣmaṇa temple) and Kurkihār, near Bodhgayā. Small undocumented Pāla images are to be found in most museums and private collections. As would be expected, they are mostly Buddhist. The two earliest dated images, however, from Nālandā and from Kurkihār, are of Balarāma (in the reign of Devapāla, c. 810-50).[39] These are also the earliest Hindu bronzes with dated inscriptions so far known in India. They differ only marginally in style from Buddhist icons. In later centuries the proportion of Hindu bronzes increases, just as stone sculpture increasingly portrays Hindu gods.

Pāla bronzes were usually gilded, often inlaid with silver, and their prabhāmaṇḍalas are almost invariably edged with small flames. Where the halo is not solid, struts, often disguised with a blossom, may extend to it from the upper part of the figure – an exclusively Pāla feature. Nālandā images are often distinguished by very strongly shaped mouths and eyebrows. Pāla bronzes vary in size from standing Buddhas as much as 3 ft (90 cm.) tall to small ones measured in inches. They vary equally in complexity, from single figures surrounded by a simple halo to deities seated on intricate thrones raised on multiple bases and accompanied by attendants [158]. Impressive as these are as technical accomplishments, it is the simpler compositions such as the seated Tārā which have a greater emotional appeal [159].

Pāla stone sculpture shares with that of Gandhāra the onus of a vast production, of being instantly recognizable because of the not very attractive stone (particularly when polished) in which it is carved, and finally of an unappealing appearance of metallic precision, in Kramrisch's phrase, particularly in its last and most important phase.[40] To be fair, Pāla sculpture, unlike Gandhāra, is almost always of a high technical standard, and the figures surrounding the main image are usually carved carefully and in considerable detail; occasionally the central figure, generally seated, like the superb Siṁhanāda in Birmingham, is of great beauty [160].

Perhaps the most striking aspect of later Pāla sculpture in its ripest and most luxuriant form is the massing of all the traditional motifs and themes of Indian art – the vegetal scroll, the throne, the makara, the kinnaras and flying *vidyādharas* (the minor mythological figures) as well, in the case of the innumerable standing Viṣṇus, as all the avatars in miniature, the female figures in the most sinuous bhaṅgas and elaborate adornments – around a central figure increasingly rigid and formalized and wearing a particularly vapid and artificial smile. What is more, the icon arises not from the memory of ancient historical events, as in Buddhist images of earlier times, or from timeless myth,

160. Siṁhanāda from Sultanganj.
Twelfth/thirteenth century. Polished black slate.
*City of Birmingham Museum and Art Gallery,
Gift of Samuel Thornton*

but from fairly recent metaphysical and more or less occult speculation. There is no real iconographic invention: the innumerable members of the Vajrayāna pantheon are distinguished merely by the addition of arms and heads and the continual redistribution of the old stock in trade of emblems, symbols, and weapons.

While the earlier post-Gupta sculptors, particularly in Bihār, used sandstone or the grey stone of the Gayā area, Pāla sculpture is almost invariably in a polished form of the much darker schist of the Rājmahāl Hills. Its wide distribution, all the way from Samataṭa (southeastern Bengal) and Varendra (north Bengal), both now in Bangladesh, to western and southwestern Bengal and Bihār, testifies to the excellent communications maintained throughout the Pāla empire. Although the style is remarkably uniform, its nearest equivalent being that of Orissa, regional differences can be discerned, particularly in iconography.[41]

The Mahāyāna, as expounded in the first and second centuries by such teachers as Nāgārjuna, although denying all reality except that of the void or emptiness (śunyatā), was far from pessimistic. The Bodhisattvas were the great exemplars of compassion (karuṇa) (one of the names of Avalokiteśvara was Mahākaruṇika), and the doctrine allowed for the transfer of merit, as attested in countless dedicatory inscriptions of images where the donor asks that the merit he has earned by his gift be transferred to his mother and father and all sentient creatures. Furthermore, the blessed were to be reborn in Sukhāvatī, the most important of the Mahāyāna heavens, under the aegis of Amitābhā. Female deities, counterparts of Buddhas and Bodhisattvas and corresponding to the śaktis of Hindu gods, were early introduced, some (one or two even boasting four arms) already appearing in the late Buddhist caves at Ellorā (seventh-eighth centuries). A considerable element in later Mahāyāna Buddhism corresponds to Hindu *bhakti*, the devotion to a personal god, just as later Mahāyāna ontology is marked by striking parallels to the monism of Śankara.

Buddhism and Hinduism thus veer towards a syncretism, which is eventually most successfully achieved in Nepal and in parts of southeast Asia.

The influence of the essentially esoteric tantric form of Buddhism known as the Vajrayāna (or sometimes Mantrayāna) came to dominate iconography in eastern India, as well, of course, as in Nepal and Tibet.[42] Tantric Buddhism is magical rather than mystical in that the worshipper seeks to attain his desires, whether of union with the god or simply of obtaining powers (siddhis), by compulsion – i.e. by dint of intensive meditation on highly detailed descriptions of the god or on complex diagrams (yantras). Magical formulae or spells (mantras) can also be uttered. Related to the esoteric forms of Hindu worship at the time (vāma mārga) are the largely secret rites in which the taboos of Hindu society are consciously flouted: sexual union takes place with a partner who is envisioned as a śakti, intoxicating liquors are drunk and meat is eaten. Although the existence of such practices is attested by a considerable body of literary evidence in the form of highly technical texts, there is some question as to how widespread they were; the Śaiva tantrism of Gorakhnātha and others, for instance, tended to be concentrated amongst groups of ascetics.

Buddhism was in decline, and the way was open to the triumph in Bengal of orthodox Brahmanical Hinduism (Kūlinism) or the devotional theism of bhakti preached by Chaitanya and already heralded by Jayadeva in the thirteenth century. This corresponded to the great popularity in western India of devotional Vaiṣṇavism and the cult of Krṣṇa (Mīrābai). It is surprising indeed, considering the technical competence and the patronage which must have lain behind the splendid productions of the Pāla workshops, that so many divinities of the Mahāyāna received such elaborate formulation in eastern Indian images. It is in Nepal and Tibet, however, that the tantric Buddhist pantheon was to find its full expression. It is significant that only one image has been found,

at Pāhārpur, of the god in actual coitus with his śakti, while in Tibet it is one of the most common iconographical expressions.[43]

There is a considerable body of exegesis by modern scholars of the *sādhanas*, the prescriptions upon which the images of tantric Buddhism are based.[44] One of the major dichotomies is between *śānta* (peaceful) and *krodha* (angry) gods, or aspects of gods. The 'angry' gods are usually shown in the *ālīḍha* or archer's pose, with the front leg flexed, the rear drawn back stiffly.[45] Crowned and bejewelled Buddhas, unthinkable to early Mahāyāna iconography, now appear, and multiple heads (faces) increase, some, like Mārīcī, incorporating a sow's head, others a bull's. The five Dhyāni Buddhas or Jinas are not only linked to Bodhisattvas but given śaktis; attributed colours, mudrās, magic syllables (*bījas*, literally 'seeds') like *ya*, *hūṃ* or *hriḥ*, and vehicles; and equated with the *skandhas* ('aggregates') and assigned to directions or the zenith, joining the other divinities in more and more complex 'mystic' or cosmological diagrams. New Bodhisattvas, including Kṣitigarbha, increase the original five to eight. Tārā, the most important śakti, takes on five colours, each incorporating one or more forms – Bhṛkuṭī among the yellow, Kurukullā the red, for instance. Over the five Jinas is now set Vajradhara or Vajrasattva, or both, with the Ādi Buddha, the Primordial Buddha, a purely philosophical or metaphysical concept. The Bodhisattvas appear under many names, with corresponding colours, numbers of arms, vahanas, etc., each prescribed in a sādhana. An example is Siṃhanāda, a form of Avalokiteśvara whose name, 'the lion's roar', originally referred to the teaching of the Buddha [160]. Two popular representations of Mañjuśrī, seated in vajrāsana and holding the sword and the book, are called Sthiracakra or Arapacana, depending on their colour and whether they have attendants. Arapacana is a mantra, *a-ra-pa-ca-na*, each syllable assigned as a bīja to one of the five Jinas.[46] As in early Buddhism, but in much greater numbers, gods of Hinduism take their places in the system,

from Mahākāla (Śiva) to the rather obscure horse-headed god Hayagrīva, usually in horrific forms as Dharmapālas (guardians of the Dharma, or Law), descendants of the ancient guardians of the quarters. Numerical imperatives and the five principal colours (white, red, blue, green, and yellow) figure largely in this swarming pantheon, with many iconographic forms created, one suspects, only to complete a series and often embodying a purely abstract concept, if any.

Brahmanical icons were produced in greater and greater numbers as the Pāla period progressed.[47] Liṅgas are the most prevalent. Among Śaiva images, Umā-Maheśvara is at first the most popular, followed later by Sadāśiva. The baby beside the recumbent figure of a woman, once thought to be Kṛṣṇa but now firmly identified as the infant Śiva, is the icon referred to in the sādhanas as Sadyojata. Dancing Śivas and images of Gaṇeśa also occur, and Sūryas, popular throughout eastern India during the whole period, abound. Predominant among Vaiṣṇava images are the four-armed Viṣṇus standing in samapada, very like the standing Sūryas, and identified as one or other of the *caturviṃśati murtayaḥ* (twenty-four embodiments or images) according to which of the four hands of the god holds which of the four principal emblems of Viṣṇu. Already set forth in the Agni Purāṇa (*c.* 850), this is the outstanding Hindu example of the mechanical iconographic creations of later Indian sculpture for tantric Buddhist images.[48] The Trivikrama icon, with the god striding out, is referred to as a representation of the Vāmana avatar because the name Trivikrama had already been pre-empted for one of the caturviṃśati murtayaḥ.

Sculpture in eastern India has now in general achieved a distinctive, highly conventionalized style whose further evolution over a period of nearly five hundred years is relatively easy to trace.[49] At the outset, the stele is rounded at the top, the base has at most one projection (*ekaratha*), and there is often a vahana. The central image continues to be a re-

lief, only its legs cut out from the ground. The stele, edged by a pearl band or a complex leaf moulding, by the end of the tenth century has become slightly pointed at the top, crowned by a kīrttimukha. The base is pañcaratha or even *saptaratha* (having seven projections). The number of attendants has increased, and there are often elaborate throne backs with elephants, vyālas, and haṁsas on either side. Trefoil arches are not uncommon. In the final period, from the end of the eleventh century to the end of the twelfth, the main figure is entirely cut out, but for the head, and therefore in the round.[50] Women's headdresses form great ballooned knots at the side or take the form of flat or mango-shaped caps like those of Venetian doges.

Artistic evaluation of Pāla and Sena sculpture is still in a tentative stage. Scholars who have studied it in detail are naturally inclined to emphasize its aesthetic merits. Picron sees in the proliferation of background figures and ornament an ardour which makes the least of motifs vibrate[51] and, in the massed display of every minor figure and motif of Indian art, an affirmation of iconographic orthodoxy.[52] Kramrisch, in the first study of Pāla and Sena sculpture from an art-historical point of view, published as long ago as 1929, makes the most illuminating comments. She notes the contrast between 'petrified bodies and over-sensitive gestures' and remarks that, as the style progresses, the legs of the central figure become more rigidly columnar, or the bhaṅga more exaggerated, while the treatment of the arms depends not on period but on the quality of the work.[53] The Buddha and the great gods Viṣṇu and Sūrya remain stiff and erect, evidence of the 'unshakeable existence of God', while the Bodhisattvas and the goddesses assume the relaxed poses of *lalitāsana* (where the drawn-up leg is horizontal) and *mahārājalīlāsana* (where it is vertical). Action, as in the frequent ālīḍha pose, even vigorous or violent, conveys an inner attitude, not mere transitory motion. A comparison with the more folk-inspired terracotta sculpture at Pāhārpur makes the distinction quite clear.[54] Contrasting the bustling life of

the ground with the central figure which, in the case of the Sūrya from Gaṅgā Sāgar (now in Philadelphia) [161] is entirely in the round, Kramrisch further shows these later images to consist of two and even three plastic layers; that they remain essentially unified despite such complexity testifies to great innate vitality.[55] She provides a further insight into Pāla art, as well as much other later North Indian sculpture, by the observation that the conscientious delineation of jewellery is prompted rather by a sense of orderliness and an appreciation of wealth than by the 'joyous optical perception' of Cola sculpture, particularly the bronzes.[56] Kramrisch's appreciation of Pāla sculpture ultimately focuses on a dialectic between its abstract and its realistic qualities.[57]

A very few temples survive even from the later period, nearly all of them in the Burdwān, the former Mānbhum, and Baṅkura districts of west Bengal. Most are of brick and all have Latina Nāgara śikharas. They resemble Orissa temples, with the distinguishing feature of having no maṇḍapas.[58] Temple IV, probably the earliest of the Begunia group at Barākar, Burdwān District, is well preserved in stone.[59] Brick temples, usually very dilapidated, are notable for their high sanctum walls (*bāḍa* or *prastāra*) and straight-sided śikharas, abruptly rounded at the top (Siddheśvara at Bahulārā, Baṅkura District; Jaṭār deul in the wild tract of the Twenty-Four Parganas and Khulna districts known as the Sundarbans). There is an interesting but ruinous pair of temples at Dihar, Baṅkura District.[60] Evidence for the use of wood in sculpture and temple architecture is scanty, but one long pillar carved with a woman, in as sophisticated a style as any of the works in stone and probably of the eleventh century, is the most important wooden sculpture to have survived from ancient India.[61]

The typical Bengal temple is of more recent date. It can easily be mistaken for one of the later mosques, built as it is in the indigenous style, with curved eaves and massive pillars and often with multiple śikharas. The terracottas on the walls, in a lively folk style, are of considerable sociological interest.[62]

161. Sūrya from Gaṅgā Sāgar. Late twelfth century. Polished black slate.
Philadelphia Museum of Art

0 | | 10FT
0 | | 3M

162. Sunak, Nilakaṇṭha temple. Tenth century. Elevation (partly reconstructed)

THE LATER HINDU PERIOD

CHAPTER 16

WESTERN INDIA, MĀLWĀ, AND MADHYA PRADESH

The northern Indian temple entered its last major phase in the tenth century over an area extending from the desert city of Jaisalmer down through Gujarāt into Saurāṣṭra and northern Mahārāṣṭra, and including the whole of Madhya Pradesh. Orissa continued to develop a style of its own, although participating in many of the same aesthetic trends. The multi-spired śikhara is introduced, and flat, unadorned wall space begins to fill up [162]. Niches spread to the bases and the lower registers of the śikhara. The mūrtis with their accompanying figures usually occupy a continuous band, often in two and sometimes even three registers; niches with round or square colonnettes frame and separate rather than contain them. Where niches assume a dominant position it is usually, and sometimes in superimposed registers, to accent the *bhadras*, the cardinal or inter-cardinal projections of the ground plan. Walls and superstructure tend to coalesce, with niches perching above the cornice.[1] The increasing number of projections and indentations on plan are carried up through the towering bases and then the walls, forming more and more vertically laminated surfaces. In many temples, the modulations of the ground plan extend buttress-like from sub-base to cornice, where they are continued by *uruśṛṅgas* (subsidiary śikharas) up to the very pinnacle of the temple. In front of the shrine proper, the larger temples soon acquire a closed *maṇḍapa*, then an open hall for dramatic performances or dance,[2] often a

separate building, and, at the very forefront, a free-standing toraṇa, two pillars supporting an *aṇḍolā* (multi-cusped) arch.[3] By the mid eleventh century, Jain temples are surrounded by a rectangle of little shrines, to the number, at first, of twenty-four.[4]

The prāsāda and the maṇḍapas are extremely lavishly decorated outside; barely a square foot has escaped the indefatigable chisel of the stone-carver. The vertical order established in the post-Gupta period still provides the overall framework, often duplicated and even triplicated and transformed beyond recognition by all but the expert eye.[5] The *kapotāli*, the most Indian of all horizontal architectural elements, are knife-edged, with almost no vertical projection, the old gavākṣas and birds reduced to meaningless segments. A new half-rosette on the bottom edge of a moulding is extended upwards to form a tapering triangle. Lotus-petals and gavākṣa honeycombs are carved in the flat 'en reserve' technique. Bands of endlessly repeated kīrttimukhas, elephants, horses, and men take over the base, with vidyādharas further up. The individual elements, although increasingly linear, stereotyped, and repetitive, break up to produce a vibrant surface, yet coalesce into soaring, co-ordinated masses to create what are probably the most moving religious edifices ever conceived.

Contrary to Orissan practice, the passion for ornament spills over inside the maṇḍapas. Columns, niched at the base, rise into intricately sculptured octagonal and circular forms. The

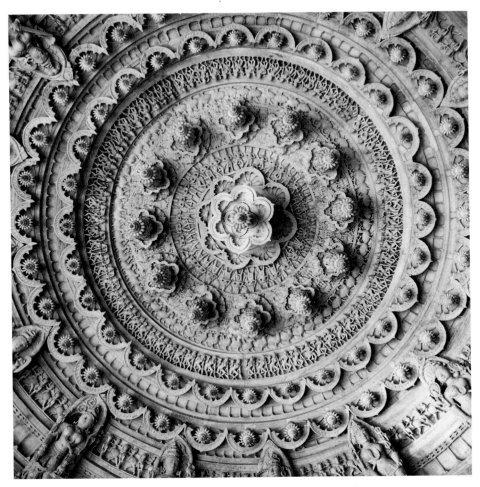

163. Dilwārā, Mount Abu, Vimala-vasahī temple, Sabhā-Padma-Mandāraka, ceiling. *c.* 1150

old circular ceilings gain in elaboration, be-
coming near-domes carved with unbelievable
complexity, as are the straight sections be-
tween the supporting pillars, with vertical
brackets bearing female figures either at the
base or radiating in spokes on the dome-ceiling
itself, from whose centre drop one or more
stamen-like elements [163]. Most elaborate of
all are the meghanāda maṇḍapas, sometimes
two-storeyed, with *aṇḍolā toraṇas* (cusped

arches used exclusively as decoration) between
each pair of pillars. The ultimately trabeate
structure, requiring densely packed supports
which rule out large spatial effects, is unques-
tionably lightened and relieved by the abun-
dance of ornament.

The little temple of Ambāmātā at Jagat (960),
one of the earliest of the period in Rājasthān to
be dated, is both an architectural gem and a
sculptural treasury.[6] Part of its charm derives

from its transitional style [164]. The main śikhara does not stand alone, but most of the smaller ones are simply lined up above the intervening wall space. The most beautiful apsarases and splendid mounted vyālas stand almost in the round against the wall surfaces

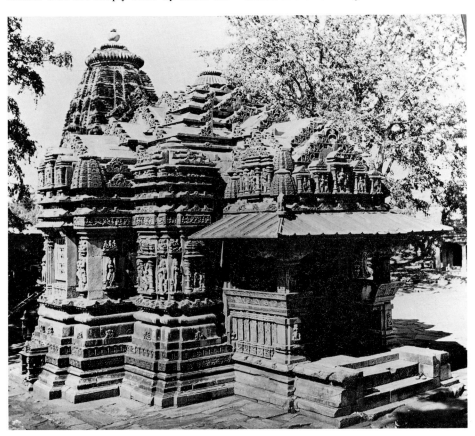

164. Jagat, Ambāmātā temple. 960

cornice of the prāsāda, the closed maṇḍapa, and the porch, the last two with phāṁsanā roofs. Earlier western traits include the geometrically patterned jālas, the double kapotāli cornice, and the large lotus moulding under the niches. The main bhadras and the corner projections have niches with very original udgamas: little low pillared pavilions with seated figures topped by triangular śūrasenas. A square pilaster bearing full-length figures projects boldly from the themselves, and, above, charming pairs of seated figures project with equal boldness, inviting comparison with the large-scale relief figures flanking the niches at the Early Coḷa Puḷḷamaṅgai temple.[7] Above, the width of each projection, are panels of spirited vidyādharas. Except for the dikpālas, the images are almost all of women, as would be expected in a śakti temple. Some of them are of considerable iconographic interest.

The Mahāvīra at Ghanerao, also mid-tenth-century, is another transitional temple of considerable originality if much less beauty.[8] It has, alas, suffered many modifications. The pillars and pilasters of the closed maṇḍapa are remarkably plain. Rather small niches occupy a median band on the walls. With a little antarāla, a closed and then a small open maṇḍapa, and finally a porch, the plan forms a double cross with arms of equal length, very similar, on a more subdued scale, to those of the largest Khajurāho temples, with the notable exception that the pillars of the closed maṇḍapa form an octagon. Ceilings (*vitānas*) are of exceptional beauty and variety, particularly the samatala vitāna over the door, with its central medallion of closely massed dancing figures and battling warriors on vyālas. On the brackets of the utkṣipta ceiling over the same maṇḍapa stand women with children at their feet, sheltered by trees. Underneath are elephants. The twenty-four *devakulikās*, small shrines forming a rectangle open at the front surrounding the main shrine, were built between fifty and seventy-five years later. Unfortunately its superstructure is entirely renovated. Iconographically the temple walls present an extremely rich array of Jain vidyādevīs and yakṣīs.

Other early dated temples are at Unwas (959) and Eklingji (971).[9] Both have base mouldings of a Cola simplicity. Unwas has a single niche in the main bhadra of each façade, and a plain median band running around the walls. Its anekāṇḍaka śikhara is of brick, as occasionally occurs in the region. The walls of Eklingji, the Śaiva shrine of the family deity of the kings of Mewār, are totally undecorated, as earlier at Baroli and Roḍā.

The walls of the Mahāvīra at Sewāḍī (*c.* 1000–25), one of the earliest Bhūmija temples (discussed later in this chapter), are plain except for a single niche in the middle of each façade of the prāsāda.[10] Their starkness is otherwise relieved by a development on plan already present in embryo in the Ghateśvara temple at Baroli and perfectly exemplified in the Navalakhā at Sejakpur, which however has the usual

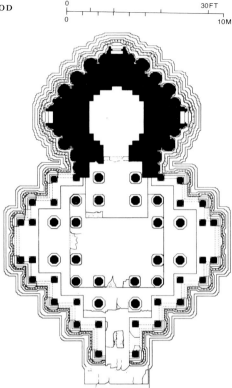

165. Sejakpur, Navalakhā temple. Eleventh century. Plan

lavish decoration [165].[11] The salient corners of the pañcaratha plan, except those of the main bhadras, are capped on the two outer faces by what amounts to a triratha knob, breaking up the wall surface with additional verticals grouped in great clusters, capped above the cornice by superimposed Bhūmija śikharas which carry them up to the very summit of the temple. This is usually achieved, however, with different ground plans.[12]

The kumbha of the base of the Mīrā temple of *c.* 1050 at Āhār (Āhāḍ), an ancient site just outside Udaipur, demonstrates an early stage in the pointed triangular development of the half-rosette motif which eventually reached the mosques of Gujarāt.[13] The fine sculpture is more angular, more linear, more tormented in its

compositions than at the Ambāmātā at Jagat, but still vibrant with life. The Sās-Bahu at Nāgdā, in the immediate neighbourhood of Eklingji, with its famous twin shrines, is a rare example at this period of a Rājasthāni temple on a large jagatī.[14] The toraṇa of the Mahāvīra temple at Osian was added in 1018, and it is to the eleventh century that most of the devakulikās belong. Their ground plans, dictated by their *latina* (single-spired) superstructures, are more in accordance with eighth- and ninth-century types.

The remarkably uniform building style can be seen fully developed by the middle of the eleventh century.[15] The Sun (Sūrya) temple at Moḍherā (unfortunately without its śikhara), with its superb holy tank, its steps, platforms, terraces, and miniature shrines, is very well known [166 and 167].[16] In the underground cella of the sanctum stands the pedestal of the Sūrya image. The *raṅgamaṇḍapa*, a hall for the performance of music and dance, is later. Many other fine shrines, unfortunately few with their śikharas intact, survive throughout the area, from the far west (Kirāḍu) to deepest Saurāṣṭra.[17] Mostly lacking a jagatī, they have a very high and sparsely decorated *kumbha* or pot-shaped moulding at the base and a chādya projecting at the bottom of the śikhara. The best example, including a rather stumpy multi-turreted tower, is the Śiva temple at Kirāḍu, which still has its superstructure entire [168].[18] Other distinctive features include a large reverse-curve lotus moulding in the 'reserved' technique at the very base, not unlike that of early Coḷa temples but much more textured, and a strict formula for the arrangement of the bands on the sub-base, although the zone of humans is sometimes replaced by lively scenes from the Kṛṣṇalīla or the Rāmāyaṇa.

The plans of the prāsādas derive from the pañcaratha[19] forms of the previous period,

166. Moḍherā, tank and raṅgamaṇḍapa. Eleventh century

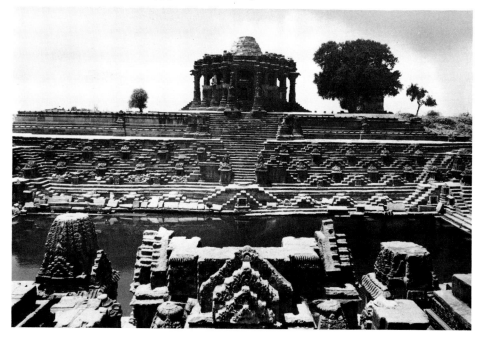

167. Modherā, Sun temple.
Eleventh century. Plan

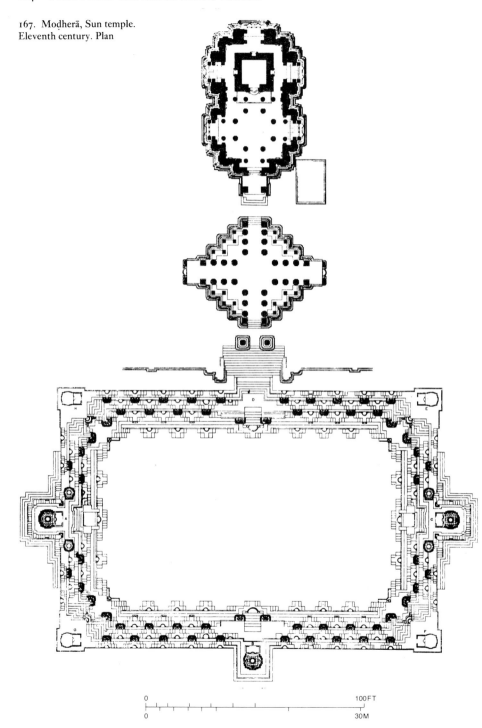

0 100 FT

0 30M

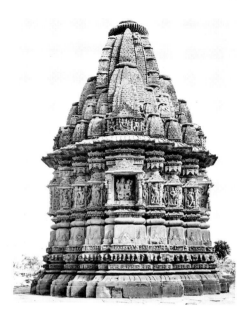

168. Kirāḍu, smaller Śiva temple, from the east. Eleventh century, second quarter

although it is difficult at first sight to understand how [165 and 168]. What has happened is that each set-back of a façade (on plan), except usually in the central bhadra, is of equal length to the following section of wall (which is always parallel to the bhadra), so that a square is transformed into a diamond, except for the flattening at the tips where the bhadras, bearing the principal niches, remain. The projecting angles or corners then swell, as we have seen, into many-faceted buttress-like projections. These greatly expanded corners bear figures on their two 'outer' faces, almost always in niches formed by the usual colonnettes, frequently flanked by thicker, square or rectangular ones, usually segmented. Apsarases or *munis* (sages or seers), rarely vyālas after 1050, stand in the intervening recesses. The

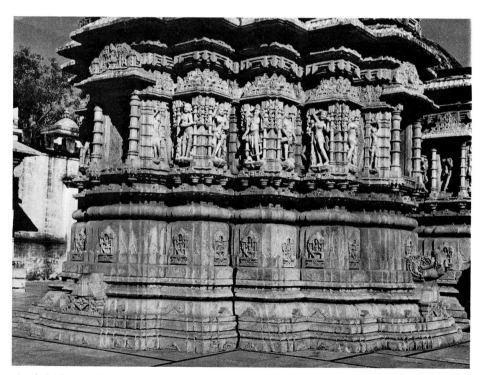

169. Sādri, Pārśvanātha temple, from the south-east. *c.* 1000

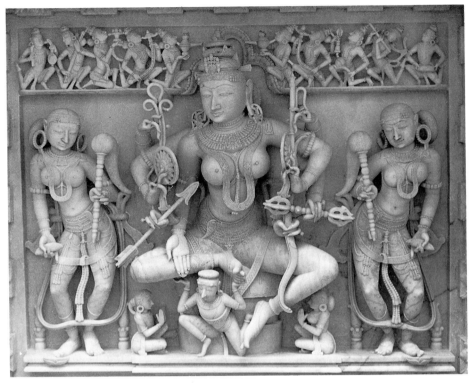

170. Dilwārā, Mount Abu, Vimala-vasahī temple, goddess. *c.* 1150

niche pediments have become lacy triangles in which the gavākṣa components are barely traceable. Each of the amplified corners then changes into a round pillar topped by a capital so stylized that one cannot tell whether it is pot and foliage or fan-palm; at any rate, it consists of prominent but plain lanceolate elements dropping from the corners of a thin abacus. The niches of the deep bhadras are echoed by an equally large niche above the cornice. Along with the Kirāḍu and Saurāṣṭra temples, the fine Padmaprabhā at Nāḍol near Rāṇī and Pārśvanātha at Sādri near Rāṇakpur [169] bear witness to the wide dissemination of the style.[20]

The closed maṇḍapa preceding the sanctum in all but small and usually accessory shrines continues the vertical order of the prāsāda up to the main cornice. Above, the roofs are usually saṃvaraṇā, with up to a score or more 'bells', as in the splendid Mahāvīra at Kumbhāriā.[21] The pillars and ceilings, now veritable domes, are as richly carved as the exterior. Figure sculpture takes the form of corbels ending in human torsos (always male) and bracket figures (always female), and some of the ceilings are richly peopled [163 and 170]. In such temples as the Vimala-vasahī at Dilwārā (Mount Abu) [171] and the Samiddheśvara at Chitor, additional light is admitted by an entrance on each side as well as at the front.[22] The raṅgamaṇḍapa, however, is largely open, so the order and sequence of the prāsāda is not carried above the *pīṭha* (sub-base). Its short walls

usually take the form of blind balustrades, topped by a seat-slab and its kakṣāsana. Dwarf pillars (full-scale ones in the interior) support the roof. Except for the abundance of decoration, the presence of aṇḍolā toraṇas between the pillars, and the occasional second storey, the arrangement is much the same as in the preceding period.

The finest standing raṅgamaṇḍapa, in this case detached, is at Modherā. It adheres largely to the basic types of pillars and architraves, as do the smaller, ruined raṅgamaṇḍapas of the

Viṣṇu shrine at Kirāḍu and the Sās-Bahu at Nāgdā, two hundred miles apart. At Modherā, the sculptural decoration of every inch of the surface, the lavish use of aṇḍolā toraṇas, and the rather febrile style of the figure carving all help to lighten a rather stolid building.[23] Exceptionally, the short walls bear mūrtis in small niches.

Including its holy tank, the Modherā temple extends some 250 ft (75 m.) along the main axis. The twelfth-century Śaiva Rudramahālaya at Siddhpur, also in northern Gujarāt, was of

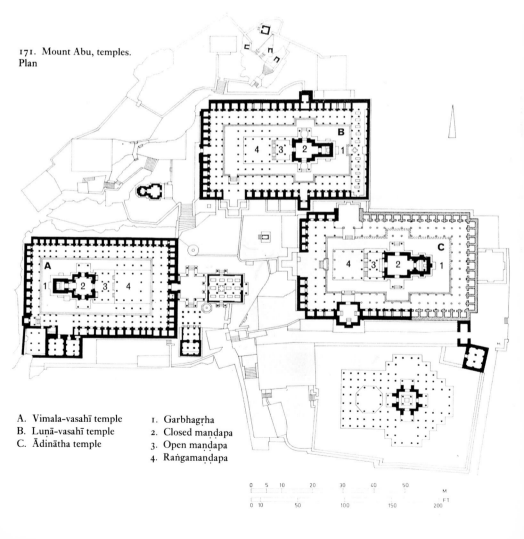

171. Mount Abu, temples.
Plan

A. Vimala-vasahī temple
B. Lunā-vasahī temple
C. Ādinātha temple

1. Garbhagṛha
2. Closed maṇḍapa
3. Open maṇḍapa
4. Raṅgamaṇḍapa

0 5 10 20 30 40 50
 M
0 10 50 100 150 200 FT

equal extent if the symmetrical array of sub-sidiary shrines is included.[24] Of the great Śiva shrine, however, there only remains a toraṇa and a little of the two-storey raṅgamaṇḍapa. Of the great temple of Somanātha at Somanātha Pāṭan (Prabhās Pāṭan), rebuilt after its destruc-tion by Mahmud of Ghazni in 1025-6 and again on a grand scale in 1169, spoliation has left little more than a ruin.[25]

Special to the south of our area, particularly Gujarāt, with outstanding examples at Jhinjhavāḍā and Dabhoi, near Baroda, are the elaborately decorated town gateways, which appropriate some of the stylistic features of temples. So do the step-wells, including the Rāṇī Vāv (eleventh-century) outside Anahilwāḍa Pāṭan, perhaps the earliest and most ornate, lined as it is with images in niches like the walls of a shrine.[26] The slightly later Sahasra Liṅga Talāv has the impressive remains of an intricate network of canals and sluices with bathing steps and shrines.[27] The Mādhavā Vāv in the Surendranagar District of Gujarāt, to a different design and belonging to the thir-teenth century, is fairly well preserved but has hardly any sculpture inside.[28]

The Vimala-vasahī at Dilwārā or Delvada (Mount Abu), begun in 1032, marks the be-ginning of a development peculiar to the Jains in western India. The temple is walled in by rows of small shrines, so that only the śikharas are visible from outside: in fact it becomes an interior precinct, increasingly colonnaded and roofed, where the prāsāda and gūḍha (closed) maṇḍapa occupy quite a small area and are visually not very important. The wall of shrines, it is true, has a long history, and the enclosure and roofing of much of the temple is not foreign to the south of India. The Vimala-vasahī is constructed entirely of white or shaded marble from nearby Kumbhāriā, where there is another important group of shrines in the same stone. It is the principal aim of architect and sculptor to beautify the interior.[29] Some columns run on above an additional set of corbels to gain additional height. The porcelain-like marble lends an

ethereal purity. Because it is near-transparent, and because of the light from open spaces and double-storey maṇḍapas, the interiors have none of the gloom of similar South Indian halls. There is however an inherent insipidity about the stone which lack of variety and dif-ference of scale in the larger elements does nothing to relieve: the fifty-four surround-ing devakulikās, for instance, are practically identical.

The sculpture, however, can be startlingly beautiful [163 and 170]. The ceilings outside some of the little shrines are carved with a riot of themes from the Kṛṣṇalīla and other Brah-manical texts, and individual figures of great verve and beauty form patterns of astonishing inventiveness. A curious, somewhat later, and rather uncanonical addition is the elephant-hall, with rows of these beasts bearing on their backs a minister and his son and their ances-tors. In the very similar Lūṇa-vasahī near by, built in 1232-48 by the minister Tejapāla, the elephant-hall is integrated behind the sanc-tum, separated by perforated stone grilles.[30] Such halls never recur. All these temples are well documented both in devotional literature and in the inscriptions lavished by the western Indian Jains on their monuments and images.

Nowhere is Jain iconography so rich, var-ied, and distinctive as in western India.[31] The vidyādharas and yakṣīs have parallels in the Brahmanical pantheon; more original are the intricately worked stone medallions and ceil-ings and the carved or painted yantra panels. Dated metal images survive in their thousands, and a progression can be traced towards stereo-typed and even geometric forms. They are often inlaid with silver, or zinc. Temple sculp-ture abounds in rare – sometimes unique – representations, usually to established formu-las. Additional arms and symbols from an old and familiar store are combined in many dif-ferent ways to swell the ranks of a pantheon to which metaphysical speculation or sectarian predilection were constantly adding new mem-bers.

Sculptural style is once more unsectarian.[32]

Full, rounded forms become more slender and linear, no longer burdened with the heavy jewellery of the men and women at Baroli. The large, spherical breasts, sharply indented waists, and heavy hips of the traditional Indian aesthetic give way to more slender feminine forms. The delicious surface modelling of fleshy areas vanishes. The 'fascination with beautiful women' persists, however, amount-ing almost to an obsession.[33] Limbs are over-extended, poses angular and skilfully con-torted. Faces remain broad, but are dominated by huge almond-shaped eyes; noses (where they survive) grow sharp and thin, the chin clearly defined. For all the vibrancy of their often exaggerated poses, the women are lan-guid, absorbed in all sorts of dalliance. Figures twist around their axes to the point of nearly

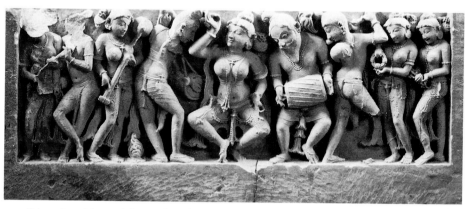

172. Frieze of musicians and dancers from the Purāṇa Mahādeva temple, Sikar.
c. 973. Cream and tan sandstone.
Cleveland Museum of Art, John L. Severance Fund purchase

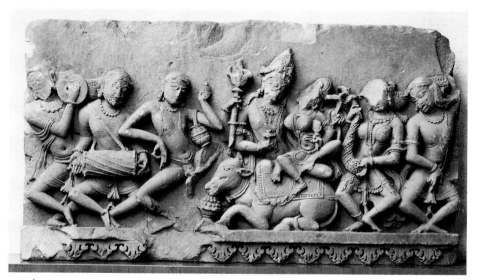

173. Śiva and Pārvatī on the bull Nandi, flanked by musicians and dancers,
from the Purāṇa Mahādeva temple, Sikar. c. 973.
Kansas City, William Rockhill Nelson Gallery of Art, Atkins Museum of Fine Arts

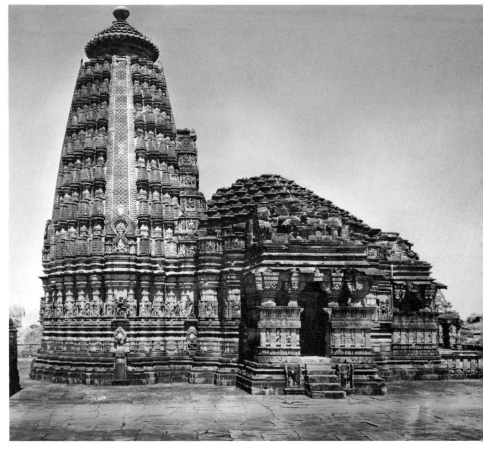

174. Udaipur, Udayeśvara temple, from the south. 1059–80

presenting both a rear and a front view: at the back, the lower half of the body is treated with particular poignancy. Perhaps the most successful stylization is the stick-like feminine leg, stiff throughout its length and bent slightly backwards.[34]

This transformation in aesthetic goals and values, one of the four or five great watersheds in the long history of Indian sculpture, is well illustrated in two superb friezes, both believed to come from one (or two) totally ruined temples near Sikar, in the former Jaipur state and one of the northernmost sites in Rājasthān.[35] In

the first, the rhythm of the dancer and her skilfully grouped attendant musicians is conveyed with great subtlety in a variety of strikingly beautiful poses [172]; note especially how the figures at the ends are smaller than the principal one. The other frieze is manifestly later; here the writhing legs forming repeated geometrical patterns give a wilder, stronger rhythmical effect [173].

The Bhūmija temple[36] is principally to be identified by its śikhara. It is anekāṇḍaka, its uruśṛṅgas, numbering up to nine and gradually decreasing in size, in rows of as many as four

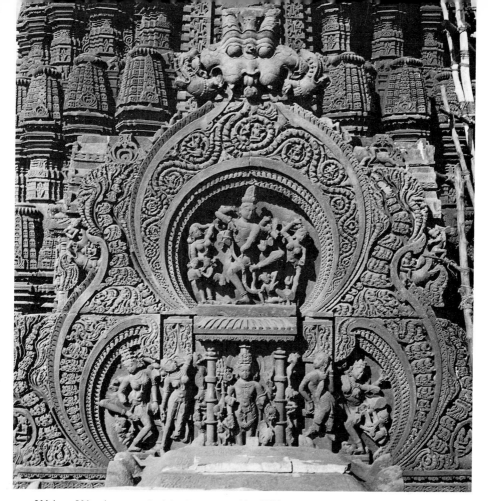

175. Udaipur, Udayeśvara temple, śukanāsa, eastern side of śikhara. 1059–80

between each of the four spines (*latās*) which rise up at the cardinal points from the main bhadras and the śukanāsa. The earliest Bhūmija temple appears to be the Mahāvīra of the first quarter of the eleventh century at Sewāḍī, Pāli District, in Rājasthān, although the plain, heavily plastered superstructure and plan indistinguishable from that of the typical western Indian temple of the time render it slightly suspect.[37] Although Bhūmija temples are to be found in Rājasthān and northern Mahārāṣṭra, with one or two in Gujarāt and eastern Madhya Pradesh, most are in Mālwā, where the type is

believed to have originated. Almost always nirandhāra, the plans are either of the type just discussed or circular–cum–stellate, where a square is rotated around a central point, producing angular projections.[38]

The Udayeśvara temple at Udaipur, not many miles from Vidiśā in Madhya Pradesh, is generally acknowledged to be the finest of the Bhūmija temples [174]. Begun in 1059 and consecrated in 1080, it is saptaratha and saptabhūmi, seven superimposed rows of little spirelets, five to each row, standing on individual supporting podia (*kūṭastambhas*) and growing

progressively smaller towards the summit.[39] In conjunction with the plan, the effect is of clearly demarcated ribs or buttresses soaring up from the lowest element of the sub-base all the way to the āmalaka. A single register of large figures, each framed by colonnettes, is crowned not by a pediment but by a kūṭastambha which, interrupted by the multiple mouldings of the cornice, supports one of the bottom-row spirelets. The recesses between the figures are filled with a bold lotus scroll. A multiple niche at the base of each latā is surmounted by a large gavākṣa and then by a kīrttimukha, rare in northern India; further tiers are added to the exceptionally high śukanāsa, with niches rising one above the other on its sides as well [175]. The doorway to the sanctum is a superb example of this period, the flanking pilasters now projecting to half their diameter while the pavilions of the lintel stand out in much higher relief than hitherto. The very large cruciform closed maṇḍapa, with porches and entrances on three sides, is covered by a fine saṁvaraṇā roof. Surrounded by seven subsidiary shrines, on a lofty platform, the Udayeśvara is one of the grandest temples in India, mercifully preserved almost intact.[40]

The fine 'Sūrya' temple[41] at Jhālrāpāṭan is exceptional in having uruśṛṅgas on the latās, as well as two registers of sculpture. In the same region, the Band Deorā at Rāmgarh (Kotah District) has more obviously western Indian traits, such as the numerous bands on its base, with an extra frieze and a reverse lotus moulding in the sub-base.[42] The pilasters flanking the doorway are in fact pillars, completely in the round. The sculpture is stiff and lifeless. A number of these temples have busts of Śiva cardinally placed at the base of the āmalaka, corresponding to the faces of a caturmukha liṅga. The Bhūmija temple is a splendid creation with a well proportioned superstructure, its regularly arranged little subordinate śikharas strung out, in Stella Kramrisch's phrase, like 'gigantic beaded garlands'.[43]

Navabhūmi temples (with nine superimposed rows of miniature śikharas), such as the

Siddheśvara at Nemawar in Mālwā and the Uṇḍeśvara at Bijolia (Bhilwara District) in Rājasthān, are notably unsuccessful. The topmost row of *śṛṅgas* (miniature śikharas) are too small and too crowded, the whole silhouette too pointed and curving inward too much at the top.[44] The type has sanction in the śāstras, but is patently unmanageable, at least by the builders involved – a clear example of the conflict of one of the categorizations so dear to the śāstras with constructional and aesthetic verities.

In northern Mahārāṣṭra the well known Ambarnātha temple (1060) has affinities with the Udayeśvara, while the triple-shrined temple at Balsāne (Dhulia District) and the Maṅkeśvara at Jhodga (Nasik District), as well as the Goṇḍeśvara at Sinnar, are related both to contemporary Karṇāṭaka temples and to those of Rājasthān.[45] In Gwalior Fort, that architectural treasure-house, the larger of the two Sās-Bahu temples, of the end of the eleventh century, was one of the great shrines of the period.[46] Its prāsāda no longer exists, but the size of the three-storey maṇḍapa, with its cruciform plan and multiple balconies, suggests that it may have been Bhūmija, as does the fact that it was a royal foundation.[47]

Khajurāho in east-central Madhya Pradesh was the capital of the Candella kings from the early tenth to the twelfth century, yet no secular buildings at all remain in what is now a mere village (apart from the appurtenances of a much visited tourist site). That building and sculpture in stone were exclusively dedicated to religious ends is proved by the thirty-five or so temples at the site, most of them intact, a number more in ruins – in their ensemble the greatest achievement of the North Indian temple builders, covered with an almost unbelievable abundance of sculpture and cradled in a largely bucolic setting.[48]

Three or four temples, built unlike the others of granite, or of granite and cream-coloured sandstone, are distinct from the rest. The most interesting is the Chauṅsaṭ Yoginī (sixty-four female tantric goddesses). The survivors of the sixty-four cells around a rect-

angular court (perhaps the only remaining non-circular layout among temples of this type in India) have primitive Nāgara śikharas.[49] Close inspection of the plain mouldings of these little shrines and their doorways, the presence of śukanāsas, and the median bands on the walls all point to their being provincial, almost 'jungly' (*jangala*), realizations, probably hampered by the intractability of the stone, of more sophisticated buildings rather than the products of a much earlier stage of development. They have been dated to the last quarter of the ninth century.

Somewhat later and more developed are the Lālguān Mahādeva, the Brahmā temple, and the sizeable Mātangeśvara, the first to be all of sandstone. They are plain and lacking in decoration or sculpture, in total contrast to later temples, and their śikharas are non-Nāgara. For all that, the Mātangeśvara is a sophisticated conception, its extremely prominent bhadras surmounted by large balconies. The markedly pyramidal bhumiprāsāda superstructure, topped by a ghanṭā, is divided into shallow rathas and varied by the large but rather embryonic uruśṛngas on three sides and a śukanāsi of a sort. Non-Nāgara superstructures will appear no longer over the prāsādas of Khajurāho temples but rather in a rich assortment over manḍapas and little subsidiary buildings like the Varāha shrine and the

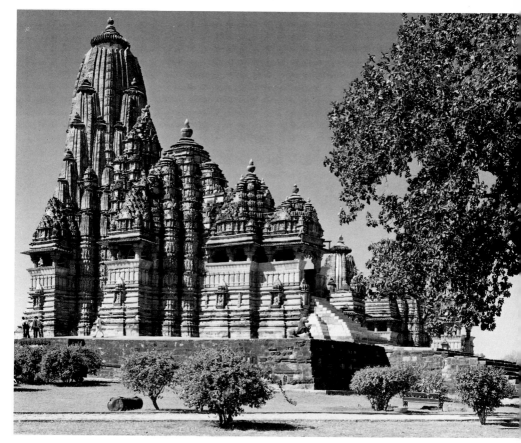

176. Khajurāho, Kaṇḍarīya Mahādeo temple, from the south. *c.* 1000

Nandi maṇḍapa of the Viśvanātha temple. Less than half a century older than the better known ones, the Mātaṅgeśvara and the other early temples suggest either a suddenly aborted line of architectural development or, as suggested above, a distinct type.[50]

The principal temples at Khajurāho, whether Śaiva, Vaiṣṇava, or Jain, betray negligible architectural differences of sectarian origin;[51] indeed they represent the apogee of the central variant of the North Indian temple style during the later Hindu period. The most distinctive examples, and the grandest at Khajurāho, are relatively early, built between 950 and 1050. Considering their modest and atypical predecessors, it is astonishing that the style should have reached its zenith in so short a time. The slightly later temples, like the Ādinātha and the Duladeo, show a *rapprochement* to architectural styles further west, as well as a thinning out of the sculptural style.

The Kaṇḍarīya Mahādeo, the Lakṣmaṇa, and the Viśvanātha, all oriented towards the east, are the most fully developed at Khajurāho and the supreme achievement of the unitary temple structure in India [176]. The plan is a double cross with arms of equal length [177]. A high flight of steps leads to a small open mandapa, followed by a larger columnar maṇḍapa, which in turn leads to the large closed maṇḍapa, its four central pillars supporting an elaborate utkṣipta ceiling. The space around the garbhagṛha, with its small antarāla preceded by two pillars which accent the hall space beyond, all contained and modulated by the outer walls, go to create an exceptionally spacious and rationally planned interior, unusually well lit on account of the wide passages or transepts leading to balconies on the bhadras of both prāsāda and closed maṇḍapa. The passages are of equal length, for the plan is a true double cross. Both prāsāda and closed maṇḍapa are saptaratha (pañcaratha in the Lakṣmaṇa), but the plans are diamond-shaped, of the kind noted above. The Lakṣmaṇa is pañcāyatana, as originally was the Viśvanātha.

The greatest variations in elevation consist in the superstructures over the maṇḍapas and the design and proportions of the multi-spired śikharas. The three temples stand on high platforms, in the Lakṣmaṇa decorated with long friezes. Sub-base and base are very high. The base has small niches in the centre of each bhadra and a further niche each for the maṇḍapa and the porch. The mouldings are

177. Khajurāho, Kaṇḍarīya Mahādeo temple. *c.* 1000. Plan

0 10FT
0 3M

N

still bold, with prominent curves and well-defined elements, although the kapotālis, as further west, are thin. The four bands of the sub-bases of many western Indian temples are reduced to three, with narratives or scenes from daily life a frequent substitute. Lively, unsophisticated, in a style tinged with folk art, these scenes, which include incidents from the ubiquitous Kṛṣṇalīla, are of considerable interest for social history. Much of the purely decorative work is lifeless and cursory, particularly the vegetal scrolls, in a 'reserved' technique with the minimum of cuts, and pendant elements below mouldings are often reduced to plain triangular, sometimes overlapping, teeth. On the wall above the base, except where balconies intervene, are three registers of sculpture, each forming a continuous band, punctuated not by niches, or even by framing colonnettes, but by the projections and recessions of the walls. Constantly repeated are a male divinity flanked by two female attendants, and then by vyālas, on a pañcaratha projection. An exceptionally high śukanāsa fronts the śikhara, topped by a lion and warrior figure. The śikharas themselves cluster uruśṛṅgas around them, rising to varying levels, and numbering as many as eighty-four on the Kaṇḍarīya Mahādeo.

The Kaṇḍarīya Mahādeo is the largest of the temples, its śikhara reaching 102 ft (31 m.) above the platform, and aesthetically the most successful; that it is in fact of no great size is disguised, in the manner of so many of the finest Indian temples, by its breathtaking monumentality. The effect, as in all great buildings, is differently achieved or emphasized according to the point of view. In profile, it soars by virtue of the progressively rising roofs of the maṇḍapas, culminating in the śukanāsa in front of the main śikhara. Internally, the steady ascent is marked by an upward step at each of the halls, finishing at the garbhagṛha. Stability is emphasized first by the unusually great outward slope of the lower base mouldings, as if to grip the platform, then by their horizontal lines, and particularly by

those of the wall surfaces with their thrice-repeated continuous bands of large figure sculptures. The balconies, their long horizontal openings shaded by prominent stone awnings, provide the same horizontal emphasis for the maṇḍapas. At the same time, as in so many temples of this period, great buttress-like projections rise from ground level up beyond the cornice and, metamorphosed into uruśṛṅgas, terminate at different points around the main śikhara. Nowhere is this soaring effect more lyrically achieved than in the Kaṇḍarīya Mahādeo, its multitude of śikharas shooting up to various heights. Bolts fired at the firmament at the top of their trajectory, or the jets of a fountain, come to mind as visual similes, but the master image is the world-mountain, Meru, surrounded by lesser peaks – a conception basic to the Indian temple.

Through an aṇḍolā toraṇa springing from the mouths of makaras, thus also a makaratoraṇa, arched between the two outer columns of the porch (not preserved in the Viśvanātha), the worshipper enters the slightly wider open maṇḍapa, with the usual benches and sloping seat backs between the pillars. The square of piers in the centre of the closed maṇḍapa is transformed by architraves into the circle of the elaborate utkṣipta ceiling, surrounded by smaller ceilings. The garbhagṛha is entered through an elaborate doorway, preceded by two or three ardhacandra steps which raise the floor level to the highest point of the interior. There is no dearth of images, placed in accordance with the ritual and devotions of the Śaiva tantric system.[52] Apsarases are tenoned into the corbel-brackets or the ceiling corners of the closed maṇḍapa; the most famous, from the Lakṣmaṇa temple, are now in the Indian Museum, Calcutta [178]. On the external walls of the garbhagṛha are two or three registers of images and attendants corresponding to those on the exterior of the prāsāda. Cunningham counted the astonishing number of 646 on the outside and 226 on the inside of the Kaṇḍarīya Mahādeo, most of them 2½ to 3 ft (75–90 cm.) high.[53]

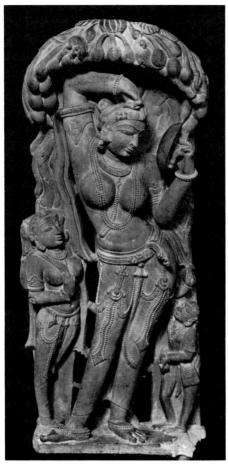

178. Lady with a mirror, bracket figure
from the Lakṣmaṇa temple, Khajurāho.
c. 1000. Sandstone. *Calcutta, Indian Museum*

The walls of other important temples at
Khajurāho with simpler and less extensive plans
bear the same double or triple tiers of sculp-
ture. The Pārśvanātha, although sāndhāra, is a
simple rectangle without transepts (and hence
balconies) but with a curious separate shrine
at the rear. The appearance is box-like,
underlining the importance of the build-up

of maṇḍapas in the temples just discussed.
Citragupta and Jagadambī are nirandhāra,
the balconies restricted to the mahāmaṇḍapa.
Caturbhuja and Vāmana are *ekāṇḍaka* (single-
spired). Here the balconies on the prāsāda are
replaced by superimposed niches at the bhad-
ras, framed by round or square colonnettes, in
accordance with general practice in western
India and Madhya Pradesh. A particularly
good example of this is the Duladeo, probably
the last important temple to be built, relatively
small and on a stellate plan. The prāsāda and
śikhara are among the most beautiful at Kha-
jurāho. Some of the sculpture is extremely in-
dividual – still angular and plastically rather
thin, it has a specially hieratic quality and is
innovative in costume and headdress. Finally,
the Nandi pavilions of the Viśvanātha and the
Varāha are two distinguished little shrines. Ex-
cept that it is open on all sides, the Viśvanātha
Nandi, with parapets and seat backs between
the pillars supporting the saṁvaraṇā roof, is
simply a detached version of the open
maṇḍapas on the larger temples. The Varāha
Nandi pavilion houses a huge black stone
image of the Boar.

The multitudinous deities on the walls in-
clude avatars of Viṣṇu, Śiva in many guises,
Mātṛkās, *parivāra* deities (i.e. positioned accord-
ing to strict precepts), and the dikpālas, an un-
precedented number of them with consorts.
Invariably pleasing, they are monotously alike
on account both of poverty of iconographic
invention and the fact that the image, in mov-
ing to the walls of the temple, loses much of
its particularity. Exceptional are the composite
images – Harihara Pitāmāha or Dattātreya, Hari-
hara Hiraṇyagarbha (Sūrya with the features of
Brahmā, Viṣṇu, and Śiva), and a six-headed,
four-legged, twelve-armed Sadāśiva combining
the characteristics of Brahmā and Viṣṇu.

The cult images, also stereotyped, usually
stand in samapada. An exception is the Viṣṇu
of the Caturbhuja; the makaratoraṇa behind
his head evokes later Coḷa images [179]. In
general, gods and goddesses are distinguished
by their headdress, by a diamond-like mark on

their chests, by a *vanamālā*, the long flower-garland reaching to or below the knee, and (rarely) by having more than two arms. As

179. Khajurāho, Caturbhuja temple, Viṣṇu Caturbhuja. *c.* 1050

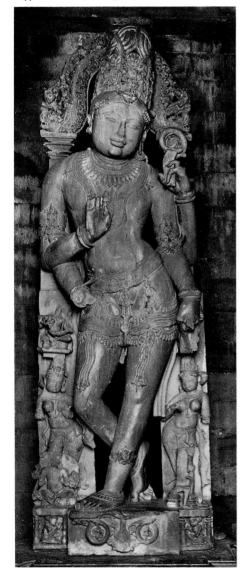

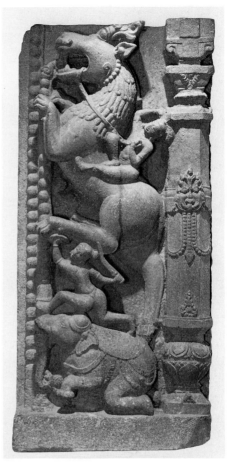

180. Vyāla perhaps from Madhya Pradesh. Tenth/eleventh century. Granite. *San Francisco, Asian Art Museum, Gift of the Asian Art Museum of San Francisco*

usual, most memorable are some of the countless feminine figures, apsarases and *surasundarīs* (beautiful inhabitants of the heavens), under a tree in the age-old tradition of the śālabhañjikā,[54] standing as attendants in a flexed pose, or – best of all – languid and nonchalant, adjusting their hair, fingering a breast or an eyebrow, with the total concentration which only the

privileged of a very sophisticated society have ever been able to focus on their own persons. As in western India, the hallmarks of the style are the sharp edges and acute angles of their infinitely varied and sometimes contorted poses, some at the very limits of credibility. In the earlier temples, among them the Lakṣmaṇa and the Pārśvanātha, figures are heavier, shorter, and more rounded than they later became in, for instance, the Kaṇḍarīya Mahādeo [181]. The lion-and-man groups, and, to a lesser degree, the vyālas, are quite different; their qualities are summed up by Stella Kramrisch, the most inspired of all writers on Indian art, as 'neither baroque nor . . . romantic; it has nothing to do with idealism but builds with symbol-elements of form the concrete reality (*mūrti*) of the work of art' [180].[55]

The women are instinct with a sophisticated eroticism. A great deal of speculation, some of it reaching the wilder shores of fantasy,[56] has been evoked by the multiple groups engaged in complicated and often well-nigh acrobatic forms of sexual union [181]. Erotic sculpture has formed an important part of the Indian tradition from earliest times, ranging from men and women standing in mere proximity to explicit depictions of every kind of frankly sexual activity.[57] Almost certainly they appear on religious buildings partly because they are considered auspicious, associated as they are with fertility and joy. Another reason, often given by the man in the street in India, is that they protect the temple from lightning, which may at first appear risible; but in fact they do have apotropaic roles. The groups of as many as four men and women engaged in various forms of coition, on the same level and of the same size as the images of the gods, may be somewhat similarly explained. It was recently pointed out that they occur only on the outer walls of the antarāla, which joins the prāsāda to

181. Khajurāho, Kaṇḍarīya Mahādeo temple, mithuna figures on the south outer wall of the antarāla. *c.* 1000

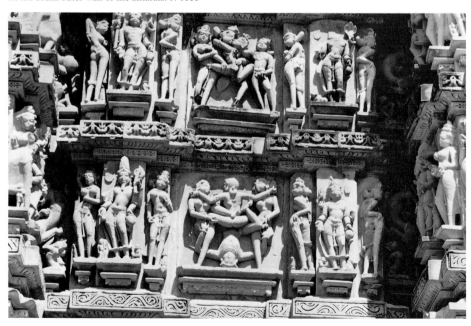

the maṇḍapa,[58] an area for which there is no prescribed iconography. What is more, it is a junction, and junctions or transitions are traditionally places of weakness or danger, and therefore in need of special protection; in some temples the prāsāda and maṇḍapa, their masonry bonded insufficiently or not at all, have separated.[59] But the elaboration of the sexual acts at Khajurāho would appear to be simply a manifestation of the sophistication, not without a certain playfulness, which pervades so much of the sculpture there.

There is no parallel in the north for the second flowering of Hindu and Jain architecture which takes place in parts of western India in the fifteenth century, two centuries after the conquests of the Delhi Sultanate and the virtual elimination of Hindu power north of the Vindhyas.[60] Centred on Mewār, it was due partly to the protection afforded by the military prowess of that kingdom's rulers and the staunchness of its clans, partly to the wealth of the Jains and their assiduity in building up their great mountain centres of pilgrimage, notably Girnār, Śatruñjaya, and Mount Abu.[61] The style, of a fair degree of originality, which flourished under the great Maharāṇa Kumbhā is represented at Chitor, still then the capital of Mewār, by the Ādivarāha ('Mīrabai's temple') beside the Kumbhaśyāma with its śikhara and roofs, the Kīrttistambha (1440s), and the little Śṛṅgaracauri, a caturmukha temple dedicated to Śantinātha in 1448 and now partly built into a fortification wall. More nearly a simple revival of the art of the Solankīs are the Jain tower, the Mānastambha, unless original, the Adbhutanātha, the Śatavisī temple, and the Surajpola, the solitary gateway on the eastern side of the great rock. A trio of fifteenth-century temples at Girnār are also largely reinterpretations of the Solankī style. Five fine temples of the same period are to be found in the far-western desert city of Jaisalmer, a further example of the concentration of architecture at this time in remote fastnesses.

Outstanding temples were also built in the secluded valleys and hilly ranges of Mewār and near Mount Abu - the Pārśvanāthas at Varkāṇā and at Sirohi, for instance, Sirohi particularly remarkable for the extreme, not very successful projection of the bhadra niches above the cornice, veritable balconies, and the prominent curved brackets supporting them as well as the prominent chādya. These can also be seen on the Adbhutanātha at Chitor. The Varkāṇā temple is not unique (the Pārśvanātha at Rāṇakpur is another example) in having subsidiary śikharas which are themselves anekāṇḍaka, a development far from surprising in view of the Hindu tendency to multiply component elements and the passion at this period for more and more intricate schemes.[62] The greatest of these temples is the Ādinātha at Rāṇakpur, also in a remote valley on the borders of Mewār and Mārwār.[63] Its vast interior was carried out unmodified to the last column, from an extremely complex plan. Compared to it, the great South Indian temples, similarly shut off from the exterior by their high walls, appear as unplanned and chaotic [266]. However, like the first of the 'enclosed' Jain temples discussed earlier in this chapter, the Vimala-vasahī at Dilwārā, this culminating effort suffers from certain architectural weaknesses and an inherent monotony.

A very high jagatī supports the eighty-four devakulikās of the Rāṇakpur Ādinātha [182 and 183]. The principal entrance is on the west. Flights of steps lead to a three-storey balānaka (the hall at the entrance to a temple), the most conspicuous feature of the exterior, where the entrant is plunged into near-darkness from which he emerges into the subdued light and crowded columns of the temple interior, mostly roofed, though light is admitted through the upper, open storey of the storeyed (meghanāda) maṇḍapas as well as from four relatively small open courts. The central shrine is caturmukha, four addorsed figures of the first Tīrthaṅkara facing the four entrances - a type of sarvatobhadra Jain image that goes back to the Kuṣāṇa period at Mathurā. An upper shrine has four similar openings approached over the terrace roofs of the temple. There are

182 and 183. Rāṇakpur, Ādinātha temple,
exterior view (*above*) and plan (*opposite*)

four subsidiary shrines, and the temple is
pañcāyatana as well. Domes on columns com-
plete the square, and the main sanctum has a
dome at each cardinal point, the largest on the
west, over the rangamaṇḍapa. The pillars below
the domes (not true domes of course) form
octagons; the largest has two concentric rows
totalling twenty pillars. The many ceilings are
of great delicacy and variety, and not all cir-
cular; many are samatala, with circular central

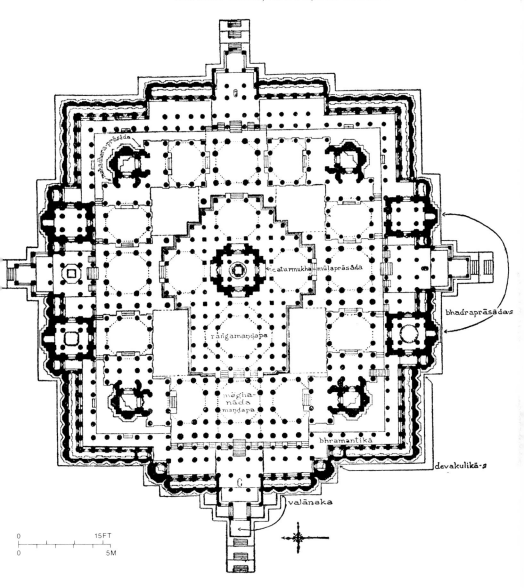

184. Dilwārā, Mount Abu, Vimala-vasahī temple,
front maṇḍapa, samatala ceiling with kalpavalli,
a vegetal scroll depicting a fabulous creeper.
Mid twelfth century

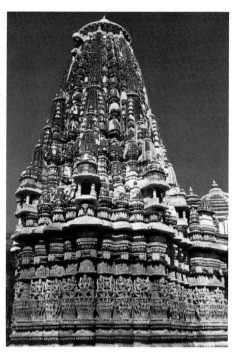

185. Rāṇakpur, Sūrya temple, from the south.
Fifteenth century

medallions bearing vegetal motifs, as bold in
conception as they are lacy in detail. The curl-
ing leaf volute, as old as the early Gupta
period, has reached its final form in the most
impressive and original decorative feature of
the period [184].

The Sūrya temple at Rāṇakpur is of modified
Bhūmija type with an unusual eight-ratha plan
(stellate, with eight bhadras) [185]. Each
bhadra is still marked by a large niche-balcony
above the cornice, crowned by a latā with
śikharas. There are thus eight latās, the rows of
small śikharas between them excessively
crowded though fewer in number. The seated
Sūryas on the walls are much reduced in height,
supported by horses with hind legs elongated

to form brackets. The seat backs of the
maṇḍapa repeat these equine brackets.

The two 'towers of victory'[64] at Chitor,
unique for the Brahmanical and Jain tradi-
tions, show the capacity of Indian temple-
builders, at a very late date, to erect a quite
different type of structure on a monumental
scale. Although there is considerable inscrip-
tional and some literary evidence, some con-
fusion between the two buildings seems to
have arisen in the past.[65] The taller, more
regular in its outline and rather like a Chinese
pagoda, was built under the direct orders of
Mahārāṇa Kumbhā between 1440 and 1448. An
ingenious arrangement of stairs leads to the
top of the nine-storey building, 120 ft (37 m.)

186. Chitor, Adbhūtanātha temple,
Maheśa (Sadāśiva). *c.* 1500

187. Amber, palace and fort.
Seventeenth/eighteenth century

high, the interior walls rich with effigies of gods, most of them identified by labels. At the fifth storey are reliefs of the builders. The smaller tower, 75 ft (23 m.) high, of seven storeys, and unquestionably Jain, has a chunkier and more complex outline. Both are richly carved outside.

The figure sculpture demonstrates the final ossification of a style which first emerged in the tenth century. Heads tend to be perfect spheres, the completely stylized features merely imposed upon them. Tubular limbs give some of the figures a toy-like appearance. The exaggerated feminine bhaṅgas are stiff and awkward. The Maheśa mūrti in the Adbhūtanātha temple at Chitor [186], crude, wooden, and flat-faced, proves that the significance of one of the greatest of Indian iconographic conceptions has been forgotten:[66] Śiva's side faces are turned forward, negating the cosmic centrality intended by turning each to a cardinal point.[67]

There was a third, much lesser artistic flowering in parts of western India, as well as in the adjacent region of Mathurā, during the tolerant reigns of Akbar and Jahāngir, when Rājput political resistance had been eliminated. An admixture of elements from the Indian Muslim tradition becomes apparent. The Jagdish temple (1651) at Udaipur, the new capital

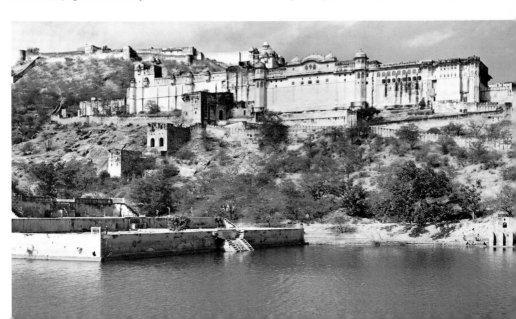

of Mewār, was built in the traditional style, but the figure sculpture on the walls shows a radical departure from the past. Instead of the thousand-year-old diaphanous dhoti clasped at the waist by a jewelled girdle, with loops and streamers hanging down upon the thighs, women wear the long, opaque skirt (*ghāghrā*) of the Chawand miniatures.[68] The *chatrīs* (funerary temples) of the Jodhpur kings at Mandor, somewhat later, are Hindu and devoid of figure sculpture. New motifs from the Muslim repertory include the bands of birds and lower halves of rosettes which may be seen, sometimes earlier, decorating the fine secular architecture of Gujarāt, of which a good deal has survived. Sculpture in wood, painted, contin-

ues in Gujarāt to this day, much of it on houses. Far to the north, at Brindavan, a few temples in a frankly hybrid style survived the destructions of Aurangzeb, their plain śikharas of a quite distinct design. Only the maṇḍapa remains, however, of the largest, the Gobind Devī, built in 1590.[69] Much energy was devoted at this late period to the building of palaces and even more to fortresses and the fortification of older structures, on a scale incalculably greater than in Europe. A flat-topped hill was selected and entirely surrounded with fortifications. Chitor is $3\frac{1}{2}$ miles (6 km.) long; huge also are Raisin, Kālanjar, Ranthambhor, Gwalior, and the Maratha forts of the eighteenth century [187].[70]

ORISSA

The exquisite little Muktesvara at Bhubaneswar, set by a small tank in a charming spot in this city of temples close to the Parasurámésvara and the Gaurī, is unquestionably the jewel of Orissa architecture [188]. Whether of the ninth or the tenth century, it marks a definite break with the post-Gupta temples of the region.[1] Its jagamohana (or mukhasālā) is almost square on plan, with little galleries at right angles to the main axis. Even more important, it has a pīḍā roof (a *pīḍā* being the name in Orissa for the courses or storeys of the developed regional version of a bhūmiprāsāda superstructure), as will the maṇḍapas of all subsequent

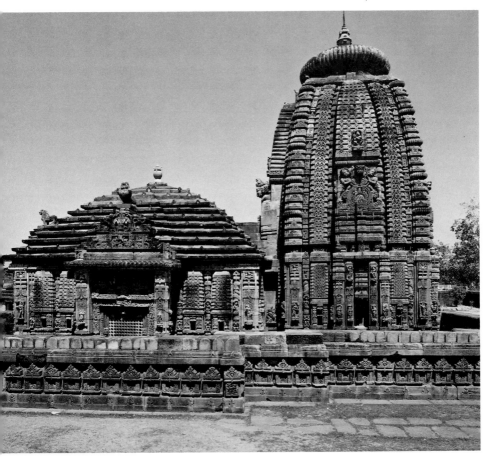

188. Bhubaneswar, Muktesvara temple. Ninth/tenth century

Orissa temples; this, in turn, indicates a transition from the Deccani affinities of the earlier maṇḍapas to something more closely related to North India. The exuberance and beauty of the carving which covers every inch represents, on the other hand, along with the Varāhī temple at Chaurasi, the culmination of the preceding post-Gupta phase.[2]

This small shrine (the sanctum measures only 7 ft; about 2 m.) consists of a deul (prāsāda) and a jagamohana, surrounded by a splendidly carved parapet, entered through the only toraṇa so far known in Orissa.[3] The deul is a modified pañcaratha, with a prominent niche on the bhadras surmounted, above the cornice, by an Orissan śūrasena – a *bho* – consisting of a large, almost semicircular gavākṣa surmounted by a kīrttimukha flanked by two yakṣas leaning against it rather in the manner of European heraldic supporters.[4] At the corners are large pilasters against which stand the voluptuous women so dear to North Indian architecture, in Orissa called kanyās, in a multitude of lively poses. Above the cornice, which is clearly defined by a recessed band, variously decorated (an archaic feature), āmalakas punctuate the corners of the śikhara (*gaṇḍi*).[5] Next to the bhadra, a much smaller and narrower niche is topped by tight rows of kapotas all the way up the gaṇḍi, meshed in a fine net of interlaced gavākṣas which carries on above the bho. Related to the post-Gupta *jālagavākṣas*, a honeycomb of little gavākṣas, this decoration lightens the rather oppressive effect of the tightly packed kapotas, sometimes numbering up to a hundred, which compose the upper surface of the deuls. There is an abundance of charming vignettes, usually with a woman who sometimes stands by an open or half-open door, an original conception taken up in latter-day Bengal,[6] but also with grotesques, ascetics, and groups. All are neatly framed in squares and rectangles, usually with pearl borders, giving a strong sense of orderly planning reinforced by the almost exact balance between the deeply cut verticals and horizontals of the whole building. As in the approxi-

mately contemporaneous Gaurī near by, leaf ornament links one base moulding to another, and there are both pairs of little jars in the neck of the cornice and also that characteristic and original Orissa invention, the large round *nāga* pilaster, the serpent's tail curling around it in a wide spiral.[7] Quite exceptionally, the jagamohana of the Muktesvara has an elaborately carved ceiling not unlike the utkṣipta type to the west, with the Seven Mothers and Vīrabhadra in its eight lobes.

Orissa at this period differs from the rest of northern India in the shape of the temple gaṇḍis, the plainness of the interiors, and the much smaller number and size of the images on their outer walls. Gaṇḍis rise with an almost imperceptible inward curve to the top, where, their thickness little reduced, they are crowned with huge heavy āmalakas surmounted by *khapuris*, flattish bell-shaped elements, then a jar, and finally a trident or cakra, usually in metal, or an ākāsa (ether) liṅga.[8] Caryatids – squatting grotesques or double-haunched lions (*dopicchas*) – support the āmalaka at the cardinal and sometimes also the inter-cardinal points. Lions project like question marks above the bhos. With one notable exception, urusṛngas, if present, are inconspicuous. The Bhūmija type is unknown; urusṛngas are superimposed in single vertical strips. Without balconies or internal pillars except in the largest examples, maṇḍapas are completely devoid of sculpture or carved ceilings inside.

Although far from plain, exteriors present a very different appearance from those to the north and west. The complex ground plans have the same buttress-like projections which carry all the way up the gaṇḍi, but the lower part of the deul is treated quite differently. Except at the bhadras, niches or frames for images give way to solid appliqué aedicules with pīḍā or modified khākarā roofs.[9] The relatively small images are carved in relief on grounds filling the entrance to these little shrine-pavilions. Women in seductive poses abound, and so do vyālas, usually trampling small elephants. A marked conservatism

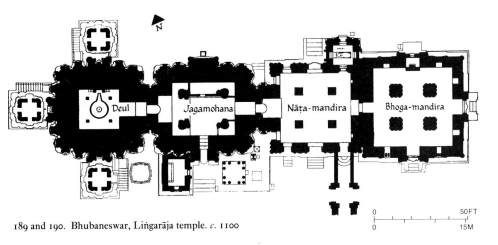

189 and 190. Bhubaneswar, Liṅgarāja temple. *c.* 1100

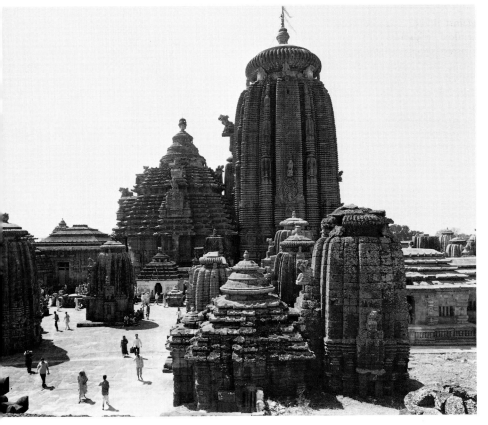

accounts for the retention of laterally cut foliage and the ubiquitous row of pearls used as a frame. Orissa temples of all periods are usually fairly well preserved.[10]

At Bhubaneswar, the celebrated Liṅgarāja (originally Tribhuvaneśvara, Lord of the Three Worlds, a designation of Śiva which has given its name to the town), built *c.* 1100, dominates the other temples.[11] It consists of four connected structures in a line – the great deul, the jagamohana, and, added later, the *nāṭa-mandira* (dance hall) and the *bhoga-mandira* (hall of offerings) [189] – extending half as far again as the prāsāda and halls of the Kaṇḍarīya Mahādeo at Khajurāho. They are surrounded by a multitude of subsidiary shrines, including the fine Pārvatī, which also consists of four buildings. The compound wall has a platform inside from which it could be patrolled, and there is some evidence that it had a defensive function. The deul, rising to a height of some 160 ft (45 m.), is generally acknowledged to be the greatest surviving achievement of the Orissa temple builders, though it is atypical in that the gaṇḍi commences its inward curve immediately above the cornice [190]. The plan of the deul is a modified pañcaratha, not unlike that of the Ghaṭeśvara at Baroli and of many temples in Gujarāt. In the large deep niches of the bhadras, reached by flights of steps to platforms with pīḍā-type roofs, are chlorite statues of Gaṇeśa, Kārttikeya, and Pārvatī, with a smaller niche above them. Five mouldings make up the base, and the wall is bisected by a course of three, as in many later Orissa temple buildings. The miniature shrines (*pīḍā-muṇḍis* and *khākharā-muṇḍis*) at the corner and the intermediate rathas are in particularly high relief, carrying above the triple moulding images of the dikpālas, below, scenes in relief. In both cases the pavilion niche is the dominating feature and not the image or scene. In the recesses, vyālas trampling elephants occupy the lower register, kanyās dwarfed by towering pedestals the upper. The cornice consists of ten mouldings, almost indistinguishable from the close-packed horizontal elements of the tower.

Above, bhos are surmounted by vyālas and elephants on little projecting platforms, and from there upwards the central projection of the tower (Orissa: *rāhā*) is decorated with the same gavākṣa net as the Mukteśvara. Alongside the rāhās are three superimposed śṛṅgas, relatively small, so that the tower still gives the impression of being a rekha deul. The ten octagonal corner āmalakas, likewise reduced in scale, contribute to the illusion that the gaṇḍi consists of simple vertical elements. Dopicchas act as caryatids at the summit, with four-armed squatting figures above the rāhās. The interior of the deul is hollow, with two chambers above the garbhagṛha, and stairs built into the thickness of the walls.

The jagamohana of the Liṅgarāja is impressive in its own right, its pīḍā roof rising to a height of 90 ft (about 30 m.), thus breaking the smooth line of maṇḍapa roofs ascending to the prāsāda which is such a successful feature of the largest temples at Khajurāho. For the first time, the pīḍās are in two tiers, with a throat between them, each façade with a double set of bhos crowned by a lion, one above and one below the throat. The vertical sections between the pīḍās of the lower tier bear relief friezes of the military cavalcades so dear to Orissa temples of the post-Gupta period. The jagamohana has two balustraded windows, another feature which is unique to Orissa. One of them was converted into an entrance at the time when the nāṭa-mandira and bhoga-maṇḍapa were added. Four massive piers support the ceilings of these three buildings.

The Brahmeśvara, datable to *c.* 1061, is a beautifully preserved pañcāyatana complex within a low compound wall with an ornate little pīḍā-roofed gateway, its lintel carved with the navagrahas.[12] The deul has a single row of uruśṛṅgas immediately above the cornice, somewhat larger at the bhadras. Its style is essentially that of the Liṅgarāja, confirming the tentative dating of the larger temple.

The smaller, later Ananta Vāsudeva has the same succession of buildings as the Liṅgarāja, with the significant improvement of a fairly

even ascent of maṇḍapa roofs. Built in 1275, it is the only Viṣṇu temple of importance at Bhubaneswar although, under the Gaṅgā dynasty, Vaiṣṇavism was in the ascendant,[13] even the dedication of the Liṅgarāja being altered to Harihara and its ritual modified. The Megheśvara can be confidently dated to the end of the twelfth century. The completely plain walls of its jagamohana, bisected by the usual three mouldings, are reminiscent of certain temples in western India and Madhya Pradesh, adding weight to the suggestion that there is a greater significance than has usually been accorded to this treatment of the wall surface.[14] The gaṇḍi is remarkably curved, almost bulbous; yet the gaṇḍi of the Ananta Vāsudeva, a century later, retains the old largely rectilinear outline.

The deul of the beautiful Rājarāṇī[15] is exceptional in having marked affinities to temples in Madhya Pradesh [191]. The ground plan is a diamond, and the thirty or so uruśṛṅgas, rising to different heights and some of considerable size, cluster around the gaṇḍi as they do at Khajurāho and in the west. A complete set of dikpālas guards the corner projections of the lower half of the walls, which also bear feminine figures.

191. Bhubaneswar, Rājarāṇī temple. Eleventh/twelfth century

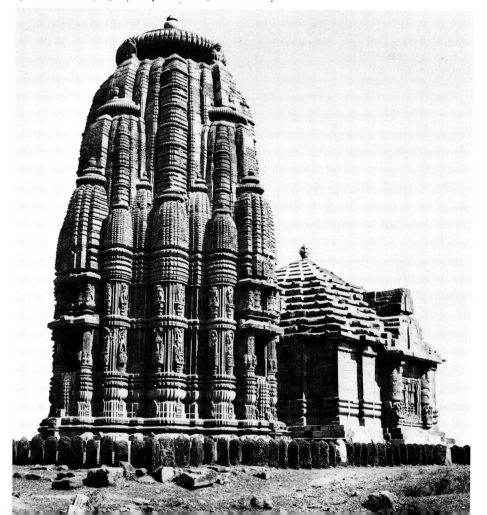

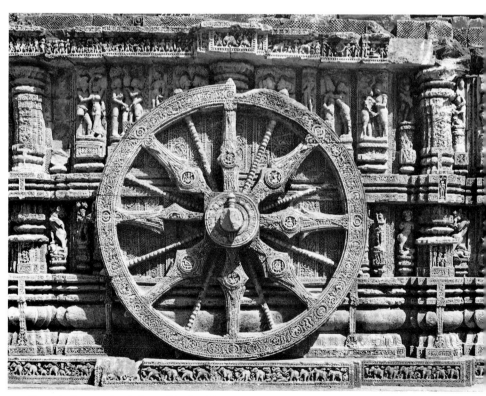

193. Konarak, Sun temple, platform of deul and jagamohana, stone wheel.
Mid thirteenth century

Of great interest but little architectural merit, the Bhāskareśvara shows the *sthāpati* and *sūtradhara* (roughly equivalent to architect and surveyor) responding to unusual demands. The enshrined liṅga, 9 ft 3 in. (2.74 m.) high, the upper part missing, was originally a free-standing pillar.[16] The first storey of the deul (there is no jagamohana) is a sort of terrace platform whose four doors lead into the sanctum at ground level; the second, with a single door, consists of a gallery around the side walls whence priest and faithful could make their offerings to the upper part of the liṅga. The Bhāskareśvara (Śiva as god of the sun), a plain triratha with very prominent bhadras rising above the cornice as pīḍā-type subsidiary śikharas merging into the central one to form an unusually squat superstructure, is similar in general outline to the Mātuluṅga temple at Khajurāho.

The famous temple of the seaside town of Puri, a Vaiṣṇava shrine of Kṛṣṇa, originally as Puruṣottama, the Supreme being, later as Jagannātha (Jagat-nātha, the Lord of the World), is one of the great pilgrimage places of India. It is ironic that the worship of the sportive folk-hero god, whose cult at Puri is entirely benign, should have given to the English language the word *juggernaut*, 'a fearful vehicle of destruction'.[17] The sinister aspect of the goggle-eyed painted wooden images of Jagannātha, Balabhadra, and Subhadra, nearly all face, which constitute the triadic divinity has undoubtedly contributed to the awe which the temple has inspired among non-Hindus [192].[18]

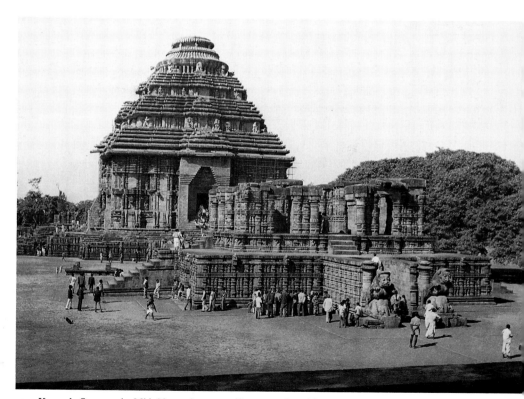

194. Konarak, Sun temple. Mid thirteenth century. Dance maṇḍapa (*foreground*) in front of the large jagamohana; the great deul behind is not visible because its superstructure has collapsed

The architectural merits of the great deul, begun in 1136, are difficult to estimate, for its details have been largely obliterated by clumsy cement repairs and numberless applications of *chunam*, a white plaster-like substance. The pillared nāṭa-mandir and the bhoga-maṇḍapa are later. In the main niches stand images of Varāha (south), Narasiṁha (west), and Vāmana (north). The main assemblage is a third as long again as that of the Liṅgarāja at Bhubaneswar. The whole is remarkable (outside of South India) in having two sets of enclosure walls, or three if the two inner walls divided only by a narrow passage are counted separately.[19] The outer ones have a large gateway with a pīḍā-type roof on all four sides. Of laterite, the walls were apparently built around 1400. In the middle are the many small shrines, some relatively modern.

The Sun temple at Konarak, the last of the great Orissan shrines and, as originally planned, the largest, was built by King Nara-siṁhadeva I (1238-64).[20] Of the great deul, which must originally have stood to a height of some 225 ft (70 m.), only the base mouldings and parts of the walls and niches remain.[21] As at the Liṅgarāja, attached to the middle of each side were subsidiary shrines, with external stairs up to the niches, housing images of Sūrya. The deul stood, with the jagamohana, on a high terrace with six huge stone wheels, 12 ft (nearly 4 m.) in diameter, attached to each side, creating the illusion of a *ratha*, or celestial vehicle [193]; Sūrya traditionally rides in a chariot drawn by seven horses, and the parallel is completed by life-size stone horses on either side of the broad flight of steps leading to the jagamohana.[22]

Badly damaged, its interior filled in with sand and rubble early in the twentieth century, the jagamohana nevertheless remains the largest and most impressive building of its type [194]. Its proportions are strikingly simple: the walls are half as high as their width, which in turn is equal to the total height (100 ft; 30 m.) of the building. The superstructure consists of three diminishing tiers of six pīḍās each (the uppermost has only five), divided by wide

195. Konarak, Sun temple, musician on an upper storey of the jagamohana. Mid thirteenth century

terraces on which stand the famous musician figures [195]. The nāṭa-mandira, a separate building, as at Moḍherā, stands on a high, intricately carved platform. Much remains of the walls and piers, which resemble those of the deul and jagamohana. Between nāṭa-mandira and jagamohana stood an aruṇa stambha (Aruṇa, the god of the dawn, is traditionally Sūrya's charioteer) since removed to the Ja-gannātha at Puri. The temple, with a refectory and one or two subsidiary shrines, was enclosed by a vast wall, 865 by 540 ft (264 by 165 m.), with gateways on three sides.[23]

The period saw little sculptural evolution. The larger images, usually of black chlorite, show a certain affinity to late Pāla sculpture: the modelling is tight and the face broad, with

196. Konarak, Sun temple, deul, standing Sūrya.
Mid thirteenth century. Black chlorite

197. King Narasiṁhadeva I worshipping
the Jagannātha image at Puri, from Konarak.
Mid thirteenth century. Black chlorite.
New Delhi, National Museum

an increasingly archaic smile [196]. The works
in sandstone, on the other hand, often a trifle
naïf, have a robust if rather loose plasticity.
The sculptural fabric of the temple preserves
the pearl-bordered panels, the little vignettes,
the vegetal scroll motifs of the ninth and tenth
centuries, the individual elements unenlarged
and slightly more repetitive, but still remark-
ably unstereotyped. The erotic sculpture at
Konarak, long notorious, is mostly on a small
scale. Particularly abundant, it differs little
from coital themes portrayed elsewhere. The
figures lack the stateliness of those at Kha-
jurāho, and sexual congress never involves four
participants. An inter-mixture of recognizably
tantric divinities lends support to the attempts
often made elsewhere, usually from insuffi-
ciently localized literary sources, to link erotic
sculpture with a prevalence of *vāma mārga* (left
path) cults.[24] A unique set of stelae originally
on the walls of the Sun temple, some of the
figures all but in the round, shows King Nara-
siṁhadeva, among other activities, worshipping
at the Puri temple [197].[25]

CHAPTER 18

THE DECCAN

The Canarese-speaking regions of the Deccan plateau, from the Godavari south to the upper reaches of the Kāverī, including the regions watered by the upper Kistna and its tributaries the Malprabhā and the Tungabhadrā, continued to be a meeting-place of northern and southern styles. Nāgara temples do not generally extend below Ahmadnagar in Mahārāstra, on a level with Bombay; the Ganapati at Hāngal, below the latitude of Goa, however, has a pure Nāgara anekāndaka śikhara.[1] Also at Hāngal, a mandapa of the Tarakeśvara temple has a large samvaranā roof, although the roofs of the mandapas of Karnātaka temples at this period are uniformly flat.[2] Drāvida shrines, like the little Svayambhuveśvara near Kyāsamballi (Kolar District) with a vimāna in a late Cola style, were still built in the old Gangavādi.[3] The ascendancy of Vijayanagara, which began in the fourteenth century, coincided with a new wave of building in this essentially Drāvida style, usually mandapas and other structures added to older foundations, less frequently new temples. In spite of Muslim campaigns beginning in the early fourteenth century, notably those of Malik Kafur which took him through Halebid, the Hoysala capital, and on to Madurai in the far south, and of the ferocious wars conducted by the Bāhmanī sultans, Hindu temples and sculpture in Karnātaka have not suffered any great damage. In the south, the beneficent and advanced rule of the Mahārājas of Mysore has contributed to their preservation and thorough documentation.[4] Owing to natural decay, however, and shifts of population, few (except for those important nationally or as centres of popular devotion) are in a good state of repair.[5] The region remains of course a borderland, yet it achieves its own style. Karnātaka temples of the old Nāgara and Drāvida types showed only slight regional characteristics and sometimes, as in the Early Western Cālukya

domains along the Malprabhā, stood side by side; now their fusion in a single temple creates the Vesara style – a term which has given rise to misinterpretation and confusion owing to failures to distinguish between the nomenclature of the northern (and older) texts and the southern ones.[6] A fascinating feature of the Vesara, linked no doubt to the appearance at roughly the same time of the earliest śāstras to distinguish regional types, is that its builders were well aware of the other types, constantly reproducing them, often with a high degree of accuracy, as miniature shrines above niches, on doorway-lintels, etc.[7] Another style, the Kalinga, widespread in all but the extreme south of Karnātaka, is distinguished by sparse carving and by its straight-sided pyramidal superstructure of serried rows of kapotas, very similar, as its name implies, to that of the pīdā deuls of Orissa.[8]

The development of the Vesara style can best be followed in what was formerly called Dharwar in the 'upper' Karnātaka. There it is often termed the Cālukya style (no relation to the Early Western Cālukya) after a contemporary dynasty, the Cālukyas of Kalyani, whose long rivalry with the Colas parallels their earlier namesakes' wars with the Pallavas. The Jain temple at Lakkundi, probably of the second half of the eleventh century, is still recognizably Drāvida, though considerably altered in detail.[9] The exceptionally high storey above the main cornice contains the upper sanctum dear to the Jains. The base mouldings are plain and square-cut, except for a wide and chunky vyāla or yāli frieze and a thin sharp kumuda, both features of Cālukya temples. A fine-grained chloritic schist takes the place of sandstone.

At approximately the same time the wide double-curved eaves over the porches, later common in Vijayanagara mandapas, make

their appearance in the Mukteśvara at Chau-dadāmpur.[10] Instead of the old quarter-round kapota, the main cornice now takes the form of straight eaves, resembling the northern chādya, and even more prominent eaves surmount the principal niches. The seat backs forming a solid balustrade between the outer maṇḍapa pillars are a northern feature, and the flat and rather untypical carving of the base and pilasters also recall the northern 'en réserve' technique. Already the śikhara (in the southern sense) has a marked double curve, as do the remaining kapotas; the śikhara also loses height in relation to width, becoming rather squashed or mushroom-like. The outline of the storeys is less well defined, and mouldings and friezes, as well as pavilions, tend to be replaced by narrow uncarved vertical slabs placed on end.[11]

The ground plan of the vimāna of the very similar Siddheśvara at Hāveri became the faithfully followed norm for most of these Cālukya temples, providing in elevation for a deeply niched central projection on each side, then a massive laminated pilaster, and smaller niches at the corner projections [198 and 199].[12] In the Drāviḍa manner, projections tend to be bounded by narrow pilasters. The recesses are occupied by equally slender pilasters crowned by miniature pavilions, distant relatives of the Coḷa kumbhapañjaras but usually enveloped by foliage trailing down from a kīrttimukha, a sort of fanciful elaboration of the looped or cusped makaratoraṇa. The temple has some

198 and 199. Hāveri, Siddheśvara temple. Mid eleventh century.

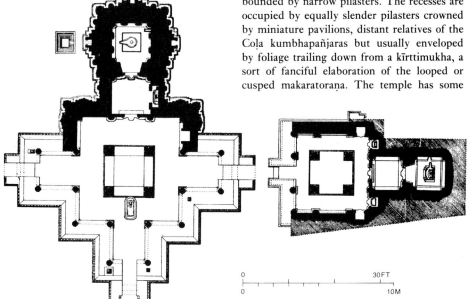

0 30 FT
0 10 M

fine images in a style related to that of the better-known Hoysaḷa sculpture in 'lower' Karṇāṭaka, but with the idiosyncrasies - the heavy jewellery and the fat faces - less marked. The figures are cut out, like many Pāla sculptures, and to all intents and purposes in the round. The surrounds, often springing from pilasters, rise to a kīrttimukha at the summit and 'are decorated either with circular vine motifs or with the cusped loops so characteristic of the later Hindu period in Karṇāṭaka. The male figures have a forthright, brooding power.

Cāḷukya temples have prominent śukanāsis, corresponding to a large antarāla followed by a maṇḍapa (locally called a navaraṅga) almost invariably larger than the vimāna and usually with at least one side entrance. The open pillared maṇḍapas beyond, where they exist, are usually larger still, on a tri- or pañcaratha diamond-shaped plan. The temples mentioned so far have a single sanctum, but two or three are not unusual. Most common is the trikūṭa variety, the sanctums on the three sides of a shared maṇḍapa. Doorways are generally elaborate, interior columns ornate, often packed too tight, and commonly circular, turned on a lathe, with plain capitals but often elaborately carved square bases. The shafts are frequently interrupted by equally ornate square or octagonal sections. Ceilings tend to be rectilinear, the more elaborate panelled with the dikpālas. An exception is in the open maṇḍapa of the Tarakeśvara, already mentioned, where the saṃvaraṇā roof shelters an utkṣipta ceiling surpassing those of Gujarāt, its central pendant over 5 ft (1.5 m.) long, miraculous testimony to the possibilities of corbelling allied to the stone-carver's art.[13] Lintels and pediments are frequently surmounted by essentially Drāviḍa makaratoraṇas.

The two sanctums of the Kāśiviśveśvara at Lakkuṇḍi, probably of the mid twelfth century, one slightly larger, face one another and are linked by a maṇḍapa and an open court [200].[14] Here superstructures from all three major Indian modes of temple architecture,

the Nāgara, the Vesara, and the Drāviḍa, figure, sometimes nearly in the round, over the niches. The principal niche has a splendid anekāṇḍaka Nāgara śikhara piercing the main cornice framed by a trefoil arch surmounted by a kīrttimukha, perhaps a distant echo of śūrasenas (or bhos) on the sides, as well as the śukanāsis of Madhya Pradesh and Orissa. This feature is repeated on the next floor. At the same time, each storey retains a hāra of quite recognizable śālās and koṣṭhas. The two doorways of the maṇḍapas and that of the larger shrine are superb, using widely different elements but each with a bimbalalāta in the form of Lakṣmī and her elephants, and 'northern' flanking pilasters of the pot and foliage type. The subbase, like that of the very similar Nanneśvara at the same site but unknown elsewhere, is also a non-southern element in what remain essentially Drāviḍa temples.[15]

The main bhadra niche of the vimāna of the Tarakeśvara at Hāngal is particularly deep and capped by a complete Vesara miniature shrine.[16] Frequently only the superstructures are shown of miniature vimānas or prāsādas. Above, at each floor, vertical slabs with the now familiar cusped loops and kīrttimukhas look at a distance like a continuous band not dissimiliar to the latā of a Bhūmija shrine. The large laminated pilaster between the bhadra and the corner projections, now almost always with blind niches, gives the appearance, moreover, of being carried up above the cornice in a form more nearly resembling Nāgara kūṭastambhas than Drāviḍa pañjaras.

In the Mahādeva at Ittagi, probably of 1112, this repetition of the principal pilasters in the upper storeys can be seen particularly clearly, although the more elaborate carving preserves the identity of the pavilions to a greater degree [201].[17] Monkeys sit among them - one of those delightful touches of naturalistic fancy which the Indian sculptor sometimes permits himself. The slender pilasters framing the central and corner projections have 'southern' capitals, and small rearing yāḷis on the abaci echo an Early Coḷa practice.[18] This is a parti-

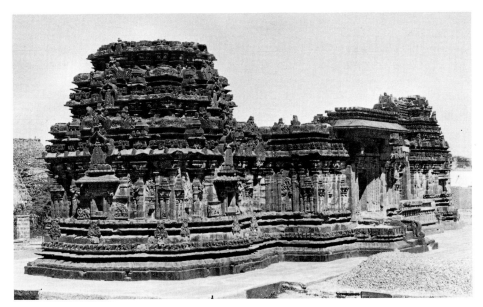

200. Lakkuṇḍi, Kāśiviśveśvara temple, from the south-west. Probably mid twelfth century

cularly fine temple, almost identical on plan to the Tarakeśvara. The (empty) niche of the śukanāsi is very deep, and Cousens suggests that it was meant for a movable image. Some of the carving of the maṇḍapa – complex swirling feathery leaf motifs, completely undercut – strongly resembles later work in Rājasthān.[19]

The trikūṭa shrine of Kedareśvara at Balagāṁve has a particularly fine warrior in combat with a lion,[20] the emblem of the Hoysalas, on the barrel roof of the characteristically extended śukanāsi. In the same village is one of the innumerable free-standing pillars (mānastambhas) usually bearing a little platform (or large abacus) and associated with Jain temples. On the platform usually sits a yakṣa, or there is a sarvatobhadra Jina image, often in a small shrine.[21] In this case, however, there is a human figure with the twin bird heads (gaṇḍa-bheruṇḍa) widespread as an emblem in Karnāṭaka until recent times.[22]

The Someśvara at Gadag, although in the same region, has stylistic affinities with the Hoysaḷa temples concentrated in 'lower' Karṇāṭaka, the old state of Mysore [202]. The base is more elaborate, including small niches.[23] The walls, overshadowed by prominent eaves, are curiously divided in two by kapotas slightly more than half way between the top of the base and the cornice. The lower register is crowded with low niches under heavy, elaborately carved stele-shaped pediments and the upper sections of pilasters. In the upper register, the superstructures of mostly Vesara miniature shrines sit on the kapota with, again, pilasters and capitals above them. The effect is bizarre and confused. The fine maṇḍapa doorway is very large, as in many Cālukya temples.

The Doḍḍa Basappā[24] at Ḍambaḷ is possibly unique in 'upper' Karṇāṭaka in having a stellate plan and a sub-base [203]. A date in the late twelfth century has been proposed for it. The angular projections of the twenty-four points of the star have a blind niche on each face, excessively elongated because of the constric-

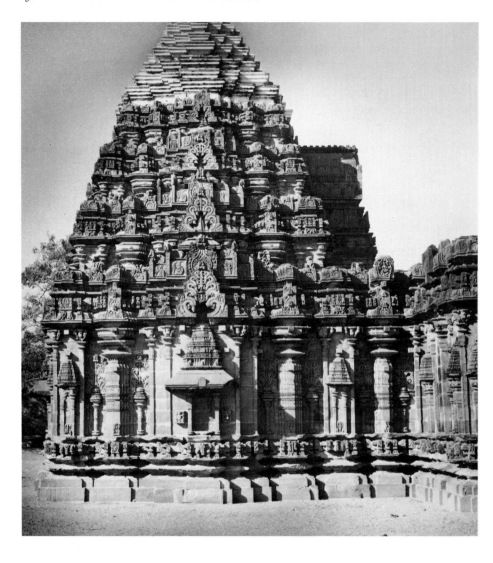

201. Ittagi, Mahādeva temple. Probably 1112

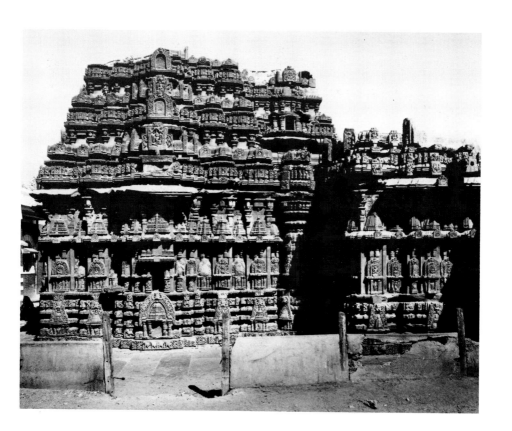

202. Gadag, Someśvara temple. Twelfth/thirteenth century

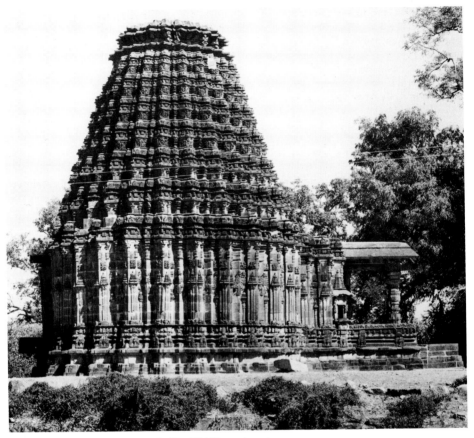

203. Ḍambaḷ, Doḍḍa Basappā temple. Twelfth/thirteenth century

tion, so that the space between the two flanking pilasters of each niche is not more than one-twentieth of their height. This is a development already heralded in other temples, for example the Mallikārjuna at Kuruvaṭṭi.[25] Even with their absurd proportions, these ridiculous niches occupy only half the height between base and cornice. Above them are minute Vesara temple superstructures, small groups of figures in high relief, and the upper parts and capitals of the incredibly thin pilasters which frame each projection. Above a conventional rather old-fashioned kapota with

gavākṣas, the same angularity persists, giving a crinkled effect to the superstructure. Although the seven storeys can be clearly distinguished, any resemblance to pavilions of the Drāviḍa order has been obliterated, the storeys consisting, in effect, of a constantly repeated selection of little pilasters, string courses, and kapotas. The grīva has practically disappeared under the low wide parasol shape of the śikhara. The stellate plan is produced from the ground up to and including the śikhara, which also has a stellate cross-section. The vimāna thus achieves a strength usually confined to certain Nāgara

temples. The plan of the navaranga, with a single entrance on the south, is also stellar; larger than the vimāna, it is based on a thirty-four-point system. A makaratoraṇa stands over the doorway to the shrine.

The later Cāḷukya or Vesara type of shrine is unquestionably based upon the southern (or Drāviḍa) one. But, as one of the most percipient authorities on Indian temple architecture has pointed out, 'A close examination of the Cāḷukyan temple (and what we say here will also apply to Hoysaḷa and to a large extent to Kākatīya buildings as well) reveals that there is a vague similarity, a faint but unmistakable flavour that distantly reminds one of the Nāgara, despite the absence of genuine and typical Nāgara features'. He goes on to say that, had it not been for the persistence of indisputable Drāviḍa elements, 'the Nāgara form could have once again leapt out of such a structural matrix'.[26] To many observers the resemblance of the Vesara type to the Nāgara is more than a faint flavour: it is an unmistakable urge, as it develops, to find equivalents to Nāgara elements and achieve Nāgara-type effects. This in turn corresponds to a desire in the Vesara type, particularly later on, to rid itself of forms acquired from wooden domestic architecture or from the rock-cut caves. The Doḍḍa Basappā at Ḍambaḷ demonstrates both these tendencies to a high degree: to cite the simplest and most striking example, the flattened, almost pancake-like 'śikhara', with its spiky edge of twenty-four points corresponding to those of the stellate ground plan of the vimāna, could easily be mistaken for an āmalaka; at least it would certainly be thought, by the uninformed, to have been derived from one [203].

The Hoysaḷa style is named after one of the famous dynasties of the Deccan which emerged around the middle of the eleventh century and is generally considered to have come to an end in the mid fourteenth, when Ballala II met his death fighting Malik Kafur in Tamilnāḍu.[27] The capital of the great Hoysaḷa kings was Dvārasamudra, the modern ham-let of Haḷebiḍ (haḷe = old; biḍu = capital), and it is there in Hāssan District and in the environs of Mysore City that their principal temples are found. Although the Cāḷukya style is its only possible progenitor, the Hoysaḷa is a development rather than a continuation of it, for Cāḷukya temples are built concurrently with Hoysaḷa ones. The Hoysaḷa style is in a sense sub-regional, highly characterized. Its emergence can doubtless be linked to the power of the dynasty, and a tradition of ivory and sandalwood carving, still strong in lower Karnātaka, may have influenced its sculpture. Nonetheless, the efflorescence of the most ornate of Indian styles, like the sudden appearance of the greatest of the Khajurāho temples, is difficult to account for satisfactorily.

The Hoysaḷa temples share the regional predilection for more than one shrine, and the larger ones stand in great walled and paved courts, as do all large temple complexes in the south. Surviving superstructures are of the Vesara type. The only important Hoysaḷa temple to have survived complete is the Keśava at Somnāthpuram (1238), in a rectangular courtyard enclosed by sixty-four little shrines.[28] It is triple-shrined, the crowning 'śikharas' no longer recognizable as such, for they are more like the crowning ghaṇṭās of certain northern Indian temple buildings [204]. The sanctums are stellate on plan, and they and the pillared common maṇḍapa stand on high platforms which faithfully follow the angular projections and re-entrants of the buildings.

The earliest major Hoysaḷa temples are at Belūr.[29] The Chenna Keśava (c. 1117), which has lost its superstructure, has a single vimāna, with sizeable exterior shrines attached to it on three sides. The main navaranga, the largest of any Hoysaḷa temple, is triratha, on a diamond-shaped plan, with entrances on both sides as well as the front. The central ceiling is of a modified utkṣipta type, the concentric rings lined with figures. The steps up to the platform, corresponding to the navaranga entrances, are flanked by miniature shrines. In front, at ground level, is a large open hall. The

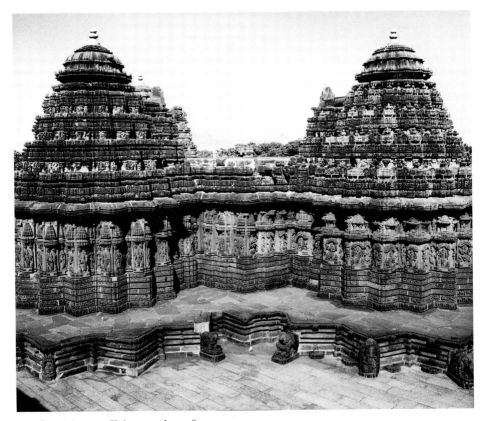

204. Somnāthpuram, Keśava temple. 1238

perforated stone screens between the exterior pillars were installed during the reign of Ballala II. Some bear geometrical designs; others illustrate stories from the Purāṇas. It is here that Hoysaḷa sculpture reaches its apogee, with splendid female figures, the equivalent, in their idiosyncratic style, of those at Khajurāho. The temple, with two subsidiary shrines, is enclosed in a huge walled court (380 by 425 ft; 115 by 130 m.) with two gateways on the eastern side.

Haḷebiḍ is now a mere hamlet, but several large temples remain, including some Jain ones. The famous Hoysaḷeśvara consists of two shrines joined together at their navaraṅgas, both very similar in plan to the Chenna Keśava at Belūr.[30] The absence of any superstructures (probably never built) and the very prominent eaves give the temple a long, low outline of which it is difficult to distinguish the component parts. Instead of open pillared halls, large nandimaṇḍapas face each shrine, one considerably larger than the other, with the curious addition of a fair-sized shrine behind the bull. Relatively large as they are, these Hoysaḷa vimānas never have interior circumambulatory passages, and the high platforms on which they stand, following every salient of the buildings, are undoubtedly meant to serve this devotional purpose, the worshipper walking

around the shrines with their rich illustrative panoply of carving on the right. The bases of the buildings themselves, sometimes as much as 10 ft (3 m.) high, with their bands of elephants, horses, grotesques, birds, and narrative panels, correspond to northern and particularly western Indian practice, and are entirely foreign to the Drāviḍa and the other Karnāṭaka styles. The walls of the vimānas and navaraṅgas are divided into two registers, the upper with pilasters and miniature shrines (or their superstructures) in high relief, the lower a succession of divine and semi-divine figures standing almost in the round, often under foliaged canopies.

Deep carving and undercutting, facilitated by the soft chloritic schist, give the richest surface texture of any temple in India, with the greatest proliferation of scenes and motifs. The decorative bands of the bases of the Hoysaleśvara temple, which carry around the maṇḍapa as well, extend for over 700 ft (213 m.), and include a zone with some two thousand elephants; the band of figures, each about half life-size, extends over 400 ft (120 m.). Vertical lines carry up from the stellate ground plan, yet the general impression is one of insufficient height, particularly as there are no superstructures. As Percy Brown wrote, 'this apparent defect is to a certain extent minimised by its [the temple's] situation within an enclosed court, which prevents contrasts with larger objects', and presents the temple structure 'like a richly carved casket in sandalwood or ivory'.[31]

The temples just mentioned have given their name to the Hoysaḷa style, a term applicable to a considerable number of others in 'lower' Karnāṭaka, for example the Lakṣmīnarasiṁha at Nugginalli, east of Hāssan, and the Mallikārjunasvāmi at Basrāḷ (1234) between Seringapatam and Bangalore, with its full complement of bands on the base.[32] Others, such as the Bhūteśvara at Koravangalam, a few miles north of Hāssan, have on their walls the elaborately framed images associated with the true Hoysaḷa style, but the simple bases

and more restrained ornamentation of the later Cālukya,[33] which continued in 'upper' Karnāṭaka in temples such as the Koṭinātha at Kuppatur (1231) and the Santeśvara at Tilivaḷḷi (1238).[34] The picture seems to be that of the Hoysaḷa style as a later development, concentrated in a few great temples in the south and undoubtedly owing much to the power and vitality of the dynasty at its apogee, while its parent, the later Cālukya style, in the north remained totally unaffected, except where it came into contact with the Hoysaḷa on the latitude of Belūr and Halebīḍ, a borderland phenomenon within a borderland. Further research, given the considerable number of dated temples, may help to distinguish a pre-Hoysaḷa or early Hoysaḷa style.

Temples of the so far insufficiently recognized Kaliṅga type can be found over the whole of Karnāṭaka, from Aihole (Temples 37 and 38) to Doḍḍagadavali, between Hāssan and Belūr (the Lakṣmīdevī of 1112), the latter with two of the finest grotesques in Indian sculpture guarding one of its sanctums [205].[35] Coḷa temples are built well into the twelfth century, particularly in Kolar District, where many inscriptions of Vikrama Coḷa have been found.[36] One such temple is the Someśvara at Kurudumale, just north of Mulbagal.[37] At the popular Gaṇeśa shrine in the same place, four splendid Vijayanagara-style maṇḍapa columns belong to the subsequent period when this style takes over in Karnāṭaka.[38] If one includes the innumerable Vijayanagara buildings, Karnāṭaka indisputably presents the greatest variety of styles of temple architecture in the entire subcontinent.

Sculptural style in Karnāṭaka at this period roughly accords, in distribution and development, with that of temple architecture. 'Upper' Karnāṭaka has no images in external niches or in high relief on the walls of the temples, but there are a good many mūrtis or cult statues because there are so many multiple-sanctum temples. For the same reason, the Cālukya sculptor was called upon to carve a great many male and female door guar-

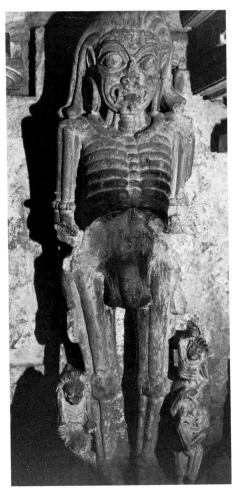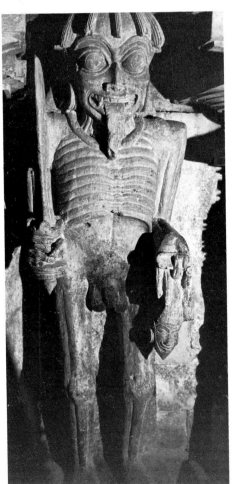

205. Doḍḍagadavali, Lakṣmīdevī shrine, demons. 1112

dians, *dvārapālakas* and *dvārapālikās*, at the entrances to shrines. Their importance (some of them are life-size) is a southern feature. Cult images, usually in a hard black stone, take the form of stelae rising to a point, the god or goddess in very high relief or actually cut out from the ground in the same way as in many Pāla sculptures. A makaratoraṇa of characteristic cusped loops or, more rarely, circular vegetal scrolls springs from a pair of flanking pilasters to frame the image, with a kīrttimukha at the summit. The beautiful seated Śiva and Pārvatī from Belgavi (ancient Balligrama), in Shimoga District, represents the later Cālukya style at its finest, based on earlier Noḷamba with an admixture of later Karṇāṭaka motifs.[39] The Viṣṇu in the much favoured form of Keśava said to have been found at Kikkeri, between Hāssan and Seringapatam, retains Cālukya features such as the ten avatars, in-

cluding the Buddha, in the makaratoraṇa [206], but is essentially Hoysaḷa, although, according to its inscription, the work of a sculptor called Dasojana from the same town of Balligrama where the Śiva and Pārvatī was found.[40] Dasojana, who is known from at least three inscribed figures on the Chenna Keśava at Belūr, was obviously one of the craftsmen who moved down to take part in the great Hoysaḷa building enterprises and helped to create the new style. Sculptors' names occur fairly often in Karṇāṭaka at this period, but Dasojana is probably unique in providing in-

scriptionally documented evidence of the movement of a sculptor and its probable implications for stylistic change. Iconography remains fairly uniform throughout the period. Besides the Viṣṇu figures, usually in samapada, Veṇugopala (Kṛṣṇa playing the flute) is popular, as is Sarasvatī, usually seated.

The properly Hoysaḷa sculpture is best seen on the walls or in the raṅgamaṇḍapas of the great temples at Somnāthpuram, Belūr, and Haḷebīḍ.[41] Carved in the same chloritic schist as the temples themselves, the figures have plump, not very shapely limbs, fattish

206. Keśava Viṣṇu with Śrī Devī and Bhū Devī from Kikkeri.
Early twelfth century.
New York, Metropolitan Museum of Art

207. Bhairava from Kṛṣṇarājapet.
Twelfth century, first quarter. Chloritic schist.
Mysore, Directorate of Archaeology and Museums in Karṇāṭaka

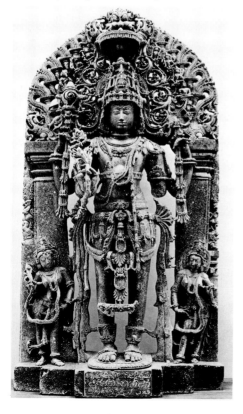

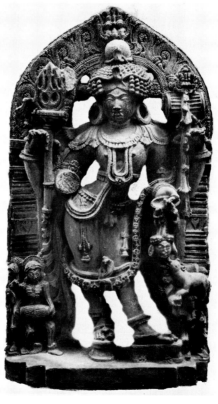

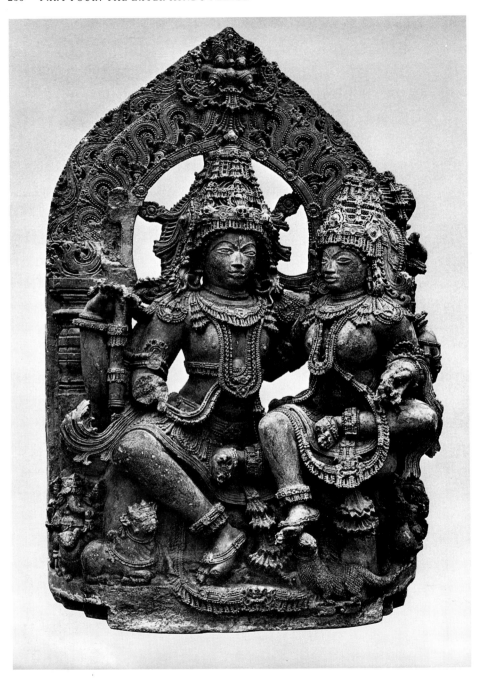

faces, and sometimes (exceptionally in Indian art) rather small eyes. The smiling visages are often not without beauty, but the style is particularly well suited to an expression of menace, as seen in the numerous images of Bhairava, an *ugra* or fearful form of Śiva particularly favoured in the south.[42] The hair dressed in snail curls and overhanging the face, a veritable wasps' nest, sometimes enhances the malevolence [207]. The more typical Hoysala figures wear their clothes and jewellery like carapaces. In what Stella Kramrisch calls the 'spiked froth' of the later sculpture, often under fringed parasols, their mukuṭas like 'stranded temple towers', the figures derive a certain grandeur from their frozen immobility [208].[43] A third style, to be seen principally in the long base relief bands, particularly the little scenes from the epics and Purāṇas, with squat globular men and animals, also animates the little ceiling dikpālas, which often include a figure on a horse.

Images in a style closely related to the late Coḷa can be seen in the Coḷa temples of the period. Cālukya and Hoysala bronzes are not common,[44] but there are large figures in some of the temples, possibly dating from the Vijayanagara period, when *repoussé* metal cladding was practised. With Rājasthān and Gujarāt, Karnāṭaka is particularly rich in hero-stones

(*vīragals* or *vīrakals*), the reliefs ranging from the crudest folk art to the highest contemporary styles. Somewhat similar stones with bold serpent reliefs, connected with nāga cults, are particularly prevalent in the west.

Āndhra adopted some features from further west – extensive maṇḍapas with turned columns, multiple-shrine temples on high podia, and the breaking up of the Drāviḍa vimāna into a myriad facets. Notable temples were built under the Kākatīyas of Warangal (*c.* 1050-1300) at their capital (in the fort, pulled down on the orders of one of the Qutb Shāhī kings) and at Palampet.[45] The Kākatīya style is at its most distinctive in sculpture, particularly the female bracket figures in polished stone, dramatically posed, their lanky bodies unencumbered by the excessive Hoysala adornment. Later, Vijayanagara's ubiquitous presence makes itself felt in the form of gopuras, including the fine one at Tādpatri. A superb example of the style, with Orissa affinities, may be seen in the Varāha-Narasiṁha temple at Siṁhacalam (Vizagapatam District).[46]

Except for the ground plans of the trikūṭa shrines at Balsāne, Bid, and Umarga,[47] the Mahārāṣṭra temples of the period, which include important Bhūmija shrines, cannot be classed as 'borderland' in plan, elevation, or wall treatment.

208. Śiva and Pārvatī seated and embracing (Umāmaheśvaramūrti). Thirteenth century. Chloritic schist. *Pan-Asian Collection, Property of R.H. Ellsworth Ltd*

SOUTH INDIA

INTRODUCTION

Culturally speaking, South India consists of three regions: the coastal and non-mountainous inland areas at the south of the peninsula; on the west coast the Malayālam-speaking districts of Karṇāṭaka and the present state of Kerala extending almost to Cape Comorin or Kanyakumari at the extreme southern tip; and finally Tamilnāḍu, the land of the Tamil-speaking people, running up the east coast to Madras. Tamilnāḍu is very different from Kerala in size and character: Kerala is a narrow coastal strip with abundant rainfall, extremely fertile and densely populated, Tamilnāḍu relatively dry and several times larger, its southern part occupying two-thirds of the peninsula. Although Karṇāṭaka points a finger southward between Kerala and Tamilnāḍu, it does not belong to South India: lying mainly on the Deccan plateau, it is an artistic borderland[1] where influences from South India and other parts of the subcontinent meet. The same applies to Āndhra, although its language, Telugu, Canarese, the language of Karṇāṭaka, and Tamil and Malayālam all belong to the Dravidian (and therefore non-Indo-European) group. Tamil has the oldest literature, going back before the Christian era, when the three traditional kingdoms of South India, the Cera (Kerala) and the Pāṇḍya and Cola (the southern and northern parts of Tamilnāḍu), were already known.

It is not satisfactory – as has often been done – to discuss the art and architecture of South India in conjunction with that of the rest of the subcontinent, for its contribution is massive, distorting the overall framework. To take only two major objections: the known artistic history of South India, with very few exceptions, does not begin until the seventh century, whereas by this time in the north there were monuments nearly a thousand years old, and the greatest heights of achievement had perhaps already been scaled. Conversely, for obvious historical reasons, there is not a great deal of temple building of artistic significance in northern India after the twelfth century, whereas in the south it continues to flourish until the seventeenth – a colossal difference in time scale.

Even more important is the fact that architecture and sculpture in South India develop in quite a different way, both conceptually and aesthetically, particularly in the period from 650 to 950, which saw their culmination. What could be more fundamentally different from the conservative, serene, and harmonious styles of the Pallava and Early Cola periods in South India than the experimentation, the exaggeration, and the baroque floridity characteristic of the contemporary post-Gupta style? The two to three hundred years that follow also tell the story of a different stylistic development: in South India, innovations are few, the old forms are followed with less and less inspiration; the greater size of certain temple buildings alone heralds a new departure. Again, how different the developments in Orissa, in Madhya Pradesh, and in Rājasthān. Style

is relatively homogeneous both in South India itself and in the borderlands; not quite so obvious is the totally different emphasis of the later phases, although the temples retain essentially the same type of fabric. The great temple cities of the south, in essence a development of the hypaethral or open-air temple, not unknown in the early Indian period but later eclipsed in the north by the importance accorded to buildings and especially the central shrine, set the final seal on the separate development of architecture.[2] It is true that certain aspects of the Vijayanagara and Nāyaka styles (fifteenth, sixteenth, and seventeenth centuries), particularly an over-density of ornament, recall similar tendencies during the later Hindu period elsewhere, but there is, once again, a *décalage* of no less than three or four centuries.

At the same time no building, no sculpture was ever created in South India that is not at once recognizable as wholly Indian. Indeed, its iconography is pan-Indian, with no more strictly regional elements than are to be found elsewhere. The same can be said of the religious concepts that underlie all Indian art. Research has shown, moreover, that the earliest manifestations of *bhakti*, the personal and highly emotional devotion to a god which was to transform the whole religious climate, are to be found in South India.[3] Less powerful, more refined, and almost invariably exuding gentleness, Pallava and Early Cola sculpture nevertheless have much in common with Gupta, yet they neither coincide in time nor are their artistic heirs even remotely similar. Here perhaps is the key. In Thoreau's phrase, South India marched to a different drum from the rest of the subcontinent, deaf to other rhythms under the compulsion of its own achievements and needs. Lest it appear to be perpetually out of step, therefore, its own artistic development slighted and the appreciation of its immense contribution diminished, it is best treated independently from its beginnings to the present.

THE PALLAVAS

The so-called Pāṇḍya beds, hollowed out of natural caves, bear short inscriptions in Aśokan Brāhmī, and graffiti on sherds of the first centuries B.C.-A.D. from Arikamedu are in a later version of the same script. The excavations at Arikamedu, near Pondicherry, south of Madras, also turned up ample evidence of trade with the Roman world: Arretine ware, amphorae of Mediterranean type, and Graeco-Roman crystal gems. Indeed Roman coins have been found all over South India.[1] Western sources refer to this commerce, and the rich Tamil literature of the Śaṅgam age (early centuries A.D.) alludes to western (*Yavana*) traders and settlers. Local ware is related to pottery from the megalithic and urn-burial sites of the lower Deccan[2] but, very curiously, few or no artefacts can be linked with the sophisticated and evidently Hinduized society of the Śaṅgam literature, in rather the same way as, two millennia earlier in the north, identifiably 'Vedic' artefacts are lacking. The only sculpture of any importance from this early period is the famous and mysterious Guḍimallam liṅga, faced with a standing figure of Śiva, still in worship in a temple a little to the north-west of Madras [209]. It is in a Sātavāhana-related style: its mysteriousness lies in the total absence so far of any object in an even remotely similar manner within many hundreds of miles, and indeed anywhere in South India.[3]

It is probably the most puzzling fact in the art history of the entire subcontinent that the earliest known monuments and sculpture in South India, with the lone exception just mentioned, belong to the seventh century. As has

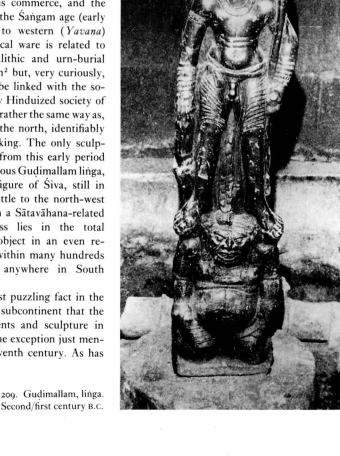

209. Guḍimallam, liṅga.
Second/first century B.C.

been seen, this was no isolated or backward region. Buddhist monuments have survived in the coastal regions of Āndhra, further north, dating from as early as the second or first centuries B.C., and of only slightly later date in Sri Lanka. One thing seems evident: the Buddhists and Jains, who flourished in South India at an earlier date, cannot have built large stūpas, the most durable of monuments, perhaps through lack of resources.[4] Unquestionably, there must have been a long tradition of building and sculpture in perishable materials – brick, wood, and perhaps metal –before the fully-fledged achievements of the Pallavas in the seventh and eighth centuries. Perhaps the switch was so long delayed because the stone available, mostly granites, was so hard, but the mystery remains, since some of the earliest surviving temples were built of the local sandstone. Brick, moreover, continued, particularly for the upper storeys. Why, then, have no earlier stone temples or sculpture survived in a land which was totally spared the violent depredations to which northern India was subjected?[5]

The Pallavas, probably of Telugu origin, are not one of the ancient dynasties of South India. Their inscriptions, unlike those of their successors, the Coḷas, were in Sanskrit. They came to rule the Toṇḍaimaṇḍalam, the regions around Madras and Kāñcī, from the third or fourth century A.D. and are best known in history for their military rivalry with the Early Western Cāḷukyas of Bādāmi. The earliest temples in the 'southern' style at Bādāmi and near by are perhaps half a century earlier than those of the Pallavas, and already there are significant differences between them, so that at most a common source, vanished for ever, can be postulated.

The monuments of the Pallavas, exceptionally well documented by scholars, consist of cave-temples and structural temples, plus a few monolithic representations of the structural ones. In some of the caves are large bas-reliefs of scenes such as Durgā riding into combat with the demon buffalo, in size and complexity similar to those in the Deccan and Konkan caves, and the largest and most elaborate sculptural composition in India is the great panel of the Kirātārjunīya, carved on the face of two gigantic boulders.[6] The principal sites are Kāñcī, the Pallava capital, an ancient and holy city, and Māmallapuram, its seaport. The earliest Pallava king to be associated with any of the monuments is Mahendravarman I (c. 600–30). Narasiṁhavarman I (Māmalla) (c. 630–68), who gave his name to Māmallapuram, also bore the title Vātāpikoṇḍa, conqueror of Vātāpi (Bādāmi). Narasiṁhavarman II (Rājasiṁha) (c. 695–722) was probably the greatest builder of his line. Certain caves in the north, notably at Mogulrājapuram, near Bezwada, and at Undavalli, the only multi-storeyed one, are in Telugu country, and not certainly the work of the Pallavas. The cave-temples in the traditional Coḷa and Pāṇḍya regions to the south are as numerous, but generally a century or two later than the Pallava ones, and none is as refined or elaborate as some of the caves at Māmallapuram.[7]

The Pallava caves, none of which approach the proportions or the complexity of plan of those at Ajaṇṭā, Ellorā, and other sites in the north, may be divided into two categories, the 'plain' and the 'elaborated'. The plain ones, widely distributed outside the main sites (only three of them are at Māmallapuram),[8] have exceedingly massive pillars, square at bottom and top and chamfered into an octagonal section in the middle, supporting equally ponderous corbels decorated on their under-sides by a simple roll moulding. Either two or four of these columns, with pilasters at each end, support the façade, which is totally plain except at Dalavāṇur, where a makaratoraṇa arches between the two central columns [210]. This tympanum motif, with a festooned and peopled arch issuing from the mouths of makaras at either end, and most beautifully elaborated, will become the standard crowning element of niches in Early Coḷa temples. Along the whole length of the façade runs the kapota moulding which continues to mark temple cornices to

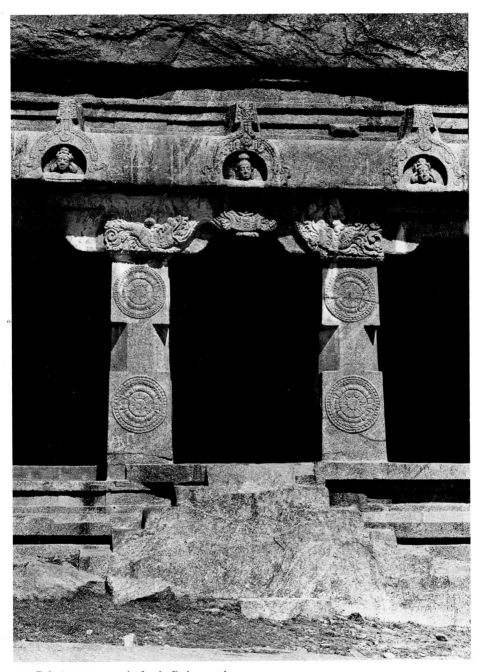

210. Daḷavānur, cave, granite façade. Early seventh century A.D.

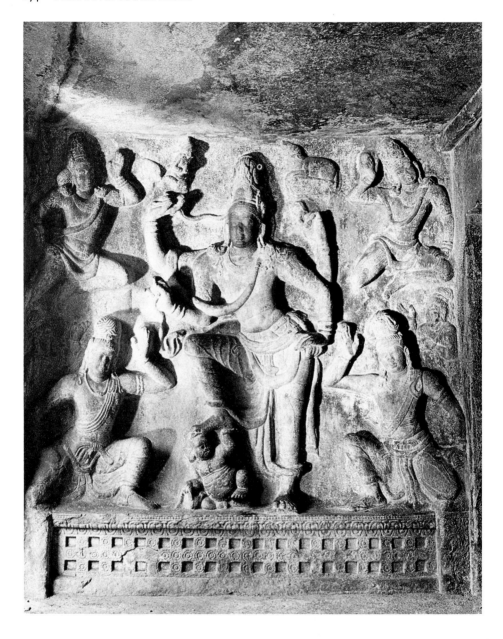

211. Tiruchirāppaḷḷi, upper cave-temple, Śiva Gaṅgādhara.
Seventh/eighth century. Granite

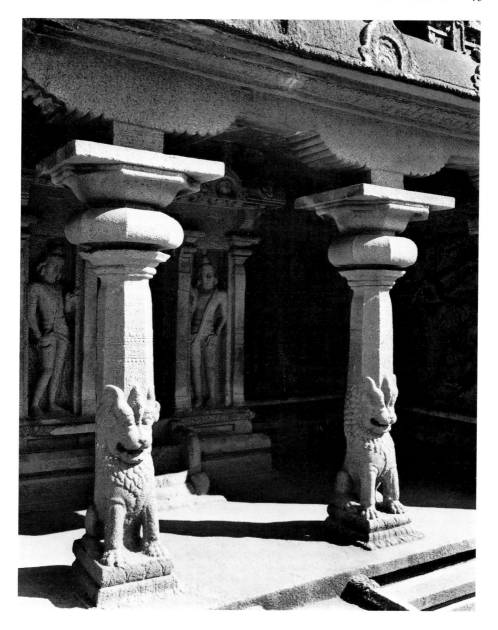

212. Māmallapuram, cave-temple, Varāha maṇḍapa, pillars of façade.
Seventh/eighth century. Granite

the present day. The five gavākṣas (Tamil: *kūḍu*) along the eaves moulding have the characteristic Pallava spade-shaped finials and enclose busts of *gandharvas*, celestial demi-gods. Their elaborate decoration is unusual, and so are the 'ears' in the form of makaras, making a very brief appearance in South Indian architectural ornament, these side extensions not being a part of the South Indian gavākṣa.

Dvārapālas, always in flexed though often rather awkward poses, are generally cut into the rock at each end of the façade. The caves are usually above ground level. The larger ones (none are more than 35 ft, or 11 m., wide, and some are unicellular) have columns inside and, either at the back or at one end, a sanctum housing a liṅga and sometimes guarded by dvārapālas, and even by dvārapālikās, their feminine counterparts. Often these sentinels lean on a large club, a pose which will become characteristic. Occasionally Śiva, Viṣṇu, or Brahmā are the mūrtis of the sanctum, or are carved on the walls of the hall. At Tiruchirāppaḷḷi (upper cave) all three appear with Durgā and Subrahmaṇya, the name for Kārttikeya in the south. Viṣṇu always stands in samapada, his cakra facing forward, and where the sacred thread is worn it is usually, but not invariably, draped over the right arm.

The sculpture is very uneven but sometimes of great distinction; the Gaṅgādhara (Śiva receiving the Ganges upon his head) at Tiruchirāppaḷḷi for example is very fine, anticipating, with its attendant figures, the elaborate panels of the 'decorated' caves [211]. In sharp contrast to those in the north, none of these caves bears anything but the minimal internal decoration – an occasional rosette on a square section of pillar or, rarely, some figures in relief, almost as an afterthought.[9] Moreover in only one monument in the whole of Tamilnāḍu does even a vestige appear of the vegetal scroll-work (ultimately of Gupta origin) that so successfully adorns the caves at Bādāmi and Aihole, and that in a rather sparse and crude version on some medallions inside the same Tiruchirāppaḷḷi cave.[10]

The 'elaborated' caves are all at Māmallapuram, popularly Mahābalipuram. Their columns, except for the corbels, are totally different from those of the 'plain' caves [212]. Relatively slender, with so many facets that they sometimes appear fluted and even round, they already include, in proper proportion and order, all the elements of the true Drāviḍa pillar and pilaster. The shaft carries the *mālāsthāna*, a low-relief band of pearl festoons, and then flares out gently to where a deep throat or indentation separates it from a cushion-like element (called the kumbha, probably for historical reasons, although it bears little resemblance to a pot or jar). Above the kumbha, a lotus element, the padma or *iḍal* (Tamil), flares out to the broad thin abacus (*phalaka*; Tamil: *palagai*). Sometimes, as in the Varāha maṇḍapa, the notched flaring iḍal, surmounted by the thinnest of palagais, is indistinguishable from the finest Early Cōḷa examples, one of the most elegant creations in all architecture. The only element still missing is the notch in the shaft before it flares, with a slight swelling above it, to become the most delicate of vases (*kalaśa*) – emphasizing what a misnomer 'pot' or 'jar' is for the cushion above it. The bases are often sedant yāḷis or lions.[11] The entablature, invariably a kapota with kūḍus, is usually topped by a row of miniature pavilions (*hāra*). Some bases consist only of three plain rectilinear elements which nonetheless establish the order and basic components for the matchless bases of many Early Cōḷa temples. Ground plans vary. The Trimūrti has no hall, and the three cells open directly on to the exterior. The Mahiṣamardinī-maṇḍapa, also in three parts, has a two-pillar portico in front of the central cell.

Architecturally elegant though sparse as these cave-temples are, interest inevitably focuses on the large mythological relief panels carved on some of the walls. Only three subjects are distinctively Tamil: Durgā as Korravai, the goddess of victory, with the deer, and male devotees apparently in the act of cutting off their heads with a sword;[12] Śrī

seated in the European fashion with great ele-
phants behind her and attendants on either
side; and Somāskanda – Śiva *sa* (with) Umā (and)
Skanda – that is, the god and his wife seated
on a throne with their infant son between them
[213].[13] The other myths are illustrated much
as they are elsewhere: Varāha carries a realistic-
ally sized Earth goddess in his arms instead of
perched on his shoulder or elbow, Durgā, as at
the Kailāsa at Ellorā, rides into battle firing a
bow at the demon buffalo [214], the Trivi-
krama and the Śeśaśayin vary little from the
Indian norm. Larger than any of these, the
Kṛṣṇagovardhana seems to have been carved
on the exterior of a boulder, for the hall in
front of it (Kṛṣṇa-maṇḍapa) is a constructed

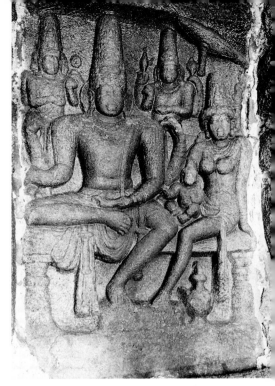

213 (*right*). Māmallapuram, 'Shore' temple,
Somāskanda group. Eighth century, first half

214 (*below*). Māmallapuram, cave-temple,
Varāha maṇḍapa, Durgā Mahiṣāsuramardinī.
Seventh/eighth century. Granite

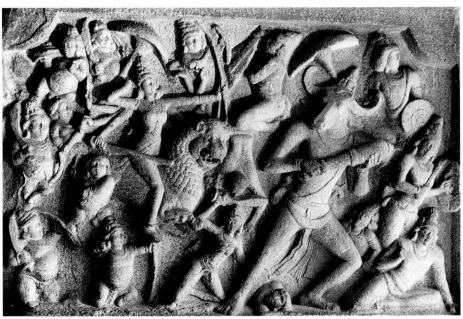

one of sixteenth- or seventeenth-century date. For all its non-South-Indian subject, at 27 ft (8 m.) it is the largest illustration of this theme and a notably early one.

The relief of most Pallava sculpture tends to be shallower than in the Deccan because of that hardness of the stone which has kept ornament to a minimum. Crowns and head-dresses are plain, little or no jewellery is worn, and no attempt is made to reproduce other textures in stone.[14] The principal figures, both male and female, are slender and delicately built and project sweetness and unmannered delicacy and refinement. The women are girl-ish, their breasts small and their hips not noticeably swelling; their bhaṅgas, in particular, are restrained by Indian standards, often just a forward thrust of the pelvis in three-quarters view [215]. It is significant that frontal poses in a flexed position are often awkward, parti-cularly those of the dvārapālas ubiquitous in Pal-lava caves. The hulking, menacing figures, in profile or with crossed legs and usually holding clubs, are always successful; the welcoming ones, full face, with flexed bodies, seem to be beyond the sculptors' ability to render con-vincingly. It is only in some of the 'elaborated' caves at Māmallapuram, where they stand somewhat sideways in very narrow niches, that, holding a flower or making a welcoming gesture, their stance is perfectly natural [212].

A mūrti of Śiva in relief, rather than a liṅga, usually presides in the little sanctums of the Māmallapuram cave-temples, often flanked by Brahmā and Viṣṇu. Sometimes no remains of carving can be detected on the back walls, so that the images must have been of stucco, wood, or even metal. The cave-temples ex-emplify sectarian tolerance, although much later some Śaiva sculptures were obliterated by usurping fanatical Vaiṣṇavas.

In one of the caves (Ādivarāha) are two notable portraits of a Pallava king and his son, each accompanied by two queens or princesses. The father-son relationship is predicated on the fact that one man is standing, the other seated; the throne, with its animal-type legs, is perhaps

215. Māmallapuram, Ādivarāha cave, King Narasiṁhavarman Māmalla and two queens or princesses. Late seventh century. Granite

the unique example of western classical influ-ence in South India [215]. These rare portrait sculptures, which bear labels of a sort, are the earliest after those of the Kuṣāṇa monarchs from Mathurā.[15] A couple of miles up the beach from Māmallapuram, at Śāḷuvankuppam, a little 'decorated' cave (the Yāḷi maṇḍapa) cut into a boulder is framed by an arch of large yāḷi heads and shoulders which covers the rest of the stone. There is a remote resemblance to the 'tiger cave' at Udayagiri (Orissa).

Perhaps the most extraordinary of all at Māmallapuram are the little monolithic shrines carved out of granite boulders near the beach.[16] There has been much fanciful speculation about them, mostly by people un-aware that similar monuments exist elsewhere in India and even in the south (Kaḷugumalai). The principal types of South Indian temple

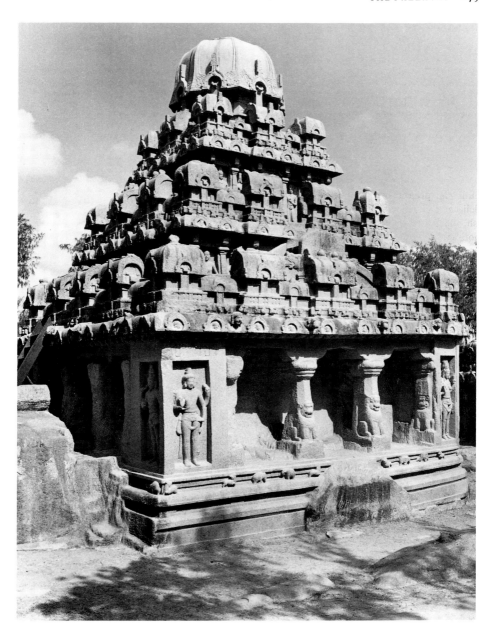

216. Māmallapuram, Dharmarāja ratha. Seventh/eighth century. Granite

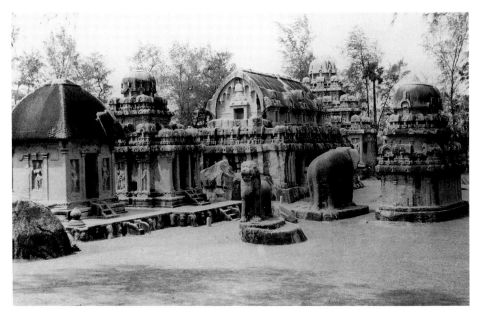

217. Māmallapuram, rathas, from the west. Seventh/eighth century

buildings, except the flat-roofed maṇḍapa, are represented, one only in embryo (Bhīma, as a prototype of the gopura with its crowning śālā).[17] Early Pallava chronology is still not established within sufficiently narrow limits to determine whether the monoliths preceded the first structural stone buildings; what is clear is that the precursors of both, in wood probably infilled with brick and plaster, are more faithfully reproduced in the monoliths which, with the exception of the 'Draupadī' (dedicated to Durgā), are in the purest Drāviḍa style with all its crispness, restraint, and sober strength. The order, like the Greek classical order, was immutable ever after: base, pilaster, corbels, entablature, and then the parapet of pavilions around a new central element, similarly ordered, and so on up to the crowning dome, square, round, or octagonal. In both the Arjuna and the larger Dharmarāja there is a walkway between the pavilions and the central element. The Dharmarāja [216] (where a stone ladder leads up to the first storey), with its

mūrtis carved into the niches of the ground floor and first two upper storeys, offers a veritable catalogue of early Pallava iconography.[18]

Like the apsidal-ended Sahadeva, Dharmarāja is unfinished. Arjuna's sanctum is half-finished and empty; in the Dharmarāja only the first-storey sanctum was hollowed out (there were to have been two, superimposed, an arrangement not unique) and it too is empty.[19] The little single-room Durgā, with a large boulder-cut lion beside it, is the only shrine in a final state, with female door-guardians, as befits a goddess, and inside a relief of Korṟavai. With its four-sided steep-pitched curvilinear roof, it is also alone in not being characteristically Drāviḍa. Although the roof-type is found much later in South India, it is closer to *Bangla* (Bengal).[20] The figures in the plain shallow niches at each storey of the Dharmarāja and Arjuna are in the finest Early Pallava style. At Māmallapuram, moreover, the Indian sculptor's ever-present sense of fun breaks out in the life-size elephant, facing in

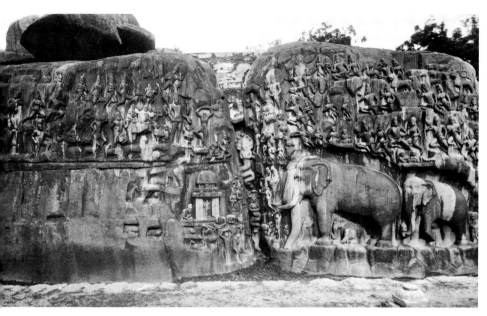

218. Māmallapuram, Arjuna's Penance (or Kirātārjunīya?). Seventh/eighth century

the same direction, cut out of a boulder beside the Sahadeva monolith. This temple was perhaps originally dedicated to Indra, whose vehicle is the elephant, but there may also be a punning reference to the name given to apsidal-ended shrines: *hastiprṣṭha* (elephant-back) [217].

The great sculptured panel variously identified as the Descent of the Ganges, Arjuna's Penance, and the Kirātārjunīya (Śiva disguised as a Kirāta, with Arjuna) is cut on the vertical faces of two huge boulders, each some 91 ft (30 m.) high and over 152 ft (50 m.) wide [218].[21] A narrow cleft dividing them from top to bottom provides the focal point for a vast congress of life-sized figures and animals, all facing the cleft or hastening towards it. They include gods, demi-gods, and sages, all in the flying position, Kirātas or wild hunters, and kinnaras, half bird, half human. A nāgarāja and a nāginī with exceptionally long serpent tails, the only free-standing sculptures, one above the other in the cleft seem to be swimming up

a waterfall, and indeed the remains of a cistern on top of the boulders indicate that on ceremonial occasions water actually did flow. Vestiges of palace buildings above also suggest royal involvement. At the foot of the cleft, in contrast to the energy and movement of the advancing throngs above, hermitage (*aśrama*) life flows calmly on beside a stream. A young ascetic fetches water, another wrings out his wet garment, yet another stands, arms raised above his head (*ūrdhvabāhu*), staring at the sun, a widespread form of religious self-torture (*tapas*). Others are in the yogic position or with the band called a *yogapaṭṭa* around their backs and knees, while an aged sage sits in contemplation before a little shrine containing a statue of Viṣṇu – an exceptional case of an image representing an image. Above, slightly to the proper right of the cleft, a four-armed figure larger than all the rest can be identified as Śiva by the long trident over his shoulder and his escort of gaṇas. Before him a bearded man stands on one leg staring at the sun with

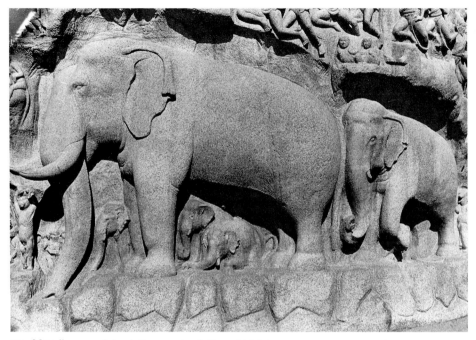

219. Māmallapuram, Arjuna's Penance, detail. Seventh/eighth century

his arms also raised in a semicircle above his head, his emaciated body testifying to the rigour of his austerities.

Such a concourse of animals and the rocky nooks and ledges they inhabit, the Kirātas and the hermitage beside a river (the newborn Ganges?), all, by Indian convention, suggest a wild and mountainous region, which the presence of Śiva confirms as the Himālayas for Kailas, one of their highest peaks, is his traditional dwelling-place. The ascetic performing tapas before the god has been identified as Arjuna, one of the Pāṇḍava brothers, who came after practising extraordinary austerities to beg from Śiva, shown with his left hand making the gift-giving gesture (*varada*), signifying the boon of his magic weapon Pinaka, so that he may take revenge on the Kuravas. The story occurs in the Mahābhārata. Popular in Pallava times, it is the subject of a long Sanskrit poem, the Kirātārjunīya, by the sixth-century poet

Bhāravi, a native of Kāñcī, and it must surely be the verse about the birds and animals forgetting their natural antipathy in the hunter-army marshalled by Arjuna's divine protector that provides the main visual theme of the great panel.[22] There are objections to this identification, however, on two grounds. The less important is that it is to the cleft, and not to Śiva and Arjuna, that all are hastening, and that some figures, in the space between the advancing horde and the cleft, actually have their backs turned to Śiva. More serious is the apparent absence of any wild boar in an assemblage which includes nearly every animal (and reptile and bird) known to Indian iconography,[23] for at the heart of the Kirātārjunīya myth is the boar sent by some Asuras to destroy Arjuna, and the intervention of Śiva disguised as a Kirāta. Both claim to have shot the animal, and a fight ensues in which Śiva, the victor, finally reveals himself. This episode explicitly

figures in most representations of the Kirā-
tārjunīya.[24] As a result of these inconsistencies,
the view that the great relief represents Arjuna's
penance has been reaffirmed.[25]

The individual figures in this vast panorama
are as fine as anything in Indian sculpture.[26]
The bearded sages in flying pose are of extra-
ordinary force and nobility, and the animals –
in which Indian sculptors have always excelled
– are outstanding. The minuscule baby ele-
phant asleep between his parent's vast colum-
nar legs [219], and the deer delicately scratch-
ing its nose with a hind leg, show a capacity
for close observation of the natural world
which is often overlooked in view of the ideal-
ization and conventionalization so prevalent in
Indian art. Near the aśrama, with mice around
his feet, stands a cat on his hind legs, front

paws above his head, like the two humans
doing penance [219, extreme left]. There is an
obvious allusion to Dadhikarna (Milk Ear), the
hypocritical cat in a popular fable, but the cat's
emaciated body and the contented scurrying
of the mice leaves open the possibility that he
is a genuine convert to asceticism and non-
violence.

The Pallavas built structural temples as
well, the earliest to have survived in South
India. The 'Shore' temple at Māmallapuram,
built in part at least by Rājasiṁha, now stands,
due to the retreat of the shore-line, in an ex-
posed and romantic position on the water's
edge, literally washed by the waves [220]. Ex-
cept for the large walled compound at the rear,
the temple is virtually intact, although its
sculpture is often weathered beyond recogni-

220. Māmallapuram, 'Shore' temple. Begun in the eighth century, first quarter

tion by exposure to salt water. It is unique in its composition: the larger shrine facing east is hugged so tightly on three sides by a wall that the space between suggests an internal circumambulatory passage. Furthermore, the smaller shrine, offset at the rear, faces west. The tall thin outline of both shrines, due to the unusual absence of hāras, suggests that they are contemporary.[27] Between the two, and largely incorporated into them, a small rectangular flat-roofed shrine houses an image of the recumbent Viṣṇu cut out of the bedrock. The other two shrines have at the back of their sanctums the Somāskanda panels obligatory for early Pallava temples, and the larger one housed one of the equally typical fluted liṅgas made from imported black basalt – a material used for the crowning finials of both, doubtless reflecting their importance in the consecration of the temple. As in all the more elaborate Pallava examples, the outside walls of these shrines are crowded with mūrtis and other figures, in plain niches, in niches with flanking half-pilasters, and on the intervening wall spaces. Narrative panels line the inside of the larger shrine's enclosure wall, and the remains of dvārapālas guard the entrances. At the corners are lion- and yāli-based pilasters; similar ones, as well as some with nāgarāja and *nidhis* (personified treasures) and even elephants at the base, relieve the enclosure walls outside, including the largely ruined one to the larger courtyard at the rear, the remains of whose small entrance gateway are guarded by an image, unique for the period, of Śiva Ekapad (one foot).

Apart from the incorporation of some of the bedrock into the plinth and lowest base mouldings of the two rear shrines, as in the Malegiṭṭi Śivālaya at Bādāmi, the Shore temple is constructed in the usual Pallava way. Some of the base mouldings consist of horizontal courses of granite, but wall surfaces, as in Drāviḍa shrines in the Cāḷukya regions, consist of blocks – albeit of granite, not sandstone – their opposite sides rarely parallel but close-fitting nonetheless, with areas left proud to be carved into pilasters and relief sculpture. In

contrast to Cāḷukya practice, many of the images in the niches were also integrally fashioned in this way; the result appears to have been a very low relief, much augmented by a plaster covering in which the details were carved, in the same way, although for a different reason, as on the granite statues of the monoliths. As in the Cāḷukya country, vestiges of other types of construction survive in some small shrines.[28]

The true Drāviḍa style manifests itself in its purest early form, i.e. adhering closest to wooden prototypes, in the Māmallapuram monoliths, although they are probably a little later than certain Cāḷukya temples in the 'southern' style. There is, in any case, no question of a direct filiation as far as surviving buildings are concerned. In the past, the 'plain' caves have been attributed to Mahendravarman I because of a famous inscription linking his name, and that of his immediate successor, to one of them, the far more sophisticated 'decorated' caves, as well as the monoliths, have been described as in the 'Māmalla' style, and the structural temples have been given to Rājasiṃha and his successors[29] – a progression which appeared to fit in tidily with the nature of the monuments and their styles. A later view, however, attributes most, if not all, of the Māmallapuram rock-cut monuments to Rājasiṃha.[30]

The Kailāsa (or Rājasiṃheśvara) temple at Kāñcī is the largest and most important of the temples built by Rājasiṃha [222]. The vimāna, of unprecedented size and complexity, is preceded by two other buildings, and the whole surrounded by the most elaborate enclosure wall of any South Indian temple [221]. An internal circumambulatory passage girdles the sanctum, and seven small shrines abut on to its external walls. Those on the sides are

221. Kāñcī, Kailāsanātha temple.
Eighth century. Plan

0 50FT
0 15M

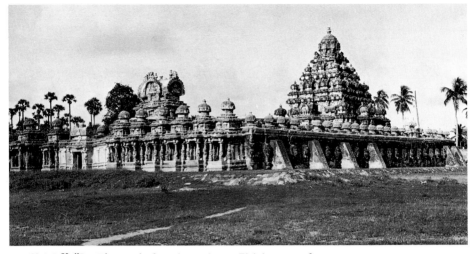

222. Kāñcī, Kailāsanātha temple, from the north-east. Eighth century, first quarter

oblong in plan, those on the corners square, conforming to the little pavilions in the hāra above, in the same way as do the bays and re-entrants in the wall surface of Early Cola temples. Conceptually, the niches in the central projections of the latter, with their images, are a taking into the body of the vimāna of these oblong shrines. The entrances to these little shrines, all housing images of Śiva in one form or another, open to the auspicious east or west, never to the north or south [223]. In front of the main shrine is a large detached pillared maṇḍapa (the structure connecting them is modern).[31] On one of the pillars is a fragmentary inscription relating to the conquest of Kāñcī by the Early Western Cālukya king Vikramāditya II (733–46).[32]

The main shrine and the maṇḍapa are enclosed by a wall of fifty-eight small shrines. The aedicule in the middle of the western side (the temple faces east), originally a gopura, has a barrel roof, as (oddly enough) do two shrines in the north and south sides of the compound wall, in line with the sanctum of the main shrine; so here, in embryo, are the entrance gopuras, sometimes on all four sides of the compound wall or walls, which dominate the

great South Indian temple-cities of a later age. On plan, the wall of shrines, consisting of a śālā between koṣṭhas, duplicates the composition of pavilions around the central element on the upper storeys of Drāviḍa shrines. No subsequent examples of this arrangement exist, and the compound walls themselves cease to be of much architectural interest.

Where the principal gopura of the Kailāsanātha temple should be, on the east opposite the entrance to the main shrine, a rectangular barrel-roofed structure of fairly ample dimensions indeed stands, but there is no question of the Mahendravarmeśvara, named after a son of Rājasiṁha, ever having been a gopura: not only does a contemporary inscription call it a shrine, but it houses an original black fluted liṅga, backed by a Somāskanda panel. Entrance to the whole temple is by makeshift gaps on either side between the Mahendravarmeśvara and the main compound wall, closed by a further courtyard, with a small gopura. The unique placing of the Mahendravarmeśvara is difficult to account for. Also most unusual is the row of small dedicatory or memorial shrines to the east, outside the temple enclosure, two of them built by queens.[33]

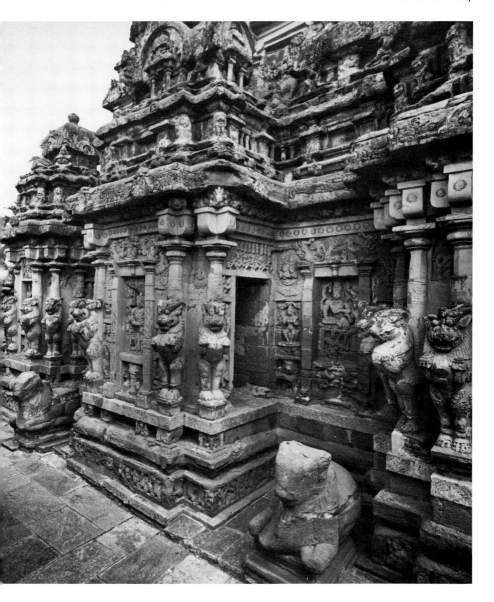

223. Kāñcī, Kailāsanātha temple, vimāna, south side. Eighth century, first quarter

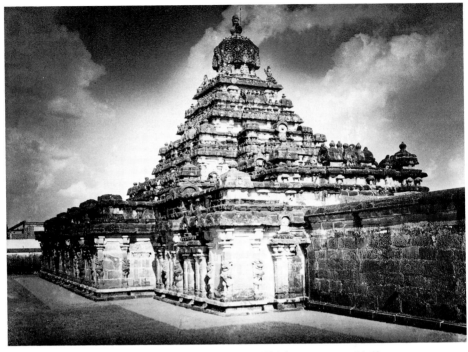

224. Kāñcī, Vaikuṇṭhaperumāḷ temple, from the south-east. Eighth century, second half

Vaikuṇṭhaperumāḷ at Kāñcī, with a vimāna actually larger than at the Kailāsa, is one of the rare Pallava temples dedicated to Viṣṇu [224]. Built by Nandivarman II, it is exceptional in having three sanctums, one above the other; in one is a standing, in the second a seated, and in the third a recumbent image of Viṣṇu. At ground level are two circumambulatory passages, the inner one entered from the antarāla, the outer, lit by openings in the outside walls, from an eight-pillared maṇḍapa attached to the vimāna. These features, except the double circumambulatory, were to recur in all the larger shrines in Tamilnāḍu. The plan of the whole temple is logical and straightforward as well as complex. All round the inside of the enclosure wall, which follows the contour of the vimāna and the slightly narrower attached maṇḍapa, runs a pillared gallery with reliefs (some with labels) relating the history of the Pallavas.[34]

Other structural Pallava temples of the eighth century include the Talagirīśvara at Panamalai (South Arcot), further south than most of the Pallava monuments but indisputably built by Rājasiṃha I. Entirely of granite (except for the replacement at the very top), it has three small shrines abutting on to the back and side walls like the more numerous ones at the Kailāsanātha in Kāñcī. The fine temple of that name at Tiruppattur (Tiruchirāppaḷḷi District) is, on the other hand, entirely of sandstone. The sanctum has an internal circumambulatory passage, with another outside behind the first-storey hāra. This temple demonstrates how far south the Pallava style extended up to the end of the eighth century.[35] Of a further half-dozen or so surviving late Pallava shrines

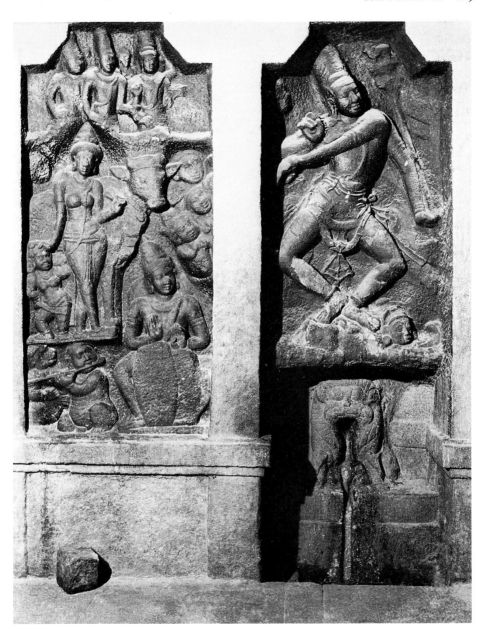

225. Tirupparankuram, cave-temple, exterior of shrine wall, Śiva dancing, with Pārvatī, Nandi, and celestial beings in the panel at the proper right. 773

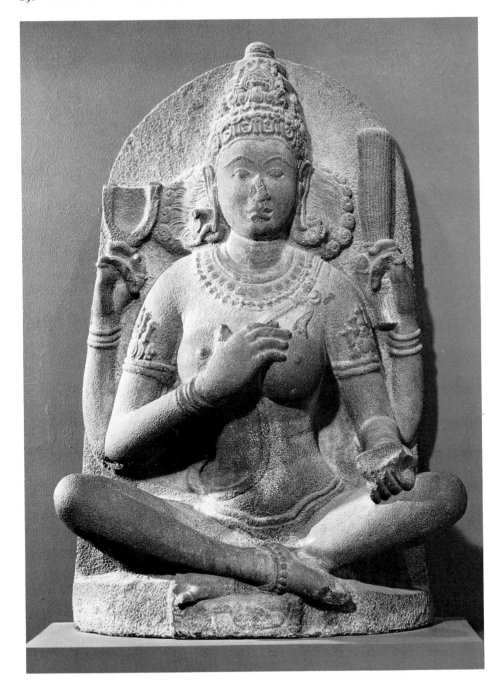

at Kāñcī, the largest are the nearly identical Muktesvara and Mātaṅgeśvara. The abundant images and carvings of these temples are so overlaid with plaster, renewed over the centuries, that it is to the Koṅgu and Pāṇḍya country cave-temples, little considered so far, that one must look to appreciate the finest sculpture of the period [225].

Ninth-century sculpture and architecture in Tamilnāḍu are still only partially studied. The temples at Takkolam near Kāñcī and at Tiruttāni (Chitoor District) west of Madras, both of the last quarter of the century,[36] differ significantly in certain details from contemporary shrines in the Coḷamaṇḍalam to the south and particularly the territory of the Muttaraiyars (the old Pudukoṭṭai State) and the area just east of Tañjavūr where the new Early Coḷa style is emerging. Very few structural temples remain from this period in the Pāṇḍya country in the far south, and their evidence is confusing.[37]

Takkolam and Tiruttāni, both with their original images, provide the only dated (and localized) evidence of the sculptural style of Toṇḍaimaṇḍalam during the ninth century and most of the tenth as well. Although inconclusive, it is of vital importance because of the exceptional quality of some scattered sculpture from the region, i.e. the images from Kāverīpakkam, now in the Madras Museum, and especially the superb Mātṛkās or yoginīs from Kāñcī, the most beautiful and moving of all such figures, now widely dispersed in museums throughout the world [226].[38] Widely known as they are, their stylistic affinities and probable date are still a matter of conjecture – a reminder of the incompleteness of our knowledge of early South Indian stone sculpture, outside of certain areas and sites, for all the intense labour in recent years of a number of exceptionally dedicated and gifted art historians.

226. Mātṛkā or yoginī from Kāñcī. Ninth/tenth century. Granite.
Arthur M. Sachler Collection

THE EARLY COLA PERIOD

The origins of Early Cola architecture and sculpture in Tamilnāḍu are not entirely clear, despite our knowledge of the preceding Pallava style. For one thing, the styles developed in two contiguous but separate parts of Tamilnāḍu. The Colamaṇḍalam (whence English 'Coromandel'), the traditional sphere of the Colas comprising the modern districts of Tiruchirāppaḷḷi, Tañjavūr (Tanjore), and South Arcot, including the rich Kāverī delta, lies to the south of Toṇḍaimaṇḍalam. The Pāṇḍyas, from the far south, defeated the Pallavas to-

227. Nārttāmalai, Vijayālaya Coleśvara temple, from the north.
Ninth century, third quarter

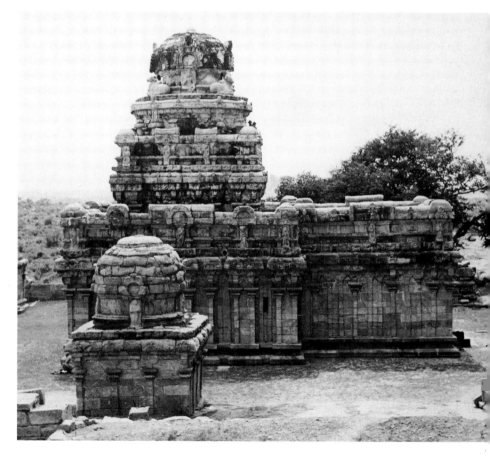

wards the middle of the ninth century, but their ascendancy soon passed to the resurgent Colas, anciently lords of Uraiyur (a suburb of modern Tiruchirāppalli, formerly Trichinopoly). The first temple associated with the Colas, at Nārttāmalai [227], bears the name Vijayālaya Colēśvara, after Vijayālaya (c. 866-70), who is generally acknowledged to have been the first of the Imperial Colas. However this dedication is attested only at a much later date, and the temple is more likely to have been built by one of the Muttaraiyars, important as marcher lords in the region south of Tiruchirāppalli which borders on Pāndya territory. The temple is remarkable for being sāndhāra, with a circular garbhagrha and central element rising out of a square vimāna, for a large ardhamandapa with reliefs of dvārapālas on either side of its entrance door, and for the absence of any niches (devakosthas) whatsoever. The extension of the hāra over the front hall, moreover, common also in Early Western Cālukya temples, and the relatively small śikhara without a perceptible reverse curve, the Vijayacolīśvara shares with the Pallava style. None of these features is found in Early Cola temples, which has led Douglas Barrett to conclude that this imposing and well-planned shrine represents the culmination of earlier developments rather than the inception of the Early Cola style.[1]

Be that as it may, by the fourth quarter of the ninth century that great explosion of temple building in the Colamandalam had begun (much of it, of course, in replacement of older fabrics) which, by the end of the next century, would make Early Cola temples as thick on the ground, in Barrett's phrase, as medieval parish churches in England.[2] Such a concentration of temples in the highest styles may once have existed elsewhere in India, but only in the Cola country have so many survived, usually in good condition. This is mainly because the area suffered no Muslim depredations, but partly due to the use of the hardest of stones (gneiss, granite, charnockite) – and another remarkable fact is that the highest concentration is found in the totally stoneless Kāverī delta.

The Early Cola style achieved its supreme creations in an astonishingly short time. Bold experimentation was not the secret of its success – there is greater diversity in the relatively few surviving Pallava temples, and none of the Early Cola temples is as large or as ambitiously planned as the Kailāsanātha or the Vaikunthaperumāl at Kāñcī. Evolution consists rather in perfecting the uniquely beautiful elements of the style and combining them, always harmoniously, in astonishingly diverse ways. Particularly admirable is the articulation of the ground-storey walls, and the treatment of the bases, consistently perhaps the finest feature of the temples.[3] Moreover the individual mūrti nowhere appears to better advantage. The adherence to a strict architectural order astonishingly similar to the western Classical-Renaissance one, which persists throughout the long history of the Drāvida style, makes these temples particularly congenial to westerners, although enjoyment is often marred because the upper storeys were of brick, now in ruins, or with their plasterwork renewed in the debased styles of recent times.

There are four outstanding ways in which Early Cola temples differ from Pallava ones. First, there are real niches of some depth, with an entablature and flanked by demi-pilasters. Usually a niche occupies the middle of the west, north, and south sides of the vimāna on the ground floor, and there is one on either side of the ardhamandapa, although there may be more, some of them unframed. They also occur at the cardinal points around the grīva, or neck, at the base of the śikhara[4] [228 and 229]. Second, there are no large rearing lions or yālis (vyālas) at the bases of pillars and pilasters.[5] Third, a rounded kumuda replaces the octagonally chamfered one in all but the plainest temples, and a fine frieze of the serried heads and shoulders of yālis and sometimes other animals runs between the upper mouldings of the base. Lastly, a ubiquitous row of tangent circles in low relief runs along the

228 (*above*) and 229 (*opposite*). Kodumbāḷūr, Mūvarkovil, Śiva and Pārvatī (Umā-Maheśvara) in the western niche of the grīva of the central shrine, with detail. Late ninth/early tenth century. Gneiss or granite

bottom edge of the main cornice moulding (*kapota*), and above it gavākṣas (Tamil *kūḍu*) topped by kīrttimukhas replace the earlier spade-shaped finials.

Some features they have in common. The corbels have the roll-mouldings and median bands of Pallava temples, but are less bulky, with an angular profile, and the rolls are interrupted by an elaborate throat moulding. While the composition and proportions of pillars and capitals remain remarkably similar, pilasters now frequently join the pillars in being octagonal or round, to greatly enriched effect; below the kaṇṭha there is sometimes superb low-relief decoration (the *mālāsthāna*), often featuring little dancing figures. Delicately elaborate makaratoraṇas almost invariably crown

the niches. In the finest temples the tiny panels formed by the bottoms of pilasters as they extend down through the base mouldings bear 'reliefs in miniature', often superb, sometimes with mūrtis, sometimes with scenes from the epics or Purāṇas. Lotus petals multiply on the base mouldings, dominated by perhaps the most beautiful innovation of the style, the huge reverse cyma with petalled border below the kumuda, as at Puḷḷamaṅgai. The occasional low-relief figures on the wall surface beside a niche are invariably small and iconographically related to the mūrti in the niche. Pañjaras, pavilion-like projections with their own kapotas and base mouldings, represent the supreme refinement of the complicated articulation of the walls in many Early Cola shrines.

Later additions have on occasion made an early shrine the centre of a large complex, but the Early Cola temple at its most complete consists only of the central shrine or shrines with an ardhamaṇḍapa, in the south a closed hall never wider than the sanctum, an enclosure wall, and sometimes a gopura. Kilaiyūr has twin shrines, Kodumbāḷūr (uniquely) three, of which only two remain standing [230]. Separate shrines for the surrounding or subordinate deities (*parivāradevatās*), including a rectangular one for the Mother, occur in some of the earliest temples. Nowhere do all these elements survive in their original forms.

The earliest shrines in the Early Cola style, at Kāḷiyapaṭṭi, Viśalūr, Tiruppur, Panangudi, and Virālūr [231], all in the Muttaraiyar region, are small, relatively plain, and entirely of stone from base to finial, as are the larger complexes at Kilaiyūr, with its twin shrines, and Tirukkaṭṭalai. They date from the second half of the ninth century and the first years of the tenth.[6] More and more temples were built over a larger and larger area, and by the reign of Parāntaka I (907–c. 940), in an almost unbelievable burst of creative energy, the Early Cola style, and indeed the Cola style of architecture, if one disregards the architectonic qualities of some later works (a function of their much greater size), had reached its apogee.

230 (*above*). Kodumbāḷūr, Mūvarkovil,
central and southern shrines
(only the base of the northern shrine remains).
Late ninth/early tenth century

231 (*left*). Virālūr, Bhūmīśvara temple,
from the north.
Ninth century, second half

Three temples in particular stand out. Perhaps the finest of all is the Nāgeśvara at Kumbakonam, Tañjavūr District, in the great rice-growing region of the Kāverī delta, probably built about 910.[7] Both shrine and ardhamaṇḍapa rest on a heavy petalled cyma recta moulding. The makaratoraṇas are superb. On the abaci of the pilasters stand female dancers and musicians or rearing yāḷis. Unfortunately, the central shrine is much disfigured by modern accretions, stucco, and paint. The images in the main devakoṣṭhas are

flanked by recessed niches sheltering what are probably worshippers, male and female, some of them iconographically unique, like the young man with moustache, beard, and elaborately dressed hair, and 'strong and noble features' [232].[8] The index finger of his right hand points upwards in *tarjanī mudrā*, the gesture of admonition or warning. The only indisputable image among these flanking figures is a Śiva as Bhikṣāṭana, the divine young ascetic, one of the very finest Early Cola creations.[9] The images in the main niches are the conventional ones, except on the south side of the hall, where Gaṇeśa is supplanted by another unique figure, a standing, simply dressed and clean-shaven man, perhaps a *svāmi* (saint), of rather fleshy mien.[10] The quality of the Nāgeśvara sculpture is very high, with the exception of one or two later replacements.

None of the parivāradevatā shrines of the Nāgeśvara is as early as the main temple, but one is only a little later and unusually elaborate for the period, with devakoṣṭhas, ardhamaṇḍapa, and dvārapālas. Enshrined there, moreover, is a large image of Sūrya which Barrett believes to be a survivor of the deities surrounding the earlier brick temple, probably as early as 870, and consequently a unique example of sculpture in the heart of the Colamaṇḍalam just before the rise of the Early Cola style.[11]

Although its sculpture is not of quite as high an order, the Brahmāpurīśvara temple at Pullamaṅgai, just off the road between Tañjavūr and Kumbakonam,[12] represents another of the supreme moments of Early Cola temple building. In a perfect state of preservation, and consisting only of the shrine, an enclosure wall, and a (later) gopura, it has all its original sculpture (except possibly the bricked-in Dakṣiṇāmūrti on the south side of the vimāna), and only the later decoration of the brick superstructure detracts from its jewel-like beauty [233]. The temple rises from a masonry-lined pit[13] filled with water in which oleanders grow, most poetically suited to the superb cyma recta moulding, carved with lotus petals,

232. Kumbakonam, Nāgeśvara temple, vimāna, bearded and moustached man flanking a niche on the west side. *c.* 910. Gneiss or granite

of the base. The figures standing on the palagais and incorporated into the tops of the pañjaras, the superb miniature reliefs at the bases of the pilasters, the carving below the necks of the pilasters and on the walls beside the niches, and the makaratoraṇas above the niches are all of unsurpassed quality and unique refinement and grace. The mūrtis occupy their usual positions: Liṅgodbhava (or occasionally Harihara or even Viṣṇu) on the west side of the vimāna, Brahmā on the north [234], Dakṣiṇāmūrti on the south; Durgā (as Korravai)

233. Puḷḷamaṅgai, Brahmāpurīśvara temple, ardhamaṇḍapa, south side.
Early tenth century. Gneiss or granite

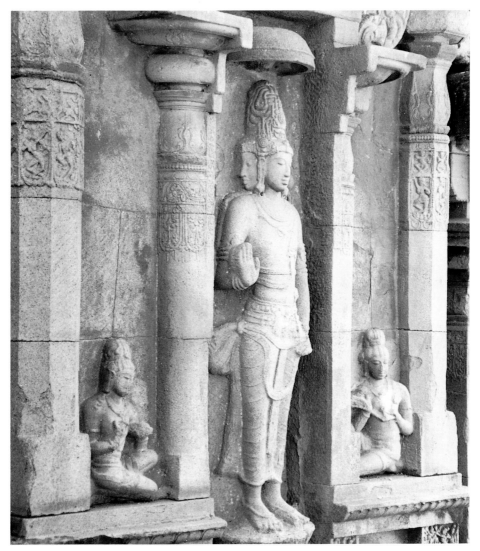

234. Puḷḷamaṅgai, Brahmāpurīśvara temple, vimāna, Brahmā on the north side.
Early tenth century. Gneiss or granite

on the north of the ardhamaṇḍapa and Gaṇeśa on the south. Perhaps not as powerful as the finest Early Cola sculpture, all have a sweetness and grace in perfect accord with the architecture. There are also two superb dvārapālas at the entrance to the sanctum, difficult to see in the dim light, as always at this period, and crudely installed. Archaically, the parapet of pavilions carries over on to the ardhamaṇḍapa.

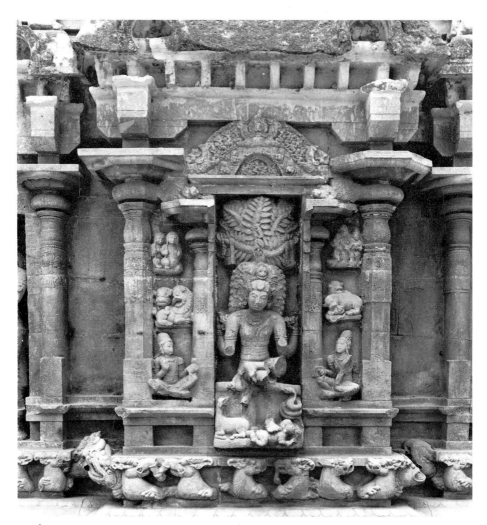

235. Śrīnivāsanallūr, Korańganātha temple, vimāna, Śiva Dakṣiṇāmūrti on the south side.
Tenth century, first half. Granite or gneiss

The Korańganātha temple at Śrīnivāsanallūr, some thirty miles west of Tiruchirāppaḷḷi, is a rare example of an Early Cola vimāna with two main storeys (the second of brick), each containing a sanctum.[14] It is also sāndhāra. Structural considerations would thus seem to account for the exceptionally thick walls of the principal sanctum. There is also a vestibule between it and the ardhamaṇḍapa. These unusual features may reflect the temple's location on the borders of Kongudeśa, the present district of Coimbatore and Salem, backed up against the Nilgiri hills. Nothing could be finer, however, and in the purest Early Cola style than

the magnificent vyāla frieze of the base, the makaratoraṇas, and the bold articulation of the vimāna walls with their alternation of square, octagonal, and (rarely) round pilasters, their capitals exceptionally stylish, with widely flaring idals and the thinnest and widest of palagais. Worshippers, male and female and in princely garb, occupy plain narrow niches. The Dakṣiṇāmūrti is particularly fine [235].

The Colas suffered a stunning if temporary setback when they lost control of the Toṇḍaimaṇḍalam to the Rāṣṭrakūṭas at the battle of Takkolam (c. 949).[15] The second half of the century is marked by the temple-building activity of Sembiyan Mahādevī, wife and mother of Cola kings and one of the great patrons of all time. Although the shrines are slightly larger, with the number of niches in the maṇḍapa increased to three on each side, compared with the contemporary Deccan and North India the Early Cola temple is modest in scale and simple in plan. Almost imperceptibly the typical petalled idal begins to appear, the niche surmounted by a śālā (first on the Karkoteśvara at Kamarasavalli, where it is blind and fails to break the uppermost base moulding, a type which is frequent later), and the denticulated edge to the lower side of base mouldings or niche lintels, the result of a different treatment of a petalled padma moulding. The first indisputably dated stone Naṭarāja, a mūrti in a niche rather than a relief on a pillar, pilaster, or wall surface, belongs to the early part of this half-century, a matter of relevance to the dating of bronze sculptures of the god dancing in the ānandatāṇḍava mode.[16]

All the principal images of the Brahmanical pantheon are represented in South India during the Cola period.[17] There is a particular predilection for Bhikṣaṭana, Śiva as the naked young ascetic, and for Śiva as Dakṣiṇāmūrti, the expounder of yoga, music, and the śāstras, who is always, where possible, facing south (dakṣina means 'south', and although there is no very convincing explanation of the name, it may account in part for the popularity of this image in South India). Śiva is represented in a greater variety of dancing poses than anywhere in India. Later in the Cola period, Kaṅkālamūrti, showing Śiva doing penance for killing a Brahman, rarely seen outside South India, becomes popular, as does Gajasamhāra, Śiva exultantly spreading out the skin of the elephant-demon he has just killed [254]. The bounding deer, almost invariably held in Śiva's upper right hand, is peculiar to South India.[18] The god's ear-rings are never a matched pair.

Although most of the temples are Śaiva, they do not preclude Vaiṣṇava images, particularly on the upper storeys, or small relief scenes

236. Karaikkal Ammai from Tamilnādu. Twelfth/thirteenth century. Bronze. *Kansas City, William Rockhill Nelson Gallery of Art, Nelson Fund*

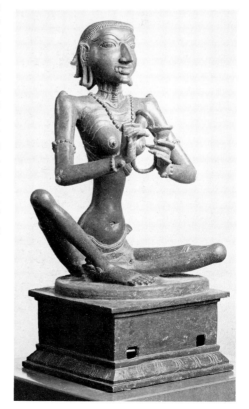

from the Rāmāyaṇa. Viṣṇu on his own is always in samapada, wearing a long dhoti, his lower left hand on his hip rather than holding a club. Śiva, on the other hand, wears a short, often pleated lower garment and adopts a great variety of poses. Mythical sages such as Narada, Kaśyapa, Patañjali, and Vyāghrapāda are frequent, and in particular Agastya, credited with bringing Sanskritic culture to the south.

The rich devotional history of Tamilnāḍu during the Pallava and Cola periods, anticipating in many ways the later bhakti movements in the north, is reflected in a whole iconography devoted to the nāyanārs (Śaiva saints) and the āḷvārs, their Vaiṣṇava counterparts. Usually in bronze, the most striking of these figures is the emaciated Karaikkal Ammai, 'the woman of Karaikkal' [236], a Śaiva saint, the only female among them. Even the great theological doctors Śaṅkara and Rāmanuja are represented. Finally, the village cults continued to thrive, as they do today, their predominantly female deities, like Pidarī, invoked as elsewhere in India against smallpox and other misfortunes in propitiatory and usually sacrificial cults. As elsewhere too, the boundaries between village and Brahmanical cults and iconography are fluid: the obese and fearful Jyeṣṭhā, for instance, of obvious village origins, was embodied in iconographically complex granite images in the same way as the Purāṇic deities. Among male village gods, the cult of Ayannār is the most widespread; to this day, large clay horses guard his rural shrines.[19]

Comparison with some of the finest Pallava sculpture at Māmallapuram provides an insight into the qualities of the Early Cola style. Least important of the differences is the enhanced detail in the latter; the jewellery and headdresses, of refined and unsurpassed elegance, are partly the result of a change in technique, with less reliance on modelling in a thick plaster coating. Male figures are less massive, indeed usually very slender. Early Cola sculpture at its finest is more intimate, more human, and makes a greater appeal to the emotions. The superb Umā-Maheśvara from the Mūvarkoil,

the god both majestic and uxorious, his consort nestling against him in all her confident femininity, has no equivalent in Pallava sculpture [228 and 229]. There is a withdrawn inwardness, again, in the faces of many of the gods [235 and 236] totally absent in the visages of Pallava figures, with their wide-open eyes. The contrast is an almost exact parallel to that observed between early Kuṣāna and Gupta faces, both the later styles achieving a miraculous balance between naturalism and an incipient stylization.

The art of casting figures in bronze has been practised in India since protohistorical times and has been common in every region, but it is in Tamilnāḍu that a high level of production and quality has been longest maintained, clinging to this day to a once great tradition.[20] The cire perdue process is used. Supreme are the Early Cola bronzes, the finest unsurpassed in any place or age. Usually without a surround (images of Naṭarāja, the dancing Śiva, are practically the only exception, and the prabhā (Tamil: tiruvāśi) around them is a large ring bordered with flames), the figure is most often unaccompanied. There is thus little room for iconographical variation. Costume and jewellery, usually worked and refined after the casting, in most cases to an exceptionally high standard, vary only slightly with the centuries. The impact is made almost exclusively by the human-divine figure.[21] The informed aesthetic evaluation of Early Cola bronzes, and to a lesser extent of all South Indian bronzes, thus makes exacting demands on the viewer's sensitivity to form, but offers some of the greatest rewards, not least among them an enhanced appreciation of the possibilities and nuances of plastic expression.

South Indian bronzes afford few clues for dating. This is particularly true of early Tamilnāḍu pieces, where opinions can diverge to the extent of a hundred and fifty years, so that a figure called Pallava by one expert may be Early Cola to another.[22] It is a source of intense satisfaction that the majority of South Indian bronzes remain in the temples to which

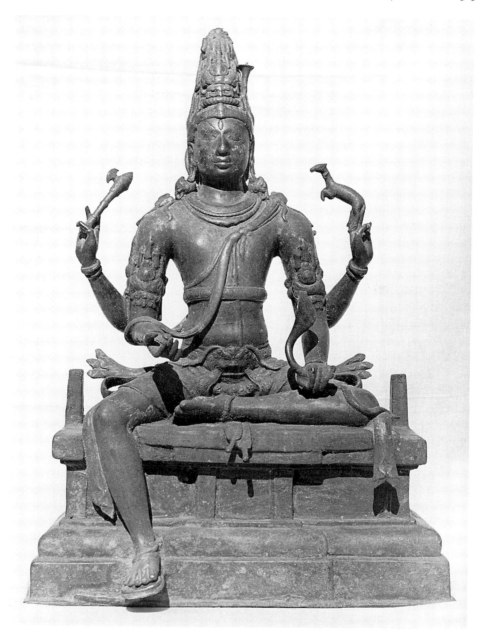

237. Śiva Viṣapaharaṇa (Destroyer of Poison) from Kilappudanur. c. 850-900. Bronze.
Madras, Government Museum

they were originally donated; but this has complicated the art historian's task to the extent even that many important bronzes have never been photographed.

Probably near the beginning of the stylistic history or lineage of Early Cola bronzes is the brooding seated Viṣapaharaṇa in the Madras Museum [237], one of the most powerful presences in Indian sculpture. The air of intense mental in-dwelling recalls the great Mahādeva at Elephanta. Exceptional are the taut modelling of the torso and the way the neck links chest and head. The Śiva Tripurāntaka in the Gautama Sarabhai collection has a similar though less powerful blend of vitality and repose. As Barrett has pointed out, it is the almost exact equivalent of the stone mūrtis of the

Puḷḷamaṅgai temple.[23] To these two superb individual figures must be added the extraordinary and almost certainly earlier Kalyānasundara (Marriage of Śiva and Pārvatī) in the Śiva temple at Vaḍakkalathur (Tañjavūr District) [238],[24] psychologically the most penetrating of all the great Cola bronzes. For all his broad shoulders and proud if not haughty air, the young Śiva is infused with a unique adolescent grace. Even more touching is the child-like, slightly knock-kneed Pārvatī, her self-consciousness emphasized by her over-elaborate headdress, which is nevertheless a beautiful and original conception.

Three details of costume and ornament appear restricted to the earlier bronzes: a jewel in the form of a pīpal leaf hanging down the

238. Vaḍakkalathur, Śiva temple,
Kalyānasundara (Marriage of Śiva and Pārvatī),
front and back views. c. 850. Bronze

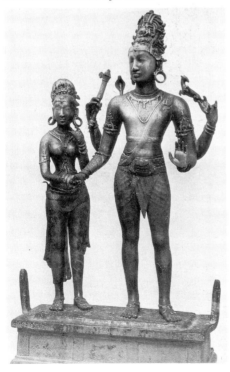
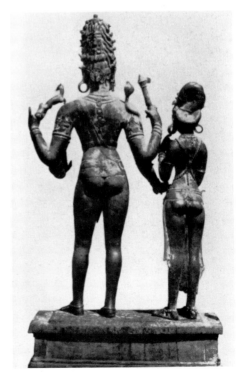

back between the shoulders; a tuft of cloth jauntily emerging from the belt just above the buttocks; and a large flat petalled jewel at the base of the neck, soon to be replaced by the wheel-shaped śiras cakra. As in the stone sculpture, the girdles of the earliest figures seem to have been tied in front by a simple knot, with the sash looped in a natural fall, as in Pallava times – or perhaps it was a regional preference. Viṣṇu's cakra held end on is an almost infallible sign of a tenth-century or earlier date. The spiral armlet ending in a leafy spray seems to distinguish standing male Śaivite figures, the many-pointed jewel worn on the arms the female figures and Viṣṇu. The superimposed lobes ending in a knob of the feminine crown (karaṇḍamakuṭa) are often obscured in the earlier figures by elaborate ornamentation.

A metropolitan style, parallel to that of the stone sculpture and similarly based on Tañjavūr District, evolves in the second quarter of the tenth century, the golden age of Coḷa bronzes when masterpieces abound, including the consort of Naṭarāja (Umā?) [239] in the Jñānaparameśvara temple at Tirumeyjñanam and the dancing boy Kṛṣṇa at Tiruchcherai.[25] By the third quarter of the century, the torsos have become more slender, the dress and ornament sheer luxury at its most splendid; examples include the Konerirājapuram and Tiruveḷvikkuḍi bronzes.[26] Already in the latter the faces are becoming stylized, with their beautifully delineated eyes and exactly parallel eyebrows [240]. For all their exquisite workmanship, their self-confident beauty of form, a personalized vision is beginning, just perceptibly, to yield to a generalized one. The transformation is complete in the Tiruveṅgāḍu Kalyāṇasundara group, now in the Tañjavūr Art Gallery, justly famous for their effective grouping as well as their beautiful patina, and

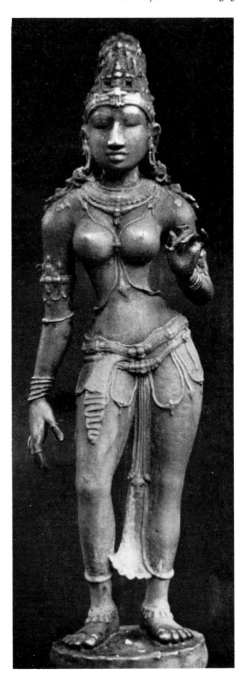

239. Tirumeyjñanam, Jñānaparameśvara temple, consort of the dancing Śiva (Naṭarāja). c. 925. Bronze

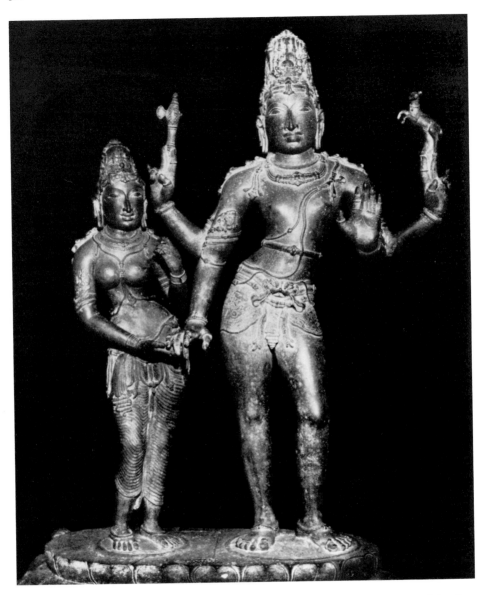

240. Kalyānasundara (Marriage of Śiva and Pārvatī)
from the Manavaleśvara temple, Tiruveḷvikkuḍi.
c. 975. Bronze. *Tañjavūr Art Gallery*

securely dated in the first decades of the eleventh century.

In the tenth century, however, the masterpieces were not limited to the heart of the Coḷamaṇḍalam. Outlying districts produced

work in a recognizably different style but of equal distinction, notably the majestic and yet quite approachable standing Viṣṇu from Koṅgu, of unsurpassed workmanship and arguably the finest representation of this god in bronze in the whole of Indian art.[27] Less suave, but extraordinarily pithy, the Naṭarāja from the same temple is framed in an exceptionally elaborate prabhā, evidence of Deccani influence.[28] Few old temples have survived in Koṅgu (the present districts of Salem and Coimbatore), which is doubtless why these great bronzes are not matched by many others from the region. At the northern limits of the Toṇḍaimaṇḍalam, another tenth-century local variant of the Early Cola style is responsible

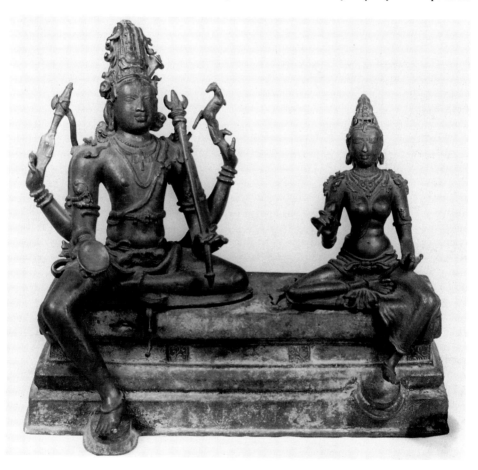

241. Tiruvālaṅgāḍu, Somāskanda
(Śiva with Umā and their child, here missing).
c. 850–900. Bronze

for the Tiruvālaṅgāḍu Somāskanda, the most beautiful, in spite of its relatively small size, of all surviving images of this type [241].[29]

The dance has been central to India's culture since earliest times, and dance in India

today still reflects the traditional gestures and poses of the dancers on one of the Bhārhut reliefs of the second century B.C. Essentially, there are two forms, *marga*, the classical, and *desi*, from the word for a region. Marga has two modes, the *tandava*, the more active and violent, and *lasya*, the softer, both expressed in *vrtta*, rhythmic movements, and *abhinaya*, which involves a repertory of facial expressions and hand gestures from which the mudrās of sculpture derive. Indeed, the relation between the dance and the static visual arts, sculpture and painting, has probably been more intimate in India than in any other culture.[30] The popularity of the dancing Śiva (Naṭarāja, Naṭeśa, the Lord of the Dance) stems from the fact that in a dancing icon, the relationship between dance and sculpture is at its most explicit, and – more important – that complex and profound metaphysical concepts of Hinduism can be expressed with extraordinary force.[31] The Naṭarāja is one of the world's greatest iconographical creations.

In the north, the image of Śiva in a variety of dancing poses first appeared in the fifth or sixth century. It was particularly popular in Orissa and in the Cālukya country, where it is usually associated with 'northern'-style temples. It was Tamilnādu, however, which adopted the dancing Śiva (Kuttaperumanadigal in Tamil) as its own, and there his dances take the greatest number of forms, of which the most beautiful, the *ānandatāndava*, famous all over the world, is an exclusively South Indian mode.[32]

The ānandatāndava form is not indisputably attested at full scale in a niche until the third quarter of the tenth century, although small representations in relief are reported from half a century earlier, suggesting that the mūrti was not then considered worthy of a niche.[33] On the other hand, Śiva in other dancing modes is known from Pallava times, and some of the earliest (and finest) bronzes are in *catura*, possibly so named because the legs form a rough quadrilateral (*catur*: four) but more likely the swift or quick (catura) dance, and *ūrdhva janu*,

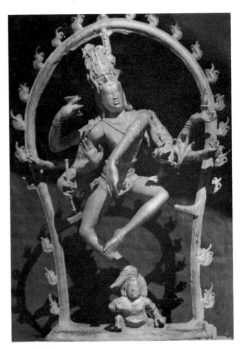

242. Nallur,
Śiva dancing in catura mode.
875. Bronze

where one knee is raised high. Only towards the end of the tenth century does the ānandatāndava establish itself as standard. Thus the Naṭarāja in the Śiva temple at Nallur (Tañjavūr District), indisputably one of the earliest dancing Śivas in bronze, its face recut, as is so often the case, still dances in the catura mode [242].[34] The spidery legs and exceptionally tall crown convey the manic violence of the frenzied god. As in all the earliest Naṭarājas, the prabhā is an arch rather than a circle; here the straight sides have a slight reverse curve, and the flames on the outer edge only three points. Exceptionally, this figure has three arms. A later image, although probably still within the tenth century, the fine example from Tiruvalanguli near the Pāndya border now in the National Museum, New Delhi, unfortunately lacks its prabhā. Although not in

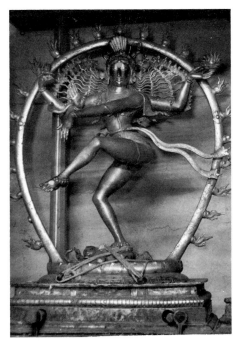

243. Vedaranyam,
Śiva dancing in ānandatāṇḍava mode.
Ninth century. Bronze

of a short dhoti, a narrow sash tied around his waist, the two ends streaming out to the proper left, and a short cloth hanging down from the left shoulder. A crescent moon, a skull, and a datura blossom adorn the god's headdress, topped by a fan of konnai leaves. Most characteristic of all are the long locks of hair streaming out horizontally on either side of the head, decked with floral wreaths, usually with a small figure of the goddess Gaṅgā amongst them. The circular prabhā is bordered with individual stylized flames, close together.[35] Some of these bronzes are over $4\frac{1}{2}$ ft (1.40 m.) tall. The fully evolved form of this type of dancing Śiva is reached by 1000 or shortly after.

The following passage eloquently sets forth some of the metaphysical concepts suggested by images of the dancing Śiva in this form:

Whether he be surrounded or not by the flaming aureole of the *tiruvāśi* (*prabhāmandala*) – the circle of the world which he both fills and oversteps – the King of the Dance is all rhythm and exaltation. The tambourine which he sounds with one of his right hands draws all creatures into this rhythmic motion and they dance in his company. The conventionalized locks of flying hair and the blown scarfs tell of the speed of this universal movement, which crystallizes matter and reduces it to powder in turn. One of his left hands holds the fire which animates and devours the worlds in this cosmic whirl. One of the god's feet is crushing a Titan, for 'this dance is danced upon the bodies of the dead', yet one of the right hands is making the gesture of reassurance (*abhayamudrā*), so true it is that, seen from the cosmic point of view and *sub specie aeternitatis*, the very cruelty of this universal determinism is kindly, as the generative principle of the future. And, indeed, on more than one of our bronzes, the King of the Dance wears a broad smile. He smiles at death and at life, at pain and at joy alike, or rather, if we may be allowed so to express it, his smile is both death and life, both joy and pain ... From this lofty point of view, in fact, all things fall into their place, finding their explanation and logical compulsion. Here art is the faithful interpreter of the philosophical concept. The plastic beauty of rhythm is no more than the expression of an ideal rhythm. The very multiplicity of arms, puzzling as it may seem at first sight, is subject in turn to an inward law, each pair remaining a model of elegance in itself, so that the

the metropolitan style, it is a beautiful expression of the strongly rhythmic (vṛtta) element in the catura mode.

Śiva dancing in the ānandatāṇḍava is invariably four-armed [243]. The upper right hand carries the small hourglass-shaped drum (*ḍamaru*), the lower makes the gesture of abhaya; in the upper left hand is a flame, and the lower left arm swings across the body, the hand languidly pointing at the god's raised foot. He stands with his right knee flexed, the foot firmly planted on a recumbent dwarf (Apasmara, or ignorance; in Tamil, Musalagan) lying on a lotus base. The left leg is raised, the knee also bent and the extended foot thrusting to the proper right. Torso and head face the spectator, and arms and legs are all in the same plane. The god wears anklets, armlets, and one or more necklaces. His garments consist only

whole being of the Naṭarāja thrills with a magnificent harmony in his terrible joy. And as though to stress the point that the dance of the divine actor is indeed a sport (*līlā*) – the sport of life and death, the sport of creation and destruction, at once infinite and purposeless – the first of the left hands hangs limply from the arm in the careless gesture of the *gajahasta* (hand as the elephant's trunk). And lastly as we look at the back view of the statue, are not the steadiness of these shoulders which support the world, and the majesty of this Jove-like torso, as it were a symbol of the stability and immutability of substance, while the gyration of the legs in its dizzy speed would seem to symbolize the vortex of phenomena.[36]

Earlier Naṭarājas can usually be distinguished because the fire is held in a bowl or dish; Gaṅgā is very frequently absent; the prabhā is not yet a full circle, the sides straightening out to meet the opposite ends of the base, and the flames with only three points;

the legs are not as strictly in the same plane as they will be later; and the hair fanning out on either side of the head forms a sort of cape behind the neck and shoulders. Several images of this type can be dated with fair certainty in the last quarter of the tenth century; one, the image from Okkur, now in the Madras Museum, may be as early as about 950.[37] Still earlier, with a less determinate and somewhat different iconography, are probably the bronzes at Śivapuram (formerly), Tandantottam, and Vaḍakkalathur, all in Tañjavūr District, and the small image in the British Museum. In the absence of earlier examples it is unlikely, however, that they date from much before 900, although a recent discovery has shown that the close dating of early – indeed of all – South Indian bronzes remains liable to major readjustments.[38]

THE LATER COLA PERIOD

The Early Cola period is said to end with the accession to the throne in 985 of Rājarāja I, probably the greatest of the Cola monarchs. There were no immediate changes in temple building or in style, and Sembiyan Mahādevī continued her activities well into her grandson's reign, but the building of the great temple at Tañjavūr (Tanjore), his new capital, indisputably inaugurated a new phase. Nearly three hundred years elapsed until the last Cola king, Rājendra III, succumbed to another short-lived Pāndya ascendancy. During this period the Colas extended their dominions to include northern Sri Lanka and undertook a successful campaign against Śrī Vijaya in Java, the only extension of India's power overseas in all its long history. Moreover a *digvijaya* (literally 'conquest of all the geographical directions') took Rājendra I, Rājarāja's great warrior son, to the Ganges. Nearer home, Rājarāja's administrative genius ensured that the Colas ruled over the stablest, best administered, and longest lived of all the early Indian polities. They also continued their age-old feuds in the Deccan, particularly with their most powerful adversaries, the Western Cālukyas of Kalyani. Some art historians have divided this long era into Middle Cola, ending with the accession of Kulottuṅga I in 1070, and Late Cola. This seems both unnecessary and unjustified, however, for too little is known about architecture and sculpture after the Early Cola period to warrant subdivision, and a turning-point at 1070 – or any other moment – must at present be arbitrary in art-historical terms.

Architecturally, the period begins with the greatest single undertaking of the South Indian temple-builder: the erection, in some fifteen years, of the great Rājarājesvara (Bṛhadiśvara) at Tañjavūr [244]. The shrine, some 210 ft (63 m.) high, the largest and tallest

in India, appears to have been consecrated in 1009-10.[1] Most temples in South India owe their siting to some holy tree (*sthalavṛksa*) with which the god was associated in ancient times, or to the localization of some Purāna story, or to ancient local legend; the Rājarājesvara, however, appears to have been an entirely new foundation, a royal monument to Cola power, which was about to reach its zenith. This is borne out by the name of the enshrined god (the Lord of Rājarāja, i.e. Śiva) and the fact that the temple never exceeded its original limits.

Within the huge walled enclosure were shrines for the parivāradevatās and the dikpālas. The shrine of Candeśvara, an independent building, survives; the eight dikpālas were housed separately against the compound wall. The two large gopuras in line are splendid achievements, the first monumental buildings of their type.[2] The handsome Subrahmanya shrine belongs to the Nāyaka period.

If the temple complex today appears somewhat underbuilt considering its great extent, the effect of the towering vimāna and its great mandapas is probably enhanced. Early Cola shrines, superb as many of them are, are comparable in size to the smaller English parish churches, the Rājarājesvara to European cathedrals. The vimāna is *dvitala*, these two vertical storeys forming the great base from which the thirteen upper storeys rise in slightly receding tiers. The crowning dome rests on a massive granite block $25\frac{1}{2}$ ft (7.7 m.) square and estimated to weigh eighty tons.[3]

An internal circumambulatory passage, also two storeys high, consists of a series of chambers with sills between them but no doors [245].[4] On the walls, paintings of the Nāyaka period were discovered, in 1930, to overlay Cola murals, including a Daksināmūrti, and Rājarāja with three of his queens worshipping

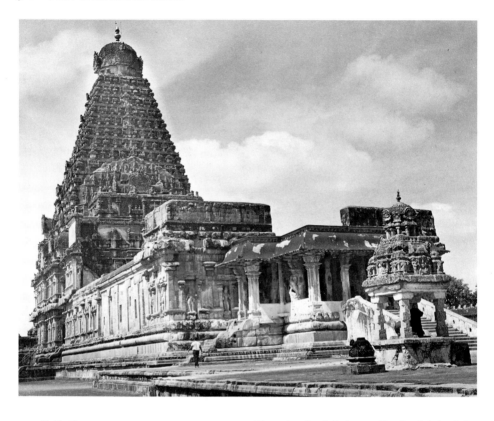

244. Tañjavūr,
Rājarājeśvara (Bṛhadiśvara) temple.
Probably consecrated 1009/10

Naṭarāja, the *kuladevatā* (family deity) of the
Coḷas, as well as one of the king with his guru.
Although badly damaged, the restored parts
constitute the most important relics of Coḷa
painting. The vimāna itself is entered by side
doorways approached by large ornamental
stairs leading to an ardhamaṇḍapa with a *sna-
pana* platform for bathing the god. To it is
attached a huge maṇḍapa of thirty-six pillars,
preceded by a front maṇḍapa with a central
entrance. In all, there are eighteen door guar-
dians flanking the various entrances and win-
dows, some of them over twice life size.

Except for a high dadoed sub-base
(*upapīṭha*), already present in some of the later
Early Coḷa temples but here proportionate to
the height of the building, the fabric of the
Rājarājeśvara shows only two major innovations.

245. Tañjavūr,
Rājarājeśvara temple, vimāna.
Plan

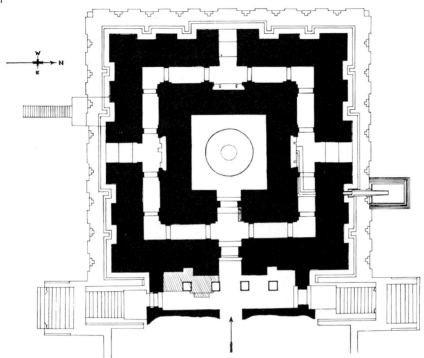

First, the middle of the corbel remained un-chamfered, leaving a square sectioned tenon [246] – a major evolutionary step.[5] Second, the *kumbhapañjara* is introduced, a pot surmounted by a flat pilaster topped by a pavilion (in this transitional case an elaborate makaratoraṇa), which will henceforth, in the larger and more complex façades, fill the recessed areas of the walls. The sculpture is difficult to

assess, for much of it is disfigured by paint and plaster. The huge size of the temple and the problem of filling two registers of niches seem to have daunted the sculptors, who apparently could not find enough different mūrtis: it is reported that the second-tala figures are all Tripurāntakas.

A great many metal images were installed in the temple at its foundation, gifts of Rājarāja,

246. Evolution of the South Indian corbel

7th-10th century 11th century 12th-13th century 14th-15th century 16th-18th century

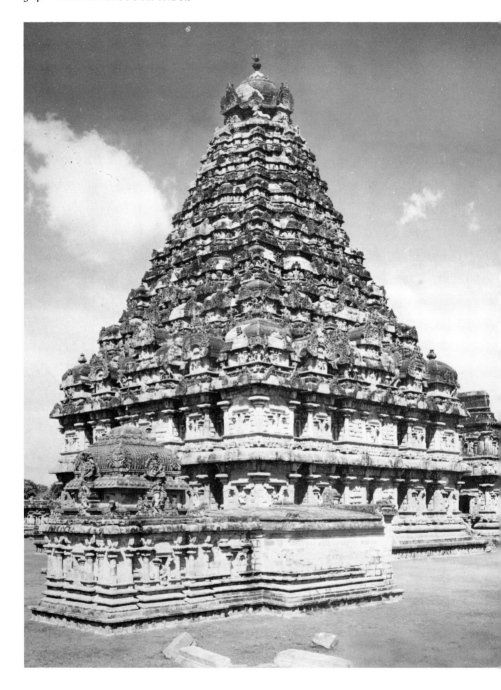

247. Gaṅgaikoṇḍacolapuram, Bṛhadiśvara temple,
vimāna, with Gaṇapati shrine,
from the south-west (*opposite*),
with section and plan (*below*). *c.* 1025

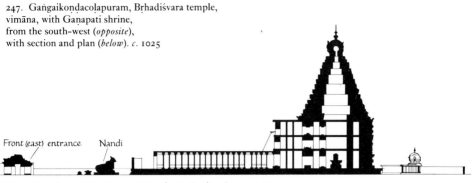

Front (east) entrance Nandi

Longitudinal section

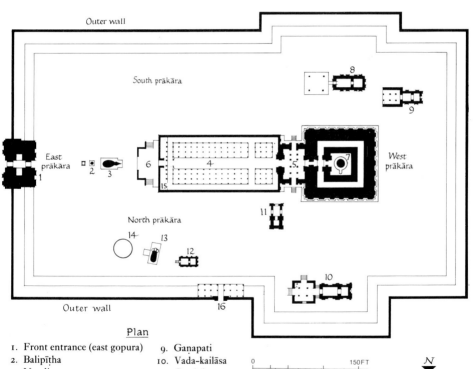

Outer wall

South prākāra

East
prākāra

North prākāra

West
prākāra

Outer wall

Plan

1. Front entrance (east gopura)
2. Balipīṭha
3. Nandi
4. Mahāmaṇḍapa
5. Ardhamaṇḍapa
6. Mukhamaṇḍapa
7. Garbhagṛha
8. Ten-kailāsa
9. Gaṇapati
10. Vaḍa-kailāsa
11. Caṇḍeśa
12. Durgā
13. Siṁha-kinarü
14. Well
15. Navagraha
16. Northern gate

0 150FT
0 50M

N

his elder sister, his queens, and important officials. We know from inscriptions engraved on the walls during the king's lifetime that they included figures of the king himself, and some mention gifts by his son and successor, Rājendra I, who served as co-ruler before his father's death. Here again, the Rājarājeśvara is unique. The endowments of most of the great temples of South India, such as Śrīraṅgam, Jambukeśvara, Tiruvannāmalai, and Cidambaram, accrued to them over the centuries, and only a small number are of royal origin. The Rājarājeśvara, on the other hand, received a complete endowment upon its inception, on a scale never before even remotely approached. Provision was made for a ritual such as was only to evolve much later in but a few other temples, for which the Rājarājeśvara doubtless set the model. Sumptuous jewellery was presented for the images, and land and its produce donated for the food and rare ointments and flowers necessary for the worship of the god. The endowment also provided for the maintenance of four hundred dancing girls, for attendants, artisans, even tailors, as well as for accountants and administrators to deal with this vast establishment. All this is meticulously set forth in inscriptions which became a virtual blueprint for the organization of the temple-cities of a later age.

The second of the great imperial temples is at Gaṅgaikoṇḍacolapuram, which Rājendra I made his capital and gave, after his digvijaya, the resounding name of City of the Cola, Conqueror of the Ganges. Nothing remains of the city, which was doubtless laid out according to the prescriptions of traditional building (vāstu) and religious (āgama) texts.[6] Gaṅgaikoṇḍacolapuram [247], although slightly larger on plan than the Tañjavūr temple – the vimāna measures 100 ft (30 m.) – is only 160 ft (50 m.) high.[7] Nonetheless, since the upper part consists of only seven storeys, the pavilions are larger. They are also free-standing. The result is a much more subtle outline, the upper part slightly concave, presaging the profile of the great thirteen-storey gopuras of a later age.

The lower section is dvitala, as at Tañjavūr, but wider in proportion to its height. Finally, there are no flat pilasters. In all, the later temple shows a closer affinity to the Early Cola style in its closing stages – the individual elements more accentuated, curves predominating over straight lines – than the rigidly rectilinear and pyramidal temple at Tañjavūr, its upper-storey pavilions little more than reliefs. The vimānas of both are entirely of stone.

There is a non-compartmented circumambulatory passage around the sanctum. As at Tañjavūr, the ardhamaṇḍapa is entered on either side by two-stage stairways. On some of the interior walls are panels carved with scenes from the Purāṇas and epics. The great maṇḍapa, mostly reconstructed, boasted a hundred and forty pillars on four plinths four feet high with a central nave between them. As all these elements, including the entrance porch to the maṇḍapa, stand on the same base with uninterrupted mouldings, they must have been built at the same time. A pair of very similar shrines on either side of the great vimāna, one partly ruined, the other converted at a later date into an Amman (goddess) shrine, are contemporary. From the now vanished city survives Rājendra's Colagaṅgā, a huge tank or lake some 3 miles (5 km.) long, probably inspired by the great tanks of Sri Lanka.

The sculpture at the Gaṅgaikoṇḍacoliśvaram is generally uninspired, heavy, and somewhat stolid. It includes the famous Caṇḍeśanugrāhamūrti [248] and the Sarasvatī, both iconographically quite rare. No provision seems to have been made for the dikpālas within the temple compound, for they are lodged in the upper tier of niches. The wall surfaces between the niches are covered more liberally than usual with relief sculpture. Like Tañjavūr, the temple retains few of the original bronze images with which it was so richly endowed. The superb altar in the mahāmaṇḍapa, with the nine planets and a sun-chariot base, is probably Cālukya, and several loose sculptures from the Deccan and Orissa were doubtless booty from Rājendra's campaigns.

248. Gaṅgaikoṇḍacolapuram, Bṛhadiśvara temple, ardhamaṇḍapa, Caṇḍeśanugrāhamūrti on the west side of the north entrance. c. 1025. Granite

Two more great vimānas were built during the Cola period. Neither is as large as the two temples just described, and by the end of the twelfth century, when the second was built, the gopura was ready to take over as the dominant feature of the temple complex in terms of height. Both temples appear to have been royal foundations, although there is not the mass of inscriptional evidence left by Rājarāja I and his son. The main floors are single-register, and the first two storeys of the spire extend over the ardhamaṇḍapa.

The Airāvateśvara temple at Dārāśuram, near Kumbakonam, was built by Rājarāja II (c. 1146–73).[8] The inner enclosure is surrounded by a pillared cloister with six sub-shrines. In front of the closed maṇḍapa is a large open porch which large stone wheels and rearing horses make into the likeness of a chariot [249]. The

249. Dārāśuram, Airāvateśvara temple, open maṇḍapa. Twelfth century, third quarter

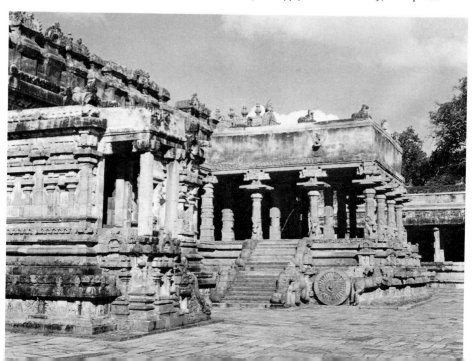

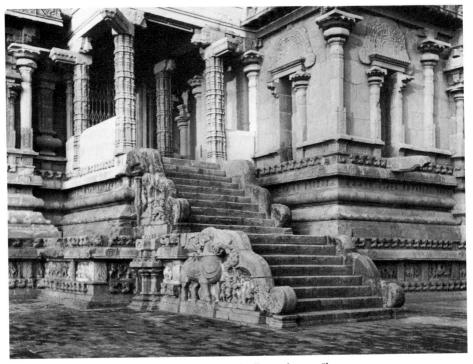

250. Tribhuvanam, Kampaharesvara temple, stairway leading to the antarāla. *c.* 1200

sedent yāḷi bases of its pillars betray an archaism occasionally to be detected henceforth in Dravidian architecture; the palagais are wide and wafer-thin to an almost ludicrous degree. The corbels on the other hand show a further advance in their long development [246]: the plain triangular tenon is now waisted and has a drop at the bottom. All the idaḷs are petalled. A separate shrine of the goddess, perhaps a little later than the main one, will henceforth, as the Amman shrine, become indispensable to every temple complex. Unique to the Airāvateśvara are the reliefs, high on the base, illustrating scenes from Sekkilar's *Periya Purāṇa*, an account of the lives of the Śaiva saints. A large and handsome dvārapāla statue found at the temple, reportedly taken from Kalyani, the Western Cāḷukya capital, is now in the Tañjavūr Art Gallery.

The Airāvateśvara had five upper storeys; the other great vimāna of the later Coḷa period, the Kampaharesvara at Tribhuvanam, built by Kulottuṅga III (*c.* 1178–1218), has six, and a rectilinear outline reminiscent of the great temple at Tañjavūr.[9] New is the importance accorded to the sub-base, its projecting pavilions provided with niches, their own full order of base mouldings, and a kapota for a cornice. In the taller gopuras the sub-base will become, to all intents and purposes, an extra storey. The Tribhuvanam temple and its gopuras also develop the traditional elements of the Drāviḍa order and their ornamentation. Kumudas and kapotas are frequently ribbed, pilasters appear of a quite un-Dravidian type, faceted and with median interruptions, and – another major advance – the central tenon of the corbels takes on an inverted bell shape with foliated and

curved sides [250]. *Nāgapadams*, small lanceolate projections at the corners where octagonal or chamfered pilasters rise from their square bases, make their first appearance in a major temple building on the maṇḍapa and porch walls, very similar on plan to those at Dārāśuram, where, curiously, the earlier form of corbel, with the plain tenon and even a faint roll-moulding on the bevels, is used [249]. The chariot-porch, with two elephants, was once multi-wheeled.

Before Tribhuvanam can be properly assessed, more will have to be discovered about developments at the very end of the twelfth century. Several new features henceforth figure in most important temple buildings; others seem to be short-lived revivals; still others, without precedent, do not recur. The impression is of a slightly bizarre vitality, and indeed of a more stimulating renewal than Vijayanagara's two centuries later.

Smaller temples proliferated, sometimes replacing older ones, during the two and a half centuries following the reign of Rājarāja I.[10] Medium-sized shrines usually have an ardhamaṇḍapa, its entrances normally at the side.[11] In many cases the smaller temples follow the larger ones in respect of alterations to layout and architectural features. They tend to become plainer, however, their sculpture less abundant, their fabric meaner. The niches of a small temple at Settur, near Karikal, are topped by śālās. The main kapota, noticeably heavier than before,[12] retains the bhūta frieze below it but the large petalled lotus moulding of the base is abandoned. The kumuda has a simple three-sided chamfer, as in Pallava temples. Corbels are of the plain tenon type [246], idals petalled, pilasters round or octagonal. No inscriptions have been found, but a date in the twelfth century seems more likely than one in the thirteenth. Other small shrines tend to be further divorced from tenth-century norms. Additional pilasters, usually square, often replace niches. The niches themselves are frequently blind, the pilasters framing a section of wall; nor do they penetrate any of the base

mouldings.[13] Main kapotas are very heavy, with a more raked section, and as the faces of the kūḍus remain vertical, they project considerably at the top, adding to its bulky appearance. The bhūta and yāli friezes begin to disappear, the former giving way to the ubiquitous padma, now largely reduced to a denticulated edge below base mouldings and even the lintels and pediments of niches. The points of the petalled idal become more serried, and on a square capital present an identical saw-toothed appearance. The restored twelfth-century Cokkiśvara temple at Kāñcī, although it has niches and a yāli frieze above the kapota, is a good example of the small temple later in the period.[14]

The questions raised by Tribhuvanam are echoed at the highly exceptional shrine at Melakkaḍambūr, 20 miles (35 km.) from Cidambaram, apparently built about 1100.[15] Its ribbed kapotas and kūḍus are usually associated with the thirteenth century and after. The pilasters are of a far more complicated ordering than the Drāviḍa mode usually allows. Below the kaṇṭha are reliefs of mūrtis, and below again complex elements, square in section but wider than the foot of the pilasters, with lotus buds instead of nāgapadams, little lion supporters and a dancer panel below, and, right at the bottom, a kapota. The palagais are crowded with dancing women and rearing yālis. Only Tribhuvanam, in the Cola period, comes anywhere close to this riot of often slightly incongruous sculpture and ornamentation.

The elevation of the vimāna of the Amṛtaghaṭeśvara at Melakkaḍambūr is equally unusual. Four stone wheels are attached to the base, with stone draught horses. The central niches on each side are preceded by a flight of steps and porches. Above them, huge kūḍus completely interrupt the main kapota, their kīrttimukhas rising to the level of the next and containing elaborate, though smaller devakoṣṭhas with images. The second storey is octagonal and considerably smaller than the first, so that there is ample room at the four corners for large koṣṭhas, themselves niched

and with rearing yāḷis or dancing figures at the corners. The grīva and śikhara are much later; otherwise the abundance of sculpture everywhere belongs to the later Coḷa period. Some of it has even been dated to the eleventh century, for it is not unlike that in the upper tier of niches of the west gopura at Cidambaram.[16] The statues of sages appear to be later. Although much of the artistic history of the later Coḷa period remains to be written, the shrine at Melakkaḍambūr must remain one of its most important monuments, and a fascinating little building in its own right.

Tribhuvanam was the last of the large vimānas, with one of the *gopuras* or tower gateways which were to dominate the elevations of even quite modest temple complexes. The earliest gopuras, such as those at the Shore temple and the Kailāsanātha in Kāñcī, were little more than doorways topped with śālas. Two or three of the tenth century have survived, usually much modified.[17] Then, at the Rājarājeśvara at Tañjavūr, early in the eleventh century, the greatest single step forward in the development of the gopura was taken, as regards both the building itself and its significance to the temple as a whole. The two gopuras, built in line on the eastern side of the temple, which form the successive entrances through the two enclosures, although dwarfed by the giant vimāna, are still larger than any earlier building in South India. In some ways they are old-fashioned, their squat outlines due to very long śālas and a limited number of storeys [251]. Never again will it be possible to actually walk around the first storey of a Drāviḍa building, behind the parapet of pavilions. What is more, at least on the outer gopura, in the middle of each end façade presides, behind this parapet and unseen from below, the directionally appropriate icon, Dakṣiṇāmūrti on the south and Brahmā on the north, carved in stone, but unfinished. The upper storeys are of brick, hollow, with constant corbelling to reduce the area of the successive storeys as in later gopuras, except that here the interior, never meant to be seen or used, consists of three separate hollow pyramids.

The Tañjavūr gopuras belong to that small class of buildings for which there are few if any precedents. Prescriptions in the śāstras for the construction of multi-storey gopuras, moreover, appear to be little more than mechanical transpositions of those for vimānas, more usually termed *prāsādas*, the word for a palace. Astonishingly, in spite of the different function of a gopura, it must still have a garbhagṛha and an ambulatory passage around it. And indeed on plan the Cidambaram gopuras resemble shrines with a rectangular sanctum surrounded by an ambulatory passage cut in half and the sides pushed apart to create the wide entrance way:[18] there is no accounting otherwise for vestibules (the term garbhagṛha is totally inappropriate) with totally meaningless and usually inaccessible passageways around them, particularly when this accords with the terms used in the śāstras.

The main features of later gopuras are already present. Two-storey vestibules open out on either side of the middle of the entrance way, each framed by massive piers en pilastre, with a monolithic doorsill between them, supporting giant corbels which in turn support monolithic lintels: all together constitute the *dvāra* or door(way). Bhūtas and nidhis, symbols of entrance in South India, appear in relief near and in the passageway; on the façade, on either side are windows (later blind) to light the upper circumambulatory passages. Unique to Tañjavūr, and testimony to an experimental stage, is the fact that the outer and inner façades make no attempt at being mirror images of one another as in later gopuras. Unique too is the inner façade of the inner gopura, with three shrines one above the other on either side of the entryway, the lower two actually with interiors, the upper a devakoṣtha. The outer façade, on the other hand, is largely given over to a pair of huge dvārapālas, arguably bigger than any on the great vimāna and hence the largest sculptures ever set into an Indian temple structure. But the supreme importance

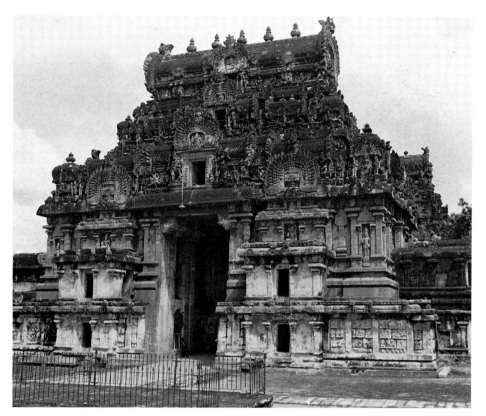

251. Tañjavūr, Rājarājeśvara temple, inner gopura, inner façade. 1014

of the Tañjavūr gopuras lies in their being in line both with each other and with the axis of the great vimāna and its maṇḍapas, and in the fact that the five-storey outer gopura is taller than the three-storey inner one. By a rare stroke of good fortune there is inscriptional evidence that they were built at one and the same time,[19] proving beyond doubt that increasing height was a conceptual requirement and nothing to do either with later date, when building skills had improved, as enclosure walls were added to some of the great temple cities, or with a desire to overshadow earlier achievements.[20] Henceforth, beginning with the Gaṅgaikoṇḍacoḷiśvaram, sizeable gopuras were

built at all the larger temples. Five storeys appears to have been the maximum until the outer gopura at Dārāśuram, assumed to have had seven because its surviving lower part is so like those of the four great Cidambaram gopuras which, with the 'Sundara Pāṇḍya' in the Jambukeśvara temple on the island of Śrīraṅgam, constitute an important group at the end of the Cola period.[21]

Altogether, Cidambaram is uniquely interesting because it is the only great temple complex to date chiefly from the twelfth and thirteenth centuries.[22] It boasts the earliest known Devī or Amman shrine, vṛtta (dance) maṇḍapa, Sūrya shrine with chariot wheels, hundred- and

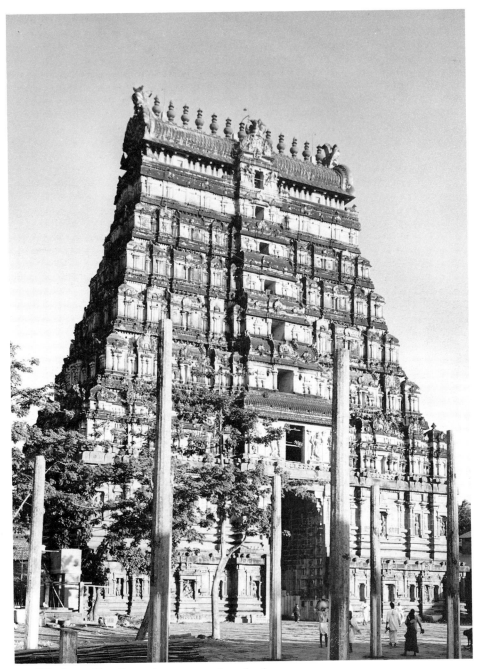

252. Cidambaram, Naṭarāja temple, east gopura, inner façade. *c.* 1200

THE LATER COLA PERIOD · 323

thousand-pillared maṇḍapas, even the first giant Śiva Gaṅgā tank, all precious examples of that period, although exact dates are elusive. The columns, in particular, of some of these and of their surrounding cloisters are of a type already seen at Dārāśuram and Tribhuvanam [249 and 250] and quite foreign to Vijayanagara. Cidambaram's three enclosure walls, if not the fourth and outermost, are also of this period.[23]

On the other hand, and partly because of the relatively early date of much of it, Cidambaram provides anything but a clear picture of the layout of a great South Indian temple complex. It is still impossible, for example, to determine its original orientation. Moreover the positioning of the four great, beautifully preserved gopuras of the third enclosure walls defies the normal rules,[24] although the buildings themselves, smaller though they are than some of the later giants, are the perfect classical expression of their type [252]. In some ways their style is old-fashioned. Astonishingly, the plain tenon corbel is universally retained. The façades, too, are conservative: śālas over niches are outnumbered by makaratoraṇas, and the

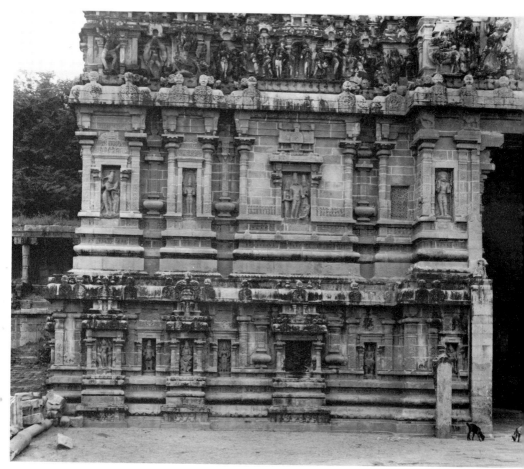

253. Cidambaram, Naṭarāja temple, west gopura, inner façade, south half. *c.* 1175

reverse-curve padma appears on the base mouldings nearest the entryways and on a smaller scale elsewhere.

Indeed what we seem to have is a compendium of the entire Cola style [253]. For example, there are four versions of the base kumuda: plain rounded, lightly ribbed, octagonal, and lightly faceted. The idals of the capitals of the rare square pilasters at the corner projections have no petals, eliminating one of the least successful combinations of the Cola style. Moreover, in order to give height to the lower (stone) portion of the building proportionate to the increasing storeys above, the sub-base is transformed into a miniature storey of its own, with niches and a full order from base to entablature – the triumphant culmination of a trend already observed at Tribhuvanam and elsewhere. Three niched pañjaras with their own base mouldings interrupting the main ones, kumbhapañjaras, and a certain crowding of all these elements perfectly set off the relative severity of the main storey above.

All the features of the great gopuras of later centuries appear, together with some refinements later abandoned. Present are the circumambulatory passages at the upper level, with their blind windows on the façades, and probably the lower ones too, sealed since the original construction. Between the dvāras, with their plain monolithic piers, are two-storey vestibules with an off-centre supporting pillar and elaborately carved entablatures; above is a coffered ceiling of ninety-one panels, each bearing figures in relief. On both sides of the dvāras, sets of four shallower but elaborately carved masonry pilasters rising all the way to the top of the entryway are divided by small kapotas into panels, each with a female dancer in a different pose.[25] The first and third kapotas of the middle pairs of pilasters are usually carried across the intervening space, forming niches which, over the centuries, have been filled with statues: Krsnadevarāya in one, a well-known nineteenth-century philanthropist in another, others unidentified. Internally, the towers consist of a single area, constantly

reduced by corbelling of the brick. The east gopura has a floor at each storey and a built-in stair all the way to the top.

Inscriptions here and elsewhere of Pāndya kings and local chieftains claiming to have built one or the other of the gopuras are not lacking, but none of the original ones here dates from earlier than the mid thirteenth century. The enclosure wall of which the gopuras form a part, and which is unlikely to have been built before at least one of them, is however associated with Kulottuṅga III (1178–1218). The power and resources of the Cola dominions were not as in the days of Rājarāja I and his son, and interruptions in building can be surmised. The west gopura, the most elaborately detailed and finely carved, was indisputably the first and served as a general model for the others. In view of its many stylistic links to an earlier time it cannot have been begun much later than 1150. The east gopura, the next in quality, probably was started during the reign of Kulottuṅga III and completed in the mid thirteenth century, when the south gopura was built. The north gopura presents special problems. It was most likely begun in the thirteenth century, the stone posts finished only when the whole edifice was completed and the statues installed by Krsnadevarāya, who claims to have built it and whose effigy it contains.

With thirty niches each, all but a few sheltering their original images (a few even identified by contemporary labels), the four gopuras at Cidambaram provide a unique and invaluable display of Late Cola iconography. The upper niches are given over (with the exception of the four dvārapālas) to major mūrtis of Śiva, often with his consort. In the lower tier, on the other hand, is an exceedingly varied assortment: Visnu, Devī, Sarasvatī, Kāma, Ganapati, Subrahmanya (the southern name of Kārttikeya), the river goddesses (rare in South India), dikpālas, grahas, sages, nāgarājas, together with rare representations of the Aśvins and Yajñapurusa.[26] The placing of the mūrtis in the lower niches is less stereotyped

254 (*left*). Cidambaram, Naṭarāja temple, west gopura, Gajasaṁhāra (Śiva slaying the Demon Elephant). Granite. *c.* 1175

255 (*below*). Cidambaram, Naṭarāja temple, east gopura, Śiva Dakṣiṇāmūrti. *c.* 1200. Polished black granite

than in the upper, where it varies hardly at all in spite of the fact that the orientation of each gopura is ninety degrees from any other.

Sculptural style differs markedly from gopura to gopura, and in the west gopura between upper and lower tier. The upper tier, in an excessively granular gneiss, continues the eleventh-century tradition with slenderer yet somewhat stodgy forms, although one Gajasaṁhāra appears to burst out of its frame [254]. Some of the lower-tier statues, in a different stone, are remarkably good, the fine texture skilfully worked to create a sense of living flesh rare in South Indian sculpture. There are some spirited compositions showing the Devī and Kārttikeya. The style of the upper tier of

the east gopura is unquestionably the finest. The images, of great elegance and dignity and many with a high black polish, testify to the continuing vitality of the great Cola sculptural tradition [255]. The north gopura images are of the Vijayanagara period; these apart, the sculpture of the Cidambaram gopuras, like their architecture, shows an essential conservatism yet rather bewildering differences in detail. Common idiosyncrasies include a makara arch on the field framing individual heads, the makaras degenerating into a circular motif, and a pair of tab-ends curling out on to the inner thighs of male figures.

The same diversity characterizes the bronze sculpture of the eleventh and twelfth cen-

turies, which is also nevertheless permeated by conservatism. Images with deeply cut kīrttimukha belt clasps, naturally looping sashes, and individualized jewellery could often be taken to be of the tenth century.[27] In others, the kīrttimukhas are in low relief, often inscribed in an oval or circle, the jewellery monotonous, the sashes looped in a square box-like fashion. Crowns and headdresses become more standardized and less ornate. *Urudamas*, the festoons or threads looping down from the girdle on to the hips, are more and more regular and conventionalized. Faces are increasingly stylized, noses sharper, figures often assume exaggerated *contrapposti* (*dvi-*

bhaṅga and *tribhaṅga*, double- and triple-flexed). The modelling of the shoulders is often unconvincing. The Naṭarājas change least of all, except in a few details: the prabhās become perfectly circular and spring from two makara heads at the base [256], and the figure frequently has a small bell (*bhṛṅgipāda*) attached half way down the lower leg. Otherwise it is extremely difficult to tell a thirteenth-century Naṭarāja from an eleventh-century one: except for the ribbed elements of the base and the fanciful treatment of the hair ends, the twelfth-century ānandatāṇḍava figure from Kunnāṇḍārkoil could belong to the time of Rājarāja I.[28]

256 (*above*). Naṭarāja. Twelfth/thirteenth century. Bronze. *Amsterdam, Rijksmuseum*

257 (*right*). Buddha, perhaps a Cālukya import, from Nāgapaṭṭinam. *c.* 1000. Bronze. *Madras, Government Museum*

No important Buddhist monuments have survived from the Cola period although Rājarāja I made a grant to a vihāra on the coast in Nāgapaṭṭinam, near where many Buddhist bronzes from various periods have been found.[29] The finest may be an import from the Cālukya country [257]. The other Buddhas are in a style of their own, presumably local but remotely reflecting Sri Lankan examples in stone. The Bodhisattvas, on the other hand, are in the prevailing Late Cola or even Vijayanagara style, to be distinguished from contemporary Hindu images only by their provenance and the symbols in their hands. An interesting group consists of miniature bronze stupas, with Buddhas and Bodhisattvas enshrined: some of them are topped by little colonnaded pavilions housing a Buddha, the stūpa element simply an onion-shaped dome above.

Jain monuments in South India all belong to the early period, and include the temples at Tirupparutikunram, a part of Kāñcī, together with a few caves and images cut into rocks in the south.[30]

VIJAYANAGARA

About 1250, major temples entered upon their period of greatest expansion. Shrines, corridors, and pillared halls multiplied, and gopuras grew taller as well as more numerous. Politically, Pāṇḍya hegemony and Hoysaḷa influence in Tamilnāḍu were equally short-lived. The 'Pāṇḍya style' of some important buildings (two of the Cidambaram gopuras, for example) is but a somewhat archaizing continuation of Late Coḷa. The Madurai Nāyakas of the seventeenth and eighteenth centuries, who moved their capital to Tiruchirāppaḷḷi in 1616, played a relatively minor role in contemporary power struggles but were considerable builders, giving their name to the last phase of South Indian architecture. The Nāyaka, however, is largely based upon the Vijayanagara style, whose emergence, spread, and eventual dominance during the fifteenth and sixteenth centuries in Tamilnāḍu and large areas of Karṇāṭaka, and instant recognizability in its most typical structure, the maṇḍapa, is one of the most remarkable phenomena in the history of Indian art and architecture.[1]

Vijayanagara itself has an extraordinary history. Driven by a resurgent Hinduism, it was born out of the incursions into the Deccan and even further south of the Delhi Sultanate, commencing with the Khaljīs and culminating in Muhammad Shāh Tughluq's attempt about 1330 to establish his capital at Devagiri (Daulatabad) near Ellorā. A Hindu capital, the famous Vijayanagara, founded at about the same time on the Tuṅgabhadrā, a tributary of the Krishna in the central Deccan, became paramount in South India under its most successful kings, notably Kṛṣṇadevarāya and Acyuta Deva. It was, however, almost constantly at war during the two hundred years of its existence with the Muslim Bāhmanī kingdom immediately to the north, which had arisen

upon the final withdrawal of the Delhi sultans, and with its successors. It thus joined the ranks of the warring states of the central Deccan, at times suffering terrible depredations from its Muslim enemies. Its internal politics were as bloody. It would on occasion act in concert with a Muslim state and recruit Muslims into its army, and much of the city's secular architecture is Indo-Muslim. But, if its military fortunes varied, Vijayanagara was never captured, its temples never desecrated, until after the final and disastrous defeat at Talikota in 1564. In its exposed northerly position, it served to divert the attention of warlike neighbours from the southern Deccan and Tamilnāḍu.

For its deep religious and cultural attachment to Hinduism there is no stronger evidence than the style of temple architecture to which it gave its name. Consider the geographical position of the city of Vijayanagara, in a Canarese- and partly Telugu-speaking region of the central Deccan, on the northern marches of the 'empire'. The Drāviḍa style of the early days had vanished centuries ago, giving way to the Vesara under the later Cālukyas and, far to the south, under the Hoysaḷas. Well-preserved pre-Vijayanagara Vesara temples at the site include one with triple shrines in the Kaliṅga (often called Kadamba) mode and a maṇḍapa with turned columns.[2] Yet Vijayanagara is a Drāviḍa style, which had persisted throughout the still largely Hindu south[3] and, with a few unimportant exceptions, remained the style of all the temples of the capital city.[4]

Vijayanagara, long deserted, is one of the most important historical and architectural sites in India, the only pre-modern Hindu city of which extensive remains, including scores of relatively complete buildings, still exist

above ground.[5] Often called by its earlier name, Hampi, it lies in a fantastic setting of lush riverine flats, hills, and towering piles of huge granite boulders, in an area rich in ancient and semi-mythical associations. It consisted of a 'sacred' area with the Kṛṣṇa, Virupākṣa, and Venkateśvara temples, a 'royal' area with palaces, zenanas, baths, the famous elephant stables, and the Hazara Rāma temple, obviously intended for royal worship [258], and a residential area with quarters named after the king who laid them out or after divine figures. This is town planning on a grand scale. Exaltation of royal power came second only to compliance with the religio-symbolic prescriptions for the division of the directions and the ordering of space.[6]

The 'sacred' area is the hilliest, with shrines perched on vast outcrops of rock or in ravines overhung with boulders.[7] Through the long straight streets leading up to the main temples, still discernible and some as much as half a mile (800 m.) long, the wooden temple cars were pulled at festivals; such a car in stone, with realistically turning wheels, stands in front of the Hazara Rāma. Of the structures, some at least two storeys high, which lined the processional routes, all that remains are rough-hewn

258. Hampi (Vijayanagara), Hazara Rāma temple, Amman shrine. Early sixteenth century

stone pillars, beams, and roof-slabs. The walls were doubtless originally of plastered wood or rubble, with wooden and thatched superstructures.

The platforms in the 'royal' area are truly monumental. Masonry often rough-hewn but perfectly jointed gives way further up to tiers with the same finely carved mouldings as the temples. The lower areas of the Mahānavami, the grandest of these platforms, presumably a royal throne room or audience hall, are carved with long friezes, some narrative, of battles, dancers, and even horses and their trainers [259]. At this time, horses were the kingdom's

considerable folk element. Steps remain, but no superstructures, so that it is impossible even to speculate upon their nature.

Vijayanagara at its apogee extended over 16 square miles (26 square km.). It had extensive waterworks, including a long viaduct. Stone walls abound, some as many as 32 ft (10 m.) high and proportionately thick, particularly around the 'royal' area; others, of less cyclopean proportions, wind off into the uplands – all reminders of Vijayanagara's military *raison d'être*. After the disastrous battle of Talikota in 1564 put an end for ever to the power of this great city it was immediately deserted.

259. Hampi (Vijayanagara), Mahānavami. Early sixteenth century

major import through the Konkan ports, for thousands were required annually for the army. Few of these non-indigenous animals survived local conditions and the Indian's proverbial lack of expertise in their care. The granite has imposed a very low relief on the sculptures; the style is bold and lively with a

It is interesting but not altogether unexpected that many of the secular buildings are Indo-Muslim – the elephant stables, for example, with a dome over each individual stall, and the Lotus Mahall with its cusped arches and bracketed chhajjās [260]. There is even a domed gateway in one of the city walls. The

open entrance pavilion to the tank in front of the Krṣṇa temple is rare in being a complete hybrid: the pillars are typically Vijayanagara, but there is a straight chhajjā instead of the double-curve kapota, and above are brick replicas of Kaliṅga shrines with nāsikas of cusped arches lined up as a hāra. Plaster decoration is common. It indicates an important difference between the Indian working in the indigenous tradition and one building to Islamic requirements that many of these buildings, or large parts of them, have survived as high as two or three storeys, while nothing remains except the bases of the exclusively Hindu

The forms of maṇḍapa pillars and piers are special to the Vijayanagar style, and the maṇḍapa itself is its most typical structure besides being, along with the gopura, the most in demand as temple areas expanded, with a corresponding increase in the activities that took place at the shrine and in the numbers of worshippers and pilgrims that had to be accommodated.[8] The principal shrines usually remained from an earlier period. The most distinctive feature of the Vijayanagara maṇḍapa, apart from its pillars and piers, is the huge reverse-curve kapota at the cornice, a borrowing from the Deccan.

260. Hampi (Vijayanagara), Lotus Mahall. Early sixteenth century

secular constructions. The Hindu tradition raised temples in stone or brick to heights of over 200 ft (60 m.) but invariably constructed secular buildings, with the exception of the bases, of impermanent materials. In part, at least, this is a reflection of fundamentally different techniques of building.

Above its base mouldings the Vijayanagara pillar consists of square sections alternating with multi-faceted, usually octagonal and complex ones, the median band with a different number of facets from those immediately above and below.[9] From the bottom of each square section, at the corners, hang heavy

261. Hampi (Vijayanagara), Kadalaikallu Gaṇeśa temple, from the south-east. Probably fourteenth century

drop-like pendants; from the top rise massive nāgapadams [261]; in the middle is usually a single low-relief mūrti, dancing girl, haṁsa, etc. Visual puns are obviously much enjoyed. The corbel is usually simple, with the pendant puṣpabodigai favoured by the Drāviḍa style from the fifteenth century onwards [246].[10] This column, ultimately a child of the pillars of the Pallava cave temples, is amazingly versatile: by increasing the height of each 'square' section to a rectangular one (of which there are never more than three) it is rendered tall, slender, and elegant; left short and massive, it is the embodiment of power and stability.

These monolithic piers are sometimes extraordinarily complex, small structures in themselves, with their elaborate bases, cornices, entablatures, and even on occasion a hāra [262]. Sometimes clusters of two or more pillarets, they are usually rectangular on plan, the dominant rearing yāḷis or horses, always mounted, surging forward from the narrow ends. Below a monumental overarching corbel projecting several feet, under the forelegs of the horses and beside them advance armed men or other figures. A reverse-curve bracket is sometimes

topped by a second, projecting even further, one or the other perhaps in the form of a human or animal atlas. In spite of their complexity and the elaborate carving, recalling the *horror vacui* which led to the decoration of every inch of stone in the contemporary maṇḍapas of Gujarāt and Rājasthān, the huge animals and almost life-sized human figures provide not only refreshing differences of scale but a pulsating vitality rare in later Indian architecture or sculpture. In the Nāyaka period, the rearing animals are often replaced by standing 'portraits'. Most of the great South Indian temples, notably Vellore and Śrīraṅgam, have maṇḍapas with rearing horses.[11] Curiously, the horses with their armed riders and men-at-arms, the embodiment of the martial spirit of Vijayanagara, are not found in the capital itself.

In other respects, the Vijayanagara style can be particularly well appreciated in the capital, for although most of the vimānas and gopuras are undated, all the Drāviḍa structures belong within the life-span of the city. The Drāviḍa style is extremely conservative, and Vijayanagara's contribution consists only of some de-

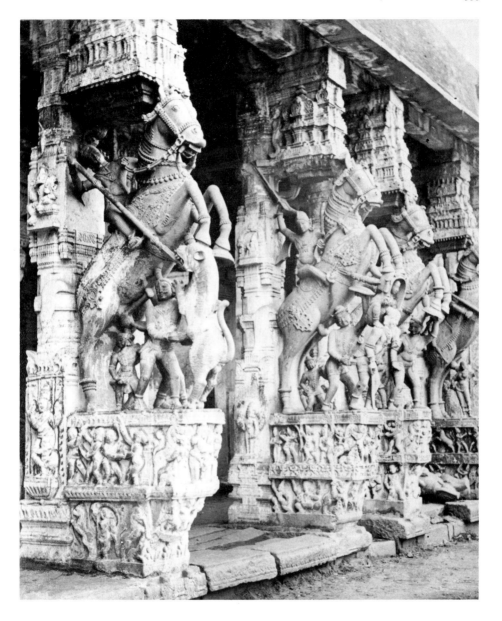

262. Śrīraṅgam, Horse maṇḍapa. Seventeenth century

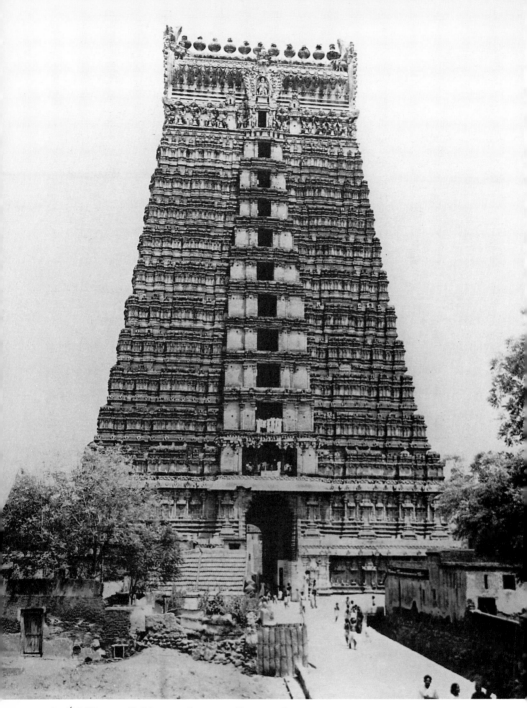

263. Śrīvilliputtur, Periaḷvar temple, gopura. Seventeenth century

gradation of the later Cola style and a few changes in detail. The wall surfaces are sparely articulated or not at all; bases tend to creep up at their expense.[12] The niches, narrower but not excessively so, as in the Nāyaka period, retain their crowning pavilions and kumbha pañjaras. A tendency to rib the kumbhas as well as kapotas and kumuda mouldings, and towards over-use of sculptured scenes on the walls, is observable in late Cola buildings in Tamilnāḍu. Over-emphatic denticulation of the padma mouldings, the idals, and the paṭṭas coarsens the general appearance, but the great double-curve padma moulding below the kumuda, the noblest invention of the Early Cola period, survives unspoilt.[13]

Additions to what are now the large temples of South India, already under way under the Late Colas, continued uninterrupted until the eighteenth century. Almost all have Vijayanagara-style maṇḍapas or gopuras, the gopuras growing taller, according to prescription, with each additional enclosure. Nine-storey gopuras of Vijayanagara times are not uncommon, rising to eleven on occasion in the seventeenth and early eighteenth centuries, for example at the Perialvar temple, Śrīvilliputtur [263]. The superstructures of these towering buildings have a very pronounced concave upward sweep, culminating in a śālā whose caitya-arch ends are topped by huge kīrttimukhas which give them, in profile, a horned appearance. Often, as at the southern gopura of the Great Temple at Madurai, the upper storeys are thronged with a pullulating mass of stucco figures of gods, demi-gods, and men, brightly painted in modern colours in the cases of gopuras recently restored.

The architectural glory of the seventeenth and eighteenth centuries, under the Nāyakas of Madurai and then Tiruchirāppaḷḷi, is the pillared galleries, like the Puḍu Maṇḍapa at Madurai or a corridor at Rāmesvaram, with standing portraits of donors, royal and otherwise, their hands in añjali [264]. Represented in relief increasingly during the Vijayanagar

264. Rāmesvaram, corridor. Seventeenth century

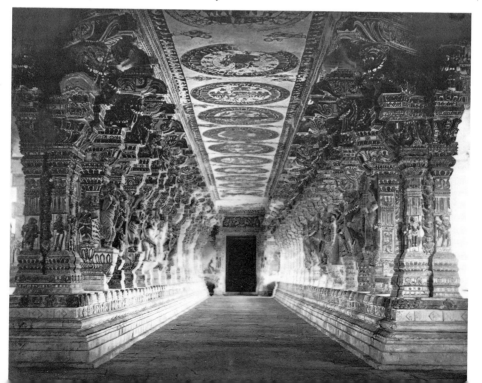

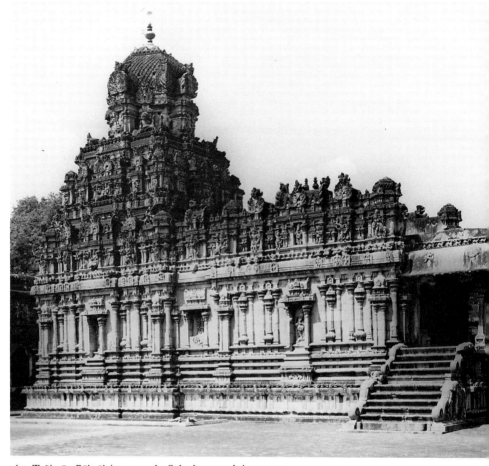

265. Tañjavūr, Rājarājeśvara temple, Subrahmaṇya shrine. *c.* 1750

period, now they are fully in the round, and usually accompanied by members of their families. Rearing yāḷis or horses generally give way to mūrtis of gods, often completely in the round, except for supports. There are beamends under the main kapotas, a Deccani feature, and, in continuation of Vijayanagara practice, small figures perched here and there among the mouldings or pavilions and ever more fantastically shaped kūḍus. The well-

known Subrahmaṇya shrine (*c.* 1750) beside the vimāna of the Rājarājeśvara at Tañjavūr is an exquisite little building [265], the culmination of the Drāviḍa style in its pure form, with a line of uninterrupted development even longer, if we exclude the Renaissance, than that of Western classical architecture.

The great temples of the south include Tirupati (actually in Āndhra), two at Kāñcī, the Arunācaleśvara at Tiruvannāmalai, Tiruvārūr,

in Tañjavūr District, the Jambukeśvara on the island of Śrīraṅgam in the Kāverī at Tiruchirāppaḷḷi, Madurai, Śrīvilliputtur, and Rāmeśvaram in the extreme south. The earliest to reach its present form (the late outermost prākāra walls simply enclose a narrow strip of temple property, some of it returned to jungle) is Cidambaram.[14] Greatest in extent, however, is the Raṅganātha at Śrīraṅgam, covering 156 acres (63 hectares), and the only one to have the full canonical number of seven prākāras [266]. At Śrīraṅgam, the most famous Vaiṣṇava temple in South India, known simply as *Koil* ('the temple'), the oldest structures are naturally towards the centre.[15] None appears to be older than the Late Cola period, although the sanctity of Śrīraṅgam harks back much farther. During the eighteenth century it saw considerable fighting between the French and English and their allies, and was briefly occupied by them as well as by Hyder Ali and Tipu Sultan, giving some credence to the theory that the high prākāra walls were primarily defensive.[16]

If they had been completed, the four great outermost gopuras would have been the largest ever built.[17] From then on they decrease in height with each prākāra, and roofs, many part of Vijayanagar and Nāyaka reconstructions and hall-building, cover a greater and greater area of each enclosure, until only the low superstructure of the main shrine, covered with gold plates, projects above them. This curious brick and plaster building consists of a round garbhagṛha crowned by a slightly oval (*vṛttāśra*) śikhara, with a pronounced śukanāsa. It faces south. The image, of Viṣṇu Yogaśayana, is of mortar, about 15 ft (4.5 m.) long, the head turned to face worshippers, i.e. to the south.[18] Apart from some fine gopuras, the only buildings of architectural importance in this vast assemblage are the splendid horse maṇḍapa, the Śeṣagirirāyar, of the late sixteenth century and the beautiful Kṛṣṇaveṇugopala shrine, probably of sixteenth- or early-seventeenth-century date.[19] The nearly life-size women, almost in the round, between the corner pilas-

ters are of great sophistication and exceptional beauty. If they do indeed belong to the seventeenth century, as their costume suggests, they are the finest examples so far known of late South Indian stone sculpture.

The innumerable maṇḍapas and individual shrines of the great South Indian temples are a vast storehouse of later iconographical lore. Nearly every pillar of the latest periods bears reliefs of gods or other figures, the latter often charming vignettes. The greatest interest of these temple cities lies, however, in their spatial organization, in the complexities of the cult and the annual round of festivals, and in the sociological organization of the not inconsiderable communities which have the temple as their *raison d'être*.[20] The three outer prākāras of the Raṅganātha contain shops and houses and a population of nearly 50,000. The expenses of maintaining a great temple and its neverceasing ritual were originally met by endowments, chiefly derived from land revenues, now mostly commuted, so that these days temples rely on state subsidies, donations from pilgrims, and, to a small extent, income from tourists.

The Vijayanagara and Nāyaka periods produced abundant sculpture in bronze and stone, the larger stone figures usually associated with maṇḍapa piers rather than niches. Generally, they show a tradition in decline, reliant on a rigid and uninspired translation of the prescriptions, including proportionate measurements, of the śāstras. Exaggerated but stiff bhaṅgas largely supersede the earlier gracefulness, although the ubiquitous baby Kṛṣṇa, crawling away with the stolen butter, or lying on his back sucking a toe, is almost invariably winsome and charming. Of some of the new stylistic currents we cannot yet say whether they stem from different schools or different periods. Some Nāyaka mūrtis exhibit a rather hard and showy naturalism together with a narrow and aquiline face. Sometimes the treatment is mannered. Styles in portrait sculpture vary widely within the highly conventionalized Indian genre. Compare the famous Kṛṣṇa-

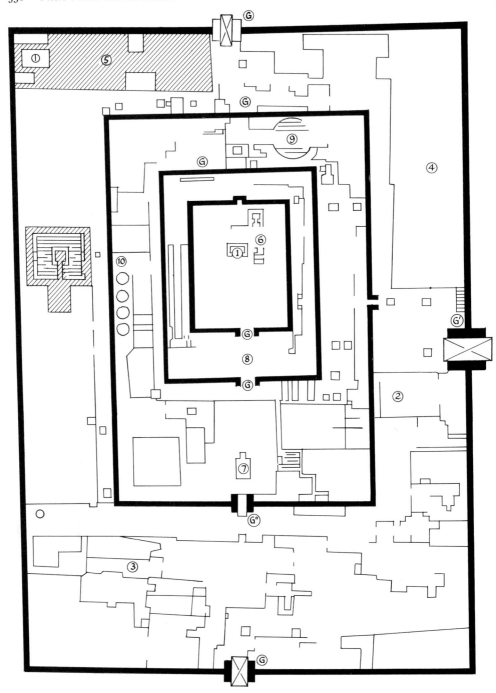

266. Śrīraṅgam, plan

1. Sanctum (mūlasthāna)
2. Śeṣagirirāyar maṇḍapa, the horse maṇḍapa
3. Kṛṣṇaveṇugopala shrine
4. Thousand-pillar maṇḍapa
5. Shrine(s) of the God's consort

6. Gayatri maṇḍapa and shrine
7. Garuḍa maṇḍapa
8. Dhvajastambha and balipīṭha
9. Candrapuṣkaraṇi tank
10. Granaries

G. Gopura
Vellai gopura (G′)
Karthigai gopura (G″)

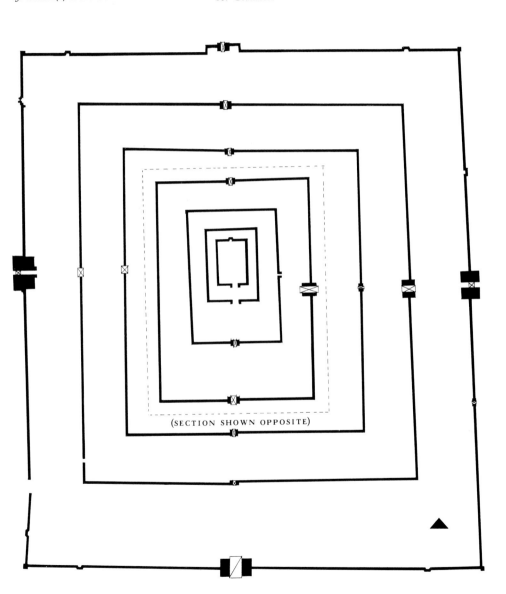

(SECTION SHOWN OPPOSITE)

devarāya and two wives at Tirupati [267] to the Todaramalla and his wife and mother also there and also in repoussé, and both to another group of the same family in the Varadarāja temple at Kāñcī:[21] all are in different styles, and all find considerable echoes in stone sculpture elsewhere.[22] The religious work which continues to be produced today, much of it for the 'restoration' of old temples, maintains a fairly decent technical standard in a 'Cola' style; indeed, a certain proportion finds its way on to the art market as genuine Cola work.

Of the ivories produced in Śrīrangam during the Nāyaka period the large polychrome figures in the innermost prākāra of the temple are probably the most important. The glass paintings of Tañjavūr from the nineteenth century to the present are miniature versions of the many surviving wall paintings.[23]

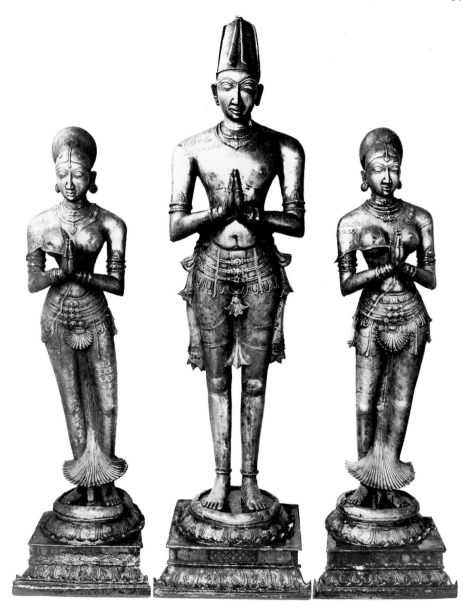

267. Tirupati, Śrīnivasaperumāḷ temple, Kṛṣṇadevarāya and two wives. Sixteenth century

KERALA

The modern state of Kerala is culturally very distinct.[1] Never more than 75 miles (120 km.) wide, it stretches for 345 miles (555 km.) along the west coast from just below Mangalore almost to Kanya Kumari (Cape Comorin). Unlike most of the rest of South India it has heavy rainfall, plentiful forests except along the coast, and a dense population, and local conditions have set their mark on art and architecture. In the south, Kerala marches with Tamilnāḍu, whence most of its cultural influences have come, whereas Karnāṭaka to the north has exerted a lesser sway. Tuḷunāḍu, the Canarese-speaking coastal area to the north, now a part of the state of Karnāṭaka, will be dealt with later in this chapter.

In the early centuries A.D. Kerala, or at least the southern part of it, belonged to the ancient kingdom of the Ceras of the Śaṅgam age. It seems to have been something of a cultural outlier of Tamilnāḍu, sharing the same range of megalithic remains and associated pottery, while the earliest inscriptional evidence of Cera rulers occurs in typical Tamilnāḍu stone-bedded rock-shelters in Karur Taluk, near the Kāverī river in Tiruchirāppaḷḷi District.[2] The caves, cut into granite rock-faces or boulders (Kaviyur, Viliñjam, Tirunandikara, to name the most important), are, with their far from abundant sculpture, in every respect closely related to the Pāṇḍya caves of the eighth-ninth centuries in the far south of Tamilnāḍu.[3] The literary evidence tells the same story. Some of the events in the Śilapaddikāram, the famous Tamil poem, probably of the sixth century, take place in the Cera country, and many of the holy places in southern Kerala are sung by the (Tamil-speaking) Vaiṣṇava and Śaiva saints; indeed two second-dynasty Cera kings of the ninth century are counted among their number.

Malayālam, which is now spoken in Kerala, did not become a separate literary language until the tenth-eleventh centuries.

As the architectural and sculptural expression of South India and, to a lesser extent, the Deccan, in a different physical environment, Kerala's significance grows with the centuries. Its unique contribution consists in the Drāviḍa-Kerala style of architecture and in the use of wood for temple construction and for sculpture. As Kramrisch has pointed out, Kerala is the only part of India where two distinct types of architecture have co-existed for centuries:[4] the Drāviḍa and the Drāviḍa-Kerala. In both, the stone Drāviḍa element evolves stylistically in unison, given provincial variations, with Tamilnāḍu. The indigenous wooden contributions to Drāviḍa-Kerala shrines and their surrounding buildings are relatively dateless.[5] We must be clear that the Drāviḍa style is not an import; it is as native to Kerala as it is to Tamilnāḍu.

As in Nepal, the continuing use of wood affords interesting insights into temple forms created in that material. It has even been suggested that Kerala's wooden pitched roofs, covered with thatch or tiles, were the norm throughout South India before the introduction of stone. Finally, Kerala has been more exposed to foreign cultural influences than most parts of India, particularly in the earlier periods from Sri Lanka close by. Fine harbours, lack of strong currents, and relative immunity to typhoons have kept Kerala and the coasts to the north in contact with western Asia and Europe from an earlier period than any other part of India - witness the old-established Jewish community in Cochin, the Christian communities dating back to the early centuries A.D., and Goa, the first major settlement by Europeans. Until the eighteenth cen-

tury, however, western cultural and artistic influences were negligible.

It is clear from literary sources that, as in most parts of the subcontinent, all the three principal indigenous religions flourished in Kerala during the early centuries A.D. At least one Buddhist monastery was still in existence in the eleventh century.[6] The early rock-shelters of the Jains have all been converted into Bhagavatī shrines, however, and Jainism appears to have nearly died out until the strong revival of Deccani inspiration, in the north and particularly in Tuḷunāḍu, in the thirteenth century.

There are two main types of shrine: the more or less pure Drāviḍa and the Kerala-Drāviḍa, with sloping and often multiple roofs. A third, largely lacking the Drāviḍa element, flourished mostly in the north, with walls of wood, richly sculptured or of a louvre type, and sloping roofs.[7] The first two share a moulded base, almost always of granite, and very often a first storey in the Dravidian order. There is a greater variety of basic ground plans than anywhere else in India: square, rectangular, apsidal (although no pure Drāviḍa example is known), and circular.[8] Stone walls are usually of laterite, though there are a few temples all of granite and, in the north, some all of laterite. Stone sculpture is relatively rare; with one exception, niches are either blind or devoid of mūrtis. Most Drāviḍa-Kerala shrines, even apsidal ones, are sarvatobhadra, perhaps with one or more blind doors [268].

Building in wood begins in one-storey Drāviḍa-Kerala shrines at the main cornice, where wooden struts or bargeboards support overhanging wooden eaves often carved in human or vyāla forms [269]. Two-storey temples have a very high hāra over the main kapota before wooden construction begins. The rectilinear roofs are pitched at angles of a little more than 45 degrees from the vertical; in the case of circular temples, they are conical. There may be a second set of roofs and even, very rarely, a third. None of the shrines is more than tritala (three-storeyed). The space

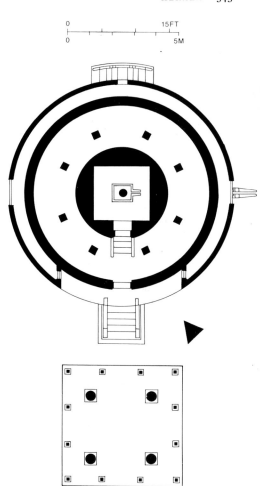

268. Kaviyur, Śiva temple.
Mid tenth century. Plan

between roofs, called the grīva in Kerala, is treated architecturally, more or less in the Drāviḍa manner, with wood or stucco figures. The mukha maṇḍapa of many square shrines accounts for a projection of the roof, in the manner of a Cāḷukya nāsika. The roofs themselves, perhaps once of thatch, are tiled and sometimes covered with copper plates. In some cases the topmost octagonal roof of a square temple, corresponding to the pure

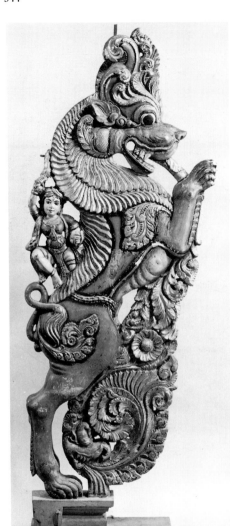

269. Yāli strut on a bargeboard.
Eighteenth/nineteenth century. Painted wood.
Private Collection

Drāviḍa śikhara, has 'dormer windows' on each of the eight sides, each with its own steeply pitched little roofs but maintaining a gavākṣa or caitya-arch-shaped façade, thus recalling the distant structural origins of the Drāviḍa style's kūḍus.[9] Circular temples of one storey (the great majority) can give the impression of being overburdened by their huge single conical roofs, the walls, often low, further dwarfed by the overhanging eaves.

Very many Drāviḍa-Kerala temples are sāndhāra. Sometimes the inner shrine, the one containing the garbhagṛha, extends up to the base of the topmost roof, divided into unused chambers by successive floors and playing a structural role, in the Nepalese fashion.[10] More often, however, the inner chamber stands, complete with its own superstructure, within the body of the temple, as can be well seen at the circular Nīramaṅkara at Nemam where the main roof is missing and the perfect little square Drāviḍa shrine within stands revealed with its śikhara, octagonal like most of its brothers, as in southern Tamilṇad.[11] Also plain to be seen is the interior row of tall encircling pillars, tenoned at the top and rising well above the cornice of the outer walls [270]. These relatively rough-hewn members are common in circular sāndhāra temples and sometimes occur in apsidal ones as well; there can even be a double row. Their purpose is obviously to support the outer roof when the inner shrine, with its own superstructure, can no longer do so. The resemblance of the circular shrines to the Sri Lankan vaṭadāgē is unmistakable, the stūpa replaced by the inner shrine, complete with base, walls with pilasters and niches, and entablature, as well as a grīva and śikhara.[12] The interior niches often shelter images of stucco or wood. Sometimes the goddess occupies the rear niche opposite the entrance in a sarvatobhadra temple. With a separate entrance thus provided for worshippers, this is the equivalent of the Amman shrine in Tamilnāḍu. Examples are the Vaḍākkunātha shrine in the temple of that name, Trichur City, and the temple of Subrahmaṇya at Karikkad-Kṣetram, Mañjeri, Malappuram District [271].[13]

The links with Sri Lanka from 850 to 1150 require little explanation,[14] but some marked similarities to Nepal (and to the sub-Himālayan

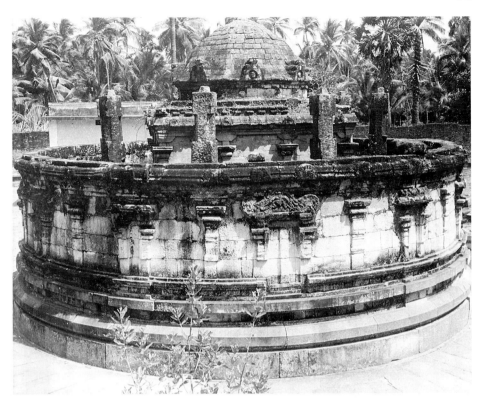

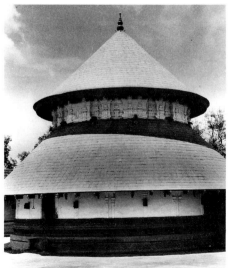

270 (*above*). Nemam, Nīramaṅkara temple. Eleventh century

271 (*left*). Karikkad-Kṣetram, Mañjeri, Subrahmaṇya temple. Eleventh century

areas of India) raise important questions, particularly the controversial issue of a common origin for the 'pagoda'-type shrine.[15] Steeply pitched rectilinear roofs, often superimposed, brackets, frequently in the form of humans or animals, to support the overhanging eaves, and the abundance of wood above a certain level are all common to Kerala and Nepalese shrines. Both tend to be sarvatobhadra, both use tiles on their roofs or sheathe them with copper. Only sāndhāra temples in Kerala are sarvatobhadra, however, and there is no multiple access to the garbhagṛha itself.

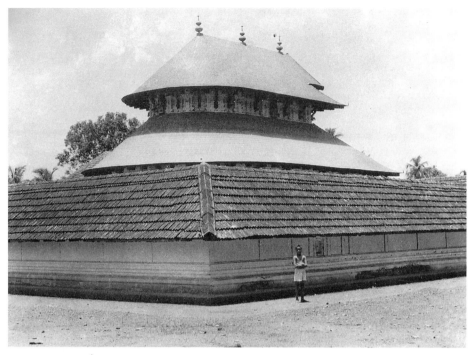

272. Nedumpura, Śiva temple, nālambalam and shrine. Ninth/tenth century

273. Vaḍākkunātha, temple, gopura, from the south. Eleventh century

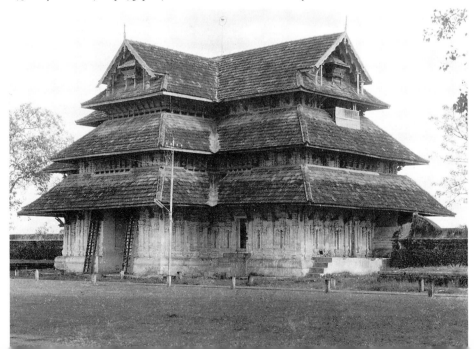

Free-standing 'pagoda' temples in Nepal are almost all square on plan and usually stand on stepped platforms whereas Kerala temple platforms (as elsewhere in India) are usually not stepped and the shrines are built on all sorts of plans. Finally, apart from wood, brick, almost unknown in Kerala, is the main material of the Nepalese shrine.

Kerala art and architecture are essentially in a local version of the South Indian tradition, adhering to ancient prescriptions although the buildings themselves are not usually very old.[16] This is nowhere more evident than in the layout of the larger temples, not only for example the Padmanabhasvāmī at Trivandrum and the Stānunāthasvāmī at Sucindram,[17] with their storeyed gopuras and great Nāyaka cloisters, barely differing from the great temples of Tamilnad, but also those where, 'filled with the indigenous shapes of its buildings and shrines, the plan of the Malabar temples is a vital form of religious architecture of all-Indian importance'.[18] Peculiar to Kerala are the *namaskara* maṇḍapas, detached from the main shrine which they precede, and perhaps housing a Nandi, and the Śāstā shrines to be found in the south-west corner of nearly every important temple complex, as ubiquitous as those of Subrahmaṇya and the Amman in Tamilnāḍu. Equally prevalent are monumental raised *balipīṭhas* (altars for offerings), usually of hour-glass shape.[19] The *nālambalams*, single-storey cloisters largely of wood, with tiled roofs, surrounding the main shrine [272] are often treasure-houses of wooden sculpture. Similar structures are provided for dance and music. Gopuras, never more than three storeys high, preserve a Drāviḍa plan while greatly exaggerating the entrance projections [273]. Their complex arrangement of pitched roofs and gables evokes powerful echoes of the wooden architecture of ancient times.[20]

There are few inscriptions, compared to Tamilnāḍu, and almost every shrine has been rebuilt above the base, often many centuries ago. It is therefore particularly difficult to trace the historical evolution of Kerala's temples. As in many a Drāviḍa building, the shape of the corbel is often the only reliable guide to the date of the walls. Moreover even a brief survey is complicated by individual trends in the four or so degrees of latitude crossing the Malabar coast, which have only rarely been under unified rule. Early circular temples are largely concentrated in the south, for Sri Lanka is nearer and there is an affinity to a type of building there. Apsidal temples, on the other hand, are strikingly absent in the far south but fairly common further north, including Tuḷunāḍu.[21] Of the earliest extant temples, of the ninth century, two, both square Drāviḍa-Kerala shrines, seem to retain most of their original walls. The first, the Kṛṣṇa temple at Tirukkulaśekharapuram (Trichur District) [274] named after the Cera king who also figures as one of the Āḷvārs,[22] has two internal circumambulatory passages, the inner one later. It is the

274. Tirukkulaśekharapuram, Kṛṣṇa temple, detail of vimāna.
Ninth century, first half

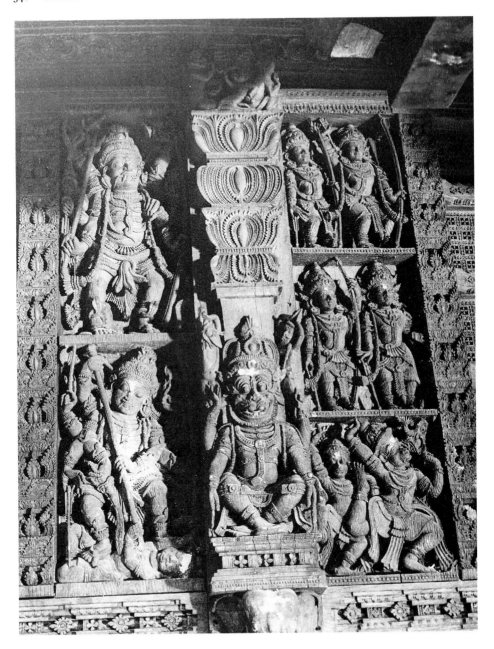

275. Kaviyur, Śiva temple, detail of carved wooden wall. Probably eighteenth century

only Drāviḍa-Kerala temple with niche sculptures, all two-armed men making a gesture of greeting. It is preceded by a fair-sized mukha maṇḍapa.[23] The second, perhaps slightly later, is the main shrine in the Śiva or Nityavichāreśvara temple at Tali, also in Trichur District.[24] Both temples have an excessively large jagatī, and an elliptical kumuda thrust forward to such a degree that the walls proper, with the upper base mouldings, begin only above it. This is an early Drāviḍa hallmark in mid and northern Kerala.[25] The curious flange-like projections at the corners of the kaṇṭha and bhadra base mouldings of both temples are said to imitate, in a crude way, the makara heads of the Early Cola style. These and a few other shrines dating substantially from before 1000 have articulated walls and niches and pañjaras with their own mouldings down to the kumuda.

The circular Śiva shrine at Kaviyur [268], or rather its *adhiṣṭhāna* (base), is firmly dated by inscriptions to before 950.[26] Around the circular inner shrine with its square garbhagṛha runs a circle of columns, all almost certainly in accordance with the original ground plan, which is rarely altered in spite of later construction or renovation of the walls and superstructures.[27] Here, the splendidly carved wooden outer walls (*bāhya bhitti*) are probably no more than two hundred years old [275].

The vast number of shrines of the eleventh to the seventeenth centuries, often rising from an earlier adhiṣṭhāna, as elsewhere tend towards over-ornamentation and excessive crowding and banality. The walls are no longer articulated (they never were in circular or apsidal shrines).[28] As late as the fifteenth century, however, the Valaya-Udayeśvara in a suburb of Trivandrum remains a fine Drāviḍa temple, with two rows of hāras and, exceptionally, a circular grīva and śikhara.[29] The late sixteenth and seventeenth centuries saw an intensification of the bhakti movement in Kerala, and this, in conjunction with the relative prosperity under Dutch trading hegemony and wise eighteenth-century rule in Travancore, led to renovation and genuine renewal. Many shrines

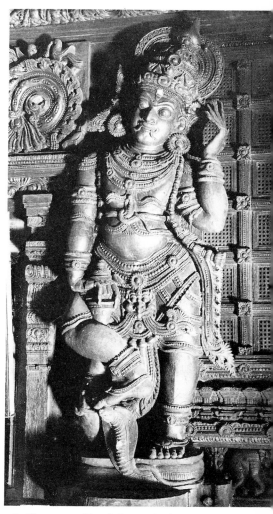

276. Chengannur, Narasiṁha temple, dvārapāla. Probably eighteenth century. Carved wood

were decked with murals, and from this period dates most of the surviving wood sculpture, for example the walls of the Narasiṁha at Chengannur, Allepey District, with its superb dvārapālas at each of the four entrances [276], its jālas, and scenes from the Kṛṣṇalīla and the Purāṇas as well as from the Kirātārjunīya.[30]

Kramrisch has noted the occasional astonishing identity of style between wooden reliefs and wall painting, particularly in the close grouping of figures; the statement that 'the many memories thus collected and adorned are more alive in the texture, one would prefer to say, than in the composition of this relief' holds good for both mediums.[31]

Kerala produced relatively little stone sculpture and – like Tuḷunāḍu to the north – no distinctive style. Some Mātṛkās of the early period from the south are indistinguishable from Early Cōḷa or Pāṇḍya work. The famous Viṣṇu from the Nīramankara at Nemam, Trivandrum District, usually dated much too late, probably belongs to the eleventh century and is reminiscent of Koṅgu work in bronze.[32] The Viṣṇu from Eramam, Cannanore District, on the other hand, with its segment of prabhāvalli between the upper hands together with the characteristic overshadowing of the forehead by the brim of the mukuṭa, has a strong Cāḷukya flavour.[33]

No distinctive style emerged either in bronze and metalwork in general, in which (in marked contrast to the Nepalese) the craftsmen of Kerala rarely showed more than a modest competence.[34] Ornate filigree prabhā-vallis often tend to overwhelm the central figures. Apparently the only iconographical type to have caught the imagination of the Kerala bronzecaster was that of Śāstā (Hari-haraputra or Ārya), a village god in Tamilnāḍu, where he is generally known as Ayannār, but in Kerala replacing Subrahmaṇya as one of the main figures in the pantheon. Every temple of any size has a shrine dedicated to him.[35] A nineteenth-century image in repoussé shows the god in *rājalīlāsana*, a seated pose where both legs are bent and drawn up on to the base; one lies flat, the other approaches the vertical; an outstretched arm rests on the latter's knee. His wild locks form a crown or halo. The body is fine and full of *prāṇa*; its ornaments 'rest lightly' on it and are 'consistently part of the vision' [277]. A more threatening nineteenth-century version, of beaten silver on wood, is one of the truly baleful Indian images.[36]

277. Śāstā (Ayannār), front and back views. Nineteenth century. Repoussé silver on wood

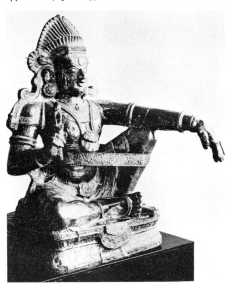
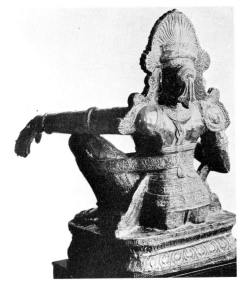

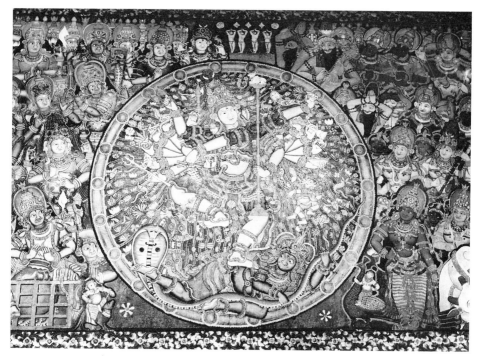

278. Ettumanur, old Śiva temple, Naṭarāja. Perhaps sixteenth century. Wall painting

Enough has survived to show that wall painting was widely practised in the Deccan and South India from Vijayanagara times onwards.[37] Against a pronounced bias towards long narrative bands copiously labelled in Tamil or Telugu, which carries on to miniatures and temple hangings, Kerala remains far truer to the mural tradition, though much influenced by the costumes of the Kathakali dance; the figures, with their smooth, inflated limbs, fill the entire ground. There is no room, as in classical Indian painting, for trees or clouds or houses, and vignettes find no place. Heads are just off full face. The earliest surviving example, a very large Naṭarāja panel (12 by 8 ft; 3.66 by 2.44 m.) in the gopura of the Mahādeva temple at Ettumanur, Kottayam District, may be as early as the sixteenth century.[38] These caparisoned figures have a gran-

deur, reminiscent of Hoysaḷa sculpture, which no other contemporary painting can match [278]. Fine murals in the Krishnapuram Palace at Kayankulam, Allepey District, include a Gajendramokṣa, and there are others in the Padmanābhapuram Palace at Padmanābhapuram, now in Tamilnāḍu (Kanyakumari District), and in two temples in Trichur District, at Trichur and Triprayar. The execution of the wall paintings in several rooms of the Mattancheri Palace at Cochin probably extended over a couple of centuries.

Kerala painting eagerly absorbs external influences; for example some of the devotees in the Gajendramokṣa mural stand, in profile, in the typical Nāyaka pose, feet thrust forward and the rump correspondingly pushed back. When closely surrounded by other figures, however, some full face with strong bhaṅgas,

279 (*below*) and 280 (*opposite*). Padmanābhapuram, palace, Gaṇeśa, with details.
Seventeenth/eighteenth century. Wall painting

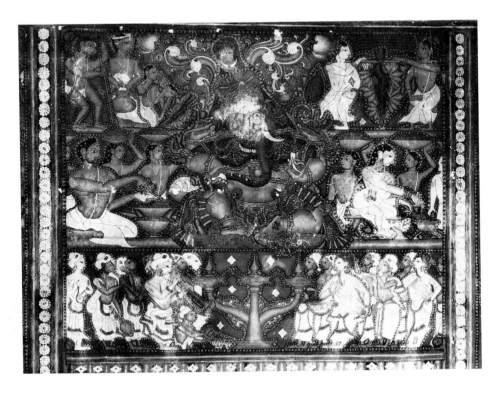

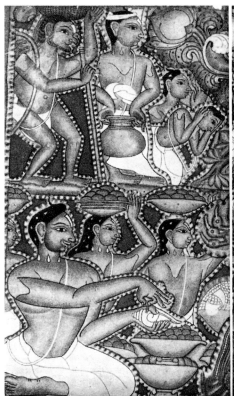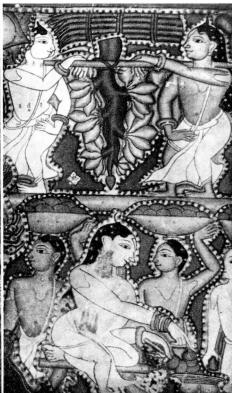

the pose becomes part of a rhythmical pattern and loses some of its absurdity. European influence is similarly absorbed with a full understanding of its techniques and its possibilities for the indigenous style. The hair of the figures in the Gaṇeśa of the Padmanābhapuram palace is touched with highlights, and the throat sinews are picked out in stylized wedges [279 and 280]. The drawing of the man with a conch shell seated with his legs drawn up under him is masterly, and a complete break from the traditional Indian way of depicting people sitting in one of the āsanas.[39] Kerala painting flourishes to this day, with a brief but marked loss of confidence in the mid nineteenth century.

The ancient region of Tuḷunāḍu, the home of the Tuḷuvas, consists of South Kanara, immediately north of Kerala, and coastal North Kanara, both districts of the state of Karnāṭaka whose window on the sea they provide. Canarese-speaking Tuḷunāḍu reflects the culture of the Deccan, and in particular Karnāṭaka, to which it has had political links throughout history, rather than of Kerala, yet so strong has been the effect of their coastal environment on architecture that they are best considered together, with Tuḷunāḍu as the northern extension of Kerala.[40] One or two pure Deccani temples, of the Kaliṅga type, are to be found, for example the Seneśvara at Baindūru, with a Cāḷukya navaraṅga, complete with fine dikpāla

ceiling reliefs, although covered with a peaked tiled roof. There is at least one Drāviḍa temple at Bhatkal, the Rāma, and a considerably earlier one at Ullal.[41] Drāviḍa-Kerala shrines with square, circular, and apsidal ground plans are numerous, particularly in South Kanara, but a high proportion have louvred outer walls. Peculiar to Tuḷunāḍu is the use of stone slabs for roofing, rather than tiles, and louvred walls of stone.[42] The twelfth century saw a strong revival of Jainism, of Deccani origin, and there are important Jaina temples at Muḍabidri and Bhatkal.

The sculpture of Tuḷunāḍu naturally shows far greater influence from the Deccan than Tamilnāḍu. Many stone and bronze images in both Early and Late Cāḷukya style have been found there, a lot of them in a provincial version. Viṣṇu as Janārdana is the most common. The seated Lokeśvara, 5 ft (1.50 m.) in height and dated 968, in the Mañjunātha temple at Kadri, Mangalore, shows strong Gaṅgā influence in the detached prabhā [281]. Whether or not imported from further east, it is the most technically accomplished of all early bronzes from South India, outside of Tamilnāḍu, and indeed from the whole Deccan.[43]

281. Kadri, Mañjunātha temple, Lokeśvara. 968. Bronze

PAINTING

Prehistoric or primitive paintings on rock faces and inside caves in India have been little studied so far.[1] Better known are the pottery designs of chalcolithic peoples, often including sophisticated stylized animals but very seldom human figures.[2] India, however, unlike China, Japan, and the Middle East, did not develop a great tradition of decorated ware, and very little was glazed.[3]

Yet Indians have always delighted in colour; no people has produced textiles of more vivid hue. Moreover, temples and monuments of stone and brick, and sculptures in stone, stucco, and terracotta, were all plastered and decorated with paint. None remains on ancient buildings; its place has been taken, if at all, by glaring whitewash for ritual purposes.[4] The plastered and garishly painted stucco and terracotta figures on the upper storeys of new or restored South Indian gopuras give some idea of what once was, though the tonalities were no doubt less harsh because natural pigments were used. Indeed much of the Indian subcontinent provides a rich source of supply of natural earth and mineral colours, including blue from the lapis lazuli of Afghanistan.

Literary sources record wall painting at every stage of Indian history, yet the only substantial ancient remains are at Ajaṇṭā, in four of the later caves. These have come to represent Indian mural painting to the non-specialist. Fragments in the much earlier Caves X

and XI show that by Sātavāhana times, if not earlier, the Indian painter had mastered an easy and fluent naturalistic style, dealing with large groups of people in a manner comparable to the reliefs of the Sāñcī toraṇa crossbars. The naturalistic and sympathetic portrayal, so characteristic of the Indian artist, of elephants frolicking among lotuses is a two-dimensional and coloured version of a scene on one of the crossbars of the north toraṇa of Stūpa I [18].[5] From Gandhāra only tiny fragments have survived although painting is known to have been widespread in the monasteries. The fifth-century murals from Miran are probably closest of all to the Gupta style, but they properly belong, together with those at Bāmiyān, to the history of painting in Central Asia, where a less humid climate has helped to preserve frescoes.

The frescoes in the second-phase Ajaṇṭā caves, and fragments at Ellorā and Bādāmi, which are all we have from Gupta and post-Gupta times outside South India, are indeed a slender remnant of the wall paintings in houses and pictures in halls attested by literary sources, particularly in the sophisticated and urban atmosphere of the Gupta period. The powerful and mighty were expected to be adept at painting portraits; discriminating connoisseurship and ample patronage were consequently to be anticipated in regard to murals.[6]

282. Ajaṇṭā, Cave XVII, scene from the Viśvantara Jātaka. Fifth century, second half. Wall painting

Probably the earliest practical precepts are those in Yaśodharman's commentary on the Kāmasūtra, the standard Indian text on sexual love, almost certainly of the Gupta period. He proposes six headings or 'limbs' (ṣaḍaṅga), interpreted by Coomaraswamy as *rūpa-bheda*, distinction of types; *pramāna*, ideal proportions; *bhāva*, expression of mood;[7] *lāvanya-yojana*, embodiment of charm; *sādṛṣya*, points of view, stance, pose, etc.; *varṇika-bhaṅga*, preparation of colours.[8] Of the more technical treatises, the Viṣṇudharmottara deals with painting under the same headings, as do such later Hindu works as the Śilparatna. These instructions were certainly intended for the wealthy rather than for mere craftsmen.

Almost all the surviving paintings at Ajaṇṭā are in Caves XVI and XVII and Caves I and II, all but a few of the second group apparently in a more developed or later style.[9] It should be added, however, that the stylistic analysis of the frescoes does not as yet rest on very secure foundations. Their main themes are taken from the jātakas. Many in Caves I and II, including those on the ceiling, borrow sculptured motifs, and would normally have been carved; perhaps resources were lacking. Particularly striking in this respect are the two world-famous Bodhisattvas painted instead of carved on either side of the entrance to the shrine of Cave I, with its seated Buddha.

The late-fifth-century paintings of Caves XVI and XVII are one of the great glories not only of Gupta but of all Indian art [282 and 283]. They are classical in the deepest sense and of the surest draughtsmanship, devoid of clichés, rich and full of life both in composition and colour. The palette is warm and full; white

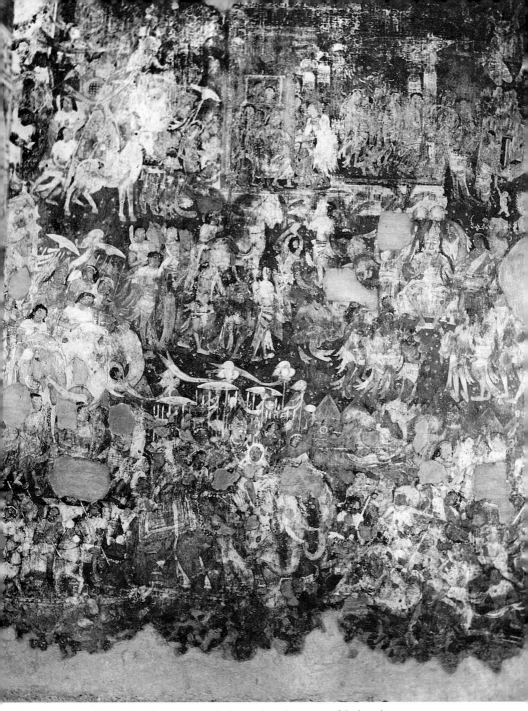

283. Ajaṇṭā, Cave XVII, rāja riding out on an elephant to hear the sermon of the hermit.
Fifth century, second half. Wall painting

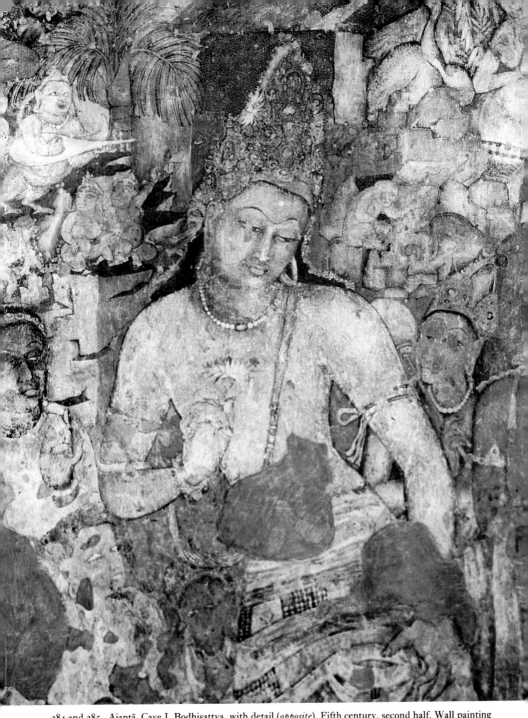

284 and 285. Ajaṇṭā, Cave I, Bodhisattva, with detail (*opposite*). Fifth century, second half. Wall painting

is used sparingly and blue hardly at all. Light is not directional but used simply to create chiaroscuro and to give body to the figures, as Giotto did. Unlike many murals in India, the themes do not occupy horizontal bands but radiate from a central figure. Their luxurious and aristocratic world of physical beauty and sensual pleasure has shocked westerners by its existence in a religious establishment, but the painters must have been accustomed to decorating secular buildings, and undoubtedly saw no need to modify their conception of, say, a king and queen, just because they were to figure in a jātaka scene on the walls of a monastery.

The paintings in Caves I and II, except for the Hārītī shrine, are in a different style, more baroque, more restless, more obviously sensual, and, going by the usual Indian pattern, later than those of the classical Caves XVI and XVII. White is liberally used for highlights and to pick out, in light feathery strokes, the filigree ornaments and ribbons, so different from the rather heavy jewellery of fifth-century sculpture. Clichés abound, particularly the girl with one leg bent back double at the knee, resting against a wall - a pose, however, which occurs at Amarāvatī, where much of the rather frenzied movements and exaggerated curves of the figures can already be seen in the latest phase. Caves I and II were thought until recently to have been hewn out a century or two later than Caves XVI and XVII, so that it was considered natural that their paintings should be in a later style.[10] Now, however, when all the caves are believed to have been completed by the end of the fifth century, dating possibilities are more fluid; the paintings could have been executed in a much later burst of activity. Many features point to the Gupta or early post-Gupta period. The nobly proportioned torsos of the great Bodhisattvas, broad of chest and thick of arm but not to the point of inflation, are a case in point; so is the idealization, which stops short of mannerism, of the beautifully arched eyebrows [284-6]. The eye is no longer represented as a perfect oval, for the

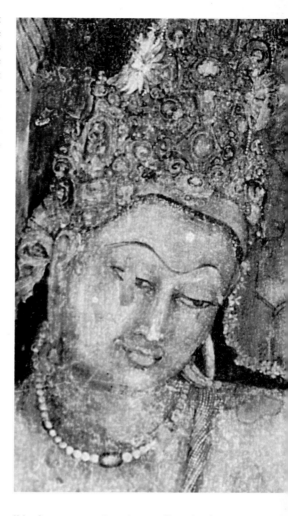

lids form a complex sinuous line, leaving a mere slit between - a tendency already manifest at Mathurā in the fifth century, when the tear duct near the nose is indicated, adding a further curve to the eye. The headdress or crown of one of the great Bodhisattvas calls to mind the great Mahādeva at Elephanta, and c. 550 is probably the latest that the Cave I and II paintings can be placed, if indeed they are not simply an example of a more advanced style co-existing with a more conservative one.

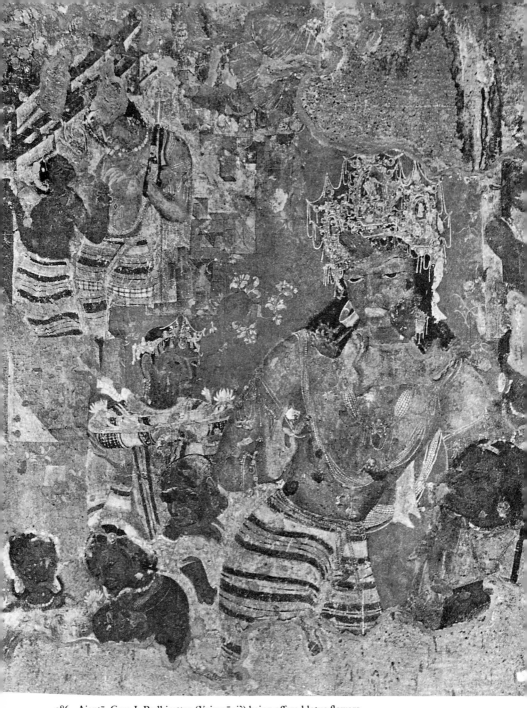

286. Ajaṇṭā, Cave I, Bodhisattva (Vajrapāṇi?) being offered lotus flowers.
Fifth/sixth century. Wall painting

The technique of the Ajaṇṭā paintings is not true fresco, in the Italian sense, but fresco secco.[11] The irregularities of the rock surface were first covered with a fairly thick layer of mud, well bonded with vegetable matter, and then thinly coated with plaster upon which the pigments were laid with a medium of glue or gum. The outlines were drawn in cinnabar red, using, according to literary sources, specially prepared stump-like rolls. Underpainting was frequent, in red or green, and the final surface was burnished. Colour was applied with a brush of animal hair. Brown, red, yellow, and green were obtained locally, from earths and rocks; only blue, got from lapis lazuli, was imported. Black was usually lampblack.[12] A much more restricted palette was used for the largely decorative patterns, notably on the ceiling of Cave II, achieving a flat effect reminiscent of textiles.

The sadly damaged murals at Bāgh are the only other examples of Gupta painting, very much in the Ajaṇṭā idiom.[13] The dancer in foreign costume is more dynamic than usual in Gupta art. The diverse patterns and colours of his dress are rendered with the loving attention bestowed on textiles by Indian painters of all periods.

In the Kailāsa and the Jain Indra Sabhā at Ellorā the line follows the contour of the human form in a misleadingly naturalistic way, for the purpose is not to place the body in space and in relation to other forms but to delineate the icon in precise terms. Certain groups are astonishingly like their stone counterparts. The colours tend to be muddy, touched up with white and blue. The protruding further eye makes its first appearance. At Bādāmi, in Cave III, the sixth-century paintings are much closer to the Gupta style. Outside South India and parts of the Deccan, no other mural painting has survived until the Mughal period.

The Mudrārakṣasa, a play of the fifth or sixth century, refers to painted clothes used by itinerant story-tellers to illustrate their tales and homilies – a practice which doubtless long predates the Gupta period.[14] This particular type, called a *yamapaṭa*, after Yama, the god of death, showed the punishment of sinners in the next world. Paṭas are known from all over India, some dating back as far as the twelfth century; and in some regions the tradition, often a folk one, is still alive.[15] Nepalese and Tibetan thaṅkas probably sprang originally from the paṭa tradition. There is ample literary evidence for portraits, but again none survives. The ability to paint a likeness, on cloth, or cloth attached to board, was a necessary accomplishment both of the upper classes[16] and of hetairai.

After the mural, the most important form of painting in India is the illustration of religious and secular texts. Because we have no illustrated manuscripts from before *c.* 1000, whereas the past four or five centuries, not notable for murals, have produced 'miniatures', many of the most exciting beauty, in their thousands, it is easy to assume that one form succeeded the other. In actual fact, it is more than likely that illustrated manuscripts existed at a much earlier date but have all been lost. Wall painting has continued to this day, although again much of it has been destroyed and what has survived is certainly not comparable to the Gupta remains.

Dated examples attest that the illustration of palm-leaf manuscripts, which continues throughout the Pāla period, was well established in eastern India by the end of the eleventh century.[17] The earliest from Gujarāt and Rājasthān are only slightly later. The eastern Indian texts, to be found in most of the principal libraries and museums of the world, belong almost exclusively to the Vajrayāna branch of tantric Buddhism, with copies of the Aṣṭasahasrika Prajñāparamitā in the overwhelming majority. At least two were produced at Nālandā, and one at the Vikramaśīla monastery in Bihar. Some were copied in Nepal.

The leaves of the talipot palm, approximately 3 in. (7.5 cm.) wide and up to 51 in. (130 cm.) long, provided the best writing material until the palmyra palm was introduced *c.* 1500. Strings were usually threaded

287. Vajragarbha or Vajrapāṇi, copied at Nālandā, found in Nepal.
c. 1200 (dated 'in the fifth year of Rāmapāla'). Palm leaf MS. *Oxford, Bodleian Library*

288. Prajñāpāramitā, with Dhyānapāramitā on her left and Upāyapāramitā on her right,
from Nepal. Twelfth century. Lower wooden cover for preceding MS. *Oxford, Bodleian Library*

through two holes in the leaves, and the whole manuscript or *poṭhī* was bound between wooden boards or covers, often painted. The leaves themselves were usually decorated with three cartouches, one in the middle and one towards each end; the rest was text. The subjects of the little pictures, not more than 2 in. (5 cm.) square, may be a Buddha or one of the deities of the Vajrayāna pantheon, single or with flanking figures, or a vignette of a major episode of the Buddha's life, or even a famous holy place symbolized by its stūpa. More ambitious compositions could be attempted on the covers, often, due to the long narrow shape, figures or objects in rows. The figures tend to be exquisitely painted images of a type known from bronze versions, in a naturalistic three-dimensional style derived from Gupta painting. Some of the eleventh-century ones bring the Ajaṇṭā frescoes vividly to mind [287

and 288]. The figures are modelled in colour in a superb technique in poses sometimes of the greatest beauty, but all expressiveness has gone; moreover these exquisite little pictures are too tiny to bear the weight of iconographic and ritual significance of their bronze and stone counterparts. Later work makes no attempt at colour shading. The figures become wooden, the heads unnaturally square. Over-developed chests and protruding further eyes doubtless derive from western India. Manuscript illustration from the rare and scattered pockets of Buddhism which remained after the savage Muslim conquests put an end to the monastic communities in the east prove the take-over of the Western style.[18] The Pāla tradition continued in Nepal and Tibet, but not in India.

The earliest surviving illustrated manuscripts in the western Indian style date from the early twelfth century.[19] They were discovered in *bhandārs*, libraries usually belonging to the whole Jain community and found principally in Gujarāt and Rājasthān, some established as long ago as the twelfth century by the last great Hindu kings of the region. Kalpasūtras, dealing with the life of Mahāvīra and other Jain tīrthankaras, and the Kālakāchāryakathā, the adventures of a Jain monk called Kālaka, predominate, but by no means all the texts are Jain, or even religious,[20] nor is the style as isolated and regional as the most idiosyncratic fourteenth- and fifteenth-century examples suggest. In the earliest versions, post-Gupta origins can still be detected: the figures are modelled in colour, and the further eye does not protrude in an exaggerated way. The conventionalized animals – haṃsas, elephants, and lions – on painted wood covers of the mid twelfth century from the Jñāna Bhandār in Jaisalmer[21] are in an unlocalized later Hindu style. Western Indian traits are shared, moreover, by some illustrated palm-leaf manuscripts of the Hoysala period in the southern Deccan, notably a sharp, elegant, but completely stereotyped line, angular features, and a tendency for the further eye to protrude.[22]

The western Indian style so closely associated with Jainism was based on Gujarāt and parts of Rājasthān and Mālwā. Jainism has always set great store by the written word, to the extent of practising a special ritual, called *jñānapūjā*, in which manuscripts are worshipped; this accounts for the huge numbers produced and for their careful preservation. The Jains were also almost obsessive about providing their stone and metal images with inscriptions.[23] The Jains were not confined to western India; merchants and bankers for the most part, they were to be found wherever trade flourished – hence the splendid illustrated manuscripts from Māndū and from Jaunpur, to the north of Varanasi. The tightly knit and conservative character of the Jain community seems to have ensured both remarkable unity of style wherever the scribes and painters worked, and the upkeep of the bhandārs under Muslim rule. Jain prosperity appears to have been unaffected by the Muslim conquest, and the production of manuscripts, which gained religious merit for their patrons, if anything increased. They certainly grew more sumptuous, with ever more lavish use of gold and sometimes even silver. The ostentatiousness of some of the manuscripts, which were of course easily hidden, has been explained as the reaction of a pious community under rulers of an alien and hostile faith; this may also partly account for the extreme conservatism of the style.

The western Indian style was fully formed by the end of the fourteenth century. Painting is in a single plane, the figures on a red or ultramarine background. Architectural elements are reduced to essentials. The hieratic little figures, and sometimes animals as well as household furniture, are little more than pictograms occupying boxes in a geometrical composition. In the best examples the line, reminiscent of some contemporary sculpture in its sharp angularity, is extraordinarily assured. Mannerisms include the extension of the further eye, the swelling torso, and a particularly tortuous arrangement of the legs in

289. Gardabhilla and Kālaka from a Kālakāchāryakathā MS. *c.* 1475. Paper.
New Delhi, National Museum

seated figures [289]. Men and women are often practically indistinguishable. Besides the background colour, the palette is a modest one of yellow, white, and green, with, in the more elaborate manuscripts, some pink and mauve. At its best, the western Indian style, particularly in its attractive use of bold textile patterns, is highly distinctive, the general effect of liveliness and gaiety curiously at odds with the seriousness of the subject matter and the sombre tenets of the Jain religion.[24]

The traditional western Indian style eschews contemporary costume, and there is little influence from Iran, where painting flourished under the Timurids.[25] One instance, however, is afforded by a painting of the Śaka king from the story of Kālaka; his crown, camail and tunic, boots, and, most of all, his face in three-quarter view derive from Mongols in Timurid paintings and not from the 'foreigners' nearer home, the Turkish conquerors of western India. That the links between Jain communities were as close as their isolation from their Muslim rulers, in all but business dealings, was complete is proved by the minimal differences in style between illustrations produced as far apart as Māndū, Delhi (Yoginīpura), and Jaunpur. The Muslims, however,

were far from being uncultivated barbarians, and they did not fail to call upon native craftsmen to build their original and splendid monuments.

By the latter half of the fourteenth century, paper had begun to supersede palm leaf.[26] The larger format – approximately 4 by 6 in. (10 by 15 cm.) – permitted considerably more elaborate compositions involving as many as a score of figures and complex border designs. It is unlikely, however, that this change was the decisive factor in one of the most extraordinary developments in all art history, whereby an arch-conservative style, ossified into the most exaggerated mannerisms, gave birth within a century to some of the most powerful and vibrant paintings ever produced on the subcontinent which were to be the source, moreover, of many of the principal elements of Indian painting in the highly creative centuries to follow.

The famous manuscript of the Kalpasūtra and the Kālakāchāryakathā, the favourite Digambara texts, in the Devasano Pado Bhandār, Ahmedabad, of *c.* 1475 show the loosening of traditional forms and an easygoing acceptance of some things Persian.[27] Now the 'foreigners', in their turbans and long *abas* (gowns), reflect

290. Two small landscapes on a single folio from a Kālakāchāryakathā MS. *c.* 1475. *Ahmedabad, Devasano Pado Bhandār*

the contemporary costume of Muslims in western India. The use of arabesques is Iranian, and so is the realistic treatment of antelopes. Actual borrowings include the man and woman riding a camel. The winged dancers in Iranian dress are particularly obtrusive

because, in general, the Timurid influence in the sumptuous borders has been completely assimilated. A little landscape [290] – and the term can be used without apology – has no specifically Persian features except a high horizon; neither, except perhaps for its naturalistic

deer, does the charmingly illustrated Vasanta Vilāsa[28] in which hieratic figures in the old western Indian convention appear alongside others dancing and kissing and some actually engaged in sexual intercourse [291]. The background is occasionally yellow.

291. Folio from a Vasanta Vilāsa MS. 1451. *Washington, D.C., Freer Gallery of Art*

The Caurapañcāśikā style, so called after the most self-consciously elegant series [292], emerges, however, with all its possibilities, in a group of fifteenth- and sixteenth-century paintings in a far more intense, less purely decorative and anecdotic vein. The texts illustrated in this style are not usually Jaina, and where and when they were painted is still a matter of controversy. Almost all in an oblong format, successors in fact to the poṭhīs, with the text on the reverse, they are firmly anchored to the western Indian painting tradition by shared mannerisms, some developed in the previous century, some considerably older.[29] Alone, the protruding further eye gives way to an uncompromising side view and

a single very large eye. The paintings are still in a single plane, with backgrounds in brilliant primary colours, and the page is often compartmented into squares and rectangles, but the expressiveness of the Caurapañcāśikā style, its elegance and often its impassioned lyricism, far exceed the achievements of the old western Indian manner – so much so that some scholars have thought that a new element derived from early Mughal painting must have been introduced, without asking themselves what contribution (apart from a couple of articles of men's attire) this essentially naturalistic style could have made to the expressive, lyrical, and non-naturalistic Caurapañcāśikā manner.[30]

A pair of dated manuscripts, one of 1516, the other of 1540,[31] share the mannerisms and some of the qualities of the Caurapañcāśikā group, but they are much cruder in execution, with a folk or bazaar element. The colophons make it quite clear, moreover, that they were carried out for members of the merchant community. These illustrations, rather inappropriately termed 'bourgeois', prove that the Caurapañcāśikā style developed early, long before the Mughal (the imperial ateliers were not set up until the 1550s or 60s), but the problem remains of the connection between 'bourgeois' work and such highly sophisticated paintings as those of the Caurapañcāśikā and the Gīta Govinda. The 'bourgeois' manuscripts of 1516 and 1540 were produced one in Delhi (Palam), the other some 50 miles from Agra; two more, in equally unsophisticated style, are from Jaunpur.[32] There has consequently been a tendency in recent years to place the whole Caurapañcāśikā group somewhere between Delhi and Jaunpur. Nevertheless, Mewār, because of its heroic Hindu traditionalism, or western Mālwā, because of the quality of earlier work, or both, because their seventeenth-century painting seems best to continue the Caurapañcāśikā style, would seem to be more likely provenances for the finer paintings.[33] Moreover, a consensus for dates twenty or thirty years on either side of 1500 seems to be emerging.[34]

The Caurapañcāśikā, the 'Fifty [Stanzas] of the Thief [of Love]', was written by the twelfth-century Kashmiri poet Bilhaṇa who, awaiting execution (so he says) for having been the lover of the king's daughter, sings of his unrepentant passion in stanzas of lyrical, passionate eroticism:

> Even now,
> I remember in secret
> her braids, loosened ties,
> wilted garlands,
> nectar-sweet smiling lips,
> strands of pearls,
> caressing luscious swollen breasts
> and longing looks.[35]

The paintings which appear alongside the eighteen stanzas of the famous N. C. Mehta manuscript, now in the Gujarāt Museum Society, Ahmedabad, are only occasionally directly related to the text,[36] but they provide an emotional and erotic accompaniment of extraordinary force [292], the intense and stately movement and poses rendered with an almost ferocious elegance. The sharp-angled break of the sari of Campavatī, the heroine, illustrates the tension that stylization can introduce. A ballet to the music of Tchaikowsky provides a similarly formalized accompaniment to an emotional and romantic statement in another medium.

At least two illustrated Bhāgavata Purāṇa manuscripts are in the same style.[37] Far less elegant, often of careless draughtsmanship, more densely populated, they are nevertheless more expressive over a much wider range

292. Illustration no. 18 from a Caurapañcāśikā MS. formerly in the N.C. Mehta Collection. Gouache on paper. *Ahmedabad, Gujarāt Museum Society*

293. Jarasandha, king of Magadha, besieging Mathurā, from a Bhāgavata Purāṇa MS.
Probably early sixteenth century. *Chapel Hill, University of North Carolina, Ackland Art Museum*

[293]. Few Indian paintings can rival the vitality of the best of them, their dramatic use of colour and the richness of the painters' fancy. Another great achievement of the style are the Gīta Govinda paintings in the Prince of Wales Museum, Bombay.[38] Jayadeva's hymn to the loves of Krṣna, Rādhā, and the other *gopis* (cow-girls, the female companions and lovers of Krṣna) in the bucolic setting of Brindavan, a theme to be illustrated thousands of times in the coming centuries, here receives perhaps its most passionate expression. The trees and vegetation, luxuriant yet stylized, carry us into the dream world of Brindavan, but at the same time, as in the picture of the forlorn Rādhā pining for the cowherd-god, the laterally curving lines of the swaying fronds create a sense of disorder and tension, the disturbing effect of thwarted physical passion [294]. Conventionally posed as most of the figures are in these Gīta Govinda paintings, on occasion a human being is caught in action, an achievement rare in Indian art.[39]

Many texts refer to wall painting during the early Muslim period in north India. It appears to have been a Ghaznavid import by the early Sultans in Delhi.[40] Later references are from such cross-cultural works as the Candāyana (Laur-Chanda) and the Mrgāvat by Muslim authors recounting old Indian folk material in Awadhi, the eastern Uttar Pradesh dialect written in Persian (Arabic) script. They de-

294. Kāma, the god of love, shooting an arrow at Kṛṣṇa and Rādhā, from a Gīta Govinda MS. *c.* 1525-70. Gouache on paper. *Bombay, Prince of Wales Museum of Western India*

scribe wall paintings with subjects from the Indian epics as well as scenes of music and dancing. No such evidence exists for early manuscript illustration by Muslims, although a case has been made that certain works were illustrated in a provincial fifteenth-century Timurid style actually in India.[41] A small number of Persian texts in a 'popular' or 'bazaar' style, probably belonging to the latter half of the fifteenth century,[42] are, even at this date, basically provincial versions of contemporary Shiraz painting, with only the odd Indian architectural feature. They are so crude as to cast doubt on any long tradition of manuscript illustration among Muslims in India, as also does a royal copy of the Skander Nāma painted,

according to the colophon, in 1531-2 for the Sultan of Bengal.[43]

Sultanate painting – i.e. sixteenth-century pre-Mughal or non-Mughal painting for Muslim courts or the Muslim community in India[44] – is in most cases readily identifiable by the Indian figures in Indian garb portrayed in an Indian manner, along with salient features from Timurid painting. The manuscripts, although mainly Persian texts, include the poly-cultural Candāyana (Laur-Chanda). It is a reminder of the political, religious, and cultural complexity of northern India at the time that one Candāyana, now shared between the museums at Lahore and Chandigarh, is illustrated in a Caurapañcāśikā style.[45]

The first notable surviving Sultanate paintings illustrate a Ni'mat Nāma produced in Māndū in the first years of the sixteenth century

295. The Sultan refreshed with a sherbet, from a Ni'mat Nāma MS. *c.* 1610.
London, India Office Library

for that eccentric ruler Ghiyās-ud-dīn Khaljī, whose fifteen-thousand-strong seraglio were trained in all the useful arts and provided members of his bodyguard.[46] This book of recipes is a stylistic curiosity, a provincial variant of the Persian Shiraz school with figures in the Indian manner very close to the Caurapañcāśikā style [295].

Very fine indeed are the illustrations of a Candāyana (Laur-Chanda) now in the Prince of Wales Museum, Bombay [296].[47] Some common features of costume led scholars at one time to include these paintings in the Caurapañcāśikā group, but Sultanate paintings never feature the black pompons that jostle at the wrists and elbows and shoulders of women, and occasionally of men as well, in the Caurapañcāśikā group. In any case, the style is very different, and the draughtsmanship, though firm and assured, less elegant. Great care has been taken with the 'architectural' framework, different in every painting – a Persian characteristic, though less elaborately and realistically conceived, with larger areas of flat decorated surfaces. Persian too are the arabesques, the 'meadows' sparsely but regularly sprinkled with plants, the rendering of tiles, and the occasional wispy 'Chinese' clouds. The colouring is exceptionally beautiful and harmonious, with cool greens and yellows and pinks unknown to Persian or other contemporary Indian painting.

296. Mainā in her chamber (upper register), Laur hearing the message of Mainā (lower register), from a Laur-Chanda MS. *c.* 1550. *Bombay, Prince of Wales Museum of Western India*

MUGHAL PAINTING

Mughal painting, like Mughal architecture, is intimately associated with the emperors of that great dynasty (see table below), but it is a much more exceptional phenomenon, unique in India and hardly to be paralleled elsewhere.[1] In the first place, it involves a fundamental change in aims and aesthetics. Previous painting in India and on her borders had been essentially non-realistic and religious; Mughal painting is realistic and almost entirely secular. Secondly, Mughal painting is virtually the creation of one man, the Emperor Akbar, and would not have been possible without his rare qualities as a man, a ruler, and a patron. An indelible stamp was likewise left by his son and successor, Jahāngīr.

one by a biographer constantly at his side for many years, and from Jahāngīr's own memoirs. Moreover portraits exist of some of the most famous artists, and the occasional detail of their lives is preserved. The accounts of visits to the Mughal courts[2] left by a small but steady stream of Europeans are not on the whole very illuminating, but the paintings, or more likely engravings, they presented to the 'great Mogul'[3] proved to be a major influence on painting. Some have been identified, for example the Dürer engraving from which Abū 'l Hasan's famous St John is copied [297].[4] So exhilarating is this abundance of documentation that it can give rise to 'fanciful historical simplification'.[5]

THE GREAT MUGHALS

Bābur (b. 1483)
(1526-30)
|
Humāyūn (b. 1508)
(1530-40, 1555-60)
|
Akbar (b. 1542)
(1556-1605)
|
Jahāngīr (Salim) (b. 1569)
(1605-27)
|
Shāh Jahān (Khurram) (b. 1592)
(1627-58)
|
Aurangzeb (Alamgīr) (b. 1618)
(1658-1707)

I'timād-ud-Dawla
|
= Nurjahān Asafkhan
|
= Mumtāz Mahall

Moreover Mughal painting is documented to an unprecedented extent. The names of scores of practitioners are known both from two accounts of Akbar written in his lifetime,

Akbar appears to have been illiterate. Not so his grandfather Bābur, the founder of the line, a poet and the author of one of the finest memoirs in any language, who in 1526 estab-

lished a foothold in North India by defeating the last of the Lodī kings at the battle of Panipat and taking Delhi. Bābur wrote in Turki, as befitted the great-great-grandson of Timur (Tamerlane), not Persian, later the official language of the Mughal court. Persianized he was, however, as his passion for laying out gardens shows, as well as a man of intellectual acuteness and great martial valour. His son, Humāyūn, driven out of India by the Afghan Sher Shāh, while in exile in Shiraz at the court of the early Safavid monarch Shāh Tamasp came to covet an atelier of painters of his own; he therefore, at great expense, took with him on his return to India two eminent Persian masters, Mir Sayyid Ali and 'Abd al-Samad.[6] Humāyūn died two years later, however, in 1556, and it is his son Akbar, who succeeded at the age of fourteen and reigned for forty-nine years, who must be credited with setting up the royal ateliers. This he did on an unprecedented scale; under the supervision of Mir Sayyid Ali, painters both Hindu and Muslim were recruited and trained. Their first major undertaking, the fourteen hundred or so paintings of the Hamza Nāma, was characteristic of Akbar's energy. It proved to be 'the training ground of Akbari painting',[7] which was henceforth to retain the stamp of Akbar's protean personality.

Unlike the Muslim captains and *condottieri* (including the first Mughal, his grandfather) who had set up their own states in a conquered North India during the preceding five centuries, Akbar liked the country and strove hard to understand it. His intellectual curiosity and open-mindedness, which led him to welcome and then to dispute with Jesuit fathers, taught him also to recognize that the people he had come to rule possessed a great and ancient civilization. His interest in the Jain religion and its preceptors is well known; he also caused the Hindu epics, the Mahābhārata and the Rāmāyaṇa, to be translated into Persian for the edification of his ministers and courtiers, as well as Indian religious and philosophical texts and such popular works as the Kathā-

297. Abū 'l Hasan: St John the Evangelist copied from the engraving of Christ on the Cross in the Passion series of 1511
by Albrecht Dürer. 1600. Drawing on paper, faintly tinted and enhanced with gold.
Oxford, Ashmolean Museum, Reitlinger Gift

saritsagāra and the Tūṭi Nāma (Tales of a Parrot),[8] all illustrated by the royal painters in the same way as the Persian texts. A master of statecraft, Akbar was vividly aware both that he was creating history and of the importance of letting his Indian subjects know that he came of an illustrious, if not very long, line of conquerors; he therefore advertised his own

298. Basawan and Chatar: Akbar riding a demented elephant on to the bridge of boats at Agra, folio 22 from the Akbar Nāma. *c.* 1590. *London, Victoria and Albert Museum*

299. Kurshidchehr freeing Hamid, from the Hamza Nāma. *c.* 1570. Gouache on cloth.
Private Collection

heroic exploits [298] and triumphant campaigns so as to discourage any thought of rebellion. In this cause he commissioned the Bābur Nāma and above all the Akbar Nāma, now in the Victoria and Albert Museum, the supreme achievement of historical painting in his reign.

Nor was this mere vainglory. A man of astonishing physical prowess, Akbar was rarely vanquished, and his conquests – unlike those of Napoleon, with whom he can in some respects be compared – were permanent: he steadily enlarged the Mughal dominions to encompass all North India, including Kashmir, Bengal, Orissa, and even parts of the Deccan. The defeated Rājput clans, the last remaining centres of Hindu power, were treated with characteristic wisdom and tolerance, their loyalty secured both by marriage alliances (his successor Jahāngīr's mother was a Rājput princess) and by the enlistment of their rājas as generals and administrators. This policy of conciliation towards the proudest and most martial of the Indian peoples undoubtedly hastened the spread of the Mughal style which was so profoundly to influence Rājasthānī painting. Another response to Akbar's special needs and desires was the turn to portrait painting, a genre foreign to both India and Persia which was to persist to the very end of the Mughal period.[9]

The Hamza Nāma paintings, on cloth backed by paper, are the largest of all Indian book illustrations, each page measuring on an average 27 by 20 in. (70 by 50 cm.) [299].[10] The text is on the back, not incorporated in the painting in the Timurid manner, though the Persian 'floating' text, much closer to the true spirit of manuscript illumination, does survive in other Akbari manuscripts. The Hamza Nāma originally consisted of some fourteen hundred paintings, of which perhaps only a tenth survive today. This vast undertaking is estimated to have taken a great number of painters fifteen years to finish during the 1560s and 70s.[11] No names can be attached to individual illustrations. There is a definite development in the style, which stems in part from the early Safavid tradition and in part from contemporary Bukhara – not surprisingly, considering

the Central Asian origins of the Mughals. Features of architecture and dress, and particularly the introduction of women, shown always in profile in the Indian manner and sometimes very dark-skinned, leave no doubt of the participation of Indian painters; specific Deccani influences can even be discerned. The fabulous adventures of the Amir Hamza, an uncle of the Prophet, are related with 'blustering vigour',[12] the violent action often rendered with gruesome realism, as when the blood of the wounded or decapitated spurts out in gory jets. Giants are given their full size, and the larger rendering than is customary of ordinary figures often lends a rather oppressive density, relieved by occasional landscapes.

One of the most sumptuous of early Mughal manuscripts is a Persian translation now in Jaipur of part of the Mahābhārata, known as the Razm Nāma or Book of Wars. The variations in style reflect the numbers of artists, whose names are written at the foot of many folios. What is more, each miniature, as was often the practice in the royal studios, was the work of two or three painters, one, usually the most senior or celebrated, responsible for the composition and drawing, another for the colouring, and sometimes a third for the faces.

Painting under Akbar went through a number of phases. The obsessive depiction of tilework, derived from Persia, is still noticeable in the Hamza Nāma. The Persian 'floating' text, high horizons, and way of rendering clouds and rocks are typical of the earlier years; so are the unassimilated Indian female figures and the Caurapañcāśikā or Sultanate compositions and visual themes, as in the 'Cleveland' Tūti Nāma.[13] The European influence increasingly evident after the first mission arrived at court in 1580 is by the 1590s completely assimilated in the work of artists such as Miskin, whose 'Faithless Wife' [300] in the Bahāristān manuscript in the Bodleian shows complete mastery of Western drapery,

300. Miskin: The Faithless Wife, from a Bahāristān MS. Gouache on paper. *Oxford, Bodleian Library*

simulation of distance by making more remote figures smaller, and perspective generally. Local lighting provides additional atmosphere in the small vignettes scattered throughout. The tricks of chiaroscuro are used with perfect confidence.

One of the glories of Mughal painting – in some pictures perhaps its supreme achievement – is its capacity to invest commonplace scenes with 'a spirit of intimacy and wonder', well seen in the Jog Vasisht, an account of Vedānta, and the Nafahat al-Uns, a collection of Sufi biographies.[14] The lighter palette prefigures the Jahāngīr period.

The technique of the Mughal painter is well known, since it was still practised here and there in the 1950s. A preliminary rough sketch might be made in charcoal. Then the final paper was prepared to an enamel-like surface by burnishing with a piece of agate. The outlines were drawn in impermanent red ink which was then traced over with a 'fixed' black pigment of gum arabic and soot and the whole covered with a coat of white thin enough for the underdrawing to show through; then the colours were put on, gold, if any, last of all. The painting was finally burnished once again, on the reverse. The paint is gouache, the medium usually gum arabic mixed with water. The colours came from mineral, vegetable, and even animal sources, including insects. By this time, the deep blue was more likely to be azurite, perhaps from as far away as Hungary, than lapis lazuli. Hair from the tails of young squirrels made the most sought-after brushes, particularly for fine work.[15]

Jahāngīr was built to a more ordinary human scale than his father, Akbar, but his capacities were nonetheless considerable and he exerted almost as powerful an influence on painting. He was both beneficent ruler and voluptuary, but it is his connoisseurship, along with his insatiable curiosity about the physical world, that is most clearly reflected in the work of his painters. Jahāngīr's memoirs leave no doubt of his high opinion of himself as a judge of painters and painting. He was already employing Āqā Rizā at Allahabad where, in rebellion against

his father, he had set up his own court; on Āqā Rizā's son, the famous Abū 'l Hasan, who was palace-born (khanazad), he bestowed the title Nādir al-Zamān, Wonder of the Age. Both Āqā Rizā, trained in the Safavid school of the late sixteenth century, and Abū 'l Hasan, who was also a master of the more characteristic Jahāngīr style, retained a strong Persian element in their painting.

Keen observation and sumptuous good taste are the keynotes of Jahāngīrī work. Portraits multiplied: the subjects, usually in profile, stand against a turquoise or dark green background relieved only by a small plant or a flight of birds in the distance. They are supremely elegant: genre was to come later. A characteristic innovation was the formalized durbar-scene-cum-group-portrait, with the Emperor ceremonially seated in the Diwan-i-Am on some notable occasion like the reception of foreign ambassadors, prominent members of the court in serried ranks below [301]. It is worth mentioning that it was at almost exactly the same time that the group portrait emerged in Holland, where several painters, Rembrandt among them, were acquainted with Mughal work.[16]

The paintings for Jahāngīr – notably by Mansur – of rare or exotic beasts and birds are splendid examples of their genre, combining the Indian artist's sympathy for animals with sumptuous Mughal realism.[17] Of greater psychological depth, however, is the superb painting, attributed to Abū 'l Hasan and now in the India Office Library, London, of squirrels in the branches of a chenar (plane) tree which no doubt recalled to Jahāngīr his beloved Kashmir [302].[18] A note of action is sounded by the 'hunter' at the foot of the tree, and the animals are truly alive, in the best Mughal manner.[19] The gold background and the painting of the tree reflect some of the exquisiteness of the late Timurid style. That Abū 'l Hasan was equally at home in a slightly archaic Persian idiom is seen in his fine painting of a bullock cart in the Sah collection, Varanasi. A somewhat clinical spirit of inquiry led Jahāngīr

301. Shāh Jahān durbar, with Portuguese envoys. 1628/58. Gouache on paper.
Varanasi, Shri Sitaram Sah Collection

302. Squirrels in a chenar tree, perhaps an allegory. 1605/27. Gouache on paper.
London, India Office Library, Johnson Collection

303. The dying Ināyat Khān. 1605/27. Gouache on paper.
Oxford, Bodleian Library

to send his painters to record the extreme emaciation of a friend and courtier about to succumb to abuses of drink and drugs. The result is the striking but cruel portrait of the dying Ināyat Khān now in the Bodleian Library in Oxford [303].

Jahāngīr had his own collection of paintings and calligraphy mounted in albums (*muraqqas*), each leaf with a sumptuous border giving a uniform format of approximately 15 by 9 in. (40 by 24 cm.), bound in such a way that two paintings or two pieces of calligraphy always appeared together. The borders, of foliage motifs with birds in early Timurid fashion, were painted in different shades of

gold and sometimes silver. In the Jahāngīr period, figures, lightly colour-washed, sometimes inhabit the foliage in the borders of the calligraphic pages: one includes some of the leading painters of the day.[20] Loose paintings have often been mounted later in place of the calligraphic texts. Under Shāh Jahān, the borders are simplified to single flowers and arabesques, lightly coloured, in the manner of the *pietra dura* decoration of his palaces.

Night scenes become popular, giving the artist the opportunity to display his skill in chiaroscuro. Nocturnal visits to holy men, Muslim or Hindu, are frequent subjects. It must be remembered that for all the secular splendour

of the court, Mughal India was deeply religious: Jahāngīr himself displayed particular devotion to dervishes and Sufi saints.[21]

Perhaps the least attractive paintings of Jahāngīr's reign are the imperial portraits with allegorical accessories possibly borrowed from the English Elizabethan or Jacobean repertory.[22] Jahāngīr stands on the terrestrial globe, or symbolic animals crouch at his feet: European cherubs suspend a scroll over his head. Once he is shown embracing his great rival Shah Abbas of Persia, a slightly smaller and considerably less robust figure; in another he shoots an arrow at a detested enemy. Although superbly painted, the relatively small format is ill suited to such grandiosity, and these pictures mark a surprising lapse in Jahāngīr's impeccable taste. As they often show him with a halo, it has been suggested that they testify to the Emperor's need in later years to be reassured of his splendour.[23]

The Mughal style was not confined to the court: great nobles like Abd-al-Rahim, the Khān-i-Khānam or 'Khan of Khans', had scribes and painters working for them. In addition, a more popular manner based on the imperial style but with folk elements soon evolved at various centres. It was used largely for stories from the Hindu epics and Rāgamālās, and at least one illustrated letter has survived.[24] Whether the popular Mughal style (sub-imperial, as it has also been termed) owes much to contemporary Rājasthānī or Mālwā art seems doubtful. Female figures and costume are similar to those of Mālwā painting, but so are they in court pictures, and it is more likely that an accepted convention was at work; other suggested resemblances, like the reluctance to group figures and the prevalence of large undecorated areas, in contrast to imperial practice, would seem to be due as much to lack of skill or resources as to any conscious imitation of early Rājasthānī or Mālwā painting. What does

appear certain is that paintings in the popular style played an important part in transmitting Mughal influence in general to the regions.

It was architecture that primarily interested Shāh Jahān, Jahāngīr's successor. The royal ateliers continued to illustrate chronicles of the reign, however (there is a Shāh Jahān Nāma as well as a Jahāngīr Nāma), and the vogue for portraiture did not slacken, though background scenes eventually threatened to engulf the subject [304]. There is a touch of effeteness in the portraits and durbar scenes of Shāh Jahān, splendid as they are. During the last ten years of his life the emperor was a prisoner in his palace at Agra, a captive of his son Alamgīr, a bigoted fanatic who, as the Emperor Aurangzeb, by incessant campaigning managed to hold the empire together until his death in 1707. He took little or no interest in the arts, however, and the imperial painters had dispersed long before, many of them to the courts of Rājasthān or the Hill States.

The brief renaissance under Muhammad Shāh (1719–48) was violently terminated in 1739 by the sack of Delhi under the Iranian Nādir Shāh; thereafter the Mughals went into irreversible decline, and the last emperor, at the time of the Rebellion of 1857, controlled little more than the territory between his palace in Delhi and Agra. Throughout the eighteenth century entertainments on terraces were painted, hunting scenes, lords and ladies in amorous dalliance, night pictures, and pastiches and even outright copies of earlier works. Colours grow rancid. Finally the Mughal style found a successor in the art produced, often by refugee painters after the two sacks of Delhi, in provincial centres to the east like Patna, Fyzabad, Lucknow, and finally Murshidabad. There Western influence is strong, partly because of the emergence of the European patron at the end of the eighteenth century.[25]

304. Shāh Jahān hunting lions, from the Shāh Jahān Nāma. 1657. Gouache on paper.
Windsor Castle, Collection of Her Majesty Queen Elizabeth II

PAINTING IN RĀJASTHĀN, MĀLWĀ, AND CENTRAL INDIA

Artists trained in indigenous styles for a time infused Mughal painting with some Indian elements, largely female types and costumes – see for example the Cleveland Tūti Nāma and the Hamza Nāma [299]. Thereafter its highly individual course was dictated by its patrons, the Mughal emperors and their high officials, many of foreign extraction, and the Rājput princes eager to adopt imperial fashions. Moreover popular Mughal art soon moved on from purely Indian themes such as Rāgamālas (of which three fine sets have survived[1]) to Mughal-influenced Rājasthāni and Deccani painting. Mughal art had grown away from its Iranian origins, but it was equally alien to the Indian tradition which revived so successfully under its stimulus, just as the Mughal rulers, for all their benevolent interest in India, never reigned as anything but foreigners. It was thus inevitable that Mughal painting should share in the slow but inexorable decline of the dynasty which created it.

Mughal painting survived rather by its all-pervasive influence on the native tradition in Rājasthān and the Deccan than through its increasingly debilitated interpretations in Delhi and new centres to the east. Indigenous painters took up its receding planes, its shading, and its detailed rendering of imaginary landscapes, developing a hitherto unknown realism, in portraits as in scenes of rampaging elephants or of the chase. Mughal influence fluctuated in vigour and in spread. It is most obvious in architectural settings, particularly the palace precincts which figure so largely in Rājasthāni painting, and in the choice of subject matter. Because of the seventeenth-century Mughal suzerainty over Rājasthān and neighbouring states, and the presence of Rājput princes in high office at the imperial court and at the head of imperial armies, native states

adopted Mughal standards of ceremonial, of architecture, and of leisure pursuits which persisted until their final demise in the mid twentieth century. For painting, particularly in the eighteenth century, this meant the glorification of the ruler in portraits and in scenes of public activity and private diversion, usually hunting. The state of affairs was similar in the Hill States.

Following their conquest by the Muslim rulers of Delhi, Mālwā and Gujarāt came early under Sultanate rule, but Rājasthān, the 'place of princes', home of the Rājputs, 'sons of princes', stood out, the last defiant bastion of Hinduism in the north, until its final subjugation by Akbar and Jahāngīr. Geographically and culturally unique, Rājasthān loses itself to the west in the great Thar desert stretching to the Indus. To the east lie the stately Chambal with its gorges and the jungles of Bundi and Kotah. The Aravalli hills which lie athwart it provided a last refuge for the Rānās of Mewār (modern Udaipur), the heads of the Sisodia clan, in their heroic resistance to Akbar. The Rājputs, descended from peoples who entered India in the wake of the Hūna invasions, were divided into clans and ruled by a martial ethic. Fiercely proud of their blood and their traditions, their code of chivalry was roughly that of medieval Europe wrought to a grimly heroic pitch; in defeat, the women immolated themselves (*jauhar*) after their menfolk had sallied forth, in saffron robes, to seek certain death. There was a tradition of bardic poetry, and the mystical and erotic cult of Kṛṣṇa found a perfervid response in this harsh but beautiful land. Love lyrics, such as the ancient and famous Amaru Śataka, 'Amaru's hundreds [of love-poems]', found a particularly receptive climate here, as did those illustrated classifications of musical modes known as *Rāgamālas*,

of which by far the greatest number of survivors are from Rājasthān or from adjacent regions whose courts were as often as not Rājput.[2] One of the leading authorities, Ebeling, has succinctly but comprehensively defined this genre:

Rāgamālā paintings are visual interpretations of Indian musical modes previously envisioned in divine or human form by musicians and poets. They show most frequently romantic or devotional situations in a somewhat stereotyped, aristocratic setting. These paintings were created in albums containing most often thirty-six or forty-two folios, organized in a system of 'families'. Each 'family' is headed by a (male) Rāga and contains five or six Rāginīs (wives), sometimes also several Rāgaputras (sons), even Rāgaputrīs (daughters), and wives of sons.... Rāgamālā painting thus appears to stand at a crossroad of Indian music, poetry and miniature painting. It labels its individual paintings with the names of musical modes; it gathers the single pages into Rāgamālā albums, which are arranged in an order similar to the 'garlands of rāgas' of ancient and mediaeval authorities of musical learning. These garlands of rāgas were devices of memorization and classification for the musician who associated the individual modes with deities to whom the rāgas were dedicated. Poets then became intrigued with this deification of Rāgas and spun elaborate situations around their characters. In fact, the poetic versions conjure up images that often have a more human than divine character or combine both in a fashion typical of many religious concepts in India.[3]

Rāgamālās in verse and music go back many centuries earlier than painted ones. Indian aesthetics are based on the concept of *rasa* (flavour), which is intimately associated with the musical modes. A given rāga or rāginī is meant to evoke a particular state of mind or mood, of which accompanying verses (*dhyānas*) may induce meditative contemplation. Such a dhyāna tradition goes back to the Naṭya Śāstra, the earliest text (around the beginning of the Christian era) to deal with music and dance. Subsequent compilations of musical theory, for instance the Saṅgīta Ratnakara (thirteenth century) and Damodara Misra's Saṅgīta Darpaṇa (earlier than 1647), added their own interpretations to those of earlier writers, often

acknowledged, but without much concern for consistency. It is not surprising that discrepancies are frequent between a dhyāna and the rāga as illustrated, for there was no transmission of iconography by visual means until the illustrated Rāgamālās of the fifteenth or sixteenth century, copyists inevitably made errors, and painters were probably barely literate. Instances of complete mislabelling are not rare.

The Rāgas, or 'heads of families', Bhairava, Mālavakauśa, Hindola, Dīpaka, Megha, and Śrī, have fairly consistent iconographies. They are, as Ebeling has noted, 'strong image makers': always Dīpak (lamp) is a princely couple with a lamp, Hindola (swing) involves persons on that ubiquitous article of Indian furniture, Megha (cloud) a rainy-season scene of rejoicing. The rāginī Vasant (spring) is invariably represented (the Rāgamālā system is anything but consistent about sex) by the arch-reveller Kṛṣṇa, dancing. Kakubha rāginī, with a vague dhyāna which does not mention them, nearly always shows a woman between peacocks, holding a garland or two;[4] Kamod rāginī, on the other hand, has a bewildering number of totally unrelated iconographies. Nāta and Deśakhyā, in spite of their feminine designations, are represented by men in combat or by acrobats.

A multitude of elements, some from different art forms and much earlier times, enter into the visual representations of a Rāgamālā. Most of the scenes are based on love, with Rādhā and the divine Kṛṣṇa ever ready, implicitly or explicitly, to step into the conventionalized and tabulated situations involving a romantic hero and heroine (Nāyaka and Nāyikā). The rāgas and rāginīs are associated with the six seasons and with the time of day; Vibhāsa, for example, where the heroine usually lies asleep exhausted by the night's love-making, is a morning rāginī. Natural sounds such as running water, and even animal noises, are among the many which easily find pictorial representation. Some of the musical modes or melodies derive from particular regions or peoples; hence rāginī names like Baṅgla and Gurjarī or the

305. Āsāvarī rāgiṇī, perhaps from Mālwā.
c. 1650. Gouache on paper.
Varanasi, Bharat Kala Bhavan

blue Āsāvarī, always strikingly shown as a tribal
woman with snakes [305]. Māru is based on the
popular love story of Dholā and Māru, in which
a resourceful camel plays an important part.

Some Rāgamālā pictures are obviously more successful than others at evoking the rasa, the feeling or mood, of the music to which they correspond; Kühnel is eloquent in praise of the complexity at its best of this very versatile form:

Whenever a girl slips along to her lover in a dark and stormy night brightened by sudden flashes of lightning, she is Rādhā who goes to see her divine bridegroom, and, in a metaphorical sense, the soul struggling with the darkness on its way to the god. The woman who, arising from her couch, expectantly looks into the night, is to be understood as Rādhā waiting for Kṛṣṇa. She is at the same time the visualization of a melody and the expression of a burning religious desire. Whoever has heard Indian music may have felt at that time to what a degree it aspires simultaneously to express the constituents of the material world and the events in the atmosphere as well as the stirrings of the soul. He may have experienced the close connections joining these different worlds of sentiments. Looking at Rāgamālā miniatures, he will accordingly surrender himself gladly to the musical vibrations the pictures are conceived to set free.[5]

The earliest surviving illustrated Rāgamālā manuscript is in the western Indian style and dates from the late fifteenth century. The tiny illustrations, usually of a single figure very like a god or goddess, might almost come from a different culture from the later Rāgamālā iconographies.[6] By the sixteenth century, Rāgamālā series of a recognizable convention begin to appear. The earliest, of which only the single illustrations survive, are the Berlin and Victoria and Albert Museum Bhairavīs, the second perhaps by the same hand and certainly from the same *atelier* as the N. C. Mehta Caurapañcāsikā.[7] The Suri Rāgamālā, in a popular version of this style, is now untraceable;[8] two others, in a related manner but probably from different regions, belong to the end of the sixteenth century.[9] With the first Bundi Rāgamālā (see below) and the series of 1605 from Mewār firmer ground is reached, and the development of painting in Rājasthān, Mālwā, and Central India can henceforth be traced, in broad outline at least. The 1605 Rāgamālā was painted at

Chawand, the 'guerrilla base' to which that great foe of the Mughal, Rana Pratap Singh, retreated after the catastrophic loss of the ancient capital Chitor [306].[10] In a relaxed but

306. Nisaradi: Dīpak rāginī from Chawand, Mewār. 1605. Gouache on paper.
G. K. Kanoria Collection

confident style, the fact that it lacks the ferocious elegance or the wild inspiration of the finest paintings in the Caurapañcāsikā style has been attributed to the beleaguered position of the Hindu rulers of Mewār and the remoteness of Chawand. But the painter's name as recorded is a Muslim one; in this last bastion of militant Hinduism it must serve as a caution against facile historical assumptions. The community in which it was painted may have been relatively uninvolved in the great events of the day. Iconographically, the Chawand Rāgamālā adheres rigorously to what was to become the standard in Rājasthān for the next two hundred years.

The Chawand Rāgamālā's claim to be the earliest dated example of painting from Rājasthān depends on the credence given to the Persian colophon to a Rāgamālā dated 1590-1 (A.H. 999) illustrated by three painters who claim to be pupils of the famous Mir Sayyid

Ali and 'Abd al-Samad,[11] giving Chunār near Varanasi as the place of execution. Iconographically in the Rājasthāni Rāgamālā tradition, it was copied extensively in Bundi. Now the rājas of Bundi had done gubernatorial service in Varanasi and been granted a palace there by Akbar, so it has been accepted that the paintings were commissioned by Bhoj Singh of Bundi (r. 1585-1607) and that they stand at the origin of the Bundi tradition. In comparison with, for instance, the Cleveland Tūti Nāma and other Mughal works of the 1580s, they are strongly influenced by the early Akbar style, so the date of the colophon seems acceptable. Its peculiar placing, however, has led to its rejection by several scholars, who prefer to date the paintings to c. 1625 on stylistic grounds.[12] In any case, it demonstrates the close links between the emerging Rājasthāni style and early Mughal painting.

307. Sahibdin: Lalita rāginī from Mewār. 1628.
Gouache on paper. *Bikaner,*
Sri Motichand Khajanchi Collection

Under Amar Singh (1597-1620) Mewār finally submitted to the Mughals. The Sisodias, treated with generosity by Jahāngīr, remained even in British days the proudest and most distant of the Indian ruling houses. At the reoccupied Udaipur, built by Rana Pratap's grandfather, Udai Singh, to replace Chitor as the capital, a Rāgamālā manuscript was painted in 1628, again by a Muslim, Sahibdin [307].[13] The old fortress, however, was not abandoned, and manuscripts painted there and others by Sahibdin have survived from the next thirty years. The Rāgamālās are lively and confident. The architectural settings, more complex and sometimes showing a plunging view, betray increasing Mughal influence, although by contemporary imperial standards they are old-fashioned and essentially Indian in inspiration. Some, like the so-called Gem Palace Rāgamālā, still have wavy horizons and small individual sprigs of vegetation. A parallel strand, usually illustrations in horizontal format from the Rāmāyana or the Bhāgavata Purāna, varies greatly in quality. Those by Sahibdin or in his style are masterly, densely peopled compositions in glowing colours [308]; others do not rise much above the level of superior folk art. Henceforth, Mewār almost ceases to evolve, repeating the earlier style with increasing folk overtones. Of the paintings glorifying the battles and pageantry of latter-day Sisodias a number, some exceptionally large, can still be seen in the palace at Udaipur.

Little or no surviving folk painting from Rājasthān is earlier than the eighteenth century: on paper it was not sufficiently treasured, and wall paintings, when they spoiled, were simply replaced by new ones, often for some particular occasion. The pre-Mughal tradition to some extent continues, however, eschewing realism in favour of conceptualization and using brilliant flat colours in large areas, appealing primarily to the emotions.

The noble ideals of the Rājput martial clans had, as so often, a darker side. An exalted sense of honour allied to an impetuous temperament all too often led to suspicion, in-

308. School of Sahibdin: Detail of a page from the second book (Ayodhyakanda) of the Rāmāyaṇa, from Mewār (probably Chitor). 1650. *London, British Library*

trigue, treachery, and murder. The linked and turbulent histories of Bundi and Kotah, two small kingdoms in eastern Rājasthān, differ little from those of other Rājput states except that the initial success of Bundi (Kotah split off from the ancient Hara kingdom only in 1625) and its later eclipse by Kotah towards the end of the seventeenth century are reflected in the paintings which have made their names famous far beyond the borders of the state of Rājasthān.

At the source of Bundi painting lies the Rāgamālā mentioned above, painted in 1591 at Chunār (Varanasi). In the early seventeenth century it grows closer, notably in the figure types, to Mughal painting of the Akbar period and the popular Mughal style, perhaps because Rao Chattar Sal of Bundi (r. 1631-58) was for most of his life governor of Agra, the source of much sub-imperial painting. Already, however, in two portraits of Rao, one before Shah Jahān, the other riding an ele-

309. Bhao Singh of Bundi in his harem garden, from Bundi. *c.* 1670. Gouache on paper.
S.C. Welch Collection

phant,[14] a partiality for flowered parterres and plantain trees, along with some ostentation in ornament, presage the later Bundi style. Under Rao's successor, Bhao Singh (r. 1650-82), recognizable by his characteristic sideburns, Bundi painting reached its first and most lyrical apogee. The palette is gorgeous, with oranges and a multitude of greens set off by areas of white. Perhaps the finest example is the portrait of Bhao Singh in his harem garden [309], in which Deccani influences can be detected; this ruler indeed spent much of his time in Aurangabad. Well known and typically fanciful is the 'Lovers viewing the New Moon' by Mohan, dated 1688.[15] A Rāgamālā set in the Kanoria collection probably of the same decade, however, still adheres closely to the style of the Chunār version of nearly a hundred years earlier, with its plunging perspective of buildings, its double-circled sun, and its peculiar seated women. Faces are different, however, and often heavily shaded.[16] The strong Akbari influence in the rendering of buildings persisted long after it had vanished in Mughal painting, and, indeed, in isolated pavilions, until the end of the eighteenth century.

The first half of the eighteenth century saw difficult times for Bundi, including endless wars and intrigues involving the decaying Mughal power as well as the now-dominant Marathas, Mahārāja Sawai Jai Singh of Amber (Jaipur), that great figure of the period, and the rival and more successful state of Kotah. Painting seems to have declined, and many works characteristically framed by broad borders of burnished red may well have been executed by Bundi painters in Kotah.

The mid-century, however, saw a revival. In some Rāgamālās and paintings of the Kṛṣṇa legend an underlying turbulence is expressed in the swaying rhythms of abundant trees and vegetation and sometimes communicated by the very ground the characters tread and the snake-like lightning in the sky. Figures tend to be squat, compositions ill organized, overcrowded, and coarsely painted. An example is the Rāgamālā in the Sarasvatī Bhaṇḍār at

Udaipur, dated 1766-8, consisting of no less than 252 paintings – the largest set known.[17] It comes from Kotah, but the artist, Dalu, may have been from Bundi, for (as in a near-copy with fewer illustrations) the paintings have wide burnished red borders. Eighteenth- and nineteenth-century portraits in the established manner have lost all realism and psychological perception and convey nothing but pompous complacency, and scenes of the chase lack the drama and visual excitement of Kotah. New, however, both in genre and style are scenes in simplified architectural settings of lovers in close embrace or nude women being spied upon at their toilette, of in Barrett's words, 'a pleasant lubricity rare in Indian art'. The faces conform to the late Mughal style which these so-called 'white paintings' so closely reflect [310].

310. Lady yearning for her lover, from Bundi. Late eighteenth century. Gouache on paper. *Fogg Art Museum, Harvard University, Gift of John Kenneth Galbraith*

If any painting was done in Kotah before the end of the seventeenth century, it cannot be told from the art of its parent state, Bundi. The first fairly certain piece, of *c.* 1695, showing Ramsingh I (r. 1695–1707) hunting at Mukundgarh already rivals Kotah's greatest achievements [311]. Kotah and Bundi are both largely jungle in the Indian sense of tracts, usually hilly, covered with small trees and not too dense undergrowth – excellent hunting

311. Ramsingh I hunting at Mukundgarh, from Kotah. *c.* 1695. Gouache on paper.
Private Collection

country. Here, such a landscape is rendered with exceptional realism and an almost calligraphic fineness of brush-strokes, extending far into the distance to broken hills with tree-lined meadows beyond and a castle (Mukundgarh?) at the upper right. In the middle and foreground deer mill together in a frightened mass, hunters lie at their barricades half hidden in the underbrush, a lion and lioness are at the decoy. In another lion hunt of equal quality, of around 1740, also doubtless inspired by the exploits of Bhoj Singh (c. 1585-1607) who, like Umed Singh of Bundi, had a lifelong passion for the sport, forest covers the whole picture. Until the beasts and their hunters are glimpsed within, the intricate network of trees and vegetation seems to form a non-representational pattern. This is the forerunner of other pictures painted with the utmost delicacy and full of a secret excitement.[18] The genre continued in a fine but more conventionalized manner well into the nineteenth century.[19]

Kotah painters excelled at rendering animals as well as violent action, as is best shown in the superb paintings and drawings of elephants running down rhinoceros or in earth-shaking confrontation one with another, a favourite Rājput spectacle [312].[20] The artists' ability to sketch from life is seen in drawings of battle and genre scenes, including a sketch-pad rendering in faultless technique of revellers in Breughelian abandon.[21]

Rāgamālā paintings have survived from every centre of Rājasthāni painting, great and small. Scenes from the epics, or from classics like the Rasamañjari or the later Rasikapriya, a late-sixteenth-century work from Orccha in Bundelkhand, are less frequent, Barahmāsa sets quite rare. The Gīta Govinda provides the source for many paintings of incidents from the Krṣna legend. Local rulers and members of their entourage are pictured in military and ceremonial pomp. Many palace murals have survived, notably at Bundi, Kotah, and Amber, though few are earlier than the eighteenth century. Paṭas, painted cloths or hangings, are usually in a folk manner but sometimes mirror the miniature styles, particularly in connection with the Rādhā-Krṣna legend. The cult of Nāthji at Nāthadvāra near Udaipur evoked a particularly sophisticated mode, in spite of the primitive representations of the god himself.[22] Miniatures in this style also exist, usually lavishly decorated in gold and relief.

To the north-west of Bundi lay one small and two large states, their histories closely in-

312. Elephants fighting, from Kotah. c. 1695. Tinted drawing. *Howard Hodgkin Collection*

313. Nihal Chand: A courtly paradise,
from Kishengarh. Gouache on paper.
Kishengarh, Palace Collection

terwoven and their rulers, all of the Rathor
clan, linked by distinguished imperial service
to the fortunes and tastes of the Mughals. The
vast Bikaner, its capital lost in the sands of the

Thar desert, traditionally served in troubled times as a safe repository for wealth as well as for paintings acquired in wide-ranging service. At Lallgarh are some Deccani paintings unique both in the palace collections of Rājasthān and as a testimony to their rulers' taste. This, together with Bikaner's wealth, and possibly a dearth of local tradition arising from its isolation, may have attracted painters from Delhi after the accession of the austere Aurangzeb deprived them of patronage, for Bikaner painting reflects Mughal style and taste at various periods perhaps more than any in Rājasthān, sometimes with a richness derived from the Deccan.[23]

Evidence of lively work in Mārwār (the land of death) early in the seventeenth century, without Mughal influence except in costume, has survived in a Rāgamālā dated 1625, not from the capital, Jodhpur, but from one of the *thi-. kanas* (fiefs) of this far-flung state.[24] Characteristic are the large eyes, with the pupil at the top. The occasional textile design, the types of furniture, and the prominence given to such accessories as lamps and pots faintly recall the painting of Gujarāt, where rulers of Jodhpur saw service. Later, however, Mughal influence reasserts itself. In the eighteenth and early nineteenth centuries Jodhpur is best known for its equestrian portraits, with towering turbans and mutton-chop whiskers, of dignitaries often as orotund as their caracoling horses.

Widely held to be the finest of all Rājasthāni miniatures is a small group of unusual size (as much as 19 by 14 in., or 48 by 36 cm.), the product of unique circumstances, painted around 1750 in Kishengarh, 80 miles (130 km.) north-west of Bundi and by far the smallest of the three Rathor states. Their history is as follows.[25] Savant Singh of Kishengarh (b. 1699) possessed the qualities of the ideal Rājput prince and was a gifted poet as well. His lyrics, under the name Nagari Das, are steeped in the Vaiṣṇava devotion of the Vallabhāchārya sect. Savant Singh's succession to the *gadi* (throne; literally 'cushion') was long contested, and eventually he abdicated and retired to Brindavan (Vṛndāvana), the scene of Kṛṣṇa's

youth, with an equally gifted singer and dancer called Bani Thani, a poetess in her own right, to whom he had had a long attachment. The poet-king of Kishengarh died in 1764.

Savant Singh was fortunate in having at his court a particularly talented artist called Nihal Chand. A portrait of him exists (as of a number of other painters from Rājasthān and the Hill States). He probably executed the paintings for which Kishengarh is famous after the abdication, but he no doubt had Savant Singh and Bani Thani in mind in creating his unique style and physiognomy; indeed, on the back of one of the paintings is inscribed the poem of Nagari Das which it illustrates. The divine lovers, Rādhā and Kṛṣṇa, are portrayed with the greatest beauty and refinement, often in court surroundings. The principal figures are almost tiny compared with the vastness of their settings [313].[26] The very distinctive faces (Rādhā's perhaps based on Bani Thani's [314]) are by no means reserved for the divine pair; exotic,

314. Nihal Chand (?): Rādhā, from Kishengarh. Gouache on paper. *Kishengarh, Palace Collection*

almost bizarre, with long noses, enormous eyes, and abrupt bony chins, they went on to become one of the clichés of latter-day Kishengarh painting. They do not occur, however, in a fine Gīta Govinda illustration of Kṛṣṇa dancing with the cowgirls dated as late as 1820,[27] indicating that Kishengarh resisted longer than elsewhere the universal decline into bazaar painting which had its beginnings in Rājasthān during the first half of the nineteenth century.

The original Kacchwaha, with its fortress capital of Amber, the nearest of the large Rājput states to Delhi and Agra, had in Sawai Jai Singh (1693-1743) the most remarkable and influential of eighteenth-century Rājput rulers. In 1718 he built the new capital of Jaipur (Jayapura, the last of many 'cities of victory' in Indian history) on a rectangular plan based on European models. His contributions to astronomy[28] and architecture are notable, but he left no impress upon painting, and later Jaipur work – perhaps because so much of it has survived – is almost synonymous with the rapid decline of the Rājasthāni tradition.

A Rāgamālā from Amber dated 1709 closely resembles contemporary painting from Bikaner: well drawn, with an attractive palette of pinks, dull reds, and mauves.[29] Slightly later, Jaipur painting blends Mughal influence with a medley of Rājasthāni elements.[30] As elsewhere, many copies were produced by means of tracing and pouncing.[31] By the early nineteenth century, painting has become coarser and colours brighter, with a lavish use of gold. Black outlines grow heavier, and the faces of the increasingly doll-like figures less delicate. The straight streets and avenues of Jaipur provided excellent material for perspective drawings based on European models. Perhaps the best late Jaipur works, competent though sometimes dull, are the heads and busts occupying the whole ground. They are usually of women, often of great beauty, with none of the exaggeration of the first example of the genre at Kishengarh [315].

315. Head of a lady, from Jaipur.
Mid eighteenth century. Gouache on paper.
West Berlin, Museum für Indische Kunst

Although Mālwā is a definite geographical region, the term must still be used as a convenient label to denote the likely place of origin of a number of fine and important sets of paintings, as well as very many individual seventeenth-century miniatures, some of which appear to be traceable to states within the area, but all linked by style. The Rāgamālā iconography is the same as Rājasthān's, and there are connections with the early painting of neighbouring Mewār. Many of the Mālwā nobility were Rājputs, and the somewhat doubtful information provided by two colophons links some paintings to the region south-east of Udaipur.[32] At the same time, there is such a gulf between the primitive savagery of one style and the poetic demureness or élan of another that two further sources cannot be ruled out: one is Māndū, in the south-west of Mālwā,

earlier a centre of painting, the other Bundel-khand, in the west of Madhya Pradesh (the old Central India), which later produced consider-able painting at courts like Ratlam. A manu-script illustrated at Aurangabad in 1650 with no particular 'Mālwā' features sets a southern limit to the style.[33]

The hallmarks of paintings at present attri-buted to Mālwā are striped rugs and horizontally striped women's skirts, and a fondness for rather elaborate but single-plane architectural settings. All three principal styles are given to two horizons and straight bands of scrollwork or haṁsas and lotuses at the bottom of the pic-ture. The earliest dated manuscript assigned to Mālwā is a Rasikapriya dated 1634 [316] which, with its wavy horizon outlined in white and often consigned to a corner of the page and its stark simplification of architectural elements, is not far removed from the Caura-pañcāśikā style, though with none of its elegance. The men have heavy lantern jaws and all the

316. Scene from a Rasikapriya MS. from Mālwā. 1634. Gouache on paper. *Private Collection*

figures the portentous immobility of much folk art. Illustrations from a Rāmāyaṇa in the Ka-noria collection are in the same style,[34] and a Rāgamālā series, most of them in the Bharat Kala Bhavan, with its squat gravid figures, has an even stronger folk element, but is far more powerful, with large areas of flat and brilliant colour. Horizons can be semicircular and double, and other natural features are dislo-cated to savage effect [305]. After the mid seventeenth century, Mālwā painting retains its folk element but loses much of its power.

The third style is the only one which may with probability be assigned to northern Mālwā.[35] It is quite different. The women are sometimes tall and lithe-limbed, with an aqui-line profile but no stylistic exaggerations. In some sets the scrollwork band at the bottom consists of arabesques of great variety, so elab-orate as to appear almost three-dimensional. The compositions however tend to be mono-tonous and unimaginative, in architectural set-tings with very distinctive corbel types or with simple forest backgrounds consisting of single trees. The finest examples are the dispersed Amaru Śataka dated (according to an untrace-able colophon) to 1651, and some Rāgamālā paintings in the Boston Museum of Fine Arts.[36] Some of the tall women have great rhythmical élan and – a phenomenon otherwise unknown in seventeenth-century painting other than Mughal – interreact psychologically with other figures [317]. Also in this style are some Rāgamālā pages dated 1681, and a slightly later complete Amaru Śataka in the Prince of Wales Museum[37] with highly simplified scrolls but figures, while less dynamic, imbued with a quiet, gentle grace.

Towards the end of the century it is this third school which continues, in a somewhat diluted manner, what is known as the Mālwā style. Black skies give way to red or blue, and architectural settings, often ornate but chaste, tend to dominate and the figures to approxi-mate to the Rājasthāni norm. In the eighteenth century the term 'Mālwā' falls into disuse as individual schools are identified.

Recent developments have focused on hitherto less well known or totally ignored 'schools' of painting. Here some caution has to be exercised. Identification of a few paintings with a thikana or fief does not necessarily indicate a school. Some paintings have originated from Sirohi and Devgarh, as well as from Rajgarh in Mālwā. Datia and Uniara, where painting went on for two generations or more, have claims to be considered schools or sub-schools.

317. Bhairava rāga, from Mālwā. *c.* 1670. Gouache on paper.
Boston Museum of Fine Arts, Gift of John Goelet

DECCANI PAINTING

Painting in the Deccan, the plateau which forms the core of peninsular India, predates Mughal painting and in fact influenced its beginnings. At the end of the fifteenth century the Bāhmāni domain broke up into five major Muslim kingdoms, most important among them Ahmadnagar, Golconda, and Bijapur, who together managed to overthrow the last great Hindu state, Vijayanagara, at the battle of Talikota in 1565. It is a reasonable hypothesis that the excellence and exceptional features of the early Deccani painting which followed is due, at least in part, to an influx of artists heir to a long but now untraceable pre-Muslim tradition, perhaps largely mural. It is surely to this, rather than to the chances of survival, that the uniform distinction of late-fifteenth- and early-sixteenth-century paintings (admittedly few) is due, for they far surpass anything in the Indian tradition in the north until the mid seventeenth century in the brilliance of their colour, the sophistication and artistry of their composition, and a general air of decadent luxury – the hallmark of Deccani painting at its finest.[1]

The Deccani style drew on many sources, not least Safavid painting, for relations with Persia were always close. Faces in three-quarter view are common; so are sprigged grounds, albeit of a distinctive type. One of the most arresting of all Deccani paintings, the famous 'Yoginī' or 'Queen of Sheba' in the Chester Beatty Library, Dublin, has a typically Safavid golden sky [318]. The Far Eastern air of the striking pair of pink and green flowering plants, lotus and chrysanthemum, derives more likely from a Chinese textile than from the Chinese porcelain circulating so widely at the time. The disjointed air of this brilliant painting is characteristic of all but the greatest Deccani work. The lady's pajama is shaded in

318. 'Yoginī' or 'Queen of Sheba', from Bijapur. Early seventeenth century. Gouache on paper. *Dublin, Chester Beatty Library*

the Mughal manner, and the painting has indeed been attributed to Farrukh Beg, who first joined Akbar in Kabul and appears to have made a long sojourn at Bijapur before becoming one of Jahāngīr's favourite painters;[2] yet, with its decadent fancifulness, it cannot be other than Deccani. Nor can the superb 'Elephant and Rider' missing from the collection of Babu Sita Ram, also assigned to Farrukh Beg [319].[3]

319. Farrukh Beg (?): Elephant and rider, from Bijapur. *c.* 1610-20.
Formerly Varanasi, Shri Sitaram Sah Collection

Partly because early paintings are so few, their attribution to one or other of the major states is fraught with problems. Moreover the assumption that portraits of rulers (to which the Deccani kings were as partial as their Mughal overlords) were done by their own court painters is a dubious one since, as we have seen, artists were often on the move. The Tarif-i-Husain illustrations are assigned to Ahmadnagar because the Persian poem celebrates a ruler of that kingdom from 1553 to 1565; internal evidence suggests that they date from almost immediately after his death. The 'Dohada' (woman touching a tree) has many features of early Deccani painting, including

tall women with small heads and characteristic saris, a fondness for floral decoration, and an imaginative composition.[4] From the same set of illustrations comes an enthroned prince[5] whom ladies are fanning not with chowries or peacock-feather fans, but with strips of cloth, as always in Deccani painting.[6] A Deccani feature, however is the reduction of buildings to totally flat screen-like panels. Probably also to Ahmadnagar belong the survivors of perhaps three or four Rāgamālā sets, frequently of unique iconography and always of highly original composition [320]. A number are still in the Lallgarh Palace, Bikaner, the spoils of war. Those not identified as particular rāgas or rāgiṇīs

320. Hindola rāga, from Ahmadnagar. Late sixteenth century. Gouache on paper.
New Delhi, National Museum

include the superbly lyrical painting in glowing colours in the collection of Edwin Binney 3rd.[7] Similar swaying forms inhabit a painting from a Bijapur manuscript now in the British Museum [321].

In the portrait identified by Barrett as of Burhān II (1591-5), the only identified likeness of a Nizam Shāh of Ahmadnagar, there is considerable Mughal influence; one of his attendants wears the six-pointed coat fashionable at Akbar's court as well as pajamas with carefully delineated folds.[8] Curiously, the further eyes protrude slightly. The faces, in three-quarter view, for all the sophistication in conveying the rotundities of the bulky ruler betray a timidity in modelling characteristic of early Deccani painting. Elsewhere, attendants are often black, for Abyssinians were frequently employed and sometimes attained high office.

Attributable to Bijapur are the fine portraits of Ibrahim Adil Shāh II (1586-1620), himself a noted practitioner of poetry and the arts. The earliest, in Bikaner, has a monumental impact and a swinging rhythm observable in few other Indian paintings. Its dynamic pose, exciting patterns of fabric and texture, and gorgeous colour set it worlds apart from the rigid formulas and rather arid elegance and good taste of Mughal portraiture. That it is no isolated phenomenon is proved by a later portrait of the same king now in the British Museum [322],[9] with a similar sense of scale and swaying rhythm and distinguished by its imaginative use of scattered and varied flowers and richly textured foliage. A note of fantastic lyricism, unique to the Deccan, is struck by a painting of the same king as a young man hawking [323]. The Adil Shāhs, including the next to last of the line, the 'Dainty King', may have been inclined to ponderous corpulence, whereas the Mughal emperors were never more than pudgy; but one wonders how much the Deccani painters' talent for portraying royal bulk had to do with the massive appearance of these rulers. The rather indefinite, scarcely modelled features are in strange contrast; what can Jahāngīr - who is reported to

321. Folio from a Ratan MS., from Bijapur. 1590-1. Gouache on paper. *London, British Museum*

have avidly studied portraits of his adversaries for clues to their characters and was accustomed to the acute psychological penetration of the best Mughal portraits - have made of these blobby countenances? Nonetheless, this school of portraiture is unrivalled in India. It owes nothing to Persia and little to Mughal painting, and one must look once again to an earlier vanished tradition, and possibly also to some thoroughly assimilated European influence.

The first indisputable Golconda painting in true Deccani style is a portrait of Abdullah

322. Ibrahim Adil Shāh II, from Bijapur. *c.* 1610–20.
London, British Museum

Qutb Shāh (1625–72) as a young man.[10] He is
seated, holding the long straight sword of the
Deccan. The superimposed registers reflect
Jahāngīrī durbar scenes, with horses and grooms
at the bottom, and individually recognizable
courtiers beside the king. Otherwise, however,
there is none of the realism so dear to the
serious-minded Mughals. All is flat, the fan-
ciful sky meeting head on the tufted pattern
on a plum-coloured background that invades
the architectural setting. The ostentatious
rows of gold vessels in both the bottom and
middle registers are also distinctively Deccani,
the broad straps affected by the king on either
side of his coat peculiar to Golconda and
Bijapur. An almost identical sprigged ground,
consisting of a grassy tuft and three simple
flowers on a dark field, and a very similar
treatment of the sky identify the Holy Family
in the Freer Gallery of Art, Washington, as
another Golconda painting of c. 1640.[11] No
European original has been identified (as can
often be done with such Mughal works), and
it may be a composite from individual paint-
ings or pattern books, or indeed spring from
actual contact with Europeans, who were
probably not uncommon in Golconda, with its
massive textile trade with the West and the
proximity of Goa and European settlements.
A striking example of the introduction of fig-
ures lifted from European paintings is the man
with a sheaf of wheat in the splendid Bijapuri
painting of an elephant, probably Ibrahim
Adil Shāh's favourite Atash Khan [319].

Persian artists could be expected to be
working in the Deccan towards the end of the
sixteenth century, and two dated manuscripts
illustrated in Golconda but in Persian style
have indeed survived.[12] The four miniatures,
perhaps of c. 1600, inserted into an otherwise
Persian Diwan of Hafiz in the British Museum
may or may not be from Golconda: Deccani
they certainly are.[13]

When Bijapur and Golconda (Ahmadnagar
had succumbed earlier) were finally extin-
guished in 1686–7, Hyderabad, originally
Bhagnagar, founded in 1589 by Muhammad

323. Ibrahim Adil Shāh II as a young man hawking,
from Bijapur. c. 1590–1600.
Leningrad, Academy of Sciences,
Institute of the Peoples of Asia

Qutb Shāh's father, Muhammad Quli, became
the seat of the Mughal viceroy and later Nizam
Asaf Jah, of a Persian family from Bukhara.
As he was a Sunni Muslim highly regarded by
Aurangzeb, it is not surprising that painting
did not flourish under his rule. Already by the
mid century, however, Deccani painting had
lost much of its distinctive character. The
many portraits of single figures standing erect
in profile against a green background in the
Jahāngīrī manner are more refined, and some-
times excellent likenessess, but lack artistic
originality. In the eighteenth century, Hydera-
bad revived as a centre of painting, with strong

late Mughal influences. Ladies disrobed or disrobing and amorous scenes are popular. The surprisingly numerous Rāgamālās, increasingly stereotyped and under Mughal influence, nevertheless retain Deccani traits, in particular the characteristic sunflower-shaped trees. Finally, a number of small states formerly part of the major kingdoms - Kolhapur, Kurnool, Khandesh, Sholapur, Wanparthy - developed individual if highly provincial styles.[14]

CHAPTER 29

PAHĀRĪ PAINTING

Pahārī ('of the Hills') painting comes from the
Panjab Hills, a relatively restricted portion of
that great mountain barrier north of the Indian
subcontinent, stretching a mere three hundred
miles in a south-easterly direction from the
Chenab river down to the headwaters of the
Ganges.[1] Some hundred miles wide, the area
lies between the Panjab plains and the high
Himālayas, roughly between the longitudes of
Lahore and Delhi, and embraces scenery and
flora of outstanding beauty and variety. It con-
sisted of states in some cases of almost imme-
morial antiquity. The largest, Jammu, at the
height of its power in the later eighteenth cen-
tury had an extent of less than five thousand
square miles; Basohli, an 'important state',[2]
covered only twenty miles by fifteen. Terri-
torial jurisdiction fluctuated with the fortunes of
war and dynastic marriages; the Rāja of Kangra,
in the early fifteenth century, even exchanged
his kingdom for another, Guler.

After Mahmud of Ghazni captured Kangra
Fort, the great stronghold of the Hills, this
poor and isolated region went its own way
until Akbar established his suzerainty as well
as a military presence based on Kangra Fort
which lasted until 1785. The Hill rājas were Rāj-
puts, as in Rājasthān,[3] and at their little courts
a very similar pattern of life evolved, based on
war, hunting, lineage, and the zenana. To an
inclination for music and a courtly and prob-
ably largely imaginary cult of romantic love
based on famous Sanskrit and Hindi works
was added a passionate religious devotion to
Kṛṣṇa and his legend. During the seventeenth
and early eighteenth centuries these small
Hindu states had the same relationship with
the Mughal court as Rājasthān, consisting of ser-
vice in the imperial armies, hostage princes in
Delhi, and the wholesale importation of
Mughal styles and fashions from dress to

architecture, including patronage of artists
to record the likenesses of these princelings
together with some of their activities both at
home and at the imperial court. The all-
pervading Mughal influence took a very dif-
ferent turn with Pahārī painting than it had,
considerably earlier, in Rājasthān.

Until a recent discovery, the earliest known
Pahārī paintings dated from as late as the last
two or three decades of the seventeenth cen-
tury.[4] Among them are three manuscripts of
the Rasamañjari, an erotic fifteenth-century
poem by Bhanudatta in which men and
women (Nāyakas and Nāyikās) are classified
according to their amorous situations or affec-
tive states. This genre, which includes several
famous works, provided a great many conven-
tional themes. Sometimes Rādhā and Kṛṣṇa
appear in the guise of Nāyikās and Nāyakas. The
style of one of these manuscripts, whose colo-
phon indicates that it was made for Rāja Kirpal
Pal of Basohli (1678-93), is highly distinctive:
elongated figures have equally elongated heads
to which the eye, drawn with the pupil far
advanced to the front, lends an expression of
passionate intensity [324]. Angular poses and
awkward, jerky gestures intensify the dramatic
effect, as in the painting in the Bharat Kala
Bhavan, Varanasi, of a woman almost spread-
eagled in her reach for a hanging lamp.[5] A
palette of great intensity, with burning oranges
and yellows and characteristic large areas of
brown, adds an air of barbaric splendour,
heightened by the dark green of the casings of
beetle's wings used for the emeralds worn by
the lovers.

These early Pahārī paintings in the Basohli
style, so called because of their association
with a Basohli rāja as well as with the Basohli
durbar (palace) collection, must not be mis-
taken for primitives from a wild environment.

324 (*above*). The resourceful Rādhā,
from Basohli. *c.* 1660-70.
Gouache on paper with inserted beetle-wing cases.
*London, Victoria and Albert Museum,
Rothenstein Collection*

325 (*right*). Rādhā and Krṣna in the forest,
from Basohli or Kulu. *c.* 1685. Gouache on paper.
Bombay, Karl and Mehri Khandalavala Collection

They have much of the ferocious elegance of
the Mehta Caurapañcāśikā paintings: like them
obviously the products of a sophisticated milieu
and a long tradition, they share with Rājasthāni
and Mālwā painting, in somewhat altered form,
a number of conventions, most obviously the
extremely elegant two-dimensional architec-
tural settings, topped by domes or pavilions,
bands of scrollwork pattern, and the use of
elaborately figured rugs.[6] Also common to the
generality of sixteenth-century Rājasthāni and
Central Indian styles are the grey water with

326. Rāja Kirpal Dev of Bahu (Jammu) smoking, from Kulu. c. 1690. Gouache on paper.
Seattle Art Museum, Eugene Fuller Memorial Collection

pink lotuses and their green pads, the inventive and varied stylization of trees, 'Chinese' clouds, and rain descending like a beaded curtain in serried lines of white dots. Slender trees with drooping flowered branches become almost an obsession.

Paintings attributed to Kulu figure prominently in the early Pahārī or 'Basohli' style, notably the so-called Shangri Rāmāyaṇa with its admixture of Mughal realism and decorative motifs.[7] The flame-coloured 'Rādhā and Kṛṣṇa in the Forest' in the Karl and Mehri Khandalavala Collection, Bombay [325], is tonally intensely vibrant; moreover its circular composition and the inventiveness and variety of the stylized trees, including the rare cypress, irresistibly recall the contemporary Bundi-Kotah school in Rājasthān. More naif works

from Chamba, equally far into the hills, continue the early Pahārī style well into the eighteenth century, as does the less idiosyncratic early painting from Nurpur.

Two persistent strains of Pahārī painting are already present in the Basohli style. The first is a fondness for the portraits of local rājas in plain white garments, often seated on the striped rugs of the Hill country, which are in many cases the principal evidence for the attribution of sub-styles to one state or another.[8] In some, like the well-known portrait of Kirpal Pal of Basohli or those of Kirpal Dev (c. 1660-1690) [326] and Anand Dev of Bahu (Jammu), the facial idiosyncrasies of the Basohli style and the treatment of the attendant figures leave little doubt that they are contemporary.[9] More subdued versions of these traits, as in

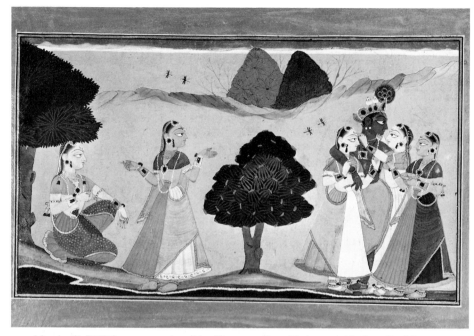

327. Manaku (?): Rādhā's messenger describing Kṛṣṇa standing with the cow-girls, from Basohli. c. 1730–5. Gouache on paper. *London, Victoria and Albert Museum*

the many likenesses of rulers of the first half of the eighteenth century, do not necessarily indicate later copies, for the portrait tradition of the Hills was, from its inception, Mughal-inspired, whether or not through Rājasthān; for example, black smudges at the armpits, characteristic of provincial Mughal work, appear in the earliest Basohli portraits. The second persistent subject of Pahārī painting is the gods of the Hindu pantheon. There are many striking works in this genre, for the Basohli style, with its strong indigenous Indian element, is well suited to the portrayal of many-headed Śivas or many-armed Durgās.

In the first decades of the eighteenth century, a horizontal format, a generally quieter tone, and the use of dark green backgrounds presage a transformation of the Pahārī style around 1750 as radical as that brought about by Akbar nearly two centuries earlier and a complete rejection of the Basohli style. An illustrated Gīta Govinda, for example, which can be confidently dated by inscription to 1730–5, mostly if not entirely painted by Manaku, while retaining some of the elements of the earlier style (most strikingly the lavish use of beetle's-wing casings) clearly adumbrates the second great Pahārī style in its landscapes with large opaque-foliaged trees and its complex grouping of figures, particularly women [327].

It was long thought that the exodus of painters into the Hills from the court of Muhammad Shāh was provoked by political instability in the Plains after Nādir Shāh's sack of Delhi in 1739 had put an end to Mughal power in all but name. The important Seu dynasty of painters, which included Manaku and his famous younger brother Nainsukh, may well have worked in the Mughal ateliers, but research has shown that the family had

lived in Guler for at least two generations.[10] An undoubted result of the turmoil in the Plains was the re-routing of the trade route to Kashmir through the comparative safety of the Hills instead of through Lahore, bringing considerable prosperity, especially to Jammu and Kangra. Jammu in particular, under two able rulers, Dhrub Dev and Ranjit Dev, was able to extend its influence over neighbouring states such as Basohli as well as to reclaim lands and privileges ceded to the Mughals. Manaku had worked in Basohli, so it is not surprising to find Nainsukh executing a whole series devoted to the activities of Balwant Singh, Ranjit Dev's younger brother, among them the first dated paintings in the fully fledged new style. A work of 1748 shows the prince listening to a party of musicians.

Nainsukh's celebrated pictures of Balwant Singh, although somewhat outside the Pahārī mainstream, are major achievements of Indian miniature painting. This exceptional artist produced on the one hand grandiose celebrations of the probably eccentric ruler enjoying the trappings of Mughal-style splendour (he seems to have been free for most of his life of any responsibilities other than the administration of princely feudal estates) and on the other irresistible and uniquely charming vignettes of his pleasurable round of daily activities, giving him, solely by this visual record, a human personality such as one glimpses only in the far greater figures of Akbar and Jahāngīr. Balwant Singh appears at his toilet, performing pūjā, surveying a building site, in camp looking cold and wrapped in a huge quilt. In the masterpiece of them all, he is once again in camp, a paunchy, tired-looking man in undress, writing in his tent at the end of the day [328]. Part of Nainsukh's genius was for individual por-

328. Nainsukh: Balwant Singh writing in his tent, from Jammu. c. 1750. Gouache on paper.
Bombay, Prince of Wales Museum of Western India

traiture, a salient feature of the later Pahāṛī style; but his alone is the feeling for genre which led him to draw the bored and sleepy young page holding a fly-whisk behind Balwant Singh. His palette consisted of delicate pastel shades, with daring expanses of white or grey.

The second great Pahāṛī style owes a great deal to later Mughal painting, particularly its receding planes, its fondness for quasi-realistic landscape, and its frequent enlargement of the figures on the page. But the spirit which emanates from the careful drawing and often swirling rhythms is quite different: it is by far the most poetic and lyrical of Indian styles. Most delightful is the Guler-Kangra idealization of woman, in flowing sari, head half covered with a shawl, demure but stately, passionate and

shy. The rare skill of the Kangra draughtsman can capture genuine psychological immediacy, as in the Abhisandhitā Nāyikā, 'she who is estranged by a quarrel', of illustration 329, or Rādhā, sulkily hunched on a low chair, resisting the entreaties of both Kṛṣṇa and her confidante.[11] At other times the artist relies on stylizations of great beauty, based on line, where the harmonies of drawing enhance the poetic mood. One of the most daring of these stylizations shows a woman seated in *rājalīlāsana*, the drawn-up leg, bent double at the knee, a perfect upright ovoid, only wider at its base [330].[12] Elsewhere the women move in pairs, emphasizing the swallow-like effect of their rounded heads and trailing veils.[13] As a rule, no such inventiveness enlivens their male companions, the princely lovers or the semi-divine

329 (*left*). Abhisanditā Nāyikā
('she who is estranged by a quarrel'),
from Guler. Ink on paper.
Patiala, Punjab Museum

330 (*opposite*). The lovesick Nāyikā simulating indifference, one of a set of drawings of the Bihārī Satsai, from Kangra.
Varanasi, Bharat Kala Bhavan

331. Kāliya Damana (Kṛṣṇa subduing the serpent Kāliya), from Guler.
Eighteenth century, second half. Gouache on paper.
New York, Metropolitan Museum of Art, Rogers Fund

Kṛṣṇa. An exception is the superb version of the Kāliya Damana, Kṛṣṇa subduing the serpent Kāliya, now in the Metropolitan Museum, New York [331]. The familiar representation of Kṛṣṇa seated on a terrace with a looped wreath lying before him, with its beautifully harmonious drawing of the torso and the folds of the dhoti below, and the bold foreshortening of the left arm, is another exception [332].

The second Pahāṛī style has often been equated with Kangra, which indeed seems to have been the source of more work in the late manner, including most of the great series, than any of the other Hill States. Its importance, and its ascendancy over much of the Hill country under the ambitious Sansar Chand (1765–1823), no doubt attracted pain-

ters[14] before the evil days of Gurkha inroads followed by subjection to the rising Sikh power and, under the British, the eventual extinction of independence of all the Hill States. Brilliant and extensive research, however, much of it on the spot, has now revealed a much more complex situation.[15] Paintings still extant in local durbars (palace collections) or in the hands of descendants of past rulers, patrons, or painters have established that while the Guler-Kangra style became a *koine* in the Hills, much painting in recognizable substyles originated in states such as Garhwal, Nurpur, Chamba, and Mandi. An all-inclusive term remains a convenience to the non-specialist nonetheless, and the most appropriate would seem to be Guler-Kangra, since the late Pahāṛī

style first appears fully fledged in Guler *c.* 1745 in works of a quality and purity never to be surpassed, while Kangra, in spite of its prolific output and outstanding achievements, produced no known works earlier than *c.* 1775.

Hill painting includes Rāgamālā series, although they do not appear to have been very popular. They conform to literal specifications, leaving little scope for poetic or imaginative treatment; the Hill classification, moreover, differs from that prevalent elsewhere in India.[16] More successful are the Barahmāsa series of twelve pictures illustrating the modes of love or courtship appropriate to each month of the year. Even they lack variety, however, for the compositions consist largely of a man and a woman facing each other against a landscape of distant scenes which, though often varied and poetically evocative, would seem more suitable to mural painting.[17] The oval

333. Abhisārikā Nāyikā
('she who sallies out into a stormy night
to meet her lover'),
from Garhwal. *c.* 1770-80. Gouache on paper.
London, British Museum

332. Kṛṣṇa casting off his garland, from Kangra.
c. 1785. Gouache on paper.
Oxford, Ashmolean Museum

format so dear to the Guler-Kangra style, combined with monotony of composition, also recalls wall cartouches.

Love is the preoccupation of most Pahārī work, much of it illustrating the situations or types of the Rasikapriya of Keshav Das (fl. 1580-1600). The elaborate classifications include the Aṣṭa Nāyikās, of which the best known is perhaps the Abhisārikā, 'she who sallies out into a stormy night to meet her lover' [333]. Love is further divided into 'Love Separated', 'Love in Union', and so on.[18] To what height of inventiveness in design and conception the Pahārī artist can nonetheless rise is demonstrated by the splendid illustrations from Kangra of *c.* 1785 to the Satsai, 'Seven Hundred [Verses]', of Bihāri Lal.[19] The 'Vil-

334. The Village Beauty
from a Bihārī Satsai series, from Kangra.
c. 1785. Gouache on paper.
The Kronos Collections

lage Beauty' is a Guler-Kangra masterpiece
[334]. Each painting has a different focus and
evokes a different mood.

So pervasive was the grip upon the imagin-
ation of the adoration of Krṣna that in most of
the Nāyaka-Nāyikā themes the lovers of Brinda-
van are either explicit or implicit. The em-
phasis is almost exclusively on the emotions of
the woman, or on the situations in which a
woman in love finds herself. This, of course,
parallels the emphasis which underlies all
Vaiṣnava devotional poetry, where it is the
raptures and distresses of the soul in love with
God (Krṣna) that are hymned, and the re-
sponses or other actions of the divinity are
described, if at all, through the eyes or emo-
tions of the devotee. The identification be-
tween Rādhā, the supreme Nāyikā, and the
human soul enraptured with God is all-pervasive.
It is irrelevant that most of the love in the
Nāyaka-Nāyikā relationships was illicit. In a
male-dominated and rigidly traditional society,
the opportunities for amorous intrigue among
well-born ladies must have been slight, in spite
of the currency of romantic stories of forbid-
den passion. Transgressions of the imagination
were legitimized by association with the love
of Rādhā for Krṣna without diminishing their
passionate intensity. As Randhawa has percep-
tively remarked:

The love norm of Hindu society is conjugal fidelity
and when *parakīyā* love, or love of a woman for a man
other than her husband, is mentioned, it is in a
spiritual sense. The sacrifice of family honour and
reputation involved in adulterous love is the symbol
of the soul's self-surrender to God. It is the highest
sacrifice that a Hindu woman can make.[20]

That some, probably very few, women made
this sacrifice for an earthly lover is probable.

Faces, very rarely in other than the pre-
ferred Indian full profile, invariably in the case

of young women, follow an idealized model
which varies hardly at all with time and local-
ity.[21] The same may be said of Krṣna and the
young Nāyakas, although now and then, as in
Rājasthān, the features of the local prince may
be detected.[22] Although the type long pre-
dates him, the good-looking young Sansar
Chand is closer to the idealized hero than the
other rulers, whose large noses and heavy-
lidded eyes dominate their portraits. Else-
where, the Guler-Kangra artist occasionally
exercised his talent for portraiture on cour-
tiers, duennas, and servants, although even
here a certain similarity suggests that they also,
after the original likeness was seized from the
life, became part of the painter's stock in trade,
and perhaps even passed into that of his des-
cendants.

Because the drawings upon the various
themes were used over and over again,
pounces even being employed as elsewhere in
India, and colour schemes were repeated as
well, Guler-Kangra paintings – which in any
case survive in vast numbers – when seen *en
masse* can induce tedium and a sense of *déjà vu*;
there are, for example, four nearly identical
series, or parts of series, of an elaborately il-
lustrated Nala and Damayantī.[23] It is then that
the connoisseur will begin to distinguish sub-
styles by means of the squatter figures of Sir-
mur, or the Mandi overloading of figures and
architectural ornament: then only will he
appreciate the beauty and clarity of line, the
chaste architectural elements, and the sheer
poesy which suffuse the very best work.

The more complex many-figured composi-
tions, usually larger and horizontal in format,
tend to illustrate set pieces of the Krṣna
legend: the cowherd god putting out the forest
fire, subduing the serpent Kāliya, or bringing
the kine back to the village at dusk, or the
naughty child turned folk-hero uprooting the
trees to which he had been tied. Of the mis-
chievous young man stealing the clothes of the
gopis, who had taken them off to bathe, and
hanging them out of reach in a tree a number
of quite different versions exist; the one in

335. Cīra Haran (Kṛṣṇa stealing the clothes of the gopis) from a Bhāgavata Purāṇa MS.
from Kangra. c. 1770. Gouache on paper. *New Delhi, National Museum*

illustration 335 is indisputably the finest, with its skilful handling of interrelated poses and its psychological penetration. The approach in the far distance of the fully clothed villagers and the rising sun peeping over the hill contribute a drama and urgency lacking in some of the other versions. These paintings occur in illustrated Bhāgavata Purāṇas and, with other great series like the 'first' Gīta Govinda and the finest of the Nala Damayantīs,[24] constitute the supreme achievement of the later Pahāṛī style, combining its lucid line and innate lyricism with a straightforward and skilful naturalism. The ability to handle large groups of figures is exceptional: anyone tempted to overstress the debt to Mughal painting need only compare these skilful, airy compositions with the figures ranked in rigid rows in Jahāngīri

durbar and battle scenes. The same gulf separates the splendid architectural drawing in the Nala Damayantīs from inferior attempts in Murshidabad painting.

Modern writers have commented on how closely the rounded hills today, the small but dense trees or clumps of trees, even the occasional great boulder, resemble the highly successful Pahāṛī landscapes (particularly of the Beas valley in Kangra) of the Guler–Kangra style.[25] The exploits of Kṛṣṇa and his often explicitly portrayed lovemaking with Rādhā take place not in the rocky, harsh surroundings of the real Brindavan (near Mathurā) but among the gently rounded hills and ample verdure of the lower Hill country. In the same way – and it has been said that Brindavan is a landscape of the mind – Italian painters set the life of

336. Śiva and Pārvatī with Gaṇeśa (unfinished), Guler–Kangra style.
Nineteenth century, first half. Gouache on paper. *Oxford, Ashmolean Museum*

Christ among the hills and towns of Tuscany and Umbria. The later Pahāṛī painters also share with them to an astonishing extent a fondness for landscapes with towns or clusters of houses in the distance. Curiously, the snow-capped mountains which brood over these smiling valleys practically never appear.[26]

A good deal of Guler-Kangra religious painting based on Puranic rather than epic or later Vaiṣṇava sources has survived, buttressing other evidence that the cults of Śiva and the Devī, long established in the Hills, survived the great vogue of Kṛṣṇa worship. The lyrical and realistic Guler-Kangra style was ill suited to the portrayal of Kārttikeyas and Durgās with multiple heads and arms, and the results are usually embarrassing, unless a slightly more palatable derivative folk style is used.[27] On rare occasions, as in the 'Śiva and Pārvatī' in the Ashmolean Museum, the grace and tenderness of the style are given full rein at the same time that the anatomically bizarre is all but eliminated (Śiva's son Gaṇeśa, the elephant-headed god, is reduced to a sort of cuddly teddy-bear cradled in Pārvatī's lap). The result is a moving holy family [336].

INDO-ISLAMIC ARCHITECTURE

CHAPTER 30

THE DELHI SULTANATE

It is a common misconception that the Mughals were the first Islamic builders in India: whatever the magnitude of their achievement, as far as Muslim architecture is concerned they succeeded to a continent-wide tradition already nearly three hundred years old when Bābur set out to conquer the north-west. The earliest Islamic buildings are connected with the establishment of a Muslim capital on the site of Delhi in the last years of the twelfth century, itself the culmination of three centuries and more of raids upon the north and west, notably by Mahmud of Ghazni (c. 1000) [337]. Even so, they rose long after the guiding principles had been established in Egypt, in the Middle East, and in Persia and Afghanistan. This tardiness, however, was more than made up for in the centuries that followed the setting up of the Delhi Sultanate, when more notable Islamic buildings arose throughout the subcontinent than perhaps in the whole of the rest of the Muslim world.[1]

As with the Hindu temple and the Christian church, the conceptions underlying the design of the Muslim mosque (*masjid*) are relatively simple.[2] Islam being in part a congregational religion, a large court is essential for the faithful, in the larger mosques enclosed by a wall lined with arcaded galleries or cloisters. On the west – from India the direction of prayer (*qibla*) towards the High Place of Islam, Mecca – are one or more *mihrabs*, usually niches or blind arcaded doorways, and a *minbar* (pulpit). Also on the west the arcade opens into a depth of several bays and is in most cases faced by what is rather inadequately called a 'screen' – a façade consisting of a monumental arch, usually in a square frame, flanked by similar smaller arches. The bays behind the façades are generally topped by large domes, sometimes partly or even completely hidden behind the screen, flanked again by smaller domes. Much of the fascination of Indian Islamic architecture lies in the enormous variety of these façades both in design and ornamentation, particularly in the provinces, and in the almost infinite possibilities of number and placing of the *minārs*, the tall towers from which calls to prayer are made.

Structurally speaking the dome is the supreme achievement, although the techniques had usually been learnt elsewhere in the Muslim world and derive ultimately from the late classical Middle East. The Islamic builders were peculiarly adept, however, at varied transitions from a square base to a round dome, and at ringing the changes on the arcaded and domed galleries within the sanctums of many mosques. There are all kinds of squinches, again often of the highest technical as well as artistic quality. The courtyard gateways, domed and with interior bays, are often notable in their own right. The true arch is the hallmark of the Islamic builder,[3] and every variation on this protean architectural element was used at one time or another, the 'four-pointed' arch predominating. After the earliest period merlons proliferated; so did decorated

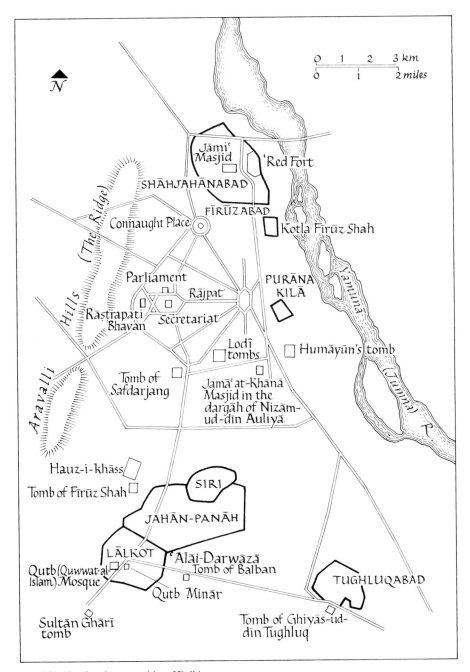

337. Map showing the seven cities of Delhi

spandrels (the sections flanking an arch in a right-angled frame), usually developing from a round boss, and perforated stone screens. Facings of different coloured stone in bold vertical and horizontal courses, and later in inlays, are to Islamic architecture what sculpture is to the Hindu temples, although the facings made full, if discreet, use of mouldings as well, often based on Hindu models.

Aesthetic weaknesses arising from ritual requirements, which the more inspired builders were able to mitigate or even turn to advantage, include the seemingly endless expanses of the low outer walls, sometimes as long as four hundred feet on a side, and the uncompromising frontality of the qibla, however beautiful. One should not compare buildings from one tradition with those of another, but it is not impertinent, with the spectacular and

meaningful profile of the Kandarīya Mahādeo at Khajurāho in mind, or the three-quarters rear view of Notre-Dame in Paris, to point out that the design imperatives of the mosque exclude the full realization, rarely achieved in any type of building, of architecture which satisfies from all angles.

Qutb-ud-dīn Aibak, the founder of the first of the five dynasties whose dominion came to be known as the Delhi Sultanate, was originally a captain and official of the Ghurid kings of eastern Afghanistan, and it was at Delhi – in name if not always in fact the Muslim capital of northern India for more than three centuries – that he built the earliest surviving Islamic structure in India, the Qutb mosque in the old Hindu citadel of Rāi Pithaurā (or Lālkot) [338]. As was almost always the case with the earliest Indian mosques, materials

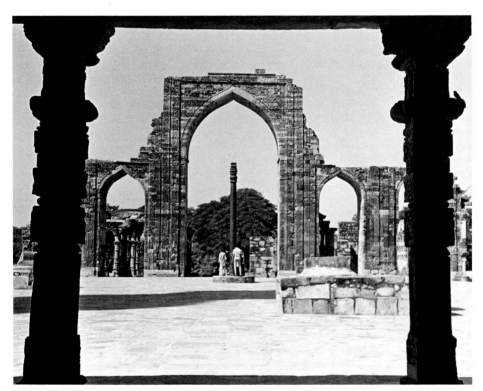

338. Delhi, Qutb mosque (with the Iron Pillar). *c.* 1200

from demolished Hindu temples were used – richly carved Hindu columns for the galleries, and a reversed Jain relief as part of the outer wall on the north.[4] Later, carved stonework was frequently recut. A few years afterwards a tall screen was built for the sanctuary (the side towards Mecca) with a central arched element nearly twice as high as the flanking arches. The Qutb mosque, or what remains of it, is of ashlar, i.e. smooth-faced blocks of tightly jointed stone, with ogee arches and richly carved vegetal decoration alternating with verses from the Quran in an ornamental Arabic script. Significantly, the arches are of corbelled construction, showing that, as in so many later cases, indigenous workers were responsible, with Hindus probably in the majority.

Beside the mosque rises the great Qutb minār, a tower of victory rather than a religious structure.[5] Originally 238 ft (73 m.) high (the top part is later), it is without equal in India, or indeed anywhere else in the Islamic world [339]. It was of four diminishing storeys separated by projecting balconies, each stage different in section – stellate, with convex flutes, or with a combination of the two; the round topmost element may represent a fourteenth-century rebuilding. The Qutb minār is distinguished from all other buildings of its type not only by its size but also by its workmanship, with bands of richly carved inscriptions from the Quran and superb stalactite bracketing under the balconies. The very first Islamic monuments in India, as well as subsequent buildings, owe a great deal to the highly skilled native masons and sculptors, with a centuries-old tradition of working in stone – witness the contemporary temples of Rājasthān and Gujarāt, and the fact that most Islamic buildings in India, unlike those elsewhere in the world, are of dressed masonry.

A third structure attributed to Qutb-ud-dīn Aibak is the Ārhāi-din-kā Jhomprā mosque in Ajmer, also largely built from the spoils of Hindu temples. The use of three superimposed Hindu pillars lends greater height to

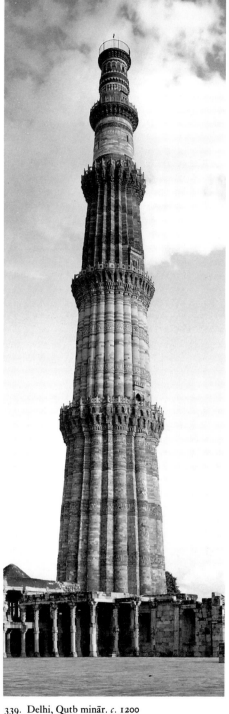

339. Delhi, Qutb minār. *c.* 1200

the galleries and behind the screen. Two other perennial themes which make their debut here are the medallions in the spandrels of the great central arch of the screen, and cusping, as in the three arches on either side. The remains of two minarets survive on top of the frame of the central arch.

The other most widespread and characteristic Indian Islamic monument is the tomb. Two survive from the reign of the next ruler, Sultan Shams-ud-dīn Iltutmish. In the first, an extension of the Qutb mosque, lies the sultan himself. White marble occurs in the elaborately carved surface inside. The squinches of the (now fallen) dome are not arched but corbelled, in traditional Indian fashion. The other tomb, the Sultān Ghārī, stands in a walled enclosure of grey granite with bastions and arcades on two of the inner sides; the small mosque sanctuary of the western one presages the combination of mosque with tomb of later times.[6] In the now ruined tomb of Balban, the true arch is used for the first time.

The ambitious building projects of the next dynasty, the Khaljīs, include Siri, the second of the seven successive cities on the site of Delhi (eight if New Delhi is included) [337]. The few surviving Khaljī structures include the beautiful 'Alāi-Darwāzā, a self-contained gateway with a dome, exquisite in the proportions and the variegated decoration of its façade, and a long bridge, most of it still standing, below the fortress of Chitor. A characteristic 'fringe' of spear-heads or fer-de-lance on the under side of the principal arches is introduced at this time. Another survival in Delhi is the Jamā'at-Khānā masjid in the dargāh (a complex containing both a tomb and a mosque) of Nizām-ud-dīn Auliyā, a famous saint.

The Tughluqs (1320–1415) have left far more of a mark on the capital and on other places in India. They built the third, fourth, and fifth cities of Delhi, palace-citadels in the Islamic manner rather than towns. The massive ruins of the third, Tughluqabad, still look down on the tomb of its builder, the founder of the dynasty, Ghiyās-ud-dīn Tughluq, an aus-

terely impressive, fortress-like little monument set in a courtyard enclosed by battlements with corner bastions rising from an artificial lake [340]. White marble is deployed liberally, if without much subtlety, in panels and bands. The walls have an exaggerated batter.

Tughluq buildings are generally of rough construction, with walls of rubble covered with cement. A shortage of skilled craftsmen created by the disastrous and short-lived move of the capital to Daulatabad, near Aurangabad, under Muhammad, the second ruler of the dynasty and the builder of Jahān-Panāh, Delhi's fourth city, may partly account for the plainness of Tughluq buildings in the old capital, largely redeemed by the solid architectonic qualities of the style.

The greatest builder of the dynasty was Fīrūz-Shāh Tughluq. The principal components of his ruined palace-citadel along the Jumna – Delhi's fifth city, the Kotla Fīrūz Shāh, built in 1354 – can still be picked out.[7] Fīrūz-Shāh also built a great many mosques, generally raised on an arched substructure. The Khirkī masjid at Jahān-Panāh and the Kalān masjid in Shāhjahānabad are exceptional in being covered, except for four small open quadrangles. In other respects their battered walls and tapered bastions at the corners and beside the projecting entrances present the typical Tughluq fortress-like appearance, and it is indeed in the monuments of this dynasty that the essentially military nature of Delhi Sultanate rule is most manifest.

The exception is the tomb of Fīrūz-Shāh (d. 1388), part of a long range of buildings called the Hauz-i-khāss. Square on plan, with central projections or bays on each side, the main structure, topped with merlons, supports an octagonal drum for the dome. Fringed arches and the typical arch-and-beam – an Islamic/Hindu compromise – appear everywhere. All in all, the tomb of Fīrūz-Shāh is a plain building of great dignity, exemplifying the Tughluq style at its best. The mausoleum of Khān-i-Jahān Tilangānī, a prime minister late in the reign, the first of the octagonal tombs

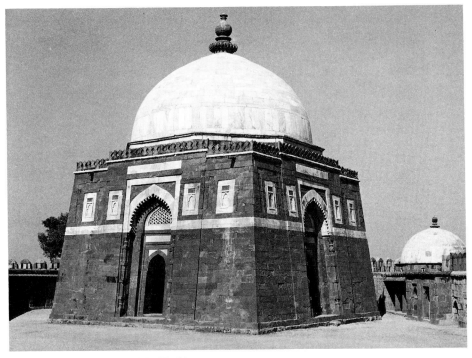

340. Delhi, tomb of Ghiyās-ud-dīn Tughluq. 1325

(though in Islamic terms the ground plan is as old as the seventh-century Dome of the Rock in Jerusalem), is surmounted by an arcaded peristyle crowned by a *chhajjā*, i.e. straight-sided eaves or a stone awning (cf. *chādya*).

The Tughluq dynasty came to an end with Timur's sack of Delhi. The following Sayyids and Lodīs (1414-1526) concentrated on the building of tombs, usually octagonal or square. The octagonal ones, which retain the earlier external batter by means of buttresses at the angles of the arched peristyle, tend to be un-impressive through lack of height, owing largely to their insufficiently raised domes. The latter are uncompromisingly box-like, their straight sides divided into as many as three storey-like registers. The arch-and-beam continues in use, and the ubiquitous *chatris* of later times, little pillared pavilions surmounted

by domes, make their first appearance around the drum of the dome. The tomb of Sikander Lodī (d. 1517) in the Lodī Gardens in Delhi has a double dome, long known in the Middle East and Iran.

Sher Shāh Sūr was the remarkable Afghan with a power base in eastern India who drove Humāyūn into exile and took over his dominions. He is associated with two buildings of almost matchless beauty, all the more remarkable when it had seemed, after the rather modest buildings of the Lodīs, that the Islamic building tradition in North India was near exhaustion. His tomb at Sasaram, in Bihār, derives, as does another fine tomb near by, from the Lodī octagonal type, but it is several times larger.[8] Furthermore, it does triumphantly away with the two principal weaknesses of its predecessors - lack of height, and an inadequate or ill

defined relationship with their surroundings – by setting the mausoleum on a stepped base in an artificial lake and then within a walled court with pavilions at the corners [341]. The octa-

prastha of the epics. The sanctum which is all that remains of the Kilā-i-Kuhna mosque within is an equally superb example of Sher Shāh's building activity. No sanctum and

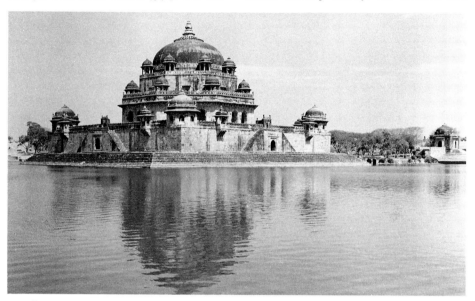

341. Sasaram, tomb of Sher Shāh Sūr. *c.* 1530-40

gonal tomb, with three arches to each side of the veranda and chatrīs above at each angle, was topped by a further octagonal storey of considerable height, the chatrīs repeated at the base of the dome. Of Chunār sandstone originally coloured, this architectural masterpiece is a fitting climax to the long tradition of pre-Mughal Islamic architecture in India.

Sher Shāh is also responsible for the fortification of the Purāna Kilā, Delhi's sixth city, upon what tradition holds to be the Indra-

façade in India possesses quite such measured dignity allied to perfect taste in the rich but restrained decoration, comparable to the achievements of Brunelleschi and one or two of his contemporaries in European architecture. From the superb semi-domed mihrab and the pillars inset beneath the fringed arches to the *opus sectile* of the arch frames, the fullest use is made of truly architectural elements to create a strength, beauty, and richness beyond anything achieved by the Mughals.

THE PROVINCIAL STYLES

The size and diversity of India are amply reflected in the multiplicity of regional Islamic styles.[1] Broadly speaking, the most interesting monuments are to be found in areas previously known for temple building, and where local and indigenous traditions of masonry and stone carving were strongest. No early mosques or tombs survive in the Panjab, on the main path of Islamic conquest, and surprisingly few in Sind, where the original Arab landings took place. Sind remained in close cultural contact with Iran: coloured exterior tiles, for instance, were first introduced in Multan. Paradoxically, it is at the other end of the subcontinent, in Bengal, where construction was also preponderantly in brick, that the earliest important Muslim buildings (apart from Delhi's) are found. The remains of the great Ādīna mosque, a grandiose conception, nearly as long as the Great Mosque of Damascus, date back as far as 1364. The aisles on the sides of the courtyard are three bays deep except on the west, where there are five, formed of abnormally thick square piers. The screen has totally disappeared, laying bare an extensive central sanctuary with a pointed-arch vault. On the end wall, the arch of the large mihrab, supported on pilasters, resembles a Pāla prabhāvalli; the large bosses above on either side are in the form of lotus rosettes. As in other early mosques, the pillars are spoils from Hindu temples.

The 'Eklākhī' tomb of c. 1425 marks the beginning of the semi-indigenous style. The curved cornices and pavilions with drooping roofs are native bamboo structures translated into brick, the material of the later temples of Bengal. There are turrets at the corners, and arched entrances, as many as eleven in the Bara Sonā masjid at Gaur, all with small domes above the internal bays; in the Chhotā Sonā masjid, a typical little Bengali curved-roofed building occupies the central position. The Bara Sonā is completely covered, protection against seasonal rainfall. Many of these buildings are faced with monotonous rectangular panels, perhaps in imitation of wattle and daub; others, like the great Dākhil Darwāzā at Gaur, are of matchless brickwork, often ornamented with terracotta, attesting to a long tradition which continued in Hindu temples well into the nineteenth century.[2] Nowhere in India did climate and local conditions as well as indigenous building styles affect the development of the mosque as profoundly as in Bengal.

The surviving architecture of Jaunpur, only thirty-five miles north-west of Varanasi, consisting exclusively of mosques, bears many resemblances to that of the Tughluqs who founded it, particularly in its rugged virility and the taper or batter of its bastions and minarets. Arch-and-beam construction is used, and the largest arches are fringed. Following Timur's sack of Delhi, under its exceptionally enlightened Sharqī rulers Jaunpur enjoyed a brief golden age, taking over from the capital as a centre for scholars and writers. It is very likely that builders trained in the Tughluq style, some of whom we know were Hindus, moved here from Delhi.[3] However the most striking and characteristic feature of the Jaunpur style, the towering propylons of the sanctuary screen with their great recessed arches, is entirely original.[4] The propylons consist of a huge recessed arch framed by tapering square minārs, of exceptional bulk and solidity, divided into registers.

The Atala masjid, the earliest and probably the finest of the Sharqī buildings, has a much smaller pylon on each side of the central one, to bridge the gulf between its great height and

two mosques are the tallest in India. Never less than 11 ft (3.4 m.) deep, the recess features a small entrance arch within the larger one, each with a beam across it, the latter surmounted by three rows of arched clerestory windows. Although the Jaunpur sanctuary screen propylons are unquestionably the most striking and original invention of Islamic builders in India, their great height points up as nowhere else the insoluble problems posed by the screen type of west end. In the Atala masjid, the dome is visible *below* the uppermost of the clerestory windows, and the rear view highlights the two-dimensionality of the screen in all its failure to meet the three-dimensional requirements of the finest architecture.[5]

The earliest mosques and tombs in Gujarāt were built at Anahilwāda Pātan and in the coastal towns of Cambay and Broach. Hindu temples were again raided for materials; that so many remain standing nonetheless is testimony to the exceptional vigour of building in the area. Another factor is the relative tolerance of Muslim rule, which – together with the cultured character of the Ahmad Shāhi sultans – must also have contributed to the supremacy of the Islamic style of Gujarāt among all the Indian provinces. Here in the fifteenth century minarets are used in countless ways to emphasize, balance, vary, or decorate the west façades. The minaret is a fairly late development in India. At first it was detached from the mosque structure and had the primary character of a tower of victory (e.g. the Qutb minār), although it also provided for the *azān* or call to prayer.[6]

Ahmedabad, founded in 1411 by Ahmad Shāh I, was eventually to boast upwards of fifty mosques of which the finest, the Jāmi‘ masjid, finished in 1423, is perhaps the most aesthetically satisfying in the whole of India [343]. Plainly visible through the central arch of the façade, flanked by two beautifully proportioned fluted minarets (their upper parts unfortunately missing), are tall, slender, closely set pillars supporting three storeys of balconies

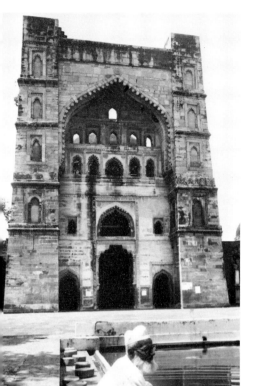

342. Jaunpur, Atala masjid. 1408

that of the rest of the mosque [342]. The Jāmi‘ masjid, built some sixty years later, omits the smaller pylons. The two wings of the sanctuary running north and south are exceptional in having vaults instead of domes. The central arched recess of the Atala masjid is treated in a particularly ingenious way, and it must be remembered that the central arches of these

343. Ahmedabad, Jāmiʿ masjid. 1423

and platforms. Through a suspended aṇḍolā toraṇa of impeccable Hindu design the colonnaded hall is entered, stretching for 210 ft (64 m.) on either side of the central area, two storeys high and partly divided off by perforated stone screens. At one end is the zenana, set apart for women. Support is by stone beams rather than by arches, and yet the general effect is one of lightness, recalling the contemporary temples of Rājasthān (for instance Rāṇakpur) with their raised halls. Obvious borrowings from the same source are base mouldings adorned with flame-like descendants of the gavākṣa, together with sloping seat backs to parapets.[7]

The plan of the new city of Ahmedabad included, along with the great mosque, a palace and a triumphal approach marked by the Tīn Darwāzā, with its three beautifully proportioned arches separated by thick fluted pi-

lasters reminiscent of the truncated mināṛs of the Jāmiʿ masjid. Corbelled out over each arch, at the base of the flat parapet topped by merlons, are small roofed balconies similar to those at the bases of the śikharas of contemporary temples (the Sūrya at Rāṇakpur [185], etc.).

Late Ahmedabad buildings include the palace buildings at Sarkhej, and the screenless mosques of Shāh Khūb Muhammad Chishti and Rāṇī Siparī, the arched or trabeate interiors of the sanctuary, with their columns, totally open to the court. The minarets – grown more slender, almost needle-like, in the Rāṇī Siparī – have been moved to each end. The ripest version of the style can be seen at Champanir, a new capital built by Sultan Mahmud Begārhā (1459-1511).[8] The outer walls are either buttressed by fluted pilasters, as at the Tīn Darwāzā, or pierced by the same balconies on massed brackets as on the frame of the central arch to

the qibla, which is immediately flanked by two very tall slender minarets – a confused and crowded arrangement, with the minarets awkwardly placed. The most striking feature of this mosque is the dome behind it, raised high on a pillared maṇḍapa-like hall.

At Dhar, and later at Māndū, in western Mālwā, the former home of the Hindu Paramāras, a powerful line of sultans of the fifteenth century onwards has left a rich legacy of mosques, tombs, and palaces, primarily of red sandstone, often faced with white marble or glazed tiles. Many features derive from Tughluq architecture: platforms or plinths often with an arcaded basement used as a serai, battered walls, and the arch (fringed with fer-de-lance) and beam arrangement.

Māndū, its extensive fortifications girdling a wildly beautiful outcrop of the Vindhyas, crisscrossed by ravines, is one of the most romantic sites in India. The Jāmiʿ masjid, approached by a long and imposing flight of steps, has a central area surrounded on all sides by arcades of eleven arches, opening on to two aisles on the eastern side, three on the north and south, and five on the west, which contains an equal number of minbars [344]. Over each of the bays thus formed rise cupolas, a hundred and fifty eight in all. Behind the Jāmiʿ stands the tomb of Hoshang, who began the great mosque if he did not finish it. The tomb, in a walled enclosure and the first in India to be entirely faced in white marble, was completed by Mahmud I (1436–69). Opposite the mosque

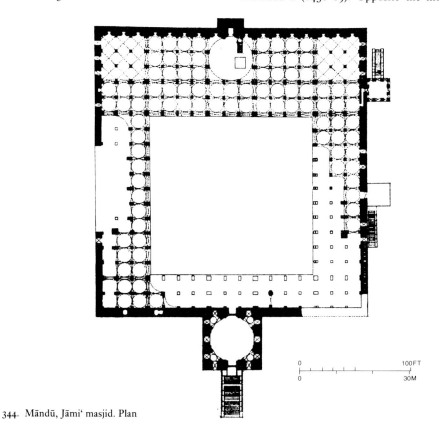

344. Māndū, Jāmiʿ masjid. Plan

0 100FT

0 30M

he built a great palace complex (the Ashrafi Mahall) of which only the basement remains. It included a *madrasa*, or college, and a tower of victory.[9] Still standing are a number of markedly individual secular buildings, notably the Hindola (Swing) Mahall, an extremely original T-shaped structure, its massive and exaggeratedly battered walls enclosing an audience chamber as well as private apartments with a zenana. Near by, the Jahāz Mahall (Ship Palace, because it is between two small lakes) is a delightfully fanciful pleasure dome, with bathing halls, arcades, and pavilions. Other palaces and pavilions are scattered over the vast expanse of Māndū, many associated with the romantic memory of Bāz Bahādur and Rūpmatī.

THE DECCAN

Except for Bijapur, the capitals founded by the powerful sultanates who succeeded the Tughluqs in the Deccan were also mighty fortresses. Many of their buildings date from the seventeenth century, before Aurangzeb's final conquest in 1678. As opposed to northern India, Islamic architecture in the Deccan was slow to adopt local features, perhaps because of its dependence on Delhi and on foreign, i.e. Persian, models and techniques.[1]

The Bāhmanīs were the first, under an official of Muhammad Tughluq, to establish an independent kingdom. After Muhammad abandoned Daulatabad as his capital, the Bāhmanīs added to its fortifications, making it the most elaborate stronghold in India. The inner citadel, a conical hill 600 ft (180 m.) high, was defended by 150 ft (45 m.) escarpments and a moat hewn out of the solid rock.[2] The lower fortifications are of unequalled ingenuity, and it has been suggested that certain elements shared with the medieval West may have been proposed by Turks or other foreign soldiers serving in the armies of the Deccan.[3]

The suggestion that the Chānd Minār at Daulatabad was built on a Baghdad model seems implausible. The Jāmi' masjid, however, completed in 1367 outside the first Bāhmanī capital, the almost impregnable Gulbarga, was erected by a Persian from a Qazvin family of architects. Entirely roofed over, it has wide arches with extraordinarily low imposts (the points where the arch begins and supporting walls, pillars, or pilasters end). The earlier Bāhmanī kings built tombs at Gulbarga in the Tughluq style. Later, double tombs appear, rectangular on plan and with twin domes, with separate burial areas for the ruler and for his family.

Bidar, to which the Bāhmanī capital was transferred, also a fortress, nevertheless sheltered within its walls palaces with audience halls and *hammams* (baths with running water), many of which show strong contemporary Iranian influence while retaining fourteenth-century Indo-Muslim traditions of stone facing, lime-plaster decoration, and rubble masonry. The famous madrasa of Mahmud Gāwān is a several-storey, partially ruined building of wholly Iranian design, with two tall minārs on the entrance side and semi-octagonal projections at the rear. The glazed tiles which covered the walls outside were imported by sea from Persia.[4] The later Bāhmanī tombs have raised or stilted domes with a slight constriction at the base of the dome proper. All the Bidar buildings rely heavily on surface decoration, with liberal use of glazed tiles, some actual imports from Persia.

The founder of the Qutb Shāhī dynasty (1512–1687) of Golconda, now a deserted city, and later Hyderabad, broke away from Bāhmanī rule, as did the 'Adil Shāhīs of Bijapur. Both capitulated to Aurangzeb in 1687. Golconda was a fortress even larger and more impregnable than Gulbarga or Bidar. The tombs of the Qutb Shāhīs have bulbous domes rising from a petalled calyx. A separate ceiling is introduced because of the increased height of the domes, surrounded outside by fanciful pinnacles and imitation battlements. The famous Chār minār, its name deriving from the minarets rising from the four corners, a kind of triumphal archway in the centre of Hyderabad, is a dignified and well proportioned building. As in so much later Muslim architecture in the Deccan, however, the details tend to be showy and lacking in substance.

Bijapur, second to none of the Deccani Sultanates in the turbulence of its short history, nevertheless boasts the greatest abundance and the highest standard of Islamic monuments in the Deccan, despite the rather uninteresting

345. Bijapur, Jāmiʿ masjid. 1576

local brown basalt of all its buildings. One very early mosque (1320) built before the foundation of the state utilized Hindu remnants as elsewhere, including an entire temple maṇḍapa for an entrance gateway. Of the earlier buildings, decorated in stucco and cement, the Gagan Mahall (Sky Palace) boasts a tremendous façade arch, 70 ft (21 m.) wide. Much of the construction is wooden, including the four massive pillars supporting the upper apartments (now missing) and the elaborately carved window frames. Similar pillars are found in the later Āthār Mahall, probably designed as a palace but converted to enshrine two hairs of the Prophet. Also among the earlier structures is a relatively well-preserved ʿidgāh, a Muslim building used only for certain religious occasions and consisting simply of a large screen with mihrab and minbar before which the faithful assemble to pray, without any enclosure.

The Jāmiʿ masjid, built by ʿAli ʿAdil Shāh in 1576, was the largest yet erected in the Deccan [345] and the most successful creation of the Bijapur style, conveying, in Cousens's phrase, an impression of 'restful massiveness'.[5] The enclosing walls, usually plain expanses of masonry and one of the weakest features of the Indian mosque, are here relieved outside by an arched gallery with a corridor, echoed

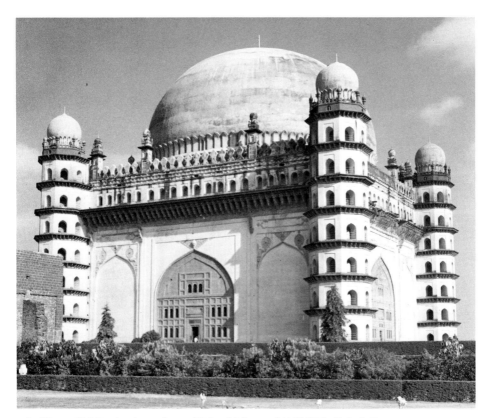

346. Bijapur, Gol Gumbaz (mausoleum of Sultan Muhammad 'Adil Shāh, died 1656)

below by a blind arcade. The façade of the sanctum has seven arches to a depth of five bays rising from piers rather than pillars, a feature of the Bijapur style. Below the single dome is an open space created by the elimination of four piers. The other bays have domical ceilings which, like those of the galleries around the three sides of the court, do not project above the roof, as they do in the Māndū Jāmi' masjid and elsewhere. The elaborately painted and gilded mihrab is the work of Muhammad, a later sultan, who promoted this type of decoration, besides lifting the restriction on human figures in murals (e.g. in the Āthār Mahall). The mosque, never quite completed, unfortunately lacks the two minarets which were to have risen at the ends of the eastern wall.

Within the square enclosure of the Ibrahim Rauza (a *rauza* is a tomb with an associated mosque) the two structures, of similar size, face each other on a platform, with a fountain between. Both have prominent chhajjās on closely packed brackets, and fretwork merlons or balustrades around the dome. The interior of the tomb is intricately decorated. The ceiling is a flat carved stone, 24 ft (7 m.) square, a tour de force made possible by the exceptional tenacity of Bijapur mortar which frequently alone holds together masonry of an inferior order. The

arch spandrels on the façade of the mosque are filled with ornamental Arabic script, freely and creatively executed, and painted, with an effect very similar, on a larger scale, to contemporary Persian manuscript illumination.

Even the relatively sober twin buildings of the Ibrahim Rauza have their corner minarets topped with onion domes, and little replicas of the parent building appear as pinnacles between them, a strange echo of the reduplication of Hindu temple architecture, and most particularly of subsidiary śikharas clustered around the principal one. Some of the latest Bijapur monuments are positively theatrical, combining flamboyant imagination with insubstantiality. An example is the Mihtar Mahall – actually the gateway to a mosque – with its over-length straight brackets supporting over-hanging balconies, one or two hung with stone chains, virtuoso performances much in favour with the Indian stone carver at this time for Hindu as well as Muslim buildings.

In striking contrast is the simplicity and virility of the Gol Gumbaz, the mausoleum of Sultan Muhammad (died 1656), then the largest single-chambered building in India, its huge dome covering a space vaster than in the Pantheon [346]. A cube, with pagoda-like minarets rising from ground level at the corners, its proportions are perfect. Great restraint is exercised in the chhajjā, with a clerestory above, and in the ring of lotus-like petals at the base of the dome. Further evidence of the astonishing technical expertise of the Bijapur builders is the unequalled system of waterworks, with deep underground conduits.

THE MUGHAL PERIOD

Humāyūn's mausoleum in Delhi (c. 1565), raised largely by the unremitting efforts of a devoted widow, inaugurates the Mughal tradition, derived from their Persian heritage, of building tombs in vast formal gardens with important entrance buildings [347]. The tomb itself also owes much to contemporary Persia. Set on a vast high podium containing rooms, it is a fore-taste of the Tāj Mahall, with its great central bayed arch, flanking wings with arches of the same kind, its raised dome and its chatrīs. Only the tall minarets are missing, and the facing is of red sandstone. Humāyūn's tomb is highly successful, which cannot be said either of Akbar's at Sikandra, between Agra and Mathurā, or of Jahāngīr's just outside Lahore, both on a grand scale but marred by eccentricities in their ele-

vations, a failing unknown elsewhere in Mughal architecture: perhaps they are incomplete.

Akbar was responsible for the monumental dressed stone ramparts of the fort at Agra and its bastioned Delhi gate. Of the earlier Mughal palace buildings there and at Lahore and Al-lahabad nothing remains, for they were all replaced by the white marble structures of Shāh Jahān, with the notable exception of the Jahāngīrī Mahall at Agra.[1] Of red sandstone, like all Akbar's buildings, it is a reflection of the emperor's wide-ranging genius and bears the hallmarks of his style, much less Persianized than that of his successors and preferring trabeate to arcuate construction, with markedly Hindu brackets and corbelling.

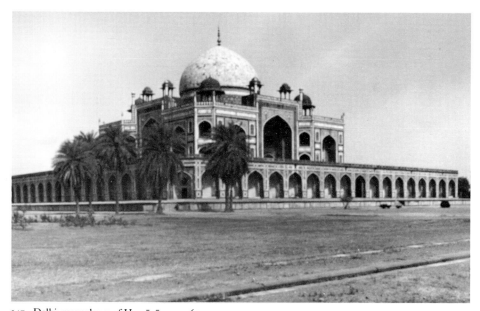

347. Delhi, mausoleum of Humāyūn. c. 1565

Akbar's chief architectural monument, however, is the new and soon deserted 'city' of Fathpur Sīkrī, near Agra, built about 1571. Most of its structures bear Akbar's general stamp, their diversity shedding light on the origin and nature of his style. Rich in 'Hindu' elements, they nevertheless have affinities with not one but several regions of India, which

dwellings remain. There are no streets, simply terraces with individual buildings – the Mughal conception of a palace – whose originality and diversity provide the main interest. Some of them are two-storeyed, again in contrast to the palaces of Shāh Jahān. The largest is 'Jodh Bai's palace', a series of apartments with Gujarātī features such as an aṇḍolā toraṇa

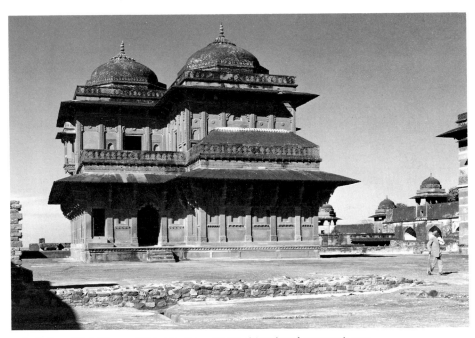

348. Fathpur Sīkrī, 'House of Bīrbal the Prime Minister' (northern haram sara). 1572

must have been Akbar's intention and have nothing to do with a lack of workers trained in Islamic or Mughal styles, for Agra is not far from Delhi, with its four-hundred-year-old tradition of Islamic building. What is more, the important mosque and (later) Buland Darwāza, are in the early Mughal style as we know it from Humāyūn's tomb at Delhi.

The Fathpur Sīkrī visited by tourists today is a palace with a very large mosque rather than a city.[2] Unlike earlier palaces, it is not inside a citadel. No traces of lower-class

and what are surely udgamas above some of the niches. The 'House of Miriam' is reminiscent of the wooden architecture of the Panjab. Wide-spreading chhajjās on elaborate brackets abound, particularly in the 'House of Bīrbal the Prime Minister' [348], where the informed can see, struggling to emerge from the conventions of Islam, the Hindu origins of the animal and vegetal forms on which the corbels and brackets as well as the gavākṣas below the pillars are based. The Diwan-i-Khass (Hall of Private Audience) is unique in

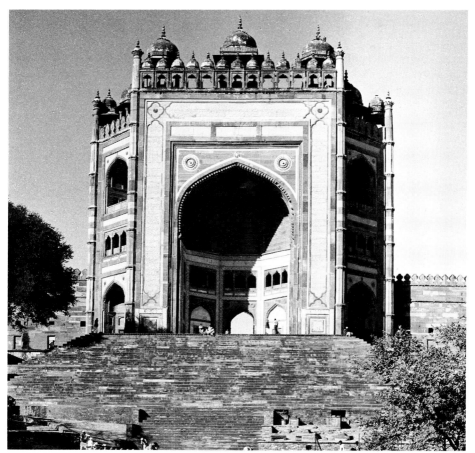

349. Faṭhpur Sīkrī, Buland Darwāza. *c.* 1571

that the capital of the central pillar widens out to create a small platform, where the emperor is imagined to have sat, with 'bridges' radiating out.[3]

The Jāmi' masjid at Faṭhpur Sīkrī is one of the largest in the country, on a conventional plan, with gateways in the middle of the three sides of the court. The interior of the sanctuary is Akbar's finest. The later Buland (high or lofty) Darwāza of *c.* 1571 is the most splendid of all such gateways to mosque or tomb, but it dwarfs the general ensemble [349].[4] In the

small white marble tomb of Salīm Chistī in the courtyard is a wealth of perforated screens and exaggeratedly serpentine brackets.

Jahāngīr, a man of great taste and cultivation with a lively interest in the world about him, appears to have been more interested in laying out gardens than in erecting buildings, a disposition in which the relative failure of Akbar's tomb, for which he was largely responsible, may have confirmed him. His own mausoleum was largely the work of his redoubtable consort, Nūr Mahall Begum. The exquisite tomb

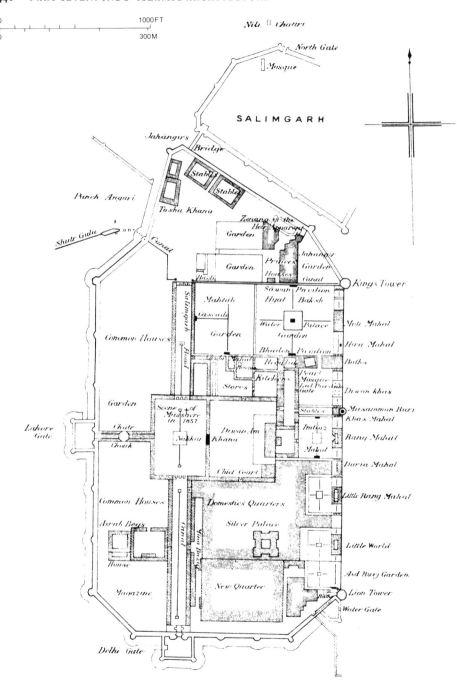

0
1000FT
0
300M

Nili ⬚ *Chattri*

North Gate

⬚ Mosque

SALIMGARH

Jahangir's
Bridge

Stables

Punch Anguri

Stables

To sha Khana

Shutr Galu

Canal

Zenana of the
Heir Apparent

Garden

Garden

Jahangir
Garden

Bagh

Princes
Houses

Canal

King's Tower

Sawan Pavilion
Hyat Baksh

Mahtab
Mahal

Moti Mahal

Salimgarh Road

Cascade

Water
Garden

Palace

Hira Mahal

Garden

Bhadon Pavilion

Baths

Common Houses

Moti Mahal
Mosque

Rangala

Pearl
Mosque
Lal Purdah
Gate

Diwan khas

Kitchens

Stores

Musamman Burj

Garden

Scene of
Massacre
in 1857

Stables

Khas Mahal

Diwan Am
Khana

Imtiaz
Mahal

Rang Mahal

Lahore
Gate

Naubat

Chatr
Chauk

Daria Mahal

Chief Court

Little Rang Mahal

Common Houses

Domestics Quarters

Silver Palace

Little World

Asrab Begs

Asd Burj Garden.

House

Canal

Yamuna

Lion Tower

Magazine

New Quarter

Water Gate

Delhi Gate

350 (*opposite*). Delhi, Red Fort. 1639-48. Plan

351 (*below*). Delhi, Red Fort, Diwan-i-Khass, hall of private audience. *c.* 1645

of her father, I'timād-ud-Dawla, at Agra of 1626 is the one notable building of the reign, supremely elegant in its formal garden with four squat minarets at the corners. The curved-cornice 'Bengali' roof of the central pavilion, and the use for the first time of pietra dura inlay with semi-precious stones, herald the style which was to follow.[5]

Before turning to some of the other buildings of Shāh Jahān's reign, the age of marble and the climax of the Mughal style, we must consider three important mosques in red sandstone relieved with marble: the one in Agra, the Jāmi' masjid in Delhi, the largest in India, and the Bādshāhī in Lahore (actually built by Aurangzeb). The finest is the Delhi mosque, with a theatrical beauty all its own, which can for once be viewed with satisfaction from every angle; in contrast, Agra is dumpy and Lahore deficient in imagination. The glazed tiling on one of the Lahore fort gateways is the ultimate product of a long tradition originating in Iran.[6]

The palace buildings of Shāh Jahān at Allahabad, Lahore, and Agra are mostly of white marble, occasionally simulated in plaster, with gilding and mirror inlay. They are essentially open one-storey pavilions, the roofs spotted with wide chhajjās and chatrīs. The pillars inside are sometimes rectangular but more often tapering or baluster-shaped, often with foliated bases. The carving, like all the decoration, is discreet and chaste. All the arches are cusped. Domes, reserved almost exclusively for mosques and tombs, are the raised bulbous onions beloved of Mughal architecture in India, quite different from the shapes current at the Iranian courts. The only concessions to native tradition are the 'Bengali' roofs of certain small buildings and pavilions and the canopies of jharokas, the audience thrones so familiar from Mughal paintings of the emperor in durbar.

In an identical style are the buildings in Shāh Jahān's new palace in the Red Fort (Shāhjahānabad), the great citadel which is Delhi's seventh city [337].[7] Shāh Jahān's palaces

vary little from Lahore to Agra, exceptional witness to an architectural style totally identified with a monarchy. The palace buildings in the Red Fort are in a unique second enclosure, surrounded by gardens [350]. Through the marble pavilions marvellously sited on the battlements along the Yamunā (Jumna) [351] run the waters of the Nahr-i Bihisht (River of Paradise), cascading at one point down a marble waterfall (in the Rang Mahall) and rising again from marble lotus rosettes encircled by pietra dura inlay (most of it unfortunately missing). The perforated marble screens which divided the pavilions into separate apartments have also largely disappeared, although the famous 'Scales of Justice' screen remains.

The Tāj Mahall at Agra, built by Shāh Jahān for his favourite wife, Mumtāz Mahall (Chosen of the Palace), is indisputably the greatest building of his reign and indeed of the whole Mughal period [352].[8] Entering through a large gateway, the visitor first sees the tomb at the end of a long garden watered by a wide canal interrupted by a fountain with large square basins. The mausoleum itself, dramatically sited on a bluff overlooking the Yamunā, is faced on either side by two identical buildings, one a mosque, the other a jawāb or 'answer' without religious significance. With its central arch, deeply embayed like the smaller superimposed arches in the wings, the two large chatrīs balancing the raised dome on each side, and the high blind-arched plinth, the Tāj brings together all the themes of Mughal architecture to form a superbly proportioned and balanced whole. The marble work is magnificent, saved by certain touches from any hint of banality. Exceptionally, the four minarets at the corners of the podium, perfectly placed, are rusticated, and their little domes are not bulbous. Participation by European architects is utter myth: no building could be more purely Mughal in style and conception. Basing himself in part on the calligraphically inscribed Quranic verses which form an important part of the decoration of this as well as other Muslim monuments,

352. Agra, Tāj Mahall. 1634

Begley has endeavoured to show, moreover, that the whole complex consciously embodies major Islamic religious and symbolic themes.[9] However this may be, he has exposed as the sentimental nonsense it is the commonly held view that the Tāj represents heartbroken devotion.

The exquisite small Motī masjid in the Red Fort is the most successful of Aurangzeb's buildings. The rapid decline which set in during his reign is typified by the mausoleum of his wife, Rabī 'a Daurānī, at Aurangabad, modelled on the Tāj Mahall, but little more than half its size. Offshoots of the Mughal style,

often interesting buildings, take the form largely of palaces. The only pre-Mughal – and indeed Hindu – palace to have survived intact is Mānsingh Tomar's of *c*. 1500 in Gwalior, commented upon by Bābur. The great palaces of Rājasthān, Jodhpur, Jaisalmer, Bikaner, Udaipur, Amber [187] – all eighteenth-century – have the usual Mughal engrailed arches, loggias on carved brackets, chatrīs, some with curved cornices, and perforated stone screens or lattices. In plan they tend to be inchoate. Similar smaller and sometimes later buildings can be found as far east as Dhaka. More uniform and symmetrical are the Bundela

structures at Orccha and Datia, near Jhansi. Planned and built as palaces, divorced from citadels and in the case of Datia from any defensive function, they are closer to the European conception, being multi-storeyed and confined to four walls. In the south, Chandragiri, near Renigunta, combines Mughal elements with, on the roof, vimāna-like towers instead of chatrīs. In the north, the nawabs, later kings, of Oudh erected in Lucknow a series of extravagant buildings, among them the Great Imāmbāra and the Rūmī (Turkish) Darwāza, in a tawdry post-Mughal style, with a surfeit of plaster decoration. With the mock-Palladian La Martinière, still used as the boys' school for which it was intended, European influence becomes intrusive, as in the Chatar Manzil and some of the other early-nineteenth-century palaces and mansions of Lucknow.[10]

SRI LANKA

BUDDHISM PRESERVED

Sri Lanka, known for a time as Ceylon (a corruption of Sinhala in colonial times), is an island state roughly the size of Ireland. The adjective Sinhalese still has cultural and historical validity, at least for the dominant sector of the population, for it is the name of their language and recalls both their ancient origins and the national emblem, the lion (Sanskrit *siṁha*).[1] Less than thirty miles from India at its closest point, Sri Lanka is nonetheless an ancient and distinct cultural entity. It is the only country in south and south-east Asia to have remained predominantly Buddhist since the days of Aśoka, and Buddhism has been the principal influence on its culture, its art, and its architecture. The high rainfall in the centre and south of this well-favoured land has endowed it with plentiful forests for timber, thus playing a determining role in its architecture. Moreover Sri Lanka's strategic location on Asian sea routes has profoundly affected its history.[2] From Roman times it has been open to influences from the West, suffering grievously from the most predatory aspects of European colonization – Portuguese, Dutch, and finally British.[3] It was the first country on the subcontinent to come completely under foreign rule when in 1815 the British abolished the last vestige of Sri Lankan sovereignty, the little kingdom of Kandy.

In the long historical perspective, however, the influence of India has been immeasurably greater. The Sihalas, the ancestors of the modern Sinhalese, arrived from India in the sixth or fifth century B.C.[4] Buddhism was brought to the island by Mahinda, a son of Aśoka; later, Āndhra was to provide the initial stimulus for sculpture in stone as well as the iconography and style for Sri Lanka's greatest sculptural achievement, the noble early standing Buddhas. Later still, in the later Anurādhapura period (*c*.459–*c*.993), sculpture is closely linked to developments in Tamilnāḍu and, to a lesser extent, the Deccan. During Sri Lanka's long history, moreover, whenever internecine disputes and the fragmentation of power caused the island's will to national sovereignty to flag, it became a prey to Tamil invasions and even to brief periods of total annexation. There remains today a large Tamil Hindu population, concentrated chiefly in the arid north. In the gathering gloom of the thirteenth and fourteenth centuries Sri Lanka was subjected to invasion and coercion by lands as distant as Orissa, South East Asia, and even China. It is therefore all the more remarkable that it has clung so tenaciously to its distinctive and ancient but continually evolving cultural heritage.

It is in the north-central region, the old Rajarata, with its vast ancient irrigation works that most of Sri Lanka's monuments are concentrated, particularly in the old capitals of Anurādhapura and Polonnaruva and in the relatively flat land near the southern coasts, the area of highest rainfall [353]. Rohana in the south-east, so often the springboard for a renaissance of national power, is also particularly

353. Map of Sri Lanka

rich in ancient remains.[5] Giant stūpas, some of them unexcavated and unrestored and dating back to the early days of Buddhism, vast monastic complexes of entirely indigenous character, the remains of palaces of equally original type, and stone sculpture, not as abundant as in many regions of India but generally of very high quality, are the chief artistic glories of Sri Lanka. A century and more of unremitting labour have resulted in the documentation, clearing, and restoration of most of the important sites,[6] and the archaeological and historical study of Sri Lanka has also benefited immensely from the existence of chronicles, the Dīpavaṃśa and Mahāvaṃśa for ancient times, and later the Cūlavaṃśa. A serious drawback for the art historian, however, is the almost total

lack of inscribed, let alone dated, stone sculpture. Until the extensive use of brick in the Polonnaruva period (c. 1055–c. 1270), the employment of perishable material, mostly wood, for all but the bases and pillars of ancient buildings has meant the utter disappearance of all the walls, upper storeys, and superstructures of countless edifices, secular as well as monastic, making it all but impossible to visualize them as buildings.[7]

Following on a Late and perhaps Middle Stone Age, the Iron Age culture of Sri Lanka is related to that of South India and the Deccan, although the cists are not as large or the burial urns as elaborate.[8] It may have continued well into the historical period, which begins with the arrival of Buddhism. Already,

354. Anurādhapura, Thūpārāma. Founded third century B.C. Air view

however, there seem to have been some Brahmanical and even Jain elements, which would account for the importance to this day of certain Hindu divinities: Iśvara (Śiva), Skanda, Gaṇeśa, and Kālī, as well as the Vedic gods Varuṇa (Upulvan) and Yama (Saman), honoured on Adam's Peak. The shrine of Skanda Kumāra at Kataragama in the south-east still attracts a great popular devotion from Buddhists as well as Hindus, all apparently descended from this ancient substratum rather than from later South Indian infiltration.[9] The earliest artefacts of the historical period, as in South India, are Brāhmī inscriptions on the rock shelters of Buddhist monks. The reign of the first great king, Devānampiya Tissa (c. 250–210 B.C.), saw the reception of Mahinda and the establishment of the first Buddhist community at Mihintale as well as the foundation of the Mahāvihāra and Thūpārāma [354], with the first stūpa (Sinhalese dāgaba, Sanskrit dhātugarbha) at Anurādhapura. A succession of kings, their line interrupted by Tamil interregnums, saw Anurādhapura confirmed as the national and religious capital and the foundation there first of the Abhayagiri monastery and then of the Jetavana (third century).[10] The sacred relic of the Tooth (of the Buddha), to become the palladium of Sri Lanka, was brought from Kaliṅga in the fourth century. A cutting of the bodhi tree had long since arrived, the harbinger of the cult of relics which was to become important to Buddhism in Sri Lanka.

The Sri Lankan dāgaba rests on a tripleringed or terraced base at the foot of the hemispherical dome (Sanskrit aṇḍa). The projections at the four corners, vāhalkaḍas in Sinhalese, in association with āyaka pillars, prove close early links with Āndhra. A square harmikā was surmounted by a single parasol and later by the familiar flat-topped cone of impacted umbrellas. A hole through the centre, and in some cases an actual stone shaft, provides the most literal evidence for the stūpa as support for the axis mundi.[11] Beneath the stūpas was buried a foundation deposit (Sinhalese yantra-gala) consisting of a stone with square com-

partments filled with objects including small bronze figures of the Guardians of the Quarters.[12]

The oldest of the extant stūpas at Anurādhapura is the Thūpārāma, of Mahinda's time; according to the chronicles, the Rājamahāvihāra at Mihintale (Sinhalese Mihinduseya) was erected over the ashes of the great missionary. At first of modest size, the Thūpārāma was already very large by the reign of King Dutthagāmanī (c. 161–137 B.C.). By the first century A.D. it was covered by a wooden dome (now completely renovated), a prototype of the later cetiyaghara (Sinhalese vaṭadāgē).[13] Probably to be assigned to the same king is the considerably restored Mahāthūpa, known as the Ruvanveliseya, the most famous dāgaba in Sri Lanka, with a diameter of 295 ft (90 m.) [355]. The Abhayagiri dāgaba, of the reign of King Vatagāmanī (c. 89–77 B.C.), is even larger, while King Mahāsena's Jetavana dāgaba, the largest of all, is over 393 ft (120 m.) high, with a diameter at the base of some 377 ft (115 m.). Both remain untouched since the twelfth or thirteenth century. A stūpa at Tissamahārāma in Rohana, the Yatāla vihāra, may date from as early as the second or first century B.C.

The earliest indigenous stone sculpture, in a late Sātavāhana style, as much Konkani as from Āndhra, consists of reliefs on steles and pillars associated with the vāhalkaḍas of early stūpas at Anurādhapura, at nearby Mihintale, and at Tissamahārāma.[14] In the early Āndhra style, and hence possibly earlier, are two imports, fragments of sculptured slabs showing Buddhist scenes, one of which may date back to the first century A.D.[15] Large circular cockades worn centrally on the headdress both of a detached Bodhisattva head from the Thūpārāma, now in the Colombo Museum, and of a relief figure from the Abhayagiri vihāra resemble the cockades on some Mathurā and eastern Mālwā sculpture dating from the third to the early fifth century.[16] The eyes of the Thūpārāma head are hollowed out for shallow inlays, a feature peculiar to Sinhalese stone Bodhisattvas and Buddhas. The stone used is

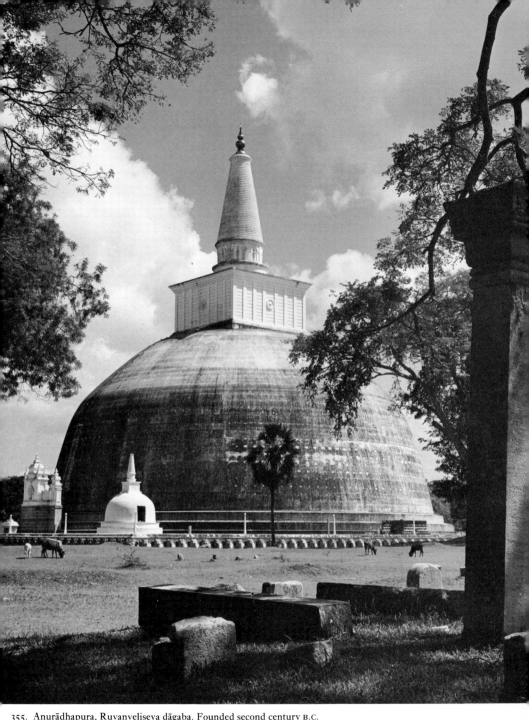

355. Anurādhapura, Ruvanveliseya dāgaba. Founded second century B.C.

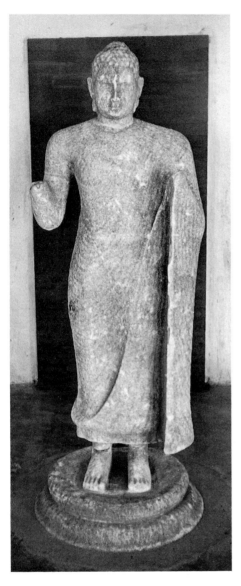

356. Standing Buddha.
Third/fourth century A.D. Limestone.
Anurādhapura Museum

always gneiss (granite), or crystalline limestone (dolomite), which turns blackish from exposure to the elements and is virtually the sole medium until the end of the Anurādhapura period (*c.* 993).

The Sinhalese sculptural genius found its supreme expression in the first figures in the round, the great standing Buddhas, sometimes as much as 8 ft (2.5 m.) high, of the third or fourth century [356].[17] Earlier images mentioned in the chronicles do not appear to have survived. The massive proportions and somewhat archaic rigidity of these Buddhas, without halos or attendant figures, lend them an austere majesty undreamed of by the plastically rather wobbly Āndhra Buddhas from which they derive.[18] They wear their robes like carapaces, and make the later standing Buddhas of Mathurā and Sārnāth appear slightly effete. So successful was their general formulation that they remain the unique type of Sinhalese standing Buddha for a thousand years; only details change as Gupta influence, mediated through the later Āndhra style, led to a regularization of the pleats of the robe into evenly and closely spaced parallel ridges, a gradual slimming of the body, and the emergence, through the robe, of the top of the lower garment (*antaravāsaka*) and the swelling of the flesh above it. The right shoulder remains bare, the right hand held shoulder-high in abhaya, the palm turned inwards at various angles; the left, equally high, holds the outer edge of the saṁghāṭī, drawn up across the body from the great horizontal roll at the bottom which was inherited from Āndhra. Below it the lower garment appears. The end of the saṁghāṭī then falls vertically down from the upholding hand, enclosing the body on that side with a projecting ridge.

The rock-cut colossus at Avukana, 46 ft (14 m.) high, with its flame-shaped finial (*śirasphota*) on the usṇīṣa and stylized face cannot be earlier than the eighth century [357], while the thirteenth-century rock-cut sculptures of the Gal vihāra at Polonnaruva give a clear indication of the style of this late

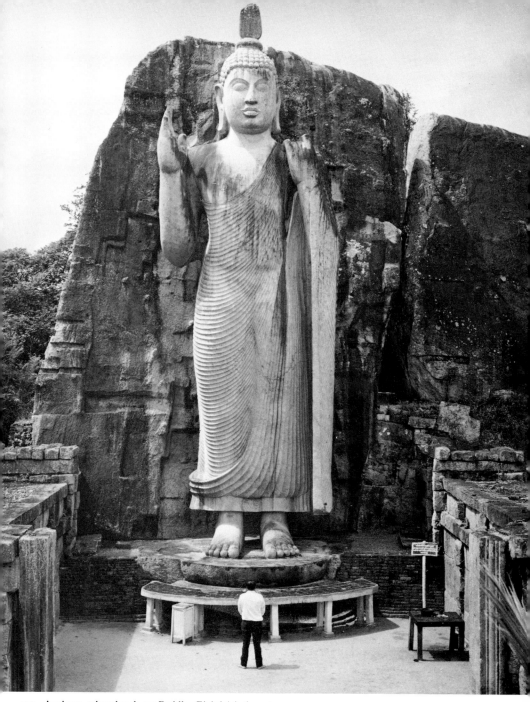

357. Avukana, colossal rock-cut Buddha. Eighth/ninth century

period. The Gupta-influenced Buddhas at Anurādhapura and Medigiriya of the three or four centuries following the appearance of the earliest Buddhas, restrained in modelling and without extraneous features, are extremely dif- ficult to date, partly because they may have been transferred to the dated monastic site where they are today from an earlier building, and even to Polonnaruva. That they, as well as the sitting Buddhas and Bodhisattvas, are

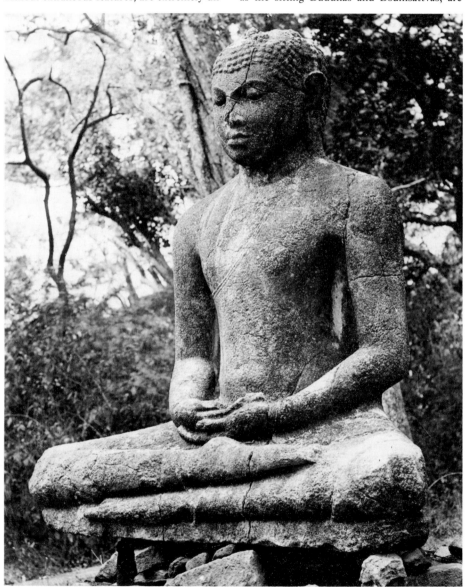

358. Anurādhapura, outer circular road, seated Buddha. Eighth century, first half

so few in number lends credibility to this hypothesis, already suggested by stylistic anomalies. Only one iconographic variant is known during all these centuries: a rock-cut standing Buddha with arms folded across his chest at the Gal vihāra.[19]

The seated Buddha likewise appears in only one pose until modern times, the legs in padmāsana, the hands in the lap in the dhyāna (or *samādhi*) mudrā; similarly, he is devoid of halo or ornament until the advent of the śirasphota, and the right shoulder is undraped. The position of the legs is common to South India and the Deccan; elsewhere, the image is usually in vajrāsana, the left foot tucked up on to the right thigh. It owes less to the early Āndhra tradition, where the right hand is usually raised in abhaya. The earliest examples, which closely resemble certain figures at Māmallapuram, are now not considered to date from before the sixth or seventh century.[20] In the integrity of their modelling, and of a graver serenity of countenance, the earliest of these seated Buddhas represent the other great achievement of Sinhalese sculpture [358].

The Buddhism of Sri Lanka, basically Theravāda, 'the religion of the Elders' (popularly but incorrectly called the Hīnayāna, or 'Lesser Vehicle'), incorporated for much of its artistic history a great deal of Mahāyāna doctrine and practice.[21] This meant the cult of Bodhisattvas, both male and female, and the creation of images of these great Beings. Male Bodhisattvas – sometimes only the heads – have been found in some numbers, but unfortunately the arms of the free-standing figures are invariably missing from above the elbows, which has led to identification problems and to the almost certainly erroneous belief that many of them represented kings.[22] Fortunately, several rock-cut colossi are intact, their hands in *vitarka*, perhaps a gesture of argumentation, *kataka*, the 'ring' gesture, or double *kataka*, proper to Bodhisattvas, and it can be assumed that the free-standing figures made the same gestures. What are then taken to be Bodhisattva images fall into two distinct types. There are rock-cut, and hence intact, versions of both: the so-called 'Leper King' or Kustarāja, and one of the standing figures at Buduruvegala [359].

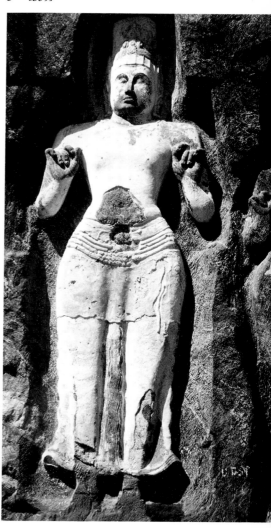

359. Buduruvegala, rock-cut Buddha. Eighth/ninth century

The first type is in princely dress, with a double or triple *kaṭisūtra* (girdle) sometimes with a makara or siṁha mukha clasp, lateral bows, sash-ends falling down on either side, and a jewelled mukuṭa, often with side-pieces: a formula familiar, in varying degrees of complexity, from Early Western Cālukya sculpture and in Tamilnādu throughout the Pallava and Cola periods. These somewhat stereotyped figures stood in samapada. Their eyes are always hollowed out for inlays, and they often have a small śiras cakra at the back of the head, as in many South Indian bronzes, except that they have a tenon for affixing a larger śiras cakra. The figures are found at Polonnaruva, Medigiriya, Situlpāvuva, Budugalge, and Tissa-mahārāma; detached heads are in the museum at Anurādhapura. Probably the oldest is the so-called Dutthagāmaṇī image, datable to c. 600.[23] The identification of these Bodhisatt-vas as Avalokiteśvara in 'princely guise' remains uncertain.[24]

The second type of Bodhisattva is more readily identified as Avalokiteśvara, this time as an ascetic.[25] He wears a distinctive type of jaṭā mukuṭa consisting of coils and loops of hair, and a long dhoti.[26] Some of the detached heads have a Dhyāni Buddha (Amitābhā) on the front of the headdress and one or more rosettes below.[27] Where the arms remain intact, as at Buduruvegala, both hands are in a version of kaṭaka.[28] At least three of these figures, including the one at Situlpāvuva [360], have what may be a lion's skin wrapped round their loins,[29] doubtless in keeping with a Mahāyāna tendency to equate Śiva and Avalokiteśvara (Śiva-Lokeśvara).[30] The finest is unquestionably the Situlpāvuva Bodhisattva, with its proud and noble head and the supreme assurance and sobriety of its modelling.[31] Affinities with sculpture at Māmallapuram suggest a seventh-century date.

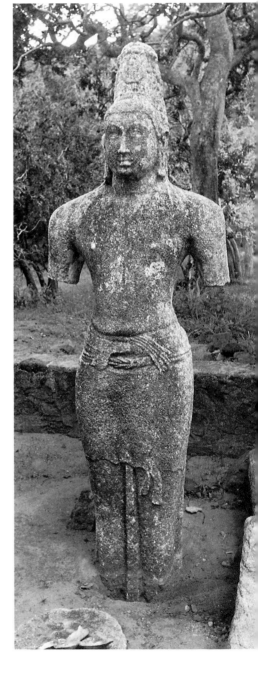

360. Situlpāvuva,
standing Bodhisattva. *c.* 700

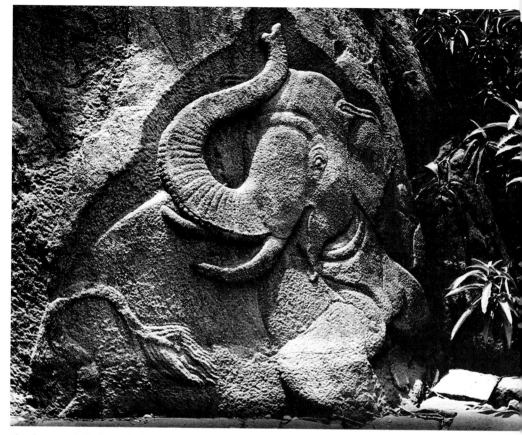

361. Isurumuni, elephant relief

From the later Anurādhapura period (c. 495–c. 993) onwards the Sinhalese produced important rock-cut sculptures, some on a gigantic scale. Of these the elephants sporting among lotuses in a bath (Sinhalese *pokuna*) near the Tisāveva lake at Isurumuni are the most beautiful, instinct with the understanding of animal behaviour so prevalent in Indian – and perhaps most of all Pallava – sculpture [361]. The excellent figure of a man seated in a characteristic pose with a horse's head beside him has been somewhat overwhelmed by scholarly attention and by the record number of identifications proposed.[32] The stiff and lumpy 'Kuṣṭarājagala' or 'Leper King' at Veligama of the tenth or eleventh century, about 10 ft (3 m.) high, now known by the four Dhyāni Buddhas in its mukuṭa to be the Bodhisattva Samantabhadra, associated with later Mahāyāna, is the most detailed Bodhisattva in princely costume.[33] The giant Buddha at Sasseruva, at 12 ft (nearly 4 m.) slightly smaller than its counterpart at Avukana, is far closer to the older free-standing Buddhas and probably earlier in date, although the division of the hairline into two arcs meeting in a joint is a late feature. The group at Buduruvegala including the giant Buddha about 43 ft (13 m.) high is

crude provincial work, unusual in Sri Lanka but partly unfinished. The figures, in part still covered with the original stucco, include women, unknown elsewhere on the island except for the two beautiful unidentified free-

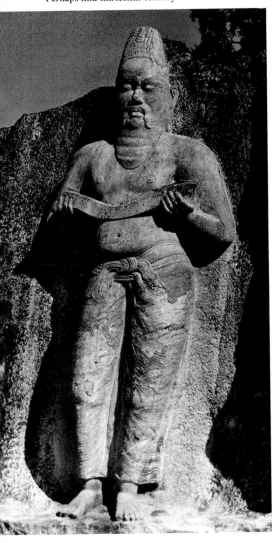

362. Polonnaruva, Potgul vihāra, sage (popularly thought to be Parākramabāhu I). Perhaps mid thirteenth century

standing fragments of unknown provenance now in the Anurādhapura Museum.[34] A giant fallen Buddha at Māligāvela is in the process of being raised. The large rock-cut figures at Polonnaruva of the twelfth and thirteenth centuries include a Parinirvāṇa Buddha and a seated Buddha with a Deccani-style throne-back at the Gal vihāra, and the well-known standing figure holding a book, long thought to represent Parākramabāhu I, at the Potgul vihāra [362].[35]

The damaged seated bronze Buddha from Badulla, probably of the fifth century and now in the Colombo Museum, ranks with the finest early bronzes of the subcontinent. Unique among Sri Lankan seated Buddhas, his hands, like those of later Bodhisattvas, are in the vitarka and kataka mudrās, the latter holding a lotus. The result is a liveliness remote from the deep repose of images whose hands are in the position of meditation. A number of small bronzes, largely of male and female Bodhisattvas, most of them seated in lalitāsana or mahārājalīlāsana, and some with four arms, testify to the extent of Mahāyānist devotion.[36] The famous Tārā (called Pattinī Devī), originally gilded, has a most commanding presence, but the exaggeratedly square haunches are anatomically disturbing and the sculptor has somewhat lost control of the legs [363]. Aesthetically more satisfying is the seated Tārā from Kurunegala, almost a companion piece.[37] Both originally had the Dhyāni Buddhas in a niche in the front of the crown.

The Buddhist monasteries of Sri Lanka are of a princely type foreign to North India and South-East Asia. Instead of the large unitary vihāra, its cells and image-houses part of an enclosure wall and opening on to an interior court containing stūpas or shrines, there are a number of individual buildings, quite densely packed, and none – except for the stūpas and, later, the image-houses – of any great size.[38] In the early Anurādhapura period (c. 250 B.C.–c. A.D. 459) the residential units (Sinhalese parivenas), halls of assembly and instruction, stūpas, and image-houses were grouped rather

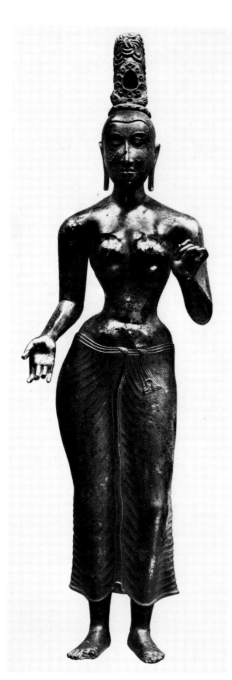

363. Pattinī Devī (Tārā) from eastern Sri Lanka.
Seventh/eighth century. Gilt bronze.
London, British Museum

haphazardly round a large central stūpa (Mahā
vihāra, Abhayagiri vihāra, etc., at Anurā-
dhapura). Except for the stūpas, nothing of all
this remains but bases, steps, and pillars,
largely - even at the great early monasteries -
of the later Anurādhapura period. Square or
rectangular ground plans are the rule for the
image-houses (Pali *paṭimāghara*; Sinhalese *pi-
limāge*), *bodhigharas* (hypaethral shrines enclos-
ing a bodhi-tree), *āsanagharas* (built to house a
Buddha throne and later superseded by the
paṭimāghara), *uposathagharas* (halls of observ-
ances), *upatthānasālās* (assembly halls), and the
general-purpose *pāsāda* [364].[39] A square, im-
penetrable shrine has been postulated, with
seated Buddhas outside facing the four quar-
ters.[40] Until the great brick image-houses of
the Polonnaruva period (*c.* 1055–*c.* 1270), how-
ever, the most impressive structure in size and
architectural importance must have been the
vaṭadāgē, a circular building housing a large
stūpa, its conical roof supported by at least one
ring of pillars;[41] at the Thūpārāma there are four
concentric rings, of the later Anurādhapura
period, however ancient the stūpa itself.[42] The
stūpa is surrounded by a vedikā in the Medigi-
riya vaṭadāgē, by a screen wall at Tiriyāya and
Polonnaruva, confirming the close affinity of
the vaṭadāgē with the circular Hindu shrines of
Kerala.

In the later Anurādhapura period, smaller
monasteries were laid out according to precise
and symmetrical plans quite unlike any others
elsewhere. The *pabbata* (Sanskrit *parvata*, a
mountain) vihāras, not usually built on moun-
tain peaks but rather associated with wilder-
ness dwellings, are to be found on the outskirts
of Anurādhapura.[43] Their relation to the Dhar-

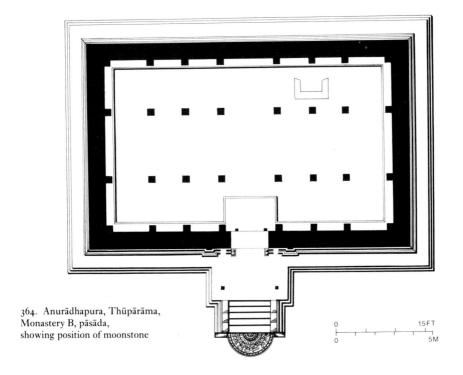

364. Anurādhapura, Thūpārāma,
Monastery B, pāsāda,
showing position of moonstone

0 15 FT

0 5 M

marucika sect and the Abhayagiri vihāra, the seedbed of Mahāyāna in Sri Lanka, has been challenged.[44] In a typical pabbata vihāra (e.g. the Vijayārāma), the focal element is the 'sacred quadrangle', a large raised terrace or rectangular walled enclosure with, each in its quarter, a stūpa, a bodhighara, an image-house, and an uposathaghara, the first two almost always on the south. Kūṭīs[45] are grouped around it, often symmetrically. The whole was surrounded by moats, an enclosing wall, or both. This disposition could be altered according to the terrain, but the four main elements were always present, each in its quadrant. The pañcāyatana parivena, its four kūṭīs forming a quincunx with the central rectangular pāsāda – the most typical grouping of this particular set of monastic buildings in the large vihāras of Anurādhapura – is another unique Ceylonese creation; so are the padhānaghara parivenas, first thought to be

little palace-buildings, where two rectangular sections are linked by a relatively narrow bridge. Unique to some of the pabbata vihāras are the flat urinal stones, carved with the same rich sobriety as the moonstones (see below).[46]

The platforms – along with some rough-hewn pillars, generally all that remain of the extensive monasteries – were usually of brick faced in stone, the mouldings, particularly at Anurādhapura, classically beautiful and meticulously executed. Accessories, also in stone, include the characteristic moonstones – semicircular projections at the bottom of the steps[47] – of which some of the Later Anurādhapura period, also flawlessly executed and of great purity of design, are among the most beautiful low reliefs of the subcontinent [365]. Balustrades flanking the steps up to the platforms have copings issuing from the mouths of makaras or elephants and occasionally reliefs on

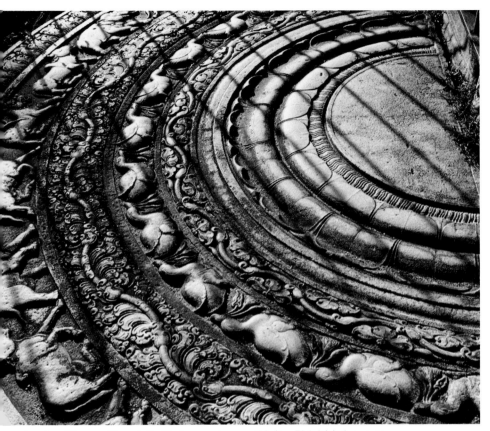

365. Anurādhapura, 'Queen's Pavilion', moonstone, partial view. Eighth/ninth century

their outer faces. They terminate in the so-called guardstones, carved with *pūrṇaghaṭas,* vases overflowing [with vegetation], to begin with, then with polycephalous nāgas, and finally with dwarf figures called *bahiravas* (actually the *śankhanidhi* and *padmanidhi* of entrances in Tamilnādu), or with the better known anthropomorphic nāgarājas, in a style very closely akin to eleventh- or twelfth-century Cola work [366].[48] The capitals of the so-called 'Trident temple' near the Thūpārāma in the form of *vajras* (stylized thunderbolts) are wholly excep-

tional:[49] otherwise there is only one type. Also unique to Sinhalese monasteries is the altar in the form of a lotus on a convoluted stem [367].[50]

Between the Early and the Late Anurādhapura periods civil war and Tamil incursions were perennial. The outstanding event was the accession of the usurper Kassapa (*c.* 477-95) who made the great boulder-mountain of Sīgiriya into a fortress-cum-palace for a god-king, transforming the earlier settlement at the base into a fortified enclosure with a

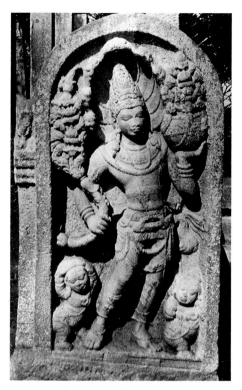

366. Anurādhapura, Abhayagiri monastery,
Ratnaprāsāda (Hall of Observances),
stair guardian or 'guardstone' with nāgarājas.
Eighth/ninth century. Limestone

367. Flower altar from Anurādhapura.
Eighth/ninth century. Limestone.
Colombo Museum

lake and pleasure-garden.[51] The rock face of
the gallery leading to the summit was painted
in tempera with the famous apsarases, in a
style related to the contemporary frescoes at
Ajantā [368].[52] Wall paintings in a late classical
manner of jātaka stories and of the life of the
Buddha survive in the Tivaṅka pilimāge at
Polonnaruva. The scenes inside many image-
houses of the Kandyan period (sixteenth to
nineteenth centuries), particularly at Kelade-
niya,[53] exemplify modern Buddhist trends in
Sri Lanka.

South Indian influence was naturally strong
under the dominance of the Colas around
1000. From this period dates the Śiva Devale

No. 2 at Polonnaruva. A small Cola temple, it
is, like No. 1, a couple of centuries later, one
of the very few all-stone buildings of ancient
times on the island.[54] From this period date
a large number of Hindu images, a few in
stone but most of them bronzes. Some of them
are imports from Tamilnāḍu, but the large
majority are the work of local craftsmen. A
seated Buddha of this period, from Tantri-
malai in the north, has the characteristic
Karnāṭaka throne-back.[55]

The remains of the ancient Lohapāsāda
(Brazen Palace) have been identified at
Anurādhapura.[56] According to the chronicles it
was nine storeys high. The palace at Panduwas

368. Sīgiriya, paintings in the gallery. End of the fifth century

Nuwara, built by Parākramabāhu I (*c.* 1153–86) while still only a local ruler, was enclosed within a brick-walled citadel with a single entrance. Large terracotta plaques bearing elephants and other motifs have been found there. It includes a large Temple of the Tooth (Daḷadāgē). Far larger is Parākramabāhu's palace at Polonnaruva, with its double enclosure walls, large open forecourt, hypostyle hall, and two very large rooms in a brick edifice with massive walls, largely ruined but still rising to three storeys. The inner enclosure is surrounded by a gallery of interconnecting rooms open to the outside. The magnificently sited palace at Yapahuva, largely of stone in a thirteenth/fourteenth-century South Indian style, includes a monumental staircase leading up to a structural gateway [369].

Parākramabāhu I unified the kingdom as well as reconciling the contending sects of the Mahā-vihāra, restored buildings at Anurādhapura and Mihintale, and repaired and extended vast irrigation systems. He made Polonnaruva his capital, undertaking there the last great architectural projects in Sri Lanka. Brick is introduced on a grand scale in the three great paṭimāgharas, with their barrel-vaults, internal staircases leading to three or four upper storeys, and copious stucco decoration.[57] The smallest and probably the oldest of the three is the Thūpārāma, with a seated Buddha. The Laṅkā Tilaka (with magnificent great fluted pilasters at the entrance) [370] and the Tivaṅka both have huge standing Buddhas of brick finished in stucco. The finest external stucco is on the Tivaṅka pilimāge, with Bodhisattvas and

369. Yapahuva, gateway and monumental stairway, from the side. Thirteenth century

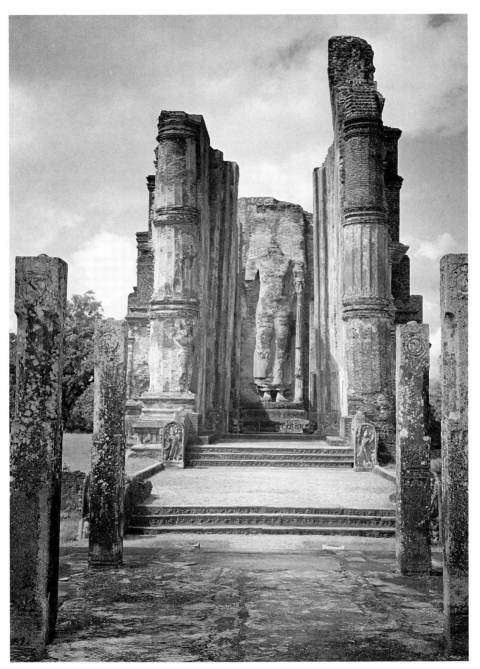

370. Polonnaruva, Laṅkā Tilaka. Twelfth century, third quarter

371. Polonnaruva, Tivaṅka pilimāge, reconstruction.
Twelfth century, second half

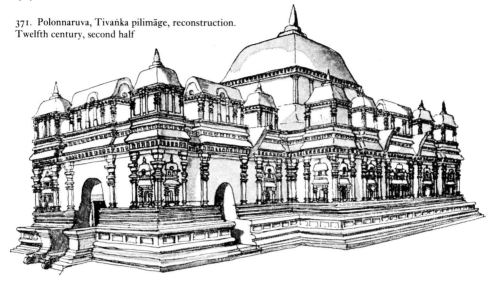

372. Polonnaruva. Twelfth century, second half. Plan of buildings

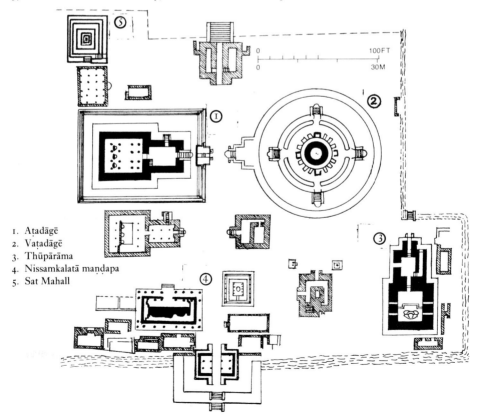

1. Aṭadāgē
2. Vaṭadāgē
3. Thūpārāma
4. Nissamkalatā maṇḍapa
5. Sat Mahall

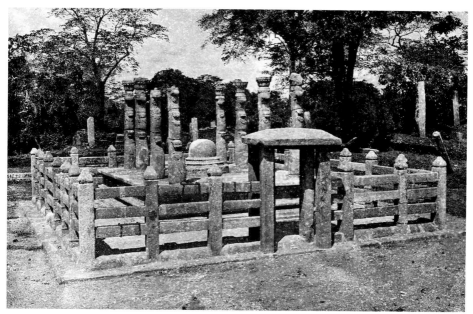

373. Polonnaruva, Nissamkalatā maṇḍapa. Twelfth century, last quarter

multi-storey miniature shrines in the late Drāviḍa mode probably imitating the now missing superstructures of these buildings [371]. In spite of this, on plan and structurally these great works are indigenous creations, owing nothing to South India.

At Polonnaruva [372], as at Medigiriya, the vaṭadāgē has seated Buddhas at the cardinal points.[58] Exceptionally, they have smooth hair, and the pleats of the robe are not indicated. The sanctum of the Temple of the Tooth (Sinhalese Aṭadāgē) was preceded by a maṇḍapa-like structure of which only the base and the columns – some of them elaborately carved, a rarity in Sri Lanka – remain. The sacred relic was housed in the upper wooden storeys.[59] The lotus-stem columns of the Nissamkalatā maṇḍapa, dated to the reign of the king of that name (c. 1187-96) by a Tamil inscription, perhaps represent the last flowering of the stone-cutter's creativity in Sri Lanka [373]. The Sat Mahall, on a square plan with six receding storeys, remains unexplained.[60]

After the Polonnaruva period, capitals migrated and national integrity declined. But the final emergence of the Kandy kingdom saw a return to purely indigenous structures, for instance the Palace and Temple of the Tooth at Kandy.[61] A great ivory-carving tradition must have existed earlier, but examples are known only from the Kandy period, notably the splendid presentation caskets and cabinets which reached Europe in the sixteenth and seventeenth centuries. Combs, daggers, and other artefacts reflect the superb craftsmanship and classical purity of design of decorative carving in Sri Lanka from the Later Anurādhapura period onwards.[62]

374. Map of the valley of Kathmandu

NEPAL

CHAPTER 35

A NATIONAL SYNCRETISM

If Nepal did not exist it would, to embroider on Voltaire, be well-nigh impossible to invent, superabundantly endowed as it is with the fruits of fifteen hundred years of artistic creation and a wealth of cultural, social, political, and even geographical paradoxes.[1] As far as its artistic and to a large extent its cultural history is concerned, Nepal consists of the valley of Kathmandu, an area of less than 200 square miles (about 300 square km.) which it is not difficult to walk across in a day, together with a few towns and sites on the valley's rim [374].[2] Yet even in comparatively recent times (i.e. the sixteenth to eighteenth centuries) this astonishingly small area housed three independent city-kingdoms. At one time, c. 1100, what is now the old quarter of the present-day capital of Kathmandu actually accommodated three separate self-governing micro-states.[3] The exiguity of the valley, its Newar population racially and culturally distinct from most of the rest of the country and with a language of its own, together with relative freedom from invasion, have all contributed to the development of Nepal's distinctive culture.[4]

Two factors have had a decisive impact. The first is that here alone among the countries in which it has flourished (including, of course, India) Buddhism continues to thrive side by side with Hinduism. The second is that centuries-long isolation, allied to a very strong sense of cultural identity, have meant that in many areas time has virtually stood still for the past four hundred years or so, so that

art flourishes in the living context in which it was created. Many people still inhabit or use the old rest-houses, monasteries, temples, palaces, and – most often – private dwellings, all fine buildings of brick and wood often partly sheathed in splendidly worked metal. Very different is the situation in India and Sri Lanka, where little traditional secular architecture has survived, except for a few pockets mainly in western India: elsewhere, apart from palaces, Rājput and Late Mughal echoes are all that linger.

It is not surprising that the first Western students of Nepal believed that they had found a living fragment of pre-Muslim India which would provide the answers to many vexing questions about the subcontinent in ancient times, and particularly its secular architecture.[5] However architecture in Nepal, as in most of the sub-Himālayas, was out of the main stream, and most of its buildings (though many no doubt follow pre-existing ones) date from after the fifteenth century. Nevertheless, the country remains unique in its fifteen-hundred-year-old heritage, nourished at virtually a single source – India – in conditions of near-total political independence.

The blurring of distinctions between Hinduism and Buddhism, accepted enthusiastically by an exceptionally tolerant people, was the result chiefly of the increasing sway over both faiths of tantric beliefs and practices.[6] Moreover certain divinities and cults took on national significance, not only in terms of ter-

ritorial extent but in the consciousness of the people. The king (or kings, under the three kingdoms) saw himself as closely associated with a god (the present kings of Nepal are considered avatars of Viṣṇu), which conferred on him not divinity but legitimacy. Hence the duplication and even triplication of shrines in the three main cities and the existence, even in such a small area, of surrogate *tīrthas* (holy places) and the almost unprecedented resiting of some of the most monumental images. Important finally in the religion of the valley is the cult of plain stones, often representing the Mātṛkās.

A few sculptures of the early Lichchavi period (300-850),[7] generally in very poor condition, with close affinities to late Kuṣāṇa work at Mathurā or early Gupta remains in the western Uttar Pradesh include a pair of Hārītīs either in a squatting or in a pralambapada pose, and a standing Bodhisattva.[8] These links with western rather than eastern India are confirmed by the discovery of numerous Kuṣāṇa coins and the fact that the Śaka era was used in the valley until the early seventh century. The affinities of the two 'royal' statues are more obscure.[9] The earliest dated inscription (464) at Cāṅgū Nārāyaṇa belongs to the Lichchavi king Manadeva, and the earliest dated sculpture (467) is the famous Viṣṇu Vikrānta in a small lone tombstone-sized shrine at Tilganga (Deo Patan), disappointingly small but iconographically remarkably developed.[10] It is difficult to believe, moreover, that the ekamukhaliṅga at Mṛgasthali (Deo Patan), in the purest late Gupta style, is later than the mid sixth century.[11]

The greatest achievement of Nepali art, probably slightly later and already in a more distinctive style, is a small group of monumental sculptures associated with kings whose names end in -gupta, notably one Viṣṇugupta (*c.* 640) who challenged Lichchavi rule in the area.[12] Water, so important to the valley (witness the many public fountains), is a theme of all of them, quite literally, for they were installed (and remain) in tanks. Great serpent

375. Kathmandu, Hanuman Dhoka palace, Kāḷiya Damana. Seventh century

coils also bulk large. In the Kāḷiya Damana in the Hanuman Dhoka palace in Kathmandu, the serpent-demon's human torso and head rise from a veritable mountain of coils as he is belaboured by the little Kṛṣṇa standing on his shoulder and head [375]. The god, neither baby nor yet quite adolescent, is naturalistically rendered in full onslaught.[13] In his small-featured, typically Nepali face signs of cruelty have been detected.[14] Two other sculptures, one over 21 ft (6 m.) long at Būdhānīlakantha, the other at Bālāju, are again totally original Nepali conceptions of the Viṣṇu Anantaśayana theme.[15] The god lies flat, his legs crossed, bedded on the great coils of the serpent half submerged in the waters of the tank [376]. The characteristic face has an aquiline nose, a sharply defined chin, a pouting lower lip, and rather fleshy jowls [377]. The crown is trilobed, with kīrttimukhas. A third such figure, in the Hanuman Dhoka, not yet properly examined, is probably of the same period.[16] It has long been associated with

376 and 377.
Būdhānīlakaṇṭha, Viṣṇu Jalaśayana,
with detail. 642

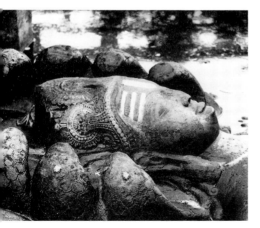

Pratāpa Malla (1641-74), who brought the Kāḷiya Damana to the palace, and the chronicles unequivocally state that it was an old Jalaśayana from a nearby site which the king installed in the Hanuman Dhoka. To this

group must be added the huge standing Viṣṇu, some 12 ft (4 m.) tall, with his two sons as āyudhapūruṣas, in the Rāmachandra temple at Paśupati (Deo Patan).[17]

Another great Lichchavi work, at Cāṅgū Nārāyaṇa, is the first complete example of the characteristic Nepali Garuḍa, on one knee, wearing his wings like a cape [378]. Such images usually crown a pillar. We cannot tell whether or not this one represents King Manadeva, beside whose inscription of 464 it was found, but there can be no doubt that it is a portrait, for the sympathetic moustached face is totally different from any other in the whole of Nepali sculpture. All these images, including the fine Varāha at Dhumvārāhī, are of course Vaiṣṇava, in spite of Nepal's predominantly Śaiva affiliation.[18] Towards the end of the Lichchavi period, a number of standing Buddhas and Bodhisattvas strongly reflect the influence of Sārnāth.[19]

The valley counts numerous large and important stūpas, of which small stone votive ver-

378. Cāṅgū Nārāyaṇa, Garuḍa.
Sixth/seventh century

sions, locally known as *Ashok caityas*, strew many of the vihāras. Some with Buddhas seated back to back round a column recall catur-mukha liṅgas, but most have high, square bases in two registers, the directional Buddhas seated on each side above, the Bodhisattvas standing below. Later the domes become more elongated, with a straight portion.

The oldest stūpas are believed to be the four situated at the cardinal points at Pāṭan, the most Buddhist of the three principal valley towns (the others being Kathmandu and Bhatgaon or Bharatpur). These stūpas have low domes of the type associated with Aśoka, although no evidence of such extreme antiquity has been found; but then Nepalese like

Sri Lankan stūpas remain unexcavated. A square harmikā and a variety of pinnacles surmount the Pāṭan buildings. The Svayambhu, on a hillock just west of Kathmandu, dedicated to the five *Tathāgatas* (Buddhas), is the main shrine of Nepali Buddhism [379]. The four Dhyāni Buddhas stand one at each of the cardinal points, with the fifth, Vairocana, between east and south high on the harmikā. Between them are five goddesses, their spiritual consorts. The pinnacle has thirteen gilded metal rings and a crowning parasol. A gilded bronze vajra five feet long stands on the top of the hill, where numerous chapels surrounding the stūpa give a foretaste of the metal architectural ornament for which the valley is famous. The steps leading up to them are flanked by pairs of horses, lions, elephants, peacocks, and garuḍas, the vehicles of the Tathāgatas. The stūpa on the adjoining hill dedicated to the Bodhisattva Mañjuśri is one of the national shrines of Nepal, for Mañjuśri is identified with Sarasvatī and consequently worshipped by Hindus as well as Buddhists.

The great stūpa at Bodhnāth is largely a Tibetan preserve, for it lies on the trade-route which was the principal access from the Indian plains to Tibet until the easier route through Kalimpong superseded it in the nineteenth century.[20] Instead of the four directional Buddhas, 108 little images of Amitābhā are set into the base of the dome which, as in all these stūpas, is low, and less than a hemisphere. The pairs of eyes painted later on the harmikās of most of the great stūpas signify the 'all-seeing eyes of Buddhahood'.[21]

The thousand years from the close of the Lichchavi period, *c.* 750, to the advent of Gurkhā rule in 1767–8 is usually divided into a post-Lichchavi (or Thakuri) phase, much of it still obscure, and the period of the Mallas of the three kingdoms, commencing in 1480 with Yakṣa Malla, which saw the construction of almost all the valley's extant buildings. Much stone sculpture and many bronzes survive from the post-Lichchavi period, when eastern India became the principal stylistic

379. Kathmandu,
Svayambhu stūpa

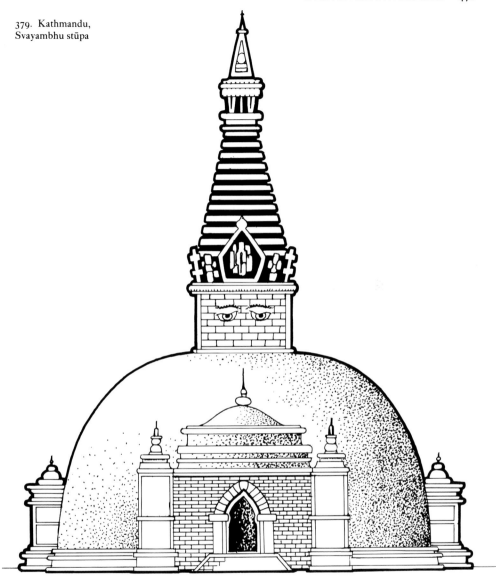

source, except for painting. Pāla influence, however, appears to be less than is usually assumed, for Nepal had firmly established its own style of sculpture. Late in the fifteenth century, the division into the three kingdoms was formalized, consolidating to an extent the plurality of the valley's little centres of power. It was about this time, after the raid of Shams-ud-dīn Ilyās, that King Sthithimalla instituted a brahmanization of Newar society which coincided with the final eclipse of Buddhism in India.

Until the eighteenth century – when Chinese influence started to permeate Tibetan, and to a certain extent Nepalese, art – Newari craftsmen and artists played a determining role in Tibet, at least in the central region around Lhasa, in the fields of painting, the decoration of monasteries, and metalwork. As long as Buddhism still flourished in eastern India, Nepal acted in part as a channel for Indian influence, but eventually it was to Newar art, often produced by resident Newari artists, that Tibet was indebted for a great deal of its artistic tradition. Except for the masterpieces of the seventh century, it would be quite wrong to class Nepalese sculpture as a regional variation of Indian art; its peculiar fluency, charm, and elegance derive from a racial character that is totally distinct.[22]

In the post-Lichchavi period a favourite among Nepalese sculptors was Garuḍāsana, that is Viṣṇu seated on Garuḍa, a partially anthropomorphized bird. The first representation, in the sanctum of the Cāṅgū Nārāyaṇa temple and unseen by any art historian,[23] is probably of c. 500, roughly the date of the image from eastern India in the Cleveland Museum of Art. A fine ninth-century example, also at Cāṅgū Nārāyaṇa, has the four-armed Viṣṇu seated majestically in pralambapada upon a squatting anthropomorphic Garuḍa whose outstretched, slightly raised arms encompass the lower part of the god [380]. The monumental ground consists of the swirling stylized tail-feathers of the man-bird.[24] Nowhere has a more generous setting been devised for Viṣṇu, with its superb balance between the plain surface of the curved bowl formed by Garuḍa's arms and the rounded outline of the ground behind the god's torso, head, and halo. As always in Nepal, Garuḍa has the head of an adolescent, and Viṣṇu holds the conch horizontally.

380. Cāṅgū Nārāyaṇa, Viṣṇu Garuḍāsana.
Ninth century

By the ninth century, haloes in Nepal have become oval, usually, like the whole stele, with a pearl and flame border.[25] The persistence of spiral armlets and of a fondness for rustication of the bases, together with constant repetition of ancient themes and poses and even details of costume, makes the dating of Nepalese sculpture between the eighth and the thirteenth centuries a daunting task.[26] It is nonetheless a capacity for pastiche that has maintained almost to this day a semblance, at least, of vitality in Nepalese sculpture, rescuing it from the total degeneracy common in India.[27] The heroic panels become more densely peopled, but psychological relationships falter, as a comparison between the latest of the known Vikrānta images, from Pharping and probably of the thirteenth century [381], with the image dated 467 makes very clear.[28] The fine ninth-century Viśvarūpa Viṣṇu at Cāṅgū Nārāyaṇa is overcrowded, even taking into account the complex iconography of this type, and the organization of the multifarious elements is somewhat simplistic.[29]

After the Lichchavi period, Viṣṇu appears most commonly standing in samapada, flanked on one side by Lakṣmī, on the other by Garuḍa, who occasionally appears in this position in western India but never in the east. It has been proposed that this icon represents the para, or highest, aspect of Viṣṇu.[30] A version exists from as late as 1695.[31] Stone Sūryas are very frequent, and caturmukha liṅgas recur throughout the valley. The oldest for which there are any references, installed in the Paśupatinātha temple at Deo Patan, or its immediate predecessor, was destroyed by the Muslim invaders, but its fourteenth-century replacement is said to be based on the original. As in Kashmir, the torso of the god, or at least two hands, is represented on all four sides of the liṅgas, as well as the head. The predominance of this niṣkala (abstract) form of Śiva and the paucity of other Śaivite icons may be due to the dominance of the Paśupatas in the formation of Nepali Śaivism.[32] The only anthropomorphic (sakala, literally 'having parts') Śaiva

381. Pharping, Viṣṇu Vikrānta. Probably thirteenth century

icon of any currency is Umā-Maheśvara, Umā sitting on the lap of Śiva or cuddling up to him, a Kalachuri creation endlessly reproduced in Nepal until modern times.[33]

Nepali sculpture at times recalls and even foreshadows Pāla sculpture,[34] although there are no pierced grounds. As a rule, however, forms are smoother and more lissom, and muscles are unknown. Nepali sculpture retains its individuality in part through a subtly different placing of sashes and ornaments. Until the twelfth century, bhaṅgas are relatively re-

strained. Thereafter, in metal sculpture, jewellery and ornament are less adornments of the flesh than important subjects in their own right. After the twelfth century vitality and originality are rare in stone but not - inexplicably - in metal, perhaps in part due to the introduction of tantric themes, which were largely confined to bronzes.

In 1278 Aneko and sixty Nepalese craftsmen were sent to Tibet and thence to China to the court of Kublai Khan, witness to the high esteem in which Nepalese metalwork was

held. The earliest surviving securely datable bronze of importance was donated by a nun from Lalitpur (Pāṭan) in 591.[35] Nearly indistinguishable in style from the rare contemporary bronze Buddhas from Uttar Pradesh and Bihār, it may indeed have been an Indian import. The robust plasticity of the fine tenth- and eleventh-century Viśvarūpa Viṣṇu now in the Boston Museum of Fine Arts and the Tārā in the British Museum [382] also parallels contemporary Indian sculpture.[36] Nepali bronzes, like Tibetan ones, often lack surrounds (*prabhāvallis*), either by design or by accident of loss. From now on, the images are often gilded.

The superb seated Avalokiteśvara from the Golden vihāra in Pāṭan, probably of the fourteenth century, is an example of Nepalese sculpture pursuing its own development [383].[37] The infinite suavity of modelling, the gentleness and calm of the seated pose, associated with yoga, and the beauty of the face are far remote from anything Indian, whether contemporary or later. This image is one of the high points of bronze sculpture in Nepal, to be rivalled only by a few pieces of the fourteenth and fifteenth centuries, among them some of the many Indras wearing mitre-shaped crowns and seated in rājalīlāsana, often without a base.

Nepal has always had a penchant for repoussé. A sheath for a Garuḍāsana Viṣṇu was made in 607,[38] and a fine gilt bronze plaque of a standing Viṣṇu with a richly worked background, now in the Los Angeles County Museum, is dated 983.[39] In the seventeenth and eighteenth centuries, if not earlier, repoussé images in the round appear, some as large as the eighteenth-century Tārā in San Francisco.[40] Edges are sharper, angles more pronounced, and there is a certain stylization, of the breasts, for example [384]. Here, as in the many architectural applications of repoussé work, the Nepalese craftsman makes metal – and to a much lesser extent wood – appear, in Percy Brown's phrase, more tensile than it really is.[41] In the later bronzes, jewellery is picked

382. Tārā.
Eleventh/thirteenth century. Bronze.
London, British Museum

out with small cabochon semi-precious stones (paste in modern examples).

Closely allied in style to the large gilt-metal seated portraits of later Malla kings set on top

383. Pāṭan, Golden vihāra, seated Avalokiteśvara. Probably thirteenth century. Bronze

B. 60. S. 22

384. 'White' Tārā. Probably eighteenth century. Copper repoussé gilded.
San Francisco, Asian Art Museum, Avery Brundage Collection

385. Bhatgaon,
King Bhupatīndra Malla (1696–1722).
Copper repoussé gilded

of pillars in front of temples or the entrances to palaces [385] are the countless votive or donor couples, often inscribed and dated.

The traditional architecture of the valley – whether private dwellings, special communal buildings (*sattals*), palaces, monasteries, or the several kinds of shrines – is of brick and timber, with sloping tile roofs.[42] The more elaborate buildings may use metal, usually copper, for finials, to cover roofs, as repoussé cladding for wooden reliefs, or – particularly beautifully – on the spouts of public fountains. Silver is exceptional, a particularly munificent offering to the god. Wooden pillars, intricately carved door and window surrounds, and elaborately patterned lattices for windows and balconies are plentiful.[43] Ground plans are usually square, the buildings, once entered from the street, grouped around a courtyard. *Caityas* (stūpas) and 'pagoda' temples occupy similar courtyards or stand detached in the streets or on the great durbar squares upon which the palaces face. The typical Newar scene is urban, the houses joined together, with paved streets and courtyards. Abundant wood-carving, together with the Newar fondness for raising buildings on wooden pillars, for screened balconies, and for building to two and three storeys, all contribute to the picturesqueness of the valley towns, unexampled elsewhere on the subcontinent.[44]

Newar architecture uses not only the same materials but the same methods of construction for all types of building. Here there is a striking and instructive parallel with the entirely wooden structures of early Indian architecture, otherwise known only from the reliefs and rock-cut caves. The forms and methods of construction may be very different, although verandas and wood lattice-work are common to both, and there is the same homogeneity between secular and sacred architecture. Even the decoration of Newar buildings, closely associated with or determined by structural features, is essentially the same throughout, varying only according to the building's importance and, secondarily, with religious or iconographic demands.

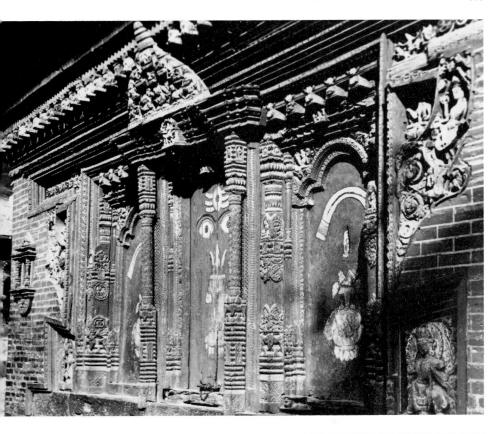

386 and 387. Kathmandu,
Jagannātha dega, side portal and detail of west façade.
Seventeenth century

The most common feature of Nepalese
buildings after the tiled pitched roof is the
wooden door or window lintel, and sometimes
the sill as well, set into a brick wall and pro-
jecting far beyond the jambs. In its most ex-
aggerated form it is responsible for the extra-
ordinary wing-like appearance of the doorways
of major temples [386 and 387].[45] The struts
(*tuṇālas*) carved with standing figures and their
vehicles or supporters extending from the
cornices to the ends of the overhanging eaves,
so arresting in Newar temples, were originally
intended to support the overhang of the heavy
tile roof, often lined with clay.[46]

A fascinating thing about Nepalese architecture is that it is possible to identify ancient themes of Indian doorways and gateways in buildings no more than two or three hundred years old.[47] The projecting lintel can be traced back to Kuṣāṇa times, and it is standard in Gupta temples. The side panels, however disguised by oblique stylized outlines, plainly originate in the positions occupied by the river goddesses in the Gupta period, and frequently bear female figures today. Some motifs on the lintels and jambs of doorways, like the beam ends in the form of lions' heads, can be traced back to Gandhāra or to Gupta temples in India proper. The zigzag round the innermost part of the door-frame, observed on a number of Gupta temples as well as at Ajaṇtā but surviving only briefly thereafter in eastern India, is plainly recognizable on the doorways of many 'pagoda' temples [386]. The difference is that the form is never anything but trapezoidal.[48] The 'alternating triangle' motif of the Gupta and post-Gupta period can be identified on at least one temple doorway.[49] The brackets or struts carved as human figures (at first yakṣīs) go back to Sāñcī. Except for the last, all these motifs had vanished in India by c. 1000. Of all the wood-carved forms of Nepal, the finest are unquestionably the early tuṇālas, probably of the thirteenth or fourteenth century, in the form of yakṣīs [388]. With the exception of a carved wooden figure found at Dhaka in Bangladesh, they are without peer in the woodcarving of the subcontinent.[50] Later tuṇāla figures are usually many-armed tantric divinities, the arms added separately.

The most common public buildings in the valley are the dharmaśālās, called *sattals* in Nepal, from Sanskrit *sattra* (almshouse).[51] They range from simple wayside shelters to the three-storeyed Kāṣṭhamaṇḍapa, the largest and (though much restored) the oldest building

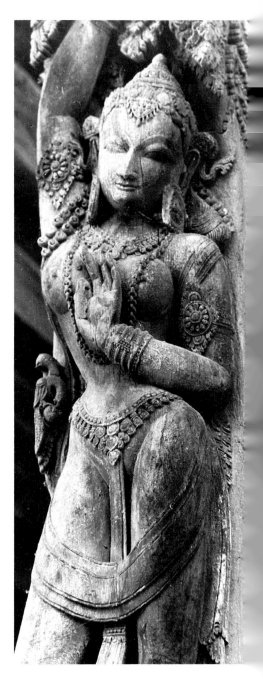

388. Panauti, Indreśvara Mahādeva, high-relief wooden tuṇāla in the form of a yakṣī or śālabhañjikā with a parrot. Late thirteenth century

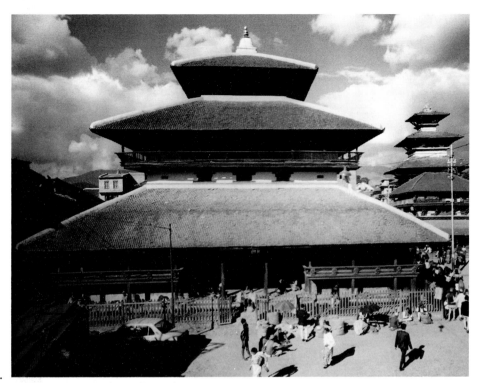

389. Kathmandu, Kāṣṭhamaṇḍapa. *c.* 1100

in Nepal in traditional style, probably dating from *c.* 1100 [389]. It has given its name to Kathmandu. The simplest type, in Nepali *pāṭī* (Newari *phale* or *phalacā*), is nearly always rectangular and consists of a platform and a two- or four-sided pitched tiled roof raised on pillars. There is usually a back wall, except when the pāṭī is built into a house. The maṇḍapa is a particular kind of sattal, always completely unwalled and almost always square. Maṇḍapas usually have only one storey and belong to the village or town, not the wayside.

The sattal proper, usually of more than one storey, 'caters to a more permanent occupation', although still the preserve of the wanderer; fixed communities preferred the monastery, Buddhist (*vihāra*) or Hindu (*matha*).[52] Sattals may have as many as four storeys, the

upper ones plentifully supplied with pillars. The ground floor usually incorporates a shrine, and sometimes even shops. This elasticity of use, and its importance in determining what the building is considered to be, is well exemplified by the Dattātreya, built by Yakṣa Malla (1428–82) in Bhatgaon, his capital, as a sattal but later converted into a temple.[53]

Vihāras (Newari *bāhā* or *bahi*) are of two storeys, sometimes higher over the shrine.[54] Centred on a courtyard, unlike Newari houses they have few windows on the outside walls. Entrance is usually by an ornamental doorway opposite the main shrine, of Śakyamuni for example, or Avalokiteśvara, guarded by Sariputra and Mudgalyana, with another above it for a tantric Vajrayāna deity. The tuṇālas are generally carved with the Dhyāni Buddhas,

390. Panauti, Indreśvara Mahādeva, carved wooden tympanum. Late thirteenth century

many-armed, crowned, and identified by their vahanas. There is always at least one caitya (stūpa) in the courtyard (sometimes a pagoda-type shrine), a pit for the sacred fire, and a maṇḍala with Vairocana at the centre and the Tathāgatas at the cardinal points.[55] Few vihāra buildings are as old as the fourteenth century, and most date from the seventeenth and eighteenth.[56]

In Nepal the gods of Hinduism and Buddhism are sheltered in many a different fashion or not at all. Besides temples, they are worshipped at *pīṭhas* (open-air shrines), in sattals and monasteries, and occasionally in private houses. The type of building depends largely on the nature of the deity and of the worship conducted there. It is usually a matter of adapting domestic types: the *āgama-chē*, the private temples of clans or associations, are very much like private houses and so are the temples of the Mātṛkās (sometimes worshipped in the form of unshaped stones), which are

391. Kathmandu, Jagannātha dega. Seventeenth century

almost always rectangular. In the sattal at Bhatgaon the Mātrkā shrines are at the cardinal and intercardinal points, with Tripurasundarī at the centre, according to a maṇḍala which determines the religious geography of the town and even the names of its various quarters.[57] A mark of sacredness is the tympanum (somewhat misleadingly called a *toraṇa*), a large panel of wood or wood sheathed in metal, usually with tantric deities in relief between addorsed makaras [390]. Above is a garuḍa or a kīrttimukha, and then a ringed, horn-like projection, a stylized form of the parasols above the caityas.[58]

Most impressive, highly specialized, and intriguing are the so-called 'pagoda' temples (Newari *dya-ga* or *dega*) [391]. As their popular name implies, they have analogues elsewhere, the closest the pitched-roof temples of Himachal Pradesh. The earliest surviving dega are the shrine of Paśupatinātha, the supreme deity of the valley, at Deo Patan (second half of the fourteenth century),[59] and perhaps the Indreśvara at Panauti, just beyond the valley (1294?). They spring up fully evolved, and modifications in later versions, some as late as the nineteenth century,[60] can easily be recognized as developments from the earliest type. The dega, on low platforms at first, are square *sarvatobhadrika* temples (i.e. with entrances on all four sides), of brick and timber, like all Newari buildings, with an internal circumambulatory passage and an inner shrine-room or garbhagrha also open on all four sides. Above is an empty shrine-room. The brick walls of the dega are structurally essential.[61] The silhouette of sloping overhanging roofs, receding in size, is common in other sorts of buildings, too.[62] The earliest of the dega appear to have had only two roofs; a third was sometimes added later. As is the case with all the more elaborate Newari buildings, the roofs have metal horn-like or bird-like elements at the bottom corners, giving them an additional 'Chinese' upturned look. The building is always crowned by a gilt metal finial which is shaped like a stūpa.

Tuṇālas extending from cornice to roof-end at an angle of 45 degrees are indispensable. There are six to a side on the lowest part of the Indreśvara, with griffins or śārdulas at the corners, to a total of twenty-eight. They include a couple of Mātṛkās, a number of yakṣas and yakṣīs [388], and, oddly enough, the Pāṇḍavas and members of their entourage.[63] The numbers of tuṇālas decrease as the building rises. Entry is usually through three doorways close together, the central one with a toraṇa above, within an extremely intricately carved surround with a cornice and separating pillars. On the sides, tying the doorways into the brickwork, is an upper bracket with river goddesses, and a lower projection with a stylized and highly stylish oblique line to its upper edge, all carved in relief with deities and other figures [386, 387, 391]. The result is the most intricate, and artistic, bonding of wood to brick ever devised. The elaboration of the doorways is in marked contrast to the completely plain - not to say mean - aspect of the circumambulatory passage and sanctum. Maṇḍapas are completely foreign to the dega - one result of their multi-directional orientation, for, in spite of their external decoration, they are in essence simple mandalas.

The two earliest surviving dega are Śaiva and enshrine caturmukhalingas. The early Nārāyaṇa temples at Pāṭan (1564), the Jagannātha at Kathmandu, and the Dvārkanātha at Bhatgaon have the same plan, with sarvatobhadrika images. The *caturvyūhas* (emanatory forms of Viṣṇu according to the Pāñcarātra doctrine) are represented on the four sides, the Nārāyaṇa invisible in the centre of the image.[64] The famous Cāṅgū Nārāyaṇa temple is a foundation of the fifth century or earlier, but no surviving building dates from before the eighteenth century. If the original temple enshrined a Garuḍāsana Viṣṇu, as appears probable, it could not have been multi-directionally oriented.[65] Some of the later dega are not, and on occasion the circumambulatory passage is divided into shrine-rooms. The platforms acquire more steps, sometimes as many as seven, as at

Taleju in Kathmandu, the largest of the dega, constructed in 1576. Roofs are added, or dega are built with as many as five receding roofs, like the Kumbheśvara in northern Pāṭan, or the better known if less impressive Nyatapola at Bhatgaon on its artificial mound.

In spite of much speculation, we still do not know the origin of the dega, or what kind of a temple it is. The best we can do is to note, for example, that superimposed sloping roofs occur in regions of high snow- or rainfall in many parts of the world, from Kerala to Norway; that Gupta temples have no maṇḍapas, and some have inner circumambulatory passages and upper shrine-rooms;[66] and that multidirectional shrines accord with ancient Indian traditions and persist until the sixteenth century, notably in Rājasthān and Kerala.[67]

Masonry temples in a Nepali version of contemporary North Indian styles appear occasionally from the seventeenth century onwards. They bow to the national predilection for pillared halls, in the form of peristyles. Śikharas tend to culminate in stūpa-like features. Secular building was resumed in the mid nineteenth century, at first in Late Mughal or Rājput styles, but turning later to European models.

Nepal has also produced a cornucopia of painting, from murals (the least important) and palm-leaf and paper manuscripts and their wooden covers [287, 288] to paintings on paper and, most important of all, on cotton scrolls (paṭas; Newari paubhās).[68] The earliest dated illustrated manuscripts, of the first half of the eleventh century, closely resemble eastern Indian ones (both ultimately derive from Ajaṇṭā), but differences in style and particularly in colour already distinguish the Nepali work, which includes Hindu as well as Buddhist manuscripts. In this it differs from the Indian tradition which, moreover, ceased abruptly after the thirteenth century, whereas in Nepal manuscripts continued to be illustrated for hundreds of years, changing over to paper without basic alteration in format. 'Illustra-tion' is perhaps a misnomer, for these hieratic little paintings of gods and goddesses, and occasionally vignettes of holy sites or Buddhist canonical events, usually bear little if any relationship to the texts: they are primarily objects for worship, and were decorated as such with holy symbols.

It is no exaggeration to say that the paṭas, until the eighteenth century almost all of the highest quality, include many of the finest paintings produced in the subcontinent over a period of several hundred years. They continue the ancient tradition of Indian scroll painting with almost no admixture of foreign styles and a negligible folk element, in contrast to the Mughal-Rājput schools. The connection between Nepalese paṭas and Tibetan thankas, many of them equally fine, is a close but complex one, and it is often difficult to distinguish between them, particularly when they portray tantric divinities in sexual congress with their śaktis, never a subject for Indian images. However the waves of Chinese influence which washed from time to time over Tibetan painting barely affected Nepal. Most important, the tradition of hanging-scroll painting was transmitted to Tibet principally by Newars, who continued to paint many of the thankas.[69] It is natural, then, in a highly Indianized society that the paṭas (and many of them are Hindu) should continue more of the ancient Indian traditions. Nepali paṭas occasionally illustrate scenes from real life, and lay donors figure largely, some of them commemorating a particular religious observance that they have undertaken. Many are votives. All this is either unknown in Tibet or cloaked in the anonymity of monastic communities.

The finest paṭas were produced between the twelfth and the sixteenth centuries. The earliest to survive is a maṇḍala dated 1367, the first of several.[70] Characteristically Nepali features include a black background and the use of a fine brick red, a 'brocaded' background of tight vegetal scrolls in red or green, the introduction of architectural motifs, and the picking out in white of tiny delicate lamps

and vessels, often overhung with equally deli-
cate festoons, all with a curious air of the Euro-
pean late Renaissance. Individual figures or
scenes in little square panels line the sides, and
parts of the consecration scene appear at the
bottom along with the donors.

The beautiful 'Green' Tārā in the Cleveland
Museum [392] is a supreme example of an-
other type of paṭa in which a divinity either
stands or is enthroned beneath a prabhā com-
posed of the same elements as the 'toraṇas' of
Nepali shrines [390]. The classical Indian style
and pose here contrast most successfully with
the typical Nepali *millefleurs* on the black
ground and the beautifully painted little
trees.[71] Another superb example of this type,

392 (*opposite*). 'Green' Tārā. Fifteenth century. Painting on cloth.
Cleveland Museum of Art, Purchase from the J.H. Wade Fund

393 (*below*). Preaching Buddha with donors. 1649. Painting on cloth.
Cleveland Museum of Art, Purchase from the J.H. Wade Fund

the mid-fifteenth-century Agastyavrata paṭa, commemorating the performance of a Hindu rite, is notable for the bold and imaginative use of brightly coloured rock forms, a Nepali favourite, for the prabhā.[72] In other paṭas close to similar Tibetan thaṅkas a tantric deity, either in angry mood or in sexual union with his śakti, backed by a large flame-edged aureole, occupies most of the painting.

Splendidly detailed paṭas illustrating, or associated with, the performance of rites for the donors are also unique to Nepali painting. The best known is the picture of the Bhīmaratha rite with outsize portraits of the couple who commissioned it.[73] Also remarkable for its prominent donors listening to a preaching Buddha in three-quarters view, which adds a note of realism, is a paṭa dated 1649, also in Cleveland [393]. Tibetan influence is responsible for the perfunctory clouds squeezed in at the top of the painting. In the typical Nepali boxes at sides and bottom are aptly chosen jātaka stories told in comic-strip style. The figure of King Pratāpa Malla, one of the more important Malla kings, in the first dated appearance of the Rājput dress which will gradually come to prevail is of great art-historical importance, and so are many other Mughal-Rājput features introduced here. Another example, unquestionably the finest so far, of the arrival of these new elements is the painting of 1664 of the same Pratāpa Malla offering the tulādāna (a gift of specie equivalent to the weight of some person balanced on a scale) before the Taleju temple in Kathmandu, with such constituents of a Mughal durbar scene as formal assemblies of courtiers and gaily caparisoned elephants.[74]

A tradition of narrative scrolls illustrating stories from the epics, the Purāṇas, and popular folk tales from the Hitopadeśa and the Pañcatantra, either rolled or joined together in accordion pleats (kalāpustakas), culminates floridly in the sixteenth century.[75] Lively as the figures are, their repertoire of poses is always somewhat limited, and it is the decorative impulse that takes over. By the end of the seventeenth century what we have is a hybrid of Nepalese elements and the imported Mughal-Rājput-Pahārī style.

NOTES

Bold numbers indicate page references.

15. 1. Neolithic cultures are characterized by polished stone implements and weapons and a degree of agriculture and settlement. The chalcolithic (chalco- means copper-) represents a further advance and the use of copper or bronze.

2. Wakankar and Brooks (1976).

3. There is a vast body of excavation reports and learned interpretation concerning these early societies. For an up-to-date and scholarly account by two practising archaeologists, see B. and F. R. Allchin (1982).

4. The date proposed by the Allchins, *op. cit.* It covers a slightly shorter period, both at beginning and end, than earlier datings. Both the principal cities, Mohenjo-daro and Harappa, are on or close to the Indus river or one of its tributaries, and hence it can be said that the civilization is centred upon it. Indian scholars prefer the term Harappan. Although considerably less remains of Harappa, owing to the depredations of nineteenth-century railway contractors, its existence was reported much earlier than that of Mohenjo-daro.

18. 5. An article by D. Srinivasan (1975-6) seeking to prove that what appears to be an erect penis is simply an element of costume is not very convincing.

6. They appear to be buffalo's rather than bull's horns. This is a possible foreshadowing of the importance accorded to Mahiṣa, the demon-buffalo, in later Indian iconography. Pallava doorkeepers are sometimes horned; the interpretation of this practice somewhat later, namely that Śiva's trident is interpolated into the two horns, with the tall crown between them, does not necessarily hold for the earlier examples.

19. 7. In spite of the fact that the first inscribed seal was retrieved by General Cunningham from Harappa in the 1850s, and despite the deployment of all the resources of modern linguistics, including the use of computers, the script remains undeciphered, principally because there are no texts of any length. Even the language remains undetermined, although it was probably Dravidian. The only indisputable steps towards a solution have resulted from excavations. The eminent Indian archaeologist B.B.

Lal (1960), (1960-1) proved, from characters incised on clay not yet baked, that the script was written from right to left, and, from graffiti on pots, that it was also in wide use, although perhaps only in the form of marks, in the South Indian megalithic culture, a further link with the Dravidian languages.

8. Because of this situation, peculiar to India, the proper application there of the term 'historical', traditionally used to refer to the past for which written records exist, and 'proto-historic', a sort of half-way house between the 'historic' and 'prehistory', is rather uncertain.

9. Sometimes referred to as Aryans by earlier scholars, from *ārya*, or 'noble', the word they used to describe themselves, these Āryas were almost certainly racially as well as linguistically distinct from the autochthonous population of India, but they have little or nothing to do with the racialist doctrines of Nazi Germany.

10. In much later times, the Indian will show a similar lack of interest in a technique which he is known to have acquired at an early date, namely the building of true arches, as opposed to corbelled ones. See Chapter 2, Note 5.

20. 11. The bronzes are unfortunately a surface find. Their association with the chalcolithic settlements at Daimabad rests largely on a single stylistic trait which occurs on a fragment of the painted pottery excavated earlier at the site. See Deshpande (1958-9).

12. There is no question as to where the Buddha was born; the inscription on the pillar erected by Aśoka on the occasion of his visit to Rummindei (the present name of the ancient Lumbini) unequivocally states: 'Here was born the sage of the Śākyas.' But his mother had left Kapilavastu, about whose actual location there has been some controversy. Several sites where Buddhist remains have been found have been proposed as contenders, of which Pīprahwā, or rather its environs, seems the most likely.

22. 13. No trace of Alexander can be found in non-Muslim Indian history, literature, or art, with one possible exception: two or three figures or heads of the Kuṣāna period at Mathurā wear ram's horns, and Alexander is often so portrayed, having been hailed by the Egyptian priests as an incarnation of the god Ammon, who wore them.

14. The name Kandahar is derived from Gandhāra, a nearby region (see p. 71). It first appears in a Persian manuscript of the thirteenth century.

15. There has been some argument as to whether Aśoka was a Buddhist and whether the way of life enjoined in his edicts reflects early Buddhist doctrines. There is no question that he was a great patron of Buddhism, that he concerned himself actively with the affairs of the Sangha, or that he visited two of the four holiest places associated wth the Buddha's life (see Note 12, above).

24. 16. Irwin (1973-6), (1981). A free-standing pillar, placed before the entrance, continues as a feature of Hindu and Jain temples to this day. The *yūpa*, or sacrificial post, on the other hand, stems from the early post-Vedic tradition. Some have survived from the early historical period. For a full list of the pillars and capitals, including fragments, see Irwin (1974), 715.

17. Although attempts have been made to show, on stylistic grounds, that the doorway of the Lomas Ṛṣi post-dates the cave by two hundred or more years, the balance of the evidence points to its being contemporary: Auboyer (1971-2); J. C. Huntington (1974-5).

18. E.g. for the Didarganj yakṣī (see p. 31). A mithuna couple, also in the Patna Museum (Arch. 8178), illustrated P. L. Gupta (1965), plate VI, has the polish too, although stylistically it cannot be earlier than the first century A.D.

26. 19. For the stūpa and the cosmic axis, Irwin (1981). At Sāñcī, the bricks of the Aśokan stūpa at the core of Stūpa I measured 16 by 10 by 3 in. (41 by 25 by 8 cm.). Bricks became steadily smaller over the centuries.

20. Barua (1934-7); Coomaraswamy (1956b).

21. The *jātakas* are ancient Indian folk tales pressed into the service of Buddhism. In them, the virtuous man or beast is invariably identified as the Buddha in an earlier incarnation.

28. 22. Deo and Joshi (1972).

23. For Amīn, near Thanesar, see *A.S.I., A.R. 1922-3*, 89 and plate V; for Lalabhaghat, Dayal (1930).

24. Sacred trees with square vedikās around them can be seen on reliefs from Pauni and in one of the caves at Udayagiri (Orissa). See also the pillar capital, 5 ft 8 in. (1.7 m.) tall, in the form of a *kalpavṛkṣa*, or wish-fulfilling tree, now in the Indian Museum, Calcutta.

25. See Coomaraswamy (1935).

26. The word *yakṣa* appears in the Ṛg Veda, the earliest of the Vedas, and in a slightly different form is still in use today.

29. 27. Marshall and Foucher, I, 342 (inscription no. 460) records that a carving at Sāñcī was done by the ivory-workers of Vidiśā.

28. For exhaustive accounts of these figures, see Coomaraswamy (1928), M. Chandra (1952-3), P. Chandra (1966). There are many reports on individual yakṣa images found all over North India.

31. 29. Plaeschke (1963), which includes a thoroughgoing stylistic analysis of female and other figures in early Indian sculpture.

30. Vogel (1908-9a); Khare (1967). The identity of the various Śuṅga, Sātavāhana, and Gupta remains near Sāñcī has been confused by the use of different names over the centuries. The nearby town of Bhilsa (hence the 'Bhilsa topes' for Sāñcī) is now known by the name Vidiśā, although the ancient Vidiśā was probably close by Besnagar (at the confluence of the Bes and the Betwa). The Udayagiri hill(s), two or three miles away, with its Gupta caves, should furthermore not be confused with the Udayagiri hill near Bhubaneswar in Orissa, also famous for its rock-cut caves.

31. See Chapter 2, Note 7.

32. *Epigraphica Indica*, XXIV (1937-8), 194-8 and plate facing p. 206; Banerjea (1942), 93-4.

33. Venkataramayya (1963). The eminent epigraphist and historian D. C. Sircar considers the inscription to be of the first century B.C.

34. Now in the State Museum, Lucknow (no. 56.394). D. Srinivasan (1979) sees it as an early embodiment of the caturvyūha concept, a view challenged by Härtel (1983), 105-9, and by Maxwell (1982). It is not likely to be the earliest image embodying Viṣṇu's avatars in a composite form, as later exemplified by his caturānana images (see Chapter 5, Note 5).

32. 35. See Note 30.

36. Marshall and Foucher (n.d.). These three volumes, by the restorer of the Sāñcī hill and its monuments (and excavator of Taxila) and the greatest Buddhist iconographer, are the most sumptuous works on Indian archaeology ever produced. For an appreciation of the aesthetic achievement of the Sāñcī reliefs, Kramrisch (1933), 30-4.

34. 37. The only historical figure mentioned in any of the early inscriptions is a Sātavāhana king, a Śatakarni, whose chief of works was involved with one of the gateways.

38. Marshall and Foucher (n.d.), plate 125a, c.

39. There is general agreement on the dates of the more characteristic and finest Amarāvatī reliefs, the late ones, and the sculpture from Nāgārjunakoṇḍa. The problem has centred on a number of reliefs, some of them from Amarāvatī, in a distinctly different

and earlier-appearing style, some of them little more than incised in outline, distinguished by the clarity of their linear definition and the sparse elegance of their decorative detail. Barrett (1954a,b), (1967-8) – whose studies of the Amarāvatī reliefs have been distinguished from those of other scholars by his attention to the actual position which the pillars, slabs, copings, etc., many of them re-used by carving the other side, must have occupied rather than an exclusive reliance on the development of motifs and style – has resolutely maintained that none of the Amarāvatī reliefs could be earlier than c. A.D. 80. This view was in part based on a conviction that the chalcolithic and Iron Age cultures of most of the Deccan prevailed in Āndhra, to the exclusion of historical, religious, and artistic developments elsewhere, until the first century A.D. This view is no longer tenable after new finds of inscriptions and reliefs. For a short summary, see Dehejia (1972), appendix 3. In particular the find of reliefs at Amarāvatī, in the local stone but in the style of Bhārhut (and likewise provided with labels, not afterwards employed in Āndhra), proves beyond doubt the existence of Buddhist reliefs there by the late second or early first centuries B.C.; Ghosh and Sarkar (1964, 1965). An even more recent discovery by excavation of the stone revetments to a stūpa, with reliefs in a style more akin to that described earlier, is dated to the second century B.C. by the Archaeological Survey; *Indian Archaeology* (1975-6), 2 and plate 1B. Pillars depicted there are all but identical to those on a stūpa slab from Amarāvatī (Barrett (1954a), plate 1A). That the older cultures continued to survive until the beginning of our era is likely, however; see Wheeler (1947-8). One of the small stūpas at Amarāvatī was built immediately upon an urn-field; see Rea (1908-9).

40. Now in the Government Museum, Madras. There is a very similar sculpture, but in higher relief, in the Musée Guimet; Barrett (1956b). The cakravartin, a much larger figure, is shown surrounded by the symbols of his exalted state, his queen, his minister, his horse.

41. Barrett (1960c). A problem about the origins and extent of Sātavāhana rule in Āndhra, in view of the Puranic designation of the dynasty as the Āndhra or Āndrabhṛtyas, has been the paucity and lateness of their inscriptions in the east. There are only two at Amarāvatī, both of the second century A.D.

42. Two male torsos in the round, from Nagaram, some sixty miles north-west of Jaggayyapeta, are the exception; see Barrett (1960c), plates 2 and 3. In a mature Amarāvatī style, their fuller three-dimensional realization reveals the essential kinship

between the Āndhra plastic conception of the human body, somewhat obscured in the small-scale and crowded figure compositions of the Amarāvatī reliefs, and that of the finest Sātavāhana as well as Mathurā Kuṣāna sculpture, although perhaps here wrought to a finer, more sensitive pitch. Cf. the Mathurā Kuṣāna Nāga in the Musée Guimet [40].

35. 43. For an account of the fate of the great stūpa and its sculptures, from its first discovery by Colonel Colin Mackenzie in 1797, Barrett (1954a), 21-6. This remarkable soldier and antiquary who, between his first visit and his second, in 1816, fought with distinction under Wellesley, later the Duke of Wellington, is one of the heroes in the history of European involvement in Asian antiquities, sometimes far from creditable, for without his intervention the Amarāvatī sculptures, in the process of being burnt for lime by a local magnate, would have been lost to the world.

44. There are a number at the site museum and isolated examples in museums elsewhere in India, in Europe, and in the U.S. A number probably still remain, unrevealed, built into dwellings in neighbouring villages and towns. There are many problems relating to Amarāvatī (the modern name of the town): one is whether it is identical with Dhānyakaṭaka, famous in Buddhist annals, well known from contemporary inscriptions elsewhere and in literature, and visited and described in some detail by Xuan Zang. His description, however, bears little relation to the site of Amarāvatī and makes no mention of the stūpa. A convincing attempt has been made to locate the ancient Dhānyakaṭaka at the present Bezwada, thirty miles away, in Bareau and Benisti (1965) and Bareau (1967a,b).

45. The reconstruction in Barrett (1954a), figure 2, has probably too flat a dome as well as a too sparsely decorated appearance; there are also several discrepancies with the author's text, doubtless on account of the excessively sketchy rendering of the decoration. The reconstruction in Brown (1942a), plate XXVIII, surely gives a more likely impression, although there was almost certainly no railing to the drum. See Barrett (1954a), 35 and 36.

46. The significance of the *āyaka* pillars, as well as the etymology of the name itself, is problematical. See Barrett (1954a), 35 and footnotes 45-7.

38. 47. This is necessarily a simplified description. For the upper part of the anda (dome), the only evidence is the slabs depicting the stūpa and stūpa slabs from other sites, for even Mackenzie, whose drawings and descriptions provide invaluable information, was too late to see anything of the upper dome.

48. Barrett (1954a), Sivaramamurti (1956), Stern and Benisti (1961). The essential difference stems from Barrett's refusal to allow that any of the sculptures are earlier than the third or fourth quarter of the first century A.D., reaffirmed in Barrett (1967-8) (cf. Note 39).

49. The final excavations were undertaken in advance of the completion of a hydroelectric project which has effectively flooded most of the site. See Longhurst (1938); Ramachandran (1953); Benisti (1959); Sarkar (1960). *Nagarjunakonda (1954-60)*, Mem. A.S.I. no. 75 (1975), vol. 1, relates only to the prehistory of the site, including the megalithic culture there.

50. This flatness may be in part due to technical changes – even a new approach to the bedding of the stone.

51. Curiously enough, examples of a very stylized and rather elegant type found at ancient stratified sites belong to a fairly restricted area (Gandhāra) and a relatively late period (c. 250-100 B.C.); Wheeler (1962), 22, 104-6. The best account of Indian terracottas, in a broad perspective, remains that in P. L. Gupta (1965), 167 ff., by Kramrisch. Das Gupta (1938, 1944) is a useful bibliography, but a great many new finds have been published since.

52. Härtel and Auboyer (1971), 44.

53. There are essentially two types of these, distinguished by the treatment of their moulded faces. The first, of great rarity, has large eyes with eyelashes and may have a stand; see Härtel and Auboyer (1971), figures 27 and 30a and plate III. The large-scale excavation at Sonkh, where both types were found, has finally enabled their dates to be fixed, the less common 150-100 B.C., the other c. 200 B.C.; see Härtel (1973a,b), (1976).

39. 54. Some, usually male and from Afghanistan, with a concave back and a tendency to be set deep in the matrix, are related to western Asian types.

55. S. K. Saraswati (1962), 98 and 101, draws attention to earlier publication.

56. In the Lahore Museum, a squatting terracotta female figure in the round, wearing a bi-cornate headdress, holds a child and appears to be pregnant. This suggests that all these single female figures are mother-goddesses. The inference is strengthened by the fact that figures wearing this characteristic headdress appear never to have been depicted in stone or on reliefs. At this period these last were almost invariably created in a Buddhist context, and mother-goddesses were never accepted, as were some other Indian divinities, by the Buddhists. See S. C. Kala (1973). The popularity of Hārītī, in Gandhāra, may be considered a partial exception.

57. Deshpande (1963).

58. R. C. Agrawala (1970).

41. 59. G. R. Sharma (1948-53) (*sic*), plate IV, b and d.

60. Khandalavala (1960); Barrett (1958c). The second bronze has one feature which connects it with Āndhra: a certain awkwardness in one of the elephant's fore-legs which is exactly duplicated in a relief from Panagiri; Barrett (1958c), plate I.

42. 61. H. K. Prasad (1968); P. K. Agrawala (1977), figures 165, 178, and 179-80. Except for the Gandhāra-style bronzes, all the metal figures referred to, solid as well as repoussé, may be found illustrated in Agrawala's useful book. See also Schroeder (1981).

62. Y. D. Sharma (1955-6); M. I. Khan (1978).

63. Barrett (1960b). Other Gandhāra-style Buddhas have since appeared.

64. Härtel and Auboyer (1971), figures 41a and b.

65. Mitra (1971), figure 63.

66. The figure is now in the Ashmolean Museum; J. C. Harle, 'An Early Indian Bronze Figure', *K. Fischer Festschrift (70th Birthday)*, to appear. There is an almost identical figure, with a spike still remaining in the head, in the Peshawar Museum; this and certain details of costume suggest that the Ashmolean figurine came from the north-west. For the probable function of this object, cf. the Pompeii and Ter ivories, which also have holes in the tops of their heads reaching far down into the bodies (Note 69, below).

67. Bloch (1906-7), figure 4; Marshall (1951), plate 191, figures 96-8; Jayaswal (1934).

68. See pp. 80-1.

69. During Caspers (1981) convincingly argues that the Pompeii ivory is not a mirror handle but one of the supports of a stool or a small table. She suggests a roughly similar function for the Ter ivory. See also Barrett (1960c) and Chapter 4, Note 32.

70. For examples, Dvivedi (1976), figures 95-7.

71. Dalton (1964) for the largest hoard, the 'Treasure of the Oxus'. Others are also in the British Museum, in the Hermitage, and elsewhere; Smirnoff (1909).

72. An example in terracotta from the Sonkh excavations near Mathurā was shown to the author by Professor Härtel. The form and the ribbing are originally Achaemenid, the feet Hellenistic. For an example in silver from Taxila, Marshall (1951), plate 188, figure 5a and b. Vessels of this type used as drinking cups are depicted on reliefs from Mathurā as well as Gandhāra. See p. 59.

CHAPTER 2

43. 1. Coomaraswamy (1930), (1931).

2. Franz (1978) illustrates a comprehensive group of those with tower-like superstructures. See our illustration 27.

3. Spooner (1912-13); Altekar and Misra (1959); Sinha and Narain (n.d.).

4. B. B. Lal (1949).

5. G. R. Sharma (1968). Some true arches were used and evidence is presented for domes. For instances of the rare but widely dispersed use of true arches in India, Coomaraswamy (1927), 73, note 4.

6. Kuraishi, rev. A. Ghosh (1951); for a modern excavation and a bibliography, Ghosh (1951); G. R. Sharma (1960).

7. Bhandarkar (1920). Not recorded at this site near Nagarī (Chitor) but found at Besnagar (Bhandarkar (1913-14), plate CVI, a) and also at Pauni. Where stone is particularly plentiful, as in the environs of Mathurā and in parts of Karṇāṭaka, such slabs, stuck upright into the ground, are used today to enclose fields, etc.

8. For Bhairat: Sahni (1937); Piggott (1943), 2-6; Mitra (1971), 42-3. There are other circular buildings containing stūpas at Guntupalli and Salihundan in Āndhra, as well as rock-cut examples there and elsewhere. One at Bhājā is a recent discovery; Deshpande (1959b), 32. For Besnagar: Khare (1967). Foundations of apsidal-ended shrines have been found at many Buddhist sites, with as many as a score at Nāgārjunakoṇḍa, as well as on top of the Khandagiri hill near Bhubaneswar.

9. Vogel (1930), plate XXIII, a. There is a bird's-eye view of an apsidal shrine on a relief from Amarāvatī; P. R. Srinivasan (1961), plate XXXVII, figure 3.

10. Vogel (1930), plate VIII, d, shows what is apparently an early version of the Baṅgla roof, as seen in the Durgā shrine at Māmallapuram. Also plates XXIII, a, LVII, a, LX, a.

11. See Note 2, above, and Barrett (1956b), figure 1.

12. Franz (1979), plate I, 1 and 2. See Chapter 23, Note 3.

45. 13. Their only predecessors, in the Barābar hills, were executed for non-Buddhist sects (see p. 24). For an up-to-date and concise account of the early Buddhist caves with a comprehensive bibliography, see Dehejia (1972). The principal caves and their inscriptions have been the subject of scholarly attention since early in the nineteenth century, in part due to their proximity to Bombay or to a railway. See Burgess (1883a), (1883b), etc.

14. The terms 'Hīnayāna' and 'Mahāyāna' are con-

veniently applied to (a) the early caves, where the stūpa is the only cult object, and (b) the fifth-century (and later) Buddhist caves, with their Buddhas, Bodhisattvas, etc.

48. 15. Also known as amygdaloid trap.

16. For a good account of the institutionalization of early Buddhist communities, see Dutt (1962).

17. Mahavagga, 1, 22, 16, translated by T. W. Rhys Davids and H. Goldenberg; S.B.E., XIII, 143.

18. The connection between Buddhist sites and the abodes of yakṣas does not seem to be implied, except in the most general sense, by the lines from the Mahāmayurī quoted by Deshpande (1959a), 69. It casts an illuminating light, however, on the co-existence of Buddhism and yakṣa worship.

19. An almost exact parallel is afforded by the situation during the early nineteenth century of the so-called Beni-Israel, the Jewish community in roughly the same region. See Lord (1976).

20. A doorway surround or part of a caitya window (gṛha mukha) at Karle was made by a man who described himself as a carpenter (vrdhaka); see Burgess (1883a), 90 and plate XLVII, nos. 4 and 6.

21. Some of the rafters at Karle were replaced in Lord Curzon's time, but the remainder are original, and inscriptions on a wooden member at Bhājā attest to its antiquity; see Deshpande (1959b). The wooden parasol atop the stūpa in the Karle caitya hall is assumed to be original.

22. For Pitalkhora, Deshpande (1959a); clearing of extensive rock-fall at this site revealed many new features as well as sculpture.

49. 23. For an eloquent description of the 'Indra' panel in terms of the artistic conceptions underlying such early Indian sculpture, Coomaraswamy (1927), 25-7. More precise proposed identifications are not convincing; Johnston (1939); Gyani (1950-1). Dehejia (1972), 115, suggests a scene from an unidentified jātaka.

51. 24. There is a tradition of martial figures wearing one or another feature of Greek or Roman dress continuing as late as the Brahmanical cave (Rāvaṇaphadigudi) at Aihole; Harle (1971). In the north-west, scale armour is sometimes depicted on Gandhāra reliefs, and Kārttikeya, the god of war, is often shown in a short tunic with scale armour. For an actual piece of such armour found in the north-west, see F. R. Allchin (1970).

52. 25. The order of succession and the dates of these rulers are of crucial importance in dating Sātavāhana and Kṣahārata rock-cut architecture and sculpture in the Konkan, the upper Deccan, and in Āndhra, as well as, tangentially, early Mathurā sculpture and that of Gandhāra. The principal sources are

lists in the Purāṇas, inscriptions on the monuments and (since they are almost invariably undated) their paleography, and, finally, Western references, notably in Ptolemy and the *Periplus of the Erythraeian Sea*, the latter itself not too firmly dated. The discrepancies between the information provided by these sources have, in the past, given rise to the 'long' and 'short' chronologies. Later, Barrett (1954a), Spink (1954), (1958), Khandalavala (1956-7), Dehejia (1972), and others all addressed themselves to the problem. From an independent reassessment of the paeleography of the relevant inscriptions as well as of the numismatic evidence, and a comprehensive study of the monuments, Dehejia has reached a middle position, which is adopted here. According to her conclusions the first of the Sātavāhanas of which there is inscriptional evidence, Simuka Sātavāhana, is dated to *c.* 130 B.C. and the last of the great kings ruling over both the western Deccan and Āndhra, Yajñaśri Śatakarni, is considered to have reigned from A.D. 152 to 181 (p. 30).

54. 26. It has been suggested that these pairs of men and women may represent donors, but as Dehejia (1972), 128, remarks, one would then expect donative inscriptions, in which the cave abounds, referring to them.

56. 27. R. Mitra (1875 and 1880); *A.R., A.S.I. 1922-3*; D. Mitra (1960b).

57. 28. If indeed they all were. Nowhere else is better illustrated to what extent 'the vocabulary [of symbols] was equally available to all sects, Brāhmans, Buddhists and Jains, each employing them in senses of their own'; Coomaraswamy (1927), 44.

29. S. K. Saraswati (1951), 517 and 518, believes that the long frieze of the Rānī and Ganeśa gumphās may be as late as *c.* A.D. 100.

CHAPTER 3

59. 1. Also the Jain icon. The Buddha image appears to have evolved independently at Mathurā and in Gandhāra at about the same time. A large and rather crude seated Buddha image, long unpublished, in the Lahore Museum, is apparently in Mathurā stone and found in the north-west; see Van Lohuizen (1981a). It would seem to establish the priority of the Mathurā Buddha image.

There is unusually abundant published documentation of Mathurā sculpture, almost entirely due to the efforts of a succession of energetic and scholarly curators of the Archaeological Museum. For the pre-Kuṣāna period, V. S. Agrawala (1933); for the Kuṣāna and Gupta, Vogel (1930); V. S. Agrawala (1937), (1948), (1949), (1950), (1951-2); N. P. Joshi

(1966). See also, with many illustrations, Diskalkar (1932). The bibliography by U. Agrawal (1973) is selective.

2. Although almost universally stated to be Sikri, the source is more likely to be a number of other quarries in the region, such as Rupbas; see R. C. Agrawala (1969a), although specifically rejected by Carlleyle (*A.S.I.*, VI, p. 22).

3. So far not published *in extenso*, but see Härtel (1973a), (1973b), (1976), *inter alia*.

4. Härtel and Auboyer (1971), plate III, figure 27.

5. See p. 42.

61. 6. For the account of Kaniṣka mistaking a Jain for a Buddhist stūpa, see *Sūtrālaṁkāra*, referred to in Foucher (1905), i, 56. While possibly apocryphal, the story illustrates both the prevalence of Jain stūpas and to what extent they were indistinguishable from Buddhist ones.

7. In Sri Lanka altars are placed beside stūpas at the cardinal points. Or is there a connection, as suggested by von Hinüber, with the curious box-like objects beside a stūpa shown on a relief illustrated in V. A. Smith (1901), plate XX? Both the function and the etymology of *āyāgapata* are still open to question: *āyāga*: offering; *paṭa*: stone tablet, are the most likely; see von Hinüber (1974), note 15, and Van Lohuizen (1949), 147-8, also 65-72 for the problems surrounding the dating and the inscription of the Āmohinī āyāgapata. Dedicated by a lady of that name, it bears a date, most likely 72, and mentions Soḍāsa, one of the well-known Western Kṣatrapa (Śaka) rulers in Mathurā and usually placed in the last decades B.C. and the very early years A.D. The date of this much worn piece is crucial since it shows a woman and her attendants in a style which does not seem to differ much from indisputable Kuṣāna-period sculptures from Mathurā. Referring the date to the Vikrama era or the era of Azes (see Chapter 4, Note 43) which commenced in 57 B.C. would give A.D. 14 as the date in the Christian era. Plaeschke (1976), one of the advocates of an extremely late date for Kaniṣka, hangs a good deal of his argument - on purely paleographic grounds - on a date reckoned in the Śaka era, A.D. 78 + 72 = 150, for the tablet. There are also Buddhist āyāgapaṭas; see G. R. Sharma (1958), plate V, figure a.

8. Van Lohuizen (1949), 149, note 16. This is due in part to an early manifestation of the Jain penchant, particularly noticeable in western Indian bronzes, for inscribing their images more frequently and at greater length than elsewhere in India. But Jain images also preponderate.

62. 9. This is the measurement provided by the Indian Museum, Calcutta, where the sculpture now is.

Anderson (1883), part I, 194, gives 11 ft 8 in. (3.6 m.) and Cunningham, *A.S.I.*, I, 339, 7 ft 4 in. (2.2 m.).

10. For an explanation of the Buddhist garments depicted in sculpture, relating them to the actual pieces of cloth and the way they are wrapped around the body, Griswold (1963).

64. 11. For a partial list of these finds, N. P. Joshi (1966), 7; also M. I. Khan (1966). Pal (1979) publishes an image almost certainly found in Gandhāra. In the case of two of the inscribed images, the sculptor is actually said to be a Mathurā man.

12. The absence of a king's name (the year 32 of the Kaniṣka era would fall in the reign of his successor Huviṣka) casts a little uncertainty on the system of dating used here, but it is generally accepted that it is the Kaniṣka era; see D. Mitra (1955) and Rosenfield (1967), 266. All these Kuṣāṇa Buddha images from Mathurā are in one way or another relevant to the problem of the origin and first appearance of the Buddha image. The latest important contribution to this much-discussed question is van Lohuizen (1981a). See also Note 1. The seated Buddha in Mathurā stone now in the Lahore Museum is of unknown provenance but it may well be the earliest known Buddha image in the round, thus affirming Mathurā's claim to have produced Buddha images slightly earlier than Gandhāra. Its presence in the Panjab, moreover, so near to Gandhāra, further confirms this, except in the very unlikely event that it was brought there in modern times.

13. Variously called the *nandyavarta* ('turned-around nandi'), *nandipada*, *triratna*, *triśūla* (an essentially Hindu term), according to von Hinüber (1974).

14. For a definition of this term see p. 76. The hand rests on a cushion-like element behind it, whose surface is cross-hatched, probably so as to simulate fabric and thus reinforce the notion that a cushion is represented; in actual fact it is probably simply a device to leave the hand connected to the main part of the stele, making it less likely to break off.

15. Rosenfield (1967), 218.

16. Mitra (1955); Pal (1979). A small number of Kuṣāṇa-period sculptures, in what appears to be the characteristic Mathurā stone, were either found at Ahichchhatra, the old Pañcāla capital, or, like the Indra, can be traced to it. For a discussion of whether or not they were made locally, in imported stone, and thus constitute a substyle, Pal (1979), 217–25.

17. See Chapter 1, Note 42.

18. The suggestion that the frame on which Hārītī sits is connected with childbirth must be rejected since Pāñcika is occasionally shown sitting on one.

19. Two or three pre-Kuṣāṇa and specifically Hindu images are known (see p. 31). The torsos from the Mora Well, illustrated in Rosenfield (1967), figure 51, may well represent two of the five Vṛṣṇi heroes, but it is doubtful whether they had distinguishing iconographical marks (p. 31). A standing colossus over 8 ft tall of a bearded and moustached ascetic, wearing only a deer(?) skin, a sacred thread, and a lower garment of some forest(?) material, has been acquired by the Mathurā Museum (MTR 77.4). The figure was holding a rosary and a water pot. By far the largest Brahmanical image of the Kuṣāṇa period so far known, it is also a unique representation of a god, testifying to the experimental nature of the iconography of the period. D. Srinivasan (1978–9) identifies it as Nārāyaṇa. T. S. Maxwell (personal communication – 23.7.82) prefers to see it as Brahmā as the god of the priestly caste.

65. 20. For a partial list of these little images, Harle (1970), (1971–2), 147, note 1.

21. V. S. Agrawala (1937); Nagar (1943); Joshi (1965); Joshi (1969a), (1972), plates 1, 2, 7, 8, 9, figures 1, 15, 24–7, 30, 32, 38, 39, 45–8; P. K. Agrawala (1971). A larger, detached Ardhanārī image is in the Victoria and Albert Museum, London.

22. R. C. Agrawala (1969a).

23. Joshi (1969b), D. Srinivasan (1979), Maxwell (1982), but see Härtel (1983).

24. V. S. Agrawala (1933); Joshi (1966), figures 1–17.

25. See pp. 89 and 101.

66. 26. It has been suggested that the second series of dates simply follows on the first, the digit for one hundred being omitted (the 'dropped hundreds' theory), but it is more likely that another, unknown era is in question, commencing around the year 100 of the Kaniṣka era. See Van Lohuizen (1949), 235, Rosenfield (1967), 106, and Chapter 4, Note 43.

27. See above, Note 7. The date of the Āmohinī āyāgapaṭa is crucial in determining the beginning of the Kuṣāṇa style at Mathurā. In spite of the name given to it, this style obviously pre-dates Kaniṣka, since fully fledged versions can be seen in sculptures dated early in Kaniṣka's reign.

67. 28. Joshi (1966), figures 43 and 44; Rosenfield (1967), figure 50, and some smaller reliefs.

29. Carter (1968).

30. It has been suggested that a scene from the Mṛcchakaṭika ('The Little Clay Cart'), an exceptionally picaresque Sanskrit drama, is depicted; Sivaramamurti (1961), 37–8.

70. 31. The term 'portrait sculpture' is used in a particular sense to indicate a sculpture which is supposed to represent an actual person and wears the

kind of crown or robe or costume he would wear, without any attempt at a likeness, the face being entirely conventionalized. See Aravamuthan (1931), which, although limited to South India, shows the general practice.

32. Rosenfield (1967), 142-3, 190, and figures 11, 43, 44.

33. The soft pointed cap, with its characteristic tilt forward at the top, which appears first on Achaemenid reliefs, has an exceptionally long history extending down to modern times when, as the 'Phrygian bonnet', it became a symbol of liberty (Marianne, the personification of republican France, habitually wears one, including on the current small coinage). For a specialized garment, the camail, a sort of cape, of apparently similar origin and equally wide dispersal in time and space, Harle (1980), (1985).

CHAPTER 4

71. 1. It appears in the Ṛg Veda, the earliest of the Vedas (see p. 19). Herodotus, the Greek historian, includes the Gandarioi in the seventh province or satrapy of the Persian Empire, and Darius, in the Behistun inscription, lists Gadara (or Gandhāra) amongst his eastern satrapies. There has been no comprehensive bibliography dealing with all the manifold aspects of Gandhāra which have a bearing on Gandhāra art (see pp. 79-80) as well as the art itself since Deydier (1950). The French have been the most active in the field, but see also the work of the Italians as well as the Japanese. Bussagli (1960) remains the most up-to-date general account.

2. The area designated by the name Gandhāra in ancient times seems to have varied little; it was still in use when the Chinese pilgrim Xuan Zang (Hsüan Tsang) visited the region in the seventh century A.D.

3. Not necessarily abroad; far and away the most important collections of Gandhāra sculpture are in the museums of Peshawar, Lahore, Taxila, and Calcutta. The State Museum, Lucknow, also has an important collection (Joshi and Sharma (1969)), as does the National Museum in Karachi. It is to the Gandhāra sculpture in the Lahore Museum, of which his father was curator, that Kipling refers in the first chapter of Kim, done by workers 'whose hands were feeling, and not unskilfully, for the mysteriously transmitted Grecian touch'.

4. See pp. 41-2. A little known and much corroded bronze of Hercules and the Nemean Lion, dug out of a mound near Quetta and now in the Indian Museum, Calcutta, is probably the largest of these imports, 2 ft 6 in. (76 cm.) high. See Garwood (1887) and Smith (1889), 141. Almost always in

stone, rarely of terracotta, 'Taxila trays' - small compartmented cosmetic dishes - have been found in Gandhāra in great numbers; Francfort (1979).

5. The attempts of Marshall (1951) to date various edifices at Taxila by the type of masonry employed, including the 'diaper', need to be reviewed.

6. Taxila is the most important city in the region in ancient times, mentioned in Western classical sources as well as an inscription at Besnagar (see p. 31). Of the three successive cities, the Bhir mound and Sirkap are pre-Kuṣāṇa and produced relatively little sculpture, whereas the walled Kuṣāṇa city, Sirsukh, has not been excavated.

7. Barthoux (1930); M. Mostamendi (1969); MacDowall and Taddei (1978), 279. Also Allchin and Hammond (1978), under Mostamendi in bibliography.

74. 8. Ingholt and Lyons (1957), figure 39B. In the West the coffered ceiling dates back to at least the second or first century B.C.

9. Illustrated in Allan (1946), figure 1, and Wheeler (1954), plate XXXIV. The suggestion by Roşu (1958) that the theme may have struck a sympathetic chord in an Indian environment at the time because of a wooden elephant having been used in a similar stratagem by a king of Avanti (Kathāsaritsāgara, II, 12) is worth noting. As Allan points out, the men are unquestionably wearing Greek dress, and there is a Western classical source for the gesture, quite unknown in representations of women in Indian art (including that of Gandhāra), of the Cassandra figure, arms stretched upwards; but the conscious foreignness of the relief might have made the suggested comparison more piquant.

10. Athene or Roma; see Gnoli (1963); Ingholt and Lyons (1957), figure 443.

11. Facenna (1962-81).

12. Rowland (1953), 78.

76. 13. Buchtal (1945), 14, figure 33. For the same pose in other scenes from the Buddha's life, Ingholt and Lyons (1957), figures 116 and 119.

14. This is the conclusion reached by Foucher, Coomaraswamy, and van Lohuizen (1949), 163 ff. An analogous process has been observed in Christian iconography whereby a misunderstood element in the way a saint or a legendary figure is represented has given rise to another entirely spurious legend: Mâle (1910), 337 and 340, quoted in Bosch (1956), 22 and 23.

15. 'Moine sans tonsure, ou roi sans parures'; Foucher (1918), II, 279.

77. 16. The Indian preoccupation, in a draped figure, is with the body beneath, and folds or pleats are indicated in such a way as to obscure the body as little as possible. The Indian sculptor was not

averse to treating fabric plastically, as can be seen in some splendid knotted sashes.

17. For a graphic representation of how it is worn, see Griswold (1963).

18. A curious feature of all the finest Buddha (and Bodhisattva) heads from Gandhāra is the contrast between the upper part, always tending towards stylization, and the highly sensuous treatment of mouth and chin, which are, of course, the fleshiest parts of the face.

19. One of the early Buddhist texts assures the faithful that they need only recall noble clansmen in their finery to know the appearance of the gods; *Mahavagga*, vi, 30, 5 quoted in Foucher (1918), II, 176-7.

20. The Greek *krobylos*.

78. 21. Ingholt and Lyons (1957), 89-90.

22. Monkeys sitting in a meditating pose, like the ascetic cat at Māmallapuram (see p. 283), add a note of real humour to the unvarying affection with which the Indian sculptor portrays animals. See Smith (1911), figure 60.

23. Harle (1974a). It now seems likely that this is an instance of a 'dropped hundred' date (see Note 43). A date of 105 (era of Kaniṣka) seems more probable in view of the mature Gandhāra style of this image, very close indeed to that of the other low-number-dated stele, the Visit to the Indraśāla Cave from Mamāne Dherī of the year 89.

79. 24. Ingholt and Lyons (1957), figures 255-7.

80. 25. Bussagli (1960), 22.

26. The colony from Barcoe in Lybia was sent to Bactria (Herodotus, *Persian War*, IV, 204). The Ionians referred to in another passage (VI, 9) were only threatened with this fate, which does not seem to reflect any particular links between Greek colonies and Bactria, but simply the Achaemenid penchant for punitive interchanges of population, and Bactria was the most remote part of their empire to which Greeks could be sent.

27. Indo-Greek is the term given to the small kingdoms or principalities north of the Hindu Kush and known (exclusively) by their coinage, on the Greek standard and bearing legends only in Greek. Indo-Bactrian refers to the coinage on the Indian standard and bearing bilingual legends (Greek and an Indian language written in Kharoṣṭhī) struck by rulers south of the Hindu Kush, although the geographical distinction has been blurred by recent finds. See Curiel and Fussman (1965), 61 and note 5.

28. For Kaniṣka, see p. 83, and Chapter 3, Notes 7 and 26. Deydier (1950) lists 435 titles (and there has been no shortage of publications since his bibliography). The date of Kaniṣka, i.e. the first year

of the era instituted by him and widely used as a base line for dates in his inscriptions and those of his successors, varies, as it has been propounded by various scholars, from A.D. 78, in which case it is the same as the uncontroversial Śaka era, to 144, and dates as late as 278 have been proposed. Attention has recently been focused on Sonkh, near Mathurā (above, p. 59), the most scientifically excavated large-scale Kuṣāṇa site in India to date, and Kuṣāṇa-related remains in Bactria and neighbouring parts of Transoxiana where Russian archaeologists have been active. For a review of the latter, Frumkin (1977); for résumés of the material in and from present-day Afghanistan, F. R. Allchin and Hammond (1978).

29. For a discussion of the Indo-Greek and Indo-Bactrian coinage, Curiel and Fussman (1965).

30. For a revision of some of Marshall's views, see Ahmad (1967).

81. 31. Hackin et al. (1939), (1954); Khandalavala (1960).

32. Dvivedi (1976). See Chapter 1, Note 69.

82. 33. For a study of the historical and cultural currents within the Kuṣāṇa empire, Rosenfield (1967). For Surkh Kotal there are provisional reports by the excavator, D. Schlumberger: see Rosenfield (1967), bibliography, and D. Schlumberger et al., Surkh Kotal . . ., I, *Mémoires de la Délégation Française en Afghanistan*, XXV (Paris, 1983).

34. For actual jewellery, said to be in the Karachi Museum, Rostovtseff (1929), plate XVIII, 5. Such jewellery is occasionally depicted on sculpture, usually in the headdresses of Bodhisattvas. A small bronze statuette of St Peter, seated, found at Charsadda and discussed in Bussagli (1954), is now untraceable. It appears to be based on the great seated bronze of St Peter in the basilica in Rome. There is some doubt as to whether this is a Late Antique or Early Renaissance work; see Rowland (1943). A stone statuette formerly in the Haughton Collection, now in the Victoria and Albert Museum, also appears to represent St Peter; see Buchtal (1945), figure 52.

35. Wheeler (1954), chapter XIII; for a particularly succinct statement of this viewpoint, Wheeler (1950), 53. No one has challenged his assertion that the technique of stucco sculpture was imported from Alexandria.

36. Foucher (1942-7), I, 55 ff. Foucher's disappointment at finding no Hellenistic remains whatsoever at Balkh makes poignant reading. The site, of course, has never ceased to be occupied.

37. Bernard (1973).

83. 38. Frumkin (1977) hints at evidence that the city is pre-Alexandrian. One crude figure found at the site, in a completely un-Hellenistic style, attests

to another culture which must have co-existed with the Hellenistic (shown to the author by H.-P. Francfort, of the Délégation Française Archéologique en Afghanistan, in Kabul in 1977). See Marshall (1960), chapter 3.

39. Taddei (1970), 83-4, 93-4; Wheeler (1962), 104-5.

40. See p. 38 and Chapter 1, Note 51.

41. Notably at Shaikhan Dheri, Charsadda.

42. Dobbins (1968); Harle (1974a).

84. 43. Another small piece has been added to the complex mosaic of dates and eras by the discovery of an incribed relic casket. The inscription, transcribed, translated, and edited by Bailey (1978), is dated in the year 63 (of the era) of Azes (ayasa). Marshall had believed ayasa to be the genitive of Azes, but this had been questioned; in the present inscription, the word ayasa is followed by the word for 'deceased' and Marshall's reading put beyond question. Bivar (1981) has shown, moreover, that the era of Azes and the Vikrama era are the same, and the relic casket's inscription is thus dated A.D. 4. At a seminar on Kuṣāna numismatics in London, in 1981, van Lohuizen proposed a dropped hundreds solution, using the Kaniska era base date for the Year 5 Buddha and other problematical dates in Gandhāra, to coincide with that postulated for Mathurā.

44. As well as in Kashmir and the Swāt Valley and parts of Ladakh and Tibet; Francke (1914), (1920).

45. Taddei (1968), (1973), (1974).

46. Hackin et al. (1959).

47. Godard and Hackin (1928); Hackin (1933); Tarzi (1977).

CHAPTER 5

87. 1. Goetz (1963), 250.

2. Ironically, it has been suggested that the glories of the Gupta age were invented by nineteenth-century Indian nationalists; Mukherjee (1962).

3. Nathan (1976), 3, quoted in Pal (1978b), 19.

88. 4. Except in very rare instances, the multiple heads of an Indian image, when part of a human body, are in fact multiple faces, since they do not have separate necks. For studies of multi-headedness and emanations in sculpture, Maxwell (1973), (1982).

5. As in Mathurā (see p. 65). A fourth face is soon added in Kashmir, in relief on the rear of the halo. This may have been in conformity with the Pāñcarātra

concept of the caturvyūhas, but Pal (1975a), 65, is probably correct in maintaining that the name Viṣṇu Caturmūrti or Caturānana, meaning simply 'four-faced', should be used for these images.

6. Von Stietencron (1972), 162, firmly rejects this possibility, as does O'Flaherty (1974), but Williams (1982), 46 and 109, does not.

7. Goetz (1963), 258. Harle (1974b) provides a survey of Gupta sculpture in stone and terracotta; most of the works discussed in Chapters 5-9 are illustrated there. Williams (1982) is a masterly study of all the architecture and sculpture of the period, with full consideration of the historical, cultural, and religious background. For the Murti remains, Stein (1937), 52-8, plates 18, 20, and 21.

8. Carved on the shaft of the Maurya column now in the fort at Allahabad. For the text with a translation, Fleet, CII, v. III, 1-17.

89. 9. The Hūnas were Central Asian invaders noted, at least in Kashmir, for their cruelty. They were probably unrelated to Attila's Huns. This point is made, and references are provided to some works of greatly different quality and varying usefulness on the history, art, and architecture of the Gupta period, in Basham (1975).

10. Rowland (1970), 243.

11. See Chapter 3, Note 26.

12. See p. 101. State Museum, Lucknow, no. J36.

92. 13. Marshall (1960) dates a good deal of the stucco work at Taxila in the fourth/fifth centuries. Admittedly his excavations were unscientific by modern standards, but there is independent confirmation for the dates. Certain features of Gupta sculpture on figures undated by inscription but nonetheless attributable with near certainty to the fifth or even sixth century, such as the 'horseshoe' or 'rainbow' way of dressing the hair, as well as the 'window', can already be seen in a very similar form on certain sculptures in the Gandhāra style. These features are described in Harle, 'Some Foreign Elements of Costume and Hair-style in Indian Art', *Professor Tucci Commemoration Volume* (to appear).

14. R. C. Agrawala (1969b); Gai (1969); Bajpai (1962). For a short account of the historical issue involved and the stylistic significance of these images, Harle (1974b); also Williams (1982), 28-9.

93. 15. For a fuller description of the caves and their sculpture, Harle (1974b); Williams (1982), 40-52.

95. 16. For alīḍha see Harle (1972b). The dates of two of these Durgās are controversial (the third is also of the older type). Harle (1971b) believes they may be contemporary in spite of the difference in style. Williams (1976) places them perhaps a

quarter-century apart, the earlier belonging to the end of the fourth century, while Barrett (1975) and Viennot (1971-2), 72-3, believe the later image to be of seventh-century date.

17. For a detailed study of the Varāha panel, Mitra (1963).

97. 18. Harle (1974b), figures 31 and 32 and notes to the plates.

19. There is no evidence to show that this characteristic Gupta headdress, with its superimposed rows of sausage curls on either side of the head, is a wig, but it is generally assumed – an assumption reinforced by its astonishing resemblance to the periwigs of Western Europe in the latter part of the seventeenth century.

98. 20. For a fuller account of Eran's Gupta antiquities, Cunningham *A.S.R.*, VII, X, Bajpai (1962) and Harle (1974b), 11, 12, 37-9.

21. Harle (1974b), figure 25 and notes, p. 12. With the Narasiṁha in the Archaeological Museum, Gwalior, the oldest image of this incarnation so far known from North India. The lion avatar on a relief slab from Kondamotu, in Āndhra, may be earlier; see Khan (1964).

22. Not altogether convincingly identified as a cakravartin (world emperor) form of Viṣṇu by P. K. Agrawala (1968).

23. Now in the Archaeological Museum, Gwalior.

100. 24. Williams (1976) for the inspired suggestion that since addorsed or quadruple figures, human or animal, atop pillars usually supported cakras, the serpent hoods above these figures have been elongated to give the illusion of additional height.

25. Marshall and Foucher (n.d.), inscription no. 835, mentions a Vajrapāṇi pillar. See also *ibid.*, pp. 50 and 254, all vol. I.

26. Sāñcī Museum, no. 2720, formerly A99; Harle (1974b), figure 41 and notes.

CHAPTER 6

101. 1. The single dated exception is the small figure in relief on the base of a pillar dated 381 (Archaeological Museum, Mathurā, no. 29.1931). It throws little or no light on the course of stylistic development. See Kreisel (1981), 329-30, figure 107; Williams (1982), 29, figure 16.

2. Mathurā Museum, no. 18.1506; Harle (1973), plates 17.3 and 17.4. Also the standing Viṣṇu in Los Angeles, if it is indeed from Mathurā; Pal (1978b), figure 3. Gupta Viṣṇus hold a fruit or seed(?) in their upper right hand to which there appears to be no clear reference in the texts. Their other hands

hold the usual disc (*cakra*), club or mace (*gadā*), and conch-shell (*śaṅkha*).

3. See Chapter 5, Note 12.

4. Harle (1974b), figure 43.

5. State Museum, Lucknow, no. J36; Harle (1974b), figure 45.

102. 6. Archaeological Museum, Mathurā, no. A5; Harle (1974b), figures 47 and 48. A third is in the Indian Museum, Calcutta.

7. The Calcutta image (see Note 6) and a rather squat standing Buddha with an over-large halo bearing an inscription dated either 203 or 280 of an unspecified era. This has been assumed to be the Gupta era, giving a date of 549/50. Williams (1974) has argued, to some effect, that a number of stylistic features point to a date some 150 years earlier, although admitting that no era yet proved to have been used at Mathurā at the time provides a date *c.* 400.

103. 8. Archaeological Museum, Mathurā, no. 76.25, with an inscription dated in the 115th year; Williams (1982), 68, figure 61.

9. See pp. 107-10.

10. The Mahāvidyādevī temple on the outskirts of Mathurā had at least two in a small modern shrine, one of them published in V. S. Agrawala (1935).

11. Harle (1965) first proposed that this head had belonged to an ekamukhaliṅga. Kreisel (1981), 298-9, and in correspondence with the author in 1983, questions this, arguing convincingly for an Aghora-Bhairava identification, in spite of the head's benign expression, either as part of a *caturmukhaliṅga* (a liṅga with four heads corresponding to the four aspects of Śiva depicted in the Sadāśiva image) or, less likely, as the head of a figure or bust.

CHAPTER 7

105. 1. Most notable among them the Didarganj yakṣī (see p. 31). There is also a splendid yakṣadevatā still in worship near Kumrahar (Asher (1980), figure 1); see also Patna Museum Arch. 8178, 8430, and 8484, of very modest size but also showing the 'Maurya' polish. The three large but much worn Ekānāṁśā figures in the Patna Museum would appear to be in the fourth-century continuation of this style.

2. A copy of a Mathurā Buddha in local stone was found at Sārnāth. One or two seated Buddhas in a local Mathurā-related style were made at Kauśāmbī, as well as the Umā-Maheśvara stele whose date is still disputed but is most likely to be *c.* 237, but see Williams (1982), 36-7.

3. There is a standing figure on the base, against

a cakra, thereby identifying the Tīrthaṅkara, best illustrated recently by Asher (1980), plate 5.

4. Kramrisch (1933), 61.

5. According to a re-reading of the inscription, Sircar (1970). The older reading of 449 was given in Harle (1974b), 19-20 and figure 55.

6. Kṛṣṇa is similarly depicted as triśikhin on the rock-cut reliefs at Patharghata; Asher (1980), plates 34 and 35. His dating of c. 500 or even earlier for these reliefs is confirmed by a 'barred disc' earring worn by Kṛṣṇa as he wrestles with Candra; Harle (1978).

7. This long carving, measuring 13 ft (4 m.) but now broken into four pieces, was probably a lintel. The mūrti at dead centre argues for this as well as the 'cut-off' provided by Sūrya and Candra at the ends. Narrative friezes do not appear until the post-Gupta period, and then usually illustrate scenes from the Kṛṣṇalīla. The problem lies in its length. There is a lintel from Sārnāth of roughly equal length (Sārnāth Museum D(d)1), but none of the extant Gupta temples, admittedly only a handful, have doorways of corresponding size, although two fragmentary jambs from Bilsar were estimated to have measured between 13 and 14 ft, which would be nearly proportionate to such a lintel; A.S.R., xi, 18. Again, the building to which the Gaḍhwā lintel belonged may not have been a shrine at all, but some other type of religious building, even a dharmaśālā, of which no examples have survived.

8. For a longer description and illustrations of details, Harle (1974b), 23 and 24, figures 71-9; also Williams (1982), plates 241-5 (references in text misnumbered).

107. 9. Professor Joanna Williams proposed in a letter (15 July 1976) to the author that this may be Bhīma, and that others in the group may represent Nakula and Sahadeva (the pair next to Sūrya) and the saintly Yuddhiṣthira as their leader, for which attribution she finds further evidence in the scenes depicted on fragments of doorjambs, in the same style, found at the site. For a slightly modified view, Williams (1982), 154 and note 168.

10. For the significance of 'wrapped' heads, still undetermined in female figures, Harle (1981).

11. Williams (1977).

110. 12. Rosenfield (1963).

13. Williams (1975).

CHAPTER 8

111. 1. Besides the temples mentioned below, the temple at Murti in the Salt Range in Pakistan, of which not even fragments remain at the site (Chapter 5, Note 7); a lintel and a few other fragments atop the Udayagiri (Vidiśā) hill; and the little temple at Eran, of which probably enough remains at the site for at least a partial reconstruction. Important sculptured elements of a Gupta temple near Nāchnā have been incorporated into a later building; Spink (1971).

2. See Chapter 11, p. 138 and Note 10. The strongest argument against a flat roof remains the total absence of such a shrine amongst the many early shrines depicted on reliefs. The sole example cited by Williams (1982) and illustrated in her figure 170, with its āmalakas and a high gavākṣa between them, would not seem to qualify on account of the āmalakas and a sort of nāsika on the roof. If anything, the building (?) represented is a maṇḍapikā.

3. See Chapter 5, Note 8.

4. Chandra (1970).

5. See p. 167. R. D. Banerji (1924); Chandra (1971), plates 132-92; Williams (1982), 117-22.

6. A.S.R., xxi, 95-8; Williams (1982), 105-14.

7. Vats (1952); Desai (1958); A.S.R., xi, 40-6; Vogel (1908-9a).

8. Viennot (1974), who dates this as well as most of the other temples to the second half of the sixth century. Meister (1982) on the other hand proposes a date in the first half of the fifth century, while Williams (1982), 138, assigns it to c. 480. Meister, as well as P. Chandra, Spink, and Williams, is not inclined to date any of the Gupta temples later than the first quarter of the sixth century. Neither Meister's nor Williams's reconstruction of the plan allows for an internal circumambulatory.

113. 9. See p. 166.

10. See p. 239. Sarvatobhadra shrines are called caturmukha in the Jain texts.

115. 11. Harle (1974b), figures 100 and 101, 94-9 and notes; Williams (1972-3).

12. Harle (1974b), figures 61 and 62. The cloth may have been rolled over a little tubular amulet-case.

13. Shah (1960).

14. Asher (1980), 22-6.

117. 15. R. C. Singh (1968-71). Harle (1974b), 31, assigned a date of c. 425 to this temple whereas Williams (1982), 84, prefers one in the mid century.

16. Mehta and Chowdhary (1966), who date the stūpa, on the strength of a relic casket found within, with an inscription according to which a King Rudrasena built the stūpa in the year 120 of an unspecified era, to the last quarter of the fourth century. The objection to this is that the decorative elements of the stūpa, and the Buddhas, are thus in advance by over half a century of anything found further

east, and yet the region was still in the hands of the western Kṣatrapas and not part of the Gupta empire. Van Lohuizen (1979a) proposes that these belong to a reconstruction of the stūpa at a later date, possibly in the sixth century, an argument strengthened by the renowned epigraphist D. C. Sircar (1965), who argues on palaeographic grounds that a date *c*. 200 is much more likely for the inscription on the relic casket, thus referring it to an earlier Rudrasena and the Śaka era, with a major reconstruction in the fifth or sixth century very likely. Williams (1982), 59, dates the Buddhas and the deccorative elements to 400-415 on stylistic grounds.

17. Cousens (1909-10). The remains of a number of other stūpas have been found in Sind. See Cousens (1929); Van Lohuizen (1979a), who notes that the stūpa is properly that of Kahujo-daro, dates it to *c*. 600 (see Note 16). Williams (1982), 94-5, believes that the similarity in the treatment of motifs at Bhitargaon suggests a similar date (see Note 15).

CHAPTER 9

118. 1. Caves 9, 10, 11, 12 and 13; 9 and 10 are the caitya halls. The caves are numbered 1 to 29 commencing at the entrance to the ravine. The later caves were added, although not in strict order, on either side of the original group.

119. 2. The basic surveys of the second-phase caves are Fergusson and Burgess (1880), Burgess (1879), (1883a), and Yazdani *et al.* (1931-46).

3. Marshall (1927); Spink (1976-7).

4. Next to the caitya window, the *kapota* is the most ubiquitous of all Indian temple architectural motifs, although in the north it tends to become either rare or transformed beyond all recognition during the Later Hindu period. Approximating a quarter-circle in section, it is used as an eaves or cornice or as one of the mouldings of the base. It becomes extremely large on maṇḍapas of the Vijayanagar period in South India and develops a reverse curve. Its origin is unknown, but in Gandhāra, where alone something very like it depends on a structural feature, it is the half-barrel-vault over a circumambulatory passage, with a lower roof than the main edifice, a 'South Indian' grīva and a śikhara over the sanctum. See Franz (1981), figures 5-8. *Kapota* is the word for a pigeon, and various reasons have been given why it is applied to this architectural element.

120. 5. Spink (1966), (1968), (1972), (1975), and (n.d.). After the most exhaustive investigations of style ever devoted to an Indian monument, Spink's timetable for the excavations at Ajaṇṭā calls for all

work there to have ceased by 500. Earlier scholars had postulated an excavation period of up to three centuries. Although Spink deduces far more about the ebb and flow of patronage - a practice of which practically nothing is known in the Gupta period - than the meagre facts allow, it is unquestionable, on grounds of style, that none of the caves are later than the early sixth century.

6. Auboyer (1949); Dhaky (1965a).

7. Stern (1972).

8. See p. 356.

122. 9. A *gaṇa*, or dwarf follower of Śiva, now in the National Museum, New Delhi; Michell (1982), no. 473.

CHAPTER 10

123. 1. J. Burgess, *Architectural Survey of Western India*, III-V; Fergusson and Burgess (1880). For a résumé of the most recent chronology of the caves, elaborated in numerous monographs, see Spink (n.d.). Its datings attempt to be too precise, and Elephanta and its successors are probably placed two or three decades too early, but it is the first chronology based on more than superficial knowledge of the history and styles of the period. Gupte (1962) provides fairly detailed descriptions of the Ellorā and Aurangabad monuments and their iconographies.

124. 2. The only inscription mentioning a temple is a Traikūṭaka one at Kanheri, but it appears to refer to a structural building. As well as coin finds in the area, the importance of Lakulīśa in all these temples associates them with the Kalachuris, who were ardent Pāśupatas. For the most recent study of the authorship and date of Elephanta, Gorakshkar (1981).

3. The emphasis accorded the Mahādeva image is shown by the fact that, like the entrance to the garbhagṛha and alone of the sculptured panels, it is flanked by guardians.

4. These images of Śiva as Lakulīśa, seated in a yogic position, obviously owe much to images of the Buddha. Lakulīśa is represented as *ūrdhva retas* (with an erect phallus) and holding a stick (Lakulīśa = *lakula*, stick; *lakulin*, one with a stick + *īśa* = god or lord with elision of the *n*).

5. See p. 115. The relationship between this sculpture and that of Gujarāt is even more apparent in two fine figures recently discovered at Parel; Gorakshkar (1982).

6. The sculptures are in the Prince of Wales Museum, Bombay, where a cast of the relief itself, still in worship, may also be seen. For an explanation

of the iconography of this unique piece, Gorakshkar (1982), but see Maxwell (1982).

126. 7. The caves are numbered from south to north.

127. 8. Mahākūṭa pillar inscription of 602.

9. Relationships such as this are of great importance in dating these earlier caves, as well as the Buddhist ones at Ellorā, since none of them bear dated inscriptions, as well as providing evidence for the migration of the workers responsible for them; Spink (1967).

10. R. D. Banerji (1928); Tarr (1970).

11. The contention that certain of these sculptures are later replacements by Narasimha Pallava after his defeat of Pulakeśin II and conquest of Bādāmi has not been proved, and a suggestion that the Narasimha image actually represents Narasimha Pallava holding a lock of his enemy's hair (Pulakeśin: possibly 'tiger-haired') in one of his hands runs counter to the presuppositions on which Indian iconography is based. In the early photographs, Narasimha's club, now missing, is still in position. It is not certain whether the 'hand' which held it, most unusually shown as a claw, was recut after the break.

129. 12. Harle (1971a). See also p. 178.

13. For structural temples with rectangular garbhagrhas and usually surmounted by a śālā, see the Vaitāl deul at Bhubaneswar, the Varāhī at Chaurasi, in Orissa, the Gaudarguḍi at Aihole, and a list of others in D. Mitra (1960a), 1-3. A śālā is a rectangular building or pavilion topped by a barrel-vault whose section is a caitya arch.

14. Levine (1966).

131. 15. Kern (1884), 408 *passim*.

16. The term 'Dhyāni Buddha' (Meditation Buddha), widely used, is retained although there is no authority for it in the texts, which simply call these Transcendent Buddhas 'Jinas' or 'Tathāgatas'.

132. 17. The name Do Thal (two-storey) is due to the fact that for a long time the ground floor was blocked up by debris.

135. 18. See p. 182.

19. *A.S.I. A.R.* (1905-6), 107-15; (1915-16), 39-48.

CHAPTER 11

136. 1. See pp. 111-13.

2. Regional styles begin to be distinguishable in the early post-Gupta period. The states of today's Republic of India are used henceforth, in most cases, to define the various regions in this broad survey of their architecture and sculpture and, eventually, painting. As finally demarcated, the boundaries of the states of the Indian Union follow, in almost all cases, the lines of linguistic division and thus have, in an overall historical context, very considerable cultural validity. The ancient names of regions, overlapping because of their imprecision and repeatedly changing over the long course of Indian history, have been generally ignored except where they are in current use by art historians as having cultural as well as geographical significance, e.g. Mālwā, Mewār.

3. R. C. Agrawala, Krishna Deva, M. A. Dhaky, M. W. Meister, O. Viennot, and others. See Note 19. In contrast, post-Gupta sculpture has received scant attention from historians of Indian art, apart from their usual almost obsessional interest in iconography. A welcome exception is Bruhn (1969), although most of the Deogarh images he considers belong to the next period.

4. Nanavati and Dhaky (1969). None of the temples are dated.

5. Meister (1976a) is surely to be followed, although without authority from the texts, in terming these shrines bhūmiprāsādas rather than temples with a phāmsanā superstructure or roof, as do Nanavati and Dhaky (1969). The essential difference between the two is that the *bhūmiprāsāda* (*prāsāda*, literally, a palace, is one of the many names for the shrine proper) is a nearly straight-sided truncated pyramid, chopped off at the top, with an āmalaka and a jar-shaped finial on top and the 'storeys' demarcated by kapotas, whereas the phāmsanā roof has sides sloping at rarely as much as 45 degrees from the horizontal composed of two or more overlapping 'boards' (*śūrpas*), often confused with stone awnings (*chādyas*) in later examples, usually with two or three large gavākṣas and surmounted by a bell-shaped finial. There are early representations of bhūmiprāsādas on reliefs and seals, and the Bodhgayā temple must be considered to be one. *Kapota* is used here to designate, in every case and throughout India, the universally recognizable characteristic inverted quarter-round moulding of Indian temple architecture, including its inverted cyma recta equivalent. The kapota is used as an element of the base and as a cornice or eaves. See Chapter 9, Note 4.

6. A collateral branch of the Early Western Cālukyas of Bādāmi ruled in the region by 700; *H.C.I.P.*, III, 156.

138. 7. Meister (1976a) totally rejects any link between Gop and temples in Kashmir, but wooden superstructures of the type from which he admits it is a conversion into stone are only found in India in regions of snow or high rainfall, which Saurāṣtra is not. It is worth noting too that the simhakarṇas on

temples like the Śrī Satyanārāyaṇa and the maṇḍapa of the north-east subsidiary shrine of the Saciya Mātā, both at Osian (figures 25, 26, and 31), as well as that of temple VII at Roḍā, are oddly analogous to the triangular pediments rising up on the sides of the phāṁsanā roofs of Kashmir temples. Noteworthy also is the fact that such pediments are nowhere else – including Kerala, Nepal, and the Himālayan regions – a feature of temples with 'pent roofs'.

Kramrisch suggests that the phāṁsanā roof did not survive over the shrines proper, in the main, because 'it did not lend itself to great development in stone or brick temples due to the meagreness, as a plastic form, of the pent roof of laminated boards'; Kramrisch (1946), I, 220.

8. The Kalinga type.

9. Kramrisch (1946), I, 150-4. Meister (1976b), however, has correctly discerned that the vertical elements of these shrines are not treated in a megalithic way but betray a wooden origin.

10. The study of these temples by Viennot (1968) is rather unfortunately entitled 'Le problème des temples à toit plat dans l'Inde du nord', since the burden of the article is that most of them were not originally flat-roofed. Viennot points out that no flat-roofed shrines are shown on any of the early reliefs, and that fallen āmalakas have been found on the ground beside some of these shrines. They may have been placed at the corners, however, so that in such small structures as these they do not necessarily imply a regular Nāgara śikhara. Meister (1976b) is probably correct in maintaining that some of the temples were flat-roofed and represented a separate tradition over which the emergent Nāgara śikhara prevailed.

11. Scholars are not agreed on what term, if any, applies to this feature in the texts. It is a pediment, not necessarily triangular, composed of a mesh or honeycomb of gavākṣas. Viennot (1976), glossary, gives jālagavākṣa (jāla is a stone window grille), Meister (1976a), glossary, śūrasena for this ubiquitous feature. Udgama simply means a pediment and can consist of a single gavākṣa.

12. Temples with upper sanctums not integrated into the main structure: Lāḍ Khān and Meguti at Aihole. In this particular case, as Meister (1976b) points out, the dominant Nāgara śikhara development is seen taking over, in a novel form, from the probably originally flat-roofed maṇḍapikā. Good illustrations of temples at Mahua, Gyaraspur, Kuchdon (Kuraiya Bir), Batesvar, Padhavali, Badoh, and Kadwaha in Meister (1976b). The illustrations in Viennot (1976), the principal work on the subject, are very small and sometimes not very good.

139. 13. Meister (1973-4), (1975-6) to an extent rediscovered this temple and correctly recognized its importance. Lin-Bodien (1980) does not accept that the dated inscription, not in situ, necessarily refers to this particular temple at Kusumā which, on stylistic grounds, she prefers to assign to the late seventh century.

14. Nanavati and Dhaky (1963).

15. Michell (1975a) for a plan of this temple.

16. Meister (1973-4), figure 12; (1975-6), figures 10-12.

17. Meister (1973-4), figure 16; (1975-6), figures 29-30.

18. For photographs of what remains, Meister (1981), who staunchly defends the date usually ascribed to the temple. Also Viennot (1976), photographs 55 and 56. Again, the date is provided by an inscription no longer in situ, and its relevance has been challenged by Lin-Bodien (1980), (1981), who adds evidence that the inscribed slab does not appear to fit the place within the temple whence it has been thought to come. The extremely complicated history of this inscription, about which accounts and arguments have accumulated, dates back to the famous Colonel Tod of Rājasthān in the early nineteenth century.

140. 19. Regional differences have so far not been sufficiently clearly distinguished, and the common features of the style still appear so predominant that it has seemed best, in such a brief summary, to treat this vast area as a unit. The two scholars who have made the most exhaustive study of these temples, Dhaky and Viennot, have taken different approaches. Dhaky (1975a) has limited himself to the temples in the western part of the region, has distinguished sub-styles therein, and has generally taken a more orthodox, if sometimes very bold, view of stylistic development. Viennot (1976) has studied the temples of the entire region. Bent on establishing a relative chronology for the temples as a whole by the study of their individual elements, she only notes, en passant, what may be regional variants and possible movements of stylistic features. Her work, however, has the great merit of making clear to the informed reader to what extent the same motifs, the same general development, occur from eastern Madhya Pradesh to the confines of the Rājasthān desert. An overview of this sort also acts as a deterrent to premature and over-facile regional groupings.

20. Just as in Orissa, South India, and other areas, a number of śāstras from these regions have survived. (Śāstras are the traditional writings, usually prescriptive, covering nearly every aspect of human activity, including architecture and the making of

images.) The oldest date from the eleventh century; see Nanavati and Dhaky (1963), 19–22; Sompura (1975); Dhaky (1975b), 125–7. Their architectural vocabularies include regional terms. These are employed here when they designate distinctive features of the regional style; otherwise terms of more widespread application are used wherever possible. When an Indian term (usually Sanskrit) is introduced it is followed by the nearest English equivalent, which is subsequently employed to avoid overloading the text with technical terms unfamiliar to the non-specialist reader. The exception is where a reference in the index is desirable. Terms such as śikhara and kapota, which refer to characteristic Indian elements and features for which there is no real English equivalent, are used throughout, to avoid a cultural distortion, except occasionally where an elementary concern for style demands some relief from constant repetition of the same word. For glossaries, often with inconsistencies between them: Nanavati and Dhaky (1969), Meister (1973–4), (1976b), Viennot (1976).

141. 21. Deva (1969), 16, is surely wrong in calling these 'quarter lotuses' (see the splendid examples in the Cikki Gudi at Aihole and at Ālampur); Meister (1975), 230, calls them 'leaf brackets'.

22. The repertory was first specifically enumerated in Harle (1977), 576–82.

23. The 'Mahāmāru' style. The brilliant study by Dhaky (1975a) of architectural style in western India during the post-Gupta period distinguishes two sub-styles, the 'Mahāmāru' and the 'Mahāgurjara' (in northern Gujarāt). Dhaky's analysis, which already suffers from over-condensation, cannot be reproduced here. Following Dhaky, however, dynastic labels for architectural sub-styles (Gurjara-Pratihāra, Paramāra, etc.) have been abandoned as unsatisfactory in this period, partly because few contemporary monuments in western India or Madhya Pradesh can be connected with royal or princely patronage.

24. As were several of the other Osian temples originally; see Bhandarkar (1908–9), whose designations of the temples have been generally adopted. Sometimes spelt Osia, the name is pronounced locally with a strong nasalization of the final 'a'.

25. Meister (1976a), 169–70 and figures 1, 9, 10, 13. The roof of the raṅgamaṇḍapa is presumably an early example of the saṁvaraṇā or 'bell' type.

143. 26. Meister (1972–3) briefly on these, as well as two panels at Vadhvān in Saurāṣṭra.

27. Bhandarkar (1908–9), 105–7. Other examples of temples with small ardhamaṇḍapas: the Sūrya temple at Umri; Āmvān, temple no. 2; triple temple at Menal.

144. 28. Bhandarkar (1908–9), 108; Dhaky (1968), 312–27.

29. For plan, Dhaky (1968), 313.

30. Viennot (1976), photographs 235 and 236.

31. *Ibid.*, photographs 129–131, 195 and 197, 198–201.

32. *Ibid.*, photographs 116–18.

33. The 'Viṣṇu' temple at Buchkala of 815 is the only early dated temple in Mārwār; *Epigraphica Indica*, IX, 198–200; Viennot (1976), photographs 122–6; Dhaky (1975a), 139–45.

145. 34. The Kālikā Mātā was originally a Sun temple, the Kumbhaśyāma a Viṣṇu shrine.

35. B. N. Sharma (1975).

36. Shah (1960), 98–114, figures 79–92.

37. Termed the 'Mahā Gurjara' by Dhaky (1975a).

147. 38. For the continuing deterioration of some important temples, compare photographs in Shah (1968), figure 91, and Viennot (1976), photograph 163; also Viennot (1973), figures 1 and 2.

39. It is difficult, on the grounds of these examples, to understand the preference for the 'Mahāgurjara' style over the 'Mahā Māru' expressed by Dhaky (1975a), 149.

40. Dhaky (1965b).

41. A head from Valabhī, plainly early post-Gupta by the style of its headdress, provides an important link with such figures as the Viṣṇu from Bhinmal; Shah (1960), figure 10; Shah (1968), figures 1, 2, 3, 5. The Sāmalājī sculpture still presents a problem; see p. 115.

148. 42. Maxwell (1975), (1982), (1983).

43. The old Kotyarka temple at Mahudī (north Gujarāt). Shah (1960), figures 29 and 30. Probably a Skandamātā; see p. 115.

44. *Ibid.*, figure 21.

45. Shah (1955–6), (1959); the dates of the two splendid bronzes from Vasantagadh were later recovered. See Shah (1975), 277.

46. Dhaky (1966); Meister (1976b), figure 2 (figures 27 and 28 show the new shape after restoration).

47. Viennot (1976), photographs 172–5.

48. Murti (see p. 89), in the Salt Range west of the Jhelum, proves the extent of the penetration westward of the Gupta metropolitan style.

49. Barrett and Dikshit (1960), plates 62, 78, 79.

150. 50. *Mārg*, XII, no. 2 (March, 1959), 28–30 and illustration; Jayakar (1956–7).

51. Tripathi (1975). Called Badoli by Viennot (1964), (1976). Retroflex 'ḍ' and 'ṛ' are easily substituted for each other.

52. Tripathi (1975), 25 (ground plan). The

overall lozenge- or diamond-shaped ground plan was always inherent in the triratha and pañcaratha ones.

53. Viennot (1964), plate 40.

54. Viennot (1976), photograph 251.

55. The central face was already totally obliterated early in the nineteenth century when the famous Colonel Tod described the temples; Tod (1920), iii, 1755.

56. Goetz (1955b).

151. 57. It is not dated. Viennot (1976), 216 and 217, like Goetz (1955b), placed it in the mid eighth century, a date in which Deva (1979) concurs, after datings of *c.* 850 in Deva (1962), (1969).

153. 58. For illustrations and plans of some of the preceding five temples: *A.S.R.*, vii, plate viii: Viennot (1976), photographs 96–100, 104–6 bis, 185–8, 189–94, 225–8. See also Deva (1968) and Meister (1975), 236–41, figure 3 and plates 19 and 20.

59. Deva (1968) claims that there are windows to the balconies.

155. 60. Viennot (1973).

61. Omitting the part between the two cornice kapotas. The proportions of these temples of exceptional type, including the Telikā Mandir because of its size, are of particular interest: measured drawings should be made, for enough of the fabric remains (with considerable interpolations).

62. Plan: *A.S.R.*, x, plate xi. As with so many Indian temples, Bhitargaon among them, photographs give a totally false indication of size, due to the monumentality of their conception. The Bajrā Math is only 39 ft (11.9 m.) wide.

63. Viennot (1976), photographs 273, 274, 276, 279, 280.

64. *Ibid.*, photographs 287–90, 301–2.

65. Viennot's 'technique en reserve'; *ibid.*, 39–40.

66. Deva (1969), 24, 'ninth century'; Kramrisch (1954), plates 107 and 108, 'eighth century'.

156. 67. See p. 124.

68. At Bajaura, Baijnath, Chamba Town, Jageśvar, etc.

69. Sivaramamurti (1961), plate 34; Bussagli and Sivaramamurti (n.d.), figure 322.

70. R. K. Sharma (1978). For other hypaethral temples of this type, and references, Kramrisch (1946), 198–9 and footnotes; p. 421, note 10.

CHAPTER 12

158. 1. In the famous praśasti, no kings from this region are mentioned amongst those defeated by Samudragupta, and the earliest dated inscriptions from the past two thousand years, on copper plates and oddly enough using the Gupta era, are from the latter half of the sixth century A.D. The present state of Orissa was traditionally divided into regions, North and South Tosalī (the area of the Mahānādi river), Trikaliṅga, Utkal in the north, and Kaliṅga in the south. The last two names, as well as Odra, the origin of Orissa, have at one time or another been applied to the whole region. See Dehejia (1979), 3 ff.

2. Dehejia (1979) is a good introduction to the temples built before 1000 with an excellent selective bibliography. D. Mitra (1966), a guide to the temples of Bhubaneswar, is a model of its kind. Panigrahi (1961) is far more detailed and provides some excellent photographic documentation.

3. Orissan traditional architectural texts have their own vocabulary of technical terms. Some of them, moreover, on palm leaf, are illustrated; for an example, Boner and Sarma (1966). Except where they have gained wide acceptance by their extensive use in modern works, the use of terms limited to Orissa has been eschewed here.

4. The Indians knew only the six planets visible to the naked eye, to which they added the sun (not, of course, a planet) and Rāhu and Ketu, the ascending and descending nodes of the moon, to make the nine planets or *navagraha*. In the system used at this period in Orissa, the *astottari*, Ketu is omitted.

5. Paraśurāma is an incarnation of Viṣṇu, so it is unlikely that his name was originally given to an obviously Śaiva temple. It is probably a corruption of Parasareśvara, Parasara being a distinguished Pāśupata *āchārya* (teacher). See D. Mitra (1966), 29.

6. Not a common type, but examples can be found in most regions of India. See D. Mitra (1960a).

159. 7. Dehejia (1979), figures on pp. 38–9. A clue to this odd arrangement may lie in the imperfect bonding between the two parts in certain Early Western Cālukya temples.

160. 8. Harle (1977), 576–82.

9. Kramrisch (1947), 180. The article is of major importance.

10. Dhaky (1974). The name of the third of these temples is given as Bhavanī-Shankar in Dehejia (1979).

11. Panigrahi (1961), figures 30–2 and pp. 16–17. Kramrisch (1947), 181, refers to this temple before its restoration.

12. See the Gauḍargudi at Aihole (pp. 172–5) and the Rāvaṇa-ka-Khai at Ellorā (p. 129).

13. Barrett and Dikshit (1960); Masthanaiah (1978).

161. 14. Boner and Sarma (1966), 66.

15. Dehejia (1979), 112, for rare published photographs of some of these figures. Blood sacrifice

(of animals), although not a central component of Hindu religion, is not rare in India; human sacrifice, as mentioned in texts and suggested by reliefs such as these, never seems to have been common and appears only in more recent times, in a tantric context. Today, of course, it is treated as murder by the authorities. See De Mallmann (1958), figure 1.

16. This suggests a possible connection between Sūrya and the cult of the Mothers.

17. De Mallmann (1964b).

163. 18. The percolation of Buddhist elements at this time into the iconography of some Hindu images has already been noted. Buddhist images are found in large numbers in parts of Orissa. Chinese and Tibetan sources refer to the importance of the Orissa monasteries, and Ratnagiri is specifically referred to as a centre of tantric Mahāyāna. Willetts (1963), 17.

19. *Ibid.*, note 2, for a useful short bibliography which includes references to the progress reports of Mrs Debala Mitra, the excavator, well illustrated in *Indian Archaeology*; D. Mitra, *Ratnagiri 1958-61, Mem. A.S.I.*, LXXX, 2 vols. (New Delhi, 1981-3).

20. *Indian Archaeology* (1958-9), plates XLA, XLIA.

21. A doorway from the (then unexcavated) Udayagiri monastery is now in the Patna Museum.

22. A close stylistic link between the style of these temples and the doorway in the Patna Museum was already noticed by Panigrahi (1957), 278.

23. R. L. Brown (1978) proposes an early-eleventh-century date based on the stylistic features of a third façade to the main shrine of Monastery 1, which has been re-erected (figures 4, 17, 18, 22, 25).

164. 24. Mitra (1960a); J. N. Banerjea (1965); excellent photographs in Boner and Sarma (1966). The unique illustrations (sketches) of the Śilpa Prakāśa are an invaluable link between actual practice as seen in surviving temples and the typically formalized text, but the correspondence between the prescriptions for a Kāmagarbha type temple and the Chaurasi temple does not seem as close as the authors suggest. It is also curious that the four manuscripts known to the editors are all dated in the eighteenth century while the text purports to be much earlier. It must be remembered also that the sketches can only date from the time of the transcription of the manuscript or possibly later.

25. J. N. Banerjea (1965) quoted in Dehejia (1979), 126-7; Boner and Sarma (1966), plate LXII b.

CHAPTER 13

166. 1. Cousens (1926) was the first major study of these temples. The most recent is Michell (1975a);

see also the review by Bolon (1979), 271-3. Bolon (1980) casts new light on the problem of dating the temples of the earlier phase. Tartakov (1980), in a useful and splendidly illustrated article, persists in assigning an excessively late date to the Malegitti Śivālaya, and his stylistic arguments for dating the Lāḍ Khān as late as *c.* 700 are not all convincing.

2. See p. 43.

167. 3. S. R. Rao (1972), (1973), but see Michell (1975a).

4. E.g. the maṇḍapa of the Paraśurāmeśvara temple at Bhubaneswar. See p. 159.

5. Settar (1969) is not entirely convincing about the Buddhist nature of the two-storey building built into the hill below the Meguti, nor is this really confirmed by Tartakov (1970), 183-4. On the other hand, a large loose sculpture of a standing figure, on the way up to the Meguti, strongly suggested a Bodhisattva when seen by the author in 1964.

6. Bolon (1980), 304, calls it a Sūrya temple.

169. 7. Harle (1971c).

8. This inscription signals not one but two firsts: it contains the earliest dated reference to the poet Kālidāsa, and it is the earliest dated inscription in which the term Śaka is actually applied to the era commencing in 78.

9. Harle (1969).

10. Michell (1975a). Bolon (1979), a brilliant article breaking much new ground, proposes another temple, a very small shrine, as the one to which the inscription of 601 refers. Tartakov (1980), on the other hand, chooses the Banantigudi, a somewhat larger edifice, also outside the Mahākūṭa compound, on the grounds that he believes that the pillar originally stood before it.

172. 11. See p. 136.

12. See Chapter 11, Note 5.

13. Balasubrahmanyam (1961); P. Brown (1942a), 63 and 64, plates XXXVI and XXXVII.

174. 14. P. Brown (1942a), plate XXXVI.

175. 15. S. R. Rao (1972), (1973) dates this temple, on the evidence of pottery finds (which is open to question), in the early fifth century, rejected as too early by Michell (1979) on grounds of style. For the inscription, *Annual Report, South Indian Epigraphy* for 1927-28, no. 289.

16. It is not a Durgā temple; its name derives from the word for fort (*durga*), its function in relatively modern times. Against the suggestion that it was originally a Jain shrine see Bolon (1980), 305, note 11.

17. Gupte (1964).

18. K. R. Srinivasan (*Indian Archaeology* (1960-1), 76) stated that the śikhara was added by an over-zealous restorer or improver, without any suggestion

as to when. The śikhara is already in place in the earliest photographs, which still show remains of the attempts to 'fortify' the temple, probably in the eighteenth century. The śikhara is similar, moreover, to others of the period, and none of the elements are out of place, as would be likely if such a large and complex structure had been reassembled at a later date on top of the Durgā temple.

176. 19. The name, again, is said to be derived from the religious office of a former occupant.

20. Clearing and excavation (see S. R. Rao, 1972) revealed the fine pillar sculptures of the north-west shrine and showed that the four-pillar porch was built before the north-east shrine, the last to be erected. For an excellent study of this enigmatic group of little temples, Michell (1978).

21. Divakaram (1970).

22. Harle (1972a); Lippe (1967), (1969-70).

178. 23. Kramrisch (1956). Examples in terracotta have been found in a number of places in northern India and the Deccan.

24. Harle (1971c). See also pp. 127-9.

180. 25. Sivaramamurti (1957).

26. K. V. S. Rajan (1958-60).

27. M. S. Nagaraja Rao (1973) and Michell (1973a) came independently to the conclusion that the Pāpanātha was a little later than the Virupākṣa. The latter makes a convincing case for a change in design immediately after the construction of the cella, without any further change in the new design.

181. 28. Bhandarkar (1883), 228-30. For the other reference, almost certainly to the Kailāsa temple, H. Lüders (1896-7).

29. The dimensions are from Fergusson and Burgess (1880) and Burgess (1883b).

182. 30. Goetz (1952), with a full bibliography in the footnotes; for good short accounts of this temple, P. Brown (1942a) and Rowland (1953).

31. Chatham (1978).

32. Even further south, Rāṣṭrakūṭa temples are rare. One, at Bhavanasi-Saṁgam, as the name implies (saṁgam: 'a meeting place of waters') lies at a confluence of the Kistna and another river. Prasad (1972) also lists other places in Āndhra with Rāṣṭrakūṭa temples. See also Lippe (1978), 146 and 183, colour plate I.

33. Cousens (1926), plates XXIIb, XXIIIb, LI, LIXa, LXI.

183. 34. Archaeological Department of Mysore, Annual Report 1935, 49-53.

184. 35. *Ibid.* 1932, 65-73. The Nolambas (ninth and tenth centuries) of Hemavati in Anantapur District, although generally feudatory to their more powerful neighbours, produced distinct styles of

architecture and sculpture; see Barrett (1958d); Sivaramamurti (1964). Nolamba work can be seen in the Bṛhadīśvara temple, Tañjavūr, and in the form of the fifty fine pillars, brought back as war booty by Rājendra Cola, in the Pañcanādeśvara temple, Tiruvaiyārū, Tañjavūr District.

36. Dhaky (1982).

37. See p. 141.

38. Archaeological Department of Mysore, Annual Report 1936, 8 and 9.

39. *Ibid.* 1939, 44-50, plates IX-XII.

40. *Ibid.* 1937, 28-38.

41. See pp. 297-9.

42. Divakaram (1971); Bolon (1980). For the latest list of all the sites, Bolon review of Michell (1975a) cited in Note 1.

187. 43. Michell (1973b).

44. Rea (1907-8), (1910-11).

45. For examples, the Elliot Collection in the British Museum; Barrett (1954b).

46. Longhurst (1924).

188. 47. M. Rama Rao (1964), (1965).

48. Sivaramamurti (1962).

49. To what extent these influences are a direct result of Vijayāditya's northern conquests (as claimed by Tartakov (1980), 70) is doubtful.

50. See p. 284.

189. 1. Still the best survey of the art and architecture of Kashmir, although rather slight, is Kak (1933). Goetz (1969) considers a number of aspects of Kashmiri art and history with great erudition but many unwarrantable assertions. Temples and sculpture with datable inscriptions are particularly rare. The twelfth-century poet Kalhana's chronicle of the kings of Kashmir, the *Rājataraṅginī*, literally the 'River of Kings', does, however, like the much older vamśas of Sri Lanka, provide a framework for pre-Muslim Kashmiri history such as is lacking elsewhere on the subcontinent. See Pandit (1958).

2. Kak (1933), 105-11, plates XV-XLII and LXXVII.

3. Kak (1923), plates Aa3 and Aa4.

191. 4. P. Brown (1942a), 187.

5. Granoff (1979) believes it to be essentially Buddhist, a view not universally accepted, and no explanation is given of the wrapped head of Umā. For this feature, see Harle (1981).

6. Pal (1975a), 16-18, with the suggestion that the angry face at the back represents the sage Kapila, the founder of the Samkhya system of philosophy.

192. 7. Actually, their metal alloy is in most cases closer to brass. Until the 1950s, only half a dozen or

so were known. For their recent appearance in such numbers, Pal (1975b), which is also the fullest account of this important branch of Indian sculpture.

8. Barrett (1962), 37.

9. For the camail, Harle (1980), (1985).

10. Pal (1975a), plate 71; Barrett (1960b); Lerner (1975), no. 1.

11. Pal (1975a), plates 12a, b, and 13.

12. *Ibid.*, 30 a, b.

195. 13. *Ibid.*, plate 26; for results of metal tests, Harle (1979), 127, 133, note 23. Lead makes casting images, particularly large ones, easier, since the molten metal flows more easily.

14. Pal (1975a), plate 11a, b, c; Goetz (1969), 77–87, plates xxvi and xxvii. See p. 145.

15. Pal (1975b), plate 16.

16. *Ibid.*, plate 17. Some doubt has been expressed, however, whether it is indeed Kashmiri.

17. This pose has been termed the *mahākaruṇika* (of great compassion); Harle (1979). The image published by Harle is the only one of this group which cannot, on purely stylistic grounds, be attributed to either Kashmir or Swāt. Doubtless deriving from a common transitional source, it is likely to have been made closer to a centre of the metropolitan Gupta style.

197. 18. Barrett (1962).

19. The Viṣṇu Caturānana in the Lakṣmīnārāyan temple, Chamba, is a masterpiece of the Kashmir style; others, such as the Śiva-Pārvatī in the Gaurishankar temple and the bronzes in temples at Brahmor and Catrarhi, are all equally fine in a more integrated, more Indian style. Pal (1975b), plates 84 a,b,c, and 85; Goetz (1955a), plates iv-vii; Jettmar (1974); Chetwode (1981).

20. Maxwell (1980), plates 4–7a.

21. Fabri (1955).

22. Tucci (1958), 322; Schlumberger (1955); Barrett (1957); Goetz (1957); K. Schmidt, F. A. Khan, *et al.* (1963), no. 328; Mishra (1972).

23. Wheeler (1950), 55–61; van Lohuizen (1959) for bibliography and references to earlier works; Taddei (1970), plates 144, 147–9.

CHAPTER 15

199. 1. In the easternmost states and territories of the Indian Union, only a fine temple doorway of the sixth or seventh century remains from the period, at Dah Parbatiyā, Tezpur District, Assam.

2. Asher (1980) only covers the period to 800. For surveys of Pāla sculpture, see Note 40.

3. Benisti (1981).

4. For an up-to-date discussion of the antiquities at the site, Asher (1980), 38–42, plates 42–59.

5. *Ibid.*, chapter 3, note 39, is mistaken in reporting that the Śankarācharya temple above Dal Lake in Kashmir is also octagonal. Only the plinth is. See p. 189.

201. 6. Cunningham, A. S. R. reports and (1892); Barua (1934); Myer (1958).

7. An approximately contemporary inscription refers to it not as a bodhighara but as the *vajrāsana-vrhad gandhakuṭi*, 'the great dwelling place [which enshrines] the adamantine throne'; Bloch (1908–9), 153–5. Gandhakuṭī, 'perfumed hall', is generally taken to mean the dwelling-place of the Buddha. See Asher (1980), 28, note 135.

8. By comparison with the only surviving Gupta brick temple, the shrine at Bhitargaon.

9. The principal evidence consists of two or three well-known reliefs from Mathurā of the Kuṣāṇa period and the famous Kumrahar sealing, the latter probably also of Kuṣāṇa date and representing a large temple very like the Mahābodhi; see Konow (1926). Franz (1978) illustrates them all.

10. This is the view of Myer (1958). Asher (1980), 27, holds for a late-sixth-century date, as does Mitra (1971), 53 and 61.

11. A number of small models in stone and bronze have been said to represent the Mahābodhi temple. Two unquestionably do so, one found on the site, now in the British Museum, the other in the Boston Museum of Fine Arts, neither exactly datable but both unquestionably pre-twelfth-century; the former does not show the corner śikharas, the latter does. Xuan Zang, who was aware of such things, does not mention them, and it is possible that they are later additions, although not (as Mitra (1971), 53, implies) as late as the nineteenth century.

12. Franz (1959). To the edifices listed in the title should be added the stylized chattras surmounting later stūpas; while some of the inferences are questionable, this is a valuable survey of the possible relationships between them. Franz (1978) illustrates all the early reliefs showing tower-like temples found so far in India. See also Franz (1979).

203. 13. *A.R., A.S.I.* (1915–16, 1919–20, 1920–1, 1921–2, 1930–4); *A.S.I. Memoir,* lxvi; Franz (1961), 187, gives page and plate references for most of the Archaeological Survey reports, but not all; A. Ghosh (1971) contains a good short bibliography.

14. Franz (1961), 195, believes that the monument was a stūpa until, in the very last phase of enlargement, it was topped by a temple with a śikhara and housing an image. Mitra (1971), 88, opts for a

shrine, relying mainly on a description of a 300 ft (90 m.) temple at Nālandā much resembling the Mahābodhi. Yet she calls the corner towers, whose tops are missing, stūpas. According to Franz's suggestion, this would not be anomalous at Nālandā. Although noting that a pañcāyatana stūpa is elsewhere unknown, Asher (1980), 46-7, believes the monument to be a stūpa (the 'Great Stūpa'), as did the excavator.

205. 15. Asher (1980), 91 and note 158, admits that the inscriptional evidence for the identification of Antichak with the Vikramaśīla monastery is inconclusive.

16. For references to Antichak, Asher (1980), 91-2, notes 157-64 and plates 209-14. Shown on innumerable sealings and in models, the earliest cruciform stūpa of which considerable remains survive appears to be the one at Bhamāla (Taxila) dated by Marshall to the fourth or fifth century. It may have been submerged recently by the damming of the Haro river.

17. Dikshit (1938); Bloch (1908-9).

18. Mitra (1971), 241, note 15 accepts the possibility of a shrine at the top, albeit a closed one because of the absence of adequate stairs up to it, but seems to favour a stūpa. Asher (1980), 91, also envisages both possibilities, although his argument in favour of a stūpa, or at least the anda of a stūpa, both at Antichak (Vikramaśīla?) and Pāharpur, rests on a dubious premise based on the great Nandangarh structure, a much earlier foundation. The little stūpa deep in its bowels, although from its shape not as early as van Lohuizen (1956), 283, maintains, still belongs to a much earlier age and would not affect the type of summit structure affixed in Pāla times.

19. The Devarānī is at Tali, some 16 miles (25 km.) south of Bilaspur, Madhya Pradesh. Stadtner (1980) proposes a date in the second quarter of the sixth century. Devarānī is the Hindi term for a husband's younger brother's wife, Jithānī (the name given to a coeval but completely ruined temple nearby) for his older brother's wife.

20. Stadtner (1980) notes these and one or two other features hitherto associated only with the Deccan and South India. When he says that 'the narrow bases and shallow sides of all of the niches indicate that stone sculptures were probably not placed in them' (p. 39), one must assume that he means that the niches were filled with stucco images, for otherwise they would have been quite without purpose. Such sculpture exists (or existed) in a cave-temple at Māmallapuram, a site to which Stadtner refers, and there is a stucco figure in the superstructure of the Lower Śivālaya at Bādāmi. Stadtner suggests that

the superstructure of the Devarānī may have been of brick.

21. See plan on p. 24 of Barrett and Dikshit (1960), who illustrate the temple itself very inadequately. See Longhurst (1909-10), plates I and III and figure I.

22. Erroneously called 'windows' by M. G. Dikshit, in Barrett and Dikshit (1960), 19.

207. 23. Longhurst (1909-10), plate II.

24. *Ibid.*, plate IV.

25. Barrett and Dikshit (1960), 15-16 and plates 50-3. See also pp. 163-4.

26. *Ibid.*, 27-32 and plates 59-77.

27. *Ibid.*, plates 78-80; Viennot (1958), figures 1, 4, 6.

208. 28. This is the view taken by Kramrisch (1929), figure 2, as regards the Hāṅkrail (Mālda District) Viṣṇu, but see Saraswati (1962), 13, and Asher (1980), 21 and 32 and plates 12 and 37. The fine Buddha from Bihārail is a mid- or late-fifth-century import from Sārnāth, and the absence of any other contemporary sculpture in Bengal, along with the fact that the rippling zigzag fall of the dhoti between the legs, as seen in Gupta sculpture in Bihar, is completely misunderstood, marks these two sculptures, and particularly the first, as rather 'jungly', and hence late copies of more sophisticated models.

29. R. D. Banerji, *A.S.I.*, *A.R.* (1911-12), 161-6, mistakenly identified as coming from Chandimau. Also Asher (1980), 29 and 30, plates 28 and 29.

30. P. C. Singh (1963); Asher (1980), 31, assumes a late-fifth- or early-sixth-century date for this sculpture, P. Chandra (1972) believes it may be as early as the fifth century.

31. K. Deva and V. S. Agrawala (1950).

32. 'Most of the sculptures are carved out of a black stone, frequently highly polished. It has been quarried in the Rājmahāl hills in the Santal Parganas of Bengal. It is known under the name "*kaṣṭi pāthar*" and is found in two varieties – one coarse grained, the other of a fine and even structure. The first variety is a basic phyllit [*sic*], mainly consisting of chlorite and talc, the latter a cericitised slate'; Kramrisch (1929), 9, with acknowledgement for analysis to the Director, Geological Survey of India.

209. 33. Asher (1980), 72-4 and plates 130-3, considers a number of sculptures from Deo Barunārk and Deo Markandeya, two sites close to the Son river and some thirty miles from the Mundeśvarī Hill. They are the first sculptures from Shāhābād District to be carved in the typical eastern Indian grey or black schist. The problem is a complex one, given the 'hinge' position of the district (the easternmost in Bihar), the tenuous basis for any sort of dating (the

inscription of Jīvītagupta II, the last of the Late Gupta kings), and the extraordinary fact that no sculpture seems subsequently to have been produced in the district, which suggests that these may have been imports.

34. Saraswati (1962), 36–90, maintained that the stone sculpture, which he divided into two groups, dated from the sixth and seventh centuries and came from an earlier Brahmanical temple, and that only the terracottas were coeval with the construction of the monument. Asher (1980), 92–3, argues convincingly that there is nothing against Hindu deities being displayed on a Buddhist monument, particularly on the lowest element; besides, there is no precedent for cast-off statuary being used in considerable numbers to decorate a stūpa or temple, particularly one as magnificent as Pāhārpur. Asher further maintains that Saraswati's two groups of stone sculpture are not based on consistent stylistic criteria: indeed, on grounds neither of style nor of costume could any be dated as early as the sixth century.

35. Also discovered in the excavations at Maināmatī was a platform with stūpas (the Koṭilā Murā) and, from a shaft in one of them, two stone plaques depicting a principal deity sitting on a long-stemmed lotus surrounded by smaller images of seated Buddhist figures (Alam (1975), plate x). In a soft grey shale, they are quite unique, and a source in Āndhra has been suggested by M. H. Rashid (1976). It should be remarked that there is a roughly similar stele in bronze from Maināmatī (Alam (1975), plate VII), and that on many of the fine bronzes from the site the divinity is on a long-stemmed lotus, again something unknown in the rest of eastern India. The region (ancient Samataṭa), mentioned as on the frontiers of the Gupta empire in the Allahabad praśasti (see p. 88 and Chapter 5, Note 8), appears to have remained politically independent from the rest of eastern India during most of its history.

36. Ahmed (1975a). Excavations at Mahāsthān, the capital of the ancient Puṇḍravārdhana, in Bogra District, the most extensive ancient site in Bangladesh, have so far yielded little in the way of artefacts from the later historical periods, with the exception of a few fine bronzes of the early Pāla period notable for their open, smiling faces (one of them is in the Victoria and Albert Museum). See Ahmed (1975b), reprint; Asher (1980), plates 228–31.

37. The earliest are probably the two images found at Dhanesar Khera in Uttar Pradesh, one seated (now in the British Museum), one, showing Gandhāra influence, standing (now in the Nelson Gallery, Atkins Museum, Kansas City); see V. A. Smith and W. Hoey (1895). The only other sculpture with a known find-place, a group discovered at Phophnar, in Madhya Pradesh, is now in the National Museum, New Delhi; see Venkataramayya (1963). The only two dated examples are in the Cleveland Museum of Art, the earlier, of 591, dedicated in Nepal. Two splendid sixth-century images belong to the John D. Rockefeller 3rd Collection; a third, seated, is probably earlier. There are fine examples in the Norton Simon Museum, Pasadena, and in the Los Angeles County Museum of Art.

212. 38. It is now in England, at the Birmingham Museum and Art Gallery, to which it was removed shortly after its discovery. For a recent review of its origins and probable date, Asher (1980), 56–8.

39. The first, dedicated during the reign of Devapāla and now in the National Museum, New Delhi, shows all the facial characteristics of Nālandā bronzes; the second, dedicated in the ninth year, i.e. 819, and now in the Patna Museum, is less idiosyncratic. A comparison with a Deccani bronze Viṣṇu of approximately the same date (Barrett (1956a), figure 9) shows remarkable similarities in the plastic treatment of the main figures. The Nālandā and Kurkihār figures are juxtaposed in Asher (1980), plates 177 and 178. The Sarvāṇī, long since stolen, from Deulbāḍī, Comilla District, dedicated by a Khaḍga queen, has an earlier but not so precisely dated inscription. The Khaḍgas ruled in the latter part of the seventh century. See Asher (1980), 64, plate 113.

40. Kramrisch (1929), 9. Major collections in the Dacca Museum, and the Varendra Research Institute, Rajshahi, both in Bangladesh, the Indian Museum and the Sahitya Bangla Parisat, both in Calcutta, and in the British Museum (Bridge Collection, of which a number are included in Chanda, 1936). The author regrets that he has not been able to consult either the forthcoming catalogue of the British Museum's eastern India holdings (W. Zwalf) or the doctoral dissertation of Susan L. Huntingdon, *The Origin and Development of Stone and Bronze Sculpture in Bihar and Bengal, ca. 8th–12th centuries* (University of Michigan at Ann Arbor, 1972). Studies so far devoted to Pāla and Sena sculpture include French (1928) (for illustrations only), Kramrisch (1929), R. D. Banerji (1933), E. Haque (1973), and Picron (1978b), (1980).

214. 41. For the stone, see also Note 32. E. Haque (1973); Picron (1980), 285–7, 292, 293. Regional distinctions are not affected, but it has been pointed out to me by Dr Gauriswar Bhattacharya that the iconographic association of the goddess

Rambhā with banana trees in Picron's article is based on a mistranslation by de Mallmann (1963), 139 and note 8, of a phrase in the Agni Purāṇa.

42. For a brief but clear and comprehensive outline of later Mahāyāna and tantric Buddhism in India, see Renou, Filliozat, and others (1953), II, 586–97.

215. 43. Dikshit (1938), plate XXXVIIIc.

44. *Sādhanamālā, Niṣpannayogāvalī,* etc.; Bhattasali (1929), B. T. Bhattacharyya (1958), de Mallmann (1948), (1964a), (1975), and others.

45. Harle (1972a).

46. de Mallmann (1975), 104 and 252.

47. Huntington (1975), 22, dates the change around the reign of Mahīpala I (988–c. 1038), and sees a shift of production to Bengal (West Bengal in India, and Bangladesh) and away from Bihār, whose attachment to Buddhism was, of course, much stronger.

48. de Mallmann (1963), 22–7.

49. This was attempted by Kramrisch (1929); Picron (1978a), (1978b), using the 'méthode Stern' and with the knowledge of a considerable number of dated images, has been more successful in her extremely useful studies, but a large enough sample of the vast numbers of Pāla and Sena images has perhaps not been taken into account.

216. 50. Sūrya in Rajshahi Museum, illustrated Kramrisch (1929), figure 36, and the Avalokiteśvara in Rome, Taddei (1967), 23, also illustrated in Picron (1978b), plate 71.

51. Picron (1978b).

52. Picron (1980), 295.

53. Kramrisch (1929), 7, 18, 19.

54. *Ibid.,* 12, note 21.

55. *Ibid.,* 10, 16.

56. *Ibid.,* 11.

57. *Ibid.,* 20. 'Realistic' refers to the fleshly qualities of Pāla sculpture. Picron (1978b), 92, alternatively affirms that in the Sena period 'la sensualité réside dans le visible, non dans le palpable'.

58. R. D. Banerji (1933), plates LXXX–LXXXV; A. Banerjee (1970), 115–20; P. Brown (1942a), 179–84, plates CXIV and CXIVc, figure 2 (with an incorrect date); Saraswati (1933), (1957), 606–9; Banerjee (1970).

59. Saraswati (1957), 606–7, argued for the seventh century, but Brown (1942a), 180, dated the temple to the ninth or tenth century, while Asher (1980), 93–4, places it no earlier than the ninth.

60. R. D. Banerji (1933), 150, plates LXXXa and LXXXIa,b,c.

61. From Dhaka (ancient Vikrampur), now in the Dhaka Museum, acc. no. 75.295; illustrated in the

Program of the First International Congress on Bengal Art, Dacca Museum, Dacca, March, 1976.

62. McCutchion (1972), (1973); Z. Haque (1980).

CHAPTER 16

219. 1. Some of these trends have already appeared in temples assigned to the post-Gupta period. See p. 155.

2. The first of these belongs to the post-Gupta Kumbhaśyāma at Chitor.

3. The earliest dated example was added to the post-Gupta Mahāvīra at Osiāṇ in A.D. 1018.

4. Like the toraṇa (Note 3) at the Osiāṇ Mahāvīra, usually later additions.

5. An exception to this general trend, in the western temples, is the high kumbha of the base, sometimes left plain, sometimes sparsely provided with small niches, which adds such a welcome note of contrast to these highly decorated temples.

220. 6. R. C. Agrawala (1964). Except for the fact that some of its female figures rival those of Khajurāho, the title of this article is quite inappropriate.

221. 7. See pp. 295 and 297.

222. 8. Dhaky (1968), 328–32, figures 10–16; K. Deva (1975b).

9. R. C. Agrawala (1965), figure 13; (1964), figure 16.

10. K. Deva (1975a), 1; Dhaky (1968), 335–41 and figures 17–18.

11. See p. 150 and Cousens (1931), plates LXI and LXV.

12. For another 'undecorated' temple, the Neminātha at Nāḍol, Dhaky (1968), 343, figure 19. For related types, the Sūrya temple at Somanātha (Prabhās Pātan) and the Sūrya temple at Than, both in Saurāṣtra; Cousens (1931), plates XII, XIII and XLVI. The ground plans are more conventional, and large nicheless images figure on the walls. See also the untypical temples at Khajurāho (p. 233). Although rough outlines of classical forms, without the finer details, are a feature of many humbler edifices, particularly in South India, these temples would seem to belong to a particular type rather than to a stifling of the sculptural impulse because of extraneous circumstances, such as a lower level of patronage.

13. R. C. Agrawala (1965), 54–5 and figures 1–2 and 9–11.

223. 14. It has been plausibly suggested that the modern name, incidentally that of two temples at Gwalior as well (see p. 232), meaning 'mother-in-law, daughter-in-law', is a vernacular corruption of Sahasrabāhu ('the hundred-armed one'), a name of Kārtavirya, the focus of a considerable cult at this

period; see G. C. Tripathi (1979), '49. Cunningham, writing in the 1860s, assumed that it was (*A.S.I.R.*, II, 357).

15. This is Dhaky's Māru-Gurjara style; see particularly Dhaky (1975a). It is claimed to be the result of the coalescence of the Mahāmāru and Mahāgurjara styles of the previous period.

16. Dhaky (1964).

17. There are four such temples within fifteen miles of Pāṭan (Anahilwāḍa Pāṭan, the old Solaṅkī capital, not to be confused with Prabhās Pāṭan, on the coast of Saurāṣṭra). For the Saurāṣṭra temples, including the Navalakhā temples at Gumli and Sejakpur, Cousens (1931). For the best and most up-to-date account of Solaṅkī temples, Dhaky (1961). Also, a number of plans and illustrations, S. K. Saraswati (1957), 583-97, figures 17-28 and plate, figures 50-8.

18. Dhaky (1967), figure 74.

19. The triratha, pañcaratha, etc. designations for different ground plans used heretofore have been retained wherever possible for simplicity's sake, although they are less suitable in this period, with diamond-shaped and even stellate plans, than *dviaṅga* (having two parts), *triaṅga*, etc. See Dhaky (1975a), 130 and figure h.

226. 20. Dhaky (1968), 344-6 and plates 20-4.

21. Dhaky (1975a), plate 62.

22. The Samiddheśvara at Chitor, associated with the great Solaṅkī king Kumārapāla (1144-74), was originally a Jain temple. The temple is called Sāmādheśva (i.e. Sāmādhiśvara) in a sixteenth-century inscription. It was rebuilt in the fifteenth century as a Śaiva shrine. For Dilwārā, see below.

227. 23. Burgess and Cousens (1903), frontispiece and plates VII, XLVII-LVI, which include a plan.

228. 24. *Ibid.*, plates VI, XXXVII-XLIV, which include a plan.

25. Cousens (1931), plates II-IX. Now even the ruins have been dismantled and replaced by a modern building.

26. Burgess and Cousens (1903), 37-8 and plate III. Also step wells at Roho, Vāyad, and Māndvā, *ibid.*, 101, plates LXXX, CIV, CVII. The restoration of the Rānī Vāv has been undertaken. So has that of Vidyādhara's step well at Sevasī, Vadodara District; A. R. of Department of Archaeology, Government of Gujarāt, 1974-5; Jain-Neubauer (1981). For Dabhoi, Burgess and Cousens (1888).

27. Burgess and Cousens (1903), 38-42 and plate XXXIV.

28. Cousens (1931), 54-5 and plates LVII-LIX.

29. The great raṅgamaṇḍapa of the Vimala-vasāhī is about 150 years later. Dhaky (1980); H. Singh (1975).

30. Dhaky (1975b), 374-5 and figure 24.

31. Shah (1955) for the complicated symbolism underlying Jain iconography. See also the miniature shrines. Also Bhattacharya (1974), Shah (1975), and a large number of articles by these and other authors on individual western Indian metal images, the great majority of them Jain.

32. More often than not, at this time, the same stone-carvers were employed indifferently by both communities. Later, however, the predominance of Jain temple building in certain areas probably led to some builders and sculptors engaging exclusively in Jain work. The rigid stance of the Tīrthaṅkaras seems to have communicated itself to other figures, but the excessively geometric conceptions of so many of the later Jain bronzes (in reality almost always brass) are far less apparent in Hindu images.

229. 33. The necessarily brief paper by Lanius (1972) is almost the only one to deal with sculptural style in western India during the period. See also Note 35. Shah (1955) is well illustrated but overladen with historical detail and does not attempt to present a coherent account of stylistic development.

230. 34. For a superb example, the figure on the Ambikā at Jagat, Shah (1965-6b), figure 33. Become a cliché, this feature is much in evidence at Khajurāho.

35. Lerner (1969) for the latest account of the site. That two different styles are involved, belonging to different aesthetic horizons, seems obvious.

36. Deva (1975c). The sense of the word is contested. Literally it means 'earth' or 'country' (*bhūmi*) 'born' (*ja*); *ibid.*, 91-2. This category of temple was identified by Kramrisch (1946), 389 (plan p. 256).

231. 37. Dhaky (1968), 335-41, and Deva (1975c).

38. The Jain temple at Tāraṅgā (Tāriṅgā) is, most exceptionally, sāndhāra; Burgess and Cousens (1903), plate CIX.

232. 39. Deva (1975c), 98-9. The not very satisfactory plan in *A.S.I.R*, VII, plate VI, is reproduced in Kramrisch (1946), 256.

40. Kramrisch (1946) has many illustrations of this temple.

41. Probably a Viṣṇu temple; Deva (1975c), 107 and plates 44-5.

42. *Ibid.*, 105-6 and plates 37-40.

43. Kramrisch (1946), 218.

44. Deva (1975c), 101, 106-7, plates 24-6, 42.

45. *Ibid.*, 103-4 and plates 31-4; Fergusson (1910), II, figures 343-4 and plate XXV.

46. See Note 14; *A.S.I.R.*, II, 357-61 and plate LXXXIX.

47. Deva (1975c), 92.

48. The temples were described by General Cunningham. Since then a fairly extensive literature

covers a number of aspects of Candella art, architecture, history, and society. More recent scholarly surveys include Deva (1959) and Zannas and Auboyer (1960), the latter splendidly illustrated and with an extensive bibliography. See also Flory (1965).

233. 49. See Chapter 11, Note 70, and p. 156.

234. 50. See p. 222 and Note 12.

51. The sizeable shrine incorporated into the rear of the Pārśvanātha temple is not repeated elsewhere, and it cannot be said that it is a function of the temple's being Jain.

235. 52. Desai (1982).

53. *A.S.I.R.*, II, 420.

237. 54. See p. 28.

238. 55. Kramrisch (1946), 368. The statement that follows - 'Residues of nomadic formulations, carried through central Asia, are stored in the repertory of mediaeval Indian motives. The tufts of curls on shoulders, haunches ... and in the face belong to it' - is debatable. See Dhaky (1965a).

56. E.g. that the notably erotic figures at Khajurāho are advertisements for the temple's prostitutes: Basham (1954), 362.

57. P. Chandra (1955-6); Donaldson (1975) contains a succinct and judicious account of erotic sculpture in India. Also Desai (1981), especially on the textual and specifically tantric background for erotic sculptures; she adds the further suggestion that figures in erotic poses may conceal a yantra.

239. 58. Meister (1979) was apparently the first to note this curious circumstance. His conclusion, however, incorporated in his title, that a pun is intended between the sexual union of a man and a woman and the junction of prāsāda and maṇḍapa, seems farfetched, or at any rate too slender an explanation to account entirely for the presence of so many and such important erotic groups.

59. E.g. at Aihole, temples 11 and 12. See also p. 159.

60. Dhaky (1965-6) first drew attention to the particular nature of this phenomenon, although some of the great achievements of the period, like Rāṇakpur, had been well known to scholars since Fergusson. The name 'Renaissance' is not particularly suitable, as Dhaky is the first to acknowledge, but his phrase 'second flowering' is perfectly apt. Dhaky's footnote 5 gives an excellent short account of Fergusson's and subsequent writing about Rāṇakpur. His article also includes an excellent description of the temple.

61. Burgess (1869).

62. Bruhn (1969), (1973) for a study of this phenomenon in Indian art.

63. See Note 60.

242. 64. The name is somewhat misleading. A contemporary inscription unquestionably refers to one of the towers as a kīrttistambha, built by Śrī Mahārāṇa śrī Khumbharṇa; see R. C. Agrawala (1957). *Kīrtti* is more usually translated as 'fame' or 'glory'. Speculation that one of the towers was erected to celebrate Mahārāṇa Kumbhā's victory over Sultan Mahmud is reinforced by the fact that the latter built one (no longer extant), in accordance with the Muslim tradition, at Māndū. But the Chitor towers are abundantly sculptured with images, both Hindu and Jain, and may equally have been raised to the glory of the Jain(?) faith as well as to that of the king.

65. The smaller of the towers is claimed to have been built in the twelfth century, and there are at least two traditions of ancient foundation; see Cousens (1905-6), 49, and R. C. Agrawala (1957). It is quite possible that these refer to older 'towers', perhaps more nearly the stambhas placed before certain temples. Confusion, moreover, has arisen because the towers are variously named as the Jayastambha, the Kīrttistambha, and the Mānastambha in later accounts. There is some doubt, however, as to whether the smaller tower may belong to the twelfth century.

243. 66. T. A. G. Rao (1914), plate facing p. 385.

67. For earlier Maheśa (Sadāśiva) images, see pp. 124, 139, 150. The side faces turned to face forward betray a folk element in the style. Such a Maheśa can already be seen in the seventh century on the deul of the Paraśurāmeśvara temple at Bhubaneswar (p. 159).

244. 68. See p. 387 and illustration 306. R. C. Agrawala (1965-6) neatly illustrates the shift between the traditional costume shown on a memorial stone of 1569 and the ghāghrās and oḍhnīs of the Jagdish temple.

69. P. Brown (1942a), 157-8 and plates XCVIII, 2 and XCIX, 2.

70. Toy (1957), (1965).

CHAPTER 17

245. 1. Dates as late as *c.* 975 and as early as the early ninth century have been proposed for this undated temple.

246. 2. See p. 164.

3. It has been suggested that this was used as a swing; the placing of an image of the god in a swing forms an important part of Hindu ritual.

4. D. Mitra (1966), figure 4. There are objections to the use of the term *vajra mastaka*; Donaldson (1976).

5. The architectural terminology pertaining to

Orissa temples is particularly well established in general use, largely because of the relatively early publication of books based on local śāstras, e.g. Ganguly (1912), Bose (1932).

6. Z. Haque (1980), figures 79 and 140.

7. The Gaurī temple is described as a *khākharā* temple, the term applied in Orissa to rectangular prāsādas surmounted by a śālā (the western Indian Valabhī type; D. Mitra (1966), 43, Dehejia (1979), 145. But the crowning element of the Gaurī is described elsewhere as a variant of this type and likened to the khākharās above some of the pavilion-niches of later Orissa temples; D. Mitra (1966), 17, plate XVII and figure 5. Indeed, it resembles more nearly a square and faceted South Indian śikhara. The earliest appearance of the characteristic nāga pilaster is perhaps on the twin temples at Gaṇḍharādi; see R. D. Banerji (1929).

8. Dhaky (1974).

9. See Note 7.

248. 10. Muslim inroads into Orissa were too late or too brief to cause much damage to temples. In all fairness, the earlier depredations of a fanatical Islam, widespread and terrible as they were, were not alone responsible for wanton damage. In Orissa, the editors of Fergusson (1910), II, 95, draw attention to 'the sordid proceedings of the Public Works Department' and the misguided antiquarian zeal of certain British military and administrative officers.

11. Panigrahi (1961), 31, 219, 228, but see also D. Mitra (1966), 52. The main icon is not a liṅga in the usual sense but a heap of stones; Kulke (1981), 35.

12. Panigrahi (1961), 41-7.

249. 13. D. Mitra (1966), 11-12. See Kulke (1981), 31, on the role the Pāñcarātra may have played at this time in the final formulation of the Puri triad.

14. See pp. 150, 222, 233-4.

15. Not in worship, and it may never have been consecrated. The name of the temple is unexplained, although it has been suggested that it derives from the particular variety of sandstone of which it is made (D. Mitra (1966), 48). It means 'king and queen' and is most likely to be a popular corruption, like Sās-Bahu, of the original name.

251. 16. Excavation has shown that this was not its original emplacement. Fragments of second- or first-century B.C. stone sculpture have been found nearby. The original pillar is not necessarily of such early date, since free-standing pillars of dressed stone have been raised during all periods of Indian art, but the fact that in the twelfth or thirteenth century a temple of novel design was built to house it would suggest that it had by then assumed con-

siderable sanctity, usually conferred by relative antiquity.

17. This derives from the huge temple car in which at a great festival the images are transported to a garden pleasance nearby, and under the wheels of which frenzied devotees would throw themselves; Kulke (1979b).

18. The origin of the iconography and style of these strange figures, reproduced thousands of times in folk paintings and painted clay figures, has long been considered tribal. This hypothesis is strengthened by the *sudarśana cakra*, a thin circular post with a rounded top covered with a chequer pattern which stands with them. Wooden posts are still cult objects among certain tribal peoples of the hinterland. Exceptional aspects of the temple's cult and the sociology of its priesthood also show strong links with non-Brahmanical elements. These and the probable origin of the triad have been the object of considerable research: R. Mitra (1880), Starza-Majewski (1969), Kulke (1973), Eschmann, Kulke, and Tripathi (1978), Kulke (1979a,b), Kulke (1981), with valuable references. Most recently, however, Starza-Majewski (1983) has traced their origin among the tangled web of Puri's long religious past to what he believes is Hindu mortuary and commemorative art. The earliest representation of Puri's Jagannātha image occurs in the famous stele representing King Narasiṁhadeva before a religious preceptor (see p. 253). Although differing markedly from the present figure, it is in the same style. The images are renewed at fairly short and regular intervals. There are some parallels between the triad and the image of Nāthji, also the focus of a Krṣṇa cult, at Nāthadvāra (see p. 393).

252. 19. See plan, Fergusson (1910), II, figure 319 taken from R. Mitra (1880). The main temple is a few degrees off the alignment of the walls.

20. Known for a long time as the Black Pagoda to distinguish it from the whitewashed deul of the Jagannātha at Puri, nineteen miles down the coast. The laterite (sandstone) of which the temple is built is coarse-grained; it grew black over the years and is extremely friable. The present reddish colour of the temple (which has been the object of considerable conservation) may be the result of paint rather than the natural colour of the stone (Alice Boner communication); D. Mitra (1966), 43, note 2, states that the redness of a temple at Bhubaneswar is due to paint. The ceiling of the jagamohana of the Sun temple was supported by iron beams 23 ft (7 m.) long; Fergusson (1910), II, 107. This is the most ambitious example in India in the use of iron clamps and bars to stabilize or support masonry.

21. Opinions vary as to when the gaṇḍi collapsed. Some believe that, too ambitious in scale for its foundations, it fell during construction. Fergusson (1910), II, 106, note 1, states, however, that most of it was still standing when he sketched the temple in 1837. This is not so, as an examination of the lithograph from his sketch makes clear. It seems strange, too, that the author of the *Aïn-i-Akbari*, although his description of the Sun temple is not first-hand, should not mention that this, the largest Hindu temple outside South India, stood partly ruined.

22. There are at least two temples in Tamilnāḍu (eleventh-twelfth centuries) where a maṇḍapa or the vimāna itself is made to simulate a chariot; see pp. 317, 319, 321. To what extent either influenced the Sun temple it is impossible to know. The idea, after all, is a simple one which could be suggested by a literary source. Sivaramamurti (1955) makes exaggerated claims for such exchanges.

23. For a reconstruction, P. Brown (1942a), plate LXXVII.

253. 24. See Chapter 16, p. 238 and Note 57.

25. Starza-Majewski (1971), 134, note 4. There are at least three examples, one in the National Museum, New Delhi, one in the site museum at Konarak, and one in the Jagannātha temple.

CHAPTER 18

254. 1. Cousens (1926), 92, plate LXXXVIIb. In its broad lines, what follows is based on the account in P. Brown (1942a), chapters XIX and XXX.

2. Cousens (1926), 91 and 92, plate LXXXVII.

3. Annual Report, Mysore Archaeological Department, 1941, 49-53, plate VI, 1.

4. Annual Reports, Mysore Archaeological Department, 1919-46; for inscriptions, *Epigraphia Carnatica*, 1894-1934 *et seq.*

5. A programme of restoration is being vigorously carried out by the Directorate of Archaeology and Museums, Government of Karṇātaka.

6. Roughly speaking, the southern śāstras apply the terms *Nāgara*, *Drāviḍa*, and *Vesara* to varieties of their own Drāviḍa type, depending on whether the śikhara is square, octagonal, or round. Kramrisch (1946) first correctly discerned the correct application of Vesara. For a clear account of earlier difficulties with the term, and a lucid and well-argued statement of its meaning, as well as those of the other regional terms, see Dhaky (1977).

7. Even to the extent of including the Bhūmija variant of the Nāgara type. Dhaky (1977), 7, even suggests that miniature representations of these may antedate the earliest surviving Bhūmija temples.

8. At one time incorrectly called the *kadamba* type, because of a particularly heavy concentration of these temples in the Kadamba area (the region of Goa); Moraes (1931).

9. Cousens (1926), 77-9, plates LXI-LXIV.

255. 10. *Ibid.*, 83-4, plates LXXVI-LXXVIII.

11. For this treatment, see also the Galgeśvara at Galagnāth and the Santeśvara at Tilivalli; Cousens (1926), plates LXXV and C. In some parts it would seem that detailed carving has simply not been undertaken, but this does not furnish an explanation for such treatment of a completely and otherwise meticulously finished temple like the Santeśvara. Its general effect of fragmentation, moreover, is in accord with the prevailing aesthetic.

12. Cousens (1926), 85-6, plates LXXIV, LXXVI-LXXVII, and LXXX-LXXXIII.

256. 13. *Ibid.*, 91-2, plate XC.

14. *Ibid.*, 79-82, plates LXV-LXXII.

15. *Ibid.*, 82, plate LXXIII.

16. Dated *c.* 1180; Dhaky (1977), 4 and 12.

17. Cousens (1926), 100-2, plates CI-CVII.

18. E.g. Puḷḷamaṅgai; see p. 297.

257. 19. See pp. 240-2. Cousens (1926), 100-2, plates CI-CVII.

20. Based on a legendary incident doubtless invented to account for the name Hoysaḷa (or Poysaḷa). The ancestor Saḷa was instructed to strike a tiger about to devour him: 'Hoy (strike), O Saḷa'. Although always referred to as a tiger (*śārdula*), the animal, a fabulous beast related, although stylistically quite different, to those in North India and Orissa, is here always depicted with a leonine mane or ruff; see *Indian Antiquary*, II, 301; Derrett (1957), 15.

21. Settar (1971).

22. Cousens (1926), 146 and figures 32 and 41. See p. 74 above for an example in Gandhāra. Of ancient Middle Eastern origin, the double-headed bird later extended to European heraldry; Stache-Rosen (1977).

23. Cousens (1926), 112-13 and plates CXIX and CXXI-CXXII.

24. Named after Basava, linked to the twelfth-century foundation of the Liṅgāyat sect which continues even today to be of great importance in the Deccan; Cousens (1926), 114-15 and plates CXXIII-CXXV.

260. 25. Cousens (1926), 103 and plates CVIII-CIX.

261. 26. Dhaky (1977), 27.

27. Derrett (1957).

28. R. Narasimhachar (1917).

29. R. Narasimhachar (1919a); A. R. Arch. Survey of Mysore (1931), 25-46; (1946), 17-23, plates

I-XIX. Del Bonta (1981) demonstrates that the large female bracket figures (*madanakais*) under the eaves of the Chenna Keśava were not provided for in the original construction. He claims, however, that they still belong to the reign of Viṣṇuvardhana (*c.* 1106-52) rather than to that of Ballala II (*c.* 1173-1220), from which date most of the additions to the temple, such as the jālas above the base frieze between the columns of the mahāmaṇḍapa and the doorways of each of the three entrances. The inscriptions on many of the bracket figures quite exceptionally give the names of the sculptors. Cf. the labels on the reliefs of the Pāpanātha at Paṭṭadakal.

262. 30. A.R., Arch. Survey of Mysore (1930), 33-60.

263. 31. *H.C.I.P.*, v, 631 (S. K. Saraswati).

32. A.R., Arch. Survey of Mysore (1933), 20-30 and plates V-VIII; 45-52, plates X-XII.

33. *Ibid.* (1936), 19-24, plates X-XII; *ibid.*, 36 and 37.

34. Dhaky (1977), 39, *inter alia*; Cousens (1926), 99 and plate C; Dhaky (1977), 13, *inter alia*.

35. Cousens (1926), plate XXV; all shrines within the enclosure except the Lakṣmīdevī itself, which is of the Vesara type. See Narasimhachar (1919b).

36. Vikrama Cola controlled the region until 1130; Derrett (1957), 60 and 73.

37. A.R., Arch. Survey of Mysore (1930), 14-16; *ibid.* (1935), 46-9 and plates XV and XVI.

38. Although it takes its name from Vijayanagara on the Tuṅgabhadrā in 'upper' Karṇāṭaka and its famous dynasty, practically all the elements of the Vijayanagara style are Drāviḍa. Its earliest examples, moreover, do not date from before the fourteenth century, and later styles which it influenced are exclusively in Tamilnāḍu. For these reasons it is considered later, in Chapter 23.

264. 39. Now in the Government Museum, Shimoga; Kramrisch (1981), figure 52.

265. 40. M.S. Nagaraja Rao (1966-7).

41. The largest collection of Hoysaḷa sculpture, though not of the highest quality, is in the National Museum, Copenhagen; Settar (1975). Most of the important collections of Indian sculpture include one or two Hoysaḷa works.

267. 42. See particularly the figure illustrated, with a memorable commentary, in Kramrisch (1981), figure 31.

43. *Ibid.*, 53.

44. A small but fine standing Viṣṇu with avatars in the prabhāvalli was in the possession of Spink and Son, London, in the 1970s.

45. Murthy (1970); B.R. Prasad (1980) gives the fullest coverage both for this and the post-Gupta

period in Āndhra Pradesh; M.R. Rao (1969); Sarma (1972).

46. Marchal (1944), plate Vb; Prasad (1980), figure 54.

47. Deglurkar (1974), figures 7, 8, 13.

CHAPTER 19

269. 1. A borderland as distinct from a bridge. 'Southern' styles do extend to a single site, Ellorā, which is well beyond the northern borders of Karṇāṭaka; conversely, stray elements common to North India can be detected as far south as Mysore (District) but not beyond. See Harle (1977), 581, note 14.

270. 2. That large South Indian temple complexes of the later periods were essentially hypaethral, or open-air, was first perceived by Kramrisch (1946), 203 and 204.

3. Hardy (1983).

CHAPTER 20

271. 1. Wheeler, Ghosh, and Deva (1946).

2. For the abundant megalithic remains in South India, K.R. Srinivasan and N.R. Banerjee (1953); N.R. Banerjee (1965); K.S. Ramachandran (1971); Leshnik (1974); McIntosh (1981).

3. Recent investigation has revealed a square vedikā around the base of the liṅga, previously concealed by the flooring. It is thus the only sacred figure surrounded by a vedikā, as depicted on reliefs, the original hypaethral shrine, so far known to have survived. On this evidence, I.K. Sarma (1978-9) dates the liṅga to the third or second century B.C., but the uprights are fluted, a feature associated with Āndhra work a century or two later. I.K. Sarma (1982), however, opts for a date in the second century B.C. (pp. 61-2). He identifies the stone as 'dark brown hard igneous rock, brittle and compact, but takes a high polish and is locally available in the Tirupati hills' (p. 50). In style, some small fragmentary figurines, including a Śiva(?), found at Arikamedu are not unlike similar figures found at late Sātavāhana sites in the northern Deccan, such as Sannathi; Wheeler, Ghosh, and Deva (1946), plate XXXVIA.

272. 4. K.V. Subrahmanya Aiyar (1911); P.R. Srinivasan and A. Aiyappan (1959).

5. K.R. Srinivasan (1975a), 198, makes the interesting suggestion that in the south the megalithic tradition of burials in stone cists had created a strong association of stone with the dead which proved a deterrent to its use in building. See also K.R. Srinivasan (1960), 140-3 and 190-2, for the obvious

reluctance to use stone for the liṅga or principal image of Pallava rock-cut shrines; the use of imported stone for the later fluted liṅgas may also be relevant (see text below).

6. Longhurst (1924-30), K. R. Srinivasan (1958), (1964), (1975a), and Jouveau-Dubreuil (1914), (1916-18), (1922), made valuable and penetrating pioneering contributions. See also Willetts (1966) for a bibliography of Māmallapuram.

7. Pattabiramin (1971) for caves in Āndhra. Sivaramamurti (1961b), Nagaswamy (1965), H. Sarkar (1970), K. R. Srinivasan (1970), G. Subbiah (1977), Lippe (1978), and Schindler (1979), for the Pāṇḍya region and for the Pāṇḍya-Cola borderland.

8. For a map of the locations of the widely scattered Pallava cave-temples, K. R. Srinivasan (1964), figure 2.

276. 9. The best-known example is the small panel of a dancing Śiva at Siyamangalam (North Arcot District); K. R. Srinivasan (1964), plates XXI-XXIII. The style suggests that it is a ninth-century rather than a tenth-century addition as proposed by Barrett (1976), 187. The dancing mode (*bhujaṅgatrāsita*? 'frightened by a serpent') is not the famous *ānandatāṇḍava*, the dancing Śiva pose as known in the West, but it is the nearest iconographical approach to it before the tenth century. See p. 308 and Chapter 21, Note 34.

10. K. R. Srinivasan (1964), plate XVIII. Although slightly outside the Pallava region, the cave was built by a Pallava king and is in pure Pallava style. It is interesting to speculate as to whether the Jain affiliations of the site account for this well-nigh unique bit of Deccani influence, for the Jains were also excavating caves at this time in Aihole and this sect have always been known for the close ties between their far-flung communities.

11. This feature is seen only in Pallava and one or two Early Cola monuments although there are archaistic revivals later; see Chapter 21, p. 293 and Note 5.

12. Harle (1963).

277. 13. Jouveau-Dubreuil (1914), II, 35, in the Martin trans. (1937), called it 'the great master design of Pallava iconography', so often does it occur. The most elaborate version, in the Mahiṣamardinī cave, is considered by K. R. Srinivasan (1964), 153, to be a prototype of the Caṇḍeśanugrāhamūrti as seen at Gaṅgaikoṇḍacolapuram.

278. 14. Details were worked in the plaster with which the reliefs were coated, many vestiges of which remain.

15. Aravamuthan (1931), 23-4, figures 2 and 3. Because of the problems of assigning birudas (see Note 30), various combinations of father and successor-son have been proposed as the subjects of these sculptures, beginning with Mahendravarman I and his father. Nagaswamy (1962), 28-30, argues that they must be Narasiṁhavarman II (Rājasiṁha) and his son Mahendravarman III. There is also a more conventionalized effigy on the Dharmarāja ratha, identified by Aravamuthan (1931), 25, figure 4, as Narasiṁha I. See also K. R. Srinivasan (1975b).

16. There are three others some distance away, all unfinished.

280. 17. See p. 286. The names of the monolithic shrines, those of the Pāṇḍava brothers and Draupadī to whom monuments of unknown origin are frequently attributed, are of later popular origin and obviously bear no relation to the original dedications of the shrines. The same applies to the term *ratha* ('car', 'chariot') used for the monoliths, perhaps because of a certain resemblance to the wooden structures on wheels which are used as part of Indian temple ceremonial. The famous car of the great Jagannātha temple at Puri is a vehicle of this sort. S. L. Huntingdon (1981) favours Ayannār over Indra or Subrahmaṇya as the deity to whom the so-called Arjuna ratha is dedicated. Her argument, based on the positions of the shrines and of the rock-cut animal vehicles, does not seem to take into account the vital question as to whether the boulders out of which they were carved could be moved. If not, it must have been the presence of suitable boulders which determined the position of shrines and animal vehicles.

18. Jouveau-Dubreuil (1914); K. R. Srinivasan (1975b).

19. A boulder with its sides roughly marked out in squares implies that the monoliths were not simply carved from the top down, although this may have been the general course of the work, and sanctums appear to have been hollowed out last; Longhurst (1928), plate IIIa. Religious considerations doubtless figure here as well as in the carving of the finials, which are invariably missing from the summits of the temples, although some have been found on the ground nearby. It is not clear whether they were integral parts of the monoliths, but probably they were not, since the installation of the finial is one of the rites associated with the final consecration of a shrine. What is more, the finials were almost certainly removed by vandals seeking the treasure traditionally supposed to be placed at their bases, which would have been impossible if they were an integral part of the shrine.

20. Given Korravai's association with wild haunts and their denizens, it is not surprising that a 'for-

eign' style was adopted for her shrine, particularly since the bent bamboos at the origins of the Bangla roof suggest a jungle environment; see Harle (1963).

281. 21. T. N. Ramachandran (1950-1), 58-89.

282. 22. *Kirātārjunīya*, 12th sarga, verse 46, quoted in Ramachandran (1950-1), 15.

23. Elephants, lions, deer, bears, two sorts of monkey, as well as a turtle, a lizard, geese, and peacocks.

283. 24. Nagaraja Rao (1979). Dr Rao has assured me that at least one wild boar, wounded by an arrow, is present in the great relief at Māmallapuram (oral communication); but even if this is true, it certainly does not occupy the prominent and focal position one would expect in a depiction of the myth.

25. Marr (1974) refers to a passage in the Śivapurāna where Arjuna makes an image of the god and meditates upon it (chapter 38, sl. 32, ed. M. Banarsidass, III, Delhi, 1969, 1237). The large figure of Śiva is thus another image of an image.

26. Excellent photographs reproduced in Zimmer (1955), figures 272-8.

284. 27. K. R. Srinivasan, who has written the definitive surveys of Pallava architecture, holds that the smaller shrine at the rear must be older since it incorporates some of the bed-rock into its base mouldings; K. R. Srinivasan (1958), 134. The Visnu image is rock-cut, and its shrines also have some base mouldings carved out of the bed-rock. Dumarçay and l'Hernault (1975) conclude on the grounds of their limited excavations of the shrine bases that the image belongs to the reign of Narasimhavarman, the small Śiva temple to that of Rājasimha, and the larger one to the reign of Nandivarman II (c. 730-96) or later.

28. Notably the central shrine of the Vedagirīśvara temple on top of the hill at Tirukkalukunram (Chingleput District), which is of simple dolmenoid construction, three huge slabs forming the back and sides and a fourth the roof. Nonetheless, as well as some other images, a Somāskanda panel is carved upon the interior surface. See K. R. Srinivasan (1958), 132.

29. Jouveau-Dubreuil (1916), Longhurst (1924-30), and K. R. Srinivasan (1960), (1964).

30. Nagaswamy (1962). In the case of many of the inscriptions on early Pallava temples it is possible to identify the king responsible only from the many *birudas* (eulogizing titles) by which he calls himself, most of them of a conventional nature. Nagaswamy makes the telling point (pp. 17 and 18) that the most important birudas of Māmalla and his immediate successor Parameśvara I occur nowhere at

Māmallapuram. He also claims that the *atyantakāma* (He of Unlimited Desires) responsible, according to inscriptions, for the building of several monuments at Māmallapuram was Rājasimha, arguing that this biruda was used exclusively by him. K. R. Srinivasan (1975a), 204-6, and S. L. Huntingdon (1981), 57, adhere to a more conventional chronology which assigns the work at Māmallapuram to Māmalla, although Huntingdon concedes that it may have continued through the reigns of his immediate successors.

286. 31. Structural pillared halls were not an innovation of the late seventh century in the Pallava region: a number of detached stone pillars have been found, once presumably belonging to such halls constructed of brick or wood and almost certainly predating the earliest stone-built monuments; see K. R. Srinivasan (1958), 131.

32. Who celebrated this event by showering the temple with munificent gifts. This is a notable example, given the bitter rivalry between the Pallavas and the Early Western Cālukyas, of the respect with which Hindu monarchs almost invariably treated the temples and even the inscriptions of their enemies. Apart from occasional and usually minor damage due to sectarian rivalries, the major cause of the destruction of temple buildings, throughout South Indian history, has been the piously well-intentioned replacement of an old shrine by a new one, which continues to this day unless prevented by the Archaeological Survey or the state archaeological authorities. See Barrett (1971).

33. Cf. memorial chatrīs and temples in Rājasthān, pp. 244, 426; also those of queens at Chitor.

288. 34. Minakshi (1941).

35. K. R. Srinivasan (1958), 115, figure 1 for a useful map showing the location of important Pallava monuments.

291. 36. Longhurst (1930); Barrett (1958).

37. K. V. Sundara Rajan (1975). Many of this author's attributions of temples are unsupported by inscriptions or even adequate stylistic analysis; many, moreover, have been reconstructed in such a thoroughgoing way that it is impossible to reach any conclusions from the illustrations provided. Cf. Barrett (1977).

38. The figures come from Kāñcī (from correspondence between Jouveau-Dubreuil and C. T. Loo, by courtesy of the latter's daughter). The group, which includes a Śiva, far exceeded the usual number of seven or eight. Their present locations, as given in Barrett (1958), 6, note 1, are not up-to-date and include some errors.

CHAPTER 21

293. 1. Barrett (1974), 45. The Vettuvankovil at Kalugumalai in Tirunelveli District, a rock-cut vimāna, provides no evidence since the ground floor was never hewn out of the rock. The recent publication of some hitherto unknown early temples in the Pāndya region, and increased speculation about the role of the Muttaraiyars, have tended to confirm Barrett's original opinion that the Early Cola style represented an original departure; see Dhaky (1971), K. V. S. Rajan (1975), Barrett (1977).

2. The Tamil word for a stone temple is *karrali*. The earlier structures were most often probably of brick. The same pious practice, alluded to in Note 32 to Chapter 20, to which we owe so many of the lovely Early Cola temples has resulted, even in this century, in the destruction of some of them. See Barrett (1971).

3. Barrett (1974), 126, 127, 131, 134, shows this great variety.

4. This term, in Drāvida temple terminology, refers only to the crowning dome. In the 'northern' type of temple, it refers to the entire tower-like structure above the sanctum.

5. There are rare exceptions; see Barrett (1974), plate 1.

295. 6. In the following necessarily brief account of this astonishing period, I have generally followed Barrett's chronology - see Barrett (1974) which, with Barrett (1965), forms his magnum opus. These closely argued accounts are the result of a first-hand acquaintance with the multitude of Pallava and Cola temples of Tamilnādu unsurpassed by any student of the subject, allied to a scholarly reluctance to accept historical evidence except after the closest scrutiny. Where the latter is missing, Barrett necessarily makes assessments based on personal appreciations of style. These books, however, are not for the casual reader. Because of Barrett's rejection of the grounds for so many of Balasubrahmanyam's datings, and consequently the latter's account of stylistic development, much space is given to argument, principally on the purport of inscriptions. Barrett illustrates, moreover, only a small proportion of the monuments and sculptures mentioned in his text, and the book must be read in conjunction with Balasubrahmanyam (1966), (1971), which are far more profusely, if less splendidly, illustrated, as well as useful books in their own right, although seriously marred by a lack of orderly method, numerous inaccuracies, and a reluctance to submit evidence to critical evaluation. Like most Indian scholars, Balasubrahmanyam favours an earlier dating than Barrett for many

temples, particularly in the early part of the period.

296. 7. Barrett (1974), 69, in agreement with Mahalingam (1967).

297. 8. Kramrisch (1954), plate 111 and note.

9. Barrett (1974), 69 and plate 10.

10. Kramrisch (1954), plate 112 and note.

11. Barrett (1974), 69 and plate 13.

12. Harle (1958a), (1958b).

13. Such pits are not uncommon; their builders probably never envisaged them, but they became necessary in later times to free the base mouldings, particularly fine in Early Cola temples, from the inevitable building up of the ground level around them. See Barrett (1974), 27.

300. 14. P. Brown (1934), (1942a), 102 and 103. As the upper storeys of South Indian temples are hollow, the internal space can easily be utilized if floors are provided: the problem is one of proper access.

301. 15. There are Rāstrakūta inscriptions on the temple at Bāhūr near Pondicherry, and some of the sculptures on its sub-base show unmistakable Deccani influence; Jouveau-Dubreuil (1914), I, 111-13; Barrett (1974), 86 and 87 and plate 43.

16. Until incontrovertible new evidence is presented, in agreement with Barrett (1965), 8, 27-8.

17. Pattabiramin (1959), Filliozat (1961), and Adiceam (1965-78), largely iconographic, are the most exhaustive studies of South Indian stone images but they do not include Vaisnava ones. H. K. Sastri (1916) remains useful. T. A. G. Rao (1914), in four volumes and plentifully illustrated, and J. N. Banerjea (1942) are the standard works on Hindu iconography. Very different in approach, they are complementary. Liebert (1976) relies almost exclusively on modern secondary written sources.

18. Kramrisch (1973).

302. 19. Dumont (1953); Adiceam (1978).

20. Gravely and Ramachandran (1932), P. R. Srinivasan (1963), Sivaramamurti (1963), Barrett (1965).

21. To appreciate to what extent this is true one has only to compare Cola bronzes to those of Kashmir, with their fascinating iconographical diversity and inventiveness and frequently inferior craftsmanship. Similarly, the elaborate surrounds of most Pāla and western Indian metal images tend to detract from the main figure.

22. This disagreement involves most of the 'early' bronzes on general principles of dating on the one hand, and the little 'Pallava' bronzes, practically all Visnus, on the other. So far, no one has commented on the remarkable fact that the latter *are* nearly all Visnus. Generally speaking, Indian scholars tend to

ascribe ninth- and even occasionally eighth-century dates to many 'early' bronzes, whereas Barrett is reluctant to date any to the ninth century and very few indeed to the first half of the tenth. The dates associated with various stylistic criteria vary correspondingly with these datings. Barrett works from a group of bronzes firmly dated by temple inscriptions to *c.* 970 and by comparison with stone sculpture in the earliest dated temples. He is also well aware that a different regional provenance within Tamilnādu can affect apparent synchronisms. The validity of the term Pallava for work produced outside Toṇḍaimaṇḍalam is one of the issues.

304. 23. Barrett (1965), 34. The recent discovery of the first Early Cola bronze with a dated inscription (917), a beautiful Umā, has tended to corroborate Barrett's conclusions and vindicate his method; see Nagaswamy (1979).

24. Nagaswamy (1970), 12-13, figures 16-17; *idem* (1971), frontispiece and figures 2 and 3.

305. 25. Barrett (1965), plates 25 and 26, 95 and 96.

26. *Ibid.*, plates 1-6, 10-12.

307. 27. P. R. Srinivasan (1963), plates XLIII and XLIV; Barrett (1965), plates 89 and 90.

28. Nagaswamy (1961a), frontispiece; Barrett (1965), plates 87 and 88. Only Barrett shows the astonishing prabhā.

29. Sivaramamurti (1963), plate 13a and b.

308. 30. Vatsyayana (1968).

31. Sivaramamurti (1974) deals in magisterial fashion with all aspects of the dancing Śiva. See also Gaston (1982). Baxandall (1974), 77-81, indicates a parallel but very limited relation between dance and the painter's art in fifteenth-century Italy.

32. The acrobatic *ūrdhva tāṇḍava*, for instance, is rarely if ever depicted outside South India. The enduring popularity of Naṭarāja in South India owes a great deal to the ancient tradition that the Lord danced in a grove of tillai trees at Cidambaram and his enshrinement there. The exceptional devotion shown to the god of Cidambaram by the Coḷas, the greatest South Indian dynasty, was also undoubtedly a factor, one of the later Coḷas even referring to him as his *kulanāyaka* or family deity. The classical dance as practised in Tamilnādu, Bharata Natyam, has been vigorously encouraged in the past fifty years and is now famous throughout the world.

33. Barrett (1976), 186 (offprint p. 10). See Chapter 20, Note 9.

34. Sivaramamurti (1963), figure 9a and b. Not surprisingly there is considerable difference of opinion about the dates of the earlier Naṭarājas (see Chapter 20, Note 9).

309. 35. This is a somewhat generalized description, for although scores of bronzes exist corresponding to it in every detail, many vary in one or two features, and by the end of the eleventh century two or three additional elements have appeared.

310. 36. Grousset (1932), 252-5, quoted in K. A. N. Sastri (1955), 730-1.

37. Barrett (1976), 187-96. As is his method, Barrett commences with a small group of sculptures closely datable from inscriptions on the temple apparently referring to them. The weakness of Barrett's method for dating is his reliance on inscriptions which, not being on the image itself, may refer to a different image or else do not necessarily provide evidence as to when the image was made. A case in question is Barrett's dating of the Vṛddhācalam Naṭarāja; Barrett (1965), 29-30, (1976), 187-8. The Vṛddhagirīśvara temple was certainly built by Sembiyan Mahādevī in 981, and in that year she presented a gold diadem to the Naṭarāja, but the image may well, and indeed is likely to, have come from an older temple and already have been of considerable age. If one accepts that the Naṭarāja at Karaiviram is contemporary with the dated Umā image (see Note 23), the whole chronology of Early Coḷa Naṭarājas will have to be re-examined. He also concludes that the Okkur Naṭarāja, of inferior quality, is a true 'primitive' of the group.

38. See Note 37. Illustrated: (a) P. R. Srinivasan (1959), figure 1; (b) Nagaswamy (1961b), figures 1 and 4; (c) Nagaswamy (1971), figures 4 and 5; (d) Barrett (1976), plate XVIII. None of these figures has the long locks of hair standing out horizontally from the head. Only (b) has the streaming waist-band.

CHAPTER 22

311. 1. The date, according to an inscription, when Rājarāja I gave the gilded pot to serve as a *stūpi* or finial; S. R. Balasubrahmanyam (1975), 19. This is the fullest and most up-to-date description of the temple, but see also Somasundaram Pillai (1958). The height of the vimāna as given by various authorities varies by as much as fifteen feet; Balasubrahmanyam (1975), 17-18. This author (p. 246) also quotes the measurements of the principal large Coḷa vimānas given in Sarkar (1974).

2. See p. 320.

3. The tradition that a ramp, presumably of earth but perhaps topped in scaffolding, was used to raise the block into position seems better substantiated than most, but the suggested length, four miles (6.5 km.), seems excessive, implying as it does a gradient of only 1 in 100.

4. See plan in Balasubrahmanyam (1975), after plates.

313. 5. With his usual percipience, Jouveau-Dubreuil, who first traced, on essentially correct lines, the long development of South Indian architecture, seized upon the shape of the corbel as the most reliable rough indicator of the period when a temple was built; Jouveau-Dubreuil (1914).

316. 6. At the village of Uttaramerur (Chingleput District), vestiges of such planning can still be traced. See F. Gros and R. Nagaswamy (1970), Schlingloff (1969), and R. Nagaswamy (1970).

7. For the best account of this temple see S. R. Balasubrahmanyam (1975). Here again there is a discrepancy in the height reported: Sarkar (1974), 6, gives our figure at 160 ft (50 m.).

317. 8. K. A. N. Sastri (1955), 717-20. The best account of both this temple and the Kampahareśvara at Tribhuvanam, K. R. Srinivasan (1948), is unfortunately not illustrated.

318. 9. Sarkar (1974); K. A. N. Sastri (1955), 720-2; also K. R. Srinivasan (1948). There is a significant difference in height between Tribhuvanam (126 ft; 38 m.) and Dārāsuram (83 ft; 25 m.). The superstructures of both these temples are of brick.

319. 10. S. R. Balasubrahmanyam (1975) has rather sketchily surveyed temples up to 1070. A few others have been published but not in sufficient numbers to warrant any but the broadest and most tentative generalizations.

11. For the Gaṅgaikoṇḍacoleśvara at Kuzambandal (Kulambandal), near Kāñcī, S. R. Balasubrahmanyam (1963), 43 and figure 30; Nagaswamy (1970), 45-7 and figures 38-40; S. R. Balasubrahmanyam (1975), 309-11.

12. Marchal (1960).

13. Already noted, most exceptionally, in a temple of the end of the Early Cola period (p. 301).

14. Nagaswamy (1970), 42-4 and figures 35-7. There is also a small shrine, apparently dated 1212, in the Varadarāja temple at Kāñcī; Raman (1975).

15. S. R. Balasubrahmanyam (1963), 47-53, plates 35-54. The author records an inscription on the ardhamaṇḍapa dated in the forty-third year of Kulottuṅga I (1070-1120).

320. 16. S. R. Balasubrahmanyam (1963), figure 42.

17. For the development of the gopura, see Harle (1963). Ignorance of their existence led to the omission of the Early Cola gopuras at Kilaiyūr and Melappalavūr, both recorded in Barrett (1974). See Harle (1963), 16 and 17.

18. Harle (1963), figures 9 and 10. It should be noted that the sketch-plans are taken at the level of the upper vestibules, to whose circumambulatory passages there are entrances (only makeshift or non-existent in later gopuras). It is possible and indeed probable that identical passages existed at the lower level, sealed forever when the courses of masonry reached the upper passages and their floors.

321. 19. Both bear inscriptions of 1014; Harle (1963), 18 and note 2.

20. Kramrisch (1946), 203 and 204.

21. This group, along with the iconography of the images in their vastly increased number of niches, is the principal subject of Harle (1963). Other groups will doubtless emerge when more is known about the buildings of the later Cola period. Gravely (1939) represents the only other step in this direction for gopuras. The Pāṇḍya period (c. 1250-1350) was first so designated by Jouveau-Dubreuil and later adopted by some other writers. The group including the Cidambaram gopuras was assumed to have been built during this period and to exemplify its style. It is best discarded. While it was the last Pāṇḍyas, in association with the Kadavas and other chieftains, who finally, in the thirteenth century, put an end to Cola rule, their success was short-lived. What is more, the buildings most closely associated with the Pāṇḍyas, the east and south gopuras at Cidambaram and the 'Sundara Pāṇḍya' at Jambukeśvara (Śrīraṅgam), are notable, above all in their style, for their faithful adherence to Cola forms.

22. The name Cidambaram, from the Tamil Cirrambalam, 'the little hall', is one of many for this holy place, some of great antiquity, and no other temple in South India has as rich a background in myth, legend, and history. See T. B. Balasubrahmanyam (1931), Somasundaram Pillai (1957), Harle (1963), and Kulke (1970).

323. 23. The fourth was partially fortified in the eighteenth century when the temple figured on several occasions during the wars between the French, their ally Hyder Ali, and the English. That Cidambaram, or at least parts of it, was incontestably used as a fort has given grounds for the widespread but totally erroneous belief that the multiplication of walls around South Indian temples, with their ever higher gopuras, were intended for defence. See p. 321 and Note 19.

24. Cidambaram is an extraordinarily idiosyncratic temple. First among its many peculiarities is its dual holy-of-holies, a pair of adjoining pavilions of uncertain date, one with wooden walls. The focus of devotion, moreover, is divided between a bronze figure of the dancing Śiva and the ākāśa (ether, and hence invisible) liṅga, the first from ancient tradition and the latter originating in a Sanskrit 'etymology' for Cidambaram: cit, consciousness, + ambara, gar-

ment, = 'clothed in consciousness'. Again a unique situation in a large temple, there is, very near, a shrine of Viṣṇu of almost equal holiness. To compound confusion, the inner *prākāras* (concentric enclosures) are now almost entirely roofed and much transformed by a forest of colonnades, admittedly of high quality, the product of extensive 'restoration' over the past hundred years.

324. 25. Each of these, in the west gopura, bears a label from the Nāṭya Śāstra identifying the *karaṇa* or movement depicted. See Harle (1963), 52, note 1.

26. Harle (1962).

326. 27. Barrett (1983-4).

28. Sivaramamurti (1963), plate 26.

327. 29. T. N. Ramachandran (1965).

30. T. N. Ramachandran (1934); Sivaramamurti (1961b), plate 16; Lippe (1978), plates 192-5.

CHAPTER 23

328. 1. The scope and means of dissemination of the Vijayanagara style have so far not been investigated.

2. *Homage to Hampi*, *Mārg*, XXXIII, no. 4, figures 47, 49, 50; see also *ibid.*, p. 77.

3. The identification of the Drāviḍa style with South India is permissible provided that a strict historical perspective is maintained. As we have seen from the earliest surviving examples, temple buildings in South India, with the exception of Kerala and a few in Tamilnāḍu (e.g. the Durgā ratha at Māmallapuram and some subsequent small shrines with the same type of 'Bengali' roof), have all been Drāviḍa. But Drāviḍa buildings as late as the ninth century survive from the Early Western Cālukya region, north of Vijayanagara, and some much later ones in parts of Āndhra, Kerala, and in Tulunāḍ. Furthermore, important elements of the Drāviḍa style, notably the dome-shaped śikhara, can be seen on Kuṣāna reliefs from Mathurā and, a little later, from northern Āndhra, and certain actual examples survive from Gandhāra (Takht-i-Bahi, Balo in Swāt); Franz (1979), 16-18, figures 21 and 22. The final exclusive localization and, with it, the full development of the Drāviḍa style in the south is a phenomenon of the second millennium.

4. *Op. cit.* (Note 2), 77. There are also a considerable number of gopuras of the purely South Indian type, although one at the Virupākṣa temple has a superstructure strongly marked by Deccani (Āndhra?) influence. The diamond-shaped plans of two large maṇḍapas in the Vitthala temple, common in the Deccan and in northern India, are quite foreign to the Drāviḍa style.

329. 5. There are accounts of Vijayanagara in its heyday by both Muslim historians and European visitors. Its fifteenth- and sixteenth-century ambiance was, like that of the Deccani Sultanates, a cosmopolitan one with contacts with South East Asia and even China through the settled Arab communities of the Konkan and with the West through Christian Goa. Vijayanagara has not in the past attracted the attention it deserves. Sewell (1900) and Longhurst (1917) consist of relatively superficial historical and descriptive accounts. A large-scale survey of the site is being undertaken by an international team under the sponsorship of the Archaeological Survey of India and the Department of Archaeology and Museums, State of Karnātaka, led by Dr George Michell, of which the first fruits, in the form of site plans, architectural measured drawings, and photographs of hitherto unpublished monuments, have appeared in *Homage to Hampi*, *op. cit.* (Note 2).

6. The town-planning processes by which essentially upstart petty rājas achieved legitimation in the hinterlands of Orissa, as described by Kulke (1980), is highly relevant to the planning of Vijayanagara. Its two founders, although direct heirs to the Yādava kingdom of Devagiri, had seriously compromised their legitimacy by a conversion, albeit fairly brief, to Islam.

7. Besides the granite so thickly strewn around the site that it is possible occasionally to mistake a heap of boulders for a building, there is also a dark green chlorite which is very sparingly used.

331. 8. The great colonnaded corridors are treated here as maṇḍapas, as are the frequent galleries around the inside of the enclosure walls. The dharmaśāla (pilgrims' rest house) usually takes the form of a maṇḍapa in South India.

9. If the thousand-pillared maṇḍapa in the great temple of Śrīraṅgam belongs to the late thirteenth century, for which there seems to be fairly good evidence from inscriptions, this type of column must pre-date the Vijayanagara period. Again the little-known Late Coḷa period appears to be the matrix for most of the features of the Vijayanagara style. See V. N. H. Rao (1967), 60; Auboyer (1969).

332. 10. It is not unusual, on wayside maṇḍapas of no great age, to see the plain wedge-shaped tenons of the Coḷa period.

11. In the Kalyāṇa-maṇḍapa of the Varadarāja temple at Kāñcī, the god and goddess of love, Manmatha, riding on a haṁsa, and Rati, on a peacock, have been inserted side by side amidst a row of rearing horses and their riders, the same scale and general outline being cleverly maintained; see Raman (1975), 53, 156, and 172, figures 9 and 33. This is a superb

example of the wit so frequently displayed by the Indian sculptor.

335. 12. An exception is a gopura of the Venkateśvara temple at Vijayanagar (*Homage to Hampi, op. cit.* (Note 2), figure 72) where the bold projections and recesses are crowded into lateral wings which are not sufficiently wide. The same may be said of the gopura of the Virupākṣa temple illustrated on the cover. Otherwise, with its fine upapīṭha, provided with its own niche and varied base mouldings, it would not be out of place at Cidambaram. The Amman shrine of the Hazara Rāma shows the same bold articulation, but the base and sub-base dwarf the walls; Harle (1957), figure 4.

13. Harle (1957) and particularly figure 4 showing the Amman shrine of the Hazara Rāma at Vijayanagara. For another Vijayanagara-style shrine, dated *c.* 1487, see the Perundēvi-Tāyār in the Varadarāja temple, Kāñcī, in Raman (1975), figures 7 and 40D.

337. 14. Harle (1963), 35.

15. V. N. H. Rao (1967); for a briefer account, Auboyer (1969). Almost without exception, the great temples have flourished because of a sanctity already attested to in the literature of the Śangam age (first–fifth centuries) and in the songs of the Vaiṣṇava and Śaiva saints (up to 1000), although architectural remains of early date rarely survive.

16. The truth of the matter is that, with their high outer enclosure walls, the large temples invited military occupation and fortification. This is a very different matter.

17. The height estimated by Auboyer (1969), 20, would have been approximately 195 ft ('une soixantaine de mètres'). This seems more likely than Fergusson's 'nearly 300 ft' (*c.* 90 m.). The most advanced, when construction was abandoned, is the south gopura, completed up to the main cornice (i.e. the stone areas).

18. V. N. H. Rao (1967), 84. Non-Hindu visitors are generally not allowed beyond the fourth prākāra.

19. The date of this temple is highly controversial. Auboyer (1969), 20, assigns it to *c.* 1300; V. N. H. Rao (1967), 4 and 58, places it in the period of the Nāyakas of Madurai. The fluted pilasters and the outsize heads in the gavākṣas of the main kapota seem to support this date. The shrine would repay detailed study.

20. A considerable number of sociological studies have been undertaken.

340. 21. V. N. H. Rao (1967), 80 and plate; Raman (1975), figure 37.

22. Because these portrait sculptures usually represent relatively recent historical figures whose dates are known, and because they are so numerous,

in stone as well as bronze, a study would no doubt shed a great deal of light on the complex stylistic trends of a period which has so far been both artistically condemned and ignored.

23. Sivaramamurti (1968), 99-137 and 156-61 and bibliography; Bramzelius (1937).

CHAPTER 24

342. 1. In comparatively recent times, the southern portion of the state of Kerala was known as Travancore, or Travancore-Cochin, with Malabar and part of South Kanara (which administratively formed part of the Bombay Presidency) to the north. The whole coast south of the Konkan, i.e. below Goa, was known as the Malabar coast. Many of the Europeanized names for coastal towns have been relinquished in favour of their original Indian ones, e.g. Calicut is now Kozhikode, Quilon Kollam.

2. Almost certainly the site of Vāñji (Karūr), the ancient Cera capital. A port on the west coast and extensive trade are recorded by Western classical authors, but it is significant that the abundant finds of Roman coins come from places well inland, in Tamilnādu.

3. Geologically, Kerala consists of an alluvial coastal strip, plains with laterite, and hills of granite, gneiss, or charnockite. See Sharma (1956).

4. Kramrisch *et al.* (1952), 21-2.

5. The Kerala components of architecture, while basically wooden, do include thatch or tile roofs or, if Tuḷunad indigenous temples are included, roofs of stone slabs and even walls of the cross-bar or louvre type converted into stone from wooden prototypes.

343. 6. A Buddhist monastery in Kerala was widely enough known to be pictured in an eastern Indian manuscript of 1015, now in Cambridge; Sarkar (1978), 51.

7. Sarkar (1978) maintains the high standards of the Archaeological Survey of India in works of this kind. As its title implies, it deals principally with temple architecture, although sculpture and painting are included. There are also the excellent volumes of the Travancore Archaeological Series.

8. Two examples of the extremely rare, although ancient, oval (*vṛttāyata*) ground plan are attested: Sarkar (1978), 71-3.

344. 9. For a Śiva temple at Tiruvanchikulam, the capital of the second Cera dynasty, roughly contemporary with the Early Coḷas, see Sarkar (1978), plate XXB. Most of the temple and the roof are much later. Also the Mādāttilappaṇ Śiva shrine, Peruvanam, plates XXVIIA and LXXIV.

10. E.g. the Śiva temple at Tali (Sarkar (1978), 160-1, plates XVIIA, XVIII, and LXXIII) and the Lakṣmīnārāyan at Panniyur (plate XVIIC), where outer walls are missing and the inner shrine is seen supporting the topmost roof.

11. *Ibid.*, plate XXXVIIB.

12. *Ibid.*, 4, 50, 71.

13. *Ibid.*, 200-2 and 204.

14. That there are few if any vestiges of contacts with Sri Lanka in the southernmost districts of Tamilnāḍu, which are closer still geographically, can probably be explained by the powerful expansionism of the Coḷas, causing the movement to be entirely in the opposite direction during this time.

345. 15. See p. 484. As will be shown below, the common elements reduce themselves to the steeply pitched rectilinear roofs, extensive use of wood, and the use of struts or bargeboards to support the overhanging eaves, features found in regions of high rainfall in many parts of the world. In a wider cultural sphere there are some curious resemblances between Kerala and Nepal or the sub-Himālayan regions. The latter is deemed, as is Kerala, to have been created by Paraśurāma. The Mātṛkās are worshipped as stones in both places. One of the most successful creations in metal is Śāstā in Kerala and Indra in Nepal, both shown seated. Finally, a phenomenon probably to be explained by cultural contacts is the presence in Tuḷunāḍu, at least, of the Śaiva tantrism of Gorakhanātha which played, and still does, an important part in Nepal. See Chapter 35, Note 52.

347. 16. Extant śāstras from Kerala are relatively late (e.g. the *Tantrasamuchchaya*, fifteenth century) but, as elsewhere, based on older traditions.

17. Pillai (1953); Pieper (1980).

18. Kramrisch *et al.* (1952), 13, and plan of Ettumanur temple on p. 14.

19. Sarkar (1978), figure 17.

20. *Ibid.*, plate XXXVA.

21. *Ibid.*, figure 5, and figure 6, which also shows a very high concentration of apsidal temples around Madras, and curiously nowhere else in Tamil-nāḍu.

22. *Ibid.*, 154-8, plates XI-XIII, figure 26.

349. 23. The mukha maṇḍapa in Kerala is narrower than the vimāna, following the Tamilnāḍu not the Early Western Cāḷukya practice.

24. Sarkar (1978), 160-1, plates XVIIA, XVIII, and LXXIII.

25. There is some indication that this distinctive type of adhiṣṭhāna does not represent the earliest form. In three temples, it sits on a necessarily earlier and more conventional adhiṣṭhāna, with an octagonal

kumuda, which now serves as an upapīṭha; *ibid.*, 169-72, plates XXIA and B.

26. *Ibid.*, 165-6, plates LVII and LVIII and figure 30.

27. All the changes are rung on the external and internal shapes of the inner shrines of circular temples. The commonest is square externally and internally; the rarest, the circular interior.

28. A possible exception is the Pārthasārathi temple, Pārthivaśekharapuram, Kanyakumari District; Kramrisch *et al.* (1952), plate III; Sarkar (1978), 135-8, figures 8 and 18. The walls are articulated and yet the corbels suggest a fourteenth-century date for the walls. It is now, of course, in the state of Tamilnāḍū.

29. Kramrisch *et al.* (1952), plate XIII; Sarkar (1978), 255-6, plate LXIX, figure 62.

30. Sarkar (1978), plate LVI; for other fine examples of wood carving see plates LIVB and LV.

350. 31. Kramrisch *et al.* (1952), 75 and 77, plate LII.

32. Sarkar (1978), 108, plate XLIC; Kramrisch *et al.* (1952), 63, plate XXXV.

33. Sarkar (1978), 107, plate XXIV.

34. The distinctive rafter shoes provide a good touchstone if compared to similarly functional metalwork elsewhere, for example the praṇālas of Nepal; Kramrisch *et al.* (1952), 67 and 68, plate XLI; Sarkar (1978), 122, plate LXVIIB.

35. Dumont (1953); Adiceam (1967), (1978).

36. Kramrisch *et al.* (1952), 69, plates XLIII, XLIV, and XLV.

351. 37. Sivaramamurti (1968) - actually a survey of painting in the Deccan as well as South India, with a useful bibliography. See also V. R. Chitra and T. N. Srinivasan (1940).

38. Kramrisch *et al.* (1952), plate LXIII. It is more likely to belong to the first half of the eighteenth century, as suggested by Sarkar (1978), 124 and 259.

353. 39. Kramrisch *et al.* (1952), plate LXVI, p. 155, and plates LXVIII and LXIX.

40. Bhatt (1975). More than its modest title implies, this is a compendium of Tuḷuva culture compiled with scholarly care by the late Professor S. Gururaja Bhatt. It is, moreover, plentifully illustrated, although the standard of reproduction leaves much to be desired.

354. 41. *Ibid.*, plates 352-5 and 360(a); for the Drāviḍa temples, Cousens (1926), plate CLI, where the temple is designated 'Raganatha', doubtless a mis-spelling for 'Raghunātha' (p. 137), and Bhatt (1975), plates 357(d) and 360(a).

42. Cousens (1926), 136 and 137 and plates CXLIII-CXLVIII, all at Bhatkal.

43. Bhatt (1975), plates 300 and 301. It seems unlikely to be an import. Bhatt illustrates two other bronzes in the same style and kept in the same temple: plates 302a and 337. This is not a Buddhist image, Bhatt argues (pp. 290-9), but belongs to the Śaiva tantric Nātha-Pantha cult and can be equated with Matsyendranātha. A similar cult, also with Gorakhanātha as one of its saints and founders, and similarly an outgrowth of Buddhist Vajrāyana, has long been established in Nepal. See Chapter 35, Note 52.

CHAPTER 25

355. 1. Wakankar and Brooks (1976) and bibliography. For a conscientiously compiled general bibliography of Indian painting, Hingorani (1976).

2. Fragment of painted pot from excavation at Daimabad, Mahārāṣtra, now in the Prince of Wales Museum, Bombay.

3. See pp. 59 and 442 and Chapter 33, Note 5.

4. The disappearance of almost all mural painting of any antiquity can be attributed to the ravages of a particularly inclement climate, the impermanence of most Indian secular building, and a disinclination, until modern times, to preserve anything in its original form.

5. A good idea of these fragments is provided by the line drawings in Aal et al. (1967).

6. This is in marked contrast to the low social rank accorded to artists in later times, when they were regarded as artisans and craftsmen.

356. 7. The theory of rasa is succinctly expounded in Coulson (1981), 21-4; see also Chatham (1981).

8. Coomaraswamy (1927), 88. These terms have been somewhat differently defined: rūpa-bheda, variety of form; pramāna, proportion; bhāva-yojana, the infusion of emotion; lāvaṇya-yojana, creation of lustre and iridescence; sādṛṣya, portrayal of likeness; varṇika-bhaṅga, colour mixing to produce the effect of modelling; Sivaramamurti (1968), 17.

9. Yazdani and others (1931-46), sumptuously produced, illustrates the total corpus of paintings at Ajaṇṭā. Aal et al. (1967), more readily found, is useful.

359. 10. See p. 120 and Chapter 9, Note 5.

361. 11. R. H. de Silva (1962).

12. Aal et al. (1967) has a useful chapter on the materials used by the painters of the Ajaṇṭā murals.

13. Marshall (1927).

14. Viśākhadatta, Mudrārākṣasa, Act I.

15. A Jain painting on cloth in the western Indian style, in the Sarabhai Nawab Collection, is dated c. 1360; M. Chandra (1949a), figure 176. The Kara-Khoto proto-thankas, even if painted in Central

Asia, attest to a Pāla tradition of painted cloths; Auboyer and Beguin (1977), 75-85.

16. Coomaraswamy (1927), 88.

17. For a scholarly and up-to-date vue d'ensemble, Saraswati (1971). See also Losty (1982), 5-8 and 18-36; Conzé (1948); de Mallmann (1965); Stooke (1948).

363. 18. Pal (1965); M. Chandra (1971).

19. But see, for possible eleventh-century examples, Khandalavala and M. Chandra (1969), 1, note 2. The style has been called the 'Jain' or 'Gujarāt' style, but although the majority of the manuscripts have been found in Gujarāt, Māndū and locations in Rājasthān also figure largely as provenances or find places for them, and the manuscripts are by no means all Jain. There is also very early authority for the term 'Western [Indian] Style'.

20. For example, the illustrated Vasanta Vilāsa (dated 1451), a poetic effusion on spring of a well-known type, in Old Gujarāti, though there are also Sanskrit versions. It contains erotic passages as well. See W. N. Brown (1962).

21. Nawab (1959), 6, figures 1-19 (between pp. 10 and 19).

22. Sivaramamurti (1968), figures 45-52.

23. See p. 61 and Chapter 3, Note 8.

364. 24. Barrett and Gray (1963), 56.

25. The frequent decoration of horses with spots has been cited as an example of Persian influence. It is not noticeable in Persian painting, although the use of spots, rare in India, is common in the decoration of ceramics in Iran.

26. For the earliest dated western Indian illustrated manuscript on paper, of 1366, Gorakshkar (1964-6). Paper had long been in occasional use.

27. Khandalavala and M. Chandra (1969), 29-43, plates 3,6, and 7 and figures 45-96.

366. 28. See Note 20.

29. The tree or branch spreading laterally into the picture is a very old convention going back to Arab painting of the twelfth century; the basket-weave depiction of water is of even greater antiquity in Iran. Mannerisms which have appeared by the fourteenth century include the following. (1) Costume. The orhnī (veil or wimple) ballooning out behind the head. The veil draped diagonally across the chest. The tendency for scarves, clothing ends, etc., to stand up stiffly from the body. The ends of clothing, both male and female, portrayed as a point falling down like a tail in seated figures. What appear to be little pouches or purses where the sari is fastened around the waist. The tendency for the lower garment's hem, of both sexes but principally of

women, to jut forward. (2) *Other*. Flat top of woman's head. Breasts shown by two overlapping half-circles. Skies with every shape of horizon, and sometimes only covering a corner, but with the horizon always outlined with a white band. The practice of placing seated figures at the top or further edge of any carpet or cushion. For an up-to-date list of the Caurapañcāśikā manuscripts, Doshi (1978-9), note 2.

30. The problem of where in the sixteenth century to place the Caurapañcāśikā group has long bedevilled scholars; the *kulāhdar* turban, wound around a projecting boss, and the short *jāma*, or male skirt, with points (*chākdār jāma*), are now generally considered to have already been in vogue by the end of the Lodī period (1451-1526) and not an innovation of the Mughal court.

31. Khandalavala and M. Chandra (1963); *idem* (1959-62).

32. Rai Krishnadasa (1955-6); Askari (1955).

33. A good case for a Mewār origin is made by Barrett and Gray (1963), 61-72, confirmed by Losty (1982), 49 ff.

34. The evidence of some hitherto unpublished manuscripts and painted pothī covers, some from eastern India, has, in the last few years, tended to push back the date of the emergence of the Caurapañcāśikā style to the end of the fifteenth century; see Losty (1975), (1977) and (1982), 48 and catalogue nos. 31, 32, 35; Doshi (1978-9). Furthermore, a Mewār origin would tend to associate the finest paintings with the great days of Rānas Kumbhā (1433-68) and Sanga (1509-28); Losty (1982), 48-51. Losty's argument is partly based on the general premise that 'in an Indian context, it is rarely the case that comparatively crude manuscripts ... are the forerunners of an advanced courtly style, rather than provincial derivatives from it'.

367. 35. Stanza 17, Northern Recension; translation Miller (1971), 110.

36. Shiveshwarkar (1967).

37. Khandalavala and M. Chandra (1969), plate 21 and figures 199-200; Barrett and Gray (1963), 67; Welch (1973), plate 7; Spink (1971b), figure 11; Lerner (1974), no. 1; Khandalavala and Mittal (1974), figures 1-4; Pal (1978a), plate 3.

368. 38. Khandalavala (1953-4); Pal (1978a), figure 201.

39. 'Kāma shooting an arrow at Krṣna and Rādhā', illustrated in Khandalavala and M. Chandra (1969), plate 23, shows Rādhā taking refuge in Krṣna's arms and looking back at the menacing god of love in a most spontaneous movement realistically depicted. Another striking example is the woman in one of

the Vasanta Vilāsa vignettes throwing herself on to a throne to embrace her lord; W. N. Brown (1962), figure 71.

40. Digby (1967).

369. 41. On stylistic and calligraphic grounds: Fraad and Ettinghausen (1971). Similar attributions, also on stylistic grounds, in Binney (1973), catalogue nos 2, 3, 4, 7, 8, and 9.

42. A Khamseh, a Sikandar Nāma (part of the Khamseh of Nizāmī), a Hamza Nāma and a Shāh Nāma; Khandalavala and M. Chandra (1969), plate 8, figures 101-16, 115-26, 127, and 128.

43. Skelton (1978).

44. At one time there was a tendency to label all non-Mughal painting in India in the fifteenth and sixteenth centuries as Sultanate painting.

45. Khandalavala and M. Chandra (1969), figures 188-95. Losty (1982), 51, believes these paintings to be from the same atelier as the Mehta Caurapañcāśikā ones.

370. 46. Skelton (1959).

47. Khandalavala and M. Chandra (1959-62), 27-31 and figures; there is also an inferior illustrated manuscript of the Candāyana (Laur-Chanda), also in Sultanate style, in the John Rylands Library, Manchester; Khandalavala, M. Chandra, P. Chandra, P. L. Gupta (1961).

CHAPTER 26

372. 1. The word 'Mughal' (often spelt Mogul in the past) is the same as Mongol and refers to the Mongol origins of the dynasty. Although Barlas Turk on the paternal side, Bābur was descended from the Mongol Genghis Khān on his mother's. Mughal painting was first known as 'Indo-Persian painting'.

2. It is well to remember both that the court was where the emperor was in semi-permanent residence, and also the age-old penchant of Muslim monarchs in North India to build new cities for themselves. Depending on the exigencies of war and the predilections of the sovereign, the 'court' (which was synonymous with the capital) was first at Agra, under Akbar, then at his newly-built Fathpur Sīkrī, then at Lahore; Jahāngīr as heir-apparent had his court at Allahabad, also a Mughal city. Shāh Jahān built a new capital for himself, Shāhjahānabad, the present Delhi, with his palace in the Red Fort.

3. 'Agra and Lahor of great Mogul' are shown to Adam after the Fall, along with other kingdoms of the earth, in *Paradise Lost*, xi, 391.

4. Ashmolean Museum, Reitlinger Collection. Also flower paintings, Skelton (1972).

5. Falk (1976), 167.

373. 6. Painting by Mir Sayyid Ali while in the atelier of Shāh Tamasp is known, and two paintings are attributed to him during his Indian period; P. Chandra (1976), 18–21.

7. S. C. Welch's phrase, quoted in Binney (1973), 24.

8. P. Chandra (1976).

376. 9. 'Abu'l Fazl has recorded that Akbar had started to form a collection of portraits of the leading men of his time but it is not possible to assign any existing portraits with complete confidence to his reign'; Barrett and Gray (1963), 102.

10. It has been suggested that a tradition of tent hangings lies behind the cloth surface and exceptional size of these Hamza Nāma paintings. The earliest surviving painting of the Mughal school, depicting the male ancestors of the Mughal dynasty, is also on cloth. It was originally 45 in. (108 cm.) square. Now in the British Museum, it is illustrated in Pinder-Wilson (1976).

11. See Glück (1925), to be superseded by the all-colour edition being prepared by the Akademische Druck- und Verlagsanstalt, Graz, Austria. Most of the surviving paintings are in Vienna. For the dates, P. Chandra (1976), 66 ff.

12. W. G. Archer, quoted in Binney (1973), 25.

13. For a full discussion of early Akbari painting, P. Chandra (1976).

378. 14. Barrett and Gray (1963), 96.

15. P. Brown (1942b); M. Chandra (1949b).

16. Auboyer (1955), with reference, 271, note 1, to Sarre (1904). Also de Loewenstein (1958).

17. Of these, the famous painting of a zebra presented by an Abyssinian mission, now in the Victoria and Albert Museum, typifies Jahāngīr's interest in exotic animals. Illustrated in black and white in W. G. Archer (1960), plate 26; in colour in Welch (1978), plate 27.

18. Jahāngīr, accompanied by most of his court, made the journey to Kashmir over the Banipal pass fourteen times.

19. There is an intriguing mystery about the subject matter of this painting, one of the loveliest of all Mughal miniatures. Its unusually large size almost precludes its being part of a manuscript. Furthermore, the squirrels are of a species which is not native, while the clothes of the 'hunter', who, incidentally, carries no gun, are more European than Indian. It is probably based on a European allegorical work, but the source has so far not been identified; see Falk and M. Archer (1981), 59 and 60. It is not disputing the likelihood of such a source to remark that it is not precisely true, as the authors

state, that Indians never hunted or kept squirrels. Paintbrushes made from hairs taken from the tails of young squirrels were considered the best, particularly for fine work; see P. Brown (1924); M. Chandra (1949b).

381. 20. Barrett and Gray (1963), 102.

382. 21. *Ibid.*, 100.

22. Ettinghausen (1961).

23. G. D. Lowry (1983).

24. P. Chandra (1960).

25. Binney (1973) illustrates a fairly representative collection of eighteenth- and nineteenth-century Mughal and Mughal-style painting; also Beach (1978). For art produced by Indians specifically for the British, either individual patrons like Lady Impey in the early days or a collective market later, M. Archer (1947), (1955), (1970), (1972); M. and W. G. Archer (1955), (1967); Welch (1973).

CHAPTER 27

384. 1. The early Manley Rāgamālā, now in the Victoria and Albert Museum, the Laud Rāgamālā in the Bodleian Library, Oxford (Stooke and Khandalavala, 1953), and the Berlin set (E. and R. L. Waldschmidt, 1975).

385. 2. Ebeling (1973), which claims to be inclusive, with its systematic treatment is invaluable as a research tool, although perhaps a little uncritical in assigning the Rāgamālās to schools on grounds of style. In addition to illustrating more Rāgamālā paintings than any other work, references are given to all illustrations published elsewhere. See also E. and R. L. Waldschmidt (1967), (1975) and Dahmen-Dallapiccola (1975). Powers (1980), a long review of the above works, also puts Rāgamālā into a wider art-historical context.

3. Ebeling (1973), 13–14.

4. *Ibid.*, 116, 130, 138, 147.

387. 5. Kühnel (1937), 25, quoted in E. and R. L. Waldschmidt (1975), 27.

6. Nawab (1956), plates A–G; ten illustrated in Ebeling (1973), 121.

7. E. and R. L. Waldschmidt (1975), figure 116; *idem* (1967), figure v; W. G. Archer (1958), plate 3; see illustration 292 and p. 367, above.

8. W. N. Brown (1948).

9. Krishna (1961); Nawab (1956).

10. Kanoria (1952-3).

388. 11. See p. 373. Beach (1974), 6–10.

12. M. C. Beach, K. Ebeling, and R. Skelton all accept the early date for the paintings.

13. Khandalavala, Chandra, and Chandra (1960).

391. 14. W. G. Archer (1959), figures 2 and 3.

15. P. Chandra (1959), plate 2; also Beach (1974), figure 29.

16. Beach (1974), figures 32 and 33.

17. Ebeling (1973), 217-20 and illustration; Beach (1974), 39.

393. 18. Beach (1974), figures 60, 91, 93, 129, 130.

19. Beach (1974).

20. Beach (1974), figures 71-5. An equally fine drawing, with some colour, is attributed to Bundi (P. Chandra, 1959, plate 6). A low squat wall, over the top of which the elephants jousted, can be seen inside the main palace at Udaipur.

21. Beach (1974), figure 77.

22. Skelton (1973b).

395. 23. Barrett and Gray (1963), 154-5.

24. K. S. Singh (1960). Another Rāgamālā, in the same style, is dated 1634; see Khandalavala, Chandra, and Chandra (1960). Illustrations to a Bhāgavata Dasmaskandha dated 1610 in the Pustaprakash, Jodhpur Fort, are probably not from Jodhpur.

25. Dickinson and Khandalavala (1959).

26. It is conceivable that Nihal Chand was tempted to introduce these disparities of scale by the example of prints or drawings of the gardens of Versailles or Schwetzingen, with their minute figures proceeding up the mile-long alleyways. A drawing directly inspired by, if not a near-copy of, one of these is from Kishengarh, *c.* 1750, and may be the work of Nihal Chand; Welch (1978), 130 and figure 58.

396. 27. Dickinson and Khandalavala (1959), plate XV.

28. Kaye (1918).

29. Andhare (1972).

30. The origins of these elements are controversial. See E. and R. L. Waldschmidt (1975), 465-7.

31. *Ibid.*, 467.

32. The first is an illustrated Amaru Śataka dated according to an untraceable colophon 1650/1 from Nusratgarh (Nasratgadh), possibly a town near Sironj, in extreme north-east Mālwā; see N. C. Mehta (1935). Narsyang Sahat, probably Narsingarh, in north-central Mālwā, is given as the place of origin of the second, a Rāgamālā set, according to the colophon dated 1680; Khandalavala (1950), 55. For a long discussion of Mālwā painting A. Krishna (1963).

397. 33. Doshi (1972). The fact that the manuscript came to light in a Jain temple in Udaipur should serve as a strong caution against assuming that the modern find-place of a manuscript affords any indication of its place of origin.

34. W. G. Archer (1958), plate VII.

35. See Note 32.

36. See Note 32 for the first; Pal (1967a), figures 53, 78.

37. See Note 32 for the first; for the second M. Chandra (1951-2).

CHAPTER 28

400. 1. For an account of the relatively recent discovery of Deccani painting, Skelton (1973a).

2. Skelton (1957).

3. Illustrated *ibid.*, figure 14; Sah (n.d.), no. 67.

401. 4. The exuberance of floral decoration, derived from a wide variety of sources, is paralleled in the contemporary textiles from Golconda.

5. Barrett and Gray (1963), 116.

6. Goswamy (1962) attributes this to the vassal status of the Deccani kings (who were never given their royal titles by the Mughal emperors) rather than to a regional distinction.

403. 7. Binney (1973), cat. no. 118. Ebeling (1973), 155-8, lists and illustrates them all, including some known only by eighteenth-century copies, and gives their present whereabouts. Colour reproductions: Goetz (1950), plates II and IV; Barrett (1958a), plates 3 and 4; Barrett and Gray (1963), 119; W. G. Archer (1960), plate 13. It has been suggested that perhaps none of these paintings belonged to conventional Rāgamālā sets; Ebeling (1973), 156.

8. Barrett (1958a), plate 5.

9. Barrett and Gray (1963), 127.

405. 10. Barrett (1958a), plate 8, there identified as Muhammad Qutb Shāh of Golconda (1611-26); Skelton (1973a) has convincingly shown that it must be his son Abdullah, who came to the throne in 1626 at the age of twelve.

11. Barrett (1960a), plate III, figure 6.

12. *Ibid.*, 10.

13. *Ibid.* Skelton (1973a) accepts the Golconda attribution; Goswamy (1962) is surely mistaken to doubt that they are even Deccani.

406. 14. Mittal (1963), which also refers briefly to Kurnool (Cuddapa) and Arcot painting.

CHAPTER 29

407. 1. W. G. Archer (1973), the author's major work, is indispensable to the study of Pahārī painting, assembling as it does all the relevant historical, political, and geographical information as well as the history and attributions, where known, of the more important paintings. There is also an exhaustive critical bibliography. Archer is a critic of great sensitivity and discernment. The material is organized by

individual Hill state, some of them relatively obscure, perhaps unconsciously patterned on the splendid gazetteers produced by the Indian Civil Service in which Archer had a distinguished career. The inevitable drawback is that no painting considered remains unassigned to a particular state, in many cases on stylistic grounds open to future questioning. For a different methodological approach, see Note 8. Except where illustrations in colour exist elsewhere, reference will be to Archer's illustrations wherever possible.

2. W. G. Archer (1973).

3. This may account for the inclusion, at one time, of Pahārī painting with Rājasthānī painting under the general name of Rājput painting.

4. There exists an illustrated Pahārī manuscript of the Mārkaṇḍeya Purāṇa apparently dated in the late sixteenth century; C. Glynn, University of California (Berkeley) Ph.D. thesis. The reading of the date, however, which is expressed as a chronogram, has been questioned.

5. Khandalavala (1958), plate C; Randhawa (1959), plate 37.

408. 6. See p. 397.

409. 7. Illustrated in W. G. Archer (1973), II, 240, figures 2(i) and (ii).

8. B. N. Goswamy's researches into contemporary records have revealed a great deal about families of painters and their movements, and he has tended to emphasize their role in determining stylistic shifts. See, for example, Goswamy (1972).

9. Illustrated in W. G. Archer (1973), II, 246, figures 7 and 11.

411. 10. Randhawa (1955), (1959); Goswamy (1965). For résumés, see W. G. Archer (1973), II, 76 and 186.

412. 11. Randhawa (1962), figures 52 and 53.

12. *Ibid.*, figure 35; for a nude version, Randhawa (1966), plate XI.

13. 'Lady Listening to Music', Guler, *c.* 1750, illustrated in Barrett and Gray (1963), 177. The similarity of these gracefully clothed women to bird or animal forms is particularly stressed in the vertical Kāliya Damana, Mukandi Lal Collection, Lucknow, M. Lal (1968), colour plate 2, where the women rising out of the water beside the serpent are actually depicted as mermaids. See also illustration 331.

414. 14. An entry in the journal of Moorcroft, an English visitor to Kangra in 1820, mentions that Sansar Chand kept several painters; Archer (1973), I, 251.

15. After the pioneer Coomaraswamy, O. C. Gangoly, Goetz, Randhawa, Barrett, Gray, Moti Chandra, Goswamy, and, of course, Archer and Khandalavala, along with a number of younger scholars.

415. 16. E. and R. Waldschmidt (1967), 33-47.

17. Mittal (1955), Seth (1976). The Pahārī murals which have survived are very close in style to the miniatures.

18. Randhawa (1962), chapters V-IX.

19. Randhawa (1966).

417. 20. *Ibid.*, 24.

21. There is a portrait of the 'Basohli rānī' of Rāja Govardhan Chand of Guler, one of the rare women's portraits. Interestingly, in a group family portrait, the rāja is recognizable by his features, his rānī only by the position she occupies, her face being identical to the purely conventionalized ones of her ladies in waiting; Archer (1973), II, 105, figure 26, and 108, figure 38.

22. Archer (1973), I, 284-6; II, 198, figures 9, 10; 199, figures 11-14; 200, figures 15-17; 201-2, figures 18-24.

23. Hero and heroine of an episode in the Mahābhārata. Archer (1973), I, 299-303; II, 218-20, figures 49-50; 221-3, figures 49 and 50 consist of drawings in sanguine. Also Eastman (1959), Goswamy (1975).

418. 24. See Note 23. Of the drawings, no. 50 is in the Boston Museum of Fine Arts, and of the coloured series no. 53 is in the Karan Singh collection in Jammu, India.

25. Archer (1973), I, 293a. Both Archer and Randhawa, from their extensive travels in the Hills, vouch for the way in which so many paintings in the Guler-Kangra style echo various Pahārī landscapes.

420. 26. Just as, according to Archer, they are ignored by the people of the Panjab Hills to this day.

27. For example, the Mārkaṇḍeya Purāṇa manuscript in the Lahore Museum; Aijazuddin (1977), no. 41 (i-xxxiv).

CHAPTER 30

421. 1. The documentation of Islamic architecture in India is far more compact and easily accessible than that of either Hindu or Jain temples. The important monuments are usually located in cities, surviving or abandoned, and they have been well documented in Archaeological Survey of India publications before 1930. Since then, with the partial exception of certain Mughal buildings, they have not attracted much investigation. The historical facts are, of course, immeasurably easier to establish thanks to the Muslim preoccupation with recording

events and dates in histories, memoirs, and inscriptions. P. Brown (1942b) remains the best general account. See also Marshall (1928) and articles in the *Encyclopedia of Islam*, new edition, 1960-82 and continuing.

2. The design is in question here, the plan, and the location of the various elements of the edifice. In elevation the Hindu temple, because of its symbolic significance, is based on far more complex conceptions.

3. Not unknown, but almost never employed by Hindu builders. See Chapter 1, Note 10.

424. 4. I owe this fact to Mr Simon Digby, who has read this chapter. Other facts and suggestions provided by him, particularly in the earlier sections dealing with pre-Mughal times, a field in which he is pre-eminently at home, have been incorporated in the text.

5. The nearest roughly contemporary minārs are the two at Ghazni in south-west Afghanistan (eleventh century) and the one at Jam in the eastern part and probably the Ghurid capital (twelfth century); see Vercellin (1976), with references to Maricq and Wiet (1959) etc.

425. 6. Naqvi (1947).

7. For an artist's re-creation, Brown (1942b), plate XIV.

426. 8. C. B. Asher (1977).

CHAPTER 31

428. 1. The provincial styles are considered in the roughly chronological order of their development as adopted by P. Brown (1942b), 32.

2. See p. 216.

3. *A.S.I.*, XI, 110-18, plate XXXVII, 4, 5, and 6.

4. Führer and Smith (1889).

429. 5. For a good rear view, P. Brown (1942b), plate XXXII, 2.

6. See Chapter 30, Note 5. Other free-standing minārs are the Fīrūz at Gaur, the Chānd at Daulatabad, and of course 'Alā-ud-dīn Khaljī's gigantic companion to the Qutb Minār, of which only the base was completed.

430. 7. In Gujarāt, the building of Jain temples continued at their mountain sites of Girnār and Śatruñjaya, as did that of step-wells (*wāvs*) like that of Adalaj in the traditional mode but with their ornament reduced and rendered abstract.

8. Nath (1979).

432. 9. See pp. 242-3.

CHAPTER 32

433. 1. Marshall (1928) makes this point (p. 629).

2. The only entrance was by a tortuous tunnel which could be made impenetrable by the emission of smoke from a fire lit in a special chamber with a flue; Marshall (1928), 630-1, plate XLI.

3. *Ibid.*, 362.

4. Merklinger (1976-7). For a comprehensive survey of the Islamic architecture of the Deccan, Merklinger (1981).

434. 5. Cousens (1916).

CHAPTER 33

437. 1. *A.S.I.*, *A.R.* (1902-3), 61-7, plates 9 and 10 and figure 1.

438. 2. Rizvi and Flynn (1975) is an excellent study which dispels many of the misconceptions which had arisen about Fathpur Sīkrī and its buildings, the latter frequently bearing fanciful names devised by ignorant guides, e.g. 'Jodh Bai's palace' for the principal palace in the women's quarters (*haram*), 'Bīrbal's house' (dated 1572 by a graffito in Hindi) for the northern palace in the women's quarters, and the 'House of Miriam' for the Sunahra Makān or 'Golden House', so called because of the abundance of gold in its frescoes which probably depicted episodes from the Hamza Nāma and not Christian scenes, as propounded by guides. On one of the eaves-brackets there is a small relief of Viṣṇu being worshipped by Hanuman. There were two Maryams (Marys) at Akbar's court, one his mother, the other his Rājput wife, the mother of Jahāngīr, neither a Christian, needless to say.

439. 3. For a completely different view of the function and purpose of this building, R. Nath (1976a), 7-21. Rizvi and Flynn (1975), 38, show that it was certainly not the 'Ibādat Khāna', where Akbar initiated his well-known religious discussions, and the structure is most probably to be identified as the jewel house.

4. The sayings in an inscription on this building, attributed to 'Jesus, blessings be upon him', with their stoic other-worldliness bear little relation to Christ's teachings.

442. 5. For extensive treatment of the decoration of Islamic buildings, and particularly Mughal ones, in India, R. Nath (1970), (1976b).

6. Begley (1981); Vogel (1912); see p. 433.

7. The Mughal capital was where the court was, and it is curious that both Akbar and Jahāngīr avoided Delhi.

8. R. Nath (1976b). Not surprisingly, there is a considerable literature about the Tāj Mahall, and of

course there are contemporary accounts. Most of this is referred to in Begley (1979).

443. 9. Begley (1979). Begley (1978-9) reveals the important role played by individual calligraphers in the decoration of Mughal buildings.

444. 10. Brown (1942b), chapter XXII and pp. 113-14.

CHAPTER 34

445. 1. Architectural and other terms will, unless otherwise noted, be given in Pali, the scriptural language of Theravāda Buddhism, the religion of the Sinhalese. When Sinhalese terms are used, the phoneme more rigorously written as a with two dots above will be given as e, a common practice.

2. It is not accidental that, in the early days of the Second World War, it was the only portion of the Indian subcontinent to be seriously threatened by Japanese naval power.

3. Sri Lanka (Taprobane) was well known to classical writers. Roman coins have been found on the island and some were still in circulation when the Portuguese arrived. A small ivory model of a Roman quadriga has recently been identified as the earliest known chessman. See Van Lohuizen (1981b), (1984).

4. Gujarāt is now favoured as the original home of the Sihalas, but the linguistic evidence is not clear, and they have left no archaeological remains dating from their arrival or early settlement.

447. 5. Boisselier (1979), a model of its kind, filled a long-felt need for a short but comprehensive and scholarly account of sculpture and architecture in Sri Lanka. See also annual reports of the Archaeological Survey of Ceylon (first report, 1890) and *Epigraphica Zeylanica*, II (1912-).

6. A recent high point has been the work on the stūpa at Dedigama, Parākramabāhu's birthplace, and the setting up of an exemplary small museum. For a brief but authoritative account of archaeological work in Sri Lanka, Boisselier (1979), 30-54. A UNESCO-sponsored project aimed at the conservation and restoration of the antiquities of the 'Triangle' (Anurādhapura, Polonnaruva, and Sīgiriya) is now in hand.

7. Marchal (1944), 29, writing of the remains of the Lohapāsāda at Anurādhapura, emphasizes the sense of frustration and bewilderment before such forests of rough-hewn pillars holding up nothing and standing at various angles from the vertical: '... mais quand on voit sur place ces fûts quasi informes de piliers très rapprochés, de sections inégales et d'une taille très grossière, on se demande comment on peut

réaliser avec ses vestiges une construction aussi importante qu'une demeure royale à plusieurs étages.'

8. B. Allchin (1958).

448. 9. Paranavitana (1953), (1958). For modern transformations in belief and practice among Buddhists in Sri Lanka, Gombrich (1971).

10. The foundations of the early monasteries (*vihāras*) are recorded in the vamśas. The stūpa was an essential component; although their erection is not usually recorded, it is always assumed, and where archaeological evidence exists, it confirms that the stūpas of the great early vihāras date from their foundation.

11. The theory propounded at some length by Irwin (1973), (1974), (1975), and particularly (1976), (1981), who appears not to have been aware of the Sri Lankan examples. See also pp. 24, 26, above. Small reliquaries of beaten gold in the form of a stūpa show them plainly, and besides providing evidence of the shapes of the early stūpas further testify to the close links with Āndhra, where similar reliquaries of *c.* 100 have been found. The earliest, from the Rājamahāvihāra at Mihintale, dated to the early third century B.C. by Van Lohuizen, does not show such a pillar or shaft but instead a curious arrangement of two poles holding up the simple flat parasol. See Boisselier (1979), 94 and 95; Rea (1908-9), plate XXVII, b,c,d; Van Lohuizen (1981b), 62; also p. 26, above.

12. Well displayed in the new museum at Dedigama, *yantragalas* were also placed under the images in the image shrines (*paṭimāgharas*). They were also placed under or behind the lotus pedestals of some of the huge rock-cut images of the Buddha, the one at Avukana for instance; Dohanian (1977), 80.

13. The supporting pillars were probably of wood; the present pillars ringing the stūpa belong to the seventh or eighth centuries. See Liyanaratna (1972), figures 1, 2, 3.

14. Devendra (1958a) and Mode (1963) both have plentiful illustrations of sculpture; Devendra, however, stops at 1000. Mode's table of illustrations includes useful references, but some of his dates and identifications are no longer tenable.

15. Devendra (1958a), figures 108 and 109. It is always assumed, without any evidence, that all imports from Āndhra into Sri Lanka are from Amarāvatī, whereas the stylistic evidence they provide is too meagre to identify them as such, and the same stone was used at all the Āndhra sites.

16. Boisselier (1979), figure 20, and Devendra (1958a), figure 102.

450. 17. The figure (shown in Boisselier (1979), figure 24) stands, abominably restored at the time of

writing, with a new head, hands, and feet, among other Buddhas in the new vihāra beside the Ruvanveliseya. For other early standing Buddhas, see Mode (1963), figures 126–33. They are recognizable by the similarity to their Āndhra prototypes in the way the pleats of the robe are treated: incised lines, or pairs of lines, fairly widely spaced, with a slight swelling of the cloth between them. For Āndhra prototypes, Coomaraswamy (1927), figures 138 and 139; Mitra (1971), figures 25 and 132; Michell ed. (1982), figure 329.

18. The absence of halos, either integral or separately fitted, is a notable aspect of all Sinhalese Buddhas, whether standing or seated. Some Āndhra Buddhas, on the other hand, have tenons at the back of the head, for detachable halos, and these almost invariably appear on Sinhalese Bodhisattvas.

453. 19. Long believed to represent Ananda, the Buddha's last disciple, because of the proximity of the Buddha in parinirvāna close by. There is another example at the small museum near Tissamahārāma.

20. Dohanian (1977), chapter VII, argues this point on the basis both of style and of his belief that these seated Buddhas, when found *in situ*, for example in the vaṭadāgēs at Medigiriya and Polonnaruva, face the cardinal directions and thus represent the Buddha's immanence in space, a Mahāyāna concept. A slightly earlier date than the seventh century which Dohanian proposes for the creation of these figures can be argued, however, and on the same grounds of their similarity to Pallava sculpture. There is no reason to assume that stylistic trends were always set by the Tamils, bearing in mind that the Sinhalese had already been creating masterpieces in stone for two or three centuries.

21. See Dohanian (1977); Silva (1971).

22. The only one of these free-standing figures to have retained its arms is so badly worn overall as to make many of its features unrecognizable. Identified by Mode (1963), 96, figure 150, as Bhātika Abhaya, a king of the late first century A.D., it stands near the famous 'Dutthagāmanī' figure on the terrace of the Ruvanveliseya. It cannot be earlier than the sixth century since it wears simple pearl armlets of a type which made their first appearance in India in the fifth century (Bāgh caves) and a little later at Kanheri. The hands are in añjali, a gesture befitting a royal devotee but unheard of for a Bodhisattva. Doubtless because of this, the 'Dutthagāmanī' has now been provided with complete arms, including pearl armlets, and makes the same gesture! For an illustration of this statue in its original armless state, Coomaraswamy (1927), figure 294. The unique 'Bhātika Abhaya' figure leaves open the possibility that all the

other free-standing armless figures in princely attire made the same gesture and represent kings as devotees, but this seems unlikely.

454. 23. See Note 22. Indications of an early date are the fluted tubular form taken by the fold of the dhoti between the legs, the slight fold-over of this garment at the top, a Gupta hallmark, and the unusual *karandamakuta*, without side-pieces or a tall central portion. The rather meagre torso may also be an indication of early-seventh-century date. At any rate, this type of princely costume does not evolve in India until the Early Cālukyas.

24. A key document remains uninterpreted: a section of a relief in Palnad marble, found at the Piduragala monastery near Sīgiriya, showing two Bodhisattvas (see Dohanian (1977), figure 56). It obviously belongs with the better known fragment showing three Buddhas illustrated in Boisselier (1979), figure 23. The third/fourth-century date assigned to these fragments by Boisselier and by van Lohuizen (1981b), 21, is untenable because of the 'Cālukya' costume worn by the Bodhisattvas, and both fragments must be dated to the late seventh or early eighth centuries in spite of the somewhat earlier appearance of the Buddhas (Dohanian (1977), 89). What is more, although both Bodhisattvas are in 'princely' costume, one wears a karandamukuta, the other a jatāmukuta (although not of the Sinhalese type), suggesting that in contemporary Āndhra, at least, two different Bodhisattvas were designated by these headdresses, and that both could not be Avalokiteśvara, even in different guises.

25. Precedents in India can be found in the later Konkan and Mahārāstra caves; Dohanian (1977), 34 and 35, citing de Mallmann (1948).

26. The bronze head and torso found in the Kistna delta and now in the Victoria and Albert Museum, London, illustrated in Dohanian (1977), figure 8, of the sixth or seventh century and variously identified as Avalokiteśvara and Śiva, wears a less elaborate and stylized version of this headdress. The small rosette at the base is known, however, from one or more of the Sri Lanka heads.

27. One detached head has a small stūpa in the headdress; Mode (1963), figure 158.

28. More accurately described as *simhakarna* (lion's ears), another term for kataka. The generally low standard of these sculptures may account for this simplified version and its extension to both hands (*hasta*). *Kataka mudrā*, the 'ring' gesture, is appropriate for Avalokiteśvara as it is the position of the hands when they hold the lotus.

29. Besides Situlpāvuva, a figure at Buduruvegala, one of the rock-cut figures there, and a bronze from

Giridara (Boisselier (1979), figure 52). A lion's head is plainly indicated on the Giridara bronze; on the other two figures the pelt is much more summarily, but unmistakably, indicated.

30. Dohanian (1977), 42-5.

31. It is made of gneiss, the eyes are lightly incised for a shallow inlay, and at the back of the head, as with many of the 'princely' Bodhisattva types, is a large rosette and a tenon for affixing a prabhā. Apparently unnoticed so far, the figure in his jaṭāmukuṭa is standing, not seated.

455. 32. These are reviewed by van Lohuizen (1979b), who correctly identifies the figures as the South Indian god Ayannār (Śāstā in Kerala). Considering that images of Ayannār in this characteristic pose are common a few hundred miles to the north, this tardy recognition is an indictment of the parochialism which has so often bedevilled the study of art history on the subcontinent. Van Lohuizen points out that the inferior quality of the horse's head is due to its being largely composed of modern cement.

33. Van Lohuizen (1965); Prematilleke (1978). Dohanian (1977), 72, confidently asserts that the figure represents Mañjuśri, without citing any textual evidence.

456. 34. Mode (1963), figures 171 and 172. The unfinished appearance of the Buduruvegala figures may be due to the fact that the details were meant to be applied on a stucco coating.

35. The figure is most likely to represent a ṛsi, and several have been proposed; see Gunasinghe (1958). A likely clue is provided by an attendant figure on a slab from the Girihandu vihāra, near Ambalantota, in Palnad marble and bearing a relief of a standing Buddha, or more likely Bodhisattva, with a horse behind him and attendant figures, one almost identical to the Potgul vihāra rock-cut statue; Dohanian (1977), 90 and figure 57.

36. Dohanian (1977), figures 3-7, 9, 14, 19-31, 35-6, 40, many of them in the Nevill Collection in the British Museum. Nos. 20 and 40 are Pāla imports. For a large standing bronze Buddha of the seventh or eighth century, Godakumbura (1963).

37. Dohanian (1977), figures 23 and 24.

38. Bandaranayake (1974a). In this exhaustive work, the distillation of a century's excavation, research and scholarship is presented and evaluated. The evolution of the various architectural features and details of what remains of the Anurādhapura monasteries is also described and illustrated in considerable detail. It should be remembered, however, that this work is exclusively concerned with the vihāras of Anurādhapura and, while they occupy a preponderant position, there are remains, sometimes

important and extensive, of vihāras at many other sites, most notably Medigiriya and, of course, Polonnaruva.

457. 39. Bandaranayake (1974a).

40. Bandaranayake (1974a), figures 53 and 54. The famous 'Buddha of the Outer Circular Road' is associated with the second of these shrines at the Abhayagiri vihāra, Anurādhapura.

41. The frontispiece of Bandaranayake (1974a), illustration no. 354, an aerial view of the Thūpārāma vaṭadāgē, shows the scale on which it was built and how impressive it must have been.

42. Liyanaratna (1972).

43. Prematilleke and R. Silva (1968); Bandaranayake (1974a), 58-85.

458. 44. By Bandaranayake (1974a), 70, who sees in the forest-dwellers (vanavāsins or āraññavāsins) simply one of two 'counterpoised monastic tendencies'.

45. The small square buildings in which the monks lived, two to a kūṭī. They and the buildings which housed the latrines and washrooms were the smallest of the monastic buildings.

46. Devendra (1967).

47. Devendra (1965).

459. 48. Paranavitana (1955); Devendra (1958b); Prematilleke (1966). The symbolism of the nidhis (treasures) is made more explicit by streams of coins pouring from padma and śankha.

49. Liyanaratna (1972).

50. A square altar of this type can be seen in the centre of the maṇḍapa of the Brahmanical cave at Aihole.

460. 51. Paranavitana (1950).

52. R. H. de Silva (1962), (1971). Fragments of paintings from the relic chamber of the Mahiyangana dāgaba in south central Sri Lanka have been dated to the eleventh century, but some may be earlier; Ward (1952).

53. Coomaraswamy (1956a), chapter 9; Kramrisch (1925); D. B. Dhanapala, The Story of Sinhalese Painting (Maharagama, Ceylon, n.d.); Gombrich (1971); Gatellier (1983).

54. One other is the Gedigē at Nālandā (Matale District), of the eighth-ninth century, and believed to be a Mahāyānist shrine.

55. Mode (1963), figure 119.

56. See Note 7.

462. 57. Bandaranayake (1965).

465. 58. Dohanian (1969-70). Compare the fifth-century seated Buddhas at the four entrances to the great stūpa at Sāñcī.

59. A precedent for this is the structure shown on an early Āndhra relief; Barrett (1956b).

60. A suggestion that it is a special kind of stūpa, the World Mountain, known in Siam and from a Pāla ivory, seems plausible; Dohanian (1969-70), 38 and 39, figures 6 and 7.

61. Bandaranayake (1978) makes the point that these types always underlay buildings of the early periods, a fact masked by the disappearance of all but their stone components.

62. Coomaraswamy (1956a).

CHAPTER 35

467. 1. The use of the word 'paradox' here may well be objected to by some of the many scholars who have attempted in recent years to describe and account for the complexities of Newar culture: one man's paradox may be, to another, two conceptually related phenomena. The author has in mind, however, the general reader with some knowledge of the art and culture of the subcontinent such as he might acquire by reading this book, and speaks from his own first contact with Nepal, which was baffling.

2. The present kingdom of Nepal dates from the Gurkha conquest of 1768. It consists of the Terai, a continuation of the North Indian plains, and the mountainous region leading up to and including many of the highest Himālayan peaks, extending some 500 miles (800 km.) from east to west. Although Buddhism must have arrived early, no Aśokan remains have been found except in the area of the Buddha's birthplace on the Indian border. The first mention of Nepal in a historical document is in Samudra Gupta's praśasti.

3. Slusser and Vajracharya (1974), 206-7 and figure 34 (map).

4. The Newars, whose distant origins are obscure, speak Newari, a language of the Tibeto-Burmese group. Nepali, on the other hand, is related to North Indian languages. Except for the savage raid of Shams-ud-dīn Ilyās c. 1350, Nepal has been spared foreign invasions; the kingdom of Gurkha, whose kings continue to rule Nepal today, is in western Nepal.

5. '... I believe that if the materials existed and it were possible to write an exhaustive history of the architecture of the valley of Nepal, it would throw more light on most of the problems that are now perplexing us than that of any other province of India' (Fergusson (1910), I, 275); 'Nepal is still an authentic replica of an India that has disappeared' (S. Levi (1905), quoted in P. Brown (1942a), 196).

6. '... one might almost consider Nepalese Buddhism and Nepalese Hinduism as different religious aspects of a single social system, at least as

far as the Newars are concerned' (Snellgrove (1961), 113).

468. 7. The relation between the Lichchavis of the Buddha's time, the famous 'daughter of the Lichchavis' whom Candragupta I married, and the Nepali dynasty of the same name is largely a matter of conjecture, but the geographical and chronological closeness of the last two makes some link almost certain.

8. Pal (1974), plates 54, 58, 59.

9. Ibid., plates 62 and 64.

10. Ibid., plate 1. Some confusion is occasioned, for those who do not know the area well, by the practice, part of the intense localism of the valley, of quoting the names of tiny localities, sites, or temples without a larger localizer. Deo Patan is the larger locality in which Paśupatinātha (temple), Mrgasthali (a wooded hill), and Tilganga are found, all within sight of each other. It also includes the reputed site of the Lichchavi palace, Kailāsakūta. The Viṣṇu Vikrānta mūrti, depicting the three giant strides of Viṣṇu, is more usually called Trivikrama. Only conjectures are available to explain why the inscription of 467 is repeated on a similar but stylistically slightly later image; Pal (1974), plate 2.

11. Ibid., plate 121; M. Singh (1968), 174. The latter's identification of the face of this Śivaliṅga as Pārvatī's cannot be accepted, and other identifications must be treated with caution.

12. Slusser and Vajracharya (1973a).

13. Pal (1974), plates 90 and 91. The crown worn by Kṛṣṇa in plate 90 is modern.

14. S. Kramrisch (1964), 24. Kramrisch (p. 23) claims to see the same trait in the famous standing 'royal' portrait, figure 1.

15. These are probably most correctly Jalaśayana ('lying on the waters') Nārāyaṇa images. The Bālāju image, however, holds Śaiva emblems, the akṣamāla and the kamandalu, in his upper pair of hands, and it has been suggested that he represents Viṣṇu Yogaśayana. Slusser and Vajracharya (1973a) propose in this seminal article that the Bālāju image, the Bāla ('young')-nīlakantha, was the original and not the larger Būdhā ('old')-nīlakantha, the epithets to be taken in the sense of 'minor' and 'major', reflecting size, not age. If the author's interpretations of chronicle and inscriptional evidence are correct, both images were installed by Viṣṇugupta c. 640.

16. Slusser and Vajracharya (1973a), 125-6.

469. 17. Ibid., 127-31 and figure 19; Slusser and Vajracharya (1973b); Lippe (1962).

18. This can be accounted for in a number of ways. The sectarian composition of the valley in the seventh century, in terms of numbers or propor-

tions, cannot be known. Powerful rulers, with the example of the great Guptas, would be naturally attracted to Viṣṇu with his kingly and conquering aspects.

19. Pal (1974), plates 8, 166–8.
470. 20. Snellgrove (1961), 94.
21. *Ibid.*
473. 22. 'The Newari sculptor, in his intention, remained true to the Indian original. A power stronger than this conscious aim wrought the transformation of the human figure and its modelling according to his own physiognomy and his own way of looking, feeling and forming. But it is not his full-blooded self, moved in its utmost depths, to which he has recourse'; Kramrisch (1964), 26–7.

23. It has never been photographed and access to the image is forbidden even to Hindus unless they have a particular place in the Vaiṣṇava socio-religious society of the valley. A metal sheath, however, dated 607, made to replace an earlier one which had become dilapidated, is in two portions, suggesting that the image is headless, or has a replacement head; Slusser (1975–6), section ii and illustrations.

24. Compare this composition with that of the seated Kārttikeya in the Bharat Kala Bhavan, Varanasi, illustrated in Harle (1974b), figure 65, and p. 20, to which the author would now be inclined to attribute a seventh-century date.

25. This motif already appears around the border of an inscriptional stele dated 642; Pal (1974), figure 169.

26. For illustrations of dated sculptures see Pal (1974), figures 1, 8, 9, 12, 27–49, 51, 103, 104; Toth (1963), figures 6 (of 1768) and 8 (of 1819). The Garuḍas illustrated in Pal (1974), figures 98–104, provide a useful series for stylistic comparisons. The royal effigies on pillars in front of palaces, e.g. that of Bhupatīndra at Bhatgaon, are also useful evidence of changing modes of dress, as are the innumerable donor or worshipping couples, usually dated.

27. The little 'Tārā' in the Ashmolean Museum, more likely modelled from an Umā of a seated Umā-Maheśvara image (cf. image in H. K. Swali Collection, illustrated Pal (1974), plate 137), and a number of others cast from the same mould, almost certainly dating from the early part of the century, is a charming pastiche of a sixteenth-century figure. It was first published by A. K. Coomaraswamy in 'Indian Bronzes', *The Burlington Magazine*, XVII (1910), 86–94, plate I, 4. Almost all the metal ware and figures offered for sale on Janpath, New Delhi, much of it as 'Tibetan', is in fact Nepalese.

28. It is rare that images so widely separated in time should be iconographically so similar.

29. Pal (1974), figure 113.
30. *Ibid.*, 80, the others being the *vyūha*, the *vibhava*, the *antaryamin*, and the *arca*.
31. *Ibid.*, figure 48.
32. *Ibid.*, 83.
474. 33. The stone image reproduced *ibid.*, figure 128, now in the Archaeological Garden, Pāṭan, is probably correctly dated seventh century. Figures 128–38 of Pal's book illustrate a fine range of these images from the seventh to the sixteenth century.
34. Kramrisch (1964), 26, 32–3. As stated in the next paragraph, however, the links are far less close than generally assumed.
475. 35. The image is in Cleveland; see Czuma (1970) and Slusser (1975–6), section I and illustrations.
36. Pal (1974), plate 114.
37. Kramrisch (1964), figure 20 (frontispiece).
38. See Note 23.
39. Gift of the Ahmanson Foundation.
40. M. H. de Young Memorial Museum, Avery Brundage Collection; illustrated in Kramrisch (1964), no. 65.
41. P. Brown (1942a), 198.
478. 42. Macdonald and Stahl (1979), among others, contains a good and well-illustrated survey of Newar architecture, with fairly comprehensive references to the contributions of other scholars.
43. S. B. Deo (1968–9); Korn, referred to in Macdonald and Stahl (1979), 76 and 118, note 1.
44. 'More temples than houses, more idols than men ... I have no hesitation in asserting that there are some streets and palaces in Kāthmāndu and Bhātgaon which are more picturesque and more striking as architectural compositions than are to be found in any other cities in India'; Fergusson (1910), I, 274.
479. 45. Wiesner (1978), 52.
46. Stone brackets, usually carved into female figures but far further removed from any structural role, appear at widely separated places in India, notably the Mallikārjuna temple at Kuruvatti in northern Karnāṭaka (Cousens (1926), plate CIX) and, actually supporting eaves, at the Chenna Keśava, Belūr.
480. 47. For a very thorough investigation of this relationship, Wiesner (1978), chapters IV, V, and VI.
48. *Ibid.*, chapter IV, 4, a, and particularly p. 74.
49. On the Nārāyaṇa temple at Pāṭan, Wiesner (1978), plate XI, a, who curiously enough does not include this motif among those he traces back to much earlier times in India. Also at Bhaktapur, Deo (1968–9), plate XV, 2. For the 'alternating triangle', Harle (1977), 576–7 and figure 5, b and c.
50. See p. 216. Early tuṇālas in the Uku-bahal in

Pāṭan and one or two other monasteries illustrated in Pal (1974), figures 235-6; Slusser (1979), figures 35-9.

51. For a detailed description of the various types of sattal, Slusser and Vajracharya (1974).

481. 52. An added element in the kaleidoscope of Newar religious and social life is the communities of yogis, like the Kusale yogis, formerly Kāpālikas, worshippers of the great Hindu saint or *siddha* Gorakhanātha and until recently in occupation of the Kāṣṭhamaṇḍapa. Worship there is now performed by the Kānphaṭṭā (split-eared) yogis; see Slusser and Vajracharya (1974), 210-12.

53. Slusser and Vajracharya (1974), 212-16 and figures 36-40.

54. Lists in Snellgrove (1961) and Joseph (1971); also Macdonald and Stahl (1979), 81, note 2. It has still not been determined what distinction is implied by the name *bāhā* (often written *bahal*) as opposed to *bahi*. For a discussion, Macdonald and Stahl (1979), 73, 76.

482. 55. Macdonald and Stahl (1979), 79.

56. Snellgrove (1957), *passim*.

484. 57. Macdonald and Stahl (1979), 83-94.

58. *Ibid.*, figures 12 and 80.

59. Although there are earlier references to this shrine, it seems unlikely to pre-date the destruction of its liṅga by Shams-ud-dīn Ilyās in 1346/7. The date of the Indreśvara is derived from one of the annals (*vaṃśavalis*) (Slusser (1979), with full bibliographical references). Reliable as these have shown themselves to be with reference to much earlier monumental stone images (see Note 15), a brick and timber building is far more liable to destruction and can be rebuilt. It must be remembered that in the 1934 earthquake seventy per cent of the houses in Bhaktapur collapsed; Bernier (1979). None of the tuṇālas of this temple, old and fine as they are, would seem to support quite such an early date as 1297. The third storey is not an argument for a later date since further storeys were often added later.

60. This interpretation is essential to the extremely perceptive study of dega by Wiesner (1978). His thesis that these were 'state' temples, enshrining deities of 'national' importance, is well supported by the subsequent construction of other shrines of this type dedicated to Pāśupati (and Nārāyaṇa) in the three cities and elsewhere, although more textual evidence would be welcome. The Indreśvara at Panauti, which he dates considerably later than Slusser (Note 59), perhaps unaware of the vaṃśavali evidence, does not

exactly conform to his thesis, which is arguably another reason for accepting a later date for the construction of this temple.

61. Conflicting opinions have been expressed on this matter, some arguing that the brickwork is only filler, as in much traditional English timber-framed construction.

62. Such superimposed, typically Newar roofs, whatever the type of building, are what one author has termed 'the pagoda style'; Rau (1981). The usefulness of this term seems limited, however.

63. Slusser (1979).

64. Wiesner (1978), plate VII, b.

65. See Note 23.

485. 66. Wiesner (1978), 44-51, makes this point.

67. See pp. 239, 343.

68. Pal (1978a) is the first comprehensive account of painting in Nepal.

69. It has been assumed that thaṅkas depicting monks or other divines in Tibetan costumes and with marked Tibetan facial types must have been painted in Tibet, either by Tibetans or by Newaris settled there. The discovery of a sixteenth-century sketchbook of Tibetan types drawn by a Newari suggests that this assumption is not always valid; Lowry (1977), referred to by Pal (1978a), 157 and figure 219.

70. Pal (1978a) figures 72, 74, 75, 81, 82.

486. 71. It has been suggested that this is a much later copy of a fourteenth-century original, the trees showing Rājput influence, which did not appear in Nepalese painting until the mid seventeenth century; Auboyer and Béguin (1977), no. 99 (p. 120). Such copies are not unknown. It is not true, however, as the authors assert, that 'l'artiste a négligé de reproduire dans le fond le semis de fleurettes ...'; they simply do not appear on the much cut-down version of the painting illustrated by them. The trees, in their variety and delicacy of treatment, are, it is true, most unusual here. Bundi or Deccani examples come to mind. The question of date is a moot one, but one looks in vain for anything but crudely painted versions of Pahāṛī trees in later Nepali painting. The unknown painter must have been not only an exceptional copyist, if such he be, but an inspired painter in his own right.

488. 72. Pal (1978a), figure 87.

73. Pal (1977) and figure 6.

74. Pal (1978a), figure 220.

75. Pal (1967b).

BIBLIOGRAPHY

Abbreviation: *A.S.I.,A.R.* *Archaeological Survey of India, Annual Reports*

An asterisk indicates a work published too recently to be taken full account of in the text.

A. COMPREHENSIVE WORKS
1. General
2. Architecture
3. Sculpture and Metalwork
4. Painting
5. Iconography
6. Museum Collections
B. BY CHAPTER

A. COMPREHENSIVE WORKS

1. General

ALLCHIN, B. and F.R. *The Rise of Civilisation in India and Pakistan.* Cambridge, 1982.

ASHTON, L., ed. *The Art of India and Pakistan.* Catalogue of the exhibition at the Royal Academy of Arts. London, 1947-8.

AUBOYER, J., *et al. La vie publique et privée dans l'Inde ancienne.* 4 vols. Paris, 1955-72.

BASHAM, A. L. *The Wonder That Was India.* London, 1954.

BASHAM, A. L., ed. *A Cultural History of India.* Oxford, 1975.

BURGESS, J. *The Ancient Monuments, Temples and Sculptures of India.* 2 vols. London, 1897.

COOMARASWAMY, A. K. *History of Indian and Indonesian Art.* London, 1927.

CUNNINGHAM, Sir A. *A.S.I.,A.R.*, I-XXI (1862-84). (Vols. VI-VIII, XII, XIII, XVIII, XIX, XXII, XXIII by other hands.)

DUTT, S. *Buddhist Monks and Monasteries of India.* London, 1962.

FRANZ, H. G. *Von Gandhara bis Pagan.* Graz, 1979.

GRAY, B., ed. *The Arts of India.* Oxford, 1981.

GROUSSET, R. *India.* London, 1932.

HÄRTEL, H., and AUBOYER, J. *Indien und Südostasien (Propyläen Kunstgeschichte, XVI).* Berlin, 1971.

KRAMRISCH, S. *The Art of India.* London, 1954.

LOHUIZEN-DE LEEUW, J. E. VAN. *The 'Scythian' Period.* Leiden, 1949.

OHRI, V. C. *Arts of Himachal.* Simla, 1975.

RENOU, L., FILLIOZAT, J., a.o. *L'Inde classique.* 2 vols. Paris and Hanoi, 1947, 1953.

ROWLAND, B. *The Art and Architecture of India (Pelican History of Art).* 3rd ed. Harmondsworth, 1970.

SCHMIDT, K., KHAN, F. A., a.o. *5000 Years of Art in Pakistan.* Utrecht, 1963.

SHAH, U. P. *Studies in Jaina Art.* Banaras, 1955.

SIVARAMAMURTI, C. *The Art of India.* New York, 1977.

*SLUSSER, M. S. *Nepal Mandala, A Cultural Study of the Kathmandu Valley.* 2 vols. Princeton, 1982.

SMITH, V. A. *A History of Fine Art in India and Ceylon.* Oxford, 1911.

SRINIVASAN, P. R., and AIYAPPAN, A. *Story of Buddhism with Special Reference to South India.* Government of Madras, 1959.

TADDEI, M. *India.* London, 1970.

TOY, S. *The Strongholds of India.* London, 1957.

TOY, S. *The Fortified Cities of India.* London, 1965.

VATSYAYAN, K. *Classical Indian Dance in Literature and the Arts.* New Delhi, 1968.

WHEELER, R. E. M. *Five Thousand Years of Pakistan.* London, 1950.

WHEELER, R. E. M. *Rome Beyond the Imperial Frontiers.* London, 1954.

*WILLIAMS, J. G. *The Art of Gupta India. Empire and Province.* Princeton, 1982.

ZAEHNER, R. C. *Hinduism* (Home University Library). London, 1962.

ZIMMER, H. *The Art of Indian Asia.* 2 vols. New York, 1955.

2. Architecture

BANERJEE, N. R. *Nepalese Architecture.* Delhi, 1980.
BROWN, P. *Indian Architecture (Buddhist and Hindu).* 2nd ed. Bombay, 1942. (Brown, 1942a)
BROWN, P. *Indian Architecture (Islamic Period).* 3rd ed. Calcutta, 1942. (Brown, 1942b)
DEHEJIA, V. *Early Buddhist Rock Temples.* London, 1972.
DELOCHE, J. *Les ponts anciens de l'Inde.* Paris, 1973.
DEVA, K. *Temples of North India.* New Delhi, 1969.
FERGUSSON, J. *A History of Indian and Eastern Architecture,* revised by J. and P. Spiers. London, 1910.
FERGUSSON, J., and BURGESS, J. *The Cave Temples of India.* London, 1880.
FRANZ, H. G. *Pagoda, Turmtempel, Stupa.* Graz, 1978.
KRAMRISCH, S. *The Hindu Temple.* 2 vols. Calcutta, 1946.
MARCHAL, H. *L'Architecture comparée dans l'Inde et l'Extrême-Orient.* Paris, 1944.
*MEISTER, M. W., with DHAKY, M. A., ed. *Encyclopedia of Indian Temple Architecture: South India, Lower Drāvidadeśa.* American Institute of Indian Studies, University of Pennsylvania Press, New Delhi, 1983.
MERKLINGER, E. S. *Indian Islamic Architecture: The Deccan 1347-1686.* Warminster, 1981.
NATH, R. *History of Sultanate Architecture.* New Delhi, 1978.
SARKAR, H. *Studies in Early Buddhist Architecture of India.* Delhi, 1966.
VIENNOT, O. *Temples de l'Inde centrale et occidentale.* 2 vols. Paris, 1976.

3. Sculpture and Metalwork

AGRAWALA, P. K. *Early Indian Bronzes.* Varanasi, 1977.
BACHHOFER, L. *Early Indian Sculpture.* 2 vols. Paris, 1929.
BARRETT, D. *Early Cola Bronzes.* Bombay, 1965.
DAS GUPTA, C. C. 'Bibliography of Ancient Indian Terracotta Figurines', *Journal of the Royal Asiatic Society of Bengal, Letters,* IV (1938).
DESHPANDE, M. N. 'Classical Influences on Indian Terracotta Art', *VIIIème Congrès International d'Archéologie Classique.* Paris, 1963.
DVIVEDI, V. P. *Indian Ivories.* New Delhi, 1976.
GRAVELY, F. H., and RAMACHANDRAN, T. N. *Catalogue of the South Indian Hindu Metal Images in the Madras Government Museum.* Madras, 1932.

HARLE, J. C. *Gupta Sculpture.* Oxford, 1974. (Harle, 1974b)
KALA, S. C. 'Some Thoughts on Indian Terracottas', Seminar on Indian Terracottas, State Museum, Lucknow, 1973.
KRAMRISCH, S. *Indian Sculpture.* Calcutta, 1933.
LERNER, M. *Bronze Sculpture from Asia.* New York, 1975.
LIPPE, A. DE. *Indian Medieval Sculpture.* Amsterdam, etc., 1978.
RAMACHANDRAN, K. S. *A Bibliography on Indian Megaliths.* State Department of Archaeology, Government of Tamilnadu, 1971.
*SCHROEDER, U. VON. *Indo-Tibetan Bronzes.* Hong Kong, 1981.
SHAH, U. P. 'Jaina Bronzes - A Brief Survey', *Aspects of Jaina Art and Architecture,* ed. U. P. Shah and M. A. Dhaky, 269-98. Ahmedabad, 1975.
SIVARAMAMURTI, C. *South Indian Bronzes.* New Delhi, 1963.
SMIRNOFF, D. A. *Argenterie orientale.* St Petersburg, 1909.
SRINIVASAN, P. R. *Bronzes of South India.* Madras, 1963.
SWARNAKAMAL. *Studies in Metallic Art and Technology of Gujarat.* Baroda, 1976.

4. Painting

ARCHER, M. *Indian Miniatures and Folk Paintings.* London, 1967.
ARCHER, W. G. *Central Indian Painting.* London, 1958.
ARCHER, W. G. *Indian Miniatures.* London, 1960.
BARRETT, D., and GRAY, B. *Painting of India.* New York, 1963.
FALK, T., and ARCHER, M. *Indian Miniatures in the India Office Library.* London and Karachi, 1981.
HINGORANI, R. P. *Painting in South Asia - A Bibliography.* Delhi and Varanasi, 1976.
KHANDALAVALA, K., and CHANDRA, M. *New Documents of Indian Painting.* Bombay, 1969.
KHANDALAVALA, K., CHANDRA, M., CHANDRA, P. *Miniature Painting.* A catalogue of the exhibition of the Sri Motichand Khajanchi Collection. New Delhi, 1960.
LOSTY, J. P. *The Art of the Book in India.* Exhibition catalogue. London, 1982.
SIVARAMAMURTI, C. *South Indian Paintings.* New Delhi, 1968.
VATSYAYAN, K. *Dance in Indian Painting.* New Delhi, 1982.
WAKANKAR, V. S., and BROOKS, R. R. R. *Stone Age Painting in India.* Bombay, 1976.

WELCH, S. *A Flower from Every Meadow*. New York, 1973.

*ZEBROWSKI, M. *Deccani Painting*. London and Berkeley, 1983.

5. Iconography

ADICEAM, M. E. 'Les images de Śiva dans l'Inde du sud', *Arts Asiatiques* (1965–78).

ADICEAM, M. E. *Contributions à l'étude d'Ayanār-Sāstā (Publications de l'Institut Français d'Indologie*, XXXII). Pondicherry, 1967.

AUBOYER, J. *Le trône et son symbolisme dans l'Inde ancienne*. Paris, 1949.

BANERJEA, J. N. *The Development of Hindu Iconography*. 2nd ed. Calcutta, 1956.

BOSCH, F. D. K. 'Remarques sur les influences réciproques de l'iconographie et de la mythologie indienne', *Arts Asiatiques*, III, 1 (1956), 22–47.

BRUHN, K. 'Distribution in Indian Iconography', *Bulletin of Deccan College Research Institute*, XX, parts i–iv (Poona, 1960), 164–248.

CHANDRA, M. 'Some Aspects of Yaksa Cult in Ancient India', *Prince of Wales Museum Bulletin*, III (1952–3), 43–73.

COOMARASWAMY, A. K. *Yakṣas*. 2 vols. Washington, 1928.

FILLIOZAT, J. 'Les images de Śiva dans l'Inde du Sud, I, L'image de l'origine du linga (Liṅgodbhavamūrti)', *Arts Asiatiques*, VIII (1961), 42–56.

GASTON, A.-M. *Śiva in Dance, Myth and Iconography*. Delhi, 1982.

HAQUE, E. *The Iconography of the Hindu Sculptures of Bengal, up to circa 1250 A.D.* University of Oxford, D. Phil. thesis, 1973.

HARLE, J. C. 'Durgā, Goddess of Victory', *Artibus Asiae*, XXVI, 3/4 (1963), 237–46.

JOUVEAU-DUBREUIL, G. *Iconography of South India*, trans. A. C. Martin. Paris, 1937.

LIEBERT, G. *Iconographic Dictionary of the Indian Religions*. Leiden, 1976.

LOHUIZEN-DE LEEUW, J.E. VAN. 'New Evidence With Regard to the Origin of the Buddha Image', *South Asian Archaeology 1979*, 377–400. Berlin, 1981.

MALLMANN, M.-T. DE. *Introduction à l'étude d'Avalokiteśvara*. Paris, 1948.

MALLMANN, M.-T. DE. *Les enseignements iconographiques de l'Agni Purāna*. Paris, 1963.

MALLMANN, M.-T. DE. *Étude iconographique sur Mañjusrī*. Paris, 1964. (De Mallmann, 1964a)

MALLMANN, M.-T. DE. 'Divinités hindoues dans le tantrisme bouddhique', *Arts Asiatiques*, X (1964), 67–86. (De Mallmann, 1964b)

MALLMANN, M.-T. DE. *Introduction à l'iconographie du tantrisme bouddhique*. Paris, 1975.

MAXWELL, T. S. *The Iconography of North Indian Brahmanical Images Incorporating Multiple Heads and Emanatory Forms*. University of Oxford D. Phil. thesis, 1982. To be published as *Viśvarūpa* by the Oxford University Press, Delhi.

PATTABIRAMIN, P. Z. 'Notes d'iconographie dravidienne', *Arts Asiatiques*, VI (1959), 13–32.

RAO, M. S. N. *Kirātārjunīyam in Indian Art*. Delhi, 1979.

RAO, T. A. G. *Elements of Hindu Iconography*. 4 vols. Madras, 1914.

SASTRI, H. K. *South-Indian Images of Gods and Goddesses*. Madras, 1916.

SHARMA, B. N. *Iconography of Revanta*. New Delhi, 1975.

SIVARAMAMURTI, C. *Naṭarāja*. New Delhi, 1974.

SMITH, H. D. *Vaiṣṇava Iconography*. Madras, 1969.

SRINIVASAN, D. 'Early Vaiṣṇava Imagery: Caturvyūha and Variant Forms', *Archives of Asian Art*, XXXII (1979), 39–54.

STACHE-ROSEN, V. 'Gaṇḍabheruṇḍa ...', *Beiträge zur Indienforschung*. Berlin, 1977.

STARZA-MAJEWSKI, O. M. *The Origin of the Form and Iconography of Jagannātha, Balarama and Subhadrā*. B. Litt. thesis, University of Oxford, 1969.

STARZA-MAJEWSKI, O. M. *The Jagannātha Temple at Puri and its Deities*. Amsterdam, 1983.

STUTLEY, M. and J. *A Dictionary of Hinduism: Its Mythology, Folklore and Development, 1500 B.C.–A.D. 1500*. London and Henley, 1977.

VIENNOT, O. *Les divinités fluviales Gangā et Yamunā aux portes des sanctuaires de l'Inde*. Paris, 1964.

6. Museum Collections

AGRAWALA, V. S. 'Buddha and Bodhisattva Images', 'Images of Brahmā, Vishnu, and Śiva, etc.', 'Jaina Tīrthaṅkaras and Other Miscellaneous Figures', 'Architectural Pieces', *Catalogue of the Mathurā Museum*, 1–4, *Journal of the United Provinces Historical Society*, XXI–XXIV (1948–51), 42–98, 102–212, 35–147, 1–160.

AIJAZUDDIN, F. S. *Pahari Paintings and Sikh Portraits in the Lahore Museum*. London, etc., 1977.

AUBOYER, J., ed. *Rarities of the Musée Guimet*. Exhibition catalogue. New York, 1975.

BARRETT, D. *Sculptures from Amaravati in the British Museum*. London, 1954. (Barrett, 1954a)

CHANDA, R. *Mediaeval Sculpture in the British Museum*. London, 1936.

CHANDRA, P. *Stone Sculpture in the Allahabad Museum*. Bombay, 1971.

DALTON, O. M. *The Treasure of the Oxus.* 3rd ed. London, 1964.

DISKALKAR, D. B. 'Some Brahmanic Sculpture in the Mathurā Museum', *Journal of the United Provinces Historical Society*, V, part I (January 1932), 18-52.

ETTINGHAUSEN, R. *Paintings of the Sultans and Emperors of India in American Collections.* New Delhi, 1961.

GRAVELY, F. H. and RAMACHANDRAN, T. N. *Catalogue of South Indian Hindu Metal Images in the Madras Government Museum.* Madras, 1932.

GUPTA, P. L. *Patna Museum Catalogue of Antiquities.* Patna, 1965.

KAK, R. C. *Handbook of Archaeological and Numismatic Sections of the Sri Pratap Singh Museum, Srinagar.* Calcutta, 1923.

KHAN, M. I. 'Mathura Objects in Taxila Museum', *Journal of the Asiatic Society of Pakistan*, XI, I (1966).

KÜHNEL, E. *Indische Miniaturen aus dem Besitz der Staatlichen Museen zu Berlin.* Berlin, 1937.

SETTAR, S. *Hoysala Sculpture in the National Museum.* Copenhagen, 1975.

SIVARAMAMURTI, C. *Amaravati Sculptures in the Madras Government Museum (Bulletin of the Madras Government Museum, N.S. IV).* Madras, 1956.

SIVARAMAMURTI, C. *Nolamba Sculptures in the Madras Government Museum (Bulletin of the Madras Government Museum, N.S. general section, IX, I).* Madras, 1964.

WALDSCHMIDT, E. and R. L. *Miniatures of Musical Inspiration in the Collection of the Berlin Museum of Indian Art.* Part I, Wiesbaden, 1967. Part II, Berlin, 1975.

B. BY CHAPTER

PART ONE: EARLY INDIAN ART

Chapter 1: Early Monuments and Sculpture

AGRAWALA, P. K. *Early Indian Bronzes.* Varanasi, 1977.

AGRAWALA, R. C. *Human Figurines on Pottery Handles from India and Allied Problems.* Department of Museums, Gujarat State, Baroda, 1970.

ALLCHIN, B. and F. R. *The Rise of Civilisation in India and Pakistan.* Cambridge, 1982.

AUBOYER, J. 'The Cavern of Lomās Ṛṣi, Barābar Hills, Bihar', *Journal of the Indian Society of Oriental Art*, N.S. IV (1971-2), 38-43.

BANERJEA, J. N. 'The Holy Pañcavīras of the Vṛṣṇis', *Journal of the Indian Society of Oriental Art*, X (1942), 65-8.

BAREAU, A. 'Le stūpa de Dhānyakaṭaka selon la tradition tibétaine', *Arts Asiatiques*, XVI (1967), 81-8. (Bareau, 1967a)

BAREAU, A. 'Recherches complémentaires sur le site probable de la Dhānyakaṭaka de Hiuan-Tsang', *Arts Asiatiques*, XVI (1967), 89-109. (Bareau, 1967b)

BAREAU, A., and BENISTI, M. 'Le site de la Dhānyakaṭaka de Hiuan-Tsang - suivi d'une note stylistique', *Arts Asiatiques*, XII (1965), 21-82.

BARRETT, D. *Sculptures from Amaravati in the British Museum.* London, 1954. (Barrett, 1954a)

BARRETT, D. 'The Later School of Amaravati and Its Influences', *Arts and Letters*, XXVIII, 2 (1954), 41-53. (Barrett, 1954b)

BARRETT, D. 'Two Unpublished Sculptures from the Āndhradeśa', *Arts Asiatiques*, III, 4 (1956), 287-92. (Barrett, 1956b)

BARRETT, D. 'An Early Indian Toy', *Oriental Art*, N.S. IV, 3 (1958), 118-19. (Barrett, 1958c)

BARRETT, D. 'Gandhara Bronzes', *Burlington Magazine*, CII (August 1960), 361-5. (Barrett, 1960b)

BARRETT, D. *Ter.* Bombay, 1960. (Barrett, 1960c)

BARRETT, D. 'The Early Phase at Amarāvatī', *British Museum Quarterly*, XXXII (1967-8), 35-48.

BARUA, B. *Bharhut.* Calcutta, 1934-7.

BENISTI, M. 'Nāgārjunakoṇḍa, Essai de Caractériologie', *Arts Asiatiques*, VI, 3 (1959), 217-34.

BLOCH, T. 'Excavations at Lauriya', *A.R., A.S.I.* (1906-7), 119-26.

BROWN, P. *Indian Architecture (Buddhist and Hindu).* 2nd ed. Bombay, 1942. (Brown, 1942a)

CHANDRA, M. 'Some Aspects of Yakṣa Cult in Ancient India', *Prince of Wales Museum Bulletin*, III (1952-3).

CHANDRA, P. 'Yaksha and Yakshī Images from Vidiśā', *Ars Orientalis*, VI (1966), 157 ff.

COOMARASWAMY, A. K. *Yakṣas.* 2 vols. Washington, 1928.

COOMARASWAMY, A. K. *La sculpture de Bodhgaya (Ars Asiatica, XVIII).* Paris and Brussels, 1935.

COOMARASWAMY, A. K. *La sculpture de Bharhut.* Paris, 1956. (Coomaraswamy, 1956b)

DALTON, O. M. *The Treasure of the Oxus.* 3rd ed. London, 1964.

DAS GUPTA, C. C. 'Bibliography of Ancient Indian Terracotta Figurines', *Journal of the Royal Asiatic Society of Bengal, Letters*, IV (1938) and X (1944).

DAYAL, P. 'A Note on Lālā Bhagat Pillar', *Journal of the United Provinces Historical Society*, IV, 2 (1930), 38.

DEHEJIA, V. *Early Buddhist Rock Temples.* London, 1972.

DEO, S. B., and JOSHI, J. P. *Pauni Excavations (1969-70).* Nagpur, 1972.

DESHPANDE, M. N. 'Excavation at Daimabad, District Ahmadnagar', *Indian Archaeology*, ed. A. Ghosh (1958-9), 15-18.

DESHPANDE, M. N. 'Classical Influences on Indian Terracotta Art', *VIIIème Congrès International d'Archéologie Classique*. Paris, 1963.

DURING CASPERS, E. C. L. 'The Indian Ivory Figurine from Pompei - A Reconsideration of its Functional Use', *South Asian Archaeology 1979*, 341-53. Berlin, 1981.

DVIVEDI, V. P. *Indian Ivories*. New Delhi, 1976.

GHOSH, A., and SARKAR, H. 'Beginnings of Sculptural Art in South-East India: A Stele from Amarāvatī', *Ancient India*, XX, XXI (1964, 1965), 168-77.

GUPTA, P. L. *Patna Museum Catalogue of Antiquities*. Patna, 1965.

HÄRTEL, H. 'The Apsidal Temple No. 2 at Sonkh', *South Asian Archaeology* (1973). (Härtel, 1973a)

HÄRTEL, H. 'Die Kuṣāna-Horizonte im Hügel von Sonkh (Mathura)', *Indologen Tagung*, ed. H. Härtel and V. Moeller, 1-24. Wiesbaden, 1973. (Härtel, 1973b)

HÄRTEL, H. 'Some Results of the Excavations at Sonkh: A Preliminary Report', *German Scholars in India*, II, 69-99. 2 vols. New Delhi, 1976.

HÄRTEL, H. 'Zur Typologie einer Kashmir-Skulptur', *Einblicke-Einsichten-Aussichten aus der Arbeit der Staatliche Museen, Jahrbuch Preussischer Kulturbesitz*, Sonderband I (1983), 95-115.

HÄRTEL, H., and AUBOYER, J. *Indien und Südostasien* (*Propyläen Kunstgeschichte*, XVI). Berlin, 1971.

HUNTINGTON, J. C. 'The Lomās Ṛsi: Another Look', *Archives of Asian Art*, XXVIII (1974-5), 34-56.

IRWIN, J. 'Aśokan Pillars: A Reassessment of the Evidence', *Burlington Magazine*, CXV (November 1973), 706-20; '... Part II, Structure', *ibid.*, CXVI (December 1974), 712-16; '... Part III, Capitals', *ibid.*, CXVII (December 1975); '... Part IV, Symbolism', *ibid.*, CXVIII (November 1976), 734-53.

IRWIN, J. 'The Stūpa and the Cosmic Axis (Yūpa-Yaṣṭi)', *Ācārya-Vandana* (D. R. Bhandarkar birth centenary volume), 249-69. University of Calcutta, 1981.

JAYASWAL, K. P. 'Pāṭaliputra Śiva-Pārvatī Gold Plaque', *Journal of the Indian Society of Oriental Art*, II, I (1934), I.

KALA, S. C. 'Some Thoughts on Indian Terracottas', *Seminar on Indian Terracottas*, State Museum, Lucknow, 1973.

KHAN, M. I. 'Metal Statuettes from Taxila', *Studies in South Asian Culture*, VII (*Senake Paranavitana Commemoration Volume*), ed. J. E. van Lohuizen-de Leeuw, 122-4. Leiden, 1978.

KHANDALAVALA, K. 'Brahmapuri', *Lalit Kalā*, VII (1960).

KHARE, M. D. 'Discovery of a Vishnu Temple near the Heliodoros Pillar, Besnagar, Dist. Vidisha (M.P.)', *Lalit Kalā*, XIII (1967), 21-7.

KRAMRISCH, S. *Indian Sculpture*. Calcutta, 1933.

KURAISHI, M. H., and GHOSH, A. *A Guide to Rājgir*. 3rd ed. Delhi, 1951.

LAL, B. B. 'From the Megalithic to the Harappa: Tracing Back the Graffiti of the Pottery', *Ancient India*, XVI (1960), 4-24.

LAL, B. B. 'Excavations at Kalibangan, District Ganganagar', *Indian Archaeology*, ed. A. Ghosh (1960-1), 31-2.

LONGHURST, A. H. *The Buddhist Antiquities of Nāgārjunakoṇḍa* (*Mem. A.S.I.*, LIV). Delhi, 1938.

MARSHALL, J. *Taxila*. 3 vols. Cambridge, 1951 etc.

MARSHALL, J., and FOUCHER, A. *The Monuments of Sāñci*. 3 vols. Oxford, n.d.

MAXWELL, T. S. *The Iconography of North Indian Brahmanical Images Incorporating Multiple Heads and Emanatory Forms*. D. Phil. thesis, University of Oxford, 1982.

MITRA, D. *Buddhist Monuments*. Calcutta, 1971.

PLAESCHKE, H. 'Zur Datierung der "Caurī-Trägerin" von Dīdarganj', *Wiss. Zeitschrift der Martin-Luther-Universität Halle-Wittenberg*, XII, 3/4 (1963), 319-30.

PRASAD, H. K. 'Jaina Bronzes in the Patna Museum', *Shri Mahavira Jaina Vidyalaya Golden Jubilee Volume*, 275-89. Bombay, 1968.

RAMACHANDRAN, T. N. *Nāgārjunakoṇḍa, 1938* (*Mem. A.S.I.*, LXXI). Delhi, 1953.

REA, A. 'Excavations at Amarāvatī', *A.R., A.S.I.* (1908-9), 88-91.

SARASWATI, S. K. *Early Sculpture of Bengal*. 2nd ed. Calcutta, 1962.

SARKAR, H. 'Some Aspects of the Buddhist Monuments at Nagarjunakonda', *Ancient India*, XVI (1960), 65-84.

*SCHROEDER, U. VON. *Indo-Tibetan Bronzes*. Hong Kong, 1981.

SHARMA, G. R. 'Excavations at Kausambi, 1949-1955', *Annual Bibliography of Indian Archaeology* (1948-53). Leiden, 1958.

SHARMA, Y. D. 'Past Patterns in Living as Unfolded by Excavations at Rupar', *Lalit Kalā*, I-II (1955-6), 121-9.

SIVARAMAMURTI, C. *Amaravati Sculptures in the Madras Government Museum* (*Bulletin of the Madras Government Museum*, IV). Madras, 1956.

SMIRNOFF, D. A. *Argenterie orientale*. St Petersburg, 1909.

SRINIVASAN, D. 'The So-Called Proto-Śiva Seal

from Mohenjo-Daro: An Iconological Assessment', *Archives of Asian Art*, XXIX (1975-6), 47-58.

SRINIVASAN, D. 'Early Vaiṣṇava Imagery: Caturvyūha and Variant Forms', *Archives of Asian Art*, XXXII (1979), 39-54.

STERN, P., and BENISTI, M. *Évolution du style indien d'Amarāvatī*. Paris, 1961.

VENKATARAMAYYA, M. 'An Inscribed Vaishnava Image of the Second Century B.C. from Malhar, Bilaspur Dist., Madhya Pradesh', *Journal of Oriental Research, Madras*, XXIX, part 1 (1963).

VOGEL, J. P. 'The Garuda Pillar of Besnagar', *A.R.,A.S.I.* (1908-9), 126-9. (Vogel, 1908-9a)

WAKANKAR, V. S., and BROOKS, R. R. R. *Stone Age Painting in India*. Bombay, 1976.

WHEELER, R. E. M. 'Brahmagiri and Chandravalli 1947: Megalithic and Other Cultures in Mysore State', *Ancient India*, IV (1947-8), 180-310.

WHEELER, R. E. M. *Chārsada*. Oxford, 1962.

Chapter 2: Early Rock-Cut Architecture

ALLCHIN, F. R. 'A Piece of Scale Armour from Shaikhān Dherī, Chārsada (Shaikhān Dherī Studies, 1)', *Journal of the Royal Asiatic Society*, II (1970), 113-20.

ALTEKAR, A. S., and MISRA, V. *Report on Kumrahar Excavations*. Patna, 1959.

BARRETT, D. As for Chapter 1 (1954a, 1956b).

BHANDARKAR, D. R. 'Excavations at Besnagar', *A.R., A.S.I.* (1913-14), 186-226.

BHANDARKAR, D. R. 'The Architectural Remains and Excavations at Nagarī', *A.S.I., Mem.*, IV (1920).

BURGESS, J. *Report on the Buddhist Cave Temples* (*A.S.I.*, New Imp. Series, IV). London, 1883. (Burgess, 1883a)

BURGESS, J. *Report on the Elūrā Cave Temples* (*A.S.I.*, New Imp. Series, V). London, 1883. (Burgess, 1883b)

COOMARASWAMY, A. K. *History of Indian and Indonesian Art*. London, 1927.

COOMARASWAMY, A. K. 'Early Indian Architecture I - Cities and City-Gates, etc.', *Eastern Art*, II (1930), 209-35.

COOMARASWAMY, A. K. 'Early Indian Architecture - III: Palaces', *Eastern Art*, III (1931).

DEHEJIA, V. As for Chapter 1 (1972).

DESHPANDE, M. N. 'The Rock-Cut Caves of Pitalkhora in the Deccan', *Ancient India*, XV (1959), 66-93. (Deshpande, 1959a)

DESHPANDE, M. N. 'Important Epigraphical Records from the *Chaitya* Cave, Bhaja', *Lalit Kalā*, VI (1959), 30-2. (Deshpande, 1959b)

DUTT, S. *Buddhist Monks and Monasteries of India*. London, 1962.

FRANZ, H. G. *Pagoda, Turmtempel, Stupa*. Graz, 1978.

FRANZ, H. G. *Von Gandhara bis Pagan*. Graz, 1979.

GHOSH, A. 'Rājgir 1950', *Ancient India*, VII (1951), 66-78.

GYANI, R. G. 'Identification of the So-Called Sūrya and Indra Figures in Cave No. 20 of the Bhājā Group', *Bulletin of the Prince of Wales Museum of Western India*, I (1950-1), 15-21.

HARLE, J. C. 'Two Yavana Dvārapālas at Aihole', *The Professor K. A. Nilakantha Sastri 80th Birthday Commemoration Volume*, 210-13. Madras, 1971. (Harle, 1971a)

JOHNSTON, E. H. 'Two Buddhist Scenes at Bhaja', *Journal of the Indian Society of Oriental Art*, VII (1939), 1-7.

KHANDALAVALA, K. 'The Date of the Karle Chaitya', *Lalit Kalā*, III-IV (1956-7), 11-26.

KHARE, M. D. As for Chapter 1 (1967).

LAL, B. B. 'Śiśupālgarh 1948: An Early Historical Fort in Eastern India', *Ancient India*, V (1949), 62-105.

LORD, J. H. *The Jews in India and the Far East*. Westport, 1976.

MITRA, D. *Udayagiri and Khandagiri*. New Delhi, 1960. (Mitra, 1960b)

MITRA, D. As for Chapter 1 (1971).

MITRA, R. *Antiquities of Orissa*. 2 vols. Calcutta, 1875 and 1880.

PIGGOTT, S. 'The Earliest Buddhist Shrines', *Antiquity* (1943), 1-10.

SAHNI, D. R. *Archaeological Remains and Excavations at Bairat*. Jaipur State, 1937.

SARASWATI, S. K. 'Art: Architecture', *The Age of Imperial Unity: History and Culture of the Indian People*, II, 483-502. Bombay, 1951.

SHARMA, G. R. *The Excavations at Kauśāmbī, 1949-50*. Allahabad, 1960. Also *Mémoires A.S.I.*, LXXIV (1969).

SHARMA, G. R. 'Kuṣāna Architecture with Special Reference to Kauśāmbī (India)', *Kuṣāna Studies* (1968), 1-42.

SINHA, B. P., and NARAIN, L. A. *Pataliputra Excavations 1955-56*. Patna, n.d.

SPINK, W. *Rock-Cut Monuments of the Āndhra Period: Their Style and Chronology*. Dissertation, Harvard, 1954.

SPINK, W. 'On the Development of Early Buddhist Art in India', *Art Bulletin*, XL (1958), 95-104.

SPOONER, D. B. 'Mr Rakan Tata's Excavations at Pāṭaliputra', *A.S.I.,A.R.* (1912-13), 53-86.

SRINIVASAN, P. R. 'Recently Discovered Early Inscriptions from Amaravati and Their Significance', *Lalit Kalā*, X (1961), 59-60.

VOGEL, J. P. *La sculpture de Mathurā* (*Ars Asiatica*, XV). Paris and Brussels, 1930.

Chapter 3: Mathurā

AGRAWAL, U. 'Select Bibliography on Mathura Art', *Journal of Indian Museums*, XXIX (1973), 50-6.

AGRAWALA, P. K. 'Identification of the So-Called Nāgī Figures as Goddess Ṣaṣṭhī', *East and West*, XXI, 3/4 (1971), 325-9.

AGRAWALA, R. C. 'A Unique Śiva-Head in the National Museum at New Delhi', *Lalit Kalā*, XIV (1969), 55-6. (R. C. Agrawala, 1969a)

AGRAWALA, V. S. 'Pre-Kuṣāna Art of Mathurā', *Journal of the United Provinces Historical Society*, VI, part 2 (1933), 81-120.

AGRAWALA, V. S. 'Early Kuṣana Brahmanical Images at Mathurā', *Journal of the Indian Society of Oriental Art*, V (1937), 122-30.

AGRAWALA, V. S. 'Buddha and Bodhisattva Images', *Catalogue of the Mathurā Museum*, 1, *Journal of the United Provinces Historical Society*, XXI (1948), 42-98.

AGRAWALA, V. S. 'Images of Brahmā, Vishnu, and Śiva, etc.', *Catalogue of the Mathurā Museum*, 2, *Journal of the United Provinces Historical Society*, XXII (1949), 102-120.

AGRAWALA, V. S. 'Jaina Tīrthaṅkaras and Other Miscellaneous Figures', *Catalogue of the Mathurā Museum*, 3, *Journal of the United Provinces Historical Society*, XXIII (1950), 35-147.

AGRAWALA, V. S. 'Architectural Pieces', *Catalogue of the Mathurā Museum*, 4, *Journal of the United Provinces Historical Society*, XXIV (1951-2), 1-160.

ANDERSON, J. *Catalogue and Hand-Book of the Archaeological Collections*. 2 vols. Calcutta, 1883.

ARAVAMUTHAN, T. G. *Portrait Sculpture in South India*. London, 1931.

CARTER, M. L. 'Dionysiac Aspects of Kushān Art', *Ars Orientalis*, VII (1968), 121-46.

DISKALKAR, D. B. 'Some Brahmanic Sculpture in the Mathurā Museum', *Journal of the United Provinces Historical Society*, V, part 1 (1932), 18-57.

FOUCHER, A. *L'art gréco-boudhique du Gandhara*. 2 vols. Paris, 1905, 1918.

GRISWOLD, A. B. 'Prolegomena to the Study of the Buddha's Dress', *Artibus Asiae*, XXVI, 2 (1963), 85-131.

HARLE, J. C. 'On a Disputed Element in the Iconography of Early Mahiṣāsuramardinī Images', *Ars Orientalis*, VII (1970), 147-53.

HARLE, J. C. 'On the Mahiṣāsuramardinī Images of the Udayagiri (Vidiśā) Caves', *Journal of the*

Indian Society of Oriental Art, N.S. IV (1971-2), 44-8. (Harle, 1971b)

HARLE, J. C. 'Camail; Chasuble; "Cloud Collar"', *Spolia Zeylanica*, XXXV (1980), parts I and II, 265-7.

HARLE, J. C. As for Chapter 14 (1985).

HÄRTEL, H. As for Chapter 1 (1973a, 1973b, 1976, 1983).

HÄRTEL, H., and AUBOYER, J. As for Chapter 1 (1971).

HINÜBER, O. VON. 'Das Nandiyāvarta-Symbol', *Zeitschrift der deutschen morgenländischen Gesellschaft*, Supplement II, XVIII Deutscher Orientalistentag. Wiesbaden, 1974.

JOSHI, N. P. 'Kuṣāna Varāha Sculpture', *Arts Asiatiques*, XII (1965).

JOSHI, N. P. *Mathura Sculptures*. Mathurā, 1966.

JOSHI, N. P. 'Devī Ṣanmukhī yā Ṣaṣṭhī', *Bulletin of Museums and Archaeology in Uttar Pradesh* (3 June 1969), 38-41. (Joshi, 1969a)

JOSHI, N. P. 'Kucch aprakāśita kalākrtiyāṅ', *Bulletin of Museums and Archaeology in Uttar Pradesh* (December 1969), 9-18. (Joshi, 1969b)

JOSHI, N. P. *Catalogue of the Brahmanical Sculptures in the State Museum, Lucknow*, part 1. Lucknow, 1972.

KHAN, M. I. 'Mathura Objects in Taxila Museum', *Journal of the Asiatic Society of Pakistan*, XI, 1 (1966).

LOHUIZEN-DE LEEUW, J. E. VAN. *The 'Scythian' Period*. Leiden, 1949.

LOHUIZEN-DE LEEUW, J. E. VAN. 'New Evidence With Regard to the Origin of the Buddha Image', *South Asian Archaeology 1979*, 377-400. Berlin, 1981. (Van Lohuizen, 1981a)

MAXWELL, T. S. *The Iconography of North Indian Brahmanical Images Incorporating Multiple Heads and Emanatory Forms*. University of Oxford D. Phil. thesis, 1982. To be published as *Viśvarūpa* by the Oxford University Press, Delhi.

MITRA, D. 'Three Kushān Sculptures from Ahichchhatra', *Journal of the Asiatic Society, Letters*, XXI, 1 (1955).

NAGAR, M. M. 'Some New Sculpture in the Mathurā Museum', *Journal of the United Provinces Historical Society* (1943), 62-6.

PAL, P. 'A Kushān Indra and Some Related Sculptures', *Oriental Art*, N.S. XXV, 2 (1979), 212-26.

PLAESCHKE, H. 'Die Chronologie der Mathurā-Inschriften und das Kaniṣka-Problem', *Wissenschaftliche Zeitschrift der Humboldt-Universität zu Berlin, Ges. Sprachw. RXXV*, III (1976), 333-40.

ROSENFIELD, J. M. *The Dynastic Arts of the Kushans*. Berkeley, 1967.

SHARMA, G. R. As for Chapter 1 (1958).

SIVARAMAMURTI, C. *Indian Sculpture*. New Delhi, 1961.

SMITH, V. A. *The Jain Stupa and Other Antiquities of Mathura (A.S.I.*, New Imp. Series, xx). Allahabad, 1901.

SRINIVASAN, D. 'God as Brahmanical Ascetic A Colossal Kusan Icon of the Mathura School', *Journal of the Indian Society of Oriental Art*, N.S. x (1978–9), 1–16.

SRINIVASAN, D. As for Chapter 1 (1979).

VOGEL, J. P. As for Chapter 2 (1930).

Chapter 4: The Art of Gandhāra

AHMAD, N. 'A Fresh Study of the Fire-Temple(?) at Taxila', *Pakistan Archaeology*, IV (1967), 153–9.

ALLAN, J. 'A Tabula Iliaca from Gandhāra', *Journal of Hellenistic Studies*, LXVI (1946), 21–3.

ALLCHIN, F. R., and HAMMOND, N., eds. *The Archaeology of Afghanistan from Earliest Times to the Timurid Period*. London, etc., 1978.

BAILEY, H. W. 'Two Kharoṣṭhī Casket Inscriptions from Avaca', *Journal of the Royal Asiatic Society*, 1 (1978), 3–13.

BARTHOUX, J. *Les fouilles de Haḍḍa, III, Figures et figurines (Mémoires de la Délégation Archéologique Française en Afghanistan*, VI). Paris and Brussels, 1930.

BERNARD, P. *Les fouilles d'Aï Khanoum, I, Campagnes 1965, 1966, 1967, 1968 (Mémoires de la Délégation Archéologique Française en Afghanistan)*. Paris, 1973.

BIVAR, A. D. H. 'The Azes Era and the Indravarma Casket', *South Asian Archaeology 1979*, 369–76. Berlin, 1981.

BOSCH, F. D. K. 'Remarques sur les influences réciproques de l'iconographie et de la mythologie indienne', *Arts Asiatiques*, III, 1 (1956), 22–47.

BUCHTAL, H. 'The Western Aspects of Gandhara Sculpture', *Proceedings of the British Academy*, XXXI (1945), 150–76.

BUSSAGLI, M. 'An Important Document in the Relations Between Rome and India', *East and West*, IV, 4 (1954), 247–54.

BUSSAGLI, M. 'Gandhara Art', *Encyclopedia of World Art*, VI (1960), 22.

CURIEL, R., and FUSSMAN, G. *Le trésor monétaire de Qunduz (Mémoires de la Délégation Française en Afghanistan*, XX). Paris, 1965.

DEYDIER, H. *Contribution à l'étude de l'art du Gandhāra*. Paris, 1950.

DOBBINS, K. W. 'Gandhāra Buddha Images with Inscribed Dates', *East and West*, XVIII, 3/4 (1968), 281–8.

DVIVEDI, V. P. As for Chapter 1 (1976).

FACENNA, D. *Reports of Excavations at Butkara (I), 1956–1962 (Swāt, Pakistan), I.S.M.E.O. Reports and Memoirs*, I–III. Rome, 1962–81.

FOUCHER, A. As for Chapter 3 (1918).

FOUCHER, A. *La vieille route de l'Inde, de Bactres à Taxila*, 2 vols. (*Mémoires de la Délégation Archéologique Française en Afghanistan*, 1). Paris, 1942–7.

FRANCFORT, H.-P. *Les palettes du Gandhāra (Mémoires de la Délégation Française en Afghanistan*, XXII). Paris, 1979.

FRANCKE, A. H. *Antiquities of Indian Tibet (A.S.I.*, New Imp. Series, XXXVIII and L). Calcutta, 1914 and 1920.

FRUMKIN, G. 'L'art ancien de l'Asie centrale soviétique', *Arts Asiatiques*, XXXIII (1977), 183–211.

GARWOOD, J. F. 'Notes on Ancient Mounds in the Quetta Dist.', *Journal of the Asiatic Society of Bengal*, part 1, LVI (1887), 163.

GNOLI, G. 'The Tyche and the Dioscuri in Ancient Sculptures from the Valley of Swat', *East and West*, N.S. XIV, 1/2 (1963), 29–37.

GODARD, A. and Y., and HACKIN, J. *Les antiquités bouddhiques de Bāmiyān (Mémoires de la Délégation Archéologique Française en Afghanistan*, II). Paris, 1928.

GRISWOLD, A. B. As for Chapter 3 (1963).

HACKIN, J. *Nouvelles recherches archéologiques à Bāmiyān (Mémoires de la Délégation Archéologique Française en Afghanistan*, III). Paris, 1933.

HACKIN, J., et al. *Recherches archéologiques à Begram*, 2 vols. (*Mémoires de la Délégation Archéologique Française en Afghanistan*, IX). Paris, 1939.

HACKIN, J., et al. *Nouvelles Recherches archéologiques à Begram*, 2 vols. (*Mémoires de la Délégation Archéologique Française en Afghanistan*, XI). Paris, 1954.

HACKIN, J., et al. 'Le monastère bouddhique de Fondukistan', *Diverses recherches archéologiques en Afghanistan 1933–1940 (Mémoires de la Délégation Archéologique Française en Afghanistan*, VIII). Paris, 1959.

HARLE, J. C. 'A Hitherto Unknown Dated Sculpture from Gandhāra: A Preliminary Report', *South Asian Archaeology 1973*. Leiden, 1974. (Harle, 1974a)

INGHOLT, H., and LYONS, I. *Gandhāran Art in Pakistan*. Hamden, Conn., 1957.

JOSHI, N. P., and SHARMA, R. C. *Catalogue of Gandhāra Sculpture in the State Museum, Lucknow*. Lucknow, 1969.

KHANDALAVALA, K. As for Chapter 1 (1960).

LOHUIZEN-DE LEEUW, J. E. VAN. As for Chapter 3 (1949).

MACDOWALL, D. W., and TADDEI, M. 'The Pre-Muslim Period', *The Archaeology of Afghanistan*, ed. F. R. Allchin and N. Hammond, 233–99. London, etc., 1978.

MÂLE, E. *L'art religieux du XIIIe siècle en France.* 3rd ed. Paris, 1910.

MARSHALL, J. As for Chapter 1 (1951 etc.).

MARSHALL, J. *The Buddhist Art of Gandhāra* (*Memoirs of the Department of Archaeology in Pakistan*, 1). Cambridge, 1960.

MOSTAMENDI, M. and S. 'Nouvelles fouilles à Hadda (1966–1967) par l'Institut Afghan d'Archéologie', *Arts Asiatiques*, XIX (1969), 15–36.

ROSENFIELD, J. M. As for Chapter 3 (1967).

ROSTOVTSEFF, M. *Animal Style in South Russia and China.* Princeton, 1929.

ROŞU, A. 'The Trojan Horse in India: A Query', *Journal of the Asiatic Society of Bengal*, XXIV, 1 (1958), 19–27.

ROWLAND, B. 'St Peter in Gandhara: An Early Christian Statuette in India', *Gazette des Beaux-Arts*, XXIII (1943).

ROWLAND, B. *The Art and Architecture of India: Buddhist, Hindu, Jain* (*Pelican History of Art*). Harmondsworth, 1953.

SMITH, V. A. 'Graeco-Roman Influence on the Civilisation of Ancient India', *Journal of the Asiatic Society of Bengal*, part 1, LVIII (1889), 107–98.

SMITH, V. A. *A History of Fine Art in India and Ceylon.* Oxford, 1911.

TADDEI, M. 'Tapa Sardar: First Preliminary Report', *East and West*, XVIII, 1/2 (1968), 109–24.

TADDEI, M. *India.* London, 1970.

TADDEI, M. 'The Mahisamardini Image from Tapa Sardar, Ghazni, Afghanistan', *Papers from the First International Conference of South Asian Archaeologists, Cambridge, 1971*, 203–14. London, 1973.

TADDEI, M. 'A Note on the Parinirvāṇa Buddha at Tapa Sardar (Ghazni, Afghanistan)', *Papers from the Second International Conference of South Asian Archaeologists, Amsterdam, 1973.* Leiden, 1974.

TARZI, Z. *L'Architecture et le décor rupestre des grottes de Bāmiyān.* 2 vols. Paris, 1977.

WHEELER, R. E. M. *Five Thousand Years of Pakistan.* London, 1950.

WHEELER, R. E. M. *Rome Beyond the Imperial Frontiers.* London, 1954.

WHEELER, R. E. M. *Chārsada.* Oxford, 1962.

PART TWO: THE GUPTA PERIOD

Chapter 5: Introduction

AGRAWALA, P. K. 'A Note on the So-called Sūrya Statue from Pawāya', *Bulletin of Ancient Indian History and Archaeology*, II (1968).

AGRAWALA, R. C. 'Newly Discovered Sculptures from Vidiśā', *Journal of the Oriental Institute, M.S. University of Baroda*, XVIII, no. 3 (1969). (R. C. Agrawala, 1969b)

BAJPAI, K. D. 'Fresh Light on the Problem of Rāmagupta', *Indian Historical Quarterly*, XXXVIII, no. 1 (1962), 80–5.

BARRETT, D. 'A Terracotta Plaque of Mahisāsuramardini', *Oriental Art*, N.S. XXI, no. 1 (1975), 64–7.

BASHAM, A. L. 'The Gupta Style [review article of Harle, 1974b]', *Hemisphere, An Asian-Australian Monthly*, XIX, no. 10 (1975).

CUNNINGHAM, Sir A. *A.S.I.,A.R.*, I–XXI (1862–84). (Vols VI–VIII, XII–XIII, XVIII–XIX, XXII–XXIII by other hands.)

GAI, G. S. 'Three Inscriptions of Rāmagupta', *Journal of the Oriental Institute, M. S. University of Baroda*, XVIII, no. 3 (1969), 247–51.

GOETZ, H. 'Gupta Art', *Encyclopedia of World Art*, VII. London, 1963.

HARLE, J. C. As for Chapter 3 (1971–2).

HARLE, J. C. 'Remarks on Ālīḍha', *Mahayanist Art after 900 A.D., Colloquies on Art and Archaeology in Asia*, no. 2, Percival David Foundation, London, 1972. (Harle, 1972b)

HARLE, J. C. *Gupta Sculpture.* Oxford, 1974. (Harle, 1974b)

KHAN, A. W. *An Early Sculpture of Narasimha.* Hyderabad, 1964.

MARSHALL, J. As for Chapter 4 (1960).

MARSHALL, J., and FOUCHER, A. As for Chapter 1 (n.d.).

MAXWELL, T. S. 'Transformational Aspects of Hindu Myth and Iconology', *Art and Archaeology Research Papers*, IV (1973), 51–65.

MAXWELL, T. S. As for Chapter 1 (1982).

MITRA, D. 'Varāha-cave of Udayagiri, An Iconographic Study', *Journal of the Asiatic Society of Bengal*, V, nos. 3–4 (1963), 99–103.

MUKHERJEE, S. N. 'The Tradition of Rama Gupta and the Indian Nationalist Historians', *East and West*, N.S. XIII (1962), 49–51.

NATHAN, L., trans. *The Transport of Love: The Meghadūta of Kalidāsa.* Berkeley, 1976.

O'FLAHERTY, W. Review of Stietencron, *Gaṅgā und Yamunā, Bulletin of the School of Oriental and African Studies*, XXXVII (1974), 243–5.

PAL, P. *Bronzes of Kashmir*. Graz, New York, 1975. (Pal, 1975a)

PAL, P. *The Ideal Image: The Gupta Sculptural Tradition and Its Influence*. New York, 1978. (Pal, 1978b)

ROWLAND, B. *The Art and Architecture of India (The Pelican History of Art)*. Harmondsworth, 1970. (Paperback ed. based on 3rd revised hardback ed., 1967.)

STEIN, SIR AUREL. *Archaeological Reconnaissances in North-West India and South-Eastern Iran*. London, 1937.

STIETENCRON, H. VON. *Gaṅgā und Yamunā - Zur symbolischen Bedeutung der Flussgöttinen an indischer Tempeler (Freiburger Beiträge zur Indologie, Band 5, X)*. Wiesbaden, 1972.

VIENNOT, O. 'The Mahiṣāsuramardinī from Siddhi-ki-Guphā at Deogarh', *Journal of the Indian Society of Oriental Art*, N.S. IV (1971-2), 66-77.

WILLIAMS, J. W. 'New Nāga Images from the Sāñcī Area', *Oriental Art*, N.S. XXII, 2 (1976), 174-9.

*WILLIAMS, J. W. *The Art of Gupta India, Empire and Province*. Princeton, 1982.

Chapter 6: Mathurā

AGRAWALA, V. S. 'A Note on a Gupta Śiva Liṅga at Mathurā', *Journal of the United Provinces Historical Society* (1935), 83-5.

HARLE, J. C. 'The Head of Śiva from Mathura in the Ashmolean Museum - Is the Moustache Recut?', *Asian Review*, N. S. II, I (1965).

HARLE, J. C. 'Late Kusan [*sic*], Early Gupta: A Reverse Approach', *South Asian Archaeology 1971*, 231-40. London, 1973.

HARLE, J. C. As for Chapter 5 (1974b).

KREISEL, G. *Ikonographie der Śiva-Bildwerke in der Kunst Mathuras von den Anfängen bis zur Spätguptazeit*. Ph.D. dissertation, Freien Universität Berlin, 1981.

PAL, P. As for Chapter 5 (1978b).

WILLIAMS, J. 'A Mathura Gupta Buddha Reconsidered', *Lalit Kalā*, XVII (1974), 28-31.

WILLIAMS, J. As for Chapter 5 (1982).

Chapter 7: Sārnāth, Eastern Uttar Pradesh, and Bihār

ASHER, F. M. *The Art of Eastern India 300-800*. Minneapolis, 1980.

HARLE, J. C. As for Chapter 5 (1974b).

HARLE, J. C. 'A Gupta Ear-ring', *Studies in South Asian Culture*, VII (*Senarat Paranavitāna Commemoration Volume*), 78-80. Leiden, 1978.

HARLE, J. C. 'The Significance of Wrapped Heads in Indian Sculpture', *South Asian Archaeology 1979*, 401-10. Berlin, 1981.

KRAMRISCH, S. As for Chapter 1 (1933).

ROSENFIELD, J. M. 'On the Dated Carvings of Sārnāth', *Artibus Asiae*, XXVI, I (1963), 10-26.

SIRCAR, D. C. 'Date of the Mankuwar Buddha Image Inscription of the Time of Kumāragupta I', *Journal of Ancient Indian History*, III (1970), 133-7.

WILLIAMS, J. 'Sārnāth Gupta Steles of the Buddha's Life', *Ars Orientalis*, X (1975), 171-92.

WILLIAMS, J. Review of J. C. Harle, *Gupta Sculpture, Art Bulletin*, LIX, I (1977), 119-21.

WILLIAMS, J. As for Chapter 5 (1982).

Chapter 8: Temples and Sculpture

ASHER, F. M. As for Chapter 7 (1980).

BANERJI, R. D. *The Temple of Śiva at Bhumara (Mem. A.S.I., XVI)*. 1924.

CHANDRA, P. 'A Vāmana Temple at Marhiā and Some Reflections on Gupta Architecture', *Artibus Asiae*, XXXII, 2/3 (1970), 125-45.

CHANDRA, P. *Stone Sculpture in the Allahabad Museum*. Bombay, 1971.

COUSENS, H. 'Buddhist Stūpa at Mirpur Khas', *A.R.,A.S.I.* (1909-10), 80-92.

COUSENS, H. *The Antiquities of Sind with Historical Outline (A.S.I.*, Imperial Series, XLVI). Calcutta, 1929.

DESAI, M. *Deogarh*. Bombay, 1958.

HARLE, J. C. As for Chapter 5 (Harle, 1974b).

LOHUIZEN-DE LEEUW, J. E. VAN. 'The Pre-Muslim Antiquities of Sind', *South Asian Archaeology 1975*, 151-74. Leiden, 1979. (Lohuizen, 1979a)

MEHTA, R. N., and CHOWDHARY, S. N. *Excavation at Devnimori*. Baroda, 1966.

MEISTER, M. W. 'Darrā and the Early Gupta Tradition', *Chhavi*, II (1982), 192-205.

SHAH, U. P. *Sculptures from Śāmalājī and Roḍā*. Baroda, 1960.

SINGH, R. C. 'Bhitargaon Brick Temple', *Bulletin of Museums and Archaeology in Uttar Pradesh*, no. 1 (March 1968); no. 2 (December 1968); no. 8 (December 1971).

SIRCAR, D. C. 'The Reckoning of the Kathika Kings', *Journal of the Oriental Institute*, M.S. University of Baroda, XIV, 3/4 (1965), 336-9.

SPINK, W. 'A Temple with Four Uchchakalpa(?) Doorways at Nāchnā Kutharā', *Chhavi* (1971), 161-72.

VATS, M. S. *The Gupta Temple at Deogarh (Mem. A.S.I., LXX)*. Delhi, 1952.

VIENNOT, O. 'Le temple ruiné de Mukundara, entre Mālwa et Rājasthān', *South Asian Archaeology 1973*, 116-27. Leiden, 1974.

VOGEL, J. P. 'The Temple of Bhitargaon', *A.R.,A.S.I.* (1908-9), 5-21. (Vogel, 1908-9a)

WILLIAMS, J. 'The Sculptures of Mandasor', *Archives of Asian Art*, XXVI (1972-3), 50-66.

WILLIAMS, J. W. As for Chapter 5 (1982).

Chapter 9: The Later or Mahāyāna Caves at Ajaṇṭā

AUBOYER, J. *Le trône et son symbolisme dans l'Inde ancienne*. Paris, 1949.

BURGESS, J. *Notes on the Bauddha Rock Temples of Ajanta … and … Bagh*. Bombay, 1879.

BURGESS, J. As for Chapter 2 (1883a).

DHAKY, M. A. *The Vyāla Figures on the Mediaeval Temples of India*. Varanasi, 1965. (Dhaky, 1965a)

FERGUSSON, J., and BURGESS, J. *The Cave Temples of India*. London, 1880.

FRANZ, H. G. 'Ambulatory Temples in Buddhism and Hinduism', *South Asian Archaeology 1979*, 449-58. Berlin, 1981.

MARSHALL, J., et al. *The Bagh Caves*. London, 1927.

MICHELL, G., ed. *In the Image of Man*. Exhibition catalogue. London, 1982.

SPINK, W. 'Ajanta and Ghatotkacha: A Preliminary Analysis', *Ars Orientalis*, VI (1966), 135-56.

SPINK, W. 'Ajanta's Chronology: The Problem of Cave Eleven', *Ars Orientalis*, VII (1968), 155-68.

SPINK, W. 'Ajanta: A Brief History', *Aspects of Asian Art*, ed. P. Pal, 49-58. Leiden, 1972.

SPINK, W. 'Ajanta's Chronology: The Crucial Cave', *Ars Orientalis*, X (1975), 143-70.

SPINK, W. 'Bāgh: A Study', *Archives of Asian Art*, XXX (1976-7), 53-84.

SPINK, W. *Ajanta to Ellora*. Bombay, n.d.

STERN, P. *Colonnes indiennes d'Ajanta et d'Ellora*. Paris, 1972.

YAZDANI, G., et al. *Ajantā*. 3 vols. Oxford, 1931-46.

PART THREE: THE POST-GUPTA PERIOD

Chapter 10: Later Rock-Cut Temples

BANERJI, R. D. *Bas Reliefs of Badami* (*Mem. A.S.I.*, XXV). Calcutta, 1928.

FERGUSSON, J., and BURGESS, J. As for Chapter 9 (1880).

GORAKSHKAR, S. 'A Harihara Image from Jogesvari and the Problem of Dating Gharapuri (Ele-

phanta)', *MADHU: Recent Researches in Indian Archaeology and Art History*, 247-51. Delhi, 1981.

GORAKSHKAR, S. 'The Parel Mahādeva Reassessed and Two Newly Discovered Images from Parel', *Lalit Kalā*, XX (1982), 15-24.

GUPTE, R. S. *Ajanta, Ellora and Aurangabad Caves*. Bombay, 1962.

HARLE, J. C. As for Chapter 2 (1971a).

KERN, H., trans. *The Saddharma Puṇḍarīkā* (*Sacred Books of the East*, XXI). Oxford, 1884.

LEVINE, D. B. 'Aurangabad: A Stylistic Analysis', *Artibus Asiae*, XXVIII (1966), 175-204.

MAXWELL, T. S. As for Chapter 1 (1982).

MITRA, D. 'Four Little Known Khākhara Temples of Orissa', *Journal of the Asiatic Society of Bengal*, 4th series, II, 1 (1960), 1-24. (Mitra, 1960a)

SPINK, W. 'Ellora's Earliest Phase', *Bulletin of the American Academy of Banares*, I (1967), 11-22.

SPINK, W. As for Chapter 9 (n.d.).

TARR (TARTAKOV), G. 'Chronology and Development of the Chāḷukya Cave Temples', *Ars Orientalis*, VIII (1970), 156-84.

Chapter 11: Western India and Madhya Pradesh

BARRETT, D., and DIKSHIT, M. G. *Mukhaliṅgam Temples; Sirpur and Rajim Temples*. Bombay, 1960.

BHANDARKAR, D. R. 'The Temples of Osiā', *A.R.,A.S.I.* (1908-9), 100-15.

BRUHN, K. *The Jina-Images of Deogarh* (*Studies in South Asian Culture*, I). Leiden, 1969.

BUSSAGLI, M., and SIVARAMAMURTI, C. *5000 Years of the Art of India*. New York, n.d

DEVA, K. 'Extensions of the Gupta Art: Art and Architecture of the Pratīhāra Age', *Seminar on Indian Art History, 1962*. Lalit Kalā Akademi, New Delhi, 1962.

DEVA, K. 'Mālā Devī Temple at Gyaraspur', *Shri Mahavir Jaina Vidyalaya Golden Jubilee Volume*, part 1, 260-9. Bombay, 1968.

DEVA, K. *Temples of North India*. New Delhi, 1969.

DEVA, K. 'Teli-ka-Mandir', paper read at a seminar on Indian art and epigraphy held at the Center for Archaeology, A.I.I.S., Varanasi, in the winter of 1979. To be published.

DHAKY, M. A. 'Brahmānasvamī Temple at Varman', *Journal of the Oriental Institute, Baroda*, XIV (1965), 381-7. (Dhaky, 1965b)

DHAKY, M. A. 'The Old Temple at Lamba and Kameśvara at Auwa', *Journal of the Asiatic Society, Calcutta*, VIII (1966), 145-8.

DHAKY, M. A. 'Some Early Jaina Temples in Western India', *Shri Mahavir Jaina Vidyalaya*

Golden Jubilee Volume, part 1, 291-347. Bombay, 1968.

DHAKY, M. A. 'The Genesis and Development of Māru-Gurjara Temple Architecture', *Studies in Indian Temple Architecture*, ed. P. Chandra, 114-64. New Delhi, 1975. (Dhaky, 1975a)

DHAKY, M. A. 'The Western Indian Jaina Temple', *Aspects of Jaina Art and Architecture*, ed. U. P. Shah and M. A. Dhaky, 319-84. Ahmedabad, 1975. (Dhaky, 1975b)

GOETZ, H. 'The Last Masterpiece of Gupta Art: The Great Temple of Yaśovarman of Kanauj ("Telika Mandir") at Gwalior', *Arts and Letters*, XXIX, 2 (1955), 47-59. (Goetz, 1955b)

HARLE, J. C. 'The Post-Gupta Style in Indian Temple Architecture and Sculpture' (The Sir George Birdwood Memorial Lecture), *Journal of the Royal Society of Arts*, no. 5253, CXXV (1977), 570-89.

JAYAKAR, P. 'Notes on Some Sculptures *in situ* at Ābānerī, Rājasthān', *Lalit Kalā*, I-II (1956-7), 139-44.

KRAMRISCH, S. *The Hindu Temple*. 2 vols. Calcutta, 1946.

KRAMRISCH, S. *The Art of India*. London, 1954.

LIN-BODIEN, C. G. 'The Chronology of Chandrāvatī, Kūsmā, Chitorgarh: A Case Study in the Use of Epigraphic and Stylistic Evidence', *Archives of Asian Art*, XXXIII (1980), 49-60.

LIN-BODIEN, C. G. 'Note on the Durggagaṇa Inscription (V.S. 746) in the Jhālāvāḍ Museum', *Archives of Asian Art*, XXXIV (1981), 91.

MAXWELL, T. S. 'The Deogarh Viśvarūpa: A Structural Analysis', *Art and Archaeology Research Papers*, VIII (1975), 8-23.

MAXWELL, T. S. As for Chapter 1 (1982).

MAXWELL, T. S. 'The Evidence for a Viśvarūpa Iconographic Tradition in Western India, 6th-9th Centuries A.D.', *Artibus Asiae*, XLIV, 2/3 (1983), 213-34.

MEISTER, M. W. 'Kṛṣṇalīlā from Wadhwān and Osian', *Journal of the Indian Society of Oriental Art*, N.S. V (1972-3), 28-35.

MEISTER, M. W. 'A Preliminary Report on the Śiva Temple at Kusumā', *Archives of Asian Art*, XXVII (1973-4), 76-91.

MEISTER, M. W. 'Jaina Temples in Central India', *Aspects of Jaina Art and Architecture*, ed. U. P. Shah and M. A. Dhaky, 223-41. Ahmedabad, 1975.

MEISTER, M. W. 'A Full Report on Temples at Kusumā', *Archives of Asian Art*, XXIX (1975-6), 23-46.

MEISTER, M. W. 'Phāṁsanā in Western India', *Artibus Asiae*, XXXVIII, 2/3 (1976), 167-88. (Meister, 1976a)

MEISTER, M. W. 'Construction and Conception: Maṇḍapikā Shrines of Central India', *East and West*, XXVI, 3/4 (1976), 409-18. (Meister, 1976b)

MEISTER, M. W. 'Forest and Cave: Temples at Chandrabhāgā and Kansuāñ', *Archives of Asian Art*, XXXIV (1981), 56-62.

MICHELL, G. *An Architectural Description and Analyses of the Early Western Calukya Temples*. 2 vols. London, 1975. (Michell, 1975a)

NANAVATI, J. M., and DHAKY, M. A. *The Ceilings in the Temples of Gujarat* (*Bulletin of the Baroda Museum and Picture Gallery*, XVI-XVII). Baroda, 1963.

NANAVATI, J. M., and DHAKY, M. A. *The Maitraka and the Saindhava Temples of Gujarat*. Ascona, 1969.

SHAH, U. P. 'Bronze Hoard from Vasantgadh', *Lalit Kalā*, I-II (1955-6), 55-65.

SHAH, U. P. *Akota Bronzes*. Bombay, 1959.

SHAH, U. P. As for Chapter 8 (1960).

SHAH, U. P. 'A Kṣatrapa Period Head from Daulatpar, Kutch', *Bulletin of the Museum and Picture Gallery, Baroda*, XX (1968), 105-7.

SHAH, U. P. 'Jaina Bronzes - A Brief Survey', *Aspects of Jaina Art and Architecture*, ed. U. P. Shah and M. A. Dhaky, 269-98. Ahmedabad, 1975.

SHARMA, B. N. *Iconography of Revanta*. New Delhi, 1975.

SHARMA, R. K. *The Temple of Chaunsaṭha-Yoginī at Bheraghat*. Delhi, 1978.

SIVARAMAMURTI, C. As for Chapter 3 (1961).

SOMPURA, P. O. 'The Vāstuvidyā of Visvakarma', *Studies in Indian Temple Architecture*, ed. P. Chandra, 47-56. New Delhi, 1975.

TOD, J. *Annals and Antiquities of Rajasthan*. 3 vols. Oxford, 1920.

TRIPATHI, L. K. *The Temples of Baroli*. Varanasi, 1975.

VIENNOT, O. *Les divinités fluviales Gaṅgā et Yamunā aux portes des sanctuaires de l'Inde*. Paris, 1964.

VIENNOT, O. 'Le problème des temples à toit plat dans l'Inde du nord', *Arts Asiatiques*, XVIII (1968), 23-84.

VIENNOT, O. 'Un type rare de temple à trois chapelles au site d'Amvān (Rājasthān)', *Arts Asiatiques*, XXVI (1973), 125-56.

VIENNOT, O. *Temples de l'Inde centrale et occidentale*. 2 vols. Paris, 1976.

Chapter 12: Orissa

BANERJEA, J. N. 'The Varahi Temple at Chaurasi', *Felicitation Volume Presented to Mahamahopadhyaya Dr V. V. Mirashi*, 349-54. Nagpur, 1965.

BARRETT, D., and DIKSHIT, M. G. As for Chapter 11 (1960).

BONER, A., and SARMA, S. R. *Śilpa Prakāśa of Rāmachandra Kaulācāra*. Leiden, 1966.

BROWN, R. L. 'The Four Stone Façades of Monastery 1 at Ratnagiri', *Artibus Asiae*, XL (1978), 5-28.

DEHEJIA, V. *Early Stone Temples of Orissa*. New Delhi, 1979.

DHAKY, M. A. 'The *Akāśaliṅga* Finial', *Artibus Asiae*, XXXVI, 4 (1974), 307-15.

HARLE, J. C. As for Chapter 11 (1977).

KRAMRISCH, S. 'The Walls of Orissan Temples', *Journal of the Indian Society of Oriental Art*, XV (1947), 178-96.

MALLMANN, M. T. DE. 'Notules d'iconographie', *Arts Asiatiques*, V, 4 (1958), 299-302.

MALLMANN, M. T. DE. 'Divinités hindoues dans le tantrisme bouddhique', *Arts Asiatiques*, X (1964), 67-86. (De Mallmann, 1964b)

MASTHANAIAH, B. *The Temples of Mukhaliṅgam*. New Delhi, 1978.

MITRA, D. As for Chapter 10 (Mitra, 1960a).

MITRA, D. *Bhubaneswar*. 3rd ed. New Delhi, 1966.

PANIGRAHI, K. C. 'Bhauma Art and Architecture of Orissa', *Arts Asiatiques*, IV, 4 (1957), 275-92.

PANIGRAHI, K. C. *Archaeological Remains at Bhubaneswar*. Bombay, 1961.

WILLETTS, W. 'An Eighth Century Buddhist Monastic Foundation', *Oriental Art*, N.S. IX, 1 (1963), 15-21.

Chapter 13: The Deccan,
Meeting-Place of North and South

BALASUBRAHMANYAM, S. R. 'The Date of the Lad Khan (Sūrya-Nārāyana) Temple at Aihole', *Lalit Kalā*, X (1961), 41-4.

BARRETT, D. As for Chapter 1 (Barrett, 1954b).

BARRETT, D. *Hemavati*. Bombay, 1958. (Barrett, 1958d)

BHANDARKAR, D. R. *Indian Antiquary*, XII (1883), 228-30.

BOLON, C. R. 'The Mahākuṭa Pillar and its Temples', *Artibus Asiae*, XLI, 2/3 (1979), 253-68.

BOLON, C.R. 'The Pārvatī Temple, Sandur, and Early Images of Agastya', *Artibus Asiae*, XLII, 4 (1980), 303-26.

BROWN, P. As for Chapter 1 (1942a).

BURGESS, J. As for Chapter 2 (1883b).

CHATHAM, D. C. 'Stylistic Sources and Relationships of the Kailasa Temple at Ellora'. Ph.D. thesis, University of California, Berkeley, 1978.

COUSENS, H. *The Chalukyan Architecture of the Kanarese Districts (A.S.I.*, New Imperial Series, XLII). Calcutta, 1926.

DHAKY, M. A. 'The "Pranāla" in Indian, South Asian and South-East Asian Sacred Architecture', *Rūpa Pratirūpa* (Alice Boner Commemoration Volume), 119-66. New Delhi, 1982.

DIVAKARAM, O. 'Le temple de Jambuliṅga à Bādāmi', *Arts Asiatiques*, XXI (1970), 15-39.

DIVAKARAM, O. 'Les temples d'Ālampur et de ses environs au temps des Cāḷukya de Bādāmi', *Arts Asiatiques*, XXIV (1971), 51-74.

FERGUSSON, J., and BURGESS, J. As for Chapter 9 (1880).

GOETZ, H. 'The Kailāsa of Ellora and the Chronology of Rāshtrakūta Art', *Artibus Asiae*, XV, 1/2 (1952), 84-107.

GUPTE, R. S. 'An Apsidal Temple at Chikka Mahakuta', *Marathwada University Journal*, IV/2 (1964), 58-63.

HARLE, J. C. 'Le temple de Nāganātha à Nagrāl', *Arts Asiatiques*, XIX (1969), 53-84.

HARLE, J. C. 'Three Types of Walls in Early Western Calukya Temples', *Oriental Art*, N.S. XVII (1971), 45-54. (Harle, 1971c)

HARLE, J. C. 'Some Remarks on Early Western Calukya Sculpture', *Aspects of Indian Art*, ed. P. Pal. Leiden, 1972. (Harle, 1972a)

KRAMRISCH, S. 'An Image of Aditi-Uttānapad', *Artibus Asiae*, XIX, 3/4 (1956), 259-70.

LIPPE, A. 'Some Sculptural Motifs on Early Chalukyan Temples', *Artibus Asiae*, XXIX (1967), 5-24.

LIPPE, A. 'Additions and Replacements in Early Chālukya Temples', *Archives of Asian Art*, XXIII (1969-70), 6-23.

LIPPE, A. *Indian Medieval Sculpture*. Amsterdam, etc., 1978.

LONGHURST, A. H. *Pallava Architecture (Mem. A.S.I.*, XVII, XXXIII, XL (1924, 1928, 1930)).

LÜDERS, H. 'Kadata Plates of Prabhutavarsha', *Epigraphica Indica*, IV (1896-7), 332-49.

MICHELL, G. 'Dating an Important Early Cāḷukya Monument', *Oriental Art*, XIX, 2 (1973), 192-201. (Michell, 1973a)

MICHELL, G. 'The Regents of the Directions of Space: A Set of Sculptural Panels from Alampur', *Art and Archaeology Research Papers*, IV (1973), 80-6. (Michell, 1973b)

MICHELL, G. As for Chapter 11 (Michell, 1975a).

MICHELL, G. 'Temples of the Kunṭi Group, Aihole', *Oriental Art*, XXIV, 3 (1978), 297-308.

MICHELL, G. 'The Gauḍa Temple at Aihole: The Problem of the Beginning of Early Western Chalukya Architecture', *South Asian Archaeology 1975*, 135-50. Leiden, 1979.

PRASAD, B. R. 'Rāṣṭrakūṭa Temples at Bharanāsi Saṅgam', *Artibus Asiae*, XXXIV (1972), 211–24.

RAJAN, K. V. S. 'A Vishnu Sculpture from the Virupaksha Shrine at Pattadakal', *Journal of Indian Museums*, XIV–XVI (1958–60), 26–31.

RAMA RAO, M. *Eastern Cāḷukyan Temples of Āndhra Deśa*. Hyderabad, 1964.

RAMA RAO, M. *Early Cāḷukyan Temples of Āndhra Deśa*. Hyderabad, 1965.

RAO, M. S. N. *Srikanthika*. Mysore, 1973.

RAO, S. R. 'A Note on the Chronology of Early Chālukyan Temples', *Lalit Kalā*, XV (1972), 9–18.

RAO, S. R. 'Recent Discoveries at Aihole and Pattadakal', *Srikanthika*, 36–9. Mysore, 1973.

REA, A. 'Buddhist and Jain Establishments at Śankaram (Vizagapatam Dist.)', *A.R.,A.S.I.* (1907–8), 149–80.

REA, A. 'Buddhist Monasteries on the Gurubhaktakoṇḍa and Durgakoṇḍa Hills at Rāmatīrtham', *A.R.,A.S.I.* (1910–11), 78–88.

ROWLAND, B. As for Chapter 4 (1953).

SETTAR, S. 'A Buddhist Vihāra at Aihole', *East and West*, XIX, 1/2 (1969), 126–38.

SIVARAMAMURTI, C. 'The Story of Ganga and Amrita at Pattadakal', *Oriental Art*, N.S. III (1957), 20–4.

SIVARAMAMURTI, C. *Early Eastern Chāḷukya Sculpture*. Madras, 1962.

SIVARAMAMURTI, C. *Noḷamba Sculptures in the Madras Government Museum (Bulletin of the Madras Government Museum*, N.S., General Section, IX, 1). Madras, 1964.

TARR (TARTAKOV), G. As for Chapter 10 (1970).

TARTAKOV (TARR), G. 'The Beginning of Dravidian Temple Architecture in Stone', *Artibus Asiae*, XLII (1980), 39–99.

Chapter 14: Kashmir

BARRETT, D. 'Sculptures of the Shāhi Period', *Oriental Art*, N.S. III, 2 (1957), 54–9.

BARRETT, D. As for Chapter 1 (1960b).

BARRETT, D. 'Bronzes of Northwest India and Western Pakistan', *Lalit Kalā*, XI (1962), 35–44.

BROWN, P. As for Chapter 1 (1942a).

CHETWODE, P. 'Western Himalayan Hindu Architecture and Sculpture', *The Arts of India*, ed. Basil Gray, 83–93. Oxford, 1981.

FABRI, C. L. 'Akhnur Terracottas', *Mārg*, VIII, 2 (1955), 53–64.

GOETZ, H. *The Early Wooden Temples of Chamba (Memoirs of the Kern Institute*, 1). Leiden, 1955. (Goetz, 1955a)

GOETZ, H. 'Late Gupta Sculpture in Afghanistan:

The "Scorretti Marble" and Cognate Sculptures', *Arts Asiatiques*, IV, 1 (1957), 13–19.

GOETZ, H. *Studies in the History and Art of Kashmir and the Indian Himalaya*. Wiesbaden, 1969.

GRANOFF, P. 'Maheśvara/Mahākāla: A Unique Buddhist Image from Kaśmīr', *Artibus Asiae*, XLI, 1 (1979), 64–82.

HARLE, J. C. 'An Early Brass Image of a Bodhisattva with Kashmiri or Swat Valley Affinities', *South Asian Archaeology 1975*, 126–34. Leiden, 1979.

HARLE, J. C. As for Chapter 3 (1980).

HARLE, J. C. As for Chapter 7 (1981).

HARLE, J. C. 'Some Foreign Elements of Costume and Hairstyle in Indian Art', *Volume in Honour of Professor Tucci*, ed. G. Gnoli. 1985.

JETTMAR, G. *Die Holztempel des oberen Kulu-Tales in ihren historischen, religiösen und kunsthistorisches Zusammenhangen*. Südasien Institut, Heidelberg, 1974.

KAK, R. C. *Handbook of the Archaeological and Numismatic Sections of the Sri Pratap Singh Museum, Srinagar*. Calcutta, 1923.

KAK, R. C. *Ancient Monuments of Kashmir*. The India Society, London, 1933.

LERNER, M. *Bronze Sculpture from Asia*. New York, 1975.

LOHUIZEN-DE LEEUW, J. E. VAN. 'An Ancient Hindu Temple in Eastern Afghanistan', *Oriental Art*, N.S. V, 2 (1959), 61–9.

MAXWELL, T. S. 'Lākhamaṇḍal and Trilokināth: The Transformed Functions of Hindu Architecture in Two Cross-Cultural Zones of the Western Himālaya', *Art International*, XXIV, 3–4 (1980), 9–74.

MISHRA, Y. *The Hindu Sahis of Afghanistan and the Punjab A.D. 865–1026*. Patna, 1972.

PAL, P. As for Chapter 5 (1975a).

PAL, P. *Bronzes of Kashmir*. Graz, 1975. (Pal, 1975b)

PANDIT, R. S. *Kalhan's Rājataraṅgiṇī*. New Delhi, 1958.

SCHLUMBERGER, D. 'Le marbre Scoretti', *Arts Asiatiques*, II, 2 (1955), 112–19.

SCHMIDT, K., KHAN, F. A. et al. *5000 Years of Art in Pakistan*. Utrecht, 1963.

TADDEI, M. As for Chapter 4 (1970).

TUCCI, G. 'Preliminary Report on an Archaeological Survey in Swat', *East and West*, IX, 4 (1958), 279–324.

WHEELER, R. E. M. As for Chapter 4 (1950).

Chapter 15: Eastern India and Bangladesh

AHMED, N. *Mahasthan.* Reprint. Dacca, 1975. (Ahmed, 1975a)

AHMED, N. 'Recent Discoveries at Bhāsu-Bihār', *Bangladesh Lalit Kalā*, I, I (1975), 10-18. (Ahmed, 1975b)

ALAM, A. K. M. S. *Maināmati.* Dacca, 1975.

ASHER, F. M. As for Chapter 7 (1980).

BANERJEE, A. 'Gaudīya Temples and their Diffusion', *Indian Museums Bulletin*, V, no. 1 (1970), 115-20.

BANERJI, R. D. *Eastern Indian School of Mediaeval Sculptures (A.S.I., New Imperial Series, XLVII).* Delhi, 1933.

BARRETT, D. 'A Group of Bronzes from the Deccan', *Lalit Kalā*, III-IV (1956-7), 39-45. (Barrett, 1956a)

BARRETT, D., and DIKSHIT, M. G. As for Chapter 11 (1960).

BARUA, B. *Gayā and Buddha-Gayā.* Calcutta, 1934.

BENISTI, M. *Contribution à l'étude du stupa bouddhique indien - Les stupas mineures de Bodhgaya et de Ratnagiri.* Paris, 1981.

BHATTACHARYYA, B. T. *The Indian Buddhist Iconography.* 2nd ed. Calcutta, 1958.

BHATTASALI, N. K. *Iconography of the Buddhist and Brahmanical Sculpture in the Dacca Museum.* Dacca, 1929.

BLOCH, T. 'Notes on Bodh Gaya', *A.S.I.,A.R.* (1908-9), 138-58.

BROWN, P. As for Chapter 1 (1942a).

CHANDA, R. *Mediaeval Sculpture in the British Museum.* London, 1936.

CHANDRA, P. 'Some Remarks on Bihar Sculpture from the Fourth to the Ninth Century', *Aspects of Indian Art*, 59-64. Leiden, 1972.

CUNNINGHAM, A. *Mahabodhi.* London, 1892.

DEVA, K., and AGRAWALA, V. S. 'The Stone Temple at Nālandā', *Journal of the United Provinces Historical Society*, XXIII (1950), 198-212.

DIKSHIT, K. N. *Excavations at Paharpur, Bengal (Mem. A.S.I., LV).* New Delhi, 1938.

FRANZ, H. G. 'Pagode, Stupa, Turmtempel: Untersuchungen zum Ursprung der Pagode', *Kunst des Orients*, III (1959), 14-28.

FRANZ, H. G. 'Die Ausgrabungen in Nālandā und die Baukunst des späten Buddhismus in Indien', *Ars Orientalis*, IV (1961), 187-206.

FRANZ, H. G. As for Chapter 2 (1978).

FRANZ, H. G. As for Chapter 2 (1979).

FRENCH, J. C. *The Art of the Pal Empire of Bengal.* London, 1928.

GHOSH, A. *Nālandā.* New Delhi, 1971.

HAQUE, E. *The Iconography of the Hindu Sculptures of Bengal, up to circa 1250 A.D.* D.Phil. thesis, Oxford, 1973.

HAQUE, Z. *Terracotta Decorations of Late Medieval Bengal - Portrayal of a Society.* Dacca, 1980.

HARLE, J. C. As for Chapter 13 (Harle, 1972a).

HUNTINGTON, S. L. 'Some Aspects of Bengal Stone Sculptures', *Bangladesh Lalit Kalā*, I, I (1975), 19-28.

KONOW, S. *Journal of the Bengal and Orissa Research Society*, XII (1926), 179-82.

KRAMRISCH, S. 'Pala and Sena Sculpture', *Rupam*, XL (1929), 1-20.

LOHUIZEN-DE LEEUW, J. E. VAN. 'South-East Asian Architecture and the Stūpa of Nandangarh', *Artibus Asiae*, XIX (1956), 279-90.

LONGHURST, A. H. 'Ancient Brick Temples in the Central Provinces', *A.R.,A.S.I.* (1909-10), 11-17.

MCCUTCHION, D. J. *Late Mediaeval Temples of Bengal.* Calcutta, 1972.

MCCUTCHION, D. J. 'Styles of Bengal Temple Terracottas: A Preliminary Analysis', *South Asian Archaeology*, ed. N. Hammond, 265-78. London, 1973.

MALLMANN, M. T. DE. *Introduction à l'étude d'Avalokiteśvara.* Paris, 1948.

MALLMANN, M. T. DE. *Les enseignements iconographiques de l'Agni Purāna.* Paris, 1963.

MALLMANN, M. T. DE. *Étude iconographique sur Mañjuśrī.* Paris, 1964. (De Mallmann, 1964a)

MALLMANN, M. T. DE. *Introduction à l'iconographie du tantrisme bouddhique.* Paris, 1975.

MITRA, D. As for Chapter 1 (1971).

MYER, P. R. 'The Great Temple at Bodh-Gaya', *Art Bulletin*, XL, 4 (1958), 227-98.

PICRON, C. 'Gopala II ou Gopala III, X ou XIIe siècle. Datation d'une image de Siva', *Arts Asiatiques*, XXXIV (1978), 105-20. (Picron, 1978a)

PICRON, C. 'Les stèles Pala-Sena: Évolution et Chronologie', *Au service d'une biologie de l'art*, 59-97. Lille, 1978. (Picron, 1978b)

PICRON, C. 'De Rambhā a Lalitā Devī, la Devī dans la statuaire Pāla-Sena en pierre', *Artibus Asiae*, XLII, 4 (1980), 282-302.

RASHID, M. H. 'The Mainamati Sculpture', paper delivered at the First International Congress on Bengal Art, Dacca Museum. Dacca, 1976.

RENOU, L., FILLIOZAT, J., et al. *L'Inde classique.* 2 vols. Paris and Hanoi, 1947, 1953.

SARASWATI, S. K. 'The Begunia Group of Temples', *Journal of the Indian Society of Oriental Art*, II (1933), 124-8.

SARASWATI, S. K. 'Art: I Architecture', *The Struggle for Empire: The History and Culture of the Indian People*, V, 530-640. Bombay, 1957.

SARASWATI, S. K. As for Chapter 1 (1962).

SINGH, P. C. 'A Rare Viṣṇu Image in His Kevala Narasiṁha Form Found in Bhagalpur District', *Journal of the Asiatic Society*, V, 3/4 (1963), 81-2.

SMITH, V. A., and HOEY, W. 'Ancient Buddhist Sculptures from the Banda District', *Journal of the Asiatic Society of Bengal*, LXIV, 1 (1895), 155.

STADTNER, D. M. 'A Sixth-Century A.D. Temple from Kosala', *Archives of Asian Art*, XXXIII (1980), 38-48.

TADDEI, M. *Tre stele medioevali dell'India di nord-est*. Museo Nazionale d'Arte Orientale Schedel, Rome, 1967.

VENKATARAMAYYA, M. As for Chapter 1 (1963).

VIENNOT, O. 'Le temple de Ramachandra à Rajim', *Arts Asiatiques*, V, 2 (1958), 138-43.

PART FOUR: THE LATER HINDU PERIOD

Chapter 16: Western India, Mālwā, and Madhya Pradesh

AGRAWALA, R. C. 'Some Famous Sculptors and Architects of Mewar (15th Cent. A.D.)', *Indian History Quarterly*, XXXIII, 4 (1957), 321-34.

AGRAWALA, R. C. 'Khajurāho of Rajasthan: The Temple of Ambikā at Jagāt', *Arts Asiatiques*, X, 1 (1964), 43-66.

AGRAWALA, R. C. 'Unpublished Temples of Rajasthan', *Arts Asiatiques*, XI, 2 (1965), 53-72.

AGRAWALA, R. C. 'Sculptures of Mewad in Sixteenth Century', *Western Indian Art*, special number, *Journal of the Indian Society of Oriental Art*, N.S. 1 (1965-6), 30-3.

BASHAM, A. L. *The Wonder That Was India*. London, 1954.

BHATTACHARYA, B. C. *The Jaina Iconography*. Revised ed. Delhi, 1974.

BROWN, P. As for Chapter 1 (1942a).

BRUHN, K. *The Jina-Images of Deogarh*. Leiden, 1969.

BRUHN, K. 'Wiederholung in den indischen Ikonographie', *Indologen-Tagung*, 99-125. Wiesbaden, 1973.

BURGESS, J. *The Temples of Śatrunjaya*. Bombay, 1869.

BURGESS, J., and COUSENS, H. *The Antiquities of the Town of Dabhoi*. Edinburgh, 1888.

BURGESS, J., and COUSENS, H. *The Architectural Antiquities of Northern Gujerat (Architectural Survey of Western India*, IX). London, 1903.

CHANDRA, P. 'The Kaula-Kāpālika Cults at Khajurāho', *Lalit Kalā*, I-II (1955-6), 98-107.

COUSENS, H. 'The Restoration of the Jaina Tower at Chitorgadh', *A.R.,A.S.I.* (1905-6), 42-9.

COUSENS, H. *Somanātha and Other Mediaeval Temples in Kāṭhiāwād*. Calcutta, 1931.

DESAI, D. 'Placement and Significance of Erotic Sculptures at Khajuraho', paper presented at the Śiva Symposium, Philadelphia, 1981.

DESAI, D. 'Man and the Temple: Architectural and Sculptural Imagery of the Kandariyā Mahādeva Temple of Khajuraho', paper delivered at the 'Destiny of Man' seminar organized by S.A.R.A.S. and the Arts Council of Great Britain. London, 1982.

DEVA, K. 'The Temples of Khajuraho in Central India', *Ancient India*, XV (1959), 43-65.

DEVA, K. 'Mahāvīra Temple, Sewādī', *Aspects of Jaina Art and Architecture*, ed. U.P. Shah and M.A. Dhaky, 253-6. Ahmedabad, 1975. (Deva, 1975a)

DEVA, K. 'Mahāvīra Temple, Ghāṇerāv', *Aspects of Jaina Art and Architecture*, ed. U.P. Shah and M.A. Dhaky. Ahmedabad, 1975. (Deva, 1975b)

DEVA, K. 'Bhūmija Temples', *Studies in Indian Temple Architecture*, ed. P. Chandra, 90-113. New Delhi, 1975. (Deva, 1975c)

DHAKY, M. A. 'The Chronology of the Solanki Temples of Gujarat', *Journal of the Madhya Pradesh Itihasa Parishad*, III (1961), 1-83.

DHAKY, M. A. 'The Date of the Dancing Hall of the Sun Temple, Modhera', *Journal of the Asiatic Society of Bombay*, 38/1963 (N.S.), 1964.

DHAKY, M. A. As for Chapter 9 (1965a).

DHAKY, M. A. 'Renaissance and the Late Marū-Gurjara Temple Architecture', *Journal of the Indian Society of Oriental Art* (1965-6), 4-22.

DHAKY, M. A. 'Kiradu and the Māru-Gurjara Style of Temple Architecture', *Bulletin of the American Academy of Benares*, I, 35-45. Varanasi, 1967.

DHAKY, M. A. As for Chapter 11 (1968), (1975a), (1975b).

DHAKY, M. A. 'Complexities Surrounding the Vimalavasahī Temple at Mount Abu', translated from the Gujarati, *Occasional Papers, Department of South Asia Regional Studies, University of Pennsylvania*. Philadelphia, 1980.

DONALDSON, T. 'Propitious-Apotropaic Eroticism in the Art of Orissa', *Artibus Asiae*, XXXVII (1975), 75-100.

FERGUSSON, J. *A History of Indian and Eastern Architecture*. 2 vols. London, 1910.

FLORY, M. *Les temples de Khajuraho*. Lucerne, 1965.

JAIN-NEUBAUER, J. *The Stepwells of Gujarat*. New Delhi, 1981.

KRAMRISCH, S. As for Chapter 11 (1946).

LANIUS, M. C. 'Rajasthani Sculpture from the Ninth and Tenth Centuries', *Aspects of Indian Art*, 78-84. Leiden, 1972.

LERNER, M. 'Some Unpublished Sculpture from Harshagiri', *Bulletin of the Cleveland Museum of Art*, LVI, 10 (1969), 354–64.

MEISTER, M. W. 'Juncture and Conjunction. Punning and Temple Architecture', *Artibus Asiae*, XLI, 2/3 (1979), 226–34.

RAO, T. A. G. *Elements of Hindu Iconography*. 4 vols. Madras, 1914.

SARASWATI, S. K. As for Chapter 15 (1957).

SHAH, U. P. *Studies in Jaina Art*. Jain Cultural Research Society, Banaras, 1955.

SHAH, U. P. 'Some Mediaeval Sculptures from Gujarat and Rajasthan', *Western Art*, special number of the *Journal of the Indian Society for Oriental Art* (1965–6). (Shah, 1965–6b)

SHAH, U. P. As for Chapter 11 (1975).

SINGH, H. 'The Jaina Temples of Kumbhāriā', *Aspects of Jaina Art and Architecture*, ed. U. P. Shah and M. A. Dhaky. Ahmedabad, 1975.

TOY, S. *The Strongholds of India*. London, 1957.

TOY, S. *The Fortified Cities of India*. London, 1965.

TRIPATHI, G. C. 'The Worship of Kārtavīrya-Arjuna: On the Deification of a Royal Personage in India', *Journal of the Royal Asiatic Society* (1979), no. 1, 37–52.

ZANNAS, E., and AUBOYER, J. *Khajuraho*. 's-Gravenhage, 1960.

Chapter 17: Orissa

BANERJI, R. D. 'Antiquities of Baudha State', *Journal of the Bengal and Orissa Research Society*, XV (1929), 64–86.

BOSE, N. K. *Canons of Orissan Architecture*. Calcutta, 1932.

BROWN, P. As for Chapter 1 (1942a).

DEHEJIA, V. As for Chapter 12 (1979).

DHAKY, M. A. As for Chapter 12 (1974).

DONALDSON, T. 'Development of the Vajra-Mastaka on Orissan Temples', *East and West*, XXVI (1976), 419–33.

ESCHMANN, A., KULKE, H., and TRIPATHI, G. C., eds. *The Cult of Jagannāth and the Regional Tradition of Orissa*. New Delhi, 1978.

FERGUSSON, J. As for Chapter 16 (1910).

GANGULY, M. *Orissa and Her Remains: Ancient and Mediaeval*. Calcutta, 1912.

HAQUE, Z. As for Chapter 15 (1980).

KULKE, H. 'Some Remarks About the Jagannātha Trinity', *Indologen-Tagung 1971*, ed. H. Härtel and Volker Moeller, 126–39. Wiesbaden, 1973.

KULKE, H. *Jagannatha-Kult und Gajapati-Königtum. Ein Beitrag zur Geschichte religiöser Legitimation hinduistischer Herrscher*. Heidelberg, 1979. (Kulke, 1979a)

KULKE, H. 'Rathas and Rajas: The Car Festival at Puri', *Art and Archaeology Research Papers*, XVI (1979), 19–26. (Kulke, 1979b)

KULKE, H. 'King Anaṅgabhīma III, the Veritable Founder of the Gajapati Kingship and of the Jagannātha Trinity at Puri', *Journal of the Royal Asiatic Society* (1981), no. 1, 26–39.

MITRA, D. As for Chapter 12 (1966).

MITRA, R. As for Chapter 2 (1880).

PANIGRAHI, K. C. As for Chapter 12 (1961).

SIVARAMAMURTI, C. *Royal Conquests and Cultural Migrations in South India and the Deccan*. Calcutta, 1955.

STARZA-MAJEWSKI, O. M. *The Origin of the Form and Iconography of Jagannātha, Balarāma and Subhadrā*. Unpublished Oxford thesis, 1969.

STARZA-MAJEWSKI, O. M. 'King Narasimha Before His Spiritual Preceptor', *Journal of the Royal Asiatic Society* (1971), no. 2, 134–8.

STARZA-MAJEWSKI, O. M. *The Jagannātha Temple at Puri and Its Deities*. Amsterdam, 1983.

Chapter 18: The Deccan

BONTA, R. J. DEL. 'The *Madanakais* at Belur', *Kalādarśana (American Studies in Indian Art)*, ed. J. G. Williams, 27–33. New Delhi, 1981.

BROWN, P. As for Chapter 1 (1942a).

COUSENS, H. As for Chapter 13 (1926).

DEGLURKAR, G. B. *Temple Architecture and Sculpture of Maharashtra*. Nagpur, 1974.

DERRETT, J. D. M. *The Hoysalas*. Madras, 1957.

DHAKY, M. A. *The Indian Temple Forms in Karṇāta Inscriptions and Architecture*. New Delhi, 1977.

KRAMRISCH, S. As for Chapter 11 (1946).

KRAMRISCH, S. *Manifestations of Shiva*. Exhibition catalogue. Philadelphia, 1981.

MARCHAL, H. *L'Architecture comparée dans l'Inde et l'Extrême-Orient*. Paris, 1944.

MORAES, G. M. *The Kadamba Kula*. Bombay, 1931.

MURTHY, S. G. *The Sculpture of the Kakatiyas*. Hyderabad, 1970.

NARASIMHACHAR, R. *The Kesava Temple at Somanathapur (Architecture and Sculpture in Mysore*, I). Bangalore, 1917.

NARASIMHACHAR, R. *The Kesava Temple at Belur (Architecture and Sculpture in Mysore*, II). Bangalore, 1919. (Narasimhachar, 1919a)

NARASIMHACHAR, R. *The Laksmidevi Temple at Dodda Gaddavalli (Architecture and Sculpture in Mysore*, III). Bangalore, 1919. (Narasimhachar, 1919b)

PRASAD, B. R. *Art of South India: Andhra Pradesh*. Delhi, 1980.

RAO, M. R. *The Temples of Sri Sailam.* Hyderabad, 1969.

RAO, M. S. N. *Journal of the Asiatic Society of Bombay*, XLI–XLII (1966–7), 190–3.

SARMA, M. R. *Temples of Telingāna.* Hyderabad, 1972.

SETTAR, S. 'The Brahmadeva Pillars', *Artibus Asiae*, XXXIII, 1/2 (1971), 17–38.

SETTAR, S. *Hoysala Sculpture in the National Museum.* Copenhagen, 1975.

STACHE-ROSEN, V. 'Gandabherunda. Zur Tradition des doppelköpfigen Vogels in Südindien', *Beiträge zur Indienforschung.* Berlin, 1977.

PART FIVE: SOUTH INDIA

Chapter 19: Introduction

HARDY, F. M. *Viraha-Bhakti: The Early History of Kṛṣṇa Devotion in South India.* Oxford, 1983.

HARLE, J. C. As for Chapter 11 (1977).

KRAMRISCH, S. As for Chapter 11 (1946).

Chapter 20: The Pallavas

AIYAR, K. V. S. 'Origin and Decline of Buddhism and Jainism in Southern India', *Indian Antiquary*, XL (1911), 209–18.

ARAVAMUTHAN, T. G. As for Chapter 3 (1931).

BANERJEE, N. R. *The Iron Age in India.* Delhi, 1965.

BARRETT, D. *The Temple of Virattaneśvara at Tiruttani.* Bombay, 1958.

BARRETT, D. 'Two Lost Early Cola Temples', *Oriental Art*, N.S. XVII, 1 (1971), 39–44.

BARRETT, D. 'The Dancing Siva in Early South Indian Art', *Proceedings of the British Academy*, LXII (1976), 181–203.

BARRETT, D. 'Two Pandya Temples', *Beiträge zur Indienforschung*, Veröffentlichungen des Museums für Indische Kunst, Band 4, 25–44. Berlin, 1977.

DUMARÇAY, J., and L'HERNAULT, F. *Temples Pallavas construits.* Paris, 1975.

HARLE, J. C. 'Durgā, Goddess of Victory', *Artibus Asiae*, XXVI, 3/4 (1963), 237–46.

HUNTINGDON, S. L. 'Iconographic Reflections on the Arjuna Ratha', *Kāladarśana (American Studies in the Art of India)*, 57–67. New Delhi, 1981.

JOUVEAU-DUBREUIL, G. *Archéologie du sud de l'Inde.* 2 vols. Paris, 1914.

JOUVEAU-DUBRREUIL, G. *Pallava Antiquities.* 2 vols. Pondicherry, 1916–18.

JOUVEAU-DUBREUIL, G. *Vedic Antiquities.* Pondicherry and London, 1922.

LESHNIK, L. S. *South Indian 'Megalithic' Burials.* Wiesbaden, 1974.

LIPPE, A. As for Chapter 13 (1978).

LONGHURST, A. H. As for Chapter 13 (1924–30).

MCINTOSH, J. R. 'The Megalith Builders of South India: A Historical Survey', *South Asian Archaeology 1979*, 459–68. Berlin, 1981.

MARR, J. R. '"Arjuna's Penance" – A Reconsideration', paper delivered at the Conference on Recent Work in Art and Archaeology of South Asia, School of Oriental and African Studies. London, 1974.

MINAKSHI, C. *The Historical Sculptures of the Vaikunthaperumāl Temple, Kāñchī (Mem. A.S.I.*, LXIII). Delhi, 1941.

NAGASWAMY, R. 'New Light on Mamallapuram', *Transactions of the Archaeological Society of South India – Silver Jubilee Volume*, 1–50. Madras, 1962.

NAGASWAMY, R. 'Some Contributions of the Pāṇḍya to South Indian Art', *Artibus Asiae*, XXVII, 3 (1965).

PATTABIRAMIN, P.-Z. *Sanctuaires rupestres de l'Inde du sud*, I, *Andhra.* Pondicherry, 1971.

RAJAN, K. V. S. 'Early Pāṇḍya, Muttarayar and Irukkuvel Architecture', *Studies in Indian Temple Architecture*, ed. P. Chandra, 240–300. New Delhi, 1975.

RAMACHANDRAN, K. S. *A Bibliography on Indian Megaliths.* State Department of Archaeology, Government of Tamilnadu, 1971.

RAMACHANDRAN, T. N. 'Kiratarjuniya', *Journal of the Indian Society of Oriental Art*, XVIII (1950–1).

RAO, M. S. N. *Kirātārjunīyam in Indian Art.* Delhi, 1979.

SARKAR, H. 'A Pandya Rock-Cut Cave at Manappadu on Pearl Fishery Coast', *Damilica*, I (1970), 74–82.

SARMA, I. K. 'New Light on Art Through Archaeological Conservation', *Journal of the Indian Society of Oriental Art*, X (1978–9), 48–54.

SARMA, I. K. *The Development of Early Śaiva Art and Architecture (With Special Reference to Āndhradeśa).* Delhi, 1982.

SCHINDLER, G. J. 'Cave I at Nārttamalai: A Reappraisal', *Artibus Asiae*, XLI, 2/3 (1979), 235–52.

SIVARAMAMURTI, C. *Kalugumalai and Early Pandyan Rock-Cut Temples.* Bombay, 1961. (Sivaramamurti, 1961b)

SRINIVASAN, K. R. 'The Pallava Architecture of South India', *Ancient India*, XIV (1958), 114–38.

SRINIVASAN, K. R. 'Some Aspects of Religion as Revealed by Early Monuments and Literature of the South', *Journal of Madras University*, XXXII (1960), 131–98.

SRINIVASAN, K. R. *Cave Temples of the Pallavas.* New Delhi, 1964.

SRINIVASAN, K. R. 'Some Non-Pallava Cave Temples with Musical Inscriptions', *Damilica*, I (1970), 83-91.

SRINIVASAN, K. R. 'Temples of the Later Pallavas', *Studies in Indian Temple Architecture*, ed. P. Chandra, 197-239. New Delhi, 1975. (Srinivasan, 1975a)

SRINIVASAN, K. R. *The Dharmarāja Ratha and Its Sculptures*. New Delhi, 1975. (Srinivasan, 1975b)

SRINIVASAN, K. R., and BANERJEE, N. R. 'Survey of South Indian Megaliths', *Ancient India*, IX (1953), 103-15.

SRINIVASAN, P. R., and AIYAPPAN, A. *Story of Buddhism with Special Reference to South India*. Government of Madras, 1959.

SUBBIAH, G. *Pāṇḍya Architecture*. Ph.D. thesis, Calcutta, 1977.

WHEELER, R. E. M., GHOSH, A., and DEVA, K. 'Arikamedu: An Indo-Roman Trading Station on the East Coast of India', *Ancient India*, II (1946), 17-124.

WILLETTS, W. Y. *An Illustrated Annotated Annual Bibliography of Mohabalipuram on the Coromandel Coast of India, 1582-1962*. Kuala Lumpur, 1966.

ZIMMER, H. *The Art of Indian Asia*. 2 vols. New York, 1955.

Chapter 21: The Early Cola Period

ADICEAM, M. E. 'Les images de Śiva dans l'Inde du sud', *Arts Asiatiques* (1965-78).

ADICEAM, M. E. 'De quelques images d'Aiyanār-Śāstā', *Arts Asiatiques*, XXIV (1978), 87-104.

BALASUBRAHMANYAM, S. R. *Early Chola Art*, part I. Bombay, 1966.

BALASUBRAHMANYAM, S. R. *Early Chola Temples, Parantaka I to Rajaraja I: A.D. 907-985*. New Delhi, 1971.

BANERJEA, J. N. As for Chapter 1 (1942).

BARRETT, D. *Early Cola Bronzes*. Bombay, 1965.

BARRETT, D. As for Chapter 20 (1971).

BARRETT, D. *Early Cola Architecture and Sculpture*. London, 1974.

BARRETT, D. As for Chapter 20 (1976), (1977).

BAXANDALL, M. *Painting and Experience in Fifteenth Century Italy*. Oxford, 1974.

BROWN, P. 'Two Cola Temples', *Journal of the Indian Society of Oriental Art*, II, 1 (1934), 2-7.

BROWN, P. As for Chapter 1 (1942a).

DHAKY, M. A. 'Cola Sculpture', *Chhavi*, ed. A. Krishna, 263-89. Varanasi, 1971.

DUMONT, L. 'Définition structurale d'un dieu populaire tamoul: Aiyanār le Maître', *Journal Asiatique*, CCXLI (1953), 255-70.

FILLIOZAT, J. 'Les images de Śiva dans l'Inde du sud I. L'image de l'origine du liṅga (Liṅgodbhavamūrti)', *Arts Asiatiques*, VIII, 1 (1961), 42-56.

GASTON, A.-M. *Siva in Dance, Myth, and Iconography*. Delhi, 1982.

GRAVELY, F. H., and RAMACHANDRAN, T. N. *Catalogue of South Indian Hindu Metal Images*. Madras, 1932.

GROUSSET, R. *India*. London, 1932.

HARLE, J. C. 'The Early Cola Temple at Pullamaṅgai', *Oriental Art*, N.S. IV, 3 (1958), 96-108. (Harle, 1958a)

HARLE, J. C. *The Brahmapurisvara Temple at Pullamangai*. Bhulabhai Memorial Institute, Bombay, 1958. (Harle, 1958b)

*HOEKVELD-MEIJER, G. *Koyils in the Colamandalam: Typology and Development of Early Cola Temples*. Amsterdam, 1981.

JOUVEAU-DUBREUIL, G. As for Chapter 20 (1914).

KRAMRISCH, S. *The Art of India*. London, 1954.

KRAMRISCH, S. 'Śiva, the Archer', *Indologen-Tagung 1971*, ed. H. Härtel and Volker Moeller, 140-50. Wiesbaden, 1973.

LIEBERT, G. *Iconographic Dictionary of the Indian Religions*. Leiden, 1976.

MAHALINGAM, T. V. 'The Nageśvara Temple', *Journal of Indian History*, XLV, part 1 (1967), 35-8.

NAGASWAMY, R. 'Rare Bronzes from Kongu Country', *Lalit Kalā*, IX (1961), 7-10. (Nagaswamy, 1961a)

NAGASWAMY, R. 'Some Adavallān and Other Bronzes of the Early Chola Period', *Lalit Kalā*, X (1961), 34-40. (Nagaswamy, 1961b)

NAGASWAMY, R. 'Important Discoveries', *Damilica*, I (1970), 1-34.

NAGASWAMY, R. 'Pallava Bronzes from Vadakkalathur', *Oriental Art*, N.S. XVII, 1 (1971), 55-9.

NAGASWAMY, R. 'A Naṭarāja Bronze and an Inscribed Umā from Karaiviram Village', *Lalit Kalā*, XIX (1979), 17-19.

PATTABIRAMIN, P.-Z. 'Notes d'iconographie dravidienne', *Arts Asiatiques*, VI (1959), 13-32.

RAJAN, K. V. S. As for Chapter 20 (1975).

RAO, T. A. G. As for Chapter 16 (1914).

SASTRI, H. K. *South-Indian Images of Gods and Goddesses*. Madras, 1916.

SASTRI, K. A. N. *The Colas*. 2nd ed. Madras, 1955.

SIVARAMAMURTI, C. *South Indian Bronzes*. New Delhi, 1963.

SIVARAMAMURTI, C. *Naṭarāja*. New Delhi, 1974.

SRINIVASAN, P. R. 'Rare Sculptures of the Early Chola Period', *Lalit Kalā*, V (1959), 59-67.

SRINIVASAN, P. R. *Bronzes of South India (Bulletin of the Government Museum)*. Madras, 1963.

VATSYAYANA, K. *Classical Indian Dance in Literature and the Arts.* New Delhi, 1968.

Chapter 22: The Later Cola Period

BALASUBRAHMANYAM, S. R. *Four Chola Temples.* Bombay, 1963.
BALASUBRAHMANYAM, S. R. *Middle Chola Temples: Rajaraja I to Kulottunga I (A.D. 985–1070).* Faridabad, 1975.
BALASUBRAHMANYAM, T. B. 'Chidambaram in Vijayanagar Days', *Journal of the Bombay Historical Society*, IV, 1 (1931), 40–53.
BARRETT, D. As for Chapter 21 (1974).
BARRETT, D. 'A Group of Bronzes of the Late Cola Period', *Oriental Art*, XXIX, 4 (1983–4), 360–7.
GRAVELY, F. H. *The Gopuras of Tiruvannamalai (Bulletin of the Government Museum).* Madras, 1939.
GROS, F., and NAGASWAMY, R. *Uttameru̇r: Légendes, histoires, monuments, avec le Pañcavaradakshetra Māhātmya.* Pondicherry, 1970.
HARLE, J. C. 'Two Images of Agni and Yajñapurusa in South India', *Journal of the Royal Asiatic Society* (1962), nos. 1 and 2, 1–17.
HARLE, J. C. As for Chapter 20 (1963).
JOUVEAU-DUBREUIL, G. As for Chapter 20 (1914).
KRAMRISCH, S. As for Chapter 11 (1946).
KULKE, H. *Cidambaramāhātmya.* Wiesbaden, 1970.
LIPPE, A. As for Chapter 13 (1978).
MARCHAL, H. 'Le temple de Śrī Egambareśvara (Śiva) à Varada-Settur', *Arts Asiatiques*, VII, 2 (1960), 83–100.
NAGASWAMY, R. *Gangaikondacholapuram.* Madras, 1970.
RAMACHANDRAN, T. N. *Tirupparutikunram and Its Temples (Bulletin of the Madras Government Museum*, I, part 3). Madras, 1934.
RAMACHANDRAN, T. N. *The Nāgapattinam and Other Buddhist Bronzes in the Madras Museum.* Madras, 1965.
RAMAN, K. V. *Sri Varadarajaswami Temple, Kanchi.* New Delhi, 1975.
SARKAR, H. *The Kampaharesvara Temple at Tribhuvanam.* Madras, 1974.
SASTRI, K. A. N. As for Chapter 21 (1955).
SCHLINGLOFF, D. *Die altindische Stadt.* Mainz, 1969.
SIVARAMAMURTI, C. As for Chapter 20 (1961b).
SIVARAMAMURTI, C. As for Chapter 21 (1963).
SOMASUNDARAM PILLAI, J. M. *The University's Environs.* Annamalainagar, 1957.
SOMASUNDARAM PILLAI, J. M. *The Great Temple at Tanjore.* 2nd ed. Tanjore, 1958.
SRINIVASAN, K. R. 'The Last of the Great Cola Temples', *Journal of the Indian Society of Oriental Art*, XVI (1948), 11–33.

Chapter 23: Vijayanagara

AUBOYER, J. *Sri Ranganāthaswāmi: Le temple de Vishnu à Srirangam.* Paris, 1969.
BRAMZELIUS, A. W. *Die hinduistische Pantheon Glasmalerei.* Leiden, 1937.
FRANZ, H. G. As for Chapter 2 (1979).
HARLE, J. C. 'South Indian Temple Bases', *Oriental Art*, N.S. III, 4 (1957), 3–10.
HARLE, J. C. As for Chapter 20 (1963).
KULKE, H. 'Legitimation and Town-Planning in the Feudatory States of Central Orissa', *Art and Archaeology Research Papers*, XVII (1980), 30–40.
LONGHURST, A. H. *Hampi Ruins.* Madras, 1917.
RAMAN, K. V. As for Chapter 22 (1975).
RAO, V. N. H. *The Śrīrangam Temple.* Tirupati, 1967.
SEWELL, R. *A Forgotten Empire (Vijayanagar).* London, 1900.
SIVARAMAMURTI, C. *South Indian Paintings.* New Delhi, 1968.

Chapter 24: Kerala

ADICEAM, M. E. *Contributions à l'étude d'Aiyanār-Sāsta (Publications de l'Institut Français d'Indologie, XXXII).* Pondicherry, 1967.
ADICEAM, M. E. As for Chapter 21 (1978).
BHATT, P. G. *Studies in Tuluva History and Culture.* Manipal, 1975.
CHITRA, V. R., and SRINIVASAN, T. N. *Cochin Murals.* 3 vols. Cochin, 1940.
COUSENS, H. As for Chapter 13 (1926).
DUMONT, L. As for Chapter 21 (1953).
KRAMRISCH, S., et al. *The Arts and Crafts of Travancore.* Oxford, 1952.
PIEPER, J. 'The Spatial Structure of Suchindram', *Art and Archaeology Research Papers*, XVII (1980), 65–80.
PILLAI, K. K. *The Sucindram Temple.* Madras, 1953.
SARKAR, H. *An Architectural Survey of Temples of Kerala.* Archaeological Survey of India, New Delhi, 1978.
SHARMA, Y. D. 'Rock-cut Caves in Cochin', *Ancient India*, XII (1956), 93–115.
SIVARAMAMURTI, C. As for Chapter 23 (1968).

PART SIX: PAINTING

*Chapter 25: Mural Painting
and the Beginnings of Miniature Painting*

AAL, A., *et al.*, eds. *Ajanta Murals*. New Delhi,
1967.
ASKARI, S. H. 'Qutban's Mrigavat. A Unique MS.
in Persian Script', *Journal of the Bihar Research
Society*, XLI, part 4 (1955), 452-87.
AUBOYER, J., and BÉGUIN, G. *Dieux et démons de
l'Himālaya; Art du Bouddhisme lamaïque.* Exhibi-
tion catalogue. Paris, 1977.
BARRETT, D., and GRAY, B. *Painting of India.*
New York, 1963.
BINNEY, E., 3rd. *Indian Miniature Paintings from
the Collection of Edwin Binney 3rd*, I, *The Mughal
and Deccani Schools with Some Related Sultanate
Material.* Portland, Oregon, 1973.
BROWN, W. N. *Vasanta Vilasa.* New Haven, 1962.
CHANDRA, M. *Jain Miniature Paintings from West-
ern India.* Ahmedabad, 1949. (M. Chandra,
1949a)
CHANDRA, M. 'A Pair of Painted Wooden Covers
of the Kārandavyūha MS. dated A.D. 1455 from
Eastern India', *Chhavi*, ed. A. Krishna, 240-2.
Varanasi, 1971.
CHATHAM, D. C. 'Rasa and Sculpture', *Kalādarśana
(American Studies in Indian Art,* ed. J. Williams),
19-26. Oxford and New Delhi, 1981.
CONZÉ, E. 'Remarks on a Pāla MS.', *Oriental Art*,
I, I (1948), 9-12.
COOMARASWAMY, A. K. As for Chapter 2 (1927).
COULSON, M. A., trans. *Three Sanskrit Plays.*
Harmondsworth, 1981.
DIGBY, S. 'The Literary Evidence for Painting in
the Delhi Sultanate', *Bulletin of the American
Academy of Benares*, I (1967), 47-58.
DOSHI, S. 'A Fifteenth Century Jain Manuscript
from Gwalior and Some Thoughts on the Caura-
pañcāśikā Style', *Journal of the Indian Society of
Oriental Art*, X (1978-9), 30-40.
FRAAD, I. L., and ETTINGHAUSEN, R. 'Sultanate
Painting in Persian Style, Primarily from the First
Half of the Fifteenth Century', *Chhavi* (1971),
48-66.
GORAKSHKAR, S. V. 'A Dated Manuscript of the
Kālakācāryakathā in the Prince of Wales Museum',
*Bulletin of the Prince of Wales Museum of Western
India*, IX (1964-6), 56-7.
HINGORANI, R. P. *Painting in South Asia - A
Bibliography.* Delhi and Varanasi, 1976.
KHANDALAVALA, K. 'A Gita Govinda Series in
the Prince of Wales Museum', *Bulletin of the
Prince of Wales Museum*, IV (1953-4), 1-18.

KHANDALAVALA, K., and CHANDRA, M. 'Three
New Documents of Indian Painting', *Prince
of Wales Museum Bulletin*, VII (1959-62), 23-
34.
KHANDALAVALA, K., and CHANDRA, M. 'An Il-
lustrated MS. of the Āraṇyaka Parvan in the Collec-
tion of the Asiatic Society, Bombay', *Journal of
the Asiatic Society, Bombay*, N.S. XXXVIII (1963),
116-21.
KHANDALAVALA, K., and CHANDRA, M. *New
Documents of Indian Painting.* Bombay, 1969.
KHANDALAVALA, K., CHANDRA, M., CHAN-
DRA, P., and GUPTA, P. L. 'A New Document
of Indian Painting', *Lalit Kalā*, X (1961), 45-54.
KHANDALAVALA, K., and MITTAL, J. 'The Bha-
gavata MSS. from Palam and Isarda - A Con-
sideration in Style', *Lalit Kalā*, XVI (1974), 28-32.
KRISHNADASA, R. 'An Illustrated Avadhī MS. of
Laur-Chandā in the Bhārat Kalā Bhavan, Banaras',
Lalit Kalā, I-II (1955-6), 66-71.
LERNER, M. *Indian Miniatures from the Jeffrey
Paley Collection.* New York, 1974.
LOSTY, J. P. 'Some Illustrated Jaina Manuscripts',
British Library Journal, I (1975), 145-62.
LOSTY, J. P. 'A Pair of Illustrated Binding Boards
from Bihar of 1491-92', *Oriental Art*, XXIII (1977),
190-9.
LOSTY, J. P. *The Art of the Book in India.* Exhi-
bition catalogue. London, 1982.
MALLMANN, M. T. DE. 'À propos d'un MS. illustré
du XIe siècle', *Oriental Art*, XI, 4 (1965), 224-34.
MARSHALL, J. As for Chapter 9 (1927).
MILLER, B. S. *Phantasies of a Love-Thief - The
Caurapañcāśikā attributed to Bilhana - A Critical
Edition and Translation of Two Recensions with
Sixteenth Century Illustrations of the Text.* Lon-
don, 1971.
NAWAB, S. M. *The Oldest Rajasthani Paintings from
Jain Bhandars.* Ahmedabad, 1959.
PAL, P. 'A New Document of Indian Painting',
Journal of the Royal Asiatic Society (1965), 103-
11.
PAL, P. *The Arts of Nepal*, part II, *Painting.*
Leiden, 1978. (Pal, 1978a)
SARASWATI, S. K. 'East Indian Manuscript Paint-
ing', *Chhavi*, ed. A. Krishna, 243-62. Varanasi,
1971.
SHIVESHWARKAR, L. *The Pictures of the Chaura-
pañcāśikā: A Sanskrit Love Lyric.* New Delhi, 1967.
SILVA, R. H. DE. *The Development of the Technique
of Sinhalese Wall-Painting.* D.Phil. thesis, Oxford,
1962.
SIVARAMAMURTI, C. As for Chapter 23 (1968).
SKELTON, R. 'The Ni'mat Namah: A Landmark
in Malwa Painting', *Mārg*, XII, 3 (1959), 44-8.

SKELTON, R. 'The Iskander Nama of Nusrat Shah', *Indian Painting*, Colnaghi catalogue (1978), 135–52.

SPINK, W. *Krishna Mandala*. Ann Arbor, Michigan, 1971. (Spink, 1971b)

STOOKE, H. J. 'An XI Century Illuminated Palm Leaf MS.', *Oriental Art*, I, 1 (1948), 5–19.

WAKANKAR, V. S., and BROOKS, R. R. R. As for Chapter 1 (1976).

WELCH, S. C. *A Flower from Every Meadow*. New York, 1973.

YAZDANI, G., *et al.* As for Chapter 9 (1931–46).

Chapter 26: Mughal Painting

ARCHER, M. *Patna Painting*. London, 1947.

ARCHER, M. 'British Patrons of Indian Artists: Sir Elijah and Lady Impey', *Country Life* (18 August 1955), 340–1.

ARCHER, M. 'Company Painting in South India: The Early Collections of Niccolao Manucci', *Apollo* (August 1970), 104–13.

ARCHER, M. *Company Drawings in the India Office Library*. London, 1972.

ARCHER, M. and W. G. *Indian Painting for the British 1770–1880*. Oxford, 1955.

ARCHER, M. and W. G. *Indian Miniatures and Folk Paintings*. London, 1967.

ARCHER, W. G. *Indian Miniatures*. London, 1960.

AUBOYER, J. 'Un maître hollandais du XVIIe siècle s'inspirant des miniatures mogholes', *Arts Asiatiques*, II, 4 (1955), 251–73.

BARRETT, D., and GRAY, B. As for Chapter 25 (1963).

BEACH, M. C. *The Grand Mogul – Imperial Painting in India*. Williamstown, Mass., 1978.

BINNEY, E., 3rd. *Indian Miniature Painting from the Collection of Edwin Binney 3rd*. Exhibition catalogue, Portland Art Museum. Portland, Oregon, 1973.

BROWN, P. *Indian Painting under the Mughals*. Oxford, 1924.

BROWN, P. *Indian Architecture (Islamic Period)*. 3rd ed. Calcutta, 1942. (Brown, 1942b)

CHANDRA, M. *The Technique of Mughal Painting*. Lucknow, 1949. (M. Chandra, 1949b)

CHANDRA, P. 'Ustād Sālivāhana and the Development of Popular Mughal Art', *Lalit Kalā*, VIII (1960), 25–46.

CHANDRA, P. *The Tuti-nama of the Cleveland Museum of Art and the Origins of Mughal Painting*. 2 vols. Graz, 1976.

ETTINGHAUSEN, R. *Paintings of the Sultans and Emperors of India in American Collections*. New Delhi, 1961.

FALK, T. *Persian and Mughal Art*. Exhibition catalogue. Colnaghi's, London, 1976.

FALK, T., and ARCHER, M. *Indian Miniatures in the India Office Library*. London and Delhi, 1981.

GLÜCK, H. *Die indischen Miniaturen aus Haemsa-Romanes*. Vienna, 1925.

LOEWENSTEIN, J. DE. 'À propos d'un tableau de W. Schellinks s'inspirant de miniatures moghules', *Arts Asiatiques*, V, 4 (1958), 293–8.

LOWRY, G. D. 'The Emperor Jahangir and the Iconography of the Divine in Mughal Painting', *Rutgers Art Review*, IV (1983), 36–45.

PINDER-WILSON, R. H. *Paintings from the Muslim Courts of India*. Exhibition catalogue. British Museum, London, 1976.

SARRE, F. 'Rembrandts Zeichnungen nach indisch-islamischen Miniaturen', *Jahrbuch der königlich preussischen Kunstsammlungen*, XXV (1904), 143–58.

SKELTON, R. 'A Decorative Motif in Mughal Art', *Aspects of Indian Art*, ed. P. Pal, 147–52. Los Angeles, 1972.

WELCH, S. C. As for Chapter 25 (1973).

WELCH, S. C. *Imperial Mughal Painting*. New York, 1978.

Chapter 27: Painting in Rājasthān, Mālwā, and Central India

ANDHARE, S. 'A Dated Amber Rāgamālā and the Problem of Provenance of the Eighteenth Century Jaipuri Paintings', *Lalit Kalā*, XV (1972), 47–51.

ARCHER, W. G. *Central Indian Painting*. London, 1958.

ARCHER, W. G. *Indian Painting in Bundi and Kotah*. London, 1959.

BARRETT, D., and GRAY, B. As for Chapter 25 (1963).

BEACH, M. C. *Rajput Painting at Bundi and Kotah*. Ascona, 1974.

BROWN, W. N. 'Some Early Rājasthānī Rāga Paintings', *Journal of the Indian Society of Oriental Art*, XVI (1948), 1–10.

CHANDRA, M. 'An Illustrated Set of the Amaru Śataka', *Bulletin of the Prince of Wales Museum*, *Bombay*, II (1951–2), 1–63.

CHANDRA, P. *Bundi Painting*. New Delhi, 1959.

DAHMEN-DALLAPICCOLA, A. L. *Rāgamālā-Miniaturen von 1475 bis 1700*. Wiesbaden, 1975.

DICKINSON, E., and KHANDALAVALA, K. *Kishangarh Painting*. New Delhi, 1959.

DOSHI, S. 'An Illustrated Manuscript from Aurangabad Dated 1650 A.D.', *Lalit Kalā*, XV (1972), 19–28.

EBELING, K. *Ragamala Painting*. Basel, etc., 1973.

KANORIA, G. K. 'An Early Dated Rājasthānī Rāgamāla', *Journal of the Indian Society of Oriental Art*, XIX (1952–3), 1–5.

KAYE, G. R. *The Astronomical Observatories of Jai Singh* (*A.S.I.*, New Imperial Series, XL). Calcutta, 1918.

KHANDALAVALA, K. 'Leaves from Rajasthan', *Marg*, IV, no. 3 (1950), 2–24, 49–56.

KHANDALAVALA, K., CHANDRA, M., and CHANDRA, P. *Miniature Painting*. A catalogue of the Sri Motichand Khajanchi Collection. New Delhi, 1960.

KRISHNA, A. 'An Early Ragamala Series', *Ars Orientalis*, IV (1961), 368–72.

KRISHNA, A. *Malwa Painting*. Banaras, 1963.

KÜHNEL, E. *Indische Miniaturen aus dem Besitz der Staatlichen Museen zu Berlin*. Berlin, 1937.

MEHTA, N. C. 'A Note on Rāgamāla', *Journal of the Indian Society of Oriental Art*, III, 2 (1935), 145–7.

NAWAB, S. M. *Masterpieces of the Kalpasutra Paintings*. Ahmedabad, 1956.

PAL, P. *Rāgamāla Paintings in the Museum of Fine Arts, Boston*, 23–33. Exhibition catalogue. Boston, 1967. (Pal, 1967a)

POWERS, H. 'Illustrated Inventories of Indian Rāgamāla Painting', *Journal of the American Oriental Society*, C, 4 (1980), 473–93.

SINGH, K. S. 'An Early *Rāgamāla* MS. from Pali (Marwar School) dated 1623 A.D.', *Lalit Kalā*, VII (1960), 76–81.

SKELTON, R. *Rājasthānī Temple Hangings of the Krishna Cult*. New York, 1973. (Skelton, 1973b)

STOOKE, H., and KHANDALAVALA, K. *The Laud Ragamala*. Oxford, 1953.

WALDSCHMIDT, E. and R. L. *Miniatures of Musical Inspiration in the Collection of the Berlin Museum of Indian Art*. Part 1. Wiesbaden, 1967.

WALDSCHMIDT, E. and R. L. *Miniatures of Musical Inspiration in the Collection of the Berlin Museum of Indian Art*. Part 2. Berlin, 1975.

WELCH, S. C. *Room for Wonder: Indian Painting during the British Period 1760–1880*. New York, 1978.

Chapter 28: Deccani Painting

ARCHER, W. G. *Indian Miniatures*. London, 1960.

BARRETT, D. *Painting of the Deccan. XVI–XVII Century*. London, 1958. (Barrett, 1958a)

BARRETT, D. 'Some Unpublished Deccan Miniatures', *Lalit Kalā*, VII (1960), 9–13. (Barrett, 1960a)

BARRETT, D., and GRAY, B. As for Chapter 25 (1963).

BINNEY, E., 3rd. As for Chapter 25 (1973).

EBELING, K. As for Chapter 27 (1973).

GOETZ, H. *The Art and Architecture of Bikaner State*. Oxford, 1950.

GOSWAMY, B. N. 'Deccan Painting', *Lalit Kalā*, XII (1962), 41–4.

MITTAL, J. 'Deccani Paintings at the Samasthans of Wanaparthy, Gadwal and Shorapur', *Mārg*, XVI, 2 (1963).

SAH, S. S. *An Exhibition of Mughal Miniatures*. Catalogue of an exhibition of the Shri Sitaram Sah Collection, Varanasi. Calcutta, n.d.

SKELTON, R. 'The Mughal Artist Farrokh Beg', *Ars Orientalis*, II (1957), 393–411.

SKELTON, R. 'Early Golconda Painting', *Indologen-Tagung 1971*, 182–95. Wiesbaden, 1973. (Skelton, 1973a)

*ZEBROWSKI, M. *Deccani Painting*. London and Berkeley, 1983.

Chapter 29: Pahāṛī Painting

AIJAZUDDIN, F. S. *Pahari Paintings and Sikh Portraits in the Lahore Museum*. London, etc., 1977.

ARCHER, W. G. *Indian Paintings from the Punjab Hills*. 2 vols. London, 1973.

BARRETT, D., and GRAY, B. As for Chapter 25 (1963).

EASTMAN, A. C. *The Nala-Damayanti Drawings*. Boston, 1959.

GOSWAMY, B. N. 'Painting in Chamba: A Study of New Documents', *Asian Review*, II, 2 (1965), 53–8.

GOSWAMY, B. N. 'Of Patronage and Pahari Painting', *Aspects of Indian Art*, ed. P. Pal, 130–8. Los Angeles, 1972.

GOSWAMY, B. N. *Pahari Paintings of the Nala-Damayanti Theme in the Collection of Dr Karan Singh*. New Delhi, 1975.

KHANDALAVALA, K. *Pahari Miniature Painting*. Bombay, 1958.

LAL, M. *Garhwal Painting*. New Delhi, 1968.

MITTAL, J. 'The Wall Paintings of Chamba', *Mārg*, VIII, 3 (1955), 38–42, 97.

RANDHAWA, M. S. 'Kangra Artists', *Art and Letters*, XXIX, 1 (1955), 1–9.

RANDHAWA, M. S. *Basohli Painting*. New Delhi, 1959.

RANDHAWA, M. S. *Kangra Paintings on Love*. New Delhi, 1962.

RANDHAWA, M. S. *Kangra Paintings of the Bihari Sat Sai*. New Delhi, 1966.

SETH, M. *Wall Paintings of the Western Himālaya*. New Delhi, 1976.

WALDSCHMIDT, E. and R. As for Chapter 27 (1967).

PART SEVEN: INDO-ISLAMIC ARCHITECTURE

Chapter 30: The Delhi Sultanate

ASHER, C. B. 'The Mausoleum of Sher Shāh Sūri', *Artibus Asiae*, XXXIX, 3/4 (1977), 273-99.

BROWN, P. As for Chapter 26 (Brown, 1942b).

MARICQ, A., and WIET, G. *Le minaret de Djam. La découverte de la capitale des sultans Ghorides (XIIe-XIIIe siècles) (Mémoires de la Délégation Archéologique Française en Afghanistan*, XVI). Paris, 1959.

MARSHALL, J. 'The Monuments of Muslim India', *The Cambridge History of India*, III (1928), 568-663.

NAQVI, S. A. A. 'Sultān Ghārī, Delhi', *Ancient India*, III (1947), 4-10.

VERCELLIN, G. 'The Identification of Firuzkuh: A Conclusive Proof', *East and West*, XXVI, 3/4 (1976), 337-40.

Chapter 31: The Provincial Styles

BROWN, P. As for Chapter 26 (Brown, 1942b).

FÜHRER and SMITH, E. *The Sharqi Architecture of Jaunpur*. Archaeological Survey of India, 1889.

NATH, R. *The Art of Chanderi*. New Delhi, 1979.

Chapter 32: The Deccan

COUSENS, H. *Bijapur and Its Architectural Remains (A.S.I.*, Imperial Series, XXXVII). Bombay, 1916.

MARSHALL, J. As for Chapter 30 (1928).

MERKLINGER, E. S. 'The *Madrasa* of Mahmūd Gāwān in Bīdar', *Kunst des Orients*, XI (1976-7), nos. 1, 2, 144-57.

MERKLINGER, E. S. *Indian Islamic Architecture: The Deccan 1347-1686*. Warminster, Wiltshire, 1981.

Chapter 33: The Mughal Period

BEGLEY, W. E. 'Amān at Khān and the Calligraphy on the Taj Mahal', *Kunst des Orients*, XII, 1/2 (1978-9), 5-39.

BEGLEY, W. E. 'The Myth of the Taj Mahal and a New Theory of Its Symbolic Meaning', *Art Bulletin* (March 1979), 12-37.

BEGLEY, W. E. 'The Symbolic Role of Calligraphy on Three Imperial Mosques of Shāh Jahān', *Kalādarśana*, 7-18. New Delhi, 1981.

BROWN, P. As for Chapter 26 (Brown, 1942b).

NATH, R. *Coloured Decoration in Mughal Architecture*. Bombay, 1970.

NATH, R. *Some Aspects of Mughal Architecture*. New Delhi, 1976. (Nath, 1976a)

NATH, R. *History of Decorative Art in Mughal Architecture*. Delhi, 1976. (Nath, 1976b)

RIZVI, S. A. A., and FLYNN, V. J. A. *Fathpur Sikri*. Bombay, 1975.

VOGEL, J. P. 'Tile Mosaics of the Lahore Fort', *Journal of Indian Art and Industry*, nos. 113-16, 117-18 (April 1912).

PART EIGHT: SRI LANKA

Chapter 34: Buddhism Preserved

ALLCHIN, B. 'The Late Stone Age of Ceylon', *Journal of the Royal Anthropological Institute*, LXXXVIII, 2 (1958), 179-201.

BANDARANAYAKE, S. *The Vaulted Brick Image-Houses of Polonnaruva*. Oxford thesis, 1965.

BANDARANAYAKE, S. *Sinhalese Monastic Architecture: The Viharas of Anuradhapura*. Leiden, 1974. (Bandaranayake, 1974a)

BANDARANAYAKE, S. 'Sri Lanka and Monsoon Asia: Patterns of Local and Regional Development and the Problem of the Traditional Sri Lankan Roof', *Studies in South Asian Culture*, VII (*Senake Paranavitana Commemoration Volume*), ed. J. E. van Lohuizen-de Leeuw, 22-44. Leiden, 1978.

BARRETT, D. As for Chapter 1 (1956b).

BOISSELIER, J. *Ceylon Sri Lanka*. Geneva, 1979.

COOMARASWAMY, A. K. As for Chapter 2 (1927).

COOMARASWAMY, A. K. *Mediaeval Sinhalese Art*. 2nd ed. New York, 1956. (Coomaraswamy, 1956a)

DEVENDRA, D. T. *Classical Sinhalese Sculpture c. 300 B.C. to A.D. 1000*. London, 1958. (Devendra, 1958a)

DEVENDRA, D. T. 'The Symbolism of the Sinhalese Guardstone', *Artibus Asiae*, XXI, 3/4 (1958), 259-68. (Devendra, 1958b)

DEVENDRA, D. T. 'Moonstone Motifs', *Journal of the Ceylon Branch of the Royal Asiatic Society*, N.S. IX (1965), 221-8.

DEVENDRA, D. T. 'Privy Stone Ornamentation', *Journal of the Ceylon Branch of the Royal Asiatic Society*, N.S. XI (1967), 36-41.

DOHANIAN, D. K. 'The Wata-dā-gē in Ceylon: The Circular Relic-House of Polonnaruwa and Its Antecedents', *Archives of Asian Art*, XXIII (1969-70), 31-40.

DOHANIAN, D. K. *The Mahāyāna Buddhist Sculpture of Ceylon*. New York, 1977.

GATELLIER, M. 'Les peintures du temple de Kelaniya à Sri Lanka', *Arts Asiatiques*, XXXVIII (1983), 49-70.

GODAKUMBURA, C. E. 'A Bronze Buddha Image from Ceylon', *Artibus Asiae*, XXVI, 3/4 (1963), 230-6.

GOMBRICH, R. *Traditional Buddhism and the Rural Highland of Ceylon*. Oxford, 1971.

GUNASINGHE, S. 'The Statue at Potgul Vehera, Polonnaruva', *Ceylon Journal of Historical and Social Studies*, I, 2 (1958), 180-91.

IRWIN, J. As for Chapter 1 (1973), (1974), (1975), (1976), (1981).

KRAMRISCH, S. 'Some Wall-Paintings from Kelaniya', *Indian History Quarterly*, I (1925), 111-16.

LIYANARATNA, J. 'Les piliers dans l'architecture singhalaise aux époques d'Anurādhapura et Polonnaruva', *Arts Asiatiques*, XXV (1972), 89-122.

LOHUIZEN-DE LEEUW, J. E. VAN. 'The Kuṣṭarajāgala Image - An Identification', *Paranavitana Felicitation Volume*. Colombo, 1965.

LOHUIZEN-DE LEEUW, J. E. VAN. 'The Rock-Cut Sculptures at Isurumuṇi', *Ancient Ceylon*, III (1979), 321-62. (Van Lohuizen, 1979b)

LOHUIZEN-DE LEEUW, J. E. VAN. *Sri Lanka. Ancient Arts*. Exhibition catalogue. London, 1981. (Van Lohuizen, 1981b)

LOHUIZEN-DE LEEUW, J. E. VAN. 'A Unique Piece of Ivory Carving - The Oldest Known Chessman', *South Asian Archaeology 1981*, 245-53. Cambridge, 1984.

MALLMANN, M. T. DE. As for Chapter 15 (1948).

MARCHAL, H. *L'architecture comparée dans l'Inde et l'Extrême-Orient*. Paris, 1944.

MICHELL, G., ed. As for Chapter 9 (1982).

MITRA, D. As for Chapter 1 (1971).

MODE, H. *Die buddhistische Plastik auf Ceylon*. Leipzig, 1963.

PARANAVITANA, S. 'Sigiri: The Abode of a God-King', *Journal of the Ceylon Branch of the Royal Asiatic Society*, N.S. I (1950), 129-83.

PARANAVITANA, S. *The Shrine of Upulvan at Devundara* (*Memoirs of the Archaeological Survey of Ceylon*, VI). 1953.

PARANAVITANA, S. 'Sankha and Padma', *Artibus Asiae*, XVIII (1955), 121-7.

PARANAVITANA, S. *The God of Adam's Peak* (*Artibus Asiae* Supplementum). Ascona, 1958.

PREMATILLEKE, L. 'Identity and Significance of the Object Held by the Dwarfs in the Guard-stones of Ancient Ceylon', *Artibus Asiae*, XXVIII, 2/3 (1966), 155-61.

PREMATILLEKE, L. 'The "Kuṣṭarajāgala" Image at Veligama, Sri Lanka', *Studies in South Asian Culture*, VII (*Senarat Paranavitana Commemoration Volume*), ed. J. E. van Lohuizen-de Leeuw, 171-80. Leiden, 1978.

PREMATILLEKE, L., and SILVA, R. DE. 'A Buddhist Monastic Type of Ancient Ceylon Showing Mahāyanist Influence', *Artibus Asiae*, XXXI (1968), 61-84.

REA, A. As for Chapter 1 (1908-9).

SILVA, R. H. DE. As for Chapter 25 (1962).

SILVA, R. H. DE. 'The Evolution of the Technique of Sinhalese Wall-Paintings and Comparison with Indian Painting Methods', *Ancient Ceylon*, I (1971), 90-105.

WARD, W. E. 'Recently Discovered Mahiyangara Paintings', *Artibus Asiae*, XV (1952), 108-13.

PART NINE: NEPAL

Chapter 35: A National Syncretism

AUBOYER, J., and BÉGUIN, G. As for Chapter 25 (1977).

BANERJEE, N. R. *Nepalese Architecture*. Delhi, 1981.

BERNIER, R. M. *The Nepalese Pagoda, Origins and Style*. 1979.

BROWN, P. As for Chapter 1 (Brown, 1942a).

COUSENS, H. As for Chapter 13 (1926).

CZUMA, S. 'A Gupta Style Bronze Buddha', *Bulletin of the Cleveland Museum of Art* (February 1970), 55-67.

DEO, S. B. *Glimpses of Nepal Woodwork, Journal of the Indian Society of Oriental Art*, N.S. III (1968-9).

FERGUSSON, J. As for Chapter 16 (1910).

HARLE, J. C. As for Chapter 5 (Harle, 1974b).

HARLE, J. C. As for Chapter 11 (1977).

JOSEPH, M. B. 'The Vihāras of the Kathmandu Valley', *Oriental Art*, XVII, 2 (1971), 121-44.

KRAMRISCH, S. *The Art of Nepal*. Exhibition catalogue. New York, 1964.

LEVI, S. *Le Népal*. 2 vols. Paris, 1905.

LIPPE, A. 'Vishnu's Conch in Nepal', *Oriental Art*, N.S. VIII, 3 (1962), 117-19.

LOWRY, J. 'A Fifteenth Century Sketchbook', *Essais sur l'art du Tibet*, 83-118. Paris, 1977.

MACDONALD, A. W., and STAHL, A. V. *Newar Art*. Warminster, Wiltshire, 1979.

PAL, P. 'A Kālapustaka from Nepal', *Bulletin of the*

American Academy of Benares, I (1967), 23-33. (Pal, 1967b)

PAL, P. *The Arts of Nepal*. Part I. *Sculpture*. Leiden, 1974.

PAL, P. 'The Bhīmaratha Rite and Nepali Art', *Oriental Art*, XXIII, 2 (1977), 176-89.

PAL, P. As for Chapter 25 (Pal, 1978a).

RAU, H. 'On the Origins of the Pagoda Style in Nepal', *South Asian Archaeology 1979*, 513-21. Berlin, 1981.

SINGH, M. *Himalayan Art*. London, 1968.

SLUSSER, M. S. 'On the Antiquity of Nepalese Metalcraft', *Archives of Asian Art* (1975-6), 81-95.

SLUSSER, M. S. 'Indreśvara Mahādeva, a Thirteenth-Century Nepalese Shrine', *Artibus Asiae*, XLI, 2/3 (1979), 185-225.

*SLUSSER, M. S. *Nepal Mandala, A Cultural Study of the Kathmandu Valley*. 2 vols. Princeton, 1982.

SLUSSER, M. S., and VAJRACHARYA, G. 'Some Nepalese Stone Sculptures: A Reappraisal Within Their Cultural and Historical Context', *Artibus Asiae*, XXXV, 1/2 (1973), 79-138. (Slusser and Vajracharya, 1973a)

SLUSSER, M. S., and VAJRACHARYA, G. 'Some Nepalese Stone Sculptures: Further Notes', *Artibus Asiae*, XXXV, 3 (1973), 269-70. (Slusser and Vajracharya, 1973b)

SLUSSER, M. S., and VAJRACHARYA, G. 'Two Medieval Nepalese Buildings: An Architectural and Cultural Study', *Artibus Asiae*, XXXVI, 3 (1974), 169-218.

SNELLGROVE, D. L. *Buddhist Himalaya*. Oxford, 1957.

SNELLGROVE, D. L. 'Shrines and Temples of Nepal', *Arts Asiatiques*, VIII, 1/2 (1961), 3-10, 93-120.

TOTH, E. *Nepál Müvészete* (with English summary). Budapest, 1963.

WIESNER, U. *Nepalese Temple Architecture*. Leiden, 1978.

LIST OF ILLUSTRATIONS

70. Udayagiri (Vidiśā), Cave 6, Durgā. Early fifth century. Buff sandstone (A.I.I.S.)
71. Udayagiri (Vidiśā), 'Cave' 5, boar (Varāha) incarnation of Viṣṇu. Early fifth century. H 12 ft 8 in: 3.86 m. W 22 ft: 6.70 m. (J.C. Harle)
72. Head of Viṣṇu from Besnagar. Fifth century. Grey sandstone. H 1 ft 4 in: 40.6 cm. W 1 ft 3 in: 38.1 cm. *Cleveland Museum of Art, John L. Severance Fund* (Museum photo)
73. Mātṛkā from Besnagar. Early fifth century. Sandstone. H *c*. 4 ft 1 in: 1.25 m. *New Delhi, National Museum* (Museum photo)
74. Eran, boar incarnation of Viṣṇu. Late fifth century (dated 'in the first year of Toramana'). Sandstone. H 11 ft 4 in: 3.45 m. L 13 ft 1 in: 4 m. (A.I.I.S.)
75. Boar incarnation of Viṣṇu from Eran. Late fifth century. Sandstone. H 6 ft 1 in: 1.86 m. *Sagar University Museum* (A.I.I.S.)
76. Seated Tīrthaṅkara from Mathurā. Third/early fourth century. Spotted red sandstone. H 3 ft 1½ in: 95 cm. *Lucknow, State Museum* (A.I.I.S.)
77. Standing Buddha from Mathurā. Mid fifth century. Red sandstone. H 5 ft 11 in: 1.80 m. *New Delhi, President's Palace* (National Museum photo)
78. Viṣṇu from Mathurā. *c*. 500. Red sandstone. H 3 ft 4¼ in: 1.02 m. *New Delhi, National Museum* (A.I.I.S.)
79. Seated Buddha from Bodhgayā. Probably 384 (dated 'in the year 64'). Buff sandstone. H 3 ft 11½ in: 1.20 m. *Calcutta, Indian Museum* (Museum photo)
80. Kṛṣṇa Govardhana (holding up the Govardhan Mountain) from Varanasi. Fourth/fifth century. Chunār sandstone. H 6 ft 11½ in: 2.12 m. *Varanasi, Bharat Kala Bhavan*
81 and 82. Gadhwā 'lintel', sections at proper left (in two fragments) and right, with detail. Fifth century, second half. Total W 13 ft: 3.97 m. (A.I.I.S.)
83. Standing Buddha from Sārnāth. 474. Chunār sandstone. H 6 ft 4 in: 1.93 m. *Sārnāth Museum* (A.I.I.S.)
84. Seated Buddha from Sārnāth. Fifth century, last quarter. Chunār sandstone. H 5 ft 3½ in: 1.61 m. *Sārnāth Museum* (A.I.I.S.)
85. Deogarh, Daśāvatāra temple, west entrance doorway. Sixth century, first half. Red sandstone (A.I.I.S.)
86. Nāchnā Kuṭharā, Pārvatī temple. Late fifth/early sixth century (A.I.I.S.)
87. Deogarh, Daśāvatāra temple, south side. Viṣṇu Anantaśayana. Red sandstone (A.I.I.S.)
88. Skandamātā from Tanesara-Mahādeva. Sixth/early seventh century. Grey schist. H 2 ft 6 in: 76.2 cm. *Los Angeles County Museum of Art* (Museum photo)
89. Bhitargaon, brick temple, north side. Late fifth century (A.I.I.S.)

90. Ahichchhatra, river goddess (Yamunā). Fifth/sixth century. Terracotta. H 4 ft 8 in: 1.47 m. (National Museum, New Delhi)
91. Seated Buddha from the stūpa at Devnimori. *c*. 375 (?). Terracotta. H 2 ft 2 in: 66 cm. *M.S. University of Baroda, Department of Archaeology and Ancient History* (University photo)
92. Ajaṇṭā, Cave 19, façade. Fifth century, last quarter (Department of Archaeology and Ancient History, M.S. University of Baroda)
93. Ajaṇṭā, Cave 26, interior. Fifth century, last quarter (Eliot Eliosofon, Life Magazine, © Time Inc.)
94. Ajaṇṭā, Cave 19, Nāgarāja and his queen. Fifth century, last quarter (J. Allan Cash Ltd)
95. Ajaṇṭā, Cave 2, shrine doorway. Fifth century, last quarter (Eliot Eliosofon, Life Magazine, © Time Inc.)
96. Elephanta, Śiva cave, plan. Mid sixth century (A.S.I.)
97. Elephanta, Śiva cave, Mahādeva. Mid sixth century. H above base 17 ft 10 in: 5.45 m. (A.I.I.S.)
98. Ellorā, Cave 21 (Rāmeśvara), dancing Śiva. Sixth century, second half (A.S.I.)
99. Bādāmi, Cave 3, bracket figures. Dedicated 578 (A.S.I.)
100. Aihole, Rāvaṇaphadi cave, dancing Mātṛkās. *c*. 600 (?) (J.C. Harle)
101. Aurangabad, Cave 7, 'Litany of Avalokiteśvara'. Sixth century, second half (Archives of Asian Art, University of Michigan, Ann Arbor)
102. Aurangabad, Cave 7, dancing woman (Tārā?) and musicians. Sixth century, second half (Archives of Asian Art, University of Michigan, Ann Arbor)
103. Ellorā, Cave 10 (Viśvakarma), façade. Seventh century, first half (Archives of Asian Art, University of Michigan, Ann Arbor)
104. Gop, temple, from the south. Sixth century (A.I.I.S.)
105. Ladhaura, Mahādeva temple. Seventh century (O. Viennot)
106. Osiaṅ, Mahāvīra temple, plan. Eighth century, last quarter (A.S.I.)
107. Baroli, Ghaṭeśvara temple, door-guardian and river-goddess. Tenth century, first half (O. Viennot)
108. Osiaṅ, Sūrya temple (No. 7). *c*. 800 (A.S.I.)
109. Bhavanipura, Nakti Mātā temple. Ninth century (O. Viennot)
110. Roḍā, Temple VII. Late eighth century (A.S.I.)
111. Śāmalājī, Nīlakaṇṭha Mahādeva temple, Viśvarūpa. Early seventh century (U.P. Shah)
112. Viśvarūpa from Kanauj. Ninth century. H 3 ft 11¾ in: 1.20 m. *Kanauj, private collection* (A.S.I.)
113. Ābānerī, Harṣat Mātā temple, niche figures. Ninth century (A.S.I.)

162. Sunak, Nilakaṇṭha temple. Tenth century. Elevation (partly reconstructed) (Benjamin Rowland)

163. Dilwārā, Mount Abu, Vimala-vasahī temple, Sabhā-Padma-Mandāraka, ceiling. *c.* 1150 (Douglas Dickins)

164. Jagat, Ambāmātā temple. 960 (Phaidon)

165. Sejakpur, Navalakhā temple. Eleventh century. Plan (A.S.I.)

166. Modherā, tank and raṅgamaṇḍapa. Eleventh century (A.I.I.S.)

167. Modherā, Sun temple. Eleventh century. Plan (A.S.I.)

168. Kirāḍu, smaller Śiva temple, from the east. Eleventh century, second quarter (M.A. Dhaky)

169. Sādri, Pārśvanātha temple, from the south-east. *c.* 1000 (M.A. Dhaky)

170. Dilwārā, Mount Abu, Vimala-vasahī temple, goddess. *c.* 1150 (Douglas Dickins)

171. Mount Abu, temples. Plan (Volwahsen)

172. Frieze of musicians and dancers from the Purāṇa Mahādeva temple, Sikar. *c.* 973. Cream and tan sandstone. L 3 ft 1¼ in: 95 cm. H 1 ft 1⅛ in: 33 cm. *Cleveland Museum of Art, John L. Severance Fund purchase* (Museum photo)

173. Śiva and Pārvatī on the bull Nandi, flanked by musicians and dancers, from the Purāṇa Mahādeva temple, Sikar. *c.* 973. L 2 ft 9¾ in: 86 cm. H 1 ft 6 in: 46 cm. *Kansas City, William Rockhill Nelson Gallery of Art, Atkins Museum of Fine Arts* (Museum photo)

174. Udaipur, Udayeśvara temple, from the south. 1059-80 (A.I.I.S.)

175. Udaipur, Udayeśvara temple, śukanāsa, eastern side of śikhara. 1059-80 (A.I.I.S.)

176. Khajurāho, Kaṇḍarīya Mahādeo temple, from the south. *c.* 1000 (A.F. Kersting)

177. Khajurāho, Kaṇḍarīya Mahādeo temple. *c.* 1000. Plan (Zannas and Auboyer)

178. Lady with a mirror, bracket figure from the Lakṣmaṇa temple, Khajurāho. *c.* 1000. Sandstone. H 3 ft 1½ in: 95 cm. *Calcutta, Indian Museum* (Museum photo)

179. Khajurāho, Caturbhuja temple, Viṣṇu Caturbhuja. *c.* 1050 (A.I.I.S.)

180. Vyāla perhaps from Madhya Pradesh. Tenth/eleventh century. Granite. H 4 ft ½ in: 1.23 m. *San Francisco, Asian Art Museum, Gift of the Asian Art Museum of San Francisco* (Museum photo)

181. Khajurāho, Kaṇḍarīya Mahādeo temple, mithuna figures on the south outer wall of the antarāla. *c.* 1000 (A. and B. Peerless)

182 and 183. Rāṇakpur, Ādinātha temple, exterior view (A.F. Kersting) and plan (M.A. Dhaky)

184. Dilwārā, Mount Abu, Vimala-vasahī temple, front maṇḍapa, samatala ceiling. Mid twelfth century (A.I.I.S.)

185. Rāṇakpur, Sūrya temple, from the south. Fifteenth century (J.C. Harle)

186. Chitor, Adbhūtanātha temple, Maheśa (Sadāśiva). *c.* 1500. H *c.* 3 ft 1 in: 94 cm. (J.C. Harle)

187. Amber, palace and fort. Seventeenth/eighteenth century (A.F. Kersting)

188. Bhubaneswar, Mukteśvara temple. Ninth/tenth century (A.F. Kersting)

189. Bhubaneswar, Liṅgarāja temple. *c.* 1100. Plan (A.S.I.)

190. Bhubaneswar, Liṅgarāja temple. *c.* 1100 (A.F. Kersting)

191. Bhubaneswar, Rājarāṇī temple. Eleventh/twelfth century (A. Volwahsen)

192. Painted cloth hanging from the Jagannātha temple, Puri. Nineteenth/twentieth century. *Paris, Bibliothèque Nationale* (Library photo)

193. Konarak, Sun temple, platform of deul and jagamohana, stone wheel. Mid thirteenth century (A.F. Kersting)

194. Konarak, Sun temple. Mid thirteenth century. Dance maṇḍapa and jagamohana (Foto Features, Jaipur)

195. Konarak, Sun temple, musician on an upper storey of the jagamohana. Mid thirteenth century (Eliot Eliosofon, Life Magazine, © Time Inc.)

196. Konarak, Sun temple, deul, standing Sūrya. Mid thirteenth century. Black chlorite (Johnson and Hoffman)

197. King Narasiṃhadeva I worshipping the Jagannātha image at Puri, from Konarak. Mid thirteenth century. Black chlorite. H *c.* 2 ft 10¼ in: 87 cm. *New Delhi, National Museum* (Museum photo)

198 and 199. Hāveri, Siddheśvara temple. Mid eleventh century. View and plan (A.S.I.)

200. Lakkundi, Kāśiviśveśvara temple, from the south-west. Probably mid twelfth century (C.R. Bolon)

201. Ittagi, Mahādeva temple. Probably 1112 (A.I.I.S.)

202. Gadag, Someśvara temple. Twelfth/thirteenth century (A.I.I.S.)

203. Dambal, Doḍḍa Basappā temple. Twelfth/thirteenth century (A.I.I.S.)

204. Somnāthpuram, Keśava temple. 1238 (J.C. Harle)

205. Doddagadavali, Lakṣmīdevī shrine, demons. 1112 (J.C. Harle)

206. Keśava Viṣṇu with Śrī Devī and Bhū Devī from Kikkeri. Early twelfth century. H 3 ft 10½ in: 1.18 m. *New York, Metropolitan Museum of Art* (Museum photo)

207. Bhairava from Kṛṣṇarājapet. Twelfth century, first quarter. Chloritic schist. H 3 ft 3 in: 99 cm. *Mysore, Directorate of Archaeology and Museums in Karnātaka* (Directorate photo)

248. Gangaikoṇḍacoḷapuram, Bṛhadiśvara temple, ardhamaṇḍapa, Caṇḍeśānugrāhamūrti on the west side of the north entrance. *c.* 1025. Granite (A.S.I.)

249. Dārāśuram, Airāvateśvara temple, open maṇḍapa. Twelfth century, third quarter (Douglas Dickins)

250. Tribhuvanam, Kampahareśvara temple, stairway leading to the antarāla. *c.* 1200 (A.I.I.S.)

251. Tañjavūr, Rājarājeśvara temple, inner gopura, inner façade. 1014 (J.C. Harle)

252. Cidambaram, Naṭarāja temple, east gopura, inner façade. *c.* 1200 (J.C. Harle)

253. Cidambaram, Naṭarāja temple, west gopura, inner façade, south half. *c.* 1175 (J. C. Harle)

254. Cidambaram, Naṭarāja temple, west gopura, Gajasaṃhāra (Śiva slaying the Demon Elephant). Granite. *c.* 1175 (J.C. Harle)

255. Cidambaram, Naṭarāja temple, east gopura, Śiva Dakṣiṇāmūrti. *c.* 1200. Polished black granite (J.C. Harle)

256. Naṭarāja. Twelfth/thirteenth century. Bronze. H 5 ft ⅜ in: 1.54 m. *Amsterdam, Rijksmuseum* (Museum photo)

257. Buddha, perhaps a Cālukya import, from Nāgapaṭṭinam. *c.* 1000. Bronze. *Madras, Government Museum* (Museum photo)

258. Hampi (Vijayanagara), Hazara Rāma temple, Amman shrine. Early sixteenth century (India Office Library, London)

259. Hampi (Vijayanagara), Mahānavami. Early sixteenth century (A.S.I.)

260. Hampi (Vijayanagara), Lotus Mahall. Early sixteenth century (Cohn Library, Oxford University)

261. Hampi (Vijayanagara), Kadalaikallu Gaṇeśa temple, from the south-east. Probably fourteenth century (A.I.I.S.)

262. Śrīraṅgam, Horse maṇḍapa. Seventeenth century (A.S.I.)

263. Śrīvilliputtur, Perialvar temple, gopura. Seventeenth century (A.S.I.)

264. Rāmeśvaram, corridor. Seventeenth century (Captain Lyon, India Office Library, London)

265. Tañjavūr, Rājarājeśvara temple, Subrahmaṇya shrine. *c.* 1750 (A.S.I.)

266. Śrīraṅgam, plan (J. Auboyer)

267. Tirupati, Śrīnivasaperumāḷ temple, Kṛṣṇadevarāya and two wives. Sixteenth century. Life size (A.S.I.)

268. Kaviyur, Śiva temple. Mid tenth century. Plan (A.S.I.)

269. Yāḷi strut on a bargeboard. Eighteenth/nineteenth century. Painted wood. *Private Collection* (A.S.I.)

270. Nemam, Nīramaṅkara temple. Eleventh century (A.S.I.)

271. Karikkad-Kṣetram, Mañjeri, Subrahmaṇya temple. Eleventh century (A.S.I.)

272. Nedumpura, Śiva temple, nālambalam and shrine. Ninth/tenth century (A.S.I.)

273. Vaḍākkunātha, temple, gopura, from the south. Eleventh century (A.S.I.)

274. Tirukkulaśekharapuram, Kṛṣṇa temple, detail of vimāna. Ninth century, first half (A.S.I.)

275. Kaviyur, Śiva temple, detail of carved wooden wall. Probably eighteenth century (A.S.I.)

276. Chengannur, Narasiṃha temple, dvārapāla. Probably eighteenth century. Carved wood (A.S.I.)

277. Śāstā (Ayannār), front and back views. Nineteenth century. Repoussé silver on wood (Government of Travancore)

278. Ettumanur, old Śiva temple, Naṭarāja. Perhaps sixteenth century. Wall painting (A.S.I.)

279 and 280. Padmanābhapuram, palace, Gaṇeśa, with details. Seventeenth/eighteenth century. Wall painting (A.S.I. and Bruno Cassirer)

281. Kadri, Mañjunātha temple, Lokeśvara. 968. Bronze. H *c.* 2 ft 7½ in: 80 cm. (A.S.I.)

282. Ajaṇṭā, Cave XVII, scene from the Viśvantara Jātaka. Fifth century, second half. Wall painting (J. Allan Cash Ltd)

283. Ajaṇṭā, Cave XVII, rāja riding out on an elephant to hear the sermon of the hermit. Fifth century, second half. Wall painting (A.S.I.)

284 and 285. Ajaṇṭā, Cave I, Bodhisattva, with detail. Fifth century, second half. Wall painting (A.S.I. and A.K. Coomaraswamy)

286. Ajaṇṭā, Cave I, Bodhisattva (Vajrapāṇi?) being offered lotus flowers. Fifth/sixth century. Wall painting (Oxford University Press)

287. Vajragarbha or Vajrapāṇi, copied at Nālandā, found in Nepal. *c.* 1200 (dated 'in the fifth year of Rāmapāla'). Palm leaf MS. 2⅜ by 2⅜ in: 6 by 6 cm. *Oxford, Bodleian Library* (Library photo)

288. Prajñāpāramitā, with Dhyānapāramitā on her left and Upāyapāramitā on her right, from Nepal. Twelfth century. Lower wooden cover for preceding MS. 2⅜ by 7⅞ in: 6 by 20 cm. *Oxford, Bodleian Library* (Library photo)

289. Gardabhilla and Kālaka from a Kālakācāryakathā MS. *c.* 1475. Paper. *New Delhi, National Museum* (Museum photo)

290. Two small landscapes on a single folio from a Kālakācāryakathā MS. *c.* 1475. H of landscapes 4¾ in: 12 cm. W 1½ in: 3.7 cm. *Ahmedabad, Devasano Pado Bhandār* (Prince of Wales Museum of Western India, Bombay)

291. Folio from a Vasanta Vilāsa MS. 1451. W 9 in: 22.9 cm. *Washington, D.C., Freer Gallery of Art* (Gallery photo)

292. Illustration no. 18 from a Caurapañcāśikā MS.

321. Folio from a Ratan MS., from Bijapur. 1590–1. Gouache on paper. 6⅞ by 3⅜ in: 17.3 by 9.7 cm. *London, British Museum* (Museum photo, MS. Add. 16880, folio 147a)

322. Ibrahim Adil Shāh II, from Bijapur. *c.* 1610–20. 6¾ by 4 in: 17 by 10 cm. *London, British Museum* (Museum photo)

323. Ibrahim Adil Shāh II as a young man hawking, from Bijapur. *c.* 1590–1600. 11¼ by 6⅛ in: 28.5 by 16.5 cm. *Leningrad, Academy of Sciences, Institute of the Peoples of Asia* (Institute photo)

324. The resourceful Rādhā, from Basohli. *c.* 1660–70. Gouache on paper with inserted beetle-wing cases. 7 by 10⅞ in: 18 by 27.5 cm. *London, Victoria and Albert Museum, Rothenstein Collection* (Museum photo)

325. Rādhā and Kṛṣṇa in the forest, from Basohli or Kulu. *c.* 1685. Gouache on paper. 8½ by 5⅞ in: 21.5 by 14.5 cm. *Bombay, Karl and Mehri Khandalavala Collection* (Karl and Mehri Khandalavala)

326. Rāja Kirpal Dev of Bahu (Jammu) smoking, from Kulu. *c.* 1690. Gouache on paper. 7⅞ by 11¼ in: 19.5 by 28.5 cm. *Seattle Art Museum, Eugene Fuller Memorial Collection* (Museum photo)

327. Manaku(?): Rādhā's messenger describing Kṛṣṇa standing with the cow-girls, from Basohli. *c.* 1730–5. Gouache on paper. 6¼ by 10 in: 16 by 25.5 cm. *London, Victoria and Albert Museum* (Museum photo)

328. Nainsukh: Balwant Singh writing in his tent, from Jammu. *c.* 1750. Gouache on paper. 8⅜ by 11⅜ in: 21.5 by 29 cm. *Bombay, Prince of Wales Museum of Western India* (Museum photo)

329. Abhisanditā Nāyikā ('she who is estranged by a quarrel'), from Guler. Ink on paper. *Patiala, Punjab Museum* (National Museum, New Delhi)

330. The lovesick Nāyikā simulating indifference, one of a set of drawings of the Bihārī Satsai, from Kangra. *Varanasi, Bharat Kala Bhavan* (Museum photo)

331. Kāliya Damana (Kṛṣṇa subduing the serpent Kāliya), from Guler. Eighteenth century, second half. Gouache on paper. 7⅞ by 10⅜ in: 18.5 by 26.5 cm. *New York, Metropolitan Museum of Art, Rogers Fund* (Museum photo)

332. Kṛṣṇa casting off his garland, from Kangra. *c.* 1785. Gouache on paper. *Oxford, Ashmolean Museum* (Museum photo)

333. Abhisārikā Nāyikā ('she who sallies out into a stormy night to meet her lover'), from Garhwal. *c.* 1770–80. Gouache on paper. 8½ by 5½ in: 21.5 by 14 cm. *London, British Museum*

334. The Village Beauty from a Bihārī Satsai series, from Kangra. *c.* 1785. Gouache on paper. 7½ by 5⅛ in: 19 by 13 cm. *The Kronos Collections* (O. E. Nelson)

335. Cīra Haraṇ (Kṛṣṇa stealing the clothes of the gopis) from a Bhāgavata Purāṇa MS. from Kangra. *c.* 1770. Gouache on paper. 8⅞ by 12⅛ in: 22.5 by 31 cm. *New Delhi, National Museum* (Museum photo)

336. Śiva and Pārvatī with Gaṇeśa (unfinished), Guler–Kangra style. Nineteenth century, first half. Gouache on paper. 9½ by 7 in: 17.8 by 14.1 cm. *Oxford, Ashmolean Museum* (Museum photo)

337. Map showing the seven cities of Delhi

338. Delhi, Qutb mosque (with the Iron Pillar). *c.* 1200 (Douglas Dickins)

339. Delhi, Qutb minār. *c.* 1200 (A. F. Kersting)

340. Delhi, tomb of Ghiyās-ud-dīn Tughluq. 1325 (Josephine Powell)

341. Sasaram, tomb of Sher Shāh Sūr. *c.* 1530–40 (Josephine Powell)

342. Jaunpur, Atala masjid. 1408 (A.S.I.)

343. Ahmedabad, Jāmiʻ masjid. 1423 (Josephine Powell)

344. Māndū, Jāmiʻ masjid. Plan (Yazdani, Oxford University Press)

345. Bijapur, Jāmiʻ masjid. 1576 (Douglas Dickins)

346. Bijapur, Gol Gumbaz (mausoleum of Sultan Muhammad 'Adil Shāh, died 1656) (Douglas Dickins)

347. Delhi, mausoleum of Humāyūn. *c.* 1565 (Josephine Powell)

348. Faṭhpur Sīkrī, 'House of Bīrbal the Prime Minister' (northern haram sara). 1572 (A.F. Kersting)

349. Faṭhpur Sīkrī, Buland Darwāza. *c.* 1571 (Josephine Powell)

350. Delhi, Red Fort. 1639–48. Plan (G.R. Hearn)

351. Delhi, Red Fort, Diwan-i-Khass, hall of private audience. *c.* 1645 (Douglas Dickins)

352. Agra, Tāj Mahall. 1634 (Douglas Dickins)

353. Map of Sri Lanka

354. Anurādhapura, Thūpārāma. Founded third century B.C. Air view (Georg Gerster)

355. Anurādhapura, Ruvanveliseya dāgaba. Founded second century B.C. (Douglas Dickins)

356. Standing Buddha. Third/fourth century A.D. Limestone. H including base *c.* 6 ft: 1.80 m. *Anurādhapura Museum* (J.C. Harle)

357. Avukana, colossal rock-cut Buddha. Eighth/ninth century. H 45 ft 10 in: 14 m. (J. Allan Cash)

358. Anurādhapura, outer circular road, seated Buddha. Eighth century, first half. H *c.* 3 ft: 90 cm. (A.K. Coomaraswamy)

359. Buduruvegala, rock-cut Buddha. Eighth/ninth century. H 23 ft 11 in: 7.30 m. (J.C. Harle)

360. Situlpāvuva, standing Bodhisattva. *c.* 700. H *c.* 5 ft 6 in: 1.68 m. (J.C. Harle)

361. Isurumuni, elephant relief (Courtesy of the Commissioner for Archaeology, Sri Lanka)

362. Polonnaruva, Potgul vihāra, sage (popularly

INDEX

The characters c (sometimes transliterated ch), ṁ, ṅ, ṇ (ng), and ś, ṣ (sh) will be found in the alphabetical run as though they were the normal English letters c, m, n, and s. Entries in **bold** type may be used to identify gods and mythological figures, and for definitions of technical terms (cf. Chapter 11, Note 20). The index does not set out to catalogue types or features either of buildings or of works of art, and entries under such headings are selective. References to the notes are given to the page on which the note occurs, followed by the chapter number in parentheses and the number of the note; thus 528(28)[10] indicates page 528, chapter 28, note 10. Only those notes are indexed which contain matter other than bibliographical and to which there is no obvious reference from the text.

THE PELICAN HISTORY OF ART

COMPLETE LIST OF TITLES

*Published only in original large hardback format.
†Latest edition in integrated format (hardback and paperback).
‡Latest edition in integrated format (paperback only).
§Published only in integrated format (hardback and paperback).
‖Not yet published.

PAINTING AND SCULPTURE IN GERMANY AND
THE NETHERLANDS: 1500–1600* *Gert von der
Osten and Horst Vey, 1st ed., 1969*
ART AND ARCHITECTURE IN BELGIUM: 1600–
1800* *H. Gerson and E. H. ter Kuile, 1st ed., 1960*
DUTCH ART AND ARCHITECTURE: 1600–1800‡
*Jakob Rosenberg, Seymour Slive, and E. H. ter
Kuile, 3rd ed., 1977*
ART AND ARCHITECTURE IN FRANCE: 1500–
1700‡ *Anthony Blunt, 4th ed., reprinted with re-
visions 1982*
ART AND ARCHITECTURE OF THE EIGHTEENTH
CENTURY IN FRANCE* *Wend Graf Kalnein and
Michael Levey, 1st ed., 1972*
ART AND ARCHITECTURE IN SPAIN AND POR-
TUGAL AND THEIR AMERICAN DOMINIONS:
1500–1800* *George Kubler and Martin Soria, 1st
ed., 1959*
ARCHITECTURE IN BRITAIN: 1530–1830‡
John Summerson, 7th ed., 1983
SCULPTURE IN BRITAIN: 1530–1830* *Mar-
garet Whinney, 1st ed., 1964*
PAINTING IN BRITAIN: 1530–1790† *Ellis
Waterhouse, 4th ed., 1978*
PAINTING IN BRITAIN: 1790–1890‖ *Michael
Kitson and R. Ormond*
ARCHITECTURE: NINETEENTH AND TWEN-
TIETH CENTURIES‡ *Henry-Russell Hitchcock, 4th
ed., 1977*
PAINTING AND SCULPTURE IN EUROPE:
1780–1880‡ *Fritz Novotny, 3rd ed., 1978*
PAINTING AND SCULPTURE IN EUROPE:
1880–1940‡ *George Heard Hamilton, 3rd ed.,
1981*
AMERICAN ART* *John Wilmerding, 1st ed., 1976*
THE ART AND ARCHITECTURE OF ANCIENT
AMERICA‡ *George Kubler, 3rd ed., 1984*

THE ART AND ARCHITECTURE OF RUSSIA‡
George Heard Hamilton, 3rd ed., 1983
THE ART AND ARCHITECTURE OF ANCIENT
EGYPT† *W. Stevenson Smith, 3rd ed., revised by W.
Kelly Simpson, 1981*
THE ART AND ARCHITECTURE OF INDIA:
HINDU, BUDDHIST, JAIN‡ *Benjamin Rowland,
4th ed., 1977*
THE ART AND ARCHITECTURE OF THE INDIAN
SUBCONTINENT§ *J. C. Harle, 1st ed., 1986*
THE ART AND ARCHITECTURE OF ISLAM: 650–
1250‖.*Richard Ettinghausen and Oleg Grabar*
THE ART AND ARCHITECTURE OF ISLAM:
POST-1250‖ *Author to be announced*
THE ART AND ARCHITECTURE OF THE AN-
CIENT ORIENT‡ *Henri Frankfort, 4th revised
impression, 1970*
THE ART AND ARCHITECTURE OF JAPAN‡
*Robert Treat Paine and Alexander Soper, 3rd ed.,
1981*
THE ART AND ARCHITECTURE OF CHINA‡
*Laurence Sickman and Alexander Soper, 3rd ed.,
1971*
CHINESE ART AND ARCHITECTURE‖ *William
Watson, 2 vols.*

*Published only in original large hardback format.
†Latest edition in integrated format (hardback and
paperback).
‡Latest edition in integrated format (paperback
only).
§Published only in integrated format (hardback and
paperback).
‖Not yet published.

The glories of India's five-millennia-old artistic and architectural heritage are vividly illuminated in this, the first scholarly account in English to deal with the entire subcontinent, including Afghanistan, Pakistan, Nepal, Bangladesh, and Sri Lanka. Thirty years' research and first-hand knowledge of the area have enabled the author to trace the cultural contacts which have contributed to the rich mosaic of sculpture, temples, mosques, and painting that have gone towards the creation of one of the great civilizations of the world.

Starting with the Harappan cities of the Indus with their as yet undeciphered script, the development of Indian art is followed over five thousand years down to the nineteenth century. The historical period begins with the Buddha in the lower Ganges region, and sees the decoration of the great stūpas of Sāñcī and Amarāvatī at the very time that the strange hybrid art of Gandhāra, through which Alexander and his captains marched, was flourishing in the north-west. After the great rock-cut excavations unique to India, the indigenous art of Mathurā – which was to span several centuries – saw the birth of Indian iconography and the beginning of the astonishingly varied and vital repertory of sculpture which led directly to the splendours of the Gupta era, in many ways the golden age of Indian civilization.

Dr Harle goes on to chart previously neglected topics, outlining the glorious development of temple architecture which culminated in the great shrines of Madhya Pradesh and western India, perhaps the greatest material expressions of the Indian genius, and demonstrating that the well-known mosques and tombs of the Mughals – including the Taj Mahall – were only the last phase in several centuries of distinguished building. The separate treatment of South India gives their full due to the exquisite temples of the Early Coḷa period and the finest Indian bronze sculpture of all. In painting, the author